JAN STEEN

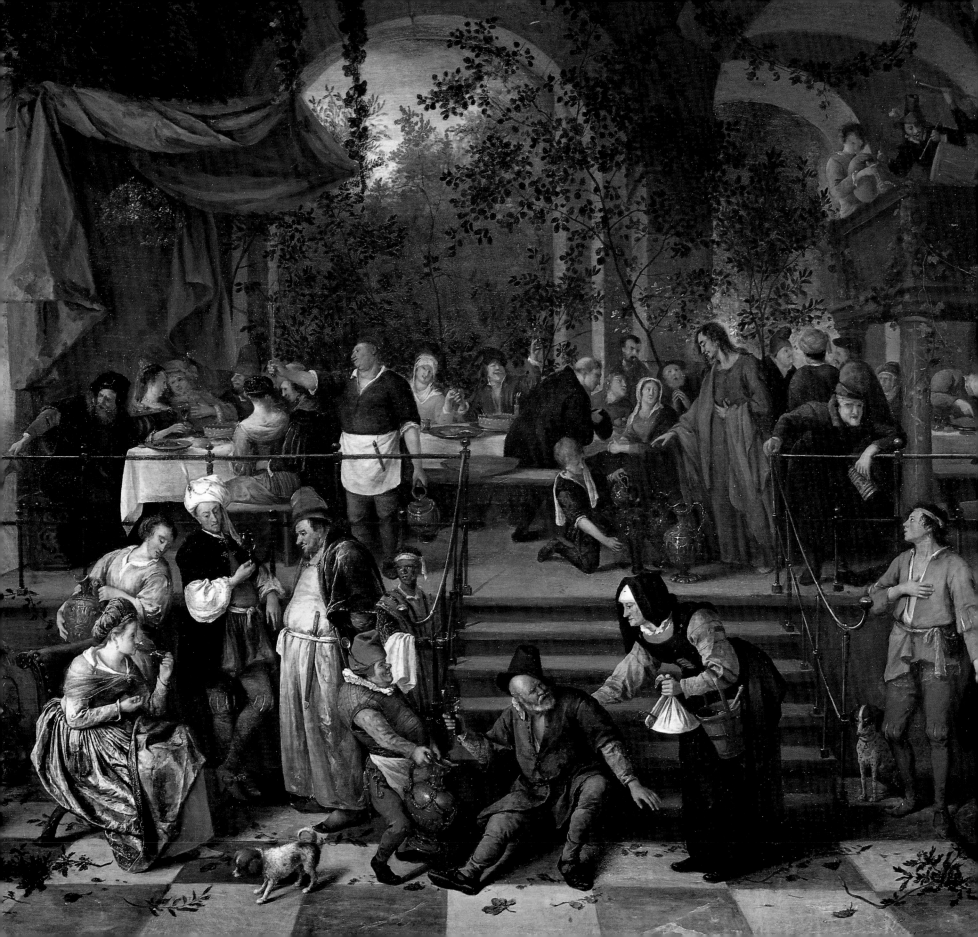

JAN STEEN

PAINTER AND STORYTELLER

H. Perry Chapman • Wouter Th. Kloek • Arthur K. Wheelock, Jr.

WITH CONTRIBUTIONS BY

Martin Bijl

Marten Jan Bok

Eddy de Jongh

Lyckle de Vries

Mariët Westermann

EDITED BY

Guido M. C. Jansen

NATIONAL GALLERY OF ART, WASHINGTON

RIJKSMUSEUM, AMSTERDAM

YALE UNIVERSITY PRESS, NEW HAVEN AND LONDON

*On behalf of its employees,
Shell Oil Company is proud to make possible
the presentation of the celebrated works of
Jan Steen to the American people*

The exhibition *Jan Steen: Painter and Storyteller* is organized by the National Gallery of Art, Washington, and the Rijksmuseum, Amsterdam.

The exhibition in Washington is supported by an indemnity from the Federal Council on the Arts and the Humanities.

NATIONAL GALLERY OF ART, WASHINGTON
28 April–18 August 1996

RIJKSMUSEUM, AMSTERDAM
21 September 1996–12 January 1997

The clothbound English edition is distributed by Yale University Press, New Haven and London, except in The Netherlands, where it is distributed by Waanders, Zwolle.

The English edition is produced by the National Gallery of Art, Washington, in collaboration with the Rijksmuseum, Amsterdam.

Editor-in-chief: Frances P. Smyth
Edited by Mary Yakush
Designed by Phyllis Hecht
Typeset in Dante and Castellar by Artech Graphics II, Baltimore, Maryland
Printed in The Netherlands by Waanders
on 150 grs MC Scheufelen

Texts by Martin Bijl, Marten Jan Bok, Arnold Houbraken, Eddy de Jongh, Wouter Th. Kloek, and Lyckle de Vries have been translated from the Dutch by Michael Hoyle.

Dimensions are in centimeters, followed by inches within parentheses, with height preceding width. Measurements are from painted edge to painted edge.

Library of Congress Cataloging-in-Publication Data
Chapman, H. Perry, 1954–
Jan Steen, painter and storyteller / H. Perry Chapman, Wouter Th. Kloek, Arthur K. Wheelock, Jr.: with contributions by Martin Bijl . . .[et al.]; edited by Guido M. C. Jansen.
 p. cm.
Exhibition organized by the National Gallery of Art, Washington and the Rijksmuseum, Amsterdam.
Includes Bibliographical references and index.
ISBN 0-89468-223-7 (paperback)
ISBN 0-300-06793-3 (clothbound)
1. Steen, Jan, 1626–1679—Exhibitions. I. Kloek. W. Th.
II. Wheelock, Arthur K. III. Jansen, Guido. IV. National Gallery of Art (U.S.) V. Rijksmuseum (Netherlands)
VI. Title.
ND653.S8A4 1996
759.9492—dc20 96–454
 CIP

COVER: detail, cat. 23
FRONTISPIECE: detail, cat. 43
ILLUSTRATIONS FOR PART-TITLE PAGES (details): page 10, cat. 25; page 24, cat. 12; page 38, cat. 7; page 52, cat. 24; page 68, cat. 27; page 82, cat. 42; page 92, cat. 32

CONTENTS

LENDERS TO
THE EXHIBITION

The Trustees of the Barber Institute of Fine Arts, University of Birmingham

Her Majesty Queen Elizabeth II

The Fine Arts Museums of San Francisco

The J. Paul Getty Museum, Malibu

Herzog Anton Ulrich-Museum, Brunswick

Kunsthistorisches Museum, Vienna

Los Angeles County Museum of Art

The Metropolitan Museum of Art, New York

Musée du Petit Palais, Paris

Museum Boymans-van Beuningen, Rotterdam

Museum Bredius, The Hague

Museum of Fine Arts, Boston

National Galleries of Scotland, Edinburgh

National Gallery of Art, Washington

National Gallery of Canada, Ottawa

National Gallery of Ireland, Dublin

The National Gallery, London

North Carolina Museum of Art, Raleigh

Norton Simon Art Foundation, Pasadena

Philadelphia Museum of Art

Private Collections

Rijksmuseum, Amsterdam

Royal Cabinet of Paintings Mauritshuis, The Hague

The Duke of Rutland

Skokloster Castle, Bålsta

Staatliche Museen Kassel

Staatliche Museen zu Berlin, Gemäldegalerie

Sudeley Castle Trustees, Great Britain

Fundación Colección Thyssen-Bornemisza, Madrid

The Toledo Museum of Art

The Board of Trustees of the Victoria & Albert Museum, London

Wallraf-Richartz-Museum, Cologne

FOREWORD

Jan Steen, one of the most admired and engaging of Dutch artists, stands apart for his wry and humorous view of the world. He is best known as a comic painter of dissolute households, quack doctors tending lovesick women, boisterous holiday gatherings, and rowdy tavern scenes. Yet Steen also produced genre paintings with a serious side, highly original portraits, and biblical and mythological histories that vary remarkably, from the quiet and intimate to the grand and melodramatic.

The careful selection of paintings in the exhibition surveys the breadth of this remarkable artist's achievement and provides an overview of his career, from his early works painted in The Hague around 1650 to those executed in the mid-1670s in Leiden. The paintings in the exhibition also provide evidence of Steen's genius as a compelling storyteller.

The exhibition and accompanying catalogue are the result of a close collaboration between the National Gallery of Art, Washington, and the Rijksmuseum, Amsterdam, that has extended over a number of years. The idea for this exhibition was proposed by H. Perry Chapman, professor of art history at the University of Delaware and guest curator at the National Gallery for the exhibition. Wouter Th. Kloek, head of the paintings department at the Rijksmuseum, and Arthur K. Wheelock, Jr., curator of northern baroque painting at the National Gallery of Art, guided the project at the two institutions. All three worked closely with Guido M. C. Jansen, curator at the Rijksmuseum and scholarly editor of the catalogue.

The catalogue also benefited from the contributions of a number of others. The noted scholar Eddy de Jongh writes lucidly about the difficulties inherent in interpreting Steen's paintings. Lyckle de Vries traces the evolution of Steen's career and the stylistic relationships between his paintings and those of his contemporaries. Marten Jan Bok, in an overview of the artist's rich and varied life, examines anew the many surviving documents about Steen. Michael Hoyle has translated Houbraken's biography, which is published here in English for the first time. Martin Bijl draws upon the evidence gathered during the restoration of several paintings. Mariët Westermann explores the many connections between Steen's work and the theater.

Jan Steen: Painter and Storyteller is made possible in Washington by the enthusiastic support of Shell Oil Company and its employees. We owe particular thanks to Philip J. Carroll, president and chief executive officer for his commitment to the National Gallery. The exhibition in Washington is supported by an indemnity from the Federal Council on the Arts and the Humanities. In Amsterdam, Visa Card Services and Fortis Nederland generously supported the exhibition.

Above all else, we are deeply indebted to our lenders whose generosity, cooperation, and good will have made this exhibition a reality.

HENK VAN OS
Director
Rijksmuseum

EARL A. POWELL III
Director
National Gallery of Art

ACKNOWLEDGMENTS

The opportunity to organize this exhibition of Jan Steen's paintings is one that we have embraced with great enthusiasm. Not only are Steen's paintings amusing, beautiful, and endlessly fascinating, but the time is also ripe for a reexamination of this artist's remarkably rich and varied achievement. Although Steen studies are complicated by the lack of a comprehensive *catalogue raisonné*, the documentary references assembled by Cornelis Hofstede de Groot (Hofstede de Groot 1907) and the information provided by Karel Braun (Braun 1980) have been extremely useful to our project. We have benefited from the work of numerous other scholars, cited in our bibliography, who have in recent years begun to give Steen the critical attention he deserves. New art historical approaches to the study of Dutch paintings, their meaning, and their place in Dutch culture and society; new ways of interpreting archival sources; and our increased scientific knowledge of artists' painting techniques have all made it possible to take a fresh look at the many fascinating questions surrounding the career and works of Jan Steen.

Steen, who was born and died in Leiden (1626–1679), moved from one artistic center to another, working at various stages of his career in Haarlem, The Hague, Delft, and Leiden. His travels and their effect on the stylistic character of his work are important for determining the chronology of his paintings. An artist who drew heavily from pictorial tradition, literary sources, and popular culture, Steen distinguished himself in particular as a comic painter. The relationship of his humor to theatrical practices and contemporary mores, the roles he played in his own paintings, and questions about how those roles reflect his own personality are among the topics explored in this exhibition and book. Steen was a Catholic artist in a predominantly Calvinist country. Although little is known about his attitude toward religion, his Catholicism, too, seems to have had an impact on his interpretations of popular festivals and biblical scenes.

Steen was at his very best a wonderful painter, with a remarkably deft touch. Yet, the quality of his work is uneven, and this may relate to the different markets for which he painted. We know that some of his finest and largest paintings were for private collectors, but many others must have been executed on speculation, for the open market. He also painted many works of lesser quality, which are not included in this exhibition. Inevitably, the exhibition will stimulate new interpretations about Steen, an artist whose paintings vary so much and about whom so many questions exist.

We are greatly indebted to H. Perry Chapman, guest curator for the exhibition at the National Gallery of Art, for proposing this exhibition and for her many contributions to the concept and character of our project. She joins us in thanking the many institutions and private collectors who have generously lent to the exhibition, and the numerous colleagues who gave it their wholehearted support: Colin Bailey, Pieter Biesboer, Albert Blankert, Peter de Boer, David Bomford, Christopher Brown, Marigene Butler, Sarah Campbell, Michael Clarke, Hans Cramer, Nora De Poorter, Bianca Du Mortier, Frederik J. Duparc, mevr. J. G. Duijn-Zegger, C. Willemijn Fock, Peter Führing, René Gerritsen, Jeroen Giltaij, Carl Grimm, Karin Groen, Egbert Haverkamp-Begemann, Johnny van Haeften, M. D. Haga, Ebeltje Hartkamp-Jonxis, Bas Dudok van Heel, John Hoogsteder, Willem Jan Hoogsteder, Jack Horn, Lea Eckerling Kaufman, Raymond Keaveney, Jan Kelch, Alison McNeil Kettering, Peter Klein, Els Kloek, Susan Lambert, Walter Liedtke, Tomàs Llorens, Christopher Lloyd, Julia Lloyd-Williams, Katherine Crawford Luber, Jochen Luckhardt, Ger Luijten, Ekkehard Mai, Jim van der Meer Mohr, Charles Moffett, Larry Nichols, Robert Noortman, Lynn Orr, Charles Roelofsz, Robert Jan te Rijdt, Joseph J. Rishel, Bernard Schnackenburg, Karl Schutz, Karin Skeri, Stephen Somerville, P. Spencer-Longhurst, Elke Stevens, Ariane van Suchtelen, Peter Sutton, Paul Taylor, Mark Tucker, John Walsh, Gloria Williams, Arno Witte, Martha Wolff, and H. W. M. van der Wyck.

We are especially grateful to Guido M. C. Jansen, curator at the Rijksmuseum, for the enthusiasm that he brought to his role as scholarly editor of this catalogue. In addition, he exhaustively researched the provenances, a task he shared with Mariët Westermann, who also contributed many astute comments that have been incorporated into the catalogue. Michael Hoyle expertly translated

portions of the manuscript from the Dutch into English, and his translation of Houbraken's biography of Steen is a welcome addition to Steen scholarship.

We are also indebted to numerous centers for scholarly research, whose staffs and resources were essential to the success of our project, including the British Library; Center for Advanced Study in the Visual Arts, Washington; Iconografisch Bureau, The Hague; Koninklijke Bibliotheek, The Hague; National Gallery of Art Library, Washington; Rijksbureau voor Kunsthistorische Documentatie, The Hague; and the Universiteitsbibliotheek van Amsterdam. We also thank the International Corporate Circle, National Gallery of Art, Washington, for their support of our project.

In the Rijksmuseum and the Rijksmuseum Foundation, the production of the exhibition and catalogue was a team effort, and the work of the individuals already cited was augmented by the contributions of Klaas Cammelbeeck, Irma Lichtenwagner, Otto de Rijk, Theo Schoemaker, Annemarie Vels Heijn, Vera de Vree, and Annelies Westendorp. Marie-Christine Vink was the liaison officer for corporate support, Frans van der Avert developed the publicity campaign, and Fieke Tissink was responsible for the educational program. Martin Bijl, Hélène Kat, Michel van de Laar, Laurent Sozzani, Gwen Tauber, and Manja Zeldenrust executed the restorations of the Rijksmuseum's paintings, which were photographed by Peter Mookhoek, Henk Bekker, Margareta Svensson, and Ben Bekooy. Marijke van de Wijst designed the installation of the exhibition in Amsterdam.

In Washington, Alan Shestack, deputy director of the National Gallery of Art, and Edgar Peters Bowron, senior curator of paintings, gave the project their unstinting support, as did numerous others. D. Dodge Thompson, chief of exhibitions, and his staff, especially Ann Bigley Robertson, aided by Stephanie Fick and Jennifer Fletcher, capably handled the organization and administration, and Susan Arensberg prepared educational materials in collaboration with Lynn Russell of the department of adult programs. Ann R. Leven, treasurer, assisted by Nancy Hoffmann, coordinated insurance; in the division of external affairs, headed by Joseph Krakora,

Sandy Masur, assisted by Diane D. Colaizzi, obtained crucial financial support; and Deborah Ziska, head of the information office, carried out the extensive publicity effort and worked with press and film crews. In the scientific department, Michael Palmer and Melanie Gifford undertook essential research on Steen's painting techniques; in the conservation department, Mervin Richard supervised the delicate process of packing and safely transporting the works to and from Washington; in the office of the registrar, headed by Sally Freitag, Lauren Cluverius Mellon, Daniel Shay, and Ellen Evangelista coordinated and carried out the shipments; in the department of visual services, headed by Ira Bartfield, Barbara Chabrowe and Sara Sanders-Buell gathered color transparencies from lenders; in the secretary-general counsel's office, headed by Philip C. Jessup, Jr., Nancy R. Breuer and Marilyn T. Shaw provided expert counsel; while Neal Turtell, executive librarian, and his staff, especially Ted Dalziel and Lamia Doumato, offered research assistance over the years. We are especially indebted to Gaillard Ravenel, senior curator and chief of the office of installation and design, and to Mark Leithauser, Gordon Anson, and Barbara Keyes, who conceived and executed the design of the exhibition in Washington.

Numerous individuals in the Gallery's department of northern baroque painting were essential to the project. In particular, we thank Quint Gregory for his dedication to our project and especially for his meticulous research for and compilation of the sizable bibliography on Steen, and Kate Haw who coordinated the administration of the exhibition within the department. We are also greatly indebted to an extraordinary group of interns for their research on Steen's paintings and for their insights and comments on the catalogue and educational texts: Aneta Georgievska-Shine, Meredith Hale, Clarissa Post, Esmée Quodbach, Melinda Vander Ploeg-Fallon, Pien Brocades-Zaalberg, and especially Alicia Walker.

Many people worked tirelessly to edit and design the English edition of the catalogue. We are especially grateful to the Gallery's editors office, under the leadership of Frances Smyth, for producing a remarkable book in spite of scheduling difficulties. In particular we would like to thank Mary Yakush, who with customary grace and skill supervised the preparation and editing of the manuscript for the English edition, and Phyllis Hecht, who created an especially elegant design. Julie Warnement and Mariah R. Seagle assisted them throughout the course of the catalogue production.

To all those who have helped bring our project to its successful conclusion, we extend our deepest gratitude.

WOUTER TH. KLOEK and ARTHUR K. WHEELOCK, JR.

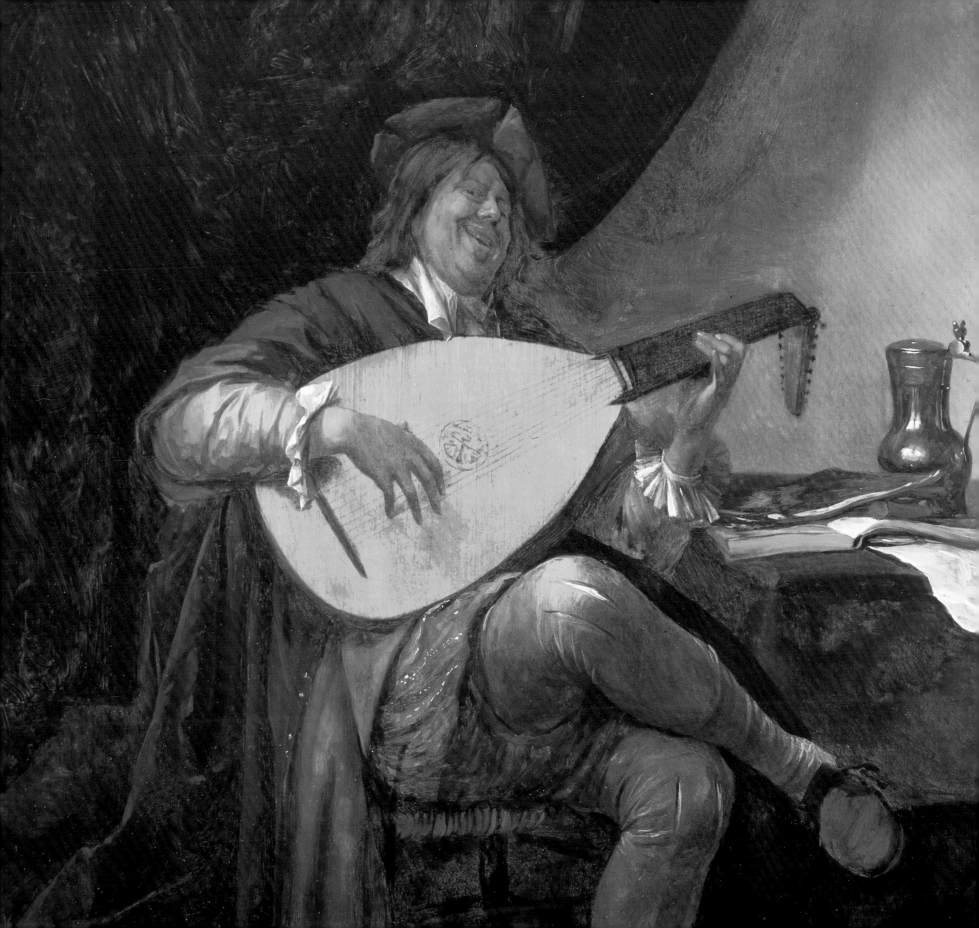

JAN STEEN, PLAYER IN HIS OWN PAINTINGS

H. Perry Chapman

Jan Steen's culture believed in the topos "every painter paints himself," yet few other artists responded to this notion quite so literally.[1] In a period when artists customarily individualized their styles and many painted self-portraits, Steen personalized his art to an unusual degree, infusing much of it with his wryly comic personality. Especially in his boisterous family gatherings and bawdy tavern interiors, he often included himself. Steen's claim, through his self-portraits, that these pictures tell his own story may be one reason why they still captivate viewers in the late twentieth century, three hundred years after his death.

Even Steen's eighteenth-century biographers found his life inseparable from his paintings. The Dutch proverb "a Jan Steen household," which originated in the eighteenth century and is used today to refer to a home in disarray, full of rowdy children, connotes a household at once like those Steen painted and like the one he intimated was his own. This conflation of art and life encapsulates the confusion that his presence in his paintings so insistently invites. Indeed, the unlikelihood of "a Vermeer household" entering popular usage, or of any other Dutch painter yielding such an expression, underscores the direct appeal of Steen's beguilingly personal narratives.

The conflation of art and life

Spotting Steen in his paintings remains a compelling aspect of his work. We know Steen's face from his one formal self-portrait and *Self-Portrait as a Lutenist* (cats. 40, 25)—but also from many genre paintings in which he plays the comic roles of fool, profligate, or rogue. Often he plays a supporting part. In *As the Old Sing, So Pipe the Young* (cat. 23) he mischievously teaches a child to smoke a pipe, thereby serving as the punning embodiment of the painting's proverb. In the *Merry Company on a Terrace* (cat. 48) he presides, as jolly tavern owner, over a scene of temptation and indulgence. Sometimes he is the protagonist. In *Easy Come, Easy Go* (cat. 15) he takes center stage

fig. 1. Jan Steen, *Antony and Cleopatra*, c. 1668–1669, oil on canvas, The Netherlands Office of Fine Arts, The Hague. Museum Boymans-van Beuningen, Rotterdam

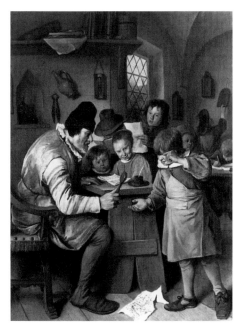

fig. 2. Jan Steen, *The Punishing Schoolmaster*, c. 1663–1665, oil on canvas, National Gallery of Ireland, Dublin

as a wastrel at Fortune's mercy, wantonly squandering his wealth on women, wine, and notoriously aphrodisiacal oysters. In *The Merry Threesome* (cat. 42) he is a besotted old buffoon, blissfully compliant as the object of his desire picks his pocket. Steen also appears in biblical and historical pictures: in *Antony and Cleopatra* (fig. 1) he is a bystander in fool's guise, who comments on the main action of the narrative.

Steen's wives (he married twice) and children also frequent his paintings and, like him, they are often cast as comic transgressors, or witnesses to transgression.[2] The children in *The Punishing Schoolmaster* (fig. 2) correspond in age to Steen's own offspring. And they look like the children in *The Feast of Saint Nicholas* (cat. 30). The same cast appears to be a little older in the *Children Teaching a Cat to Dance* (Rijksmuseum, Amsterdam). An inscription, dated 1738, on the back of *The Leiden Baker Arent Oostwaert and His Wife Catharina Keyzerswaert* (cat. 8) identifies the boy blowing the horn as "done after a son of Jan Steen." This same boy, now slightly older, appears in *The Drawing Lesson* (cat. 27). The

familiarity that arises from the repetition of these figures suggests that, even if these are not "portraits" of his family in a conventional sense, they constitute his pictorial family. This cast of characters functions much like Steen's repeated inclusion of himself as a serialized protagonist.[3]

While identifying Steen was, and is, by no means essential to appreciating his pictures, it could enhance a viewer's experience of them in different ways. Steen's closest audience would have been his family. How his children took his not always flattering treatment of them we can only wonder. Looking at his representation of himself and his first wife, Margriet van Goyen, in *The Revelers* (fig. 3) or at the way he portrays his second wife, Maria Herculens van Egmond, in the *Merry Company on a Terrace* (cat. 48), it is not surprising that one of Steen's early biographers reported that the painter Carel de Moor (1656–1738)

once came upon (Maria Herculens) in a despondent mood, complaining . . . that Jan depicted her sometimes as an indecent object, sometimes as a horny tart, or

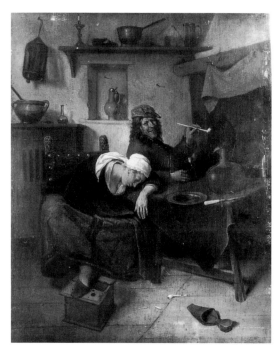

fig. 3. Jan Steen, *The Revelers*, c. 1658–1660, oil on canvas, Hermitage State Museum, St. Petersburg

sometimes as a match-maker or a drunken whore, which annoyed her. She added that she wished to be portrayed as a proper woman[4]

Steen's immediate contemporaries and clients may have derived a certain satisfaction from recognizing him and being in on the joke. Steen lived in a society that operated on a face-to-face basis and the systems for marketing paintings, especially those of high quality, frequently involved contact with the painter or a dealer who had obtained the works from the painter.[5] Descriptions in eighteenth-century sale catalogues confirm that the presence of Steen and his family members was a selling feature from early on.[6]

By Steen's day portraying oneself in a larger work was a convention that would have been familiar to the more discriminating segment of his audience. Moreover, in Holland, mercantile values fostered the competitive cultural traits of wit, exchange, and challenge. To succeed in the highly competitive art market, Dutch painters adopted innovative strategies not only for producing and selling their works, but also for differentiating themselves creatively.[7] To an urban audience that prized clever exchange, Steen's comic role-playing provided a way for him to draw attention to himself. For Steen, fashioning himself as the fool or witness to folly was a comic strategy and a complex pictorial device destined to baffle and confound us. His consistent use of his own features at once makes the artist seem eternally present and raises the question of what the "real" Steen was like. Despite the unknowableness of the man behind the mask, generations of viewers and critics have been unable to resist the temptation to construct his personality from his pictures.

Steen's critical reputation

This distinctive merger of real and pictorial life has colored writing on Steen from its inception. Eighteenth- and nineteenth-century authors conflated Steen's life with his art to craft an image of him as a jovial rake and profligate much like the character he plays in *Easy Come, Easy Go*. Modern critics, eager to separate fact from myth, and to correct the fallacy of "Jan Steen's household," have claimed that the legendary Steen has little to do with the

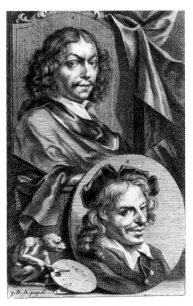

fig. 4. "Frans van Mieris and Jan Steen," in Arnold Houbraken, *De groote schouburgh…*, 1721, National Gallery of Art Library, Washington

real one. Most recently, it has been recognized that, by repeatedly portraying himself in his paintings, Steen fashioned his own persona.[8]

Steen's first biographer, Arnold Houbraken (1660–1719), wrote that Steen's "paintings are as his way of life and his way of life as his paintings."[9] Houbraken's portrait of Steen (fig. 4, at lower right), which contrasts his clever wit with Frans van Mieris' (1635–1681) sober dignity, confirmed that the artist's nature was "inclined to farce." Houbraken was a marvelous storyteller with a classicist agenda and he crafted Steen's biography largely from humorous, seemingly far-fetched anecdotes that have the ring of both contemporary farces and Steen's own genre scenes. Despite the common wisdom that Steen's earliest biographies are no more than idle gossip, we now know (see pages 25–37) that these accounts have some basis in fact, though they are exaggerated and fanciful.

Houbraken characterized the "droll" Steen as a jocular sot, a hapless ne'er-do-well, constantly in financial straits, who nevertheless was unsurpassed as a master of a lower, comic mode of painting. He begins by relating that Steen treated the daughter of his master Jan van Goyen (1596–1656) "so farcically that she began to swell" and so he had to marry her. As evidence of Steen's domestic disarray, he describes a picture much like the *Dissolute Household* (fig. 5):

The first piece that he made was an emblem of his disorderly household. The room was in complete disarray, the dog slobbered from the pot, the cat ran off with the bacon, the children rolled about wildly on the floor, and Ma sat watching, taking it easy in a chair, and as a joke Steen added his own likeness, with a roemer in hand, and on the mantelpiece was a monkey gazing at all of this with a long face.[10]

Many of Houbraken's anecdotes center around Steen's second occupation as brewer and innkeeper. Set up with a brewery by his father, Steen buys wine instead of malt. When the beer runs out and guests stop coming, he fills a vat with ducks and so brings life to the tavern—*"leven in de brouwerij brengen,"* an expression still used in the Netherlands, derives from this event.[11] Then he turns to painting to make a living. As an innkeeper who was "his own best customer," he would close shop until he could trade a painting to the wine seller.[12] The implication is that he was a sot who painted not out of love of art but solely for the basest reason, profit.[13]

Recognizing Houbraken's classicist bias and understanding his fundamental assumption that an artist's life is like his art has led to a greater appreciation of his theoretical purpose, which was to champion Steen as the exemplar of the comic painter who, like the comic actor, excelled at expressing the passions and at imitating everyday life.[14] Houbraken has been blamed for inventing the "myth" of Jan Steen. However, Steen's self-images suggest that Houbraken did not so much invent the myth as exaggerate the role Steen played in his own paintings, and possibly, though the evidence is inconclusive, in his life as well. In so doing he set in print the misconception that Steen, the master of low life, could not paint histories; hence the *Wedding of Tobias and Sarah* (cat. 32), which Houbraken at one point

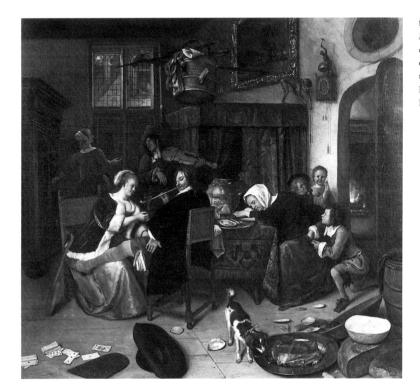

fig. 5. Jan Steen, *The Dissolute Household*, c. 1663–1665, oil on canvas, The Board of Trustees of the Victoria & Albert Museum [exhibited at Wellington Museum, Apsley House], London

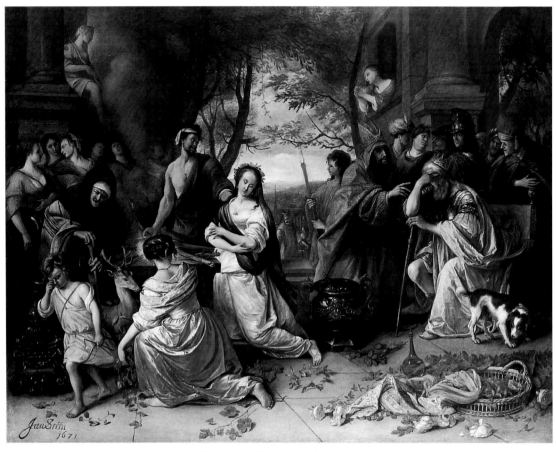

fig. 6. Jan Steen, *The Sacrifice of Iphigenia*, 1671, oil on canvas, Rijksmuseum, Amsterdam

owned, exemplifies Steen's genius as a teller of stories from daily life.[15] As in the early biographies of Rembrandt (1606–1669)and Caravaggio (1571–1610), flouting the decorum of artistic behavior and practice is evidence of anti-classicism, which renders the artist suspect.[16]

Subsequent writers quickly lost sight of Houbraken's theoretical brief as they took the myth ever more literally. Jacob Campo Weyerman (1677–1747), writing shortly after and drawing partly on Houbraken and partly on first-hand information from Carel de Moor, produced a biography that was more accurate about certain details of Steen's life and career, and more yet anecdotal.[17] Weyerman, who opens with the statement that Steen "made himself notorious in the Netherlands, both by his spirited paintings and by his comical lifestyle,"[18] largely eliminated the theoretical aspects of Houbraken's biography. Still, he credited Steen with a theoretical bent:

But however slack Jan Steen was in his behavior, he was not slack at all in his philosophical knowledge about, as well as the practice of, painting. According to Mr. Karel de Moor, artist and knight, he held forth so reasonably about every aspect of art that it was a pleasure to be a witness to his speeches.[19]

This side of Steen was almost immediately forgotten.

Joshua Reynolds' brief remarks on Steen, in his *Discourses*, encapsulate the eighteenth-century acade-mic view of him as an unschooled though innately talented imitator of nature. He praised Steen's "power in expressing the character and passions of . . . vulgar people":

I can easily imagine, that if this extraordinary man had the good fortune to have been born in Italy, instead of Holland; had he lived in Rome, instead of Leyden, and been blessed with Michel Angelo and Raffaelle for his masters, instead of Brouwer and Van Goyen; the same sagacity and penetration which distinguished so accurately the different characters and expressions in his vulgar figures, would, when exerted in the selection and imitation of what was great and elevated in nature, have been equally successful; and he would now have ranged with the great pillars and supporters of our Art.[20]

Reynolds (1723–1792) perpetuates the miscasting of Steen as a painter of peasant genre who failed miserably at historical and biblical works because he lacked the proper classical training. He regards the *Sacrifice of Iphigenia* (fig. 6) as so "ridiculous" that one is "tempted to doubt whether the artist did not purposely intend to burlesque the subject."[21]

Early nineteenth-century critics romanticized Steen's image as drunken profligate, shaping it to fit their notions of artistic genius and ideal of the bohemian artist. In 1828, the Dutch painter Ignatius Josephus van Regemorter (1785–1873) immortalized Steen's association with the tavern in his poignant *Jan Steen Sending His Son Out to Trade Paintings for Beer and Wine* (fig. 7).[22] The English art dealer John Smith, who in 1833 published the first catalogue of Steen's paintings as part of his multi-volume *Catalogue Raisonné of the Works of the Most Eminent Dutch, Flemish, and French Painters*, was the first of many to use Steen's two self-portraits as barometers of his artistic personality, thereby giving new scholarly sanction to the tendency to treat Steen's paintings as autobiography. Smith had the rakish *Self-Portrait as a Lutenist* (cat. 25) engraved for his frontispiece, as if it summed up Steen's character.[23] In contrast, he dismissed the Rijksmuseum *Self-Portrait* (cat. 40) as "an indifferently painted picture."[24] To Smith, Steen was striking proof that "every painter exhibits to a certain extent his own disposition and character in his works."[25] His biography reads as a tragi-comic moral lesson:

Unhappily his uncontrollable inclination for liquor and low company increased with his years, and perpetually plunged him and his family into poverty and distress Thus was the greater portion of a valuable life consumed, and vigorous talents destroyed[26]

Smith could praise Steen's early works for their "neatness and beauty of finishing," but

His latter productions show the baneful effects of an irregular and debauched life: they are frequently vile in subject, and consequently vile in the characters and expressions. . . . Notwithstanding this degeneracy, every picture from his hand bears the stamp of genius.[27]

Steen's critical fortunes began to reverse by the mid-nineteenth century when scholars turned to a more historical, documentary approach to achieve a balanced reconciliation of personality and fact. Dutch scholars in particular, motivated unconsciously by nationalistic concerns to rehabilitate one of the Netherlands' greatest painters, began to paint a more positive picture of Steen's life as they elevated his pictures to the status of moral lessons.[28] Tobias van Westrheene, whose *Jan Steen. Étude sur l'art en Hollande* of 1856 was the first monograph on a Dutch painter, consciously set out to temper Steen's reputation by eliminating from his biography the unsubstantiated "rhapsodie d'anecdotes" that had tainted writing since Houbraken.[29]

By the 1920s, Wilhelm Martin, director of the Mauritshuis and instigator of the first exhibition devoted to Jan Steen, had transformed Steen into "a diligent, cheerful artist, a good family man, a merry companion to those with whom he shared an occasional drink."[30] Martin found that his paintings reflected his wholesome approach to life and that his *Self-Portrait* in the Rijksmuseum represented the real Steen: its "knowing glance, and half sarcastic, half jovial" mouth are evidence that the artist is above the foolishness he paints.[31]

A year later, in the monograph by Schmidt-Degener and Van Gelder, Steen was so thoroughly rehabilitated that he had attained near preacher status: "The text of his sermon was keen enjoyment of life, and his preaching found expression in his practice."[32] Emphasizing the theatricality of Steen's art meant that his appearance in his own paintings

fig. 7. Ignatius Josephus van Regemorter, *Jan Steen Sending His Son out to Trade Paintings for Beer and Wine*, 1828, oil on panel, Rijksmuseum, Amsterdam

could be essentially play acting: "Just as Shakespeare and Moliere appeared in their own plays, Steen himself, with incredible ease, trod the boards in the midst of the characters of his imagination."[33] Steen's formal *Self-Portrait* is a mask:

It is often said that the large self-portrait in the Rijksmuseum is Steen's official portrait, which is almost a contradiction in terms. . . . he kept his face in repose, but for one brief moment only: his earnestness was only fleeting pretense . . . his every feature is challenging: his nose impudent, his mouth untidy, his chin assertive. . . . His pale, vital face with its scarcely suppressed laugh has a something outside the human that makes one think of a satyr, and of a satyr who has tasted Dionysiac joys.[34]

Subsequent scholars approached the relation between Steen and the theater more systematically, demonstrating its influence on his subject matter, costuming, and characters.[35] Once Gudlaugsson had identified a number of Steen's characters as stock comic types from the popular chambers of *rederijkers* and

traveling theatrical companies, the *Self-Portrait as a Lutenist* could be seen as Steen painting himself in the role of suitor and, hence, removed from the realm of autobiography.[36] With this theatrical context, this self-image had been transformed from "the true Jan Steen," as the French critic Thoré-Bürger put it in 1858, to a genre painting pure and simple.[37] The catalogue of the large Steen exhibition of 1958 remarks only that "Steen's sixteenth-century Spanish-inspired costume was worn by actors playing the role of suitor."[38]

Scholarship within the past twenty years has tended to question the more colorful side of Steen's personality, and, as a corollary, to be skeptical of considering his likenesses as self-portrayals. In this reappraisal of Steen's critical reputation, his legendary image as a proto-bohemian profligate has been overturned. This revisionism, which is part of a broader trend to demythologize artists and expose the historicity of notions of artistic genius, reflects the extensive reassessment of Rembrandt.[39] On the one hand, historiographic investigation has attributed Steen's popular mythic image to the early biographer. According to this view, Houbraken invented the myth of Steen's dissolute life solely to put forth his classicist theory of comic painting as a low genre of art.[40] Lyckle de Vries' perceptive analysis of the theoretical basis of Houbraken's account was oversimplified by subsequent authors who dismissed the myth altogether, despite the evidence of the paintings. On the other hand, recent critics, recognizing the impossibility of retrieving an artist's personality over the expanse of three centuries, have turned their attention to Steen's construction of a persona.[41] By seeing Steen's theatrical role-playing as a comic pictorial strategy, it is possible to reconcile his legendary loutish image with his seemingly contradictory artistic ambition, success, and sophistication.

The paradoxical Steen

In critical ways the Steen that emerges from the archival documents, and from the evidence of his paintings, is strikingly at odds with his popular image as a boorish, unschooled tavernkeeper. To be sure, the limited source material does substantiate aspects of the myth (see pages 29–33). Steen did indeed have financial troubles. He was a brewer's

son, who, in the 1650s, is mentioned as a brewer in Delft and who in 1672 was granted permission to open an inn in Leiden, though no documents confirm that he set up the business. Yet upon close examination of the pictorial evidence his activity as a brewer and innkeeper, which was so central to the early biographies, becomes just one somewhat paradoxical, aspect of his life. For underneath his uncouth image Steen turns out to be learned, witty, ambitious, and unexpectedly knowledgeable about art. His comic role-playing becomes all the more meaningful when we uncover the extent to which it is a fictional stance designed to play off against his factual self.

Steen's artistic erudition and breadth, his clientele, and his self-consciousness all belie his popular image. Despite his irreverent mockery of teachers and schooling in such pictures as *The Severe Teacher* and *School for Boys and Girls* (cats. 35, 41), Steen must have been relatively well educated. The record of his registration at Leiden University at age twenty, in 1646, suggests he had attended the Latin School, where he would have learned Latin and read the essential classics.[42] Little is known about his artistic education, but it seems that, like Rembrandt, Steen pursued a wide-ranging course of training with several masters in different towns. Houbraken says he was a pupil of Jan van Goyen in the Hague and Weyerman reports that he also studied with Nicolaes Knüpfer (c. 1603–1660) in Utrecht and Adriaen van Ostade (1610–1684) in Haarlem.[43] The similarity of his very early *Winter Landscape* (cat. 1) to a slightly earlier one by Isack van Ostade (1621–1649) (cat. 1, fig. 1) confirms that he trained in the studio of the Van Ostades, while Brouwer-like elements in his works are evidence of a broader Haarlem interest. And his history paintings seem indebted to Knüpfer's lively and unconventional historical mode. Steen must have completed his training by 1648, for in that year he became a charter member of the Leiden Saint Luke's guild. That he was a guild officer in the 1670s suggests that, beyond benefitting from the advantages of professional organization, he played an actively responsible role.

Weyerman praised Steen's "philosophical knowledge" of painting, which he set forth in long speeches.[44] But aside from this brief statement, our only evidence of Steen's ideas about art and knowledge of art theory is gleaned from his paintings. His *Drawing Lesson* (cat. 27) demonstrates that he was familiar with the theoretical principles of his day. And, through its gentle sendup of the artist, it hints at his irreverent attitude toward the lofty professional ideals to which many of his contemporaries subscribed. A fundamental aspect of seventeenth-century art theory was the relation between painting and the theater. Steen stands apart in the way he took this to heart. The *Rhetoricians at a Window* (cat. 24) is one of many works in which he represented the amateur actors of his day. He imparted a sense of theatricality to countless other works (see cats. 32, 44) by employing stagelike settings and curtains, stock types in theatrical costumes, and rhetorical gestures and exaggerated expressions.

Steen, again like Rembrandt, distinguished himself from many of his contemporaries by his artistic breadth and versatility. Whereas many Dutch painters specialized in portraiture, genre, landscape, still life, and the like, Steen painted a broad range of subjects, including biblical ones, from the outset. He seems to have set out, too, to push the limits of pictorial types, merging portraiture with genre and blurring the edges between genre and history.[45] Moreover, his paintings, despite their comic, often low and vulgar subjects, display a witty erudition and an exceptional familiarity with artistic tradition. Like Rembrandt, who was fascinated by Rubens (1577–1640) and the Italian Renaissance, Steen looked beyond his immediate milieu for inspiration, though his interests are largely in the Northern tradition of comic moralizing. From beginning to end of his career, many of Steen's works are deliberately archaizing, a characteristic that sets him apart from virtually all of his immediate contemporaries.[46] Steen's lifelong fascination with the art of Pieter Bruegel the Elder (c. 1525–1569) begins with his very early *Fat* and *Lean Kitchens* (cats. 2, 3), the latter of which reveals in the inclusion of an easel (in the back at left) an ironic appreciation for the painter's precarious social and economic status. *As the Old Sing, So Pipe the Young* (cat. 23) draws directly from Jacob Jordaens (1593–1678), who himself was at once reviving an older Flemish tradition and commenting on the master-pupil relation. This profound engagement with earlier Netherlandish art is epitomized by the compilation of Boschian and Bruegelian motifs in the late *Village Revel* (cat. 46). Steen's admiration for his most illustrious townsman, Lucas van Leyden (1489–1533), is evident in his appropriation of Lucas' figures and compositions in *The Return of the Prodigal Son* and *The Worship of the Golden Calf* (cats. 39, 47).

Moreover, his choice and handling of religious subject matter, as in *The Supper at Emmaus* (cat. 31), reveal an intimate and thoughtful knowledge of the Bible and of artistic tradition and may reflect his own Catholicism. Pointed references to Italian Renaissance works speak to the depth of his artistic knowledge and his irreverent attitude toward the past: for example, his *School for Boys and Girls* (cat. 41) recasts Raphael's *School of Athens* as low genre in order to challenge high art.[47] Further, Steen comments on works by his Dutch colleagues with a remarkably sharp wit and sophistication. The *Girl Offering Oysters* (cat. 9) seems to be a clever emulation of the Leiden fine manner.

While Steen may have had financial difficulties, he must have enjoyed considerable artistic success and this is reflected in the social prominence of some of his clients. The sale to the Swedish governor-general of Pomerania, at the very beginning of his career, of four paintings—the *Winter Landscape* just mentioned, a *Fat Kitchen* and a *Lean Kitchen* (probably cats. 2, 3), and a *Story of Hagar*—attests to his early ambition and fame.[48] Although several of his pictures were owned by brewers, they also were to be found in the collections of some of the most prominent families in Leiden, among them the Paedts and De la Courts (see cats. 49, 27). And, though he never lived there, his works were in important Amsterdam collections as well. His comic genre scenes and genrified histories, and his stance as unschooled, buffoonish painter, must have appealed to this cultural elite's particular penchant for low-brow comedy that served as a vehicle for wit.[49] The sophistication of his clientele seems to confirm that Steen's level of self-consciousness presumed an immediate audience of cognoscenti who knew the oeuvre and delighted in the challenge it presented.

Steen's comic persona

So Steen emerges as unusually accomplished, sharply intelligent, highly self-conscious, and theatrically minded, a personality radically at odds with the roguish identity he constructed in paint. Setting aside the unanswerable question of whether he actually behaved like his painted counterpart, it is possible to consider Steen's self-portrayal both as a pictorial device designed to confuse the line between art and life and as a professional stance through which he defined his artistic identity. Steen's masking is a strategy of comic inversion that worked in complex ways to proclaim at once the veracity and the theatricality of his images. In this sense, his persona relates to ideas about art and imitation, specifically about comic art that imitates ordinary life for the purpose of imparting moral truths. It was also through his roguish masking that Steen allied himself with the notion of the artist as breaker of rule and decorum, a proto-bohemian alternative to the dominant ideal of the learned gentleman painter.

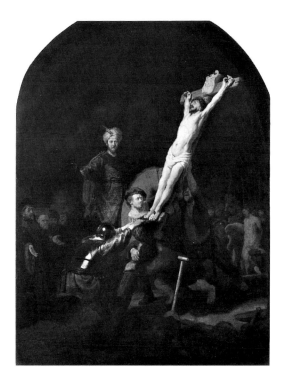

fig. 8. Rembrandt, *The Raising of the Cross*, c. 1633, oil on canvas, Alte Pinakothek, Munich

Placed against the background of sixteenth- and seventeenth-century modes of self-representation, Steen's comic self-portrayal is unique in painting yet grounded in his culture.[50]

Steen's repeated insertion of himself into his genre and historical pictures is linked to pictorial and theatrical traditions at the same time that it is highly individual. His self-images are essentially "participant" self-portraits, updated and transformed through his appreciation of comedy. Though rooted in antiquity, the practice of including oneself in a larger work as a mark of authorship took hold in the Renaissance. As Vasari and Van Mander report, many fifteenth- and sixteenth-century painters portrayed themselves in important commissions.[51] Functioning as a pictorial signature, the self-portrait spread the artist's fame and preserved his likeness for posterity. It also helped establish a link between artist and audience. Alberti had advised the painter to include a figure who addresses the viewer and draws him into the *historia*. Raphael (1483–1520) performs this role in his *School of Athens*. Making that bystander into a self-portrait transformed the artist into an eyewitness, giving him special authority to narrate, or comment on, a historical subject, or testifying to his faith in a biblical one. Albrecht Dürer (1471–1528), who appears as the only earthly being in his *Adoration of the Trinity* altarpiece, claimed for the artist a special closeness to God by virtue of his creative powers.[52]

The artist's very presence could shift the event from the distant past to the immediate present, thereby proclaiming its veracity for all times. Rembrandt's participation in his *Raising of the Cross* (fig. 8) has this effect. His appearance as one of the henchmen helping to hoist the cross fits within the tradition of the self-portrait *in malo*, in which the artist identifies with Christ's tormenters as a way to proclaim his humble devotion and inspire the viewer to do the same.[53]

Rembrandt's participant self-portraits may have provided the most immediate model for Steen's inclusion of himself in his biblical and historical pictures. But Steen, by portraying himself as a fool in such works as *Antony and Cleopatra* and *The Wrath of Ahasuerus* (cat. 44, fig. 2), recast the type in a comic mode. Antecedents for this moralizing mode of

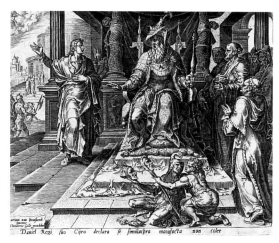

fig. 9. Maerten van Heemskerck, *Daniel and the Priests of Bel before the King of Babylon*, engraving, Rijksprentenkabinet, Amsterdam

address are found in sixteenth-century *rederijker* plays and related imagery in the form of the fools and *sinnekens* (fool-like personifications of the vices) who constituted a play's moral voice, commenting on its action, rebuking its characters, and explaining its message. (The fool derives this moral status from his dual identity as one who knows at once everything and nothing at all. He is the low, marginal figure who imparts wisdom to the highborn.)[54] In a series of prints representing the story of Daniel by Maerten van Heemskerck (1498–1574) (fig. 9), a pair of fools guides our response to the narrative. Steen's first-person presence functions analogously to the Falstaffian fool-like prologue speakers, commentators, and narrators who address audience or viewer in seventeenth-century Dutch plays and prints.[55]

Far more often, Steen cast himself in his genre paintings and in so doing he transformed the participant self-portrait into something all his own. Inserting oneself into a genre painting was a more recent permutation of the participant self-portrait. A theoretical framework for Steen's practice of including himself and his family in genre subjects can be established by examining the period's notion of comedy as the truthful mirror of ordinary daily life. Seventeenth-century literary and artistic theory,

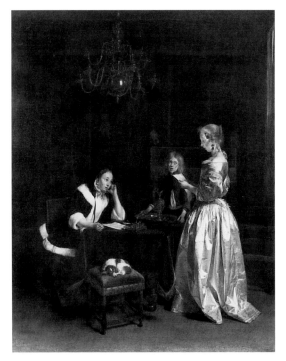

fig. 10. Gerard ter Borch, *The Letter*, c. 1660, oil on canvas, The Royal Collection © 1996, Her Majesty Queen Elizabeth II

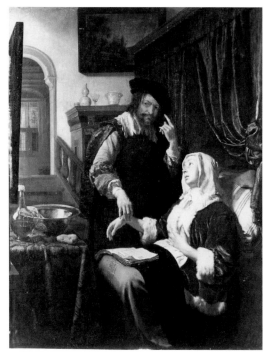

fig. 11. Frans van Mieris, *The Doctor's Visit*, 1657, oil on copper, Kunsthistorisches Museum, Vienna

by Gerard ter Borch (1617–1681), Frans van Mieris, and Johannes Vermeer (1632–1675), for he regarded such slavish naturalism as appropriate only in peasant scenes. He writes disdainfully of painters who

persuade one another that . . . it is enough to follow nature, though she be defective. . . . and such is their zeal that one paints. . . the air of his wife, though ever so ugly, with all her freckles and pimples very exactly. . . . Another chuses his clownish unmannerly maidservant for his model, and makes her a lady in a saloon: Another will put a lord's dress on a schoolboy, or his own son, though continually stroaking his hair behind his ears, scratching his head, or having a down-look; thinking it sufficient to have followed nature, without regard to grace, which ought to be represented; or having recourse to fine plaister-faces, which are to be had in abundance.[58]

Though out of keeping with eighteenth-century taste, modeling anonymous figures after family members was common practice among the genre painters most important to Steen. Gerard ter Borch's sister and brother recurrently figure in his elegant courtship scenes, as for example *The Letter* (fig. 10). Frans van Mieris, in his *Doctor's Visit* (fig. 11), casts

drawing on classical antiquity, defined comedy as the mirror of everyday life or the lifelike imitation of common or ordinary people for the purpose of moral instruction.[56]

Two authors, commenting on genre painting at the very beginning and end of Steen's century, suggest that the practice of using real models in scenes of daily life arose from a desire to achieve convincing verisimilitude. According to Van Mander, Pieter Bruegel the Elder made incognito forays to country fairs and weddings for the purpose of observing peasants' manners and customs in order to draw them *nae 't leven*.[57] Bruegel, Van Mander's exemplar of the comic, was living proof that the truthful representation of ignoble subjects was predicated on firsthand experience.

In contrast, the classicist theorist and painter Gerard de Lairesse (1641–1711) considered it indecorous to use recognizable individuals as models in what he called the *"burgerlijk"* mode of genre painting, by which he meant the genteel society painted

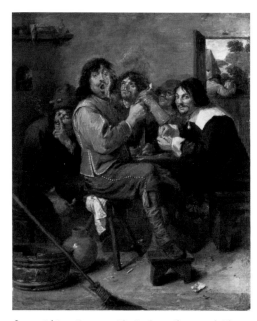

fig. 12. Adriaen Brouwer, *The Smokers*, oil on panel, The Metropolitan Museum of Art, New York

himself as the quack tending to a lovesick young woman. Jacob Jordaens, whom Steen clearly admired for his comic approach, provided an important precedent when he used himself and his family in several versions of *Twelfth Night* and *As the Old Sing, So Pipe the Young* (cat. 23, fig. 2), subjects that Steen later painted.[59] To these and other painters, painting a repertory of familiars offered evidence of the veracity of the image.

Painters also portrayed themselves up to no good in taverns as statements of their artistic identity. Weyerman reports that, according to Carel de Moor, Adriaen Brouwer (1605/1606–1638) represented himself and two of his painter colleagues in *The Smokers* (fig. 12). Brouwer blows smoke in the center, thus claiming to be like the low-life sorts he painted. In fashioning himself as a vulgar painter of peasants, inspired by wine and tobacco, Brouwer was instrumental in formulating an alternative to the dominant ideal of the learned painter.[60] A similar motivation to proclaim the artist's marginal status was probably behind Rembrandt's *Self-Portrait with Saskia* in Dresden. And Rembrandt was not the only artist to assume the role of a modern-day prodigal, carousing in the tavern, with his wife in the role of harlot.[61]

Seen in the light of these precedents, Steen's self-portrait in the *Revelers* becomes less autobiographical. Yet, while casting himself as a wastrel may have roots in tradition, Steen transforms the type by rendering it comic, by enhancing its theatricality, and by so thoroughly assimilating the role that it colors virtually his entire oeuvre. He makes the part that others played once or twice into the consistent persona of a comic satirist.

Easy Come, Easy Go (cat. 15), which has in the past been called "The Prodigal Son," is an allegory of fortune and misfortune. It gets its title from the proverb inscribed on the elaborate chimney piece, which is the focal point of a grand interior. There the theme "Easy come, easy go" plays out as the narrative of an elegant protagonist—Jan Steen—who sits at a table salting oysters while a young woman offers him a glass of wine. What are we to make of this artist who simultaneously displays his indecorous, unseemly behavior and warns of its consequences? As the wastrel in the picture, who

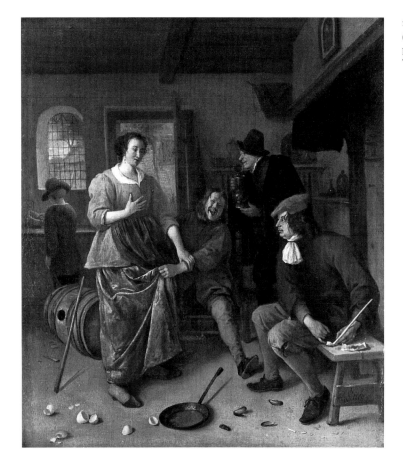

indulges in the fruits of his good fortune without a thought to the outcome of such immoderation, Steen is an affront to a society that put a high premium on self-discipline and respectability. The genteel burgher was a person of exemplary character and, as courtesy books from Castiglione onward attest, the product of self-cultivation. The Steen in the picture subverts that ideal of self-discipline; he is the comic transgressor who provokes laughter and eases tension.[62] The highly self-conscious artist who paints the picture is the moralist who points out his alter-ego's obliviousness to Fortune's fickleness. There are in effect two Steens. One invites transgression, the other admonishes because of it; one flouts self-cultivation, the other fashions a persona. That he looks out at us, laughing, suggests he is well aware that his behavior contradicts his message. Moreover, it suggests the joke is on us, for we

are left wondering whether he is himself or a character, out of himself.

The tavern is Steen's quintessential realm of temptation and transgression. Especially when wife and children are present, as they so often are in his curious conflations of inn and home, it represents the ultimate threat to the family.[63] Steen's pictures of inn and tavern life—his *Interior of an Inn* (fig. 13) and *Merry Company on a Terrace* (cat. 48), for example—testified in a particularly personal way to the veracity of the world he painted by melding his real and pictorial lives. Though other Dutch artists were innkeepers, only Steen capitalized on—mythologized—this aspect of his life by repeatedly implicating himself as a jovial host or customer and including his familiars as merry makers and carousers.[64] In the *Interior of an Inn* he is the unruly guest who can't keep his hands off the serving maid. Some years later, in the

Merry Company on a Terrace, an older Steen, identified as the innkeeper by his apron, presides over a world of temptation. Laughingly he challenges the viewer—and here I presume a male viewer—to keep his hands off a brazenly seductive strumpet in sumptuous satin with open bodice. Note the juxtaposition of Steen and the fool behind him. Both claim insight and both succumb to folly.

Steen's personae shed light on his two self-portraits. It makes little sense to ask which is the real Steen. Each is a role, each shows Steen fashioning himself in a way that suggests conscious self-presentation, and each transforms a pictorial tradition. Of his two self-images, the remarkably casual, overtly theatrical *Self-Portrait as a Lutenist* (cat. 25) corresponds most closely to the roles we have just seen him playing. Here, beside a stage-evoking curtain, he presents himself as having the jovial temperament necessary to a comic painter. This self-image, like his *Baker Oostwaert, Poultry Yard*, and *Family Portrait* (cats. 8, 12, and fig. 14), melds portraiture and genre. It also wreaks havoc with a tradition, associated with Leiden, of portraying artists playing musical instruments for poetic inspiration.[65] Indeed, Steen's image corresponds remarkably closely to the personification of the sanguine or jovial temperament in the 1644 Dutch edition of Caesare Ripa's *Iconologia*.[66] His actor's garb and extroverted personality accord with Ripa's explanation that "the power of communication is very strong in the sanguine." Steen here claims to be the down-to-earth, comic painter of ordinary people with real emotions who is inspired by Bacchus and Venus.

Whereas Rembrandt, Gerrit Dou (1613–1675), and Van Mieris repeatedly projected their social and professional fronts through formal self-portraits, Steen, as far as we know, painted only one self-portrait proper (cat. 40). Despite its veneer of tradition, aspects of the picture subvert its conventionality and point to a conscious role playing. Steen chose a

fig. 14. Jan Steen, *Fantasy Interior with Jan Steen and Jan van Goyen (Family Portrait)*, c. 1659–1660, oil on canvas, The Nelson-Atkins Museum of Art, Kansas City, Missouri

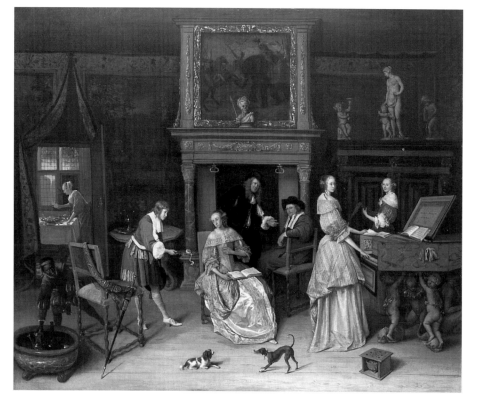

fig. 15. Frans van Mieris, *Self-Portrait*, 1667, oil on panel, Polesden Lacey, National Trust

portrait format—half-length, three-quarter view, with arm supported on a ledge—that was then associated with artists. Rembrandt, drawing on well-known portraits by Raphael and Titian (1488 or 1490–1576), had invented this type, which was widely imitated.[67] Frans van Mieris' *Self-Portrait*, dated 1667 (fig. 15), which is approximately contemporary with Steen's, makes an instructive comparison.[68] Van Mieris, alluding to the Rembrandt type, wears *antiek* garb and proclaims the elevated intellectual status of the Art of Painting: the illusionistic carving on the stone balustrade alludes to his powers of imitation; the book to the learning necessary for an accomplished painter; the drawing to *tekenkunst* (drawing), the foundation of painting; and the *tabula rasa* on the easel to invention. Though Steen makes reference to the artist portrait format, he transforms the type by abandoning its theoretical trappings and pretensions to grandeur. Instead of *antiek* costume he wears the same contemporary *burgerlijk* attire that he wears in *As the Old Sing, So Pipe the Young* and in place of the Renaissance-evoking ledge he rests his arm on an ordinary chair. The brilliant red curtain behind him, which was uncovered during the 1995 cleaning of the picture, gives this self-portrait, too, a theatrical flair that helps explain Steen's puzzling facial expression. Critics have long remarked on his slight hint of a smile, calling it "knowing," "half-sarcastic," and "a scarcely suppressed laugh . . . that makes one think of a satyr."[69] Recent technical investigation reveals that Steen did indeed originally portray himself laughing or smiling broadly; and that he then recrafted his features, making them more subtle and suggestive. The ironic expression we see now, which mischievously undercuts the portrait's decorum and belies Steen's dignified formality, still identifies him as a comedian, fully conscious of his role-playing.

Because of this role-playing Jan Steen seems to be always at our shoulder, reminding us that his authority in his paintings is crucial to their meaning. His pictures demand that we think about their maker. In Steen's time, as in the Renaissance, the idea of the artist carried elevated connotations; pictures were regarded as powerful things and the makers of good ones were seen as having special powers of invention and insight. Steen was an acutely self-conscious painter who capitalized on his age's fascination with the artist and the artistic temperament. He was a fabulous self-promoter through his paintings. There, regardless of whether he did so in real life, he fashioned himself into a comic character, perhaps as a marketing device or to ally himself with the outsider artist. Steen may have conflated his real and pictorial characters, above all, to stake his claim to special insight into human nature, into human weakness and folly. Steen painted pictures that repeatedly seem to subvert their moral brief by making the unacceptable irresistible. But ultimately, invitation becomes admonishment and complicity ends in critique. By implicating himself, Steen internalizes moral struggle, makes it visible as subjective experience. He claims the insight of the fool.

1. For the origins and currency of the notion that "every painter paints himself," Kemp 1976, 311–323; Kemp 1992, 15–23; Zöllner 1992, 137–160.

2. In 1649, Steen married Margriet van Goyen, daughter of the painter Jan, who is thought to be represented in Steen's *Woman Playing a Sistrum* (cat. 28, fig. 2) and who appeared in a number of his other paintings, including *As the Old Sing, So Pipe the Young* (cat. 23). For the birthdates of their children, see pages 28, 31, 33. Steen married Maria van Egmond, widow of Nicolaes Herculens, in 1673, and the couple had a son in 1674.

3. Although the serialized protagonist, as opposed to the stock type, is generally associated with Dickens and nineteenth-century literature, instances of serialized comic characters, comparable to Steen's self-images, occur in seventeenth-century Dutch comic prose. See Westermann 1996a. For Steen's use of his family members in pictures about the family, see Chapman 1995.

4. Weyerman 1729–1769, 2:362.

5. In the Dutch "open market" system, ready-made paintings were sold at public markets and fairs, by lottery, at auctions, by dealers and, in the case of "extraordinaire meesters," perhaps largely through the artist's studio. Walsh 1996, cites the example of collectors and visiting foreigners making the rounds of artist's studios. See De Marchi and van Miegroet 1994, 459–460, for a dispute over regulating the public sale of paintings in Haarlem, in which a group of well-established painters advocated public sales, claiming the practice benefitted young artists and that "masters who have come to perfection are not inconvenienced by public sales . . . which usually comprise ordinary works bought by people who otherwise do not buy paintings or would not visit the artist's shop or art dealer, and were it not for these sales they would never buy paintings, but please themselves with maps and other junk." See also Sluijter 1993, 27–28, for the argument that direct relations between painters and clients was part of the open market system.

6. In an Amsterdam sale of 1756, *Easy Come, Easy Go* is described as "Een uitmuntend Stuk, zynde een Binnehuis, met diverse Figuuren, verbeeldende een herberg, waarin een vrolyken Baas met een Juffertje Oesters eeten, met veel bywerk, door *Jan Steen*, zynde deszelfs Pourtrait daar in, en is dit een der kapitaalste en uitvoerigste stukken van hem bekend" (An excellent piece, being an interior, with diverse figures, representing an inn, wherein a merry fellow eats oysters with a young woman, with many accessories, by *Jan Steen*, with the Portrait of himself therein, and this is one of the most capital and most copious works known by him). It fetched a good price, fl. 380, in this high-priced sale.

7. De Marchi and van Miegroet 1994, 452–454, and Alpers 1988, for innovative competitive strategies prompted by the Dutch art market.

8. Sutton 1982–1983, 3; Chapman 1990–1991.

9. Houbraken 1718–1721, 3:12–13.

10. Houbraken 1718–1721, 3:15.

11. Quodbach 1992, 17; Harrebomee 1858, 1:98; Woordenboek 3:1599.

12. Houbraken 1718–1721, 3:15–16.

13. See cat. 27 for the theoretical triad of incentives—love of art, honor, and profit—that inspired the artist.

14. For the reassessment of Houbraken's biography of Steen, see De Vries 1973; Quodbach 1992; and Chapman 1993. Cornelis 1995 has shown that Houbraken's biographies were intended primarily to preserve the memories of great Netherlandish painters, and that his classicist theoretical interests did not structure the lives to the extent implied by Emmens 1968 and De Vries 1973 (not cited by Cornelis). Cornelis fails to explore how Houbraken's anecdotes, in the fashion of eighteenth-century biographical writing, frequently contribute to his project of championing worthy painters by creating literary portraits of them that are lively and memorable and that evoke the distinctive characteristics of their works.

15. Houbraken 1718–1721, 3:16.

16. For early biographies of Rembrandt, see Sandrart 1675–1679, 1:326; Baldinucci 1681–1728, 6:476–478; and Houbraken 1718–1721, 11:254–273; and for discussion of their classicist bias, Slive 1953, 84–94, 104–115, 177–197; Scheller 1961, 81–118; and Emmens 1968, 66–71, 77–78, 83–92. For Caravaggio see Bellori 1672, 201. Two fundamental studies of patterns of artistic behavior and identity are Wittkower and Wittkower 1963; Kris and Kurz 1979.

17. Weyerman 1729–1769, 2:347–366.

18. Weyerman 1729–1769, 2:347–348.

19. Weyerman 1729–1769, 2:364.

20. Reynolds 1797, 109–110.

21. Reynolds 1797, 236.

22. See also Regemorter's *Jan Steen and Frans van Mieris (Drinking Before Steen's Tavern)* (Amsterdams Historisch Museum) and Willem Pieter Hoevenaar's *Jan Steen and Frans van Mieris in a Merry Company* (Teylers Museum, Haarlem) of 1842. On Hoevenaar's painting, see Amsterdam 1978, 159–161, no. 49.

23. Smith 1829–1842, 4: 39–40, praises the picture as being "painted with singular delicacy in the pencilling, and transparency of colour."

24. Smith 1829–1842, 4: 61.

25. Smith 1829–1842, 4: XV.

26. Smith 1829–1842, 4: XVII.

27. Smith 1829–1842, 4: XVIII–XIX. It is no accident that the first painting in Smith's catalogue is an *Effects of Intemperance*, which he calls a "moral lesson," that features Steen and his wife as master and mistress of the house who "have recently indulged in the pleasures of the table, and are now sunk into a profound sleep."

28. For the nineteenth- and early twentieth-century reassessment of Steen, De Vries 1973; Mariët Westermann, "Jan Steen and the making of Dutch identity," paper, College Art Association Annu-

al Meeting, San Antonio, January 1995; and an unpublished essay on Van Westrheene by Esmée Quodbach.

29. Van Westrheene 1856, 1.

30. Martin 1924, 29.

31. Leiden 1926, 10.

32. Schmidt-Degener and Van Gelder 1927, 1.

33. Schmidt-Degener and Van Gelder 1927, 14.

34. Schmidt-Degener and Van Gelder 1927, 14–15.

35. Van Gils 1935; Van Gils 1937; Van Gils 1942a; Heppner 1939–1940; Gudlaugsson 1945; Gudlaugsson 1975.

36 Gudlaugsson 1975, 48.

37. Thoré-Bürger 1858–1860, 1:116.

38. The Hague 1958, cat. 21 (not paginated).

39. Slive 1953, 84–94, 104–115, 177–197; Scheller 1961, 81–118; Emmens 1968, 66–71, 77–78, 83–92.

40. De Vries 1973.

41. Sutton 1982–1983, 3; Chapman 1990–1991; Westermann 1996a. See also, Schama 1987, 392–393, for an appreciative reading of Steen's role-playing.

42. As was the case with Rembrandt, Steen's registration at the university, whether or not he actually attended it, indicates that he had received a Latin School education. See page 27.

43. Houbraken 1718–1721, 3:13; Weyerman 1729–1769, 2:348.

44. See above, note 19.

45. For Steen's merger of genre and history, De Vries 1983, 113–128; for his genre-like portraits, Westermann 1995; and, for a broader look at the convergence of genre and portraiture in Dutch painting, Smith 1987, 407–430.

46. On Steen's archaizing, see De Groot 1952.

47. Smith 1981.

48. Granberg 1907.

49. Westermann 1996a, discusses the audience to which Steen's particular brand of humor must have appealed.

50. On self-representation and the forging of identity in the sixteenth and seventeenth centuries, see Greenblatt 1980; Taylor 1989. For masking and self-presentation in Dutch marriage portraiture, Smith 1982; for Rembrandt's self-fashioning, Chapman 1990; and for a brief analysis of how these notions of identity formation relate to Steen's genre-like portraits and his own role playing, see Westermann 1995, 299–307.

51. Michelangelo, for example, painted himself as the flayed skin of the martyred Saint Bartholomew in his *Last Judgment*. For Michelangelo as the maker of his own myth, see Barolsky 1990.

52. Koerner 1993, 63–246, on Albrecht Dürer, and Wood 1993, 62–65 on Albrecht Altdorfer, provide compelling evidence of a tradition of self-referentiality in German Renaissance art.

53. Chapman 1990, 108–109.

54. For the fool, and the vast literature on this subject, see Vandenbroek 1987, 40–61, 194–197.

55. Chapman 1990–1991, 190–191.

56. Raupp 1983, 401–418; Levine 1991, 23–28; Westermann 1996a, discuss the relation between comedy and genre painting.

57. Van Mander 1604, fol. 233r; Muylle 1984, 137–144; Melion 1991, 64–65, 181.

58. Lairesse 1778, 99–100. (Lairesse 1707, 173–174, with the marginal notation, "Misbruik in't na't leven schilderen.")

59. See, for Ter Borch, Gudlauggson 1959, 2:174, no. 169; for Van Mieris, Naumann 1981, 1:49; and for Jordaens, Nemeth 1990, which discusses Steen's reliance on Jordaen's model. See also cat. 23.

60. Weyerman 1729–1769, 2:69. For Brouwer's self-portrait see Renger 1986, 51, note 22; Metropolitan Museum of Art 1984, 1:5–10; Filipczak 1987, 116–117. Raupp 1987, examines Brouwer's presentation of himself as a satiric painter. For the broader development, in the seventeenth century, of a modern notion of the artist as social outsider and even social critic, see Emmens 1968, 31–38; Raupp 1984; Levine 1991, 28–29.

61. Chapman 1990, 114–120.

62. On transgression as a comic strategy, see Stallybrass and White 1986; and Westermann 1996a.

63. For Steen's merger of tavern and home, see Salomon 1987, 315–317.

64. Other Dutch artists who were innkeepers include Johannes Vermeer and Adam Pick.

65. Raupp 1978.

66. Ripa 1644, 75–76.

67. De Jongh 1968–1969; Chapman 1990, 69–78.

68. Naumann 1981, 2:81–82, no. 66.

69. See cat. 40 for a discussion of recent technical investigations which reveal that Steen repainted his smile. For the responses of Martin and Schmidt-Degener, see above page 15. On the impropriety of laughter or smiling in portraits, see Haarlem 1986, 15, 18; and Westermann 1996a.

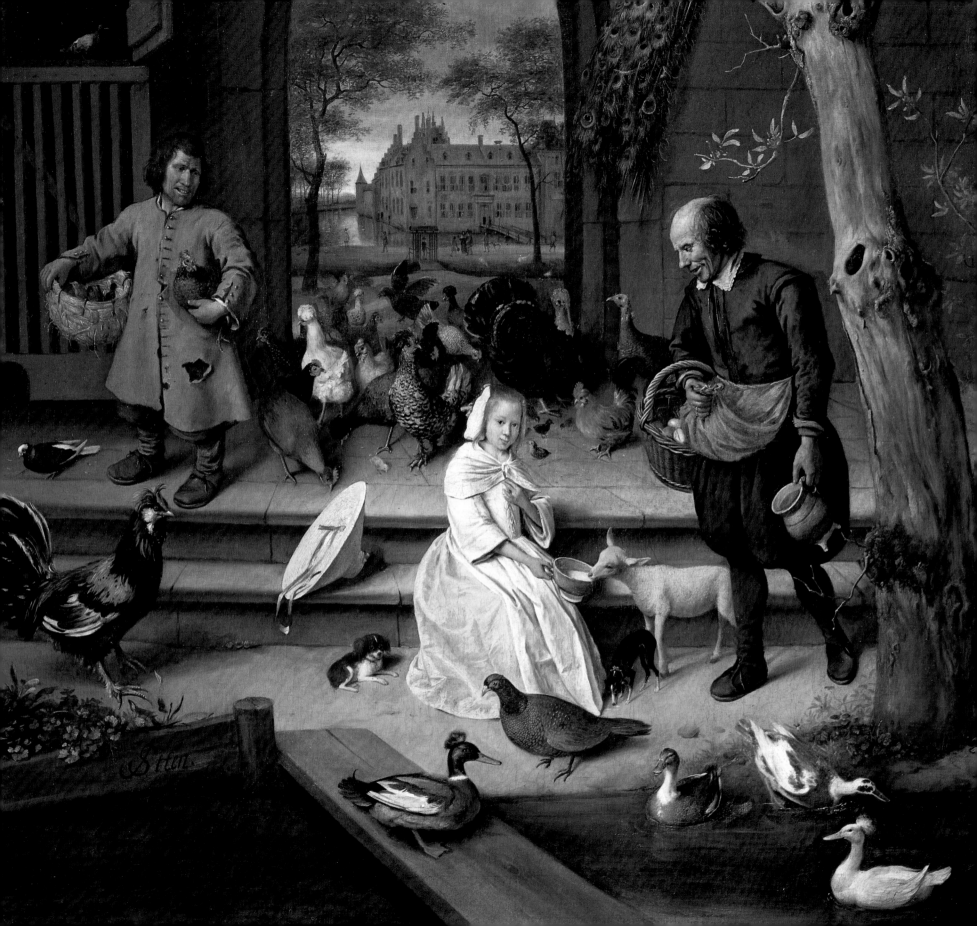

THE ARTIST'S LIFE[1]

Marten Jan Bok

*We have found that many of the facts offered
by later biographers seem doubtful at first,
but they often have some basis in reality*

(O. Naumann, *Frans van Mieris the Elder*, 1981, vol. 1, 33).

Leiden, where Jan Steen was born in 1626, was the second-largest city in Holland after Amsterdam. It was an industrial center with the cloth industry as its main manufacturing base; it also had a flourishing cultural life owing to its university. The thriving cloth industry not only provided work for thousands of artisans but also enabled the boldest entrepreneurs and merchants to amass vast fortunes. Those well-to-do classes were the mainstay of both the local luxury industries and the artistic community. The local school of painting that evolved in the seventeenth century produced artists of international renown. Leading masters included not only Rembrandt (Leiden 1606–1669 Amsterdam) and Jan Lievens (Leiden 1607–1674 Amsterdam), but also Gerrit Dou (Leiden 1613–1675 Leiden), Frans van Mieris (Leiden 1635–1681 Leiden), and, of course, Jan Steen.

Family background

The Steens were not an immigrant family but belonged to the old core of the pre-siege population. The name Steen or Stien is found in documents going back to the fourteenth century, and Jan Steen's forebears can be traced to the beginning of the fifteenth.[2] The family belonged to the city's upper middle class, and as such its members served on the boards of public institutions and in the civic guard. However, the Steens never rose to such prominence that they were co-opted into the patrician regent class through marriage, which would have enabled them to serve in the city government. Their adherence to the Catholic faith after the Reformation barred the way to political advancement forever.

When Jan Steen's great-grandmother, Duifje Havicksdr, married Dirck Dircksz Steen (Leiden c. 1520–1579), her father made her a dowry of an oil mill on the Breestraat, slightly to the east of the Old Orphanage and across from the Schoolsteeg (fig. 1.1).[3] The house was later described as "large, sturdy, notable and well-built," and had two mill buildings attached to it that backed onto the northernmost and narrow branch of the Rhine.[4] The business was later run by Dirck's son, Jan Dircksz Steen (Leiden 1560–1625).[5] The latter married twice and had at least thirteen children, the third of whom was Havick Steen (Leiden 1602–1670), the artist's father.

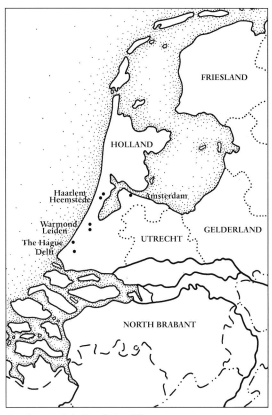

Detail, map of the Dutch Republic, 1648

Jan Dircksz Steen was still living in the Breestraat in 1622, shortly before his death.[6] At that time the household consisted of two sons, four daughters, a servant, and a maidservant. Havick, however, was reported to be living with Dirck Cornelisz "in The Bock" (fig. 1.2). This was a house on the Coorenbrug on the south bank of the New Rhine that belonged to Havick's uncle, Dirck Cornelisz van Leeusvelt, and his wife Eemsje Centen.[7] Confirmation of this arrangement is found in the tax rolls, which list "Havick Jansz, a son of Jan Dircksz Steen, taken into their home."[8] It can be deduced from these words that he was brought up by his uncle and aunt. Havick was only three years old when his mother, Swaentje Cornelisdr van Leeusvelt, died in the spring of 1606 when giving birth to her tenth child. It was not unusual for a widower blessed with as many children as Jan Dircksz Steen to place

one or more of them with relatives. Dirck Cornelisz van Leeusvelt and Eemsje Centen, who were childless, must have brought up their nephew as their own son. They made him their sole heir, with the result that he inherited "The Bock" on their death.[9]

The Van Leeusvelts had been running a grain business in The Bock since before 1581, and it continued until at least the 1620s, for in 1629 Dirck Cornelisz van Leeusvelt gave his profession as grain merchant.[10] As was customary, Havick Steen was trained in his uncle's trade and worked in the business. Upon his betrothal in November 1625 he, too, gave his occupation as grain merchant.[11]

Jan Dircksz Steen died on 20 July 1625 and was buried in Saint Peter's church (fig. 1.3).[12] The surviving inventory of his estate shows that he was worth the considerable sum of 20,000 guilders.[13] In addition to the oil mill in the Breestraat he was joint owner of the Red Halberd brewery on the Delftse Vliet (fig. 1.4). The other partners were his brother-in-law Jan Cornelisz van Leeusvelt (died Leiden 1639) and the children of his deceased brother-in-law Jacob Cornelisz van Leeusvelt (born c. 1560). Jan Dircksz also owned houses in and around Leiden and Voorschoten, and had a quarter-share in a brickworks on the Valkenburger Veer.[14] The inheritance would have been worth considerably more than 20,000 guilders had Jan Dircksz not been so burdened with debt. His heirs decided to keep six of the houses as joint property for the time being, and divided the rest of the estate between them.[15] Because there were so many children their portions were not that large. The oil mill passed to the eldest son, Dirck Jansz Steen (Leiden 1588–1633), but he shared ownership with three of his sisters.[16] The second son, Cornelis Jansz Steen (Leiden 1590–1629), who had been living in the Red Halberd brewery as overseer since 1622, inherited a quarter-share in the brewery.[17] The other quarter-share went to his sister, Catharina Steen.[18] The rest of the inheritance, estimated at little more than 110 guilders, was allocated to Havick Jansz Steen.

A few months after his father's death, Havick Steen married Elisabeth Capiteyn, the daughter of the Leiden city clerk, Wijbrand Thaddeusz Capiteyn, and his wife Grietje Goverts.[19] The marriage contract, which was drawn up on 16 October 1625, confirms that Havick Steen was not well-off. He brought only 700 guilders into the marriage from the division of his father's estate.[20] It is not clear where the couple lived after their marriage. The bride may have made her home in The Bock, or they may have moved in with her parents, but it is also possible that they went to the brewery, where Havick's bachelor brother Cornelis Jansz Steen had been living alone since the death of their sister Duifje (Leiden 1592–1624).

After Cornelis' death on 5 September 1629, his brothers and sisters decided that they would jointly retain his quarter-share in the brewery, the total value of which was assessed at 12,000 guilders.[21] The business, which had its own malt-house, was continued by Havick Steen. The following year he inherited his own share in the brewery from his uncle Jacob van Leeusvelt.[22] The remaining three quarter-shares were finally transferred to him in 1639, making him the sole owner.[23] The brewery occupied quite a large site between the Delftse Vliet and Cellebroedersgracht canals, both of which could be reached through passages and gateways (fig. 1.5).[24] Havick Steen ran his brewery in a profitable period for the brewing industry; its total output in Leiden doubled between 1630 and 1650.[25] Brewers, like oil-millers, had long belonged to the wealthiest professional groups in the city, and Havick Steen must have been rich enough to give his children a good education.[26]

Childhood

Because no Catholic baptismal registers covering the period have survived in Leiden, Jan Steen's date of birth is uncertain. Only one document mentions his age. In November 1646 he declared that he was twenty years old, so he must have been born between November 1625 and November 1626.[27] Since his parents only married in November 1625 he was presumably born in 1626. He was named after his paternal grandfather, as was customary for eldest sons.

Jan Steen spent much of his childhood on the Delftse Vliet. This was a short canal running from the city walls in the south to the Rapenburg canal in the north. In the course of the seventeenth century, the Rapenburg evolved into a desirable residential neighborhood for the wealthiest Leiden families.[28] The Vliet, on the other hand, had little to recommend it; people with more money lived nearer the center.[29]

Havick and Elisabeth had other children after Jan, seven of whom are known by name: a son, Wijbrand (Leiden c. 1638–1704), christened after Elisabeth's father, and six daughters—Margaretha, named after Elisabeth's mother, Swaentje, which was the name of Havick's mother, Maria, Emerentia, Duifje, and Catharina. Several other children died young.[30] Havick Steen and his wife drew up their will in 1632, leaving their property to each other.[31] Should one of them die and the other remarry, he or she had to set aside 5,000 guilders to provide legacies for the children when they reached maturity. The capital was to be administered by two guardians, Dirck Cornelisz van Leeusvelt, formerly Havick's own guardian, and Thaddeus Capiteyn, Elisabeth's brother. Havick and Elisabeth evidently estimated that they were worth around 10,000 guilders.

In 1636, when Jan Steen was about ten years old, the family was living on the Gedamde or Overwulfde Papengracht.[32] This broad street in the heart of the old town was created three years previously by laying a vault over a canal (fig. 1.6).[33] It is not clear whether the family lived here for any length of time. Only a few months later, in August 1636, Elisabeth Capiteyn is recorded back on the Vliet.[34] Havick Steen sold the house on the Papengracht in the spring of 1641.[35] It is also difficult to make out how long the family eventually lived on the Delftse Vliet. Havick bought another house there in 1642, but it was occupied by a ninety-year old woman until her death.[36] This must have been the house that he rented out a year later.[37] He was no longer running the brewery himself, for in 1644 he is referred to as "most recently having been a brewer."[38] It was probably around now that Havick moved to The Bock.[39] His uncle, Dirck Cornelisz van Leeusvelt, had died sometime before February 1644, and he had inherited the house and other possessions.[40] By 1647, at any rate, Havick Steen and his family were living on the New Rhine, for one of his children was buried from the house in that year.[41] The family

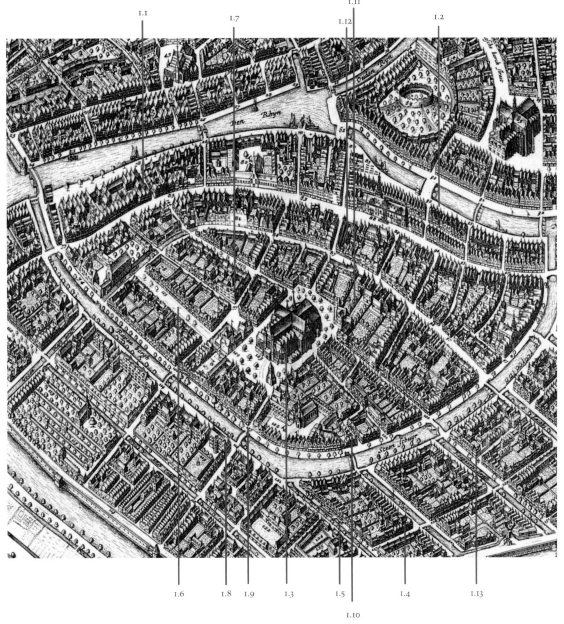

1.1 House and oil mill of Jan Dircksz Steen, Steen family home; **1.2** "The Bock,"; **1.3** Saint Peter's Church; **1.4** Delftse Vliet Canal; **1.5** Cellebroedersgracht Canal; **1.6** Gedamde or Overwulfde Papengracht; **1.7** Latin School; **1.8** Leiden University; **1.9** Bookshop of Joost Lievens de Rechte; **1.10** "The Gilded Claw"; **1.11** House and inn of Jan Steen from 1670 to 1679; **1.12** Penshal; **1.13** House of Jan Steen's second wife Maria van Egmont

continued to live there until Havick sold it in 1656.[42] A few years later, in 1662, he and his family are recorded in the ancestral home in Breestraat.[43]

Schooldays

We know very few facts about Steen's schooling. He certainly learned to read and write in primary school. The signature he appended as a witness to a notarial deed in February 1644, when he was seventeen or eighteen, shows that he had a well-formed hand.[44] It already has the distinctive capital S that is found in the signatures on his paintings. He would then have gone on to the Latin School (fig. 1.7). His attendance is implied by the only document concerning his education to have survived. It is his enrollment in November 1646, at the age of twenty, as a student at Leiden university's (fig. 1.8) faculty of letters.[45] Enrollment was only open to those who had been to the Latin School.[46]

Professional training

It was customary in the seventeenth century for children to help in their parents' business. That applied particularly to the eldest son, who was first in line to inherit it. Just as his father had been trained by his uncle to become a grain merchant, Jan Steen would have learned all the ins and outs of brewing while still a child. However, his education at the Latin School opened up other avenues, and at first sight his enrollment at the university suggests that his parents had other plans for him. But it is not at all clear why he enrolled at the university.[47] He may have enrolled to enjoy the privileges attached to membership of the university community, such as exemption from the municipal duties on beer and wine and from the obligation to serve in the civic guard.[48] In addition, members of the university committing a transgression or criminal offense could only be tried by the university court, which was generally far more lenient than the city court.[49] For a brewer's son, the first of those privileges was attractive both fiscally and financially, but the exemption from guard duty was also appealing.[50] Whatever the truth of the matter, Jan Steen never graduated, and less than eighteen months later, on 18 March 1648, he registered as a master-painter in Leiden's recently founded Guild of Saint Luke.[51]

Admission as a master to any guild implied that the artist had learned his craft under another master. The identity of Jan Steen's first teacher is uncertain, as no records of his apprenticeship have been preserved in guild archives, so one must make do with the information supplied by Steen's eighteenth-century biographers, Arnold Houbraken and Jacob Campo Weyerman. According to Houbraken, Steen was a pupil of Jan van Goyen (Leiden 1596–1656 The Hague). Weyerman adds that before entering Van Goyen's studio, Steen was apprenticed in Utrecht to Nicolaus Knüpfer (Leipzig 1603–1655 Utrecht) and then to the Haarlem painter Adriaen van Ostade (Haarlem 1610–1684).[52] Both authors based their information on the oral testimony of the painter Carel de Moor (Leiden 1655–1738 Leiden/Warmond), a friend of Steen. The information supplied by the two authors should not be dismissed out of hand, the more so since both of them record some salient details which are confirmed by documentary evidence.[53] The problem, though, is fitting this information into Steen's chronology.

Houbraken relates that Jan Steen married his teacher's daughter, Margriet van Goyen. This is confirmed by an archival document, which states that the wedding took place in The Hague on 3 October 1649.[54] However, it is doubtful that Steen was Van Goyen's apprentice at the time, for he was already a master-painter himself. Given his age it is more likely that he stayed on in Van Goyen's studio as an assistant, contributing to the older man's phenomenal output of landscapes. Young artists who had not yet set up a shop of their own could earn a living in this way, while at the same time imitating the personal style of a successful master.[55] Weyerman says that Steen was indeed mainly interested in seeing how Van Goyen painted his landscapes.[56] The distinct possibility exists, then, that Jan Steen learned the basic principles of painting from someone other than Van Goyen. He may have studied first with Nicolaus Knüpfer in Utrecht and then with Van Ostade in Haarlem in the first half of the 1640s.[57] Unfortunately, no documents survive to back Weyerman's assertion, so it must be left to style critics to make a case for such apprenticeships.[58]

Cultural background

Whatever sparked Jan Steen's interest in painting remains a mystery. Houbraken says nothing on the subject, and Weyerman merely states that someone must have pointed out to Havick Steen that his son had artistic talent because the brewer himself was certainly unaware of it.[59] Certainly, those in the milieu in which Jan Steen grew up were connected with the arts. His father's uncle, Pieter Dircksz Steen (Leiden 1561–after 1593), had been a painter and goldsmith. A more direct contact was provided by his father's sister, Marijtje Jansdr Steen (Leiden 1596–1649), who married Joost Lievens de Rechte (Leiden 1606–1649) in 1632.[60] Joost was a bookseller and the eldest brother of the famous Leiden artist Jan Lievens and of Dirck Lievens (died Dutch East Indies 1650), also a painter. Since 1633 Joost Lievens de Rechte had run a bookshop on the Rapenburg, on the corner of the Kloksteeg, not far from Jan Steen's parental home (fig. 1.9).[61] So, from an early age the future artist could have been introduced to the work of Jan Lievens by his uncle. Havick Steen, too, was in direct contact with Jan Lievens. After Havick's sister and her husband died in 1649, he was appointed guardian of the children De Rechte, and he is mentioned as such together with Jan Lievens in documents from the early 1650s.[62] Weyerman, who evidently knew that Jan Lievens regularly returned to Leiden from the mid-1660s, reports that he visited Jan Steen almost daily.[63]

There were other ways in which Jan Steen might have become acquainted with art and learning in his early years. His uncle Dirck Steen, the oil-miller, was a lover of poetry, and when he died in 1633 he left his large library to his brothers and sisters.[64] A brother and brother-in-law of Havick Steen were physicians (see notes 45, 47). His other brothers-in-law included an apothecary, a maker of geometrical instruments, and the musician Pieter van Rijnsburg (died before 1652). Finally, Havick Steen must have been on good terms with the classicist architect Arent Arentsz van 's-Gravesande, for when the latter was appointed Leiden's city architect in 1638 it was Havick Steen who stood as his guarantor.[65] Clearly, then, Jan Steen did not grow up in lowly circumstances (even if his paintings do occasionally suggest otherwise) but in a cultured, middle-class world.

The Hague years

Jan van Goyen lived near the Church of Saint Peter in Leiden until 1632.[66] He then moved to The Hague, where he remained for the rest of his life. Houbraken relates that Steen and Van Goyen got on well together, and details how Jan was on such good terms with Van Goyen's daughter Margriet that he got her pregnant (see page 93). Confronted with this *fait accompli*, both fathers agreed to the match. Later historians, writing at a time when sex before marriage was not as prevalent as it was in Steen's day, were not pleased with this tidbit of Houbraken's.[67] That Steen did indeed marry Margriet could not be gainsaid, for there was the official record of it in the register. However, no evidence for the baptism of a child born shortly after the marriage could be found.[68] Bredius therefore believed that the story really applied to the painter Jacques de Claeuw (Dordrecht 1623–? after 1676), who was also employed by Van Goyen.[69] In the spring of that same year, 1649, De Claeuw married his master's other daughter, Maria, and that summer a daughter of theirs, Geertruyd, was baptized.[70]

Steen brought 2,000 guilders, a gift from his father, to the marriage.[71] At first the young couple continued living in The Hague. Their son Thaddeus was baptized there in the Catholic church in the Oude Molstraat on 6 February 1651, followed two years later by a daughter, Eva. The precise address in The Hague where Steen lived is not known. His father-in-law owned many houses in the city, and would have ensured that his daughter and son-in-law did not lack for a home.[72]

It is difficult to determine whether Steen set up as an independent master after his marriage or continued to work under his father-in-law's wing. That the Hague carpenters' guild had three ebony frames confiscated from Steen in November 1649 suggests that he sold framed paintings without having paid the guild dues for the right to sell frames.[73] It is clear, though, that Steen painted in The Hague and started building up a reputation. For example, as early as 1650 Johan van Rhenen, a director of the municipal auction house in Utrecht, consigned a peasant wedding by Steen for sale in Denmark.[74] In July 1651, the Swedish commercial agent, Appelboom, bought four paintings by Steen at auction on

behalf of Field-Marshal Wrangel, who was governor-general of Swedish Pomerania (see cat. 1).

Jan Steen lived in The Hague until 1654.[75] He was evidently well-established there, for in March of that year he joined the Columbine Company of the civic guard.[76] In the closing years of his Hague period, however, his father-in-law began to get into serious financial difficulties, of which more below, and these problems may have prompted Steen to leave the city. He had continued to sell paintings in Leiden and kept up his membership of its Guild of Saint Luke. In the spring of 1653, for instance, he had paid his dues for two years, but the financial accounts contain the note "Has lived outside the city these past years."[77] On leaving The Hague Steen went to Delft, however, not Leiden.

Brewer in Delft

According to Houbraken, Havick Steen "placed" his son in a brewery in Delft after his marriage to Margriet van Goyen. The documentary evidence does not show that this happened right after the marriage, but apart from that Houbraken was right. In July 1654, Jan Steen leased the "Snake" brewery from the Delft brewer Dirck Jorisz van Adrichem (c. 1590–after 1664) for 400 guilders a year.[78] It was a six-year contract, commencing on All Saints' Day (1 November) 1654.[79] There was a let-out clause that allowed Steen to terminate the contract after three years. Havick Steen stood surety for his son's financial obligations. Later documents show that father and son ran the brewery as "partners," probably meaning that Havick supplied the capital and Jan had day-to-day control of the business.[80]

The Snake brewery, which was also known as the Currycomb, stood on the Oude Delft facing the Haverbrug (fig. 2.1) and diagonally opposite the house (fig. 2.2) of the sitter in the *Burgher of Delft* (cat. 7).[81] Jan Steen, who was still living in The Hague when the contract was signed, must have moved to Delft in the fall of 1654, for the house attached to the brewery was included in the lease.[82] The brewing equipment was also leased initially, but Steen later bought it from Van Adrichem.[83] That purchase probably took place as early as September 1654, when Steen borrowed 700 guilders, again with his father as guarantor.[84]

fig. 2. Detail, *Large Figurative Map of Delft*, Amsterdam, 1670–1678, National Gallery of Art Library, Washington

2.1 Jan Steen's Snake Brewery, from 1654–1657; **2.2** House of the burgher portrayed in cat. 7; **2.3** Horse Market, location of the former Delft Arsenal

Jan Steen may have decided to set up as a brewer partly because of the shaky state of the art market in 1654. The First Anglo-Dutch War had only been over a few weeks when the leasehold started. Wars usually hit the art market badly—a fact of which artists were only too well aware.[85]

There were better prospects in producing one of life's essentials such as beer than a luxury item like paintings. Because beer was drunk by people of all ages and classes, the demand for it was expected to pick up as soon as the economy began to recover. Eventually it did, but in the short term the effects of the war lingered on. In the first three years of

peace, bankruptcies sharply increased in cities such as Amsterdam and Utrecht, and it can be assumed that many people in Delft would also have had difficulty making ends meet.[86] Two other factors plagued Jan Steen's venture into brewing. On 12 October 1654, 90,000 pounds of gunpowder stored in the Delft arsenal blew up. The huge explosion devastated the town (figs. 2.3 and 3). The painter Carel Fabritius (Midden-Beemster 1622–1654 Delft) and many others lost their lives, and it was said that not a house was left undamaged. The second factor was the steady decline in the brewing industry in Delft throughout the seventeenth century. In 1600 the

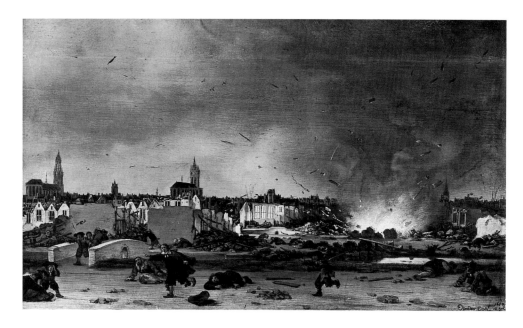

fig. 3. Egbert van der Poel, *The Explosion of the Powder Magazine in Delft, 12 October 1654*, 1654, oil on panel, Rijksmuseum, Amsterdam

town still had eighty-two breweries, but by 1645 the number had fallen to twenty-five and by 1667 to a mere fifteen.[87]

In this unfavorable economic climate, Steen was soon in financial difficulty, which Houbraken attributes entirely to his lack of business acumen. No documents survive to back these claims, but undoubtedly Steen was having a hard time in Delft. In April 1657, Dirck Jorisz van Adrichem threatened to seize the brewing equipment, and the merchant Adolf Croeser had to stand surety so that Steen could remove it from the brewery.[88] Steen was evidently unable to pay the rent. Brewing came to a halt, of course, and although, under the terms of the contract, Steen was entitled to withdraw from the business on 1 November 1657, he was already calling himself a "former brewer" four months prior to that.[89] He gave one Cornelis Strick power of attorney to collect debts owing to him in Delft, from which it can be inferred that he was planning to leave town for an extended period. In 1667 he was still settling his debts with Van Adrichem.[90]

The death of Jan van Goyen

Jan van Goyen died in The Hague on 27 April 1656, when Jan Steen and Margriet van Goyen were still living in Delft. The widow and children did not dare accept the inheritance before it had been inventoried.[91] Van Goyen had been dealing in property for many years, and the bulk of the estate consisted of mortgaged houses, which "have greatly declined and fallen in price for some time now."[92] After Van Goyen's furniture and paintings were sold in September 1656, a second auction in June 1657, of the remaining stock of houses, took place.[93] The proceeds were just enough to satisfy the creditors, and Van Goyen's widow passed her last years in the Nieuwkoop Almshouse.[94]

Havick Steen bought a house on the Nieuwe Molstraat from Van Goyen's estate for 2,110 guilders.[95] He had sold the "Bock" house in Leiden on 13 May 1656 for 8,000 guilders, and shortly afterward disposed of the Red Halberd brewery.[96] The latter fetched 22,000 guilders, which included a ledger with 4,600 guilders in outstanding debts. In 1659 he also sold his share in a glue boilery in Oegstgeest.[97] It appears that he had decided to retire from business, but in 1663 he started up a tile-works outside Leiden.[98]

Jan Steen's brother-in-law, Jacques de Claeuw, had moved from The Hague to Leiden in September 1651, when his father-in-law's financial troubles became apparent.[99] In 1662 he was living in a house called "The Gilded Claw" on Steenschuur near the Vliet (fig. 1.10).[100] His wife, Maria van Goyen, died not long afterward, and he seems to have left the city, now remarried, after 1665.[101] As a result of the problems surrounding their father-in-law's estate, Jan Steen and Jacques de Claeuw are regularly encountered in a variety of deeds from the second half of the 1650s. The last document to mention both of them relates to a transaction in paintings that took place on 13 August 1658 in the village of Heemstede.[102] On that date the painters Jan Miense Molenaer (Haarlem 1610–1668), Jan Steen, and Jacques de Claeuw sold three pictures to one Michiel van Limmen. On 13 April 1661, because he had defaulted on payment, the Heemstede court ordered Van Limmen, together with his sureties Abraham van der Schalcken and one Suyderhoef (probably the painter Jonas Suyderhoef), to pay a sum of 42 guilders and 15 stuivers.

It is not clear who had painted the works in the Heemstede transaction. It seems likely, though, that

it was conducted in Heemstede to circumvent the regulations of the Haarlem guild. Molenaer and his wife, the painter Judith Leyster (Haarlem 1609–1660 Heemstede), had owned an estate called "The Lamb" at Heemstede since 1648.[103] Since Heemstede lay outside the jurisdiction of Haarlem, paintings could be sold there free from the supervision of the Haarlem Guild of Saint Luke.[104] Molenaer had organized a painting lottery in Heemstede back in 1636, and it was through him that Steen and De Claeuw could sell paintings to residents of Haarlem without being members of the local guild.[105]

An intermezzo in Leiden and Warmond

After the failure of his experiment as a brewer in Delft, Jan Steen must have turned his full attention to painting. As mentioned, he was already calling himself a "former brewer" in July 1657. In the spring of the following year he was again paying his dues to the Leiden Guild of Saint Luke, which enabled him to sell paintings in the city.[106] At first he

fig. 4. "Jan Steen's house" in Warmond, about 1659/1660, Leiden Municipal Archives

also took up residence there.[107] It was a brief interlude, however, for in the guild's accounts there is a note with the record of Steen's dues payment for 1658 stating that he had "left the city."

Not long afterward he was living in the village of Warmond, north of Leiden.[108] Here, in 1660, he paid village taxes, from which it can be deduced that he was a full resident.[109] He lived in rented accommodation, very probably the building known as "Jan Steen's house" that still stands on the Dorpsstraat today (fig. 4). It had been owned since 1659 by Sijtje Cornelisdr, the widow of Willem Willemsz Does.[110]

Warmond had a special significance for Remonstrants in Leiden.[111] For a long time they were not allowed to build a church of their own in the city, so from 1640 to 1667 they held their services in Warmond instead. This was made possible by the Catholic lord of Warmond, Jacob van Wassenaer van Duivenvoorde (1592–1658). The list of members for 1656 includes Annetje Steen and her husband, the apothecary Claes Gael, the painter's aunt and uncle. Frans van Mieris and a few of Rembrandt's relatives are also on the list.[112] Steen's landlady Sijtje Cornelisdr and his neighbor in Warmond, the widow of the Remonstrant preacher Willem Henricus Vorstius, belonged to the Remonstrant congregation as well. It is quite possible that Steen's relatives or his friend Van Mieris were involved in his decision to settle in Warmond. In 1660, Jan Steen painted *The Poultry Yard* (cat. 12) there, and a connection between the commission for that picture and Steen's stay in Warmond almost certainly exists, although it remains unclear.

The Haarlem years

Jan Steen and his family moved to Haarlem in 1660. A child was born there that summer and was baptized in the Catholic church in the Begijnhof on 4 August, christened Havick, after Steen's father.[113] Steen's mother, Elisabeth Wijbrands Capiteyn, was the godmother of her grandchild. Two years later a daughter called Elisabeth was baptized, and on that occasion Havick Steen acted as the godfather.[114] In 1661, Steen was a member of the Haarlem Guild of Saint Luke, and the following years were his most productive.[115] It is not known where he lived in Haar-

lem, but it seems that he rented a house that was so big that he could sublet some of the rooms in 1661.[116] A large house was anyway essential, for after the birth of Elisabeth the family had five or six children. Two sons, Johannes and Constantijn, were to follow, but their dates of birth are not known.

In December 1662, Jan Steen and Margriet van Goyen had the Haarlem notary Willem van Kittensteyn draw up a deed of guardianship.[117] They appointed each other guardian, with the right to nominate other guardians from among their immediate relatives. They also excluded the city's Chamber of Orphans from any involvement in the disposition of their estate. Steen signed the deed with a very shaky monogram that is so difficult to read that the notary had to add a note certifying that it was indeed Steen's signature.[118] Clearly he was seriously ill. The document makes no mention of illness, however, and merely states that the parties were in full possession of their faculties.

The Second Anglo-Dutch War broke out in 1665, and once again a slump occurred in the art market. At the beginning of the following year Jan Steen found himself short of cash. He borrowed 450 guilders from Geldolph van Vladeracken and promised to pay him the 6 percent interest over the first year on 1 April 1666 in the form of three portraits.[119] A year later, on 30 April 1667, he assigned to Dirck van Adrichem, from whom he had leased the brewery in Delft in 1654, a claim for more than 45 guilders still outstanding against the Delft carpenter, Hendrick van Toll.[120] Steen had supplied Van Toll with beer more than ten years previously, and had the ledger to show that the debt had not been cleared. Whether there was a causal connection between the war and Steen's straitened circumstances is impossible to say, but after the Peace of Breda in July 1667 nothing more is heard about financial difficulties for a while.

Margriet van Goyen died in 1669, and was buried in Haarlem's Great Church on 8 May of that year. Jan Steen was left with a house full of children. If Houbraken and Weyerman are to be believed, he never succeeded in running his household properly thereafter. He failed to pay the bill from the apothecary who had delivered medicines to his wife as she lay on her deathbed, with the result that the pro-

ceeds from the sale of several of Steen's paintings were attached in February 1670.[121] However, Steen's circumstances were to change dramatically in the next few months as a result of his parents' deaths.

The death of Havick Steen

While Jan was in Haarlem, Havick Steen and Elisabeth Capiteyn were still living in Leiden. The old man was now in his sixties and had divested himself of most of his business interests at the end of the 1650s. The couple's other son, Wijbrand Steen, had become a wine merchant.[122] Around 1660 he seduced a maidservant with a promise of marriage. However, her social background evidently did not suit his parents, and Havick Steen bought off his son's vows.[123] In 1662, Wijbrand made a match that was acceptable to the family by marrying Catharina de Vois, daughter of the well-known Leiden organist Alewijn de Vois and sister of the painter Arie de Vois (Utrecht c. 1632–1680 Leiden).[124] In 1656, the Steens' eldest daughter, Margaretha, had married the silversmith Vechter van Grieken (died Leiden 1675), who was a prominent member of the local silversmiths' guild.[125] The daughters Swaentje and Catharina Steen remained unmarried, and Houbraken says that one of them was a "spiritual daughter" or *klopje*, which meant that she had put her life at the service of the Catholic church without entering a religious order.[126]

In 1664, Havick Steen had acquired full ownership of the old family home on Leiden's Breestraat from his sister Aeltje and her husband.[127] In April 1668, he sold it to a former burgomaster of the city, Paulus van Swanenburch, for the sizable sum of 9,300 guilders.[128] He used the money to buy himself a house with a garden, adjacent to the Langebrug, across from the Wolsteeg (fig. 1.11).[129] A few months later Havick Steen sold another house, this time on the Oude Houtmarkt.[130]

Elisabeth Capiteyn died a little over a year later and was buried in Saint Peter's on 9 September 1669.[131] Havick Steen himself did not have much longer to live. He fell ill a month after his wife's death and began putting his affairs in order. First, in October 1669, he made provision for his underage heirs, appointing his son Jan as guardian.[132] His executor was his nephew, the merchant Johannes

van Rijnsburg. He made his last will on 14 February 1670.[133] Each of his two unmarried daughters was to receive immediately the 2,000 guilders that the others had had as their dowry. Apart from that, the children were made joint heirs, although Wijbrand was to receive his inheritance in the form of an annual allowance of 80 guilders. He evidently had so many debts that his father wanted to forestall his creditors from claiming part of the inheritance.[134] Jan Steen was to have the house on the Langebrug if he wanted it, its value to be deducted from his portion.

Havick Jansz Steen died a month later at the age of sixty-seven, and was buried in Saint Peter's on 17 March 1670. Not long afterward his heirs met in Leiden to divide up the estate.[135] The only one absent was Wijbrand, who had been excluded from the full inheritance. The total value of the property and goods was 12,400 guilders. They consisted of the house on Langebrug, seven small houses on the Cingelstraat, Loyerstraat, and Cellebroedersgracht, each of which was worth 300 guilders, and some bonds. After deducting the 4,000 guilders for the two unmarried daughters, 2,100 guilders remained per child. Each heir would also have to pay a quarter of Wijbrand's annual allowance of 80 guilders. Presumably for this reason, some property, including a tile-works on the Hoge Rijndijk in Voorschoten, remained in communal ownership for the time being.[136] In May 1674 Wijbrand agreed to redeem his annual allowance from his brothers and sisters.[137] From then on he again appears as a full family member in wills and financial transactions.

Back in Leiden

Jan Steen accepted the house on the Langebrug and left Haarlem, returning to Leiden permanently. Weyerman once again appears to have been quite well informed.[138] In 1670 Jan Steen registered anew with the Guild of Saint Luke in Leiden.[139] He was evidently a respected artist, for he was immediately offered a position as the guild's superintendent of the sale of paintings.[140] The next two years he served as headman, and in 1674 was even elected dean.[141]

Jan Steen's household, which had been at sixes and sevens since his wife's death, would not have improved in the early years back in Leiden. Houbrak-

en says that creditors came hammering on the door, and indeed it turns out that Steen had ceased making mortgage payments the moment he took possession of his father's house.[142] Thaddeus, his eldest son, joined the army not long afterward. He was twenty years old in the spring of 1672 when, with war looming, he served in the company of Captain Dirck van Harencarspel.[143] A few months later, after war had broken out and the art market experienced its greatest crisis of the century, Jan Steen applied to the city of Leiden for permission to open a tavern, which was granted.[144] This tavern must have been "The Peace" mentioned by Weyerman, the inn where, according to this same writer, Steen's son Cornelis (known as Kees) "usually played the maid."[145] He assumed this role because, in Houbraken's words, Steen's only daughter, Catharina, was still far too young.

Steen's status as a widower came to an end in the spring of 1673, when he and Maria Dircksdr van Egmond drew up a marriage contract. The marital bed was all that they would share; their other property was to be held separately.[146] Various reasons for this are clear, the main one being that both of them had children from their previous marriages—Jan Steen six and Maria van Egmond two—who were the heirs of their deceased parents and other relatives.[147] That property was not to become intermingled. The second reason was that both the bride and groom were besieged by creditors. Maria van Egmond, like Jan Steen, had known periods of serious financial difficulties. Her first husband, the book-dealer Nicolaes Herculens, had left an insolvent estate in 1661, which forced Maria to fend for herself.[148] Houbraken reports that she earned a living by selling boiled sheep's heads and feet at the market. She would have done much of her business in the Penshal (Offal Hall), which stood on a site between the Breestraat and the Langebrug (fig. 1.12).[149] One of the two entrances to this offal market was almost directly opposite Steen's house, so it can be assumed that that is where they met. Maria van Egmond lived on the Koepoortsgracht, not far from the Langebrug (fig. 1.13).[150]

The marriage between Jan Steen and Maria van Egmond took place on 22 April 1673 in Leiderdorp. She and her children then moved into the house on

the Langebrug but she continued selling mutton at the market, undoubtedly to bring more money into the family. In the summer of 1674 a son was born of the union. He was baptized in the Catholic church in the Kupersteeg, and received the name Theodorus (but was called Dirck) after Maria's father. Jan Steen, nearing the age of fifty, now had to provide for even more children.

Death and estate

Few documents have survived from Jan Steen's final years. He continued to paint, and dutifully paid his annual contribution to the Guild of Saint Luke, but he did not hold office after 1674.[151] If Houbraken and Weyerman are to be believed, he spent many hours drinking and smoking with his artist friends Lievens, De Vois, and Van Mieris. All three were heavy drinkers, as is known from other sources, and there is little reason to believe that Steen's biographers would have unnecessarily libeled this circle of Leiden artists.[152]

Steen died in 1679, aged fifty-three, and was buried in the family grave in Saint Peter's on 3 February.[153] Maria van Egmond was left with a large family on her hands. She sold the inn a year after her husband's death.[154] The house was so heavily mortgaged that it fetched less than 1,000 guilders.[155] It has to be assumed that this was all that Jan Steen left his widow and children. He was unable to fulfill his social duty of passing on to his children the same amount of capital that he had inherited. They were not even able to retain the family grave in Saint Peter's, and in 1686 it was sold to Johannes van Rijnsburg.[156]

A few months after his father's death, Cornelis Steen married Maria Overlander, the daughter from Maria van Egmond's first marriage. Two of the children were thus now standing on their own feet, which would have eased Maria van Egmond's burden a little. Cornelis was a painter, and he succeeded his father as a member of Leiden's Guild of Saint Luke. He was made headman a year later and dean in 1693. Thaddeus, who was also a painter, married in 1682. He, too, became a member of the guild in 1684. Catharina married the artist Johannes Porcellis (Leiden 1661–1718) in 1684.

The oldest children, then, started out well, but

after Maria van Egmond's death in 1687 the Steen family fell on bad times. Many of the children and grandchildren either died young, ended up in the Leiden orphanage, or left for the Dutch East Indies.[157] Jan Steen's youngest son, Dirck, was trained as a sculptor after he was orphaned and later, according to Houbraken, earned his living at various German courts.

Epilogue

Jan Steen is traditionally regarded as a man whose "paintings are as his way of life, and his way of life as his paintings," to quote Houbraken. In modern historiography he acquired a completely new image as an earnest citizen whose paintings hold up a moralistic mirror to the beholder. This was best expressed by Swillens, an art historian from Utrecht, in 1957.

Steen must have been a serious man who was highly regarded by his contemporaries and colleagues. There is and can be no question of any debauchery in his life. Jan Steen was a solid individual and had a very good and happy married life with his wife Margaretha.[158]

Both views strike me as being partisan and I believe that the true Steen reflected some of both.

Abraham Bredius, working a century ago, unearthed hundreds of facts about Jan Steen and his family in the archives. It goes without saying that this factual information, much of it gleaned from legal sources, often fails to tell us what we would really like to know. However, as historical documents, they are usually reliable, provided one knows how to interpret them. The opposite applies to the information supplied by Houbraken and Weyerman. They provide the *petit-histoire*, the personal story that we like to read in a biography because it sheds a light on the subject's character and motives. The reliability of that sort of information, though, is often not so easy to judge.

In view of what has been said above I believe that the accounts given by Houbraken and Weyerman are more trustworthy than is generally supposed. Both based their lives on oral sources, the most important of which must have been Carel de Moor. They give so many factual details that turn out to match those in the archives that one should

not automatically dismiss other details for which there is no corroboration. The inescapable conclusion is that Jan Steen was indeed a happy-go-lucky man who drank and spent more money than he earned. He lived from one day to the next, and was thus quite the opposite of the thrifty and God-fearing Dutchman who supposedly made the Republic great. Jan Steen, in other words, lacked Calvinist self-discipline.

On the other hand, he was obviously a hard worker, for otherwise he could never have produced such a large oeuvre. He was regarded as a major artist from an early age, and in later years he served on the board of the Guild of Saint Luke in Leiden. Socially, there was nothing that could really be held against him. In addition, he was well-respected by his own family. As detailed above, his father appointed him guardian of his underage heirs in 1669. A year later, "Master Jan Steen, art painter" and his cousin Johannes van Rijnsburg were appointed guardians of the children of Matthys van Rijnsburg. And his sister, Margaretha, also made him guardian of her children.[159]

Finally, the times did not always smile on him. The brewing industry in both Leiden and Delft was on the decline, and during Jan Steen's career the art market went through several crises, the worst of which was in 1672. These circumstances accounted partly for his lack of success as a brewer and innkeeper. It is no longer possible to discover whether he earned a satisfactory living from his painting, but it certainly did not make him a fortune. He had received a share of the family capital, which had already become seriously depleted because of the large number of children who had been beneficiaries, but Jan Steen failed to pass this same level of inheritance on to his own offspring.

1. This biography was written with considerable assistance from a research team at the Centraal Bureau voor Genealogie in The Hague consisting of Yvonne Prins, Ed Unger, and Martine Zoeteman. I would like to thank them and Nico Plomp, deputy director of the CBG, for their efforts. They have reexamined almost all the known documents, checked the source references, made calendars, and compiled a new genealogy of the Steen family that will appear as an independent publication in the *Jaarboek van het Centraal Bureau voor Genealogie*. In the meantime, Van Duijn 1976 can be consulted for most of the basic genealogical data, and as a result I only refer to the original archive source in a few special cases.

Information on Steen's periods in Warmond and Haarlem were supplied by Pieter Biesboer, A. G. van der Steur, and Irene van Thiel-Stroman. P. J. M. de Baar assisted me with the Leiden period. I am also grateful to Bas Dudok van Heel, Peter Hecht, Eddy de Jongh, and Lyckle de Vries for their comments on earlier drafts.

The results of prior biographical research on Jan Steen are summarized in Bredius 1927. In the footnotes, however, I have endeavored to cite the archival source wherever possible, with a cross-reference to Bredius. Documents published since 1926 are also included with references to the relevant literature. Documents with no such reference have not been published before, to the best of my knowledge. It is worth pointing out that I did not need to use all the known documents on the Steen family for this biography.

The following abbreviations have been used:

ARA—Public Records Office, The Hague

DTB—Baptismal, Marriage, and Burial Registers

GA—Municipal Archives

GAA—Amsterdam Municipal Archives

GAD—Delft Municipal Archives

GAG—The Hague Municipal Archives

GAH—Haarlem Municipal Archives

GAL—Leiden Municipal Archives

NAA—Amsterdam Notarial Archives

NAD—Delft Notarial Archives

NAG—The Hague Notarial Archives

NAH—Haarlem Notarial Archives

NAL—Leiden Notarial Archives

NH—Dutch Reformed Church

ORA—Old Judicial Archives

RA—Judicial Archives

RAD—Judicial Archives, Delft

RAH—Judicial Archives, Haarlem

RAL—Judicial Archives, Leiden

RANH—Public Records Office, Province of North Holland

RAZH—Public Records Office, Province of South Holland

RK—Roman Catholic

SAL—Leiden Administrative Archives

2. The family's canting coat of arms certainly had six red stones (stone being "steen" in Dutch) and a black demi-lion. The sources disagree on the background colors (letter of 23 November 1995 from N. Plomp of the Centraal Bureau voor Genealogie). Van Duijn 1976, 119, describes the arms as "or, a demi-lion sable, charged with six stones gules on azure" (Een halve zwarte leeuw op goud, beladen met zes rode stenen op blauw).

3. GAL, Notary P.Az. Storm, NAL 1, 9-9-1567; Bredius 1927, 81. For the house in Breestraat see Van Oerle 1975, map 7a. It is possibly the present day no. 48. Schoolsteeg is called Varkenssteeg in early documents.

4. It is not clear whether the two buildings on the Rhine were part of the mill from the outset; they are first mentioned when the business was sold in 1668 (GAL, RAL, 44-G, Dingboeken, April 1668; Bredius 1927, 86–87). See also GAL, SAL 6612, Bonboek Gasthuisvierendeel, fol. 278, 5-5-1668.

5. GAL, Notary W. van Oudevliet, NAL 52, fol. 239, 19-9-1587.

6. GAL, SAL II, 4021, Kohier hoofdgeld 1622, Bon Gasthuisvierendeel, fol. 8v.

7. GAL, RAL, 67-4J, transport registers, fol. 204v–205v, 13-9-1656. Van Oerle 1975, map 7b. The building was one of the present-day houses Botermarkt 3, 4, or 5. It is also referred to as "The Old Bock" in seventeenth-century documents.

8. GAL, SAL II, 4021, Kohier hoofdgeld 1622, Bon Wanthuis, fol. 11: "Havick Jansz een t'uys gehaelde soon van Jan Dircx Steen."

9. Havick Steen is referred to as "the sole instituted heir of the late Dirck Cornelisz. van Leeusvelt" (eenige geinstitueerde erfgenaam van wijlen Dirck Cornelisz. van Leeusvelt) in GAL, Notary A.Jz. Raven, NAL 751, 5-2-1644; Bredius 1927, 86, 90. For the house see GAL, SAL 6611, Bonboek Wanthuis, fol. 31v. Havick Steen, as the sole heir of Dirck Cornelisz [van Leeusvelt] sold the house to Cornelis Jacobsz on 13 May 1656.

10. GAL, SAL II, 1074, 1581 census, fol. 7. GAL, Notary D.Jz. van Vesanevelt, NAL 344, 6-6-1629; Bredius 1927, 82.

11. GAL, Notary W. van Oudevliet, NAL 52, fol. 239, 19-9-1587. GAL, DTB, Huwelijken voor schepenen, 15-11-1625.

12. On the north side of the ambulatory one can still see the tombstone of Jan Dircksz Steen (see Kneppelhout van Sterkenburg 1864, col. 247; Van den Berg 1992, 72, no. 329). This grave, which bears the number 44, remained in the joint possession of his children and grandchildren until 1671, when it was transferred to Jan Steen (GAL, Archief Pieterskerk, Grafboek 1610, fol. 106, 18-3-1611; ibid. 1647, fol. 217; ibid. 1665, fol. 212v; Van Overvoorde 1926, 149–150).

13. GAL, Notary P.Dz. van Leeuwen, NAL 245, 1625; Bredius 1927, 81–82. For the purposes of comparison, Rembrandt's mother left a divisible estate of almost 10,000 guilders in 1640 (Dudok van Heel 1991, 52).

14. Jan Cornelisz van Leeusvelt died on 13 July 1639, and was buried from the Botermarkt in the Hooglandse Church (GAL, DTB, begraafboeken). Jacob's year of birth is derived from GAL, SAL II, 1074, 1581 census, fol. 7.

The brewery was originally an oil mill. It was bought by Jan Dircksz Steen in 1604, and in 1612 he sold two quarter-shares to his brothers-in-law Jan and Jacob van Leeusvelt (GAL, Stadsarchief II, 6615, Bonboek Zuid-Rapenburg, fol. 204v). It was probably then that the business was converted into a brewery, with the Van Leeusvelt brothers providing the know-how on the grain trade (fol. 206v).

In view of the building boom in Leiden in the first quarter of the seventeenth century, putting money into a brickworks must have been an attractive investment. In 1615, Jan Dircksz Steen actually had himself referred to as a brickmaker (Bredius 1927, 81–82).

15. GAL, Notary D.Jz. van Vesanevelt, NAL 348, 27-9-1639; Bredius 1927, 84.

16. GAL, SAL II, 6612, Bonboek Gasthuisvierendeel, fol. 278, undated.

17. GAL, SAL II, 4021, Kohier hoofdgeld 1622, Bon Gasthuisvierendeel, fol. 8v. That he owned a quarter-share in the brewery emerges from GAL, RAL 209, Register van ontvang van de 30e penning over de collaterale successie, October 1629–March 1630; Bredius 1927, 85.

18. GAL, SAL II, 6615, Bonboek Zuid-Rapenburg, fol. 204v.

19. When they married, Wybrand Thaddeusz Capiteyn gave his profession as "clerk of the administration of the city of Leiden" (clerc ter Secretarije der stad Leyden; GAL, DTB, Huwelijken voor schepenen, 17-6-1606; quoted from Bredius 1927, 82).

20. GAL, Notary J. van der Meer, NAL 340, fol. 95, 16-10-1625.

21. GAL, SAL II, 6615, Bonboek Zuid-Rapenburg, fol. 204v. For the estimated value see GAL, RAL 209, Register van ontvang van de 30e penning over de collaterale successie, October 1629–March 1630; Bredius 1927, 85.

22. GAL, SAL II, 6615, Bonboek Zuid-Rapenburg, fol. 204v.

23. GAL, SAL II, 6615, Bonboek Zuid-Rapenburg, fol. 204v. See also GAL, Notary D.Jz. van Vesanevelt, NAL 348, 27-9-1639; Bredius 1927, 84.

24. The brewery lay a little to the north of Bakkersteeg. In Van Oerle 1975, map 18b, the business (which was still an oil mill in 1585) is wrongly located close to the Steenschuur. For the houses and lots belonging to the brewery see further GAL, SAL II, 6615, Bonboek Zuid-Rapenburg, fols. 201Av, 204–204v, 206v–208v, 243, 246–246v.

25. De Vries and Van der Woude 1995, 380, with earlier literature.

26. Van Maanen 1978, 23.

27. He did so on his enrollment at Leiden university, which is discussed below. See *Album Studiosorum* 1875, col. 373. Many students pretended to be older than they were, but in the absence of any evidence to the contrary, this statement of his age has to be

taken at face value.

28. For the residents of Rapenburg see Lunsingh Scheurleer et al. 1986–1992.

29. Van Oerle 1975, maps 15 and 18b.

30. Bredius 1927, 85.

31. In the mid-1630s, Havick Steen had to pay 25 guilders under the 200th penny tax, indicating that he had a capital of 5,000 guilders (GAL, SAL II, 4212, kohier 200ste penning, 1635/1637; Bredius 1927, 85).

32. Bredius refers to a deed of 13 March 1636 (Bredius 1927, 85) but does not give the source.

33. Van Oerle 1975, 55.

34. GAL, DTB, Huwelijken voor schepenen, 31-8-1636; Bredius 1927, 83.

35. Bredius refers to a deed of 31 May 1641 (Bredius 1927, 85) but does not give the source.

36. GAL, Notary D.Jz. van Vesanevelt, NAL 349, 9-2-1642; Bredius 1927, 85.

37. GAL, Notary A.Jz. Raven, NAL 751, 14-6-1643; Bredius 1927, 86.

38. Bredius 1927, 86: ". . . laest brouwer geweest [in] het Rode Hellebaert." He refers to a deed of 2 November 1644 but does not give the source. On 8 June 1643 Havick Steen was still being referred to as "brewer in the Halberd" (brouwer in 't Hellebaert; GAL, RAL, 45ZZ, Vonnisboeken, 11-4-1668).

39. At first Havick Steen rented the house out. At the end of August 1644 the tenant was one Eman Joachimsz, who operated a furnace there (Genealogische Bijdragen Leiden en Omgeving 8 [1993], 66). My thanks to P. J.M. de Baar for drawing this to my notice.

40. GAL, Notary A. Jz. Raven, NAL 751, 5-2-1644; Bredius 1927, 86, 90.

41. GAL, DTB, Begrafenissen Pieterskerk, 6-5-1647; Bredius 1927, 85.

42. GAL, SAL II, 6611, Bonboek Wanthuis, fol. 31v, Nieuwe Rijn, 13-5-1656.

43. GAL, DTB, Huwelijken voor schepenen, 29-4-1662; Bredius 1927, 96.

44. GAL, Notary A. Jz. Raven, NAL 751, 5-2-1644; Bredius 1927, 86, 90. Reproduced in Braun 1980, 11.

45. Album Studiosorum 1875, col. 373. His uncle Jacobus Steen (Leiden 1612–1670 Cologne) enrolled on the same day as a medical student, giving his age as thirty, although he was actually thirty-four. Jacobus first registered with the university in 1624 (col. 182), gained his doctorate in 1648 (Molhuysen 1918, 12) and signed on as a student for the third time in 1650, but now giving his correct age (Album Studiosorum 1875, col. 407). Jan Steen had another uncle, Johannes Steen (born 1616) who enrolled first in 1629 (col. 217) and then in 1644 with the mathematics faculty (col. 347). I cannot swear that it was not this same uncle who enrolled again

in 1646, since Jan is the shortened form of Johannes. If he did it would destroy the argument for the painter's year of birth as well as for his education.

46. Only the courses at the school of engineering were conducted in Dutch and could be followed without any knowledge of Latin (Amsterdam 1975, 94). Jan Steen, however, was registered in the "Artes."

47. It is possible that Steen's parents wanted him to study medicine like his uncle Jacobus, who enrolled in the medical faculty the same day; see note 45. Another uncle, Dr. Thaddeus Capiteyn, had also studied medicine.

48. See Amsterdam 1975, 46.

49. Amsterdam 1975, 44.

50. See Knevel 1994, 194–196, for the exemption from civic guard service. Joost Lievens de Rechte, alias Justus Livius (Leiden 1606–1649), who married a sister of Havick Steen's in 1632, had also received an exemption in 1626 because he was a student (Lunsingh Scheurleer et al. 1986–1992, 5:781; he enrolled in the artes at the age of "fourteen" on 26 October 1622, see Album Studiosorum 1875, col. 163). His father contested the call-up, saying that his son was not yet twenty, so that was evidently the age at which young men were expected to start doing civic guard service. This may have been why Jan Steen only enrolled at the university at the very late age of twenty. If he did so simply to avoid being drafted, then he never seriously envisaged an academic career at all.

51. Bredius 1882–1883, 207; Bredius 1927, 90.

52. Weyerman 1729–1769, 2: 348.

53. Weyerman knew that Steen's father was called Havick Jansz, including the patronymic. In a story about the theft of Steen's clothes and paintings he states that Steen's neighbor was a cook called Gommert (Weyerman 1729–1769, 2: 356). Another source identifies him as Gommert van Groenewegen (GAL, RAL 67/5N, Transport registers, fol. 78, 22-2-1680; Bredius 1927, 95). In the same story Weyerman reports that Steen and his children were given new clothes by a "cousin Rijnsburg," which must be a reference to Johannes van Rijnsburg, who was indeed Steen's cousin. In addition, De Moor served on the board of the Leiden Guild of Saint Luke with Steen's son Cornelis for many years from 1684, and could have come by firsthand information from him (Bredius 1882–1883, 253–255).

54. GAG, DTB, Huwelijken voor schepenen, betrothal 19-9-1649, marriage 3-10-1649; Bredius 1927, 90.

55. On this practice see Bruyn 1991, 69–70.

56. Weyerman 1729–1769, 2: 349. Incidentally, Weyerman makes it appear that Steen applied to enter Van Goyen's studio mainly on account of his daughter, whom he had supposedly already met in Leiden.

57. In 1647, Knüpfer charged his pupil Pieter Crijnsen Volmarijn of Rotterdam 72 guilders a year in tuition fees (Roethlisberger and Bok 1993, 573). This made him one of the more expensive teachers.

58. De Vries 1977, 27, has pointed out that a portrait of Jan Steen by Isack van Ostade, which was in the estate left by the painter Cornelis Dusart at the beginning of the eighteenth century, could date from the period of Steen's apprenticeship with Adriaen van Ostade (Bredius 1915–1922, 1: 62, no. 363), since Isack died in 1649.

59. Weyerman 1729–1769, 2: 348.

60. On Joost Lievens see Lunsingh Scheurleer et al. 1986–1992, 5: 781–782. From 1628 onward Lievens' father lived on Breestraat, a few houses north of the Steen family's house (see Leiden 1991, 28). Ed de Heer recently discovered that Jan Steen was also related to the engraver Jan van Vliet (to be published in the catalogue of the forthcoming exhibition on Van Vliet in Amsterdam, Museum Het Rembrandthuis, 1996). See also Van Overvoorde 1926, 149–150.

61. Now No. 56, Rapenburg.

62. Bredius 1915–1922, 1: 194–197.

63. Weyerman 1729–1769, 2: 353.

64. GAL, Notary D. Jz. van Vesanevelt, NAL 246, 20-6-1633; Bredius 1927, 83.

65. Ozinga 1929, 152.

66. Beck 1972, 16–17, 29.

67. For a recent demonstration of "Houbraken-bashing" see Braun 1980, 6. Haks 1985, 96–97, gives an indication of the large percentage of marriages entered into after premarital sex.

68. It is, of course, possible that the first child was stillborn.

69. Bredius 1927, 15, 91. He did not believe in "gossip about the necessity of Jan Steen marrying" (praatjes over het noodzakelijk geworden huwelijk van Jan Steen).

70. GAG, DTB, NH Huwelijken, betrothal 11-4-1649. GAG, DTB, NH dopen (Kloosterkerk), 16-7-1649. Published in Bredius 1927, 91.

71. This emerges from Havick Steen's will (GAL, Notary J. Thieren, NAL 1115, 14-2-1670; Bredius 1927, 87–88). Weyerman bumped it up to 10,000 guilders (Weyerman 1729–1769, 2: 351). The bride's dowry is not known.

72. Beck 1972, 16–17.

73. GAG, Residentieboeken, 18-11-1649; Bredius 1927, 90.

74. GAA, Notary A. Lock, 9-4-1653; Bredius 1927, 90–91.

75. He is last recorded in The Hague in GAD, Notary E. van der Vloet, NAD, 206, akte 45, 22-7-1654; Bredius 1927, 91.

76. GAG, Archief schutterij, Schuttersboekje Colombyne vendel, 17-3-1654; Bredius 1927, 91.

77. Bredius 1882–1883, 207, 16 April 1653: "Heeft de voorgaande jaren uit dese stad gewoond"; Bredius 1927, 91.

78. GAD, Notary E. van der Vloet, NAD 2067, akte 45, 22-7-1654; Bredius 1927, 91. Steen also had to supply the lessor with beer to the value of 36 guilders annually. On Dirck Jorisz van Adrichem

see Thierry de Bye Dólleman and De Savornin Lohman 1973, 218–219.

79. Van Adrichem had a well dug for the brewery shortly before (GAD, Stadsarchief II, consentboek, deel 1, fol. 307, 18 September 1654; taken from collectie Beydals, under the heading "Jan Steen"). It had been filled in again before 30 August 1658 (in the margin).

80. GAD, Notary F. Boogert, 7-7-1657; Bredius 1927, 92.

81. Van Bleyswijck 1667, 735. The building is no. 74, Oude Delft, which still bears the name De Roskam (The Currycomb) to this day. The Beydals Collection in the Delft Municipal Archives contains, under the lemma Jan Steen, various calendars of documents relating to this brewery. Braun 1980, 12, wrongly believed that there were two separate breweries.

82. GAD, Notary E. van der Vloet, NAD 2067, akte 45, 22-7-1654; Bredius 1927, 91. Van Adrichem continued to live in the house beside the entrance to the brewery.

83. His purchase of the equipment is clear from GAD, RAD, 288, Register van borgtochten . . . 5-4-1657; Bredius 1927, 91–92.

84. GAL, Notary A. Jz. Raven, NAL 760, 16-9-1654; Bredius 1927, 91. It seems that he pledged the equipment as collateral, because when he got into financial difficulties three years later it was the equipment that was seized (GAD, RAD 288, Register van borgtochten. . ., fol. 36, 5-4-1657; Bredius 1927, 91–92).

85. Bok 1994, 121–123. It resulted in the bankruptcy of many artists in this period, the most famous being Rembrandt's.

86. Bok 1994, 156–161.

87. Van Bleyswijck 1667, 734–736. See also Wijsenbeek-Olthuis 1987, 417.

88. GAD, RAD 288, Register van borgtochten . . ., 5-4-1657; Bredius 1927, 91–92.

89. GAD, Notary F. Boogert, NAD 2001, 7-7-1657: ". . . gewesen brouwer."

90. GAH, Notary L. Baert, NAH 371-a, 30-4-1667; Bredius 1927, 93.

91. Beck 1972, 36, doc. 17-5-1656.

92. Beck 1972, 36, doc. 17-5-1656: ". . . nu eenige tijd herwaerts merckelijk in prijse zijn gesakt en verminderd."

93. Beck 1972, 36–37, doc. 27-9-1656, 6-6-1657. The creditors' order of priority was decided on 18 May 1657 (GAG, RAG, Verbalen, 18-5-1657).

94. Beck 1972, 20, 38, doc. 20-5-1672.

95. Beck 1972, 20, 37, doc. 6-6-1657.

96. For the sale of the house see GAL, SAL II, 6611, Bonboek Wanthuis, fol. 31v, 13-5-1656. The conveyance is also recorded in GAL, RAL, 67-4J, Transport registers, 13-9-1656; Bredius 1927, 86. The sale of the brewery is GAL, RAL, 67-4O, fol. 204v–205v Transport registers, 6-10-1657; Bredius 1927, 92, and is also recorded in GAL, SAL II, 6615, Bonboek Zuid-Rapenburg, fol. 115-115v.

97. GAL, Notary F. van Chingelshouck, NAL 927, 27-1-1659;

98. Van Overvoorde 1926, 149. The tile-works was on the Laanhoekse Watering, near the Haagsche Schouw.

99. The information on De Claeuw is taken from Thieme-Becker, 7: 38–39, and Bredius 1882–1883, 214. It is clear from Beck 1972, 34, doc. 25-2-1651, that he, too, ran up debts in The Hague.

100. Beck 1972, 37, doc. 6-1-1662.

101. Bredius 1882–1883, 214.

102. RANH, ORA Heemstede 547, Schepenrol, 13-4-1661. It cannot be inferred from the wording of this document that Steen and De Claeuw were living in Heemstede in 1658.

103. Broersen 1993, 24, 28.

104. For decades there had been a running battle within the Haarlem Guild of Saint Luke over the question of whether there should be some degree of freedom in art dealing in the city. On this question see Schwartz and Bok 1990, 171–173, and De Marchi and Van Miegroet 1994, 458–460.

105. Broersen 1993, 27. It can be deduced that people knew of the close association between Molenaer and Steen from a notebook kept by the painter Vincent Laurensz van der Vinne (Haarlem 1628–1702). In it he noted down the names of the painters whom he had known in Haarlem during his lifetime, and mentions Molenaer, Leyster, and Steen in a single breath (Miedema 1981, 933).

106. Bredius 1882–1883, 207, April 1658.

107. This is clear from both GAD, RAD, Register van borgtochten . . ., 5-4-1657; Bredius 1927, 91–92, and GAG, RAG, "Verbaelen," 18-5-1657.

108. Steen's stay in Warmond is dealt with at length in an as yet unpublished article by A.G. van der Steur, "Jan Steen en Warmond." Mr. Van der Steur was so kind as to allow me to study his findings, for which I am very grateful.

109. GA Warmond, Oud Archief, 21, Garingslijst, 1660. Van der Steur has shown that earlier reports that Steen paid his dues for the period 1656–1660 are incorrect.

110. ARA, RAZH, RA Warmond, Transport registers, 16-6-1659; awaiting publication by Van der Steur.

111. All the information in this paragraph comes from Van der Steur 1966 and De Graaff 1966.

112. See Dudok van Heel 1994 for Rembrandt's own contacts with Remonstrants.

113. GAH, DTB, Dopen RK Statie St. Joseph (Begijnhof) 4-8-1660.

114. GAH, DTB, Dopen RK Statie St. Anna, 11-9-1662.

115. Miedema 1981, 1037, 1041. See De Vries 1977, 51f for Steen's production.

116. GAH, RAH, Kwestierollen, 29-11-1661; Bredius 1927, 92. Jan Steen refused to hand back Cornelia Spijckers' chattels until she paid him the 18 guilders she owed him in rent for a room for the six months running from 1 November 1661 to 1 May 1662.

117. GAH, Notary W. van Kittensteyn, NAH 291, fols. 411–411v, 3-12-1662; Bredius 1927, 92.

118. Reproduced in Braun 1980, 12.

119. GAH, RAH, Transporten van roerende goederen, 1-4-1666; Bredius 1927, 93.

120. GAH, Notary L. Baert, NAH 371-a, 30-4-1667; Bredius 1927, 93.

121. GAH, RAH 26-3, Memoriaal van schepenen, 27-2-1670; Bredius 1927, 93. It was for the relatively modest sum of around 10 guilders.

122. GAL, DTB, Huwelijken voor schepenen, 29-4-1662.

123. GAL, Notary N. van der Bouchorst, NAL 939, 8 June 1661 and successive deeds; Bredius 1927, 95–96. Wijbrandt Steen was later ordered to pay the girl 12 guilders (GAL, RAL, 47-H, Vredemakersboeken, 2-3-1663; Bredius 1927, 96).

124. GAL, DTB, Huwelijken voor schepenen, 29-4-1662. For Steen and De Vois, see Doove 1968.

125. For Van Grieken see Thierry de Bye Dólleman and Van der Steur 1988, 78.

126. The klopje was probably Catharina, for Swaentje (also called Agnes) bought a place for herself in the Leproos- en Proveniershuis hospice in Gouda for 1,500 guilders in 1682, and lived there until her death. A klopje would not buy a place for herself in a public institution, but gave her money to the Catholic Church. Swaentje was forty-seven years old in 1682 (GA Gouda, Leproos-en Proveniershuis, 12, Minuten van contracten voor opname van proveniers, 10-2-1682; 10, Legger van proveniers, fol. 18, 9-3-1682 [where her age is given as forty-five]; Stadsarchief, 13, Minuut vroedschapsboek, 10-3-1682).

127. GAL, SAL II, 6612, Bonboek Gasthuisvierendeel, fol. 278, 15-7-1664.

128. GAL, RAL 44-G Dingboeken, April 1668; Bredius 1927, 86–87. See also GAL, SAL II 6612, Bonboek Gasthuisvierendeel, fol. 278, 5-5-1668.

129. Langebrug was also called Overwulfde Voldersgracht. GAL, SAL II 6614, Bonboek Zevenhuizen, fol. 6v "Volresgraft in 't poortgen," 30-5-1668. For the mortgage see also GAL, SAL II 6614, Bonboek Zevenhuizen, fol. 6v; RAL 144A, Register van dispositiën op requesten, 7-10-1673; RAL 144A, Register van dispositiën op requesten, Requestboek, 28-12-1673 (Bredius 1927, 89–90). For the precise location see Van Overvoorde 1926, 148.

130. GAL, RAL, 67-5C, Transport registers, 9-6-1668; Bredius 1927, 87. This stretch of the Rhine is now called Boommarkt.

131. This epidemic of "fevers" struck Leiden in 1669 and 1670 (with thanks to P. J. M. de Baar).

132. GAL, Notary J. Thierens, NAL 1114, 12-10-1669; Bredius 1927, 87.

133. GAL, Notary J. Thierens, NAL 1115, 14-2-1670; Bredius 1927, 87–88.

134. For Wijbrand Steen's creditors see Bredius 1927, 96.

135. GAL, Notary J. Thierens, NAL 1115, 14-4-1670; Bredius 1927, 88–89.

136. It was sold in 1671 (ARA, RAZH, RA Voorschoten, Transport registers, 1-12-1671. See also GAL, Notary J. Thierens, NAL 1115, 15-3-1670; Bredius 1927, 88. It was probably the same tile-works that Havick Steen had founded in 1663 on the Laanhoekse Watering near the Haagsche Schouw (Van Overvoorde 1926, 149).

137. GAL, Notary J. van der Stoffe, NAL 1192, 20-5-1674; Bredius 1927, 96.

138. Weyerman 1729–1769, 2: 353: He summed up the events as follows: "Ontrent die tyd stierf den ouden Havik Janszen, op het jaar duyzent ses hondert negen en sestig, en zyn Zoon Jan Steen erfde een huys tot Leyden, waar door hy zyn wooning opbrak en zich in die Stad ter neer zette, om aldaar een nieuwe rol te beginnen. Jan Steen rechte een Herberg of liever een kroegje op, ley Wyn en Bier in, stak een krans uyt, en schilderde een beeldje op zyn uythangbort dat de Vreede verbeelde, en een Olyfkransje had gevat. Hy kreeg neering genoeg, maar de betaaling was niet al te prompt, zynde het meest alle geldelooze Schilders die hem kwamen bezoeken. Frans van Mieris, Ary de Vois, Quiring Breekelekamp, en Jan Lievensz. waaren zyn dagelyksche klanten." Here, incidentally, Weyerman is not entirely reliable, for Brekelenkam was already dead.

139. GAL, Gilden 849, Lukasgilde, "Deecken ende Hooftmans boeck."

140. GAL, SAL II, 940, Dienstboeken.

141. GAL, Gilden 849, Lukasgilde, "Deecken ende Hooftmans boeck."

142. Steen's cousin, Johannes van Rijnsburg, had stood surety for this, and in October 1673 he demanded payment of the interest from Havick Steen's joint heirs; GAL, RAL, 144A, Register van dispositiën op requesten, 7-10-1673; GAL, RAL, 144A, Register van dispositiën op requesten, 28-12-1673 (Bredius 1927, 89–90); GAL, RAL, Register van dispositiën op requesten,86A, Appoinctementen, 16-2-1674.

143. GAA, Notary H. Outgers, 26-4-1672; Bredius 1927, 98.

144. GAL, SAL II, 83, Gerechtsdagboeken, 17-11-1672; Bredius 1927, 94.

145. Weyerman 1729–1769, 2: 354: "[. . .] gewoon [. . .] voor Meyd te spelen."

146. GAL, Notary C. de Haas, NAL 1053, 26-3-1673; Bredius 1927, 94.

147. Their grandmother, Anna van Raelst, the widow of Jan van Goyen, made bequests to Steen's children Cornelis, Johannes, Havick, Constantijn, Catharina, and Thaddeus in her will of 20 May 1672 (GAG, Notary M. van Heuvel, 20-5-1672; Bredius 1896, 125). Houbraken gives the number of Maria van Egmond's children.

148. GAL, RAL 90, Desolate boedels, 16-10-1661.

149. Van Oerle 1975, 420. Above the Breestraat entrance is a tablet depicting a sheep's head and feet, and another on the Langebrug side shows a whole sheep.

150. GAL, DTB, Huwelijken voor schepenen, betrothal 6-4-1673. For Maria's house see GAL, SAL II, 6618, Bonboek West-Nieuwland, fol. 106, west side of Koepoortsgracht. That canal has since been filled in and is now called Doezastraat.

151. Bredius 1882–1883, 207.

152. On this point see Naumann 1981, 1:31–33.

153. Van Overvoorde 1926, 149–150. The grave had become his property in 1671 (GAL, Archief Pieterskerk, Grafboek 1665, fol. 212v). A memorial tablet to the artist was unveiled on the pillar beside the grave in 1926.

154. GAL, RAL 67-5N, Transport registers, fol. 78, 22-2-1680; Bredius 1927, 95.

155. Van Overvoorde 1926, 149.

156. GAL, Archief Pieterskerk, Grafboek 1665, fol. 212v; Van Overvoorde 1926, 150.

157. The full details will be published in the *Jaarboek van het Centraal Bureau voor Genealogie.*

158. Swillens 1957, 236: "Steen moet een ernstig man zijn geweest, die bij zijn tijdgenoten en collega's in hoog aanzien stond. . . . Van enige liederlijkheid in zijn leven is en kan geen sprake zijn. Jan Steen was een degelijk mens en heeft met zijn vrouw Margaretha een zeer goed en gelukkig huwelijksleven gehad."

159. Respectively: GAL, Weeskamer, 106, Voogdenboek G, fol. 186, 11-6-1670: "mr. Johan Steen, konstschilder"; Doove 1968, 52, n. 52 and GAL, Notary C. de Haas, NAL 1057, akte 125, 30-6-1677; Bredius 1927, 95.

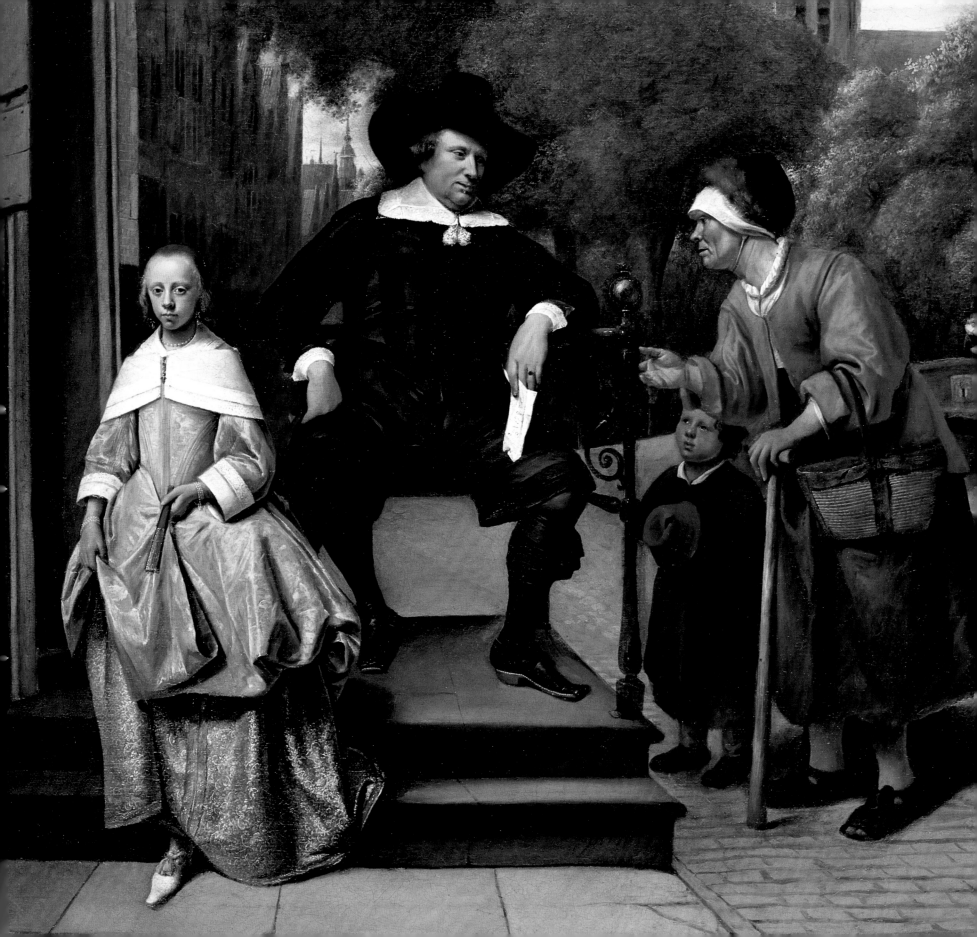

JAN STEEN, SO NEAR AND YET SO FAR

Eddy de Jongh

To Seymour Slive on his seventy-fifth birthday

Jan Steen is widely regarded as one of the most appealing of seventeenth-century artists for his directness, his manner of presentation, his humor, and his rhetorical flair.[1] Time, supposedly, has erected not a single barrier between him and us. On the contrary, his work is said to vault the centuries, making contact "vom Geiste zum Geiste." One writer commented that no one can remain unmoved by Steen, while others feel cheered by him.

Although these authors may believe themselves privileged to hold a dialogue with such a lively shade, one is tempted to ask whether any dialogue is possible, and whether or not it consists of modern-day projections onto the artist's images. It is part of the art historian's business to track down artists' meanings and, in a broader sense, to discover how the artist's contemporaries understood the images. The scarcity of documentation and the mists of time can make it difficult to bring this task to a completely satisfactory resolution, yet the posing of certain questions is no less relevant or necessary. One question that must be asked of Steen's work is: Can we understand his meaning properly if our reaction to him is essentially spontaneous?

The problem of how to understand seventeenth-century Dutch genre paintings has been much discussed over the past few decades.[2] In 1957, one author wrote of Steen's *Girl Offering Oysters* (cat. 9), "it should be remembered that a painting, as a work of art, is never important for the what but only for the how."[3] Such a view would be considered extreme today, but still opinions differ sharply on the "how" and the "what," the relation between form and content, and their relative hierarchy. While some authors tend to over-interpret iconography, leading to many unintentionally hilarious analyses, others award primacy to the formal aspects of the work, arguing that this was where the seventeenth-century artist put his powers to the test. Most exegetes operate between these two poles, and for them the meaning of a work of art is to be found in a combination of factors, both within and without the work, concerning the "how" as well as the "what."

I have gradually come to realize that the formalist approach, which seems to have evolved from a narrow-minded acceptance of the impressionist aesthetic, is sometimes adopted partly in reaction to the subjects chosen by seventeenth-century painters. That trivial, mundane subjects could be combined with brilliant painting appears to contain an unpleasant sort of contradiction for some modern art-lovers. Such subjects, however, appealed greatly to the average seventeenth-century beholder. I am thinking here of the view expressed by the Protestant preacher Franciscus Ridderus in his *Nuttige Tijd-korter voor Reizende en andere Luiden* of 1663, which can be taken as a *communis opinio*: "One must not judge paintings by the figures they contain but by the art that is in them, and by the witty connotations."[4]

It is perhaps not entirely surprising that the clichés found in seventeenth-century art, the coarse jokes, the moral and the pseudo-moral, in so far as they have been fathomed and taken at their original value, can give rise to feelings of boredom, if not distaste, in some modern viewers. Overwhelmed by a surfeit of moralizing and corniness, one withdraws to the snug citadel of one's own good taste. It even occasionally seems as if iconology, the method by which those moral exhortations, jokes, and clichés are retrieved from the mists of time, is held responsible for the didacticism and corniness.[5]

Jan Steen, in the meantime, is a special case in more than one respect. Everyone now agrees that to judge Steen's work solely or mainly on its painterly qualities would be to do a grave disservice to an artist of such an exceptional character. Moreover, it can hardly be doubted that his scenes bear a certain relation to daily life in the seventeenth century, with all its morals and customs, and with all kinds of traditional ideas. All the same, we should not misjudge Steen's "realism."[6] His scenes are never mirrors, either of ideas or situations; they are always interpretations. It is up to us to interpret those interpretations, in so far as we can.

Those interested in developments in hermeneutics may wonder whether Steen is also an attractive subject for deconstructionists and other postmodernists. Now that Rembrandt and Vermeer have been put through the post-modernist mangle, emerging unrecognizable on the other side, I would personally regret it if the same thing happened to

Steen. A Steen who suffered that fate would undoubtedly look very different from the "historical" personage, and the latter has been pummeled into weird shapes often enough already.

Some post-modernists ("the death of the author") will assert that "the historical Steen" is a naive concept, because irretrievable, as will some positivists, and unfortunately I am forced to agree with this defeatism to some extent.[7] It should be understood, though, that I have no wish to proclaim the death of Steen the author, and that I believe that his partial irretrievability should not be taken as a license to indulge in wild interpretations of the meanings in his work.

I am very well aware that the latter statement itself contains a naivety. "Meaning" is a concept as slippery as it is dynamic, and scholars in various disciplines have been making a close study of the meaning of meaning for a long time now, although this has not yielded keys to the proper understanding of someone like Jan Steen.[8] For the art historian with an iconological bent, then, there is little alter-

fig. 1. Jan Steen, *The Sick Girl*, c. 1663–1665, oil on panel, Mauritshuis, The Hague

native but to shake off the defeatism and to hobble along with naivety as one's companion. It may be a consolation to recall Gombrich's endorsement of the—naive—vision of the literary critic E. D. Hirsch Jr., who stood up for "the old common-sense view that a work means what its author intended it to mean, and that it is this intention which the interpreter must try his best to establish."[9]

Several of Steen's paintings have seduced scholars into far-fetched readings. I am thinking specifically of *The Burgher of Delft and His Daughter* (cat. 7)—a work that is as easy to describe as the pictures of a doctor taking a young woman's pulse, a Twelfth Night party, a prayer before a meal, or a fantasy about Samson and Delilah (fig. 1, cats. 18, 28, 34). However, when one tries to plumb the possible implications or symbolism of these scenes, clear differences in complexity emerge. It is highly unlikely that the doctors' visits refer to anything other than pregnancy, or to what was known in the seventeenth century as *morbus virgineus*—lovesickness.[10] Steen painted a long series of works on this evidently extremely popular theme, also known from the oeuvres of other artists. All sorts of details invariably signal the area where the meaning must be sought. Only one, fairly simple explanation exists, based on a quite straightforward iconography supplemented with relevant data from cultural history. This information, incidentally, tells us nothing of the artist's intentions. Was he being mainly facetious and ironical, or was he also being serious and, who knows, moralistic? We lack a method for divining artists' intentions, and it is here that something of Steen's "irretrievability" makes itself felt.

The Burgher of Delft and His Daughter (cat. 7) adorns the cover of Simon Schama's *The Embarrassment of Riches*, which is the main reason why the painting has become so well-known.[11] Unlike the vast majority of Steen's works, this is a portrait, albeit one with an unmistakably genrelike air. The man and the young girl, presumably his daughter, were painted from life, whereas the needy woman and her child have more the look of imaginary figures. Schama regards this interesting scene as programmatic for his central thesis that there was a constant tension in seventeenth-century Dutch society between riches and perplexity about that wealth

on the part of those fortunates upon whose heads it had rained down. Schama suspects that the painting was commissioned to celebrate the burgher's philanthropy, but because the figures are "almost perversely disconnected from each other," he detects uncertainty and disjunction in the presentation.

"Everything," he writes, "points . . . somewhat overemphatically to the requirement that the burgher should wish himself represented as the steward rather than the owner of riches, by giving some of it to the poor. But what is so striking about the painting is that he does not. Instead he hesitates while holding a paper I think may be the license announcing the woman and child to be themselves *of residence*, that is to say, the woman is a local Delft indigent who has been given particular and special permission to solicit for charity. Indeed, the sympathetically observed relationship between mother and son (in startling contrast to the non-relationship between the well-to-do 'father and daughter') would seem to support this. Our 'burgher of Delft,' then, responds to the embarrassment of his riches—of house, daughter, rich apparel—by being a judge in the sight (literally) of the church, an arbiter of the deserving poor, the figure for whom they may stand at the gate."[12]

Schama reads a great deal more from the painting than the supply of visual information permits. It is impossible to say whether the woman has been given official permission to seek support, let alone that we can see evidence for this in "the sympathetically observed relationship between mother and son." And how can we assume that the seated gentleman's reaction is prompted by unease about his wealth?

Remarkably, an even more fanciful reading of the Delft burgher appeared two years after Schama's.[13] The author projected almost the entire political situation in mid-seventeenth-century Delft into the painting, interpreting it as an expression of belief in the rights of town sovereignty and its leaders "as unwavering as one might expect to find in the early years of the first stadholderless period."[14]

The sitter, his solid bulk spread out on the bench, is one of those powerful regents. Steen may have given the "arc of his sturdy legs" that shape to create a visual rhyme with the arch of the new

stone bridge, "graced by the armorial shield and signifying municipal affluence."[15] His charming daughter invites us "to embrace the burgher's faith in the system of local oligarchic dynasticism and his hope that the political tradition he embodies will continue in the future with the next generation of his family."[16] From the man's placement between his daughter and the indigent woman (not beggar), the author deduces that "the painting uses gender to reinforce reciprocity as the ideal, and breaks down the assumption of non-republican hierarchy attaching to the burgher's central position."

One problem in interpreting seventeenth-century Dutch paintings, particularly genre paintings, is the want of a contemporary guide to their meaning. The art theory of the day, which was mainly concerned with history painting, is silent on the kind of pictures that Steen produced. The books of theory contain not one iota of information on the way in which a particular symbolism, concerning lovelorn maidens, for instance, or current local politics, could be worked into narrative compositions.[17]

Yet it is possible to argue successfully that the doctor's visit is an image of an erotic disorder, while the interpretations of *The Burgher of Delft and His Daughter* as an expression of the embarrassment of riches or as an encapsulation of a political ideal are improbable and even arbitrary. I have no hesitation in asserting that, objectively, there is a difference in the supply of visual information. In the first case, iconography points to specific connotations, and no reasonable, alternative avenue remains open. The iconography in the second case is far less imperative and certainly less obvious. A Cupid shooting arrows, whether or not he is dressed as a seventeenth-century lad, is considerably less ambiguous, especially when placed in close proximity to a lovesick lady, than the tower of the Oude Kerk, the sheet of paper held by the worthy gentleman of Delft, or the arched shape of his legs.

In *The Burgher of Delft and His Daughter*, not a single motif has been indisputably found to symbolize any sort of embarrassment or political ideology. Those meanings have simply been imposed on the picture. By contrast, the basis for the interpretation of the doctor scenes lies within the paintings themselves. The details that offer firm footholds are

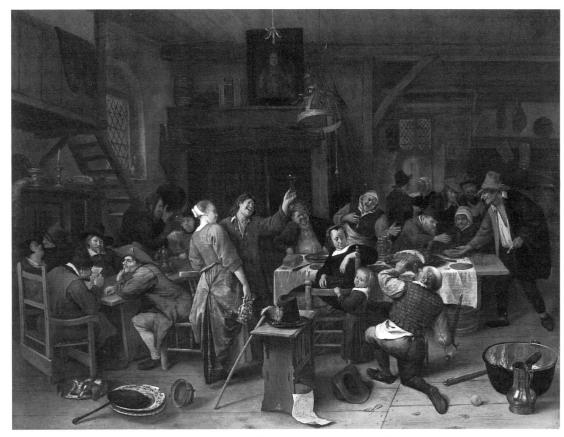

fig. 2. Jan Steen, *Prince's Day: Celebrating the Birth of Prince William III*, c. 1668, oil on panel, Rijksmuseum, Amsterdam

within the framework of the picture itself (no one will question the semantic charge of doctor, Cupid and doleful patient), details which can serve as pegs on which to hang certain facts known from the history of culture, such as those concerning medical treatment based on pathology of the humors.[18] Information from within and information from without mesh seamlessly in this case and thus yield a fruitful result.

The Burgher of Delft and His Daughter is one of the few portraits that Steen painted. He preferred narrative painting, rarely even attempting landscapes and still life. The bulk of his oeuvre is devoted to human activity in its myriad facets and variety, with subjects taken from the Bible, mythology and classical history, but above all from the daily life of his own age.

Steen transposed that life he saw into art, by filtering it through his imagination, using a not very complex but well thought-out rhetoric. However he deployed his vehicles of meaning, prominently or less conspicuously, forte or piano, highly naturalistic or skimming along the bounds of reality, in most cases they would have had an effect on the initiates among his public. To say that Steen's rhetoric was not very complex, incidentally, assumes that he is entirely fathomable. This pretension, though, is difficult to sustain. It is clear that one part of his oeuvre can be taken at face value while another part must be read on a second level, and that he refrained from true intellectual *tours de force*. Instead he challenged his viewers to indulge in some light mental gymnastics in order to unravel ideograms composed mostly of everyday commonplaces.

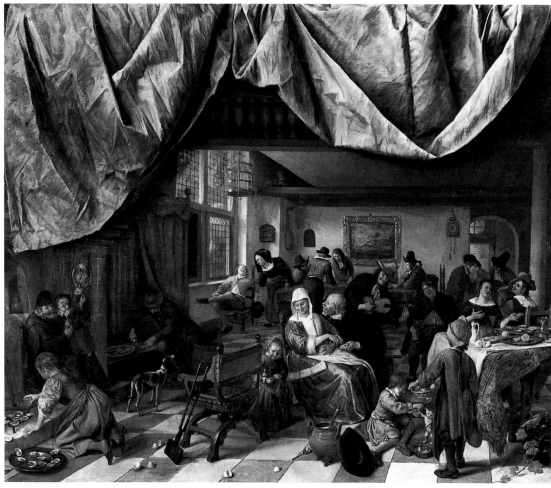

fig. 3. Jan Steen, *The World as a Stage*, c. 1665–1667, oil on canvas, Mauritshuis, The Hague

His Daughter, does contain explicit political motifs and thus political implications. *The World as a Stage* reflects a view of mankind, and the *Self-Portrait as a Lutenist*, finally, can be understood as a metaphor for an important part of Steen's oeuvre.[21]

The quintessence of that latter picture lies not so much in the lute-playing as in the artist's ad hoc identification with a comic actor. This presentation corresponds strikingly with the theatrical nature of many of Steen's works.[22] Perhaps Steen is here putting into practice what the painter and writer Samuel van Hoogstraeten (1627–1678) was to prescribe a few years later for the depiction of "the passions," making emotions visible through the physiognomy. This also includes laughter. "If one wishes to derive honor from this, the noblest aspect of art," Hoogstraeten argued, "then one must transform oneself completely into an actor." He advised the painter to depict the passions by practicing before a mirror, thus becoming "both performer and beholder."[23]

Steen's scenes are most closely related to comedy and farce, albeit in varying degrees. In biblical and mythological scenes, he often drags that lofty genus down by interpreting it in part as travesty and by "disturbing" the elevated subject matter with comic and vulgar goings-on.[24] For example, the little boy urinating into the mouth of Goliath's decapitated head during David's triumphal entry is a motif borrowed from Maerten van Heemskerck (1498–1574), which classicist theorists, at least, would have disqualified as a breach of decorum (page 79, figs. 21 and 22).[25] Most of Steen's artist contemporaries would have taken good care not to joke about biblical subjects, but the blending of genres, or at least the inclusion of "unseemly" details, was not unknown in earlier centuries. Medieval art certainly displays satirical and obscene details designed to catch the viewer's eye.[26]

The lute-playing actor was not the only role that Steen wrote for himself. We encounter him in various scenes, sometimes playing an unmistakably rhetorical part as commentator or intermediary between the event and the beholders.[27] No simple answer exists either to the seemingly paradoxical question of the extent to which these ego documents are meant to be personal, or to the question

When distinguishing between the simple and the multiple reading it is important to consider what has been said above about meaning and irretrievability, and to realize that the distinction is a construct to help us bridge historical distance. A simple reading appears sufficient for works like *The Feast of Saint Nicholas* (cat. 30), the *Adoration of the Shepherds*, or for renderings of people playing skittles and *kolf*. These straightforward narratives are related without comment, and they do not require any further probing.[19]

That may not be the case with *Samson and Delilah* of 1668 (cat. 34). It poses, at least, the unanswerable

question of whether Steen, like Joost van den Vondel in his drama *Samson of Heilige Wraeck* of 1660, is implying that the Old Testament figure should be regarded as a prefiguration of Christ.[20] To put it loosely, the flesh-and-blood Samson could in fact be read as "Christ" on a different level. While it is highly unlikely that Steen used this traditional typology, it cannot be ruled out in principle. This is a matter of irretrievability.

In perceiving deeper dimensions in works such as *Prince's Day*, *The World as a Stage,* and *Self-Portrait as a Lutenist* (figs. 2, 3, and cat. 25) we are on firmer ground. *Prince's Day*, unlike *The Burgher of Delft and*

of the effect toward which Steen aimed.

Steen's oeuvre is now reasonably well-defined. We know his few genuine self-portraits, which enable us to identify the same face in other scenes, even when it is wearing a grin or a grimace.[28] Seventeenth-century collectors, to whom photographs of Steen's output were unavailable, might not have recognized the face. If they bought paintings on the open market, they might not have had an idea of the identity of that one laughing figure, especially if the painting had changed hands previously.[29]

Whatever effect Steen might have sought, from time to time he could not resist treading his own stage. He was certainly not the only seventeenth-century artist who turned himself into one of the protagonists in a painting. A striking example of this from the early 1630s is Rembrandt's appearance as an assistant executioner at the feet of the crucified Christ (page 17, fig. 8).[30] Explained as the image of sinful and blameworthy man, this manner of presentation has been associated with a well-known poem by Jacobus Revius from the same period in which the poet sets himself up as the one responsible for Christ's execution: "It is I, O Lord, I who have done this to you."[31]

A good number of poems were written in the seventeenth-century with a first-person narrator as sinner, not only by Revius but also by Bredero, Huygens, Krul, Stalpart van der Wiele, and others.[32] Bredero expressed himself very evocatively on this personal level, especially in his thirty-six-line *Liedeken van mijn zelven*. He laments, with passion and remorse, his defects and sins, and not surprisingly the weakness of the flesh also puts in an appearance.

For fleshly lusts seduce and fawn on me
When freely I succumb to passion.
Yet even as I taste its pleasure they rob me
Of my name, my good renown, my soul's very rest.[33]

If one looks for parallels between Bredero and painting, the searchlight soon falls on Jan Steen. One can regularly catch a figure with his features in the act of indulging his "fleshly lusts," among others in a painting in the National Gallery, London, that bears the bland title *Interior of an Inn* (page 19, fig. 13).[34] There, with a lewd grimace,

"Steen" lifts up a young woman's skirt while she, lending no ear to Venus, tries to push him away with her left hand.

But is there really a parallel between Bredero and Steen? Did he also mean to represent himself as a sinner, and a remorseful one at that? Bredero implores the "great King of Heaven" to reform him with his grace, but the skirt-chasing Steen shows not the least desire to be reformed.[35] To suggest that Steen had not the slightest intention of representing himself like that is unjustifiable. Perhaps that was indeed his intention. Unfortunately, we have no cognitive apparatus that enables us to pronounce conclusively on the subject. To put it another way, the artist is once again not speaking his true mind.

The real question is whether he could have displayed his deeper feelings, even if he had wished to. It is to be feared that the medium of painting is inadequate to communicate such a *tour de force*.

fig. 4. Adriaen van de Venne, frontispiece, *Tafereel van de Belacchende Werelt*, 1635, Rijksprentenkabinet, Amsterdam

Steen could have included a *vanitas* damper in his scene, as he did in *The World as a Stage* (fig. 3), but to portray himself and above all to make himself understood in the role of a lecher with two souls in his breast, the one lustful and the other full of penitence, is technically impossible for a painter. Such a dualism, in this case of a first-person narrator, can be expressed in words but not in paint, unless the artist has recourse to a not very subtle allegorical idiom.

We can speculate whether Steen intended to portray himself as a sinner in his many scenes that seem to be at odds with official morality. We could also replace that possible sinfulness with folly, a concept that was closely related to the sinful. Much hot air was wasted on the subject of folly in the seventeenth century. One bumps into such writings at every turn, but the book that immediately springs to mind in connection with Steen is by an older contemporary of his: Adriaen van de Venne's *Tafereel van de Belacchende Werelt* of 1635 (fig. 4).[36] That title, which can be translated as "Picture of the World to be ridiculed," as well as parts of the book itself, strike me as being eminently applicable to a whole series of Steen's paintings, which do, after all, show human conduct with a high dose of folly. They are, in essence, *partes pro toto* of the world, and the world must be laughed at, according to Van de Venne (1589–1662).[37] That maxim brings us back to the theater, for since classical antiquity the stage and the world stood in a metaphorical relationship to each other.[38] It was a very common image, used among others by Vondel in a couplet of 1637 that was inscribed on the architrave above the entrance to the Amsterdam Playhouse: "The world is a stage. Each plays his part and is allotted his portion."[39]

Another illuminating text in this respect is the prologue to a volume published in 1639 by Johannes Orisandt, a long-forgotten author from Van de Venne's circle.[40] Both writers cite the story of "the wide-famed philosopher Democritus, who rightly derided and mocked the world with all its company."[41] But we "thoughtless worldlings," says Orisandt, cannot laugh at the world "without jeering at ourselves, for the foolish world is within us." So here we meet the writer as fool who laughs at

himself as well as at others. It is possible that Steen cast himself in the role of fool on several occasions, with the age-old aim of telling the truth through laughter, *ridendo dicere verum*, while also laughing at his own follies. Perhaps it is this dualism that is being expressed so exuberantly by Steen the lutenist. A penny for his thoughts!

Some writers and poets employed a handy paradox when making the world laughable. Expatiating at length on vice and sin, they assure their readers of their good faith in a preamble. Vice had to be held up to public view if virtue was to be propagated fruitfully.[42] *Deugden-spoor in de on-deughden des werelts aff-gebeeldt* (Exhortation to Virtue through the Portrayal of the World's Vices) was the programmatic title of a 1645 book of emblems, and the principle could not have been enunciated better.[43]

Adriaen van de Venne and Jacob Cats similarly defend the presentation of vice. It is good, Van de Venne argues, "for folly to be recognized in order to shun it in the world."[44] And Cats expects, as he con-

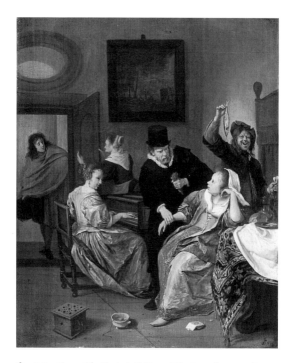

fig. 6. Jan Steen, *The Doctor's Visit*, c. 1668–1670, oil on panel, Philadelphia Museum of Art, John G. Johnson Collection, Philadelphia

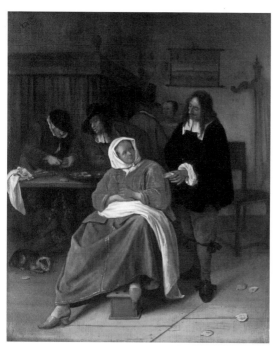

fig. 7. Jan Steen, *Man Offering an Oyster to a Woman*, c. 1662–1666, oil on panel, Reproduced by courtesy of the Trustees, The National Gallery, London

fig. 5. Cornelis Troost, *Jan Klaaz or the Supposed Servant Girl: the Marriage Proposal to Saartje Jans*, 1738, pastel, Mauritshuis, The Hague

tends in the detailed prologue to his much-discussed *Self-Stryt* that "the wild impulses of the flesh" can be useful to the reader, "just as it is not strange that the virtues can turn even shortcomings to their advantage."[45] One occasionally finds the same principle applied in prints, which depict vice but have censorious inscriptions urging the viewer to practice virtue.[46]

Writers had the edge over painters in that their medium offered every opportunity to legitimize the portrayal of the sinful. Sadly, not everyone was convinced of their sincerity. The strict Remonstrant poet and clergyman Dirck Rafaelsz Camphuysen berated poets who said that they were combating evil by describing it at length.[47] And as to painting, Camphuysen had not a good word to say about it. He was utterly convinced that this "seductress of the eyes" thrust "the heat of lust into the depths of the heart."[48] He was by no means the first, though, to criticize art on moral grounds. A century earlier Erasmus had also been critical of paintings, and

considered it disgraceful that even churches displayed titillating scenes of sinfulness, no matter that they were from the Bible, on the pretense that they served to encourage meditation on the retribution that lay in store for the sinners.[49]

One can easily guess how the heirs of Erasmus and Camphuysen reacted to Steen's work. For Pastor Ridderus, whom we have already heard speak approvingly of the "witty connotations" in paintings, Steen would often have gone too far, for Ridderus belonged to the Voetians, a rigidly orthodox movement within Dutch Calvinism.[50] Frivolities like *The Interior of an Inn* would certainly not have been found hanging in the houses of such people, and this applies equally to puritan Catholics (Steen's coreligionists) and to right-minded Mennonites.

Mennonites would have had an extra reason for distrusting Steen if they had been able to survey the whole of his oeuvre. He ridiculed them on several occasions, undoubtedly speculating on his public's familiarity with what was believed to typify Men-

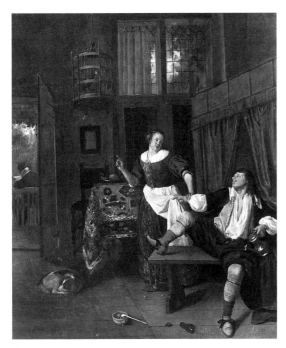

fig. 8. Jan Steen, *The Eager Lover*, c. 1665, oil on panel, present whereabouts unknown

nonites: separation from the world, a rule of life enforced by discipline, and stiff in demeanor and dress (the latter generally an unfashionable black with a remarkably tall hat).[51] Writers also mocked Mennonites. They are portrayed as bigots and hypocrites in the "Meniste Vrijagie" by the poet Jan Jansz Starter (1623) and in the sensational comedy by Thomas Asselijn, *Jan Klaaz of Gewaande Dienstmaagt* of 1682, which fifty years later was to inspire a series of amusing pastels by Cornelis Troost (1696–1750) (fig. 5).[52] The people Steen typified as Mennonites, who pop up here and there in his paintings of merry companies, look just like Troost's stiff sticks. In their conspicuous woodenness they make a fine contrast with the ease and clamorousness of Steen's other characters.

In one of his versions of *Twelfth Night* (cat. 18), Steen shows a defenseless Mennonite (defenselessness being an important Mennonite tenet) provoked by a fool who holds a stick in front of his victim, from which two eggs and a sausage dangle.[53] It hardly needs pointing out that we are not exactly

dealing with the irretrievable Jan Steen here. Obscene jokes of this kind are ageless, and Steen loved them.

His comestible references to the male organ are varied. In one of his doctor scenes we see Steen himself commenting on the forthcoming diagnosis by brandishing a herring and two onions (fig. 6).[54] Elsewhere he makes abundant use of oysters, the shells of oysters and mussels, chamberpots, tobacco pipes, slippers, a caged parrot, a coal-pan, and kitchen utensils—all of them choice motifs for alluding to the genitals, both male and female, to coitus and pregnancy (figs. 7, 8).[55]

In *The Interior of an Inn* from the late 1660s he laid it on with a trowel, as he so often did. The central action is bolstered by a number of the above ingredients, which would have heightened the sexual atmosphere for those who knew their onions.[56] Mussel-shells have already been mentioned as well-known female symbols. Eggs were regarded as an aphrodisiac as early as the middle ages and included in ribald scenes long before Steen, by Cornelis Matsys (c. 1510/1511–after 1556/1557) and Jan Matham (1600–1643), for instance, in engravings with inscriptions that leave little to the imagination (figs. 9, 10).[57] The eggshells taken in combination with the saucepan at the woman's feet probably refer to the expression "cracking eggs into a pan," which was one of the many Dutch synonyms for coitus and was used as such by Matthijs van de Merwede in his infamous, priapic book, *Roomse min-triomfen*, of 1651.[58] The action of the man seated on the right, who is stuffing his pipe with his little finger, speaks for itself. Steen used it more than once (fig. 11), as did such painters as Hendrick Pot (before 1585–1657) (fig. 12) and Willem van Mieris (1662–1747).[59] And no one will doubt that the barrel with the large bung-hole and the stick leaning against it also allude to sexual intercourse.

The number of Steen's works in which eroticism or sexuality play a part, in whatever form or gradation, is truly impressive. This predilection, one could almost call it obsession, manifests itself not only in genre scenes—"merry companies in wine or ale-houses, or dark corners, where more warm flesh is fingered than bought," as Houbraken put it—but also in works with biblical or mythological

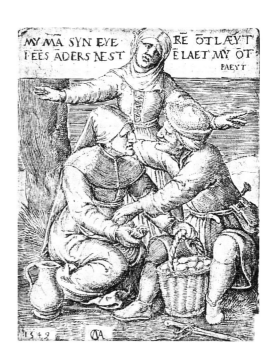

above: fig. 9. Cornelis Matsys, *Allegory of Adultery*, 1549, engraving, Rijksprentenkabinet, Amsterdam

below: fig. 10. Jan Matham after Adriaen van de Venne, *Peasant with eggs*, c. 1635, engraving, Rijksprentenkabinet, Amsterdam

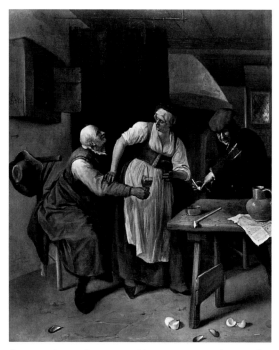

fig. 11. Jan Steen, *The Amorous Old Man*, 1665–1668, oil on panel, private collection

subjects like Samson and Delilah, Tamar and Amnon, Bathsheba with David's letter, Lot and his daughters, Antony and Cleopatra and Antiochus and Stratonica. Oddly enough, though, nudes are conspicuous by their absence.[60]

As is to be expected, Steen's preoccupation with eroticism and sexuality is at its most outspoken in the genre paintings. This raises the question of whether his frankness, a good example of which is provided by *The Interior of an Inn*, does not conflict with the uncomplicated image of the painter as propagandist for the middle-class family, as some scholars prefer to see him.[61] The prevailing morality that cherished the family as a "foundation stone of cities" or the cornerstone of society was based on the Christian doctrine of the virtues, which demanded regulation of the sexual impulse as well as observance of decorum *in sexualibus*.[62] One would have expected this to produce a different sort of iconography and symbolism, with the emphasis on chastity and marital fidelity, as it is in seventeenth-century marriage portraits. However, the vagaries

of the evolution of imagery in this period allowed many paradoxes to bloom. If he had been asked, Steen would probably have invoked, how sincerely we do not know, the supple principle of promulgating virtue through the depiction of vice.

It seems fairly obvious that Steen chose motifs in his paintings according to what he thought his public wanted. He would not have competed for the favors of the puritan minorities; it would probably have been a waste of time anyway. We can assume that most of his works were bought by a reasonably tolerant, possibly slightly libertine clientele from the middle classes, the milieu from which the artist himself came. In contrast to all the moralizing that went on in the seventeenth century, as an unwritten compromise between taboo and abandon, there was a remarkable liberalism of language and mode of expression—a liberalism that later generations often found difficult to swallow.[63] In any event, the purchasers of Steen's paintings would have been able to stand a shock or two. In fact, there is little reason to doubt that they prized

fig. 12. Hendrick Pot, *A Merry Company at Table*, 1630, oil on panel, Reproduced by courtesy of the Trustees, The National Gallery, London

his witticisms, also and perhaps especially those of a sexual and scatological nature.

Jokes of this kind are found in a considerable number of seventeenth-century books, and not just those aimed at a humbler readership. A certain penchant for licentiousness was also part and parcel of the humanist tradition.[64] The recent publication of the large collection of jokes of Aernout van Overbeke, a Hague lawyer who almost but not quite belonged to the upper crust, confirms yet again that intellectual level and low humor were by no means mutually exclusive in the seventeenth century.[65]

"Two poor French people, husband and wife. R. 'Do they have means?' R. 'Oui, ils ont mil écus ensemble. C'est à dire ils ont mis le culs ensemble.' "[66] I can hardly see a modern-day lawyer in The Hague lovingly recording something like that.

What is interesting is that a number of Van Overbeke's jokes have points of contact with Steen's paintings. The following one is based on the age-old theme of the ill-matched couple.[67] "An old man, on being taken to task for marrying such a young girl, replied: 'You can get a really good fire going with a small bit of dry wood.'" The theme of unequal lovers is found in Steen in a variant that also had a long tradition; he depicted a young woman who can choose between an old and a young admirer (page 59, fig. 11).[68]

With both Steen and Van Overbeke the joke often hinges on polysemy, the applicability of words (or things) in more than one meaning. Both, for example, seized on the double meaning of the Dutch word *kous*, or stocking, Steen in some paintings that will be discussed shortly, and Van Overbeke in his joke number 1783,[69] which makes play of the Dutch custom of putting one's shoe by the hearth on Saint Nicholas' Eve in the hope of finding a present in it the next morning. "Mr Jacob van den Burch, a stiff-jointed old fellow, received a visit from a young woman the day before the feast of Saint Nicholas. She said to him: 'I'll come and bring my shoe tomorrow evening,' to which he replied: 'It would be better if you brought your stocking.' 'I fear,' she said, 'that I would get little or nothing in it.'"

Humor is an aspect of human communication that does not usually stand the test of time. As

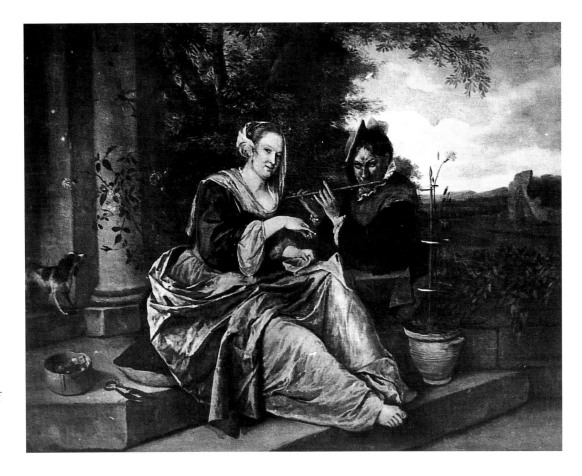

fig. 13. Jan Steen, *The Red Stocking*, c. 1670–1672, oil on canvas, private collection

noted at the beginning of this essay, it is difficult for us to gauge the value of some seventeenth-century witticisms. One suspects that jokes like the ones about the two poor French people, the little piece of wood and the stocking were considered a lot funnier in the seventeenth century than they are today. Anyone reading farces, facetiae, anecdotes, and other jokes from that period will not be amused by all of them and will certainly not always laugh at what was then considered the right moment. Some, moreover, have simply become incomprehensible.

Something similar applies to Jan Steen, and it is underlined by his affinity with Van Overbeke. The fact that he scatters jokes left and right is still clear to us, and the meaning of a good number of them still seems completely transparent. Inevitably, though, we will not catch certain subtleties and

nuances, and in some cases we will probably miss the point altogether. The meaning of the attribute with which the fool teases the Mennonite will be understood by the modern viewer instantly, even without the benefit of a dirty mind. However, the fact that a saucepan and eggshells can symbolize coitus is part of a lost body of knowledge, although it turns out that it can be rediscovered with a little difficulty. That sounds a bit portentous given the inanity of the motif, but the same could be said about many others that are equally inane on their own but which together make up a not inconsiderable part of the world of Jan Steen's imagination.

Such trivia were important precisely because of their referential function. For the viewer they served as extra stimuli. Steen's public would have derived part of their enjoyment from the minor mental gymnastics required to decode certain details, and in so doing reveal the "witty connotations." It was not only the artist's unvarnished manner that was attractive. His use of metaphor and disguise, and the way in which he introduced meaningful elements, led to him being awarded the honorable, posthumous mention by Houbraken as "most witty in invention."[70] Steen's "verbality," that is closely allied to metaphor, must also have been to the public's taste.[71] Here I am referring to the fact that his work contains motifs of every kind that turn out to be nothing more than visual translations of words, puns, sayings, or proverbs. "Cracking eggs into a pan" is one. The viewer is being invited to translate the image back into the word.

A painting like *In Luxury Beware* (cat. 21) consists solely of proverbs cast as images. In fact, it is an old-fashioned iconography, this compilation of wise saws in the tradition of Pieter Bruegel (1528–1569).[72] Such paintings were rarely produced in Steen's day, even though proverbs and sayings were still a vital part of everyday language.[73] The general view was that proverbs were in principle open to several interpretations, "being entirely pliable and supple for many matters," said Cats, an authority in this area as well.[74] That pliability would have appealed to Steen and his public. But just how flexible *In Luxury Beware* was intended to be, and how flexibly it was read by owners and bystanders, is something that again escapes us.

Sometimes the verbality takes the form of just a single word in a visual guise. Examples of this are found in paintings in which a young woman seated on a bed is putting on or taking off a stocking, or in which a woman is darning one (cat. 19, fig. 2, and fig. 13).[75] The Dutch word for stocking had the secondary meaning of the female pudenda in seventeenth-century usage, as did "mussel" and "oyster." Innocent readers who have just missed the point of Van Overbeke's joke about the stocking can now rejoin the party. It was not only Van Overbeke and Steen who made play with this ambiguity, but others like Adriaen van de Venne, in his role as painter, and Cornelis Dusart (1660–1704) (figs. 14, 15).[76] Writers of farces and poets also had a merry

fig. 14. Adriaen van de Venne, *"Geckie met de kous,"* c. 1630, oil on panel, Muzeum Narodowe, Warsaw

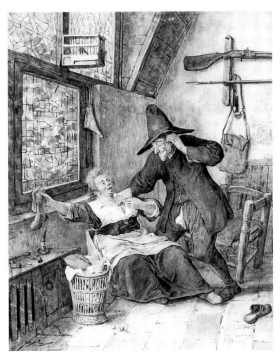

fig. 15. Cornelis Dusart, *The Lascivious Couple*, 1687, watercolor, British Museum, London

still life with lute, music-book, and wreathed skull. The other work, which was painted a few years earlier, lacks this vanitas element. Does this discrepancy force us to conclude that one version of the subject should be interpreted in the sense of transience and the second in some other way?[78] Is it as simple as that? I suspect not. I suspect that we are not only being confronted with transience here, but once again with the impossibility of retrieving Steen's intentions.

I have deliberately placed the emphasis on Steen's irretrievability. In addition to some iconologically dubious interpretations, the study of his oeuvre has yielded a series of very solid ones. But precisely because Jan Steen often creates the illusion that he is speaking to us as a good acquaintance, as charming as he is extrovert, as someone who has no desire to hide his feelings, it is easy to get the idea that he can be read like an open book in every sense. The truth, I believe, is a little different, namely that even Steen does not speak his true mind in certain respects, and never will. One does not need to embrace post-modernist principles in order to grasp this epistemological problem. Jan Steen, so near and yet so far—a cliché it may be, but we will have to make do with it.

time with stockings. The scabrous poet Mattheus Gansneb Tengnagel says of a girl that "she had her stocking darned with an unthreaded needle."[77]

It is almost inconceivable that Jan Steen painted young women busy with their stockings without intending the pictures to have a sexual connotation. His own repertoire pleads against his innocence. That need not prevent some modern viewers from believing that the artist was mainly concerned with beauty and the rendering of fabrics—they are superb paintings, after all. In my view, though, these works are representative examples of the natural way that painters of the day combined aesthetic and triviality, and at the same time gave a pointed meaning to that triviality.

When comparing the two scenes of a girl pulling on or taking off a stocking during her toilet, one runs into a further problem, which is also found in other groups of related scenes. The larger painting of the two, which was executed in 1663, has as the eye-catching motif in the foreground a

1. De Vries 1992, 7.

2. A limited selection of relevant articles: Sluijter 1991b; Falkenburg 1991; De Jongh 1992a; De Jongh 1992b; and Franits 1994.

3. Van Wessem 1957, 7a–7b: ". . . wij wel moeten bedenken dat een schilderstuk als kunstwerk nooit belangrijk is om het wát, maar alleen om het hoe."

4. Ridderus 1663, 221: "Men moet de Schilderijen niet oordeelen na de beeltenissen die daar in staen/ maer na de konst in de selvige/ en na de aardige beduidingen."

5. A typical remark in this respect is the one made by C. Ebbinge Wubben, former director of the Museum Boymans-van Beuningen: "Mâle verliest zich niet in, toch eigenlijk vervelende, interpretaties zoals je die vindt in de catalogus 'Tot Leeringh ende Vermaeck'" ("[Emile] Mâle does not lose himself in what are in fact boring interpretations of the kind found in the catalogue *Tot Leeringh ende Vermaeck*"), cited in Odding 1994, 89.

6. De Vries 1977, 102–110.

7. For a post-modernist reading of Rembrandt, see Bal 1991. Illuminating work has been done on post-modernism by the Groningen philosopher of history, Frank R. Ankersmit, notably in Ankersmit 1990. See also Serres 1988.

8. See, for instance, the celebrated study by [C. K.] Ogden and [I. A.] Richards 1923, and Hermerén 1969.

9. Gombrich 1972, 4.

10. Petterson 1987.

11. Schama 1987, 573–575.

12. Schama 1987, 575.

13. Muller 1989.

14. Muller 1989, 287.

15. Muller 1989, 278.

16. Muller 1989, 276.

17. De Jongh 1993, 24.

18. Petterson 1987.

19. Braun 1980, respectively nos. 199, 288 and 308; 18, 19, 57, 118 and 119; 13, 31, 37, 52 and 73.

20. Steen also treated this subject more than once; see Braun 1980, nos. 297 and 298. Further: Kirschenbaum 1977, 68, 69, 113–114; Vondel 1927–1937, 9:173–279; and Smit 1962, 3:159.

21. For *Prince's Day* see De Vries 1992. For *The World as a Stage* see Amsterdam 1976a, 236–239. For the *Self-Portrait as a Lutenist* see Chapman 1990–1991, 188, and Chapman 1993, 149.

22. Heppner 1939–1940, 22–48; Gudlaugsson 1945; De Vries 1976; Chapman 1990–1991, 186–191; and Chapman 1993, 142–150.

23. Van Hoogstraeten 1678, 109–110: "Wilmen nu eer inleggen in dit alleredelste deel der konst, zoo moetmen zich zelven geheel in een toneelspeeler hervormen. . . . Dezelve baet zalmen ook in 't uitbeelden van diens hartstochten, die ghy voorhebt, bevinden,

voornaemlijk voor een spiegel, om te gelijk vertooner en aenschouwer te zijn."

24. See De Vries 1983, 113–128. On the hierarchy of genres see Raupp 1983; and Muylle 1986. On travesty and related genres see Hempel 1965.

25. Kirschenbaum 1977, 114–115. It is this particular detail that was singled out in the "dialogue of the dead" between Peter Paul Rubens and Jan Steen, where Steen is accused of a lack of propriety in his history paintings. The dead Rubens says: "You once painted the triumphal entry of David after he had slain the giant Goliath. In it you tried to add to the joy and glory by inserting all kinds of joyful incidents, even showing a quack performing on his stage and a child in the act of pissing into the mouth of the giant's decapitated head" ("[. . .] gy hebt eens de triomfeerende intrede van *David*, na het verslaan van den Reus *Goliath*, geschilderd, in welk Tafereel gy de vreugd en glorie hebt willen vermeerderen door allerhande vreugde-bedryven, ja zelfs door een Kwakzalver op zyn Theater te doen speelen, en door een Kindje te verbeelden, dat het afgeslagen hoofd van den Reus net in den Mond pist"); see *Maandelyksche berichten* 1747, 54. A breach of decorum of a similar order, the two dogs mating in Rembrandt's *St. John the Baptist Preaching*, was condemned by Samuel van Hoogstraeten as "an abhorrent indecency in the circumstances of this story" (". . . een verfoeilijke onvoeglijkheit tot deze Historie"); see Van Hoogstraeten 1678, 183.

26. Holl 1974, 3:cols. 337–338, 4:cols. 46–49.

27. Raupp 1984, 258–262; Chapman 1990–1991 and Chapman 1993; Muylle 1986, 159.

28. Braun 1980, 8–9.

29. There is also some scattered evidence to the contrary; see Chapman 1990–1991, 183 n. 3.

30. Chapman 1990, 108–114. In this connection see also Bergström 1966, 164, where it is suggested that Rembrandt depicted himself as a "modern-day Prodigal Son."

31. Revius 1976, 222: "Ick bent, ô Heer, ick bent die u dit heb gedaen." For an English translation of Revius's poem "Hy droech onse smerten" (He Bore Our Griefs), see Chapman 1990, 113.

32. Bredero 1966, 293–294, 300–302; Huygens 1968, 43–47; Krul 1644, 150–151, Stalpart van der Wiele 1960, 85, 103, 131.

33. Bredero 1966, 301:
"Want mij verleidt en vleit het vleiselijk verkiezen,
Als ik na wens en wil mij lodder in de lust,
Doch als ik die geniet, zo doet ze mij verliezen
Mijn naam, mijn goede faam en mijnder zielen rust."

34. National Gallery London 1991, 430–431.

35. Bredero 1966, 302: ". . . grote Koning der Hemelen."

36. Van Vaeck 1994b.

37. Muylle 1986, 137–139.

38. Curtius 1963, 138–144; Barner 1970, 86–134.

39. Vondel 1927–1937, 3:512: "De weereld is een speeltooneel, Elck speelt zijn rol en krijght zijn deel."

40. Van Vaeck 1994b, 3:619–620, 842–843.

41. Van Vaeck 1994b, 3:619–620: ". . . dien wijtberoemden Philosooph *Democritus*, die de Werelt met al haren aenhangh te recht uytgelacchen en bespot heeft. . . . onbesinde Wereltlingen . . . sonder ons selven uyt te lacchen; want de geckelijke Werelt is in ons."

42. Amsterdam 1976a, 28; Van Vaeck 1994b, 3:613.

43. The author is Petrus Baardt, and the anthology was published in Leeuwarden.

44. Van Vaeck 1994b, 2:311: ". . . datmen Dwaasheyt kent om deselve te schouwen op de Werelt."

45. Cats 1700, 179: ". . . de dertele invallen des vleesch, . . . gelijck het niet vreemt en is dat de deuchden zelfs de gebreken haer tot voordeel weten aen te legghen."

46. An example is Jan van de Velde's engraving of people playing backgammon, which is condemned as an "improper urge" in the inscription. See Munich 1982, 37. There are numerous variants in the relationship between word and image in prints, and by no means always is there a contrast in terms of virtue and vice. See Renger 1984; and the detailed study by Ackermann 1993.

47. Kamphuyzen 1624, 403. See also Schenkeveld-van der Dussen 1986, 143.

48. Kamphuyzen 1624, 419: ". . . verleydster van 't gezicht, . . . hit van lust in 't diepst van 't herte."

49. Muller and Noël 1985, 129–131.

50. Groenhuis 1977, 96–97; and Van Lieburg 1989, for a perceptive view of the theologian Gisbertus Voetius and his followers.

51. Kuipers 1980; and Van Deursen 1991, 338–351. Figures resembling Mennonites in Steen's oeuvre appear in such works as the *Family Scene* (Braun 1980, no. 134), *Twelfth Night* (cat. 18), and *The Twins* (Braun 1980, no. 294). The figure with the duck on his shoulder in *In Luxury Beware* (cat. 21) has been taken for a Quaker, see De Groot 1952, 91.

52. For Starter's poem and its influence see Snoep 1968–1969, 115–123; Kuipers 1980, 226–227; Asselijn 1968, 103. On Troost's pastels see The Hague 1993, 54–61.

53. The figure regarded here as a Mennonite is identified as the master of the house in Van Wagenberg-Ter Hoeven 1993–1994, 85.

54. Braun 1980, no. 315. The same motif is found in Braun 1980, no. 224.

55. On oysters and mussels see Bax 1979, 259–260; De Jongh 1971, 169. On chamberpots: De Jongh 1968–1969, 45–47. On pipes: Gaskell 1987, 125 and 127. On slippers and mules: De Jongh 1968–1969, 36–37, and Franits 1993, 77–79, with a different interpretation. On the parrot: Woordenboek, 12: pt. 1, col. 362.

56. Sutton 1982–1983, 32 and 34.

57. Bax 1979, 191–194. Brussels 1985, 36 (no. 55): "My man syn eyeren ontlaeyt / in enes anders nest en laet my ontpaeyt" ["My husband puts his eggs in another's nest and leaves me unsatisfied"]). For Jan Matham after Adriaen van de Venne see Amsterdam 1976a, 252: "Wanneer ick 't heb verkerft en Trijn begint te schreijen / Neem duske pillen in, dan kan ick haer weer peijen" ("When I have spoiled things and Kitty starts screaming I take these pills, then I can please her again").

58. Van Merwede van Clootwijck 1651, 17 and 141.

59. Also in an obscene play on words; see Woordenboek, 16:col. 683. Gaskell 1987, 127. In Pot's painting the gesture is being made by the old procuress.

60. Houbraken 1718–1721, 3:18: "Vrolyke gezelschappen in Wyn- of Bier-kroegen, of winkels daar men meer warm vlees betast, als koopt." Kirschenbaum 1977, 67–71; and Tümpel 1991, 21.

61. De Vries 1977, 101.

62. De Jongh 1986, 31.

63. This liberalism was curbed a little in the closing decades of the century; see De Jongh 1968–1969, 57–58. Also Leuker 1991, 64–65 and 266; and the comments on that book by Van Stipriaan 1994. Another relevant work is Böse 1985, 50–60.

64. See, for instance, Poggio 1968, 205–211 (afterword by Gerrit Komrij, the translator). Also: Schmidt 1986.

65. Van Overbeke 1991; and Dekker and Roodenburg 1984.

66. Van Overbeke 1991, 253 (no. 1458): "Twee kaele Franschen aen malkanderen getrouwt zijnde: R. 'Hebben sij oock middelen? R. 'Oui, ils ont mil écus ensemble. C'est à dire ils ont mis le culs ensemble.' "

67. Van Overbeke 1991, 279 (no. 1621): "Een out man berispt werdende dat hij soo een jong meysken getrouwt hadt, soo seyde hij: 'Men steeckt met een kleyn dor houtje wel een groot vier aen.' " On this subject see Stewart 1979.

68. Braun 1980, no. 195. The young man has been given a flute as a phallic symbol. For "love triangles" see Stewart 1979, 71–77 and 173–179.

69. Van Overbeke 1991, 299–300 (no. 1783): "Mijnheer Jacob van den Burch, een out en stram knecht sijnde, kreech 's daegs voor St. Nicolaesavont besoeck van een jonge juffrou, dewelcke seyde: 'Morgenavont sal ick mijn schoen comen brengen.' 'Breng liever u kous,' seyde hij. 'Daer vrees ick,' seyde sij, 'dat ick weynich of niet in soude krijgen.' " Jacob van den Burch was a poet, member of the States-General and Burgomaster of Arnhem; see Van Overbeke 1991, 404.

70. Houbraken 1718–1721, 3:18: ". . . zeer geestig van vinding."

71. De Jongh 1993, 29. In this connection see also Van Vaeck 1988.

72. De Groot 1952, 63–66; De Vries 1977, 88. Jacob Jordaens, of course, has to be mentioned as a direct predecessor of Steen in this area; see d'Hulst 1982, 357. Important background information will be found in Meadow 1993.

73. Compare Tuinman 1727, 2:[XXII]. Also: Van Vaeck 1994b, 3:808–825.

74. Cats 1665, A2v: ". . . geheel buyghsaem en reckelijck zijnde tot veelderley saecken." See also Van Vaeck 1994a.

75. Woordenboek, 7:pt. 2, cols. 5863 and 5869; Amsterdam 1976a, 245 and 259; and De Vries 1976, 24.

76. Amsterdam 1976a, 259–260; and De Jongh 1994, 8–9.

77. Tengnagel 1969, 65: ". . . haer kousen had doen lappen / Met een Naeltjen sonder draet."

78. According to Braun 1980, no. 109, it is possible that the panel in the Rijksmuseum was originally much larger, and that "the central section was sawn out." If that is true, symbolic elements might have been removed. The composition of the Amsterdam painting gives few grounds for this suggestion. Unfortunately, cradling precludes inspection of the reverse (kind communication of Wouter Kloek).

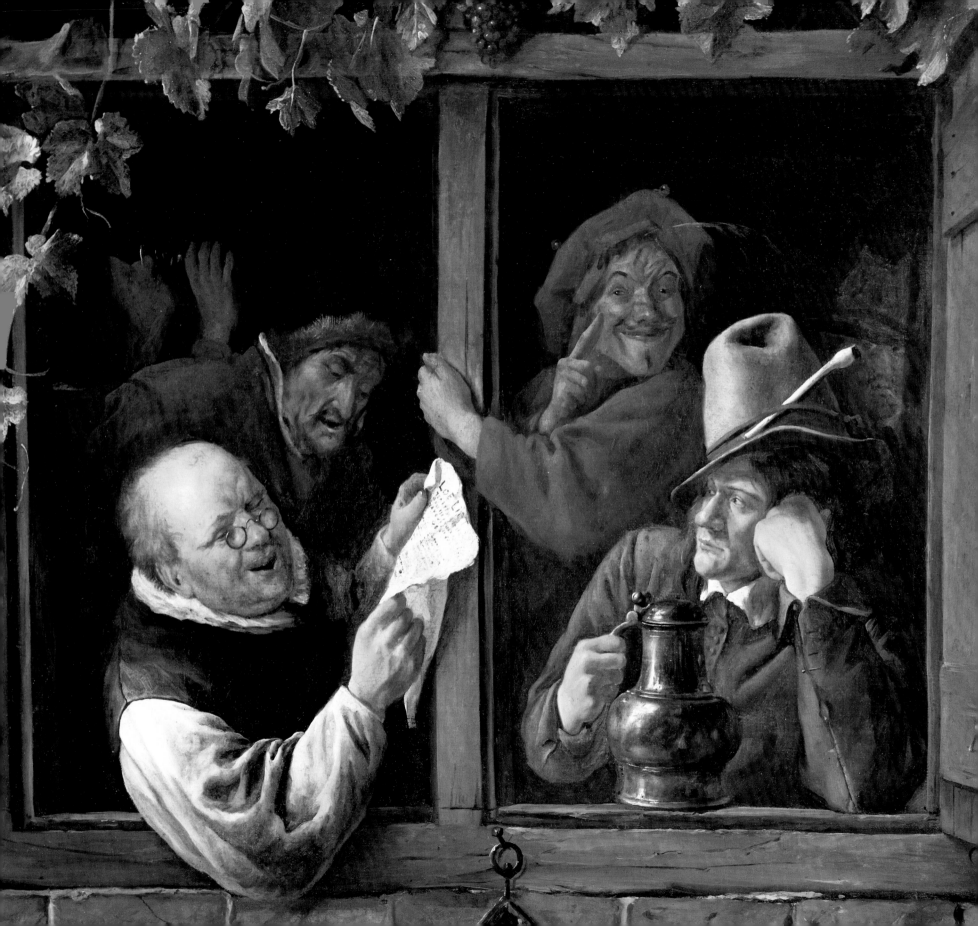

STEEN'S COMIC FICTIONS

Mariët Westermann

Just what is the story of Jan Steen's *Doctor's Visit* (cat. 16)? An eighteenth-century observer considered it a simple, domestic narrative: "A sick little Lady, sitting before her bed, with her hand to her head while a Doctor standing near her feels the pulse of her other hand, and discourses about the disease with a woman standing next to him."[1] Modern art historians have recast the tale, emphasizing its many allusions to lovesickness, from the boy who acts as Dutch Amor to the maiden's melancholic gesture, from the Italianate painting of Venus and Adonis to the ribbon smoldering in the brazier, a malodorous remedy used for women faint with uterine disorders.[2] They have noted that Steen imparted comic flavor by including a copy of a jester by Frans Hals (c. 1582/1583–1666).

Rather than resolve the situation, Steen left his story open-ended. For what is the nature of this illness? Is the lady pregnant or has her lover left her, as the painting of Venus and Adonis intimates? Is the older woman a mother, matchmaker, or midwife? And who is the butt of Steen's jest—the grieving maiden or the doctor, who seems to be self-important, as the eighteenth-century description indicates? Does his slight smile indicate pontification or understanding? Is the purse his, or that of the absent lover, who may be the focus of the boy's smiling address? Or is the doctor the lover in disguise? By dropping narrative hints, Steen encourages viewers to put words to the picture—a painting that may itself be indebted to texts. Several seventeenth-century jokes create similarly ambiguous situations alluding to fainting spells, illicit desire, pregnancy, matchmakers, and pedantic or ignorant doctors.[3]

Steen's paintings have prompted viewers across the centuries to transform his implied narratives into comic tales, and to find specific sources for his works in comic literature. This essay examines how eighteenth-century authors wrote about Steen, and suggests that these earliest critics justly situated his paintings in relation to a wide variety of Netherlandish comic texts, from jokes, proverbs, and poems to performed comedies and farces. Modern art historians have shown that Steen represented theatrical settings and costumes. They have also claimed that Steen was deeply involved with amateur playwrights and actors known as *rederijkers* or rhetori-

cians, but his engagement with them was probably distant rather than direct. While Steen occasionally did take themes from earlier comic texts, his works more frequently participated actively in a variegated comic culture, contributing as much to it as they received from it. Steen's creative relationship to literary and pictorial comedy indeed made his pictures meaningful for his audience.

Paintings into narratives

Steen's paintings have frequently inspired authors to write elaborate stories about his life. He featured as a protagonist in two installments of a successful series of *Monthly Reports from the Other World . . . Consisting of Conversations between All Sorts of Dead Potentates and Personalities of Rank*, published in 1747.[4] The title engraving (fig. 1), which presents

fig. 1. Simon Fokke, "Peter Paul Rubens Meets Jan Steen," Etched title page to *Maandelyksche berichten uit de andere waerelt*, January 1747, private collection

Steen in fictive conversation with Peter Paul Rubens (1577–1640), signals the distinction between the painters. Rubens gestures rhetorically as Steen kneels in the sand, scribbling such stock elements of his paintings as comic faces, a beer barrel, and a man relieving himself. While the Flemish painter wears a gentleman's hat and cloak, Steen sports a crumpled costume. Over two hundred and fifty pages, their dialogue contrasts Rubens, the born gentleman, diplomat, and painter of elevated themes, with Steen, the boozing lazy-bones who happens to be an accomplished painter of low life. He confesses the premarital impregnation of his wife, chronic insolvency, and neglect of his household, and allies himself with notoriously dissolute painters such as Frans Hals and Adriaen Brouwer (1605 / 1606–1638). Many of Steen's self-incriminating anecdotes are clearly based on his paintings, and as such they are derived partly from the first biographies of Steen by Arnold Houbraken (1660–1719; pages 93–97) and Jacob Campo Weyerman (1677–1747).[5] But with Rubens as humorous foil, the *Report from the Other World* creates a more elaborate narrative equivalent to Steen's amusing paintings.

Answering eighteenth-century expectations that biography should be both lively and evocative of a subject's character, Houbraken and Weyerman had not only constructed Steen's life in the image of his paintings of households, inns, and lovers, but they had also structured it as comic literature.[6] The format of Houbraken's account—a string of anecdotes interspersed with proverbs, moralizing comments, and descriptions of paintings—is indebted to seventeenth-century jest books, the popular compendia of hundreds of jokes, anecdotes, and witticisms known as *apophthegmata*, often told by, and even about, a central narrator.[7] The themes and earthy phrasings of Houbraken's anecdotes about Steen's premarital dalliance and his courtship of his second wife recall jests from these collections and farces. Weyerman intended his biography to better Houbraken's as a good read. To this end, he added several salacious episodes, and organized Steen's life as a breathless sequence—a form reminiscent of picaresque narratives.[8] Both biographers used these comic modes of writing to evoke Steen's paintings, whose laughter-inducing effects they describe in detail.[9]

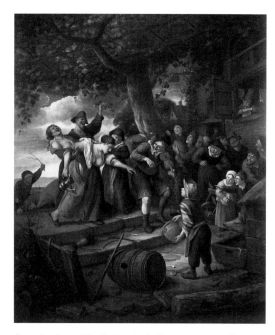

fig. 2. Jan Steen, *The Pig Must in the Pen*, c. 1673–1675, oil on canvas, Mauritshuis, The Hague

The impulse to translate genre paintings into comic descriptions is not unique to Steen's reception. In 1656, for example, paintings of a quack and a street singer by Brouwer inspired another painter, Willem Schellinks (1627–1678), to write short, witty verses that describe and interpret the scenes and praise their maker at the same time.[10] To evoke the peasant representations of Steen's probable teacher Adriaen van Ostade (1610–1685), Houbraken cited the long poem *Boerekermis* ("Peasant Fair") by Lukas Rotgans (1645–1710), a rollicking account of peasant pleasure and violence at a fair.[11] But Steen's paintings have yielded unusually rich narrative descriptions, particularly in eighteenth- and nineteenth-century sale catalogues, which frequently discerned the painter himself within his comic scenarios. In 1816, for example, a catalogue entry retold Steen's *As the Old Sing, So Pipe the Young* (cat. 23) as an autobiographical scene, in which the old, singing woman is transformed into Steen's mother reading a newspaper to his second wife, while a servant pours wine for his first wife and the painter teaches his son to smoke.[12]

The narrative hints of Steen's paintings also challenged eighteenth-century viewers to see his works as similar to, or even as representations of, specific comic texts. Houbraken did so when he reported that Steen had deflated a respectable portrait of his wife, painted by Carel de Moor (1655–1738), by adding a basket of sheep's meat in reference to her lowly trade. To evoke the result Houbraken cited a poem by Jan Vos (1610–1667):

Rut painted Saint Tony from life:
But Peter added Rut's own wife,
Why did Peter make this dig?
Saint Tony is always with a pig.[13]

Houbraken must have found Vos' debasement of a painting as witty as Steen's: Saint Tony, farcical for Anthony, was tempted by a woman, and was usually represented with the pig he cured. Perhaps to give a bawdier edge to the poem, Houbraken actually mis-cited it, substituting "woman" for Vos' "pig" in the last line.

In a more direct suggestion that Steen painted scenes from comic literature, a sale catalogue of 1744 mentions a *History of Arent Pieter Ghysen* by him.[14] This peasant name opens a famous comic song by Gerbrand Adriaensz Bredero (1585–1618) from his widely read *Groot Liedboeck* (1622).[15] In the song, the middle-class, urban narrator visits a country fair.[15] Although initially enjoying the coarse peasant dialect and pleasures, he quickly runs for cover when the intoxicated peasants start to fight. The reported size of Steen's painting suggests it might be identified with *The Pig Must in the Pen* (fig. 2), which includes the roaring drunk characters and village setting sung by Bredero.[16] As it is not known which painting the cataloguer described, however, it is impossible to ascertain if Steen intended an actual representation of Bredero's poem. But the recorded title offers one of the earliest acknowledgments that Steen's paintings were situated within literary comic culture.

Nevertheless, it was not until the first half of the twentieth century that art historians began to study Steen's relationship to comic texts. Following Wilhelm Martin's lead, Sturla Gudlaugsson and Albert Heppner, among others, elucidated Steen's work by reference to theatrical themes and performance strategies.[17] Although they saw Steen's rela-

tionship to the theater as rather too direct and unmediated, thereby ignoring the ironies of his theatrical representations and the ways in which he transformed comic material pictorially, my study of these problems is indebted to their fundamental insight that Steen's paintings were informed by theatrical and literary practice.

Sister arts

Steen's reciprocal relationship to literary culture stands in an elevated Renaissance tradition. Poets and painters throughout Europe shared an understanding of their arts as sisters in the registration and communication of knowledge and "passions," as emotions were termed. They endlessly rephrased the statement from the *Ars Poetica* of Horace (65–8 B.C.) that painting is as poetry, in the sense of sharing its freedom to invent and its purposes of teaching and entertaining.[18] Paraphrasing Plutarch (A.D. 46–120), they gave circular definition to painting and poetry, calling painting mute poetry, and poetry a speaking painting.[19] The playwrights Joost van den Vondel (1587–1679) and Jan Vos suggested that the topos held especially for theater, presumably because on stage texts were enacted for the eye as well as the ear.[20]

Although writers applied the image of sibling rivalry primarily to serious genres such as history painting and tragedy, or portraiture and sonnets, several authors claimed a similar relationship between

fig. 3. Adriaen van de Venne, "The Ship of Reyn-Uyt (Clean-Out)," engraving from his *Tafereel van de belacchende werelt*, 1635, National Gallery of Art Library, Washington

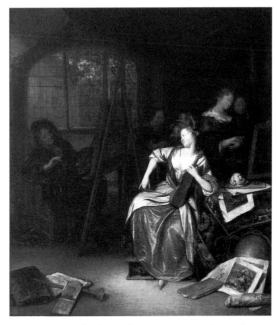

fig. 4. Richard Brakenburg, *The Poetic Muse Terpsichore in the Painter's Studio*, 1690s, oil on canvas, private collection

fig. 5. Samuel van Hoogstraeten, "Terpsichore, the Poetess," etching from his *De hooge schoole der schilderkonst*, Rotterdam, 1678, Department of special collections, University of Chicago Library

comic texts and pictures. Adriaen van de Venne (1589–1662), the most consistently comic painter-poet of the seventeenth century and Steen's most significant predecessor, restated it in his long comic poem *Tafereel van de Belacchende Werelt* (Scene of the Laughable World).[21] Even his boorish yokel Tamme Lubbert (Lame Lubbert, a standard farcical name) knows that "Everything that in the World is soiled or over-pearled, is written and printed in verse," and Van de Venne makes clear in the same breath that "picture-art" likewise "is the fruit and buttress of knowledge." Elsewhere Van de Venne remarked that painting "points out" and poetry "gives the reason," and that both preserve the memory of things.[22] In illustrated comic poems and in paintings of rustics and urban low-lifes, usually captioned with a satiric inscription, Van de Venne answered his own definition of the enriching symbiosis of texts and images (fig. 3).[23]

Richard Brakenburg (1650–1702), the most original interpreter of Steen's themes, articulated the relationship between painting and poetry in a comic picture that draws out implications of Steen's own *Drawing Lesson* (fig. 4; cat. 27).[24] In a studio as cluttered as Steen's, a painter is working at his easel, rather than instructing a young woman. Brakenburg transformed Steen's demure maiden, who acts as her teacher's unwitting muse, into an extroverted source of inspiration, dressed in a yellow skirt similar to that worn by Steen's girl. With her lusty smile, décolletage, and demonstratively displayed silks, she embodies the painter's muse of comic tales, inflaming artists with desire to paint.[25] But her violin and bow, and the colorful plumes on her head, specify her as Terpsichore, one of the nine muses of painting invoked by Samuel van Hoogstraeten (1627–1678) in his treatise of 1678. Van Hoogstraeten had Terpsichore, whom he called "the Poetess," preside over a busy studio in the title etching to the sixth section of his book (fig. 5).[26] In Van Hoogstraeten's text, she is the muse of coloring and of handling the brush, an expertise signalled by her multi-hued feathers and her dexterity with the lyre and bow.[27] In Brakenburg's painting, Terpsichore the Poetess, at once

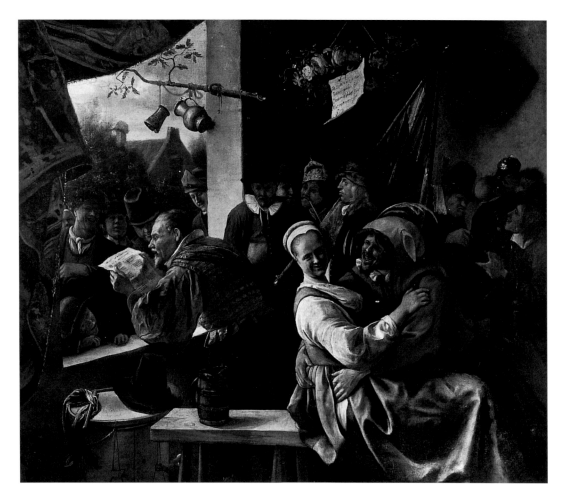

fig. 6. Jan Steen, *Rederijkers Carousing*, c. 1665–1668, oil on canvas, Musée Royale des Beaux-Arts de Belgique, Brussels

of, theatrical societies (cat. 24).[28] Analysis of these paintings suggests, however, that Steen and his customers shared a rather mixed view of traditional theatrical practices.

In the Netherlands, the chambers of rederijkers had been a primary site of literary and theatrical activity since the late fifteenth century, each self-respecting town boasting at least one society. Rederijkers traditionally gathered in private meetings and in occasional competitions of chambers from all over the Netherlands.[29] One of the most spectacular of these performance contests known as *landjuwelen* (jewels of the land), the one held at Antwerp in 1561, marked the finest period of rederijker achievement. The last *landjuweel* to be organized in the northern Netherlands took place in 1616.[30] Although the companies remained active into the eighteenth century, their membership fell off rapidly and their literary and theatrical activities were gradually assumed by professional authors and actors.[31] Artists, who had traditionally been involved with the chambers as members or designers, were not as active in them in Steen's time as they had been throughout the sixteenth century. There is no evidence that Steen ever belonged to a chamber, not even in Haarlem, where several of his colleagues are recorded as members.[32] The first text to place Steen among rederijkers is a sale catalogue entry of 1800, which claims the artist represented himself laughing, holding a flute glass, with three other rhetoricians shown half-length in a composition like the *Rhetoricians at a Window* (cat. 24).[33] With its emphasis on jolly revelry, this sale catalogue entry acknowledged the dissolute character of Steen's rederijkers, who participate for the feasting rather than the poetry. His *Rederijkers Carousing* (fig. 6) indeed seem to follow a Dionysiac muse rather than Lady Rhetoric, their traditional patroness.

By the mid-seventeenth century, such mockery of rederijker traditions had become standard fare in jestbooks, comedies, and literary treatises aimed at an educated public. The rederijkers were charged with pedantry, quarrelsomeness, rampant revelry, and poor literary gifts. Bredero, whose plays were produced by semi-professional actors in Amsterdam, soon to call themselves Netherlandish Academicians, repeatedly ridiculed the constant disputations of

muse of painterly control and comically seductive damsel, alludes to the common thematic range of painting and poetry, and also to their shared practices of representation. By restating the implicit narrative of Steen's *Drawing Lesson* in these terms, Brakenburg may have acknowledged Steen's own concern throughout his production with the equivalences and differences between comic texts and pictures.

Fairs and rederijkers: Steen and traditional comic theater

Steen's frequent representations of rederijkers and of fairs, the most popular venues for theater, encouraged modern art historians to hypothesize his direct involvement with, and perhaps even membership

rederijkers.[34] Upon the demise of the Amsterdam chamber in 1637, an anonymous *Treur-klacht* (Lament) gave a scathing account of the reasons for Lady Rhetoric's decline, in terms that seem to forecast Steen's *Rederijkers Carousing*:

Here comes a beer waiter, his hands full of jugs,
Goes up and down, among all the lugs,
Shouts loud as he can, "Hey all of you here
Who now needs some more Rotterdam beer?"
Yonder's a young oaf, scouring all sections,
'For a nickel or a dime, who wants some confections?'
There is a sailor who smokes up the place,
His fog causes people to turn about face.[35]

The lamentor also criticized the rederijkers for knowing the rules of poetry as well as the ass knows ABC and for privileging farces over the intricate allegorical plays of yore.[36] In his painting Steen rendered some rederijker doggerel on a placard suspended above the revelry it evokes:

Rhyming of dry fare
Is what fine Bacchus Poets do
Rhyme freely, as you dare
But there must be victuals, too.

These lines, equally unpolished in Dutch, do not evoke true rederijker verse, but rather the sorts of inscriptions previously appended to prints of peasant festival. In an engraving of peasant "Baccha-

nals" after Maerten de Vos, peasants such as Tony Spillbeer and Hank Drybread are ridiculed for their poor dancing form (fig. 7). In this as well as Steen's case, the juxtaposition of dry food and Bacchic inspiration not only refers to the laving of dry throats, but also to the arid, inelegant styles of peasant dance and rederijker verse.[37]

Steen's Haarlem colleague Cornelis Dusart (1660–1704), who probably owned the painting, recognized that Steen had represented the rhetoricians as old-fashioned. In a copy he drew after it (fig. 8) he added the inscription:

This is Envy's nature and chime
Naught to praise but things of old time.[38]

Dusart ironically attributed this statement to the rederijker reciting from a window, making him proclaim his own outdatedness.

fig. 8. Cornelis Dusart after Jan Steen, *Rederijkers Carousing*, 1690, graphite, brush, and brown wash on paper, private collection

fig. 7. After Maerten de Vos (1532–1603), *Egg Dance*, engraving, Rijksprentenkabinet, Amsterdam

fig. 9. Hendrick Bary after Adriaen van Ostade, *Rederijkers at a Window*, c. 1650–1680, mezzotint, Rijksprentenkabinet, Amsterdam

Steen also applied conventions of peasant pictures to his *Rhetoricians at a Window* (cat. 24). Adriaen van Ostade, who drew this rederijker theme repeatedly, favored the formula of people hanging out of windows for peasants. An etching of *Rhetoricians* after Van Ostade (fig. 9) has an inscription on the drunken Dirty Bride, presumably recited by the man with the sheet. This theme had become a fixture of peasant painting in the tradition of Pieter Bruegel (c. 1525–1569).[39] Urban theater critics after mid-century, too, debased rederijkers by calling them peasants specializing in obscene farce.[40]

Steen's pictures of fairs are hardly innocent transcriptions of theatrical sites, either (fig. 10). Before 1637, when the first Dutch professional theater opened in Amsterdam, public performances were almost exclusively given by rederijkers or traveling troupes at the *kermissen* (fairs of religious origin) and *jaarmarkten* (annual markets) held in towns.[41] At

these movable feasts of market stalls, drinking establishments, and entertainment booths, performances ranged from elaborate farces to the boastful antics of quacks. Steen's paintings of fairs usually include such acts, and occasionally focus on the charlatan as the embodiment of the seductive deceitfulness and the folly of the fair—characteristics that, to learned contemporaries, made the fair resemble theater itself.[42]

The kermis had assumed these meanings in sixteenth-century prints and, slightly later, in poems on fairs.[43] In Van de Venne's *Scene of the Laughable World*, the fair at The Hague encompasses and represents the world, comic in all its foibles and follies. The kermis shared this worldly metaphor with theater, as stated in Vondel's famous lines inscribed above the entrance to the Amsterdam theater: "All the World's a Playing Set / Each Plays His Part, His

Share Will Get."[44] Even the structure of Van de Venne's text is theatrical, as the urban nobleman Reyn-Aert (Pure-Sort) presents a succession of motley characters at the fair, from fishmonger and quack to beggars and fortune-telling gypsies, all of whom have their moment in the spotlight. Like the *Scene of the Laughable World*, Steen's fairs and markets gather a wide social variety of visitors, from vagrant to city slicker, and a range of purveyors of goods and services, strewn throughout the landscape without particular emphasis on any one vignette. All of Steen's fair paintings locate the observer at a social remove, whether by giving a surveyor's view of small figures (page 70, fig. 2), or by focusing in close-up on the ludicrous antics of fair performers (cat. 46). The elegant urban visitors in Steen's fairs stand in for such viewers, of at least the same class as Steen himself. They may be as amused as Van de

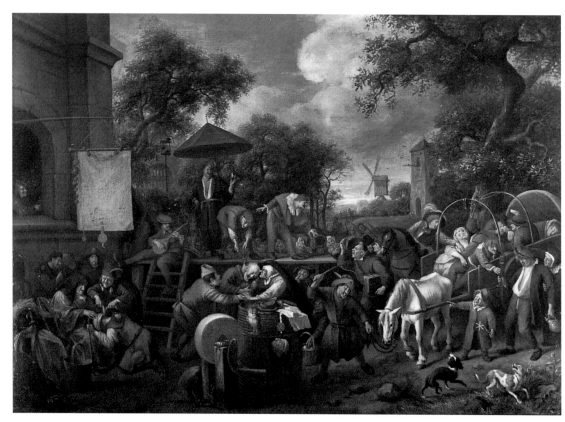

fig. 10. Jan Steen, *Village Fair with Quack*, c. 1673, oil on canvas, Rijksdienst Beeldende Kunst, The Hague

Venne's Reyn-Aert, but they do not engage directly with the earthier fair dwellers. Steen distilled the complex attitudes of his viewers toward traditional theatrical practice—part fascinated delight, part distanced distaste, part nostalgia for an inaccessible culture of rustic laughter that was never quite theirs.

Texts into pictures

While Steen's paintings of fairs and rederijkers participate generally in a comic culture of the urban middle class, some of his works represent specific products of that culture, including poems and captioned prints. From the beginning of his career, Steen painted such stock comic situations as the *Fat* and *Lean Kitchens* (cats. 2, 3), and *The Toothpuller* (cat 26, fig. 3), and the stone operation.[45] From the mid-1650s he developed a repertoire of comic themes set in a more upscale milieu than that of his most significant comic predecessors, including Adriaen van de Venne and Adriaen van Ostade. In seventeenth-century comic texts, too, the middle-class society represented by Steen had increasingly replaced the peasant scene as setting. Like those plays and jokes, Steen's production primarily concerns the amusements and trials of courtship, marriage, child rearing, and housekeeping.

Occasionally, Steen's situations look like direct visual translations of the written narratives. He repeatedly took up the challenge of matching the incisive narratives and pictorial language of Bredero, particularly through an evocative use of costumes, postures, gestures, and facial features.[46] Steen's *Choice between Age and Youth* conflates two poems by Bredero on two sets of incompatible lovers (fig. 11). Although Steen could refer to a visual tradition of ill-matched lovers, he seems to have taken Bredero's poems, rather than pictures, as his point of departure, and created pictorial alternatives for the strategies of the comic texts.[47] In the first poem, a maiden refuses the advances of a wealthy old suitor in favor of those of a young man, and in the second a young man prefers a maiden to a rich crone twice his age.

Steen ingeniously fused the plots of the two poems by pairing the two sets of lovers into one couple, which he placed under a bell crown inscribed with the words "Dat ghy soekt, soek ick mé," or "What you seek, I seek too." This phrase is

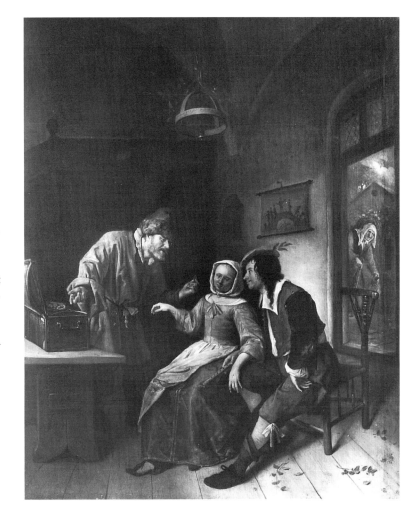

fig. 11. Jan Steen, *Choice between Age and Youth* ("*What you seek, I seek too*"), c. 1662–1665, oil on panel, Muzeum Narodowe, Warsaw

the oft-repeated tag line of Bredero's poems, spoken by the young adults to tell their daft suitors that, like them, they want young flesh rather than money. Steen reconverted Bredero's descriptive language into gestures and physiognomies, thus letting his characters perform the texts. The maiden's limp hand mimics the old man's impotence, loudly ridiculed by Bredero's girl who laments she'd remain a virgin if stuck with his body. Her gesture frequently marks this problem of old lovers in seventeenth-century comic images.[48] The contrast between the rich man's stooped posture and the young lover's swagger articulates discrepancies of sexual prowess.[49] Steen's old man wears loose-fitting clothes, which seem to translate Bredero's derisive appellation

"Hansjen Hangebroek" (Johnny Hangdownpants). The lock-jawed, stooping woman with receding mouth and long nose seems to match Bredero's taunting descriptions of the "shrivelled hag" as "stick-out chin," "snivel-nose," and "tough toothless beast." Steen clearly spelled out Bredero's point that promises of wealth should not override the desirable practice of matching partners by age. This theme held appeal in the Dutch Republic, as writers on marriage from Jacob Cats to Petrus Wittewrongel agreed that love was a prerequisite for marriage, and that spouses should be social and financial equals. Steen's lecher flaunts his money and his hag clutches her purse, while the young lovers sit unimpressed before a print that represents people acting

properly, in accordance with their stages in the span of human life.[50]

That Bredero intended his poems comically was self-evident, as he placed them in a collection identified as "boertig" (farcical). Moreover, his protagonists have comic names such as "Lammert-Vaar" (Lame-Daddy) and they speak in the simple meter and Amsterdam dialects of his comic mode. To establish the farcical character of his painting, Steen used several techniques indebted to theatrical practice. The immediate clue to the painting's comic status appears almost dead-center, in the smiling face of the young woman inviting the beholder to laugh along. Seventeenth-century comic texts and plays are punctuated by prompts encouraging readers and viewers to laugh, and they frequently describe protagonists as laughing to set the proper

fig. 12. Samuel van Hoogstraeten, "Thalia, the Farce Actress," etching from his *De hooge schoole der schilderkonst*, Rotterdam, 1678, Department of special collections, University of Chicago Library

tone for reception of the narrative.[51] The direct address to the audience issued by Steen's maiden was a traditional feature of rederijker performance, in monologues or dialogues. Although criticized after mid-century by theorists who favored the closed, unified structure of classicist French theater, comic actors continued the practice.[52] Steen fleshed out the comic scene by dressing the old man in the antiquated or provincial clothes favored in comic performance.[53] The young man's collar is more up-to-date, but his beret with branch befits a comic suitor rather than a serious gentleman. Like many of Steen's figures, he wears a loose outer stocking, folded over, that recalls the buskin or soft boot of antique comedians, as remarked by Netherlandish writers and as worn by Van Hoogstraeten's muse Thalia, "the farce actress" (fig. 12).[54]

Pictorial strategies of Steen's comic mode

Analysis of Steen's *Choice between Age and Youth* suggests that it is as instructive to consider how his pictures make themes comic as it is to hunt for 'sources' he might have read. Such an approach can clarify the different resources and pleasures of pictures and texts. Many of Steen's comic means, including his uses of gesture and modes of address, answer the ancient definition of comedy as the literary genre closest to actuality, as "an imitation of life, a mirror of good mores, an image of truth."[55] The reality effect of comic texts and paintings was essential to comedy's joint functions of entertaining and teaching, its charge of presenting a mirror of life, but paradoxically of life as it should not be lived.[56] To create a convincing fiction of such life, theorists admonished playwrights and actors to give characters the modes of speech, gestures, and costumes proper to their ages, professions, and social stations.[57] Renaissance writers on art required a similar decorum in the visual arts. Carel van Mander accordingly praised Pieter Bruegel for showing "the peasants, men and women . . . naturally, as they really were, showing their boorishness in the way they walked, danced, stood still or moved."[58] Evoking this reputation of Steen's illustrious comic predecessor, Houbraken noted Steen's uncanny ability to differentiate social classes, and defined it as especially crucial to the comic painter.[59]

fig. 13. "Various Ways to Hold a Glass," etching from Gerard de Lairesse, *Groot schilderboeck*, Amsterdam, 1707

But while Steen matched postures and gestures with age, sexual prowess, and class, as he did in his *Choice between Age and Youth*, he also misapplied such codes to comic effect. His dangerously seductive women, for example, offer drinks with elegant gestures. In a treatise on painting, Gerard de Lairesse (1641–1711) illustrated such delicate handling as appropriate to ladies, rather than to Steen's temptresses (fig. 13; compare cats. 15, 21).[60] The classicist theater critic Andries Pels (1631–1681) abhorred such violations of decorum while acknowledging that they raised appreciative laughter from the audience.[61]

This kind of inversion of social and pictorial codes was a principle of comic representation applied by Netherlandish painters from Bruegel to Hals and from Van de Venne to Steen. The laughing faces in their paintings, for example, are effective cues precisely because laughter was inappropriate in serious portraits. Steen's *In Luxury Beware* (cat. 21) is often called "The World Upside Down" for good reason, as this dissolute household turns topsy-turvy the ideal of a well-managed, nuclear family. Steen constituted this inversion by numerous individual reversals or misappropriations of marks of proper familial life. In contemporary family portraits, for example, music is metaphoric for familial harmony, but Steen's lowly fiddle and flute suggest a tune more appropriate to taverns. The same white walls that form pristine backdrops to the domestic idylls of Pieter de Hooch (1629–1684) or Johannes Vermeer (1632–1675) here form a set for Steen's unruly scene.[62]

Inversion of serious pictorial codes offered Steen one way of creating comic disorder. The poet Jan

Vos, prolific author of unruly texts and plays, explicitly stated that disorder offered a truer image of reality than order.[63] *In Luxury Beware* musters many of Steen's means for creating disorderly, comic truth. He juxtaposed bright, even clashing colors, the yellow and light blue of the inviting damsel vibrating against the pinks, reds, and maroons of her lover and her chair. The attention of the different figures is dispersed, mirroring and modeling our distracted looking, at this painting as in life. Steen scattered numerous objects, all carefully painted to demand our detailed attention, and none lies straight. He heightened the visual cacophony by catching the bowl just breaking, the tankard just falling, the barrel still emptying out.

Loose brushwork often contributed to Steen's disorderly reality, most pointedly in his *Self-Portrait as a Lutenist* (cat. 25). Well before Steen, Brouwer, Van de Venne, and Adriaen van Ostade reserved their loosest strokes and muddiest smudges for peasants and urban wastrels. In a poem relevant to Steen's self-portrait, Vos linked the looseness of a painting to the looseness of its maker:

To L. the painter, when he showed me a certain painting.
Because it's loosely made, love this picture I do
But to my distress, as loose as your painting are you.[64]

These lines, themselves loosely constructed, suggest that Steen may have intended the swift, brownish brushwork of his self-portrait to underscore the unruliness of his pictorial comic persona.[65]

Steen employed other means to enhance the viewer's experience of witnessing comic life without mediation. Foreground figures seen from behind suggest physical proximity and encourage us to enter (cats. 18, 26, 49).[66] But by their apparent unawareness of us such figures also suggest we have stumbled upon the scene. Paradoxically, the opposite strategy of having a character address the viewer (fig. 11; cats. 9, 14, 48) is equally realist, as it erases the border between pictorial and actual worlds.

Steen's most innovative realist strategy, his inclusion of his self-portrait in his scenes of revelry and dissolution, exploits this function of the direct address.[67] His presence seems to offer a guarantee that he witnessed the scene. Comic authors and actors, too, frequently employed this fiction of the eye-witness who transcribes comic scenes from life. Authors of jest books always made this claim about their anecdotes, even though they endlessly reworked material from other texts.[68] In performances, actors used asides to the audience to announce their expectation that the events represented on stage would probably soon be turned into a comic play. The players thus winked at the spectators to pretend that actors and audience alike were witnesses of actual events, which would become the stuff of comedy.

Steen's laughing self-portraits, always addressing the viewer directly, in the context of a compromising situation also sharpened the satiric bite of his scenes, making viewers complicitous in pleasure as well as censorship. This demand on the beholders, who are at once invited to join the reveling fools and made responsible for judging them, was a common strategy of comic texts. Van de Venne warned readers that, like the real world, his *Scene of the Laughable World* was full of unsalutary situations, and that readers should judge these for themselves. If they did not appreciate such elements, they should look aside. This was clever advice, for alongside his main text Van de Venne printed marginal riddles, quips, and proverbs to encourage the reader to think further about the text (fig. 14)—more than 1,750 complex glosses that are as ambiguous as the allusions with which Steen packed his *In Luxury Beware* (cat. 21).[69] Like Van de Venne's verbal virtuosities, Steen's visualization of proverbs, such as the pig at once running off with the tap and nuzzling a rose, offers viewers delight at the painter's wit even as it guarantees moral grounding. Analogously to Van de Venne, who designated his world as "laughable," Steen ensured satiric interpretation of his luxurious household by privileging the viewer with clues that are not seen by the painted transgressors. These pointers include the key indicting the sleeping woman, who should be guarding it as mistress of the house; the ominous basket above the scene, containing signs of poverty and transgression; the tell-all proverb "In Luxury, Look Out" at lower right; and the monkey who, like the painter, stops time to watch and mock from above.

Steen registered his identity as comic artist, at once profligate and satirist, not only in his self-portraits and in the motif of the observant monkey.[70]

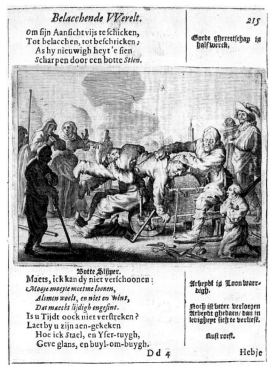

fig. 14. Adriaen van de Venne, "The Sharpener of Dull Wits," engraving and letterpress from his *Tafereel van de belacchende werelt*, 1635, National Gallery of Art Library, Washington

Indebted to the Bruegelian tradition, Steen must have been aware of Bruegel's reputation for salt, or wit, and he may also have known this rhetorical metaphor from Dutch paintings and epigrams.[71] Salt features prominently in Steen's wittiest paintings, from the *Girl Offering Oysters* (cat. 9), who is just sprinkling on a dusting, to *Easy Come, Easy Go* (cat. 15), where a generously filled saltcellar is convenient to the painter's use.

Like many painters, Steen also used signatures to call attention to his name, the Dutch word for "stone." He often carved this name into stone ledges, columns, or lintels (cats. 19, 40). In his *Village Fair* (fig. 10) it marks a sharpening stone, the metaphoric tool for sharpening blunted wits. The foolish yokels in that painting seem in particular need of Steen's sharpening wit, for they are spellbound by a quack and his assistant, who is, appropriately, a 'stone sur-

geon,' removing imaginary stones from a dupe's neck. Steen's stone imagery deliberately recalls the comic conflation of knife sharpener and stone surgeon in Van de Venne's *Laughable World*.[72] In a self-reference forecasting Steen's signature stone, Van de Venne likened his own "Round Laughable World" to a sharpening stone for dull wits (fig. 14).

Archaism and stylistic versatility

Like Steen's early Bruegelian paintings and his picturing of proverbs, his *Village Fair* (fig. 10) revives and transforms sixteenth-century pictorial formulas, combining such conventional comic motifs as the quack, the stone operation, the wagonload full of good-for-nothings, and the pilgrim who is being blindfolded by a fool and a woman, perhaps a fortune teller. As so often in sixteenth-century comic pictures and in Steen's work, the viewer is offered interpretive clues that remain invisible to the protagonists, one of whom is literally blind. An owl, the nocturnal bird proverbial for its inability to see (cat. 41), and two winking men address the beholder directly. Steen clustered these references around his sharpening stone and a lean man who looks up from inside a barrel, quite possibly the Greek cynic Diogenes, who could not find one honest person in the market, even with a lantern.[73] Steen staged all these figures in an archaic Netherlandish village, exemplified by a pictorial encyclopedia of laziness after Cornelis Metsys (c. 1508–after 1584), including the familiar perched owl (fig. 15). Steen also used this structure for his *Village Revel* (cat. 46), which incorporates details of the print such as the idle coopers, the birdhouse attached to the inn, and the stork, referring to the proverbially lazy act of "looking after the stork."[74]

In the seventeenth century such archaisms were seen as comic in themselves. For their humorous effect in an upscale urban context, seventeenth-century plays and songs frequently used outdated forms, such as the rederijker verse known as *rondeel* or the narrative formula of guilds of riff-raff traveling in vessels.[75] Van de Venne devoted several pages of his *Laughable World* to the ship of Sint Reyn-Uyt (Saint Clean Out, or Broke), a boat full of drunks, adulterers, spendthrifts, and beggars (fig. 3). In late medieval comic culture, these metaphoric ships

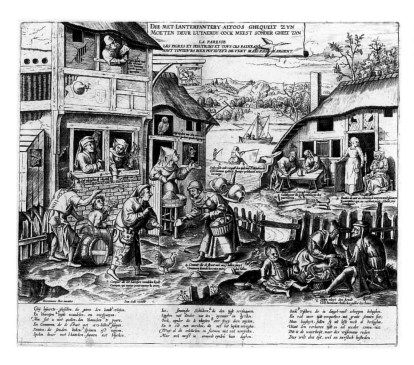

fig. 15. Pieter Huys (1522–1562) after Cornelis Metsys, *Nine Proverbs on Laziness*, engraving, Rijksprentenkabinet, Amsterdam

traveled to the mythic destinations of Lazytastyland and Flatpurse, but Van de Venne's lot heads for a seventeenth-century institution, the "Gast-Huys" or guest-house for the destitute and unemployed. The small boatload of monks, children, and boors fighting and indulging at the right of Steen's *Village Revel* alludes to this tradition, which he interpreted explicitly in his painting of revelers in a ferry marked *Rijn Uijt*, again, "Clean Out" (cat. 4).[76] Steen sharpened the theme by filling the vessel with types closer in social rank to Steen's audience than previous painters had hazarded.

The variety of pictorial means Steen employed to construct his fictions of comic truth in part accounts for the stylistic inconsistencies of his oeuvre, and for the difficulty of describing his "artistic development" in the conventional sense. Throughout his career, Steen seems to have moved from model to model, rivalling and parodying artists as diverse as Frans Hals, Jan Miense Molenaer, Adriaen and Isack van Ostade, Jan van Goyen, Nicolaes Knüpfer, Bruegel, Gerard Ter Borch, Frans van Mieris, Rembrandt, Raphael, and Paolo Veronese.[77] But Steen's variegation of modes was probably not merely the

result of a search for realist comic means or of an attempt to emulate predecessors and peers. It is consistent with Steen's identity as comic painter as enacted in his pictorial role play. In his *Schilder-Boeck* of 1604, Carel van Mander considered the Protean ability to metamorphose oneself by imitating others the supreme talent of the *cluchtspeler* (comic actor), the figure with whom Steen so often identified pictorially.[78] Van Hoogstraeten indeed applied Van Mander's notion of comic metamorphosis to artistic style, for he had the muse Thalia, the Farce Actress, preside over the question of how to imitate and emulate other artists (fig. 12).[79]

The challenges of history for the comic painter

Since genre painting with its fictions of everyday life was the proper preserve of comedy, the elevated genre of history, which represented episodes and characters larger than life, would seem off limits to a deliberately comic painter. The available modes of history painting in the Republic were by and large serious, encompassing the Caravaggist tradition of Utrecht, the classicist mode practiced in Haarlem

and The Hague, and the vivid gravity of Rembrandt and associates in Amsterdam. Yet the tradition of Ovidian paintings of the loves of the gods, as practiced by Hendrick Goltzius and Joachim Wtewael, as well as some of Rembrandt's early history paintings, allowed for a mixture of serious and lighter-hearted modes.[80] Moreover, as Jan Vos wrote ironically, ostensibly about himself, even the most destitute writer can put great deeds on stage.[81]

Steen indeed developed a vivid, bustling mode of history painting. Many of his history themes lend themselves to comic representation: the Mocking of Ceres, the Philistines deriding Samson, the Satyr satirizing folk wisdom, or sumptuous feasts such as the *Wedding Feast at Cana* (cat. 43), *Wrath of Ahasuerus* (cat. 44), and *Banquet of Antony and Cleopatra* (page 11, fig. 1). Most of Steen's historical narratives allowed for the inclusion of elements more at home in genre painting, from contemporary furnishings to stock comic characters such as fools. Steen's elaboration of history paintings with small sub-plots in the *Wedding Feast at Cana* or the *Capture of Samson* (cat. 34, fig. 2) recalls a technique of tragicomedy, a mixed genre of theater that had been introduced in the Netherlands at the beginning of the seventeenth century. Many of these "happy-ending tragic plays," as they were called, included intermezzi between

comic characters, from peasants and jesters to lawyers and doctors. Several comic narratives presented analogous mixtures of classical gods and Amsterdam quacks.[82]

To forge a pictorial equivalent for this mixed mode, Steen referred to prints after the banquet scenes of Veronese, enlivened with animals, jesters, and dwarfs. Steen's *Wedding Feast at Cana* (cat. 43) seems to honor Veronese's grand masterpiece on a delicate scale, replicating both its structure and details such as the dwarf (fig. 16).[83] He also transformed pictorial formulas of book illustrations for related history themes. His *Amnon and Tamar* (cat. 36) revised Van de Venne's illustration in Jacob Cats' *Houwelyck* by articulating the implications of Cats' account (fig. 17).[84] Although Tamar had been the victim of rape and subsequent rejection by her stepbrother Amnon, who faked lovesickness, Cats chastised her for her foolishness in entering Amnon's chamber.[84] To enact Cats' text, Steen introduced a character in fool's dress who exposes Tamar to our example and invites us to laugh at her.

Like many of Steen's genre paintings, his most bustling history scenes, such as the *Samson and Delilah* (cat. 34) or the *Worship of the Golden Calf* (cat. 47), are archaizing, as they visualize a tragicomic theatrical mode that had been fashionable in

fig. 16. Paolo Veronese,
The Marriage at Cana, 1562–1563,
oil on canvas, Musée du Louvre

fig. 17. Adriaen van de Venne, *Amnon and Tamar*, engraving from Jacob Cats, *Houwelyck*, Middelburg, 1625, Universiteitsbibliotheek, Amsterdam

the first decades of the century but had lost favor to the more economical structures of Vondel's tragedies. In their crowded, complicated settings, accentuated gestures, and facial distortions, these paintings also evoke the spectacular, even gruesome productions of Jan Vos.[85] In the 1660s his popular plays for the Amsterdam theater had begun to reap moral as well as aesthetic criticism. In the visual arts, more restrained works by classicizing artists such as Gerard de Lairesse gained acclaim in just this period, and critics, including the theatrical authority Pels, began to denounce Rembrandt's violations of classical decorum.[86] By casting his history paintings of the late 1660s and 1670s in deliberately retardataire, non-classicist modes, Steen created a comic mode of history that was consistent with his identity as comic artist.

Audience and function

Like Steen's comic genre paintings, most of his history pictures speak of issues relevant to their primarily urban, middle-class audience.[87] This public shared the concern of Steen's *Choice between Age and Youth* and *Amnon and Tamar* with proper courtship, sexual discipline, and socially and financially balanced marriage. Middle-class stakes in controlled courtship and equal marriage are articulated directly in treatises, legal documents, and sermons, and more implicitly in jokes and comedies performed in the Amsterdam theater. Similarly, a rich and fre-

quently contradictory urban discourse propelled the professionalization of medicine, and Steen's images of quacks and pretentious doctors commented on and participated in this process. Even traditional themes such as the ship of fools or the fair frequented by lazy boors attained new resonance for the urban élite of the Dutch Republic, whose prosperity depended on an ideology and practice of hard work and financial responsibility.

Yet the more private character of easel painting, compared with the public status of legal ordinances, printed texts, and censored theater, allowed comic pictures other functions than superior laughter. To fulfill its theoretical task of exposing the world as it is, comic texts and pictures should frankly represent abuses, from untidiness, wastefulness, and drunkenness, to quarrels, deceit, lechery; from boorish performance to traditional religious feasts, widely derided in the Republic as "Popish." Without official interference (though not without Calvinist criticism), comic painters and their customers could paint and view these forbidden pleasures in vivid, lifelike detail. The editorial comments Steen inserted to be noticed by viewers but not by the transgressors within the paintings, allowed beholders to look at leisure, secure in their privileged understanding of the satiric character of these scenes. Steen frequently displaced onto urban types the comic transgressions his predecessors had ascribed to peasants.[88] He thereby gave his comedy added bite, although he blunted it by typing the protagonists as boorish or anachronistic, and thus presumably different from their viewers.

A leisurely, ultimately superior look at the abuses of near-peers must have offered middle-class viewers at least unconscious reprieve from the pressures of living polite in seventeenth-century society.[89] Ironically, comic pictures thereby served a relief function similar to that which an urban élite had long attributed to fairs and carnivals—but for peasants rather than themselves. In the middle-class imagination and actual social policy, such communal festivities had traditionally acted as safety valves, presumably creating sanctioned channels through which peasants and urban "low-lifes" could vent discontent.[90] By including urban visitors in his village fairs, Steen hints at this elision of borders between "high" and "low" comic cultures, a collapse that is evident also in the voracious taste of élite authors such as Constantijn Huygens for all levels of comedy, from smutty farces to witty epigrams.

For some viewers, Steen's archaizing means may have served a nostalgia for the rustic pleasures of communal feasting and performance. Dusart, who may have owned Steen's *Rhetoricians* (figs. 6, 8) and who specialized in scenes of harmless peasant enjoyments, could well have seen them in such light. By representing robust rederijkers in sizable works, Steen echoed contemporary assessments of them as coarse but essential precursors of the seventeenth-century poets who had put Dutch literature on its feet.[91] One of Steen's prominent customers, the wealthy Hendrick Bugge van Ring of Leiden, owned six paintings by him, including a peasant fair, peasant games, and a "large . . . merrymaking on Three Kings' night," the latter very likely Steen's largest, and only nocturnal, *Twelfth Night* (cat. 18).[92] This picture of proscribed religious festival may have given Bugge van Ring, member of a Catholic brewers' family, particular nostalgic pleasure.

With their sophisticated pictorial and textual references, many of Steen's paintings assume a high level of audience preparation. Although his history paintings mostly represent well-known stories, their innovative mixture of elevated passions and low comic vignettes as well as their transformations of pictorial precedents would have appealed most to viewers familiar with the available modes of history painting and drama. Steen's self-portraits and other authorial insertions would have been meaningful primarily to customers knowledgeable about self-portrait traditions and the self-referentiality of comic texts. Crammed full with delicately painted objects and allusions, his paintings could stimulate entertaining and learned discussion among cognoscenti. Aware of this ancient function of comic texts and pictures,[93] Steen usually painted open-ended narratives or mid-stream situations, preventing closed and singular interpretation and thus sustaining repeat viewing, just as Van de Venne encouraged multiple readings of his *Laughable World*. Picturing, prompting, and defying texts, Steen's comic fictions are conversation pieces in the fullest sense of the words.

For their sharpening comments I thank Egbert Haverkamp-Begemann, H. Perry Chapman, Arthur K. Wheelock, Jr., Guido Jansen, Mary Yakush, and Aneta Georgievska-Shine.

1. Sale catalogue, Johan Pieter Wierman, Amsterdam, 18 August 1762, no. 40.

2. Wellington Museum 1982, no. 163; Van Gils 1920. Dixon 1995, 143–147, rightly points out that art historians have frequently misread Van Gils 1920 by stating that the ribbon in the brazier represents a pregnancy test. Nevertheless, several ambiguous seventeenth-century jokes linking female desire to illicit pregnancy suggest that viewers might have attributed the woman's swooning to morning sickness, to be alleviated by "odor therapy," in Dixon's evocative term. For such ambiguous jokes, Van Gils 1917, 151–152, 164–170; *Nieuwen clucht-vertelder* 1669, 150, 187; Van Vloten 1878–1881, 3: 126.

3. Westermann 1996a.

4. *Maandelyksche berichten* 1747. On the series and its sources, Hanou 1985.

5. Houbraken 1718–1721, 3: 12–30; Weyerman 1729–1769, 2: 347–366.

6. On the relationship between Steen's life, art, and early biographies, pages 11–23; Westermann 1996a.

7. Koopman and Verhuyck 1991.

8. On a picaresque narrative of 1651, Schenkeveld-van der Dussen 1989; compare Huygens 1653 and the late seventeenth-century *Amsterdamsche lichtmis* 1983. An early prose text with picaresque elements, published in 1624, is *Avontuer van twee goelieven* 1988. For Weyerman's own rather picaresque life and works, Broos 1990.

9. Houbraken 1718–1721, 3: 16–18; Weyerman 1729–1769, 2: 352, 362–63, 366.

10. Cited by Westermann 1996c.

11. Houbraken 1718–1721, 1: 348; Rotgans 1708.

12. Sale catalogue, Hermina Jacoba Countess de Thoms, Warmond (P. van der Schley, C. S. Roos, J. de Vries, P. C. Huybrechts), 31 July 1816, no. 35.

13. Houbraken 1718–1721, 3: 25–26; Vos 1726, 1: 437. On Steen's portrait practices, Westermann 1995.

14. Sale catalogue, Pieter de Klok, Amsterdam, 22 April 1744, no. 76. The painting fetched the high price of 165 guilders.

15. Bredero 1622, 5.

16. The print illustrating Bredero's poem represents an interior, however, as does a painting of 1662 on the theme by Jan Miense Molenaer (c. 1610–1668). The sale catalogue title may thus refer to one of Steen's peasant taverns, somewhat resembling Molenaer's picture. For the print, Bredero 1622, 4; for the convincing identification of Molenaer's *Arent Pieter Ghysen*, Weller 1992, 1: 180–181, 194–198, 254–256.

17. Martin 1909b, esp. 142–146 and 154; Van Gils 1935 and Van Gils 1937; Fischel 1935; Gudlaugsson 1938 and Gudlaugsson 1945; Heppner 1939–1940.

18. For the phrase *ut pictura poesis*, Horace 1929, 1.361; the *Ars Poetica* became well known in the Dutch Republic through translations by De Hemelaer 1612, Vondel 1654, and Pels 1677; see Schenkeveld 1991, 119–120. Generally on the *ut pictura poesis* topos, Hagstrum 1958 and Gent 1981; for the seventeenth-century Netherlands, Emmens 1956, Emmens 1981, and Weber 1991.

19. P. Dubbels even called poetry and painting "twins" in this respect; *Olipodrigo* 1654, 2: 97.

20. Vondel 1660, A2r–[A2]v; Vondel 1661, 4–5; Vos 1667, introduction.

21. Van de Venne 1635, 119. Van de Venne had previously worked out the relationship in a serious mode; Van de Venne 1623, 55–68, esp. 59–62.

22. Van de Venne 1623, 62–63.

23. Plokker 1984; Van Vaeck 1994b.

24. Hofstede de Groot 1928, 1: no. 47b, as Frans van Mieris. Correctly attributed to Brakenburg by Willem van de Watering; sale catalogue Old Master Paintings, Sotheby's, London, 7 July 1993, no. 107, color ill.

25. For erotic love as painterly inspiration, Sluijter 1991–1992; on colorful, especially yellow silks as agents of seduction, Westermann 1996a. In a particularly explicit poem, a woman "with bodice unlaced wide" encourages a painter "wild of heart" to grind his paints and "portray her squarely in Venus' book." She is pleased with the portrait, although his paint has made her wet and his brush is not quite as "stiff" as that of a painter who "once portrayed [her] twice in one hour"; [Barth] 1624, 183–186.

26. Van Hoogstraeten 1678, 214–215. The classical muses often appeared in comic, even lewd poetry. In a poem for newlyweds, Terpsichore encourages the bride to hurry away from the feast to reap the pleasures of the bed; *Amsterdamse mengelmoez* 1658, 2: 50.

27. Van Hoogstraeten represented Terpsichore playing the lute with the more traditional lyre at her feet. By substituting a violin, Brakenburg let the muse pick up the instrument Steen had hung on the back wall of his *Drawing Lesson*. He also allowed her to act out more fully her role as prescribed by Cesare Ripa in his *Iconologia*. Ripa described Terpsichore as a "light-hearted Maiden of pretty visage," holding "in the left hand a Lyre, and in the right one a bow." Ripa 1644, 337, 340.

28. Schmidt-Degener and Van Gelder 1927, 83; Bredius 1927, 38; Fischel 1935, 65; Heppner 1939–1940; Gudlaugsson 1945, 6–7.

29. Mak 1944.

30. Brandt and Hogendoorn 1992, 346 n. 2.

31. Brandt and Hogendoorn 1992, 337–340, 345–46, 349–353; Smits-Veldt 1991, 14–18.

32. For productive relationships between painters and rhetoricians, particularly in the sixteenth century, Heppner 1939–1940, 22–23; Veldman 1976; Gibson 1981.

33. Anonymous sale catalogue Leiden (Delfos, Honkoop), 28 October 1800, no. 2. The entry describes a composition known in several versions, none autograph, including paintings

in Munich and in The Hague (Braun 1980, nos. 218, 218a, ill.).

34. Bredero 1617, vss. 1448–1471. Calvinist moralists shared this view of rederijkers; Duker 1893–1915, 2: 248.

35. *Treur-klacht* 1637, 11. Its arguments were anticipated in the publication of one of the last large rederijker competitions in the Dutch Republic; *Nootwendich vertoogh* 1614, iiijr.

36. The ramshackle poetry of seventeenth-century rederijkers became a stock motif of comic texts; see *Vaeck-verdryver* 1620, 41; Sweerts 1698–1700, 1: 53, 109–110.

37. As is often the case with Steen's inscriptions, the one on the placard in his *Rederijkers Carousing* has become difficult to read— but it certainly includes a juxtaposition of dry food and drink. For an alternative reading of the text that maintains this contrast, see Heppner 1939–1940, 27 n. 1. Close in tenor is a verse on an etching of a peasant wedding by Pieter van der Borcht, which ends with the ironic observation "The worse the food, the better the drinking." Sullivan 1994, fig. 16. In seventeenth-century jokes, dryness is often metaphoric for sexual as well as artistic impotence.

38. An inventory prepared after Dusart's death in 1704 included a painting of *"Cameristen* [Chamber Members] by Jan Steen." In the sale catalogue of his possessions it was described as "painted glowingly and forcefully, and executed in lively manner"; Bredius 1915–1922, 1:30, no. 25. For the drawing, sale catalogue, Dutch, Flemish and German Drawings, Christie's, Amsterdam, 12 November 1990, no. 131. Dusart also changed the poem on the placard into another doggerel poem, suggesting that one point of Steen's inscription was the nonsensicality that made it virtually interchangeable with other inelegant rhymes. I am grateful to Johan Bosch van Rosenthal for the photograph.

39. For Bruegel's representation, Sullivan 1994, 57–58. Hendrik Bary's print after Adriaen van Ostade has been analyzed by Ackermann 1993, 161–162.

40. Vanden Plasse 1638, A4r; Pels 1677, 91–92; Harmsen 1989 (on a tract written in the 1680s by the classicizing literary society Nil Volentibus Arduum), Day 8.

41. Albach 1977; Brandt and Hogendoorn 1992; on new theatrical organizations in the seventeenth century, Grootes 1992.

42. Fairs: Detroit Institute of Arts; private collection; and Maurits-huis, The Hague; Braun 1980, nos. 74, 75, and 81, ill. Quack in close-up: Amsterdam, Rijksmuseum, Braun 1980, no. 89, ill. The deceptiveness and folly of theatrical representation were denounced sharply by Calvinist preachers, who in the same breath agitated against fairs and other communal entertainments; Ampzing 1630; Prynne 1639; *Hollandt ont-kermist* 1672; Duker 1893–1915, 2:234–270; Groenendijk 1984 and Groenendijk 1989.

43. On the standard repertoire of peasant fair imagery, first articulated in prints with inscriptions from the middle of the sixteenth century, Raupp 1986, esp. 301–302, and Van Vaeck 1994b, 3:659–677.

44. Vondel's lines were based on Petronius' phrase "totus mundus agit histrionem," most famously incarnated in Shakespeare's "All the world's a stage . . ." (*As You Like It*).

45. *The Toothpuller*: Mauritshuis, The Hague, Braun 1980, no. 32, color pl.; *Stone Operation*: Rijksmuseum, Amsterdam, Braun 1980, no. 89, color pl.

46. Besides the *Arent Pieter Ghysen* mentioned above, Steen painted *Ascagnes and Lucelle*, the lovers of Bredero's tragicomedy *Lucelle* (1616); sale catalogue, Willem Fabricius, Haarlem, 19 August 1749, no. 26. Gudlaugsson 1947 and Heppner 1939–1940, 47, proposed to identify this reference with a painting now in the Corcoran Gallery of Art or a related work in the collection of the Marquess of Bute (Braun 1980, nos. 279, 312), but both paintings seem to be taller and wider than the painting in the 1749 sale and the price of 19 guilders seems low for either of those rather finely executed works. The Fabricius composition probably did resemble these paintings, both of which are indebted to prints of the scene by Willem Buytewech (1591/1592–1624) and Jan van de Velde II (1593–1641).

47. Stewart 1979. Bredero's poems were illustrated with two engravings, one anonymous and one by Michiel Le Blon (1587–1658) after Willem Buytewech; Steen seems to have ignored them except for one gesture (note 49).

48. In an etching by Romeyn de Hooghe (1645–1708) to one of Bocaccio's bawdy tales, one woman makes the gesture while ridiculing the presumed impotence of an old gentleman; Boccaccio 1697, 1: 60.

49. It does so explicitly in another of De Hooghe's illustrations to Boccaccio 1697, 1: 177; for the sexual charge of the invasive leg, Steinberg 1968. The engravings to Bredero's poems posit the contrasts of swagger and sexual inadequacy less forcefully, but Steen did use Le Blon's gesture of arm akimbo with hand bent back for the vigorous young man. For Buytewech's drawing and Le Blon's print, Rotterdam 1974, nos. 45, 142, ill.

50. On these types of prints, Cleves 1983; for Steen's print in this painting, Salomon 1987, 321–325.

51. Westermann 1996a; for the rederijker tradition, often slinging insults at the audience, Pleij 1975.

52. Westermann 1996a. Van Hoogstraeten 1678, 190, derided this theatrical practice and advised painters against it.

53. The derisive charge of Steen's costumes was first noted by Gudlaugsson 1938 and Gudlaugsson 1945. For a valid critique of Gudlaugsson's theatrical sources, Kettering 1983, 113–114; the point remains that Steen represented outdated costumes to brand characters or situations as comic, and that he shared this practice with contemporary theater.

54. For other versions of the buskin in Steen's paintings, cats. 32, 34, 41, 47. The antique convention of the comic buskin was noted by Vanden Plasse 1638, B3v, among others.

55. Donatus attributed this definition to Cicero; it was well-known in the Netherlands. Vanden Plasse 1638, [A3]v, [B1]v; Schrevelius 1662, ***2–[***5]v.

56. For the felicitous phrase "reality effect" to register the historical conditions of pictorial or literary realism in any culture, Barthes 1986.

57. Pels 1677, 68–69; for other Dutch renderings of the requirement, Van Hamel, 1918, 148–150; Harmsen 1989, Days 16 and 18.

58. Van Mander 1604, fol. 233r.

59. Houbraken 1718–1721, 1: 377; 3: 16–17, 18–19. De Lairesse also required lifelike differentiation of gender, age, and social type through gesture and posture; De Lairesse 1707, 1: 33–34, 49–50, 52–64. These recommendations for painters often use theatrical analogies, and theater critics offered similar advice; see Pels 1681, 53, and Pels 1677, 67–69, 71, 83–85.

60. De Lairesse 1707, 1: 53–54.

61. Pels 1677, 69; for other sources on the comic effect of inappropriate gestures, and for the subversive salting gesture of the *Girl Offering Oysters* (cat. 9), Westermann 1996a.

62. Steen's inversions are analogous to textual parodies, such as Dirck Pers' mock encomium to "Suyp-Stad" or "Booze-City," which inverts moralist rhetoric against drink, or Hieronymus Sweerts' prose parodies of the prescriptive household books of Jacob Cats; Pers 1628; Sweerts 1678. On *In Luxury Beware*, Westermann 1996b, 10–15.

63. Vos 1667, introduction.

64. Vos 1726, 1: 515.

65. See page 20.

66. Compare Braun 1980, nos. 204, 230, 233, and 346.

67. On Steen's self-portraiture, see pages 17–21 and cat. 25.

68. Westermann 1996a.

69. On the deliberate obscurity and ambiguity of these glosses, Van Vaeck 1994b, 3:804–825.

70. Artistic identification with monkeys had a hallowed tradition; see Janson 1952 and Westermann 1996c.

71. In an epigram of 1572 below Bruegel's portrait, Dominicus Lampsonius (1532–1599) considered his comic pictures "full of salt"; Lampsonius 1572, 19. For Frans Hals' use of the topos, Van Thiel 1961; on the salt in the epigrams of Constantijn Huygens, Ter Meer 1991, 23–29.

72. Van de Venne 1635, 210–223.

73. Sale catalogues of 1745 and 1762 included a painting of Diogenes looking for honest people at the market, including a quack on his theater and a drunk woman on a wheelbarrow. Although the description combines elements of fig. 10 and cat. 46, the dimensions and details of the recorded picture preclude identification with those works.

74. The correspondences between Steen's *Village Fair* (fig. 10) and *Village Revel* (cat. 46) extend beyond pictorial structure to the Diogenes motif and the reference to wits in need of sharpening; the inn in the *Revel* is called "MISVERSTANT," or "the foolish wit."

75. For uses of the rondeel in skits at élite weddings or in clever comic compilations, *Olipodrigo* 1654; *Amsterdamse mengelmoez* 1658; and Sweerts 1698–1700.

76. A reference to "Een scheepie Rijn uijt" by Steen in the inventory of François van Hillegaert of Amsterdam, made up in 1707, may be identifiable with this painting, and establishes contemporary recognition of Steen's debt to the tradition. I am most grateful to Bas Dudok van Heel for giving me access to transcriptions of numerous Amsterdam inventories.

77. See also pages 69–81.

78. Van Mander 1604, Bk. 5: 17v.

79. Van Hoogstraeten 1678, 192–195.

80. Compare for example Goltzius' *Danaë Receiving Jupiter* in the Los Angeles County Museum of Art (The Hague 1990, no. 22), Wtewael's two versions of *Mars and Venus Discovered* in the Mauritshuis, The Hague, and at the J. Paul Getty Museum, Malibu (Broos 1987, no. 70, and Lowenthal 1995), and Rembrandt's *Diana and Her Nymphs* in Anholt (Bruyn et al. 1982–1989, 2: no. A92).

81. Vos 1726, 1: 249, about "S.O.V. Tooneel-Poëet" (S.O.V. Theater-Poet), in which "S.O.V" inverts "V.O.S."

82. Characteristic tragicomedies are Starter 1618; De Koning 1610; and De Koning 1618. See the description of the mixed genre in Plautus 1617, [B]v. For prose narrative, Sweerts 1689.

83. For prints after Veronese available in the seventeenth century, Rome 1978, and Paris 1992, nos. A 33 and A 39, figs. 121, 126.

84. Cats 1625, part 2, 46–49.

85. On Vondel, Vos, and classicist theater in the second half of the seventeenth century, Smits-Veldt 1991, 89–121. For a classicist critique of tragicomic mixtures, Pels 1677, 81–82.

86. Slive 1953, 77–103; Emmens 1968, esp. 38–124. Halewood 1993 has suggested that Rembrandt's representations of elevated themes in "low" modes bear the marks of Protestant conceptions of all humanity as flawed but capable of receiving God's grace.

87. For an analysis of early owners of Steen's work, up to 1730, Westermann 1996c, Chapter Two.

88. For Bredero's explicit comments on his earlier, reversed displacement of the disreputable behavior of urban citizens onto peasants, Bredero 1622, [*4–*4]v.

89. Westermann 1996a.

90. On the relief function of traditional festive culture, Pleij 1979, 51–62.

91. Pels 1681, 11–15.

92. Bredius 1927, 99; on Bugge van Ring, Fock 1990, 7, 10, 25. His inventory, Leiden, 30 March 1667, included "a large piece being a merrymaking on Three Kings' night by Jan Steen." The 1662 date of the Boston painting, its unusually large size, and its night setting all suggest identification with this reference. I am grateful to Professor C. Willemijn Fock for giving me the precise texts of Bugge van Ring's inventory entries.

93. Sullivan 1994, 34–36.

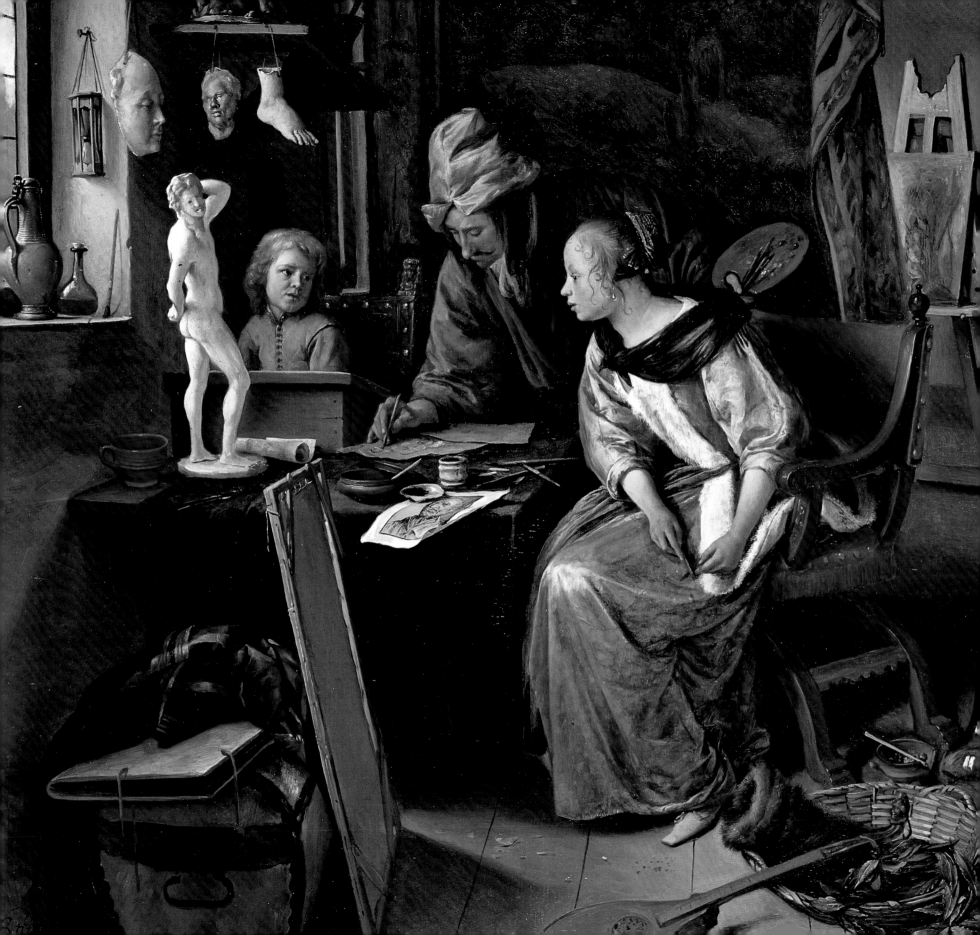

STEEN'S ARTISTIC EVOLUTION IN THE CONTEXT OF DUTCH PAINTING

Lyckle de Vries

The first drawing lessons that Jan Steen received were not necessarily oriented toward his later profession; they may have been part of an all-round humanistic education. It is not unlikely that Steen's decision to become an artist was dictated by circumstances. Like his father Havick Steen, Jan was trained to be a brewer, but when he was ready to start out on a career in this field, a serious crisis in the Dutch brewing industry began to make itself felt. Brewing and painting were to play a permanent role in Steen's life story. His first biographer, Houbraken, knew about this fascinating combination and he was convinced that Steen had produced a number of works "inspired" by alcohol. In the course of time, that "fact" was all too often used as an excuse for the attribution of mediocre paintings and these were, in their turn, used as proof that Houbraken had been right. Thus it was that irresponsible art historical work reinforced the image of the irresponsible painter-brewer. The easily recognizable borrowings and the great stylistic differences in Steen's oeuvre were also taken as evidence of lightheartedness, of the same carefree *joie de vivre* that supposedly characterizes the figures in his paintings.

Admittedly, the hand of the beginner is easily recognized in Jan Steen's early works. His period of training as a painter was remarkably short and this seems to offer a far more plausible explanation of certain shortcomings than Houbraken's theory of beer and wine. But anatomical implausibilities, glaring errors in perspective, and a certain awkwardness in arranging groups of figures can be found in paintings from all stages of his career. The artist could have surmounted his shortcomings by setting himself a narrow task and striving for perfection within those self-imposed boundaries, but he seems to have chosen other priorities. Unlike those of his contemporaries with whom he is most often compared, he did not develop into a "trade-mark painter"; his work displays no mechanical repetitions of effective poses, favorite attributes, and successful details. Instead of becoming a "super-specialist," Jan Steen seems to have aimed at being a "general painter": a figure painter who demonstrated with his richly varied oeuvre that he had mastered everything, however diverse, that was part of his craft.

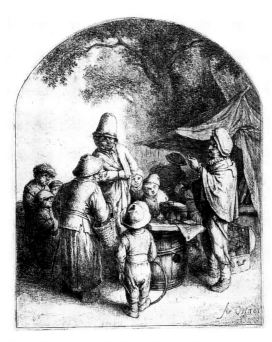

fig. 1. Adriaen van Ostade, *The Quack*, 1648, etching, Rijksprentenkabinet, Amsterdam

It is not clear whether Jan Steen developed his ambitions over the years or if he started out with those grand ideas. In fact, his beginnings were rather humble. When he left the Haarlem studio of Adriaen van Ostade (1610–1685) he probably took a set of impressions of his master's etchings (fig. 1), from which he then borrowed and varied all sorts of motifs. This applies, for example, to the *Peddler Selling Spectacles* (Braun 16) and certainly to the *Toothpuller* of 1651 (cat. 26, fig. 3). The latter panel, which is dated three years after Van Ostade's etching, shows how quickly the young painter had managed to free himself from his exemplar. The differences do not yet reveal great craftsmanship but betray a tendency to enhance the narrative element rather than develop a setting that establishes the mood. In comparison to Van Ostade's figures, Steen's are brought to the foreground, move more theatrically, and have livelier facial expressions.

The next leap forward was the *Village Wedding* of 1653 (cat. 6). Within a short period Steen produced five more variants on this theme derived from a

fig. 2. Jan Steen, *Horse Fair at Valkenburg*, c. 1650–1653, oil on canvas, Victor de Steurs Foundation

be traced back via a painting by Gabriël Metsu (1629–1667) (fig. 5) to an etching by Rembrandt (1606–1669) (fig. 6).[2]

Most of the portraits Steen painted have a narrative slant also, which make this section of his oeuvre rather exceptional. As is the tendency of modern photographers such as Annie Leibovitz (b. 1950), the painter made his sitters act out an intensified version of their roles in daily life. In this way, there can be no misunderstanding about the fact that we are confronted with a hard-working baker (cat. 8), an enchanting adopted child (cat. 12), or a family harmonious in both their relationships and their musicmaking (page 20, fig. 14). The so-called Burgher of Delft (1655; cat. 7) acts the part of a member of the gentry prepared to lend an ear to the complaints of an honest beggar-woman. Since Steen's sitters are involved in stories that relate to their own daily lives, these portraits look like genre scenes and sometimes one might have doubts about how best to categorize them. The steps in front of the "Burgher's" house on the main canal in Delft prompted a pictorial structure that may be compared to the composition of many scenes of begging and selling by Jan Steen and other artists as

sixteenth-century model.[1] He continued to make such groups of closely related paintings throughout his career. His best-known later "theme and variations" is the *Doctor's Visit* (compare cat. 16). To his inexhaustible imagination, even such a familiar theme continued to offer fresh opportunities.

Within the multifarious oeuvre of Jan Steen, not all genres were treated equally. Since he seems to have been driven mainly by the impulse to narrate, he could never become a true landscape painter. He was the son-in-law of Jan van Goyen (1596–1656), but I find it hard to believe that he ever was his pupil. The *Winter Landscape* of c. 1650 (cat. 1) is the one that best fits within the Dutch landscape tradition, although it reminds one less of Van Goyen than of Isack van Ostade (1621–1649). The fairs, market scenes, and inn gardens that Steen regularly painted in the 1650s became increasingly narrative in nature; the figures, in other words, began to demand more attention than their setting. The *Horse Fair at*

Valkenburg (fig. 2) is a fine example of this trend. Later in Steen's career, the figures and the story they tell would dominate the pictorial space so strongly that one can no longer speak of landscape at all.

Different as they may be, genre scenes have much in common with biblical and mythological subjects, since both types of painting relate stories. Early in his career, Steen tried to overcome the limitations that resulted from his training, by expanding his repertoire with biblical and mythological stories. His first attempts, like some of his genre pieces, are still semi-landscapes, such as the *Erysichton Selling His Daughter* (fig. 3). In the meantime, Steen studied the work of other figure painters, directly or in prints. Understandably, he did not direct his attention to artists executing monumental commissions for Huis ten Bosch Palace or the Amsterdam Town Hall, but to young genre painters like Johannes Vermeer (1632–1675) and Gabriël Metsu (1629–1667). Steen's *Dismissal of Hagar* (fig. 4), for example, can

fig. 3. Jan Steen, *Erysichthon Selling His Daughter*, c. 1652–1654, oil on panel, Rijksmuseum, Amsterdam

fig. 4. Jan Steen, *Dismissal of Hagar*, c. 1655–1657, oil on canvas, Gemäldegalerie Alte Meister, Dresden

above right: fig. 5. Gabriël Metsu, *Dismissal of Hagar*, c. 1637, oil on canvas, Stedelijk Museum "De Lakenhal," Leiden

below right: fig. 6. Rembrandt, *Dismissal of Hagar*, 1637, etching and drypoint, Rijksprentenkabinet, Amsterdam

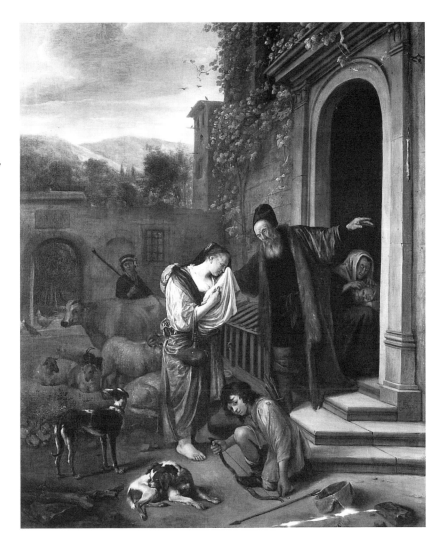

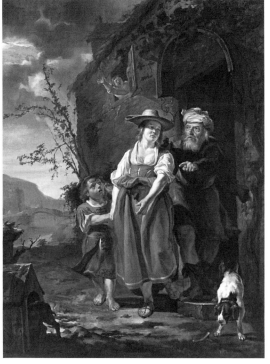

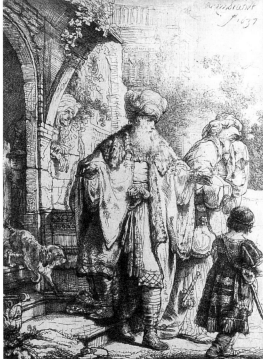

well. Steen's own *Ladies Listening to Musicians* of 1659 (cat. 7, fig. 2) bears a close compositional resemblance to this exceptional portrait.

Isolating a motif from a larger whole to strengthen its impact helped Steen to make his work more narrative. Many had used the device before him. Both Rembrandt and Gerrit Dou (1613–1675), for instance, had restricted their narrative scenes to a single half-figure in the opening of an upper door or a window. This form of contact between indoors and outdoors—between painted figure and viewer—was also a common motif in the etchings of Adriaen van Ostade. Steen provided his personal variation on the window motif in two compositions with boisterous rhetoricians (cat. 24 and cat. 24, fig. 2). The way in which the Leiden baker Arend Oostwaert and his wife (cat. 8) are framed by a window and a door in their portrait of 1658 give this composition the look of an enlarged detail from a genre scene of people selling produce (compare cat. 8, fig. 3); again, the initial idea might have stemmed from an etching by Adriaen van Ostade.

Only about forty of Steen's paintings are dated, and they are spread irregularly throughout his oeuvre. The fact that no fewer than five dated works survive from 1659 and 1660 seems to indicate

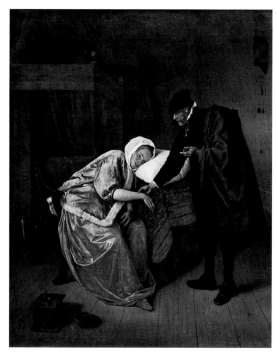

fig. 7. Jan Steen, *The Sick Woman*, c. 1660, oil on canvas, Rijksmuseum, Amsterdam

that the painter himself attached great importance to the developments of those years. Indeed, shortly before his move from Warmond, near Leiden, to Haarlem, one does note major changes in his work. It is true that some warning signs occurred, but the rapidity with which these changes took effect creates the impression that the artist deliberately set out to make a fresh start. The tendency toward large formats and monumental compositions that can occasionally be noted in earlier works was to become more pronounced, mainly due to the example of Jacob Jordaens (1593–1678). At the same time, Steen expanded his range to include elegant conversation pieces, although he never entirely abandoned low-life scenes.

After c. 1650, the leading masters of genre had turned increasingly to scenes with richly clad figures in elegant interiors. Harking back to earlier models like Dirck Hals (1591–1656), the most influential innovator of high-life genre was probably Gerard ter Borch (1617–1681). Frans van Mieris

(1635–1681) in Leiden, Nicolaes Maes (1634–1693) and Samuel van Hoogstraeten (1627–1678) in Dordrecht, Pieter de Hooch (1629–1684), and Johannes Vermeer (1632–1675) in Delft, and a few others, all struck out in the same direction. The extent to which they were leaders or followers is difficult to establish. What they had in common was their preference for small, vertical formats and compositions with just a few figures. Painting with a meticulous finish came to be more and more highly valued. The figures, their dress, behavior, and surroundings, and also the painting technique, suggested distinction and costliness. The great success enjoyed by Frans van Mieris may have been one of the motivating reasons for Steen's switch from rough-edged peasant genre scenes to more elegant interiors. Around 1660 he made a few calculated attempts to emulate Van Mieris and Ter Borch but soon enough, Steen succeeded in separating their subject matter from their style. He set out to combine the themes of the *fine painters* with the expressiveness of his own earlier peasant scenes and the monumentality of Jordaens' large canvases. The result of this alchemical blending process was unique.

Frans van Mieris' earliest dated work is the *Doctor's Visit* of 1657 (page 18, fig. 11). The subject does not often recur in Van Mieris' oeuvre, but all the more so in the work of Jan Steen (cat. 16), where more than just a painting technique is found. Apparently, Steen was most fascinated by what was least characteristic of Leiden in it. The view through to an upper room at the back, where a window in the rear wall leads the gaze even further, is not a standard element in the Leiden repertoire. It is a quotation from Delft and Dordrecht painters such as De Hooch, Maes, and Van Hoogstraeten. Jan Steen applied it in every conceivable variation. The table truncated by a corner of the frame and the profile view of a woman beside it are a general but unmistakable reference to Ter Borch. The choice of Dou and Van Mieris, Ter Borch, and De Hooch, Maes, and Van Hoogstraeten as Steen's sources of inspiration is fairly obvious. Metsu is often mentioned among those who influenced Steen, but in my opinion they were both influenced by the same examples at the same moment, since they were both constantly searching for new avenues and

opportunities. This explains the close affinities in their development.

In 1659 Steen painted his finely executed *Ladies Listening to Musicians*, in which two well-dressed young women listen to a hurdy gurdy player and a flutist. One is immediately reminded of the so-called *Burgher of Delft and His Daughter* of 1655 (cat. 7) and the *Dismissal of Hagar* (fig. 4), but new elements are the stone arch that closes off the composition at the top and the women's fine attire. The *Weary Traveler* (Braun 111) is closely akin to the previous composition. The so-called *Poultry Yard* of 1660 (cat. 12) is too exceptional within the oeuvre for it to be compared properly with contemporaneous genre paintings, apart from the ever more meticulous execution. The *Sick Woman* (fig. 7) shows the artist in a dialogue with Gerard ter Borch (compare page 18, fig. 10), this time without the mediation of Frans van Mieris. The indeterminate space, the wooden floor, the position of the bed, and the concentration on a central group of figures that is brought out from the background by light and color make this the most Ter Borch-like of Steen's paintings. The restrained action of the doctor and his patient greatly reinforce this impression.

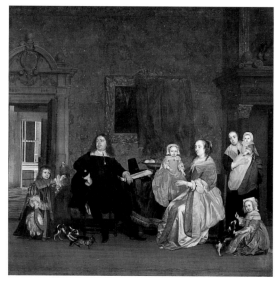

fig. 8. Gabriël Metsu, *The Valckenier Family*, 1657, oil on canvas, Staatliche Museen zu Berlin, Gemäldegalerie

A work that has far more of Leiden and Van Mieris about it is a picture of 1659: *Acta Virum Probant* (cat. 10). Comparison with Van Mieris' well-known *Duet* of 1658 (cat. 10, fig. 2) reveals several broad similarities in subject, composition, and painting technique. The differences, though, are more telling: the half-length figures are replaced by Ter Borch-like full-lengths, the characters have eyes for more than their music, which makes the tension between the two of them palpable, and the door to the next room has been given a function in the narrative, as a servant boy enters with a lute so the two can really play together. The *Bathsheba Receiving David's Letter* of c. 1659 (cat. 11) belongs to the same group of fascinating experiments. But what neither Van Mieris nor Ter Borch ever did is precisely what makes this painting at once so exceptional and so typical for Steen. A biblical story is here disguised as a genre scene. In Steen's oeuvre, there are more examples of this drastic method for bringing moral lessons from the bible and practical experience from daily life together (compare Braun 367 and cat. 38).

No other artist of Jan Steen's generation produced such diverse works at one and the same time. In contrast to that part of his oeuvre just discussed, other works stand out for their monumental composition, large size, and horizontal format. A capital depiction of the saying *Easy Come, Easy Go* (cat. 15, fig. 1) bears the date 1660. Most unusually for him, Jan Steen made a smaller variant of it in 1661 that improves the earlier version in several details (see cat. 15). The relationship between figures and setting is more successful than in the first attempt, where an oversize chair was inserted to prevent the room from looking a little too empty. The *Family Portrait* (page 20, fig. 14) is very close indeed to the 1661 version of *Easy Come, Easy Go*, and thus reveals nothing unexpected in Steen's development in the years around 1660. At the same time it is very close to certain contemporary works by Metsu, his *Visit to the Nursery* of 1661 (The Metropolitan Museum of Art, New York), for instance, and his so-called *Portrait of the Valckenier Family* (fig. 8). In my view, Steen's *Family Portrait* and Metsu's *"Valckenier"* both are portraits in the guise of genre pieces.[3] Both artists may have looked at earlier family portraits

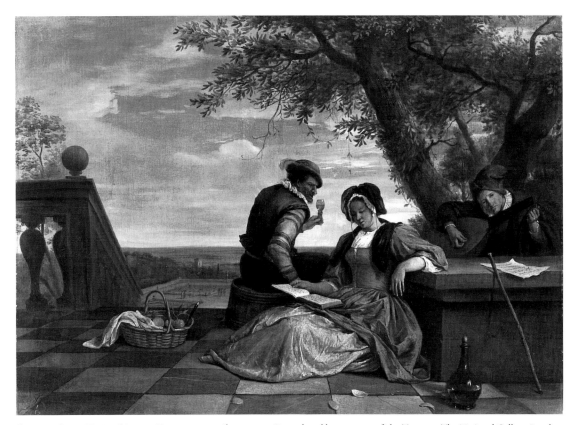

fig. 9. Jan Steen, *Musicmaking on a Terrace*, c. 1663, oil on canvas, Reproduced by courtesy of the Trustees, The National Gallery, London

set in elegant interiors, such as those by Cornelis de Vos (1585–1651), Thomas de Keyser (c. 1596–1667), or Gonzales Coques (1618–1684).[4] The small, fairly informal portraits of Gerrit Schouten, his wife and parents (see cat. 29) were executed in 1665. This group of four and Steen's *Self-Portrait* (cat. 40) stand out in his production as relatively conventional portraits, whereas all others are genrelike compositions (cats. 7, 8, 12, and page 20, fig. 14).

Balancing human figures with the space that encapsulates them must have been Steen's main concern when he made such compositions as his *Easy Come, Easy Go*, or his *Family Portrait*. In a few of those experiments, he learned the trick very rapidly. This is evident from the way in which he enlarged the scale of his figures in relation to the size of his paintings. The lively *In Luxury Beware*

once bore the date 1663 (cat. 21). The grouping of the figures is very compact. The thieving child at the left, the reproving woman at the right, and the voluptuous young woman in the foreground are at the corners of a compositional triangle. Life and theatricality are put into this somewhat labored arrangement through a complex network of gestures and gazes that really tell the story represented. The *Dancing Couple* (cat. 20) is also dated 1663. Here the vine-covered pergola that Steen had used in other inn gardens (compare cat. 17) frames the entire scene, one of the artist's largest and most beautiful works, and no less impressive than his large interiors of the same period. In the amusing *Musicmaking on a Terrace* (fig. 9), an old man and a young woman have to delay their vocal and amorous duet while the lutenist tunes his instrument. On the

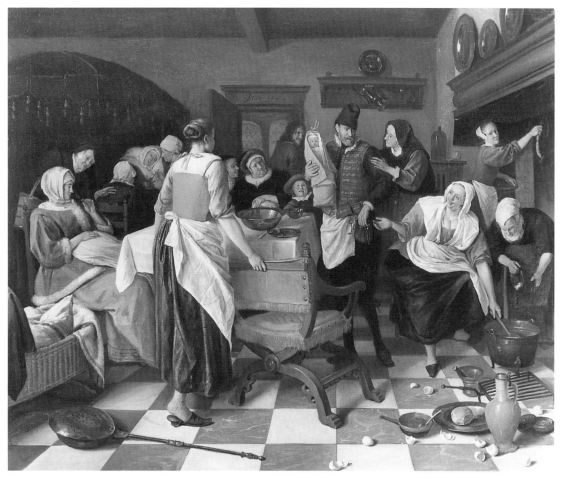

fig. 10. Jan Steen, *The Celebration of the Birth*, 1664, oil on canvas, Reproduced by permission of the Trustees of the Wallace Collection, London

woman drinking wine are nothing more than an adaptation of Steen's technique to the uncommonly large format. Hals had not painted a genre scene for more than twenty-five years when Steen arrived in Haarlem, and I have been unable to detect any influence of the older master on the younger.[5] Steen's scenes with children are related, however, to the work of two artists from Hals' immediate circle—Judith Leyster (1609–1660) and Jan Miense Molenaer (c. 1610–1668).[6]

Not everything that Jan Steen made in his first years in Haarlem was equally large and imposing. Small and medium-sized works echo the developments noted above to a greater or lesser extent. Subject, visual tradition, and the size of the painting are practical matters that often governed the artist's decisions more directly than his "artistic development" as reconstructed today. A superb *Prayer before the Meal* (cat. 13) is dated 1660 and contains a long inscription that makes the iconography of this and related paintings comprehensible. If Steen ever tried to vie with Vermeer it was in this painting, which has a general affinity with the latter's pictures in Brunswick and Berlin.[7] And yet, Metsu appears to

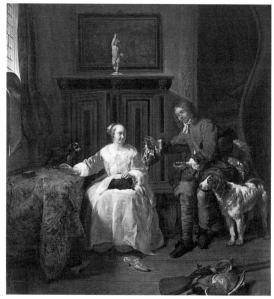

fig. 11. Gabriël Metsu, *The Hunter's Present*, c. 1658–1660, oil on canvas, Rijksmuseum, Amsterdam

evidence of its execution, quality, and facial types, it belongs, I think, among the divergent group of outdoor scenes from the beginning of the 1660s.

Soon enough, Steen's routine and his great talent for improvisation began to play a greater role again than deliberation and construction. In the process, his compositions became flatter, the spatial relationships less clear, and the web of gazes and gestures more important for holding the group of figures together. What this means is possibly best demonstrated in *The Celebration of the Birth*, dated 1664 (fig. 10). One of Steen's illustrations of the proverb *As the Old Sing, So Pipe the Young* (cat. 23)

also demonstrates the narrative power of this approach. It belongs to the finest achievements of his best years, just as the *Effects of Intemperance* (cat. 38, fig. 1) and the *Children Baking Pancakes* (Braun 161). Steen's paintings from the first half of the decade are sometimes compared to the works of Johannes Vermeer because of the strong colors of the clothing and the brightness of the whitewashed walls. In my view that resemblance is superficial, and not the slightest similarity appears in the compositional methods. A reference to Frans Hals' (c. 1582/1583–1666) rough brushwork is also misplaced. In *As the Old Sing* the dashing brushstrokes in the skirt of the

fig. 12. Samuel van Hoogstraten, *View in a Corridor (The Pair of Slippers)*, c. 1656–1658, oil on canvas, Musée du Louvre, Paris

have been a more likely source of inspiration (fig. 11). Metsu's confrontation with Vermeer was only to begin a few years later and would go far deeper.

In 1663, the same year in which the *Dancing Couple* (cat. 20) and *In Luxury Beware* (cat. 21) were made, Steen also painted the much more finely handled *Woman at Her Toilet* (cat. 19). Here the young woman is seated on the edge of her bed, looking provocatively at the viewer. The idea of a genre painting with just one figure who draws the beholder into the action was not new. It was used regularly by the Utrecht Caravaggisti in the 1620s, and Frans van Mieris later played variations on it.[8] At first sight the arch-shaped opening that frames the scene recalls works of the Leiden school, but it also conjures up associations with Delft. A few years later, for example, Vermeer used an open door as a "frame within a frame" in his *Love Letter* in the Rijksmuseum and, somewhat later again, De Hooch applied

the same formula.[9] Like them, Steen found his inspiration in Samuel van Hoogstraeten. He even took from that Dordrecht master the key sticking straight out of the lock into the picture (fig. 12). Without that amusing detail it would be difficult to read the shape of the door, which opens inward.

Several of the elegant companies that Jan Steen painted in the early 1660s are placed in the corner of a room, sometimes with an open window in the left wall. This program was used and varied by a number of artists, so there is little point in trying to identify Steen's models in each case. What he did not imitate is their careful attention to the placement of figures in three-dimensional spaces. This is

clearly demonstrated in two paintings of the early-to mid-1660s. Both the *Doctor's Visit* (cat. 16) and the *Proposal* (Braun 272) show a slow-witted, elderly husband in the background behind a lively young woman in the foreground. In both cases Steen shows not the left but the right corner of the room. This reversal of the standard arrangement is not very common in Dutch genre painting. It reduces the effectiveness of the mathematical lines of the interior, while strengthening the spatial effect of the narrative line of gestures and gazes, that runs from front right to rear left. In his *Proposal* (fig. 13) Steen reduces the entire setting to a floor and part of a rear wall with an open door. If one imagines the scene without

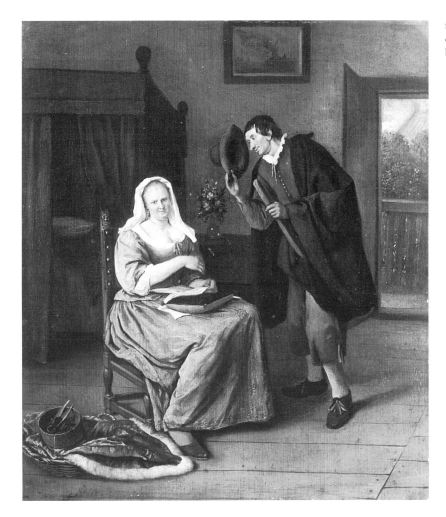

fig. 13. Jan Steen, *The Proposal*, c. 1665, oil on panel, Art market, New York

fig. 14. Cornelis Bega, *Saying Grace*, 1663, oil on canvas, Rijksmuseum, Amsterdam

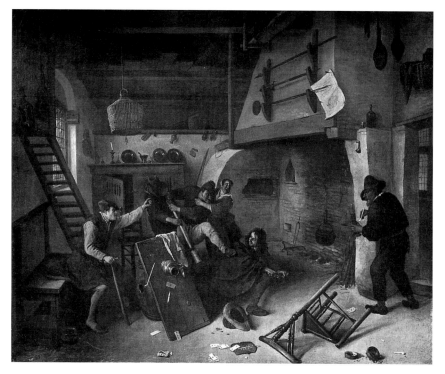

fig. 15. Jan Steen, *Interior of an Inn with Cardplayers Fighting*, 1664, oil on canvas, Alte Pinakothek München

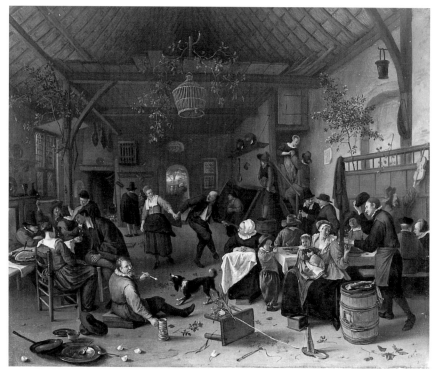

fig. 16. Jan Steen, *Interior of an Inn with a Dancing Couple*, c. 1664–1665, oil on canvas, The Royal Collection © 1996, Her Majesty Queen Elizabeth II

the figures, it loses the three-dimensionality that the story infuses into it. The spatial simplification is taken even further in *Children Teaching a Cat to Dance* (Braun 267) and the *Unequal Couple by a Harpsichord* (Braun 210), for here only a rear wall defines the location.

The freedom with which Steen treated and sometimes amalgamated different visual traditions is one of the most fascinating aspects of his work, certainly in his Haarlem period. In contrast to his contemporaries, he reduced the distance between elegant interiors, more middle-class interiors, and peasant scenes. Sometimes it is even difficult to make out if the scene is of an orderly peasant inn or a simple and not too strictly run household. What the peasant interiors of Jan Steen and Cornelis Bega (1631/1632–1664) have in common, compared to those by their teacher Adriaen van Ostade, is the reduction in the number of actors and the concentration on one group of figures that dominates the composition. Steen, more than Bega,

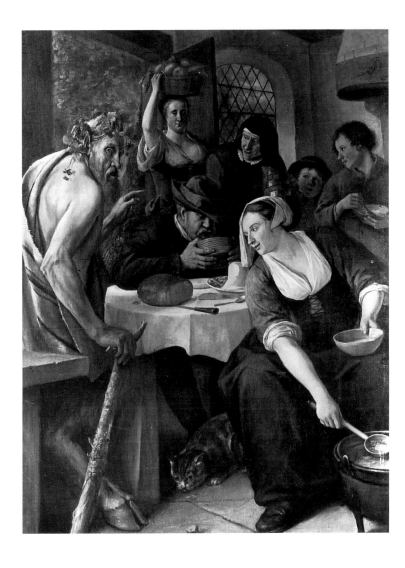

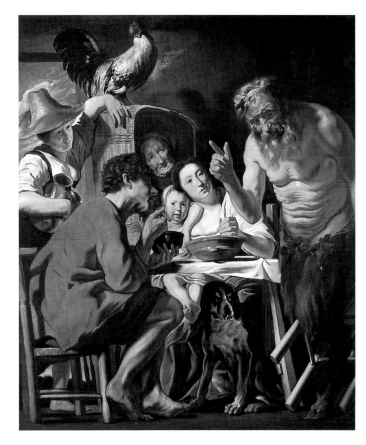

left: fig. 17. Jan Steen, *The Fable of the Satyr and the Peasant*, c. 1668, oil on canvas, Museum Bredius, The Hague

right: fig. 18. Jacob Jordaens, *The Satyr and the Peasant*, c. 1620–1621, oil on canvas, Göteborg Konstmuseum, Gothenburg

decided that the peasant genre was suitable not only for sketching a mood and an atmosphere but also for telling stories comparable to those in domestic and elegant genre scenes (fig. 14). In order to bring out the point of his stories, Jan Steen heightened the expressiveness of gestures and physiognomies, sometimes almost to the point of caricature, whereas Cornelis Bega gave his peasants a rare dignity.

In the mid-1660s Steen experimented with views, taken along the longest axis, through deep barns with thatched roofs. Again he had found new inspiration in the work of his old master Adriaen van Ostade. Compared to the broad, shallow, stagelike

sets in most of the other compositions, this perspective creates a totally different impression. The *Interior of an Inn with Cardplayers Fighting* is dated 1664 (fig. 15). The attempt to depict a spacious room led to a somewhat unhappy relationship between figures and setting. More successful works are the *Interior of an Inn with a Dancing Couple* (fig. 16) and the charming *School for Boys and Girls* (cat. 41). In the latter the left wall is once again omitted. The *Prince's Day* (page 41, fig. 2) is somewhat smaller and the figures are on a reduced scale relative to the picture surface.[10] The room in the tavern is fairly deep but appears less so due to the lack of a right wall. Its palette

seems to suggest that it was painted somewhat later than the *School*, probably in the late 1660s.

The vertical format and large size of the *Punishing Schoolmaster* (page 12, fig. 2) and the *Fable of the Satyr and the Peasant* (fig. 17) come as something of a surprise for subjects from the peasant tradition, since they are more than 110 cm. in height. In the case of the *Fable of the Satyr and the Peasant*, Steen's ever-present predilection for imposing compositions was stimulated by the example of Jacob Jordaens (fig. 18).[11] The Flemish artist painted genre pieces with numerous tightly packed and almost life-size figures, and he depicted the fable about the chilled

fig. 19. Jan Steen, *The Alchemist*, 1668, oil on panel, Cà d'Oro, Venice

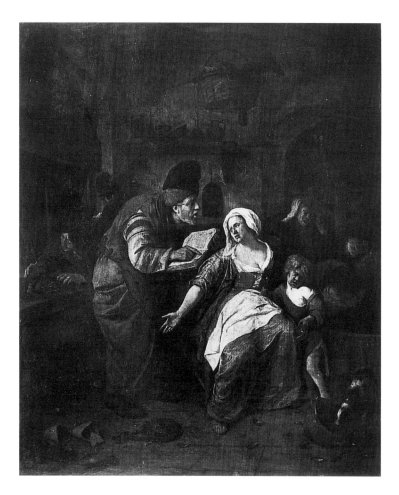

fig. 20. Jan de Bray, *David Playing the Harp*, 1674, oil on canvas, Herzog Anton Ulrich-Museum, Brunswick

satyr on more than one occasion. Comparison of Steen's fabulous creature with the *Punishing School-master* makes it clear that its scale and monumentality were not the result of an isolated experiment.

The concentration of dated paintings in the years 1667 and 1668, like those of 1659 and 1660, should be interpreted as a sign of a new and deliberate change of course on Steen's part. Some of those works will be discussed later. Here I want to mention four closely related works. An *Interior with Tric-Trac Players* (Braun 280) is dated 1667, as are the *Banquet of Anthony and Cleopatra* (Braun 283) and the *Lucelle and Ascagnes* (Braun 279). From 1668 there is an *Alchemist* (fig. 19). Although two of these four paintings are histories, they fit in well with the earlier genre scenes. *Lucelle and Ascagnes*, in particular, is

conceived in a very genrelike way. The *Banquet of Antony and Cleopatra* would have looked equally domestic if there had been a piece of gilt leather in the background instead of the obligatory pillar and drapery. All of these paintings are small or medium-sized, in vertical formats, with just a few figures. The gilt leather hangings, silk dresses, and oriental table-rugs are associated not only with prosperity and abundance but also with a more muted lighting, swifter brushwork, and a different, slightly darker palette. Even in the painting of the penurious *Alchemist*, the group does not really stand out from the dim background, despite the fact that it is a whitewashed wall instead of a dark leather hanging. Around the mid-1660s one finds Pieter de Hooch using gilt leather hangings instead of white-

washed walls, and his colors, too, became darker and the furnishing of his interiors more costly.[12] The changes discussed here are no more than shifts of emphasis, resulting not from the assimilation of outside influences but from the dynamics of Steen's own development, in which stagnation and repetition were out of the question.

Steen regularly crossed the borders between different specialties. As a result, his genre pieces have more narrative than one finds in the work of his contemporaries, some of his history paintings look like genre pieces, and all of his histories differ essentially from those of other Dutch artists from the period, such as Jan de Bray (1627–1697) or Gerard de Lairesse (1641–1711). Next to theirs, his work must have seemed old-fashioned as well as lacking in decorum (fig. 20). One reason for this is that he did not differentiate his protagonists by their behavior; whether playing in a farce or a biblical drama, their gestures and facial expressions remain the same. Moreover, Jan Steen never followed the fashion of reconstructing classical dress faithfully, which would have banished his tales from his own day to a distant and unreal past. Had he dressed the men and women of his genre pieces in the latest fashions and his biblical or mythological figures as Romans

he would have accepted a separation between genre and history, often labeled "modern" and "antique" painting in those days. Both categories, however, belonged to literary fiction and served the same end: to amuse, move, and instruct the public.

Although Steen quite evidently regarded genre and history as equivalent in principle, they do not balance each other numerically in his oeuvre. It appears from the dated works that he painted more histories in the late 1660s and after 1670 than he did earlier in his career. Adriaen van Ostade was the only genre painter of note in Haarlem after Cornelis Bega's death in 1664. Whereas Haarlem genre painters had ceased to be innovative a circle of prominent history painters were still at work in the city. Did Jan Steen set out to vie with fellow townsmen like Jan de Bray? One can also presume, and the one conjecture does not rule out the other, that circumstances forced him to search for a sphere of work that would bring him an adequate income.

Like the *Alchemist* (fig. 19), the *Samson and Delilah* (cat. 34) is dated 1668. The two-dimensional, broad design of the composition is related to that of the large genre pieces of the same period. Here, too, one finds a shallow stage and a ribbon of figures held together by gazes and gestures, with light and color bringing out the main characters. The *Sacrifice of Iphigenia* (page 14, fig. 6) is from 1671, as is the *Triumph of David* (fig. 21). These large canvases contain numerous figures, and their distribution over the surface looks effortless. The main subject, which is framed by asides, is given the requisite emphasis through color nuances and the use of detail. When necessary, an elaborate still life adorns the foreground. One provocative detail in the *Triumph of David*, which Steen took from a print after Maerten van Heemskerck (1498–1574) (fig. 22), is a boy urinating on Goliath's decapitated head.[13] In the one hundred years or more that separated the two artists, humor and mockery had become the preserve of genre painting, and solemn dignity that of history painting, but Jan Steen paid little heed to that distinction. *The Wedding of Tobias and Sarah* (cat. 45) is very genrelike in conception. This picture and the monumental *Prayer of Tobias and Sarah*, which is now being reconstructed (cat. 32, fig. 1), are close to the *Sacrifice of Iphigenia* (page 14, fig. 6)

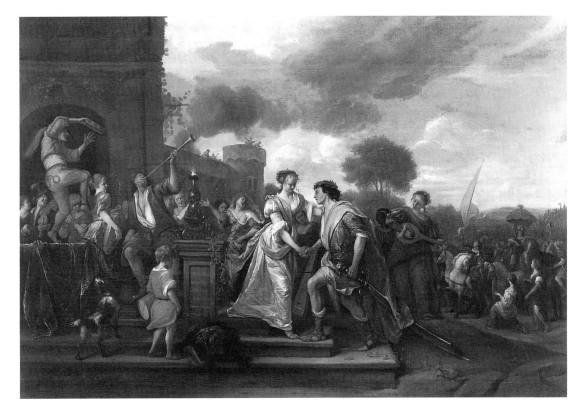

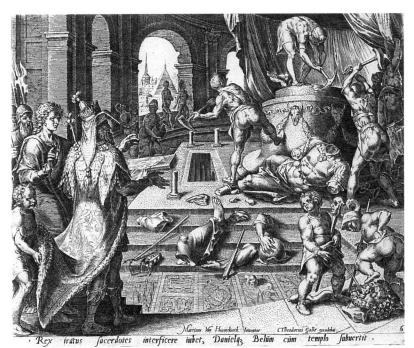

`Rex irátus facerdotes interficere iubet, Danielq̃ Belūm cūm templo fubuertit .`

above: fig. 21. Jan Steen, *The Triumph of David*, 1671, oil on canvas, Statens Museum for Kunst, Copenhagen

left: fig. 22. Philips Galle after Maerten van Heemskerck, *The Destruction of the Statue of Bel*, 1565, engraving, Rijksprentenkabinet, Amsterdam

fig. 23. Jan Steen, *Interior of an Inn*, 1674, oil on canvas, Musée du Louvre, Paris

and the *Triumph of David* of 1671 (fig. 21), but since the story requires the presence of only a few figures, the resemblance to genre works of the 1660s is greater than it is in the other history paintings around 1670.

Jan Steen's further development as a history painter can be deduced from his *Expulsion from the Temple* of 1675 (Braun 363) and the *Marriage Feast at Cana* of 1676 (cat. 43, fig. 1). The difference with the works from around 1670 is gradual. The relatively small figures are scattered loosely through the spacious interior. The setting consists of little more than a tiled floor bordered at the back by a cursory piece of architecture. The manner is looser and more transparent, and the colors are brighter. The same features are found in the large *Interior of an Inn* of 1674 (fig. 23) and the *Garden Party* of 1677 (cat. 49), which will be discussed in conjunction with Steen's late genre pieces.

The *Worship of the Golden Calf* (cat. 47) and *Moses Striking the Rock* (cat. 47, fig. 1) are situated in landscapes. Both contain a seated woman in an exotic headdress who plays an important role in the narratives. She bears a superficial resemblance to the seated woman in the foreground of Lucas van Leyden's *Dance around the Golden Calf* (cat. 47, fig. 2). That triptych and Steen's version of the theme have an affinity in the types of figure, numerous details of the dress and, above all, in the composition. Steen often made use of sixteenth-century models for his genre paintings, but as a rule they are iconographic borrowings that were camouflaged by stylistic adaptation. In his late history paintings the artist looked to sixteenth-century examples for their vocabulary of form. In doing so he returned to the roots of his art. While history and genre grew further and further apart in the late seventeenth century, Jan Steen must have understood how closely akin they had been a century earlier.

Jan Steen painted many genre pieces in his Leiden period, from 1670 until his death in 1679. The few dated genre scenes, combined with the dated history paintings, give some idea of the direction he took after 1670. It was not defined by a dialogue with his colleagues, since few artists could tempt him into emulation any longer. Adriaen van Ostade was now sixty years old. Cornelis Saftleven (1607–1681) and Hendrick Sorgh (1610/1611–1670) belonged to his teacher's generation. Metsu was no longer alive, Maes had taken up portraiture, and, from Steen's perspective, Van Hoogstraeten, Jacob Ochtervelt (1634–1682), and De Hooch had nothing new to offer anymore. After 1659, Jan Steen had distanced himself from the *fine painters* and, therefore, the innovations that took place in Dutch genre painting after 1670 were of relatively little interest. The trend was set by Frans van Mieris, Caspar Netscher (1639–1684), and Godfried Schalken (1643–1706). Where before his dialogue with his colleagues had always served to expand his range and enhance his potential for expression, the forty-four-year-old Steen had found his style and defined his sphere of action. Within those limits there were plenty of new avenues to explore. Like Frans Hals and Rembrandt, he renewed himself in his closing phase, extrapolating tendencies that were initiated in his

own earlier work. Toward the end of his life Steen was neither a "leader" nor a "follower"; he had gradually set himself apart.

Although the brushwork of many of the works that I place in Steen's final years is looser and more dashing than that in the paintings executed before 1670, the new development is to be found mainly in the exuberance of his narrative style. In the earlier paintings the narrative usually had a recognizable point and an unmistakable moral. While to move, to instruct, and to amuse remained the quintessential duties of a narrative painter, after 1670 Steen seems to shift the emphasis toward sheer enjoyment. As in the histories from his Leiden years, *Interior of an Inn* of 1674 (fig. 23) contains a mass of small figures in a large space, scattered loosely over the tiled floor in large and small groups. There is no clearly defined principal actor, but the small group in the foreground adequately sums up what is transpiring. The *Garden Party* (cat. 49) of 1677 has the same festive lightness in its coloring, use of detail, and narrative. The elegant outdoor companies of earlier artists like Dirck Hals have here been updated in a very personal way. The *Parable of the Rich Man and Lazarus* (Braun 367) looks like a compact version of the *Garden Party*. The foreground is filled with large genrelike figures who brighten the life of the rich man with music and wine. With the pithiness of a proverb, the inscription *In weelde siet toe* (In Luxury Beware) states a moral that places the work firmly in the context of genre painting. Yet in this New Testament parable, Steen moved the main actors back toward a cursorily sketched background, as Lucas van Leyden and other sixteenth-century artists had done.

In this essay I have argued a chronological order for a selection of Jan Steen's paintings. The distinguishing features of the oeuvre are its great diversity, narrative character, and in some cases, monumentality. Those aspects, of course, are not disconnected. A high degree of specialization would have restricted the narrative element in Steen's work to an increasingly refined repetition of a limited number of stereotype tales. A monumental design made the stories more convincing and penetrating. Even before Théophile Thoré-Bürger characterized Jan Steen as a "painter of comedies" in 1858, many peo-

ple had recognized humor and story-telling as the nucleus of his work. More than once he was called the Molière of painters.[14] All the means available to a painter were made subservient to that narrative interest. The pictorial realization, which is often refined but also occasionally careless in the details, is invariably at the service of the content. That content, seldom summarized in forthright inscriptions, is a succession of familiar lessons in living wisely: ten commandments and a thousand prohibitions. But this is not to characterize Jan Steen as a disgruntled moralist. He was more of a cabaret artist, comedian, or comic playwright who confronted his public with the old values and truths it loved, expressing himself not in words but in paint. The moralization, however, takes on an unexpected topicality as a result of Steen's provocative presentation. The choice between good and evil is once again as clear as day, and the audience's position no less so. The spectators may be kept briefly in a state of amusing confusion, but in the end "the others" are always the ones mocked for their foolish misbehavior.

1. The subject is not uncommon in the work of Maerten van Cleve and his circle. See for instance the series of six marital scenes, auctioned in Cologne, November 20–22, 1986, lot nr. 30. In 1987, this series was in a private collection in Wassenaar.

2. Kirschenbaum 1977, 107, with a reference to Hamann 1936. De Vries 1977, 39 n. 63, points to a related work by Nicolaes Maes (HdG 1) that was destroyed by fire in Berlin in 1945.

3. See The Hague 1990, no. 58. For a different opinion, see De Vries 1991. Groeneweg 1995 rightly questioned the identification of the sitters of Metsu's "Valckenier" group and the painting's date. She is convinced that it is not a portrait at all; in this respect I do not agree with her.

4. See, for instance, the *Portrait of Anthony Reyniers and His Family* by Cornelis de Vos in the Philadelphia Museum of Art (inv. no. W02-1-22) and the *Portrait of a Couple (The Young Scholar)* by Coques in the Gemäldegalerie, Kassel (inv. no. 151).

5. For divergent views arguing the significance of Hals' precedents for Steen, see cat. 25 and Westermann 1995b.

6. Molenaer and Leyster, in their turn, borrowed subjects from Dirck Hals, whose role as a renewer of genre is still a little understated; see Haarlem 1993, nos. 13 (Leyster), 25–26 (Dirck Hals), 30–31 (Molenaer).

7. Blankert 1978, nos. 8, 11.

8. See, for example, Van Honthorst's *Merry Fiddler* in the Rijksmuseum (inv. nr. Sk-A-180) and the *Woman Stringing Pearls* by Frans van Mieris in the Musée Fabre in Montpellier, which is dated 1659; Naumann 1981, 2: no. 25.

9. Blankert 1978, no. 22 (Rijksmuseum, Amsterdam). In De Hooch's case see, for example, his *Couple with a Parrot* in Cologne; Sutton 1980, 110, no. 122.

10. De Vries 1992.

11. De Vries 1977, 57, nn. 107, 108; Museum Bredius 1991, no. 157.

12. Sutton 1980, cat. nos. 55–58, 77, 78.

13. Hollstein 1949, 8: 247, no. 539.

14. De Vries 1977, 13–14, nn. 66, 71.

THE ARTIST'S WORKING METHOD

Martin Bijl

Anyone wishing to know how Jan Steen made his paintings has to consult the works themselves. There are no known written sources from Steen's own day; neither the artist nor any of his contemporaries said anything about his working methods. Nor do the eighteenth-century biographers Arnold Houbraken and Jacob Campo Weyerman, who were both painters, discuss the subject. It was not until 1982 that theories about Steen's method were aired as a result of an examination of his paintings in the Philadelphia Museum of Art.[1] It is not surprising that it has all taken so long, for Steen's oeuvre is large and still not clearly defined, and there are also great differences in quality. Moreover some of his pictures are finely executed, while others are broadly painted. Successful and disappointing works can be found in all stages of his career. The present exhibition has provided an impetus for expanding the limited focus of the 1982 investigation of Steen's technique. Six paintings have been restored at the Rijksmuseum, and researchers and conservators from other institutions have enthusiastically communicated their own findings to the author.[2]

Although Steen's use of materials does not appear to differ greatly from that of his contemporaries, this investigation has sought to detect personal features of his method. In addition, it seemed possible to distinguish differences between the youthful, mature, and late work. The results, presented below, are grouped according to the various layers of a painting—support, ground, underdrawing, and painted surface. No analysis of the varnish has been made, because no original varnishes have been found on Steen's paintings.

Support

In the Netherlands, paintings were traditionally executed in oil on oak panels from the Baltic region, which were of a finer quality than oak from the Low Countries. In the sixteenth century, following the Italian example, canvas became increasingly popular and widely accepted as a support. In the course of the seventeenth century it became as important as oak, but never supplanted it completely. As early as 1618, for example, Peter Paul Rubens (1577–1640) observed that "small things are more successful on wood than on canvas."[3] This distinction became the general pattern, by and large, but it cannot be taken as an unbreakable rule. Jan Steen, too, tended to use wood for his smaller paintings and canvas for the larger ones. From the sixteenth century artists also painted on copper, but Steen is known to have done so only on one occasion.[4]

The partial displacement of oak by canvas was the result of various factors. The vulnerable trade route meant that good panels were not always easily accessible.[5] Canvas also had the advantages of price, weight, and the fact that it could be rolled up, making it easy to transport. Large panels gradually fell out of favor. In Rubens' oeuvre, for example, panels more than two meters wide are not unusual, and in the 1630s Rembrandt (1606–1669) and Frans Hals (c. 1582/1583–1666) were still painting panels up to 130 cm wide. Steen's widest panel measures 106 cm, and in his case the percentage of panels gradually declined.[6] Approximately one-third of the work from his early period is on panel. In his productive Haarlem years this percentage fell to a little under half, dropping to around a quarter in his late Leiden period.

In 1650, at the very beginning of his career, the second war between Sweden and Poland brought imports of Baltic oak to a virtual standstill. All the panels of Baltic oak used by Steen that have been dated dendrochronologically, that is, by their annual growth rings, are from before 1650.[7] Native oak then became popular as a surrogate, even though its coarser, brittler structure made it less suitable as a support.[8] So far six panels of Baltic oak and seventeen of native oak have been found. The former are all slightly older, which suggests that stocks were exhausted. This information does not help establish the chronology of Steen's often undated paintings. Study of the annual rings in native oak panels, on the other hand, can be of assistance. For example, the theory that the *Toothpuller* in the Museum Boymans-van Beuningen, Rotterdam (Braun 88) is a late work is confirmed by the growth rings.[9]

The size of a panel can also provide interesting information. In the seventeenth-century, towns and regions used different lengths of foot, and thus of inches, and these would have been applied by the local cabinetmakers and panelmakers. Study of the

modules used for panels from the fifteenth and sixteenth centuries has demonstrated that they were followed very closely,[10] and the same is undoubtedly true of the seventeenth century. The size of a panel painting can therefore be matched against those local units of measure, indicating whether it was made in Leiden, The Hague, or Haarlem—provided it still has its original measurements.

The *Winter Landscape* (cat. 1) is an example of a painting that has survived intact. It was auctioned in The Hague in 1651 and measures 97.5 cm, which corresponds closely to 36 Hague inches. The fat and lean kitchens (cats. 2 and 3), which are believed to have changed hands at the same sale, measure 91.8 cm, which coincides almost precisely with 34 Hague inches.[11] Two other pendants of the same subjects in Cheltenham are 39.4 and 39.6 cm wide—almost exactly 15 Rhineland inches (39.3 cm). That was the measure that was used in Leiden, among other places, but of course this information does not tell us whether these panels should be placed in Steen's early or late Leiden period.[12]

The Cardplayers (cat. 14), which can be dated around 1660, displays the marked influence of Pieter de Hooch (1629–1684) and could therefore have been executed in Delft. However, it also profits from the work of Frans van Mieris (1635–1681), Gabriël Metsu (1629–1667), and Gerard ter Borch (1617–1681), so it could equally well have originated in Leiden or Haarlem. It is 60.6 cm wide, which can easily be related to the Haarlem module (22 x 2.76 cm, or 60.7 cm). Theoretically, of course, Steen could have taken panels with him when he moved house, but this is unlikely since there was no shortage of panels and canvases in the towns where he lived. Moreover, a source of 1676 makes it clear, albeit indirectly, that it was considered undesirable to cart supports back and forth.[13] The death of the Leiden *plumuyrder* Leendert van Es (died 1676), the artisan who supplied primed panels and canvases, created problems for the local painters, who were forced to seek permission to buy their supports elsewhere. The free trade in unpainted panels and canvases, in other words, was clearly not standard practice.

When Jan Steen painted his *Poultry Yard* (cat. 12) at Warmond in 1660 he very probably did so on canvas that he had brought with him from Leiden, for it would not have been easy to get hold of artists' materials in the village. The canvas closely matches the Rhineland unit of measure, but it would be wrong to jump to a conclusion from this, for far too little is known about how the sizes of canvases were established.

The panel with *The Merry Threesome* (cat. 42), which with its width of 49.5 cm also fits in well with the Rhineland module, does permit one to conclude that it was painted in Steen's later years in Leiden.

Steen's oeuvre also includes seven paintings on canvas glued onto panel.[14] These "marouflages" often look as if they date from the seventeenth century, and it is not impossible that the artist chose this support himself. The dendrochronological examination of one of these marouflages reveals that the panel does indeed come from the seventeenth century and that the oak was felled before 1650.[15]

What is not clear is why the canvases were pasted onto panels; perhaps the reasons differed from case to case. The canvas of the so-called *Parrot Cage*, for instance, has cusping along the left and right sides. This is a distortion in the weave created when the canvas is attached to a stretching frame for priming. On the right this cusping extends about 20 cm from the edge of the canvas, and on the left about 7 cm from the edge. The top and bottom, however, have no distortions. It can therefore be assumed that this canvas came from a larger piece strung in a temporary frame. A reduction in size, caused, for example, by a tear along the tacking edge, may have been the reason it was pasted onto panel. The absence of secondary cusping, which is created when the painted canvas is transferred from the stretching frame to a strainer, might also indicate that the canvas was immediately pasted onto the panel.[16]

In Steen's day it seems that small canvases were quite often cut from larger, primed pieces. Several of Rembrandt's pendant portraits, for example, were painted on a single piece of stretched and primed canvas that was later cut in two.[17] The quite frequent absence of cusping on two or three sides of small paintings indicates that they, too, were often cut from a large piece of primed canvas. It is difficult to say just how common this practice was, and whether it was the artist himself or an assistant who wielded the knife and did the stretching, or even perhaps a specialist craftsman. Unfortunately, research on the units of measure for canvases is greatly complicated by the many rigorous restorations that have been carried out in the past. Most seventeenth-century canvases were relined in the nineteenth century, that is to say reinforced with a supporting canvas pasted onto the back. When that was done, the original edges were usually cut off, destroying valuable information about the way the canvas was stretched.

In the studio shown in *The Drawing Lesson* (cat. 27) are two paintings, both of them probably on canvas. The fairly large one in the foreground has been attached to a frame with cords, and the cusping set up by the tension is clearly visible. The light from the window falls onto the inside edge of the stretching frame, behind the canvas. The painting on the easel, given its thickness and the light ground around all the edges, also seems to be a canvas, but it has already been strung in a strainer.

Steen's *Sacrifice of Iphigenia* (page 14, fig. 6) is an exception in that the original edges were not removed when it was relined. They are unpainted but primed. The primary and secondary cusping shows that the canvas was first laced in a larger frame and was then placed in a strainer, which gave it its final size. A reasonable assumption is that the size of the stretching frame was based on the local unit of measure, but as already said, great caution should be exercised here. Canvas stretches, and then there is the question of whether one should take into account the primed or painted canvas when determining the unit of measure. If the painted surface of the *Sacrifice of Iphigenia* is assumed to correspond to the size of the original strainer, it turns out that the size cannot be defined so precisely: 168.5 to 169 cm. This painting, which is dated 1671, comes from Steen's Leiden period, so that width should be a multiple of Rhineland inches. It is not. However, the largest of those two measurements does correspond to the Haarlem module.[18] Perhaps Steen began the painting in Haarlem and completed it in Leiden.

Ground

Steen allowed the ground to play an important part in his paintings. In almost all of them it can be seen to some extent through the paint layer. It is sometimes left bare in isolated spots,[19] or between two passages of color. It is almost always a light shade, sometimes warm, sometimes cool, and it inflects the tonality of the entire picture. It is therefore important to discover whether Steen applied his own grounds or bought his panels and canvases ready-primed. Until recently it was generally assumed that the priming was done by assistants or pupils, but doubt has now been cast on this assumption by the discovery in the archives of the profession of *plumuyrder*, or primer. It may well be that priming was left to specialists.[20] The study of Rembrandt's method has revealed that many of his paintings have double grounds, the second of which was probably applied in his own studio in a color that anticipated the finished painting.[21] Rembrandt's method does not match that of Frans Hals'

paintings with double grounds. There the second layer was applied over a wet, first ground, both of which generally have the same composition.[22] Research on Jan Steen's grounds is still too unsystematic for firm conclusions to be drawn, but some of the findings do provide clues. It seems that the theory that Steen's grounds varied from one town to another, which would suggest that they were applied by different primers, is untenable. On the evidence of the research done so far it appears that the grounds of his Hague, Haarlem, and Leiden paintings do not significantly differ from each other.

The first layer of ground on Dutch seventeenth-century panels usually consists of chalk and glue. X-radiographs of Steen's panels, which are still few in number, reveal differences in treatment. The pores of the wood were sometimes rubbed with lead white and sometimes not (figs. 1 and 2).

Steen's canvases have single, double, and even triple grounds, usually of cheap oil paint. Triple grounds are rare, and seem to be mainly intended

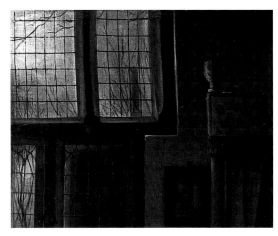

fig. 3. Detail of the window at the upper left of *The Feast of Saint Nicholas* (cat. 30). The distortions in the canvas originated after Steen had finished the painting.

to give the painting a different tonality. In the case of double grounds, the composition of the mixtures in both layers is sometimes comparable, although one of the layers occasionally contains more expensive pigments. This occasional complexity in the composition of one of the layers is interesting, because it appears to deviate from the standard practice of Steen's contemporaries. It has been suggested that paint residues were mixed with the ground, but given the effect they have on the finished result it seems that they were chosen very carefully. It is perfectly possible, in other words, that the priming was done in Steen's studio.

Some of his paintings have severe distortions along the edges, which were quite definitely caused after the picture was finished but before the ground and the paint film had dried. This points to a very rapid manner of working (fig. 3). The *Feast of Saint Nicholas* (cat. 30) is one such painting. The belief that Steen must have completed at least three paintings a month in his Haarlem period reinforces the supposition that he worked swiftly.[23] To achieve that average Steen would have had to keep up a fast tempo in summer as well as in winter, when paint dries more slowly.[24]

fig. 1. X-radiograph, *The Quack*, Rijksmuseum, Amsterdam. Lead white was rubbed into the pores of the wood.

fig. 2. X-radiograph, *A Couple Drinking*, Rijksmuseum, Amsterdam. No lead white may be discerned in the pores of wood in this painting.

fig. 4. Detail, fig. 1 in cat. 23. The preparatory sketch in brown paint that Steen used for the shaded passages.

fig. 5. Detail, cat. 24. Work on this figure progressed only as far as the preparatory stage in a sketch in brown paint.

be seen to a greater or lesser extent in almost all the panel paintings. They were left bare in a few places, one being to the right of the fireplace in *The Cardplayers* (cat. 14). The "open" brushwork and its transparency is clearly visible. This treatment is only occasionally found in the canvases, such as the *Sacrifice of Iphigenia*. It is to be feared that the low relief in the paint layer was flattened when the canvases were relined. The purpose of this underpaint of broad, fluid brushstrokes was probably to tone down the often light-colored grounds.

The local underpaints, beneath the poultry in *The Fat Kitchen* (cat. 2), for example, are in a separate category. The prominence of the plucked birds is due to a carefully applied and quite thick underpaint in a pale yellow that is lighter than the topmost layer of the light-colored ground. Steen allowed the ground to show throughout much of the painting. The effect of the underpainting becomes clear when one compares the brightly lit birds with the mother and two children below them. The use of color is similar, but the lack of an

Painted sketches

Examining the underdrawing with the aid of infrared reflectography, which has yielded excellent results with fifteenth- and sixteenth-century paintings, proved impossible in Steen's case. However, the transparency of the paint, gaps between adjacent passages of color, and wear sometimes enable a painted sketch to be seen with the naked eye or through the microscope.

Such sketches with the brush were found in almost all the paintings examined. Executed in dark brown or black, they can sometimes be seen beneath the background figures but are better visible in parts of the foreground figures, such as the yellow dress and apron of the girl in the foreground of *As the Old Sing, So Pipe the Young* (fig. 4). The figures in the middleground were also prepared with a sketch of this kind, but Steen's technique tends to hide it. The sketch of the figures in the background, on the other hand, is often visible (fig. 5). It is noteworthy that this preparatory work is found mainly in the foreground—in the figures and some details.

It is also striking that Steen used it in both complex and simple compositions. It can be seen in the intricate *Moses Striking the Rock* (cat. 47, fig. 1) in Philadelphia and in the straightforward *Portrait of Gerritsz Schouten* (cat. 29a).[25] Steen's primary intention was probably to define key parts of the composition. The sketches, done alternately with a thin and a broad brush, also conveniently form the basis for the shadows of the drapery folds—again mainly in the foreground figures. They are clearly visible in *The Cardplayers* (cat. 14), by the shirt of Oostwaert the baker (cat. 8), and by the lower arms of the young woman in *The Merry Threesome* (cat. 42). Such an effective way of working has never before been encountered by this author in seventeenth-century paintings.

Underpainting

Raking light reveals a coarse underpaint beneath *The Leiden Baker Arend Oostwaert and His Wife* (fig. 6), which very probably dates from the second half of the 1650s. These crude, brown brushstrokes can

fig. 6. Detail, cat. 8 seen in raking light.

fig. 7. Detail, cat. 42. Here the underpainting is clearly visible.

underpaint in the latter group gives a very different, slightly fragile and tender effect. This form of underpainting is encountered in other works as well, and is always restricted to isolated passages. It can be seen, for example, by the trousers of Arend Oostwaert (cat. 8) and those of the principal figure in *The Merry Threesome* (fig. 7). The degree of underpainting varies from one picture to another, but there is almost always at least one passage where it was used. The underpaints are sometimes plain, in a single color, and sometimes a varied preparation complete with lights and shadows. Most are in earth colors or grays, the latter having the look of classic dead coloring.

Paint layers

Tribute was being paid to the Leiden *fijnschilders* at an early date, and particularly to Gerrit Dou (1613–1675).[26] There is not a trace in Steen's earliest work of any influence of his famous fellow-townsman. The work of Rembrandt, once of Leiden, also had no impact on Steen's early oeuvre. In those pictures, which already have a clearly recognizable style, one does detect the marked influence of Steen's teachers, especially Adriaen and Isack van Ostade (1610–1685; 1621–1649).

The stylistic comparison with the work of Adriaen van Ostade is particularly interesting as far as the genre paintings are concerned. However, there are major differences in treatment between the two

artists. Adriaen's work is more carefully finished, and almost invariably it is only in the background that a ground or underpainting can be glimpsed beneath the opaque paint layer. Jan Steen applied his paint far more loosely, in a way that recalls the work of Isack rather than Adriaen van Ostade, although more "slapdash," as shown by *The Tooth-puller* in the Mauritshuis (cat. 26, fig. 3). The ground plays an important role, because it can often be seen through the paint, which, although opaque, is thin. Often, too, Steen left it bare, for example between the victim's shoulder and the background figures in the same picture.

These early paintings are built up from the back toward the front, a classic seventeenth-century method that entailed painting the background first while leaving reserves for passages planned for the foreground. These were then painted in the reserves, with their edges just overlapping the background. The object of this method was to make the more distant passages look as if they were indeed further away. It is difficult to identify the artist from whom Steen picked up this practice. The more painterly manner of Isack van Ostade appears to be close to Steen's. For example, an early work like *The Fat Kitchen* (cat. 2) has striking similarities to Isack's *Interior of a Barn* of 1642 in the Rijksmuseum.[27] The latter is painted entirely in transparent colors applied with transparent and melting brushstrokes that are nevertheless quite stiff-bodied. The ground in the *Interior of a Barn* is also visible almost everywhere, and thus plays the same role as it does in *The Fat Kitchen*. One notable feature is that the background appears to have been painted around the group of figures.

Nicolaes Knüpfer (c. 1603–1655), another artist who is mentioned as one of Steen's teachers, frequently worked with transparent colors. However, he almost always painted the central elements of his compositions over a carefully prepared, often polychrome underpainting and gave his pictures quite a smooth finish. In that respect, his manner did not serve as a model for Steen.

After completing his training, Steen spent some time in the studio of his father-in-law, Jan van Goyen (1596–1656), but that experience seems to have had little effect on his own work. One similar-

ity is the use of pinkish colors as the underpaint for the sky. The dark pink beneath the sky in the *Horse Fair at Valkenburg* (page 70, fig. 2), for instance, is very reminiscent of Van Goyen.[28] The landscape elements in this picture, incidentally, are again laid down from back to front.

The *Skittle Players outside an Inn* (cat. 22), executed around 1663, was also painted from back to front, but in an unusual way. The trees were reserved, but much of the fence is painted over the background. The horse and the skittle players, in turn, were superimposed on the fence and the background. The figures on the left, though, were planned from the start, and given the odd "contours" around them, may even have been painted first.

For a while in the mid-1650s, Jan Steen painted in a style reminiscent of the so-called *fijnschilders*. Paintings like the *Woman Scouring Metalware* in the Rijksmuseum (fig. 8), which is unfortunately in poor condition, and above all the *Girl Offering Oysters* (cat. 9), are remarkably detailed in the fore-

fig. 8. Jan Steen, *Woman Scouring Metalware*, 1654–1658, oil on panel, Rijksmuseum, Amsterdam

ground,[29] and recall the work of Gerrit Dou and Frans van Mieris respectively.

A few years later Jan Steen evolved a highly personal manner of painting, which Marigene Butler has aptly described as "painting with the tip of the brush."[30] Using the point of the brush, Steen applied paint thinly in every direction, modeling as he went. This technique gives these pictures a very meticulous look. In reality it is a very efficient way of working. The ground can still be seen through the paint layer, and the underlying brush sketch contributes to the chiaroscuro. At the same time, the forms are built up by the direction of the brushstroke. This "tipping" of the canvas or panel with the brush creates a touch that is thick in the middle and thins out toward the edges—a variegated effect that contributes to the liveliness and recognizability of Steen's "handwriting." Used to excess, though, it would look nervous, which is why Steen reserved the technique for prominent, central passages. For the second plane he used a flat and rather opaque manner, and for the third (if present) an almost sketchy treatment. This is the technique he followed for the rest of his life. Among its many advantages, it enabled him to achieve a high output and to paint both finely and broadly.

This way of working is well illustrated by *The Cardplayers* (cat. 14). The woman's dress is painted with that superb, airy touch that allows the ground and sketch to contribute fully to the overall effect. The rug on the table and the two men behind it are more opaque. That also applies to the woman in the dark dress, but the maidservant on the left is far freer and more transparent, as are the vessels behind her. The gray of the background was clearly painted around the kitchenware. The same is true of the background around the long-haired man who is bending forward. In addition, it seems that Steen saw Pieter de Hooch preparing his views into a distance, for like him he underpainted this passage with what appears to be a cool, dark color. There is also the brown, brushy layer mentioned earlier. Parts of it have been left bare between the view into the back room and the fireplace, the main purpose being to tone down the light-colored ground of this shadowed area. The simple perspective is flawed and appears to have been handled

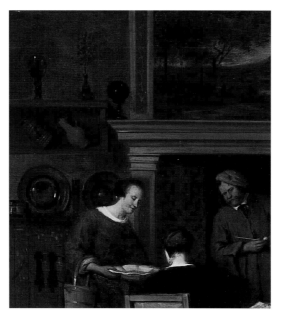

fig. 9. Detail, cat. 14, showing how the background was painted around figures and objects.

rather casually, indicating that Steen did not share the preoccupation with perspective that is so typical of Delft artists.

Steen's primary interest, as Abraham Bredius put it, is the "quite remarkable relationship between all the figures in his paintings,"[31] and Steen did, indeed, devote considerable attention to the protagonists. As already noted, sketches beneath the figures are often visible. Steen focused chiefly on the crucial passages, sketching them and working them out in great detail, again working from back to front within each group. It very often looks as if first the background was painted around the figures and then the foreground (fig. 9). There are also many sinuous "aureoles" around Steen's figures that take the form of very broad outlines. These, too, are due to his way of working. The sequence is not entirely clear. Is the space left around the figures the result of too large a reserve, or were the backgrounds painted around them later? Whatever the answer, in very many cases Steen then filled in these spaces, often in a color that bears little relation to those around it. In order to "free" the figures from the

background, locks of hair and suchlike were extended into the aureoles. It is not known how common this method was. It is more often found in portraits but until now was unknown in genre scenes.

In this matured phase Steen's technique does resemble that of Nicolaes Knüpfer, the painter who was probably his first teacher. He, too, lavished great care on his principal actors, although he handled them completely differently. Knüpfer also used opaque paint for the figures in the middleground, while those in the background are sketchy, like Steen's. The "space" between two passages that is sometimes found with Steen, the background painted around the figures and the important role given to the ground in transparent backgrounds, can also be found in Knüpfer's work. Finally, Knüpfer also painted small background figures over finished passages.[32]

To return to the aureoles: Steen was sometimes a little lax when eliminating open spaces between figures and background colors. Outlines are clearly visible in *The Sick Woman* (page 72, fig. 7), and they are particularly broad around the doctor's legs. The black clothing remains just within them, with the result that the light ground can be seen here and there between the "outlines" and the dress (fig. 10). These pronounced aureoles are almost always visible to the naked eye in paintings from the late 1650s onward, and seldom do they have the same color as the adjacent passages (this may have been exaggerated by wear and discoloration). As a result, these outlines can almost be seen as an element of Steen's style, just like the very visible pentimenti in Rembrandt's work.[33]

In 1670, after losing his wife and both parents within a year, Jan Steen moved from Haarlem back to Leiden. Most of the works from this late period are in a "freehand" manner with a notably lighter palette (cat. 49, for instance). There was a sharp drop in his output, and he also began making larger compositions. Some were not very successful, like the *Sacrifice of Iphigenia* of 1671 (page 14, fig. 6). The composition is rather weak and many of the details are poorly developed. A fine work like *The Merry Threesome* (cat. 42), however, shows Steen displaying greater virtuosity in this period. Here he used a dark, umberlike layer as preparation for the "open"

fig. 10. Detail of *The Sick Woman* (page 72, fig. 7). Before painting the doctor's legs, Steen inserted part of the background but left too much reserve.

brushwork of the sky. The trunk, branches, and leaves of the tree were scratched into the paint while it was still wet (fig. 11),[34] and a few touches of color were then added to the leaves with thinnish, red-brown paint.

After a painting was virtually complete came the "finish," a standard part of seventeenth-century practice. It usually consisted of adding shadows and touches of light—the so-called lights. These are clearly visible on the collar in *The Merry Threesome*. Steen, though, added all sorts of other details as well, such as the monochrome gridiron against the wall, or the globes on mounts at the corners of the mantelpiece in *The Cardplayers* (cat. 14), which have a different finish to that of the kitchenware. What is even stranger is that, throughout his career, Steen also added key elements to the composition in this final stage. The skinny man trying to get into the *Fat Kitchen*, who establishes the link with its companion piece, is one such last-minute addition. He is the only figure not worked out beforehand in the sketch, but given the angry reaction of the fat man brandishing a ham he must have been planned from the

outset. Important elements were added at the very end in other paintings, such as the dogs in the *Garden outside an Inn* (cat. 17) and the *As the Old Sing, So Pipe the Young* (cat. 23, fig. 1).[35] Typically "Jan Steen household" details, such as the saucepan and eggshell in the latter picture, may also have been added during or just before the finishing stage. In some works, details of this kind were worked out fully in the original conception, like the sleeping dog in *The Cardplayers* (cat. 14). This is also true of the wine-cooler and the sword, although they differ slightly from the sketch seen beneath the picture surface.

This kind of minor deviation from the drawing is quite common—for instance in the head and neck of the girl in *The Merry Threesome*—in contrast to *repentirs* or pentimenti, which are alterations made to passages already painted. The *repentirs* that have been found often appear to be color corrections. One such is the elimination of a red area in the dress of the baker's wife (cat. 8), and of the red cap of the child sitting on its mother's lap in *As the Old Sing, So Pipe the Young* (cat. 23, fig. 1). Steen evidently felt that these touches of color were too strong and distracting.

These changes were made with a certain nonchalance and, as noted, must always have been visible to the naked eye. The effect is slightly reminiscent of the "careless" pentimenti and autograph retouchings in Rembrandt's work, and Steen's outlines or aureoles. Ernst van de Wetering has recently demonstrated that painting with "splotches" was a deliberate aspect of Rembrandt's manner, and was based on theories of painting that go back to Titian (1488 or 1490–1576).[36] Is it possible that there is some echo of that kind of thinking in Steen? According to Weyerman, he was certainly interested in theories and ideas about painting.

But however slack Jan Steen was in his behavior, he was not slack at all in his philosophical knowledge about, as well as the practice of, painting. According to Mr. Karel de Moor, artist and knight, he held forth so reasonably about every aspect of art that it was a pleasure to be a witness to his speeches.[37]

His audience included some pretty notable names—De Moor (1656–1738), Frans van Mieris, and Jan Lievens (1607–1674) among others. So Steen cer-

tainly had some theoretical knowledge of his craft, but that is not very surprising, for it seems likely that painters in every town held different ideas about art.[38] Steen lived in four major cities, and it is perfectly possible that his work is a synthesis of those various views.

Jan Steen's use of pigment is no different to that of his contemporaries. Until now it has not been possible to discover whether he used different materials in different cities, and there is not yet enough information about his media for any conclusions to be drawn. It can be assumed, though, that the poor condition of the curtain around the bed in *The Sick Woman* (page 72, fig. 7), which consists primarily of indigo, is due to a problem with the medium. Whereas most of the paint film of this picture is remarkably well preserved, despite being rather thin here and there, the green of the curtain has deteriorated badly. It should be mentioned in passing that the paint was applied thinly in most of Steen's pictures.

It appears that Jan Steen developed a personal variant of the customary seventeenth-century manner of painting. This might imply that pictures that deviate from it in a technical sense should be examined again as to their authenticity. One painting that differs slightly from Steen's method, but which is quite definitely autograph, is the *Rhetoricians at a Window* (cat. 24). It appears to have been painted

fig. 11. Detail, cat. 42. Steen scratched the branches and leaves in the sky while the paint was still wet.

very rapidly,[39] and here it is interesting to read what Weyerman has to say about a "contest" between Jan Steen and Frans van Mieris.

His opponent had barely departed when Jan Steen seized a small canvas on which he painted three rhetoricians hanging out of a window and singing at a peasant fair. It was such a wittily composed and artfully painted work that it seemed a miracle to those versed in art how such a piece could be completed in so short a time, for it was completely finished by that same afternoon.[40]

Of all the scenes of rhetoricians in Steen's oeuvre, the one in Philadelphia best fits this description. It is true that there are four rhetoricians, not three, but Weyerman was writing long after he had seen the picture. It is therefore worth taking a closer look at its structure. The ground plays an important part throughout the composition and, in a radical departure from Steen's normal practice, there is no underpainting. A brown-black sketch can be seen beneath most of the component parts, and it is covered with a single layer of oil paint. The secondary figures in the background are monochrome, and can be described as almost unfinished. The ghostly figure on the right, in particular, is no more than a rough, brown outline. Taken together with the underlying brush sketch in black, there is nevertheless a visual unity. An improvement was made to the secondary figure on the left, but he is still sketchy. The two rhetoricians in the middleground are also rather cursory, but they are done in opaque paint and completely cover the sketch. The restrained lighting clearly places them in the middleground. The brightly lit foreground figures are described with airy, varied touches, creating a diversified rendering of materials. The close proximity of the brick wall is suggested by a texture in the paint imitating its surface. Everything appears to have been done with great haste—an impression that is heightened by the scratches in the wet paint. These can be considered as corrections, and can be seen between the red hat and the forehead of the figure with the raised forefinger. Only the foliage appears to have been added later. Although it is not absolutely certain that this is the painting described by Weyerman, the possibility is too intriguing to go unmentioned.

1. Butler 1982–1983.

2. Twenty-four works in the Rijksmuseum were examined as part of this project, as were some twenty-five paintings in other museums, some of them only with the naked eye, magnifying glass, or microscope. X-radiographs and infrared reflectograms were available for some of the paintings studied. Karin Groen of the Central Research Laboratory and Gwen Tauber of the Rijksmuseum carried out paint analysis on a number of these paintings. A detailed report will be published in the account of the restoration work carried out in the Rijksmuseum.

3. Letter of 26 May 1618 to Sir Dudley Carleton; Magurn 1955, 65: "It is done on a panel because small things are more successful on wood than on canvas; and being so small in size, it will be easy to transport."

4. Sutton 1992, 192–196, no. 65, *The Sleeping Couple* (Braun 1980, no. 93). Unfortunately, it was not possible to examine this support.

5. The closing of the Sound in the first war between Sweden and Poland (1626–1629) interrupted supplies of Baltic oak. The second war (1650–1655) brought an end to the flourishing trade in wood from the Baltic region; see Wazny and Eckstein 1987, 509-513.

6. The following estimate is based on the list of works in Braun 1980.

7. The dendrochronological examination was carried out by Dr. Peter Klein of Hamburg University. Copies of his reports on specific paintings are preserved in the conservation department files, Rijksmuseum.

8. In the case of "native" oak, Dr. Peter Klein speaks of "Niederlände-West Deutschland." It is more accurate to leave the place of origin undefined.

9. See cat. 2, note 5; dendrochronological examination carried out by Peter Klein on 19 September 1995 (c. 1675).

10. The author is preparing a publication on this subject. The most important source for the local differences in measurements in Holland is Verhoef 1983.

11. Since Steen painted several versions of the fat and lean kitchens, the identification of the paintings in the Hague sale is still uncertain; see also cats. 2 and 3.

12. Braun 1980, nos. 29 and 30. The width of the *Lean Kitchen* given in Braun is incorrect; it is in fact 39.6 cm (with thanks to curator George Breeze at the museum in Cheltenham for his letter of 26 June 1995). Wouter Kloek (cat. 2, note 5) assumes that these two paintings are from Steen's later period.

13. Van de Wetering in Bruyn et al. 1982–1989, 2:20.

14. They are Braun 1980, nos. 57, 224, 248, 275, 283, 321, and 367. According to Braun's dating, one of them can be placed in Steen's early period (Braun 57), five in the Haarlem period, and one (Braun 367) in the later years in Leiden.

15. It is the so-called *Parrot Cage* in the Rijksmuseum; Braun 1980, no. 244.

16. On this point see Van de Wetering in Bruyn et al. 1982–1989,

2:15–43.

17. Bruyn et al. 1982–1989, 2: nos. A 54–55 and A 78–79.

18. At that time the Haarlem inch was 2.76 cm, so 61 inches makes 168.4 cm. Add 2 mm for the thickness of the canvas wrapped around the strainer and one arrives at a total of 168.6 cm.

19. For example, by the child on its mother's lap in Rijksmuseum's *As the Old Sing, So Pipe the Young.*

20. Van de Wetering in Bruyn et al. 1982–1989, 1:19–20. See also Bredius 1915–1922, 2:52, 4:1392, and Miedema 1980, 94–95 and 442.

21. London. 1988a, 27–30.

22. Groen and Hendriks 1989, 109.

23. This is based on the oeuvre catalogue in Braun 1980.

24. For artists' complaints about the long time it took paint to dry in winter see, for instance, the letter from Rubens to Pierre Dupuy of 20 January 1628; Magurn 1955, 231. See also the manuscript by De Mayerne, who gives the drying times of various oil paints in summer: De Mayerne 1901, 262. It is tempting to believe that Steen painted his *Feast of Saint Nicholas* (which falls on 5 December) in November and December.

25. Gifford and Palmer, [forthcoming].

26. Notably in Angel 1642; see Sluijter 1993.

27. On loan from the Netherlands Office of Fine Arts, The Hague, cat. RBK 1992, 233, no. 2008.

28. See for example the *View of Vianen*, inv.no. Sk-A-4879, in the Rijksmuseum.

29. It is often said that in his *Girl Offering Oysters* Steen did not succeed in extending the delicate use of detail into the background. Perhaps, though, he was deliberately trying to emphasize a difference in depth.

30. Butler 1982–1983, 45.

31. Bredius 1927, 24: "[. . .] zeer bizondere samenhang tusschen al de personen op zijne schilderijen onderling."

32. See, for example, his two paintings in the Rijksmuseum; Rijksmuseum 1976, 923, no. A 1458, and Rijksmuseum 1992, 61, no. A 4779.

33. Van de Wetering 1991, 21.

34. He did the same in *As the Old Sing, So Pipe the Young*, but the result is less appealing.

35. See also the dogs in *The Brawling Cardplayers* in Berlin (Braun 346) and in the *Sacrifice of Iphigenia.*

36. See Van de Wetering 1991.

37. Weyerman 1729–1769, 2:364: "Maar hoe los dat dien Jan Steen ook was in zyn gedrag, echter was hy zo min los in de Beschouwelijke kennis, als in de Praktijk van de Schilderkonst, dewijl hy, volgens de getuigenis van den Heere Karel de Moor, Konstschilder en Ridder, zo weezendlyk redeneerde over alle de Eygenschappen van die konst, dat het een lust was zijn vertoogen by te woonen."

38. Miedema 1994, 253.

39. See a discussion of this painting in Gifford and Palmer [forthcoming].

40. Weyerman 1729–1769, 2:363: "[. . .] zo dra was zyn Mèdinger niet vertrokken, of Jan Steen nam een doekje by 't hoofd, waar op hy drie Redenrykers schilderde, die uyt een venster laagen te zingen op een Boerenkermis; een stukje zo geestryk geordonneert en zo konstiglyk geschildert, dat het een mirakel scheen aan de Konstkenners, hoe het doenlyk was om binnen dat eng bestek des tyds zo een zaak te voltooyen, want het was al op en top opgemaakt voor dien zelven middag." For another view on this matter see cat. 24.

JAN STEEN

from Arnold Houbraken's
De groote schouburgh…, 1721[1]

TRANSLATED BY

Michael Hoyle

He [Frans van Mieris] is now followed onto the stage by his fellow townsman, contemporary, and companion in art, Jan Steen, whose comic life would fill a whole book, although that is not our intention.

One whose nature is inclined to farce and jesting is more capable of depicting something serious than a melancholy person is of painting comical scenes, for the latter has an aversion to that way of life and nature and never conceives of such subjects, but keeps to himself, cherishing his tranquility. He, on the other hand, who is of a jocular spirit, avails himself of subjects of every kind, for it is the mark of true comedy that one knows how to depict and imitate everything equally naturally, both sadness and joy, composure and rage—in a word all the bodily movements and facial expressions that spring from the many impulses of the spirit. The life of Jan Steen and the contents of his artful work with the brush will bear out my words.

In general I must say that his paintings are like his way of life and his way of life like his paintings.

He was a pupil of Jan van Goyen, who loved him greatly for his wit, and on occasion, in the evenings after he had finished painting, took him out for some ale and a chat. Jan likewise loved his master, and his daughter even more, whom he treated so farcically that she began to swell by the day. Margriet (for that was her name) urged him time and again to make it known to his parents and her father so that they could marry before it became public knowledge. He seized his chance when he went with his master to the tavern, saying, "I have heard some news that will surprise you." "And what might that be?" asked Van Goyen. "What it is," said Jan, "is that Griet must to childbed." "Are you sure?" said Van Goyen. "That I am," said Jan, "as well I should be, for it was I who brought it about and I wish to marry her." This tied the knot, so that Van Goyen, who knew that things that are done cannot be undone, at least not in matters of this nature, did not berate Jan, but charged him to break the news to his parents so that they might arrange the wedding and so that everything could proceed with decorum and honor. Jan, who was a little fearful of his father, was reluctant to do so, but Griet managed to cajole him. He went to Delft, where his father

was a brewer, and told him that he was planning to marry. His father replied that it was too early to be thinking of that, and continued, "How would you earn your living?" "I do not know," said Jan, "but I do know that it is not too early to marry," for he knew that the deed was done.[2] His father, seeing that he was in earnest, said, "We will consider it when the occasion arises, and look around for a suitable object." "You do not have to worry about that," said Jan, "I went to the trouble myself. I already have one. Our Griet is a fine, well-rounded wench, and it is she I shall marry, and she is already with child." His father, seeing that the cause was lost and being not averse to money, asked, "And what will Van Goyen give with his daughter?" "There will be no trouble there," said Jan, "my master is already a fat fellow" (Van Goyen was a corpulent man). To cut a long story short, his father allowed him to marry and put him in a brewery in Delft.

Jan, who now had plenty of money in his pocket, spent his time out strolling or in the tavern, and Griet was an easygoing lass who took no care of either the household or the bookkeeping, and if someone bought beer on credit she just chalked it up. As a result, the tax-farmer once accused Jan of not paying duty and demanded to see the books but was shown the slate instead, from which he was able to make out as little as Griet herself, for she no longer knew what she had written on it. The tax-farmer insisted on a large fine, but Jan was not troubled, knowing that he was fishing in an empty pond. The matter, though, was settled, and Jan (having promised to take better care in future) was reinstated by his father. The brewing-copper was started up again, but not for long, for Jan returned to his old ways, buying wine with his money instead of malt, so that one day his beloved wife said to him, "Jan, trade is dwindling and the customers come in vain. There is no beer in the cellars, nor even enough malt for a brew. What is to be done. You are meant to keep the brewery lively." "I will keep it lively," said Jan, and after telling the men to pump the largest copper full of water, he went to the market, where he bought some live ducks. He poured the rest of the malt into the water and let the birds swim around in it. Unaccustomed to this, they flew madly to and fro through the brewery,

making such a din that his wife came to see what was up, whereupon Jan said, "Well, the brewery is lively enough now, is it not?" And his wife, loath though she was to do so, could not help laughing at his prank.

He then sought refuge in his brush. The first piece that he made was an emblem of his disorderly household.[3] The room was in complete disarray, the dog slobbered from the pot, the cat ran off with the bacon, the children rolled about wildly on the floor, Ma sat watching, taking it easy in a chair, and as a joke Steen added his own likeness, with a *roemer* in hand, and on the mantelpiece was a monkey gazing at all of this with a long face.

After a while he became an innkeeper, but when the barrels were empty he took in the tavern signboard and closed the shop. In the meantime (as he had practiced art in his youth), he occasionally painted a piece for the wine merchant, who paid for it with a new barrel. He would then hang out the signboard again and his boon companions were the first to arrive at the door to listen to his witty jokes. But this did not last long, for he was his own best customer, so that the saying "The host at the Three Crests gets drunk before his guests" could well be applied to him.

I cannot omit to mention the subject of a large painting (which was in my house for a long time before being sold to the duke of Wolfenbüttel) that showed a bridegroom and bride, two old folk, and a notary.[4] The figures' actions were depicted so naturally that it was as if one saw the event taking place before one's very eyes. The old people appeared to be setting forth their views with high seriousness to the lawyer who, with his pen on the paper, listened attentively while poised to write. The bridegroom, looking mightily displeased, stood in a pose as if stamping his foot in a fury, hat and marriage token dashed on the floor, shoulder and hands raised. He looked sideways at his bride, as if he wanted to lay the blame on the old folk and apologize to her, while she stood looking on with tears rolling down her cheeks. This was all so readily apparent from both the countenances and attitudes[†] of the figures, and from other circumstances, it was as if it were inscribed there. Another such lifelike and ingenious painting shows a gangling young beanpole who is

standing there crying because he has spied a rod or cane sticking out of his shoe instead of something tasty (the painting depicts a feast of Saint Nicholas and can still be seen in the cabinet of Mr. G. Franken in Dordrecht).[5]

Among his smaller works one finds many painted lovingly from life that are no less ingenious in their ideas. The art-loving Mr. Lambert van Hairen of Dordrecht used to have one (His Honor now being dead) of a bawdy house in which the trollops have laid a snare for a visiting dandy who is being fleeced of his money.[6] One sees the earnest look on the man's face as he ponders over which card to choose. Standing behind him is a wrinkled old procuress with a mirror, which she uses to show the card to his opponent sitting across the table, who looks the very image of a rogue. Also sitting there is a gaudy harlot anticipating the sure profit to come at the end of the game. The room and furnishings, further, are ingeniously decorated, as is the carpet on the table, which is painted in great detail. Yet Steen did not receive as much for it as one would give for it today. He was always satisfied, however.

He painted numerous works, and most are very witty in their invention. They may show merry companies in wine or beer taverns, or shops where people fondle more warm meat than they buy, and he depicted hundreds of such indecent actions in human life, or scenes that require a quieter tone, such as a school. However, buffoonery was always mixed in, such as boys pulling each other's hair, or the schoolmaster, looking as wise as their common ancestor Dionysus had once looked, exercising his school justice with a rod, while others seem fearful

† *Gestelheit* (Attitude). A. Pels, in his translation of Horace says: that in antiquity they used to employ mimes, pantomimes and embolaries between the acts, instead of choruses:

This was a spirited kind of dancing, constituting most of bodily features / To express, as if with help of human tongues, / Love, anger, worries, pains, / Wonder, joy, hope, and fear, and all that / One can call passion, before everyone's eye, / By means of contortions of the body, grimaces, strange jumps.

This serves to teach youthful painters to impress upon themselves a set image of all the movements of the body that are generated from the urgings of the soul, by which they virtually make their images speak, after the example of Jan Steen.

of it and appear as mournful as if they and their godfather were walking at the head of a funeral cortege.[7]

On the subject of funerals, I suddenly recall the depiction of a Quaker's burial, so ingenious and comic in its composition, and the people looking so ghastly, as if he had taken his models from the insane asylum, that one could not look at it without laughing.[8]

Finally, I must say that he well understood how to distinguish between people, a subject we have treated at length elsewhere, for I have seen scenes of his in which gentlemen and peasants are depicted together, but one could almost see from their stances and gestures, without paying any heed to the clothing, which was the peasant and which the gentleman. A well-educated man, as the saying goes, stands on one leg and a peasant on two. Because this attentiveness imparts a luster to art, Horace proposed it as a law for playwrights. Hear what his translator says:

It matters greatly whether a master or a servant speaks,
Or a dignified man who knows the import of his words,
Or a brash youth, a queen, a nurse,
A shrewd merchant or a simple shepherd,
A Spaniard or a Pole, a Frenchman or a Dane.[9]

And a little further on:

A peasant, then, whom you pluck from his plough or a
wood
And wish to put upon your stage, has no conversation
Like a lawyer's clerk or some such talker,
Nor like a fishwife on the Vijgendam or 't Water.
A peasant your peasant will always remain.[10]

Someone even a little versed in Pictura's academy will easily understand the poet's meaning. It is that one must try to represent a person in his own, natural state, in all his actions. To enable young painters to gain an understanding of this, I can direct them to no better example than the painting of our Jan Steen.

The reader has already seen a goodly list of his works of art unroll, which nowadays fetch ten times the sums paid when he was still alive.

On one occasion he sold a painting for which he was paid with some gold. His wife would have liked him to hand over part of it, but he ran off with it to the tavern, drank some, gambled away the rest, and yet came home merry and in good spirits. His wife, fearful of what had happened, immediately asked after the gold, which he said he no longer had, and he began laughing heartily. His wife replied that it was no laughing matter. "And why should I not laugh," said Jan. "They think they have cheated me, but it is I who have crapped on them, for each piece of gold is six grains light, which they will only discover tomorrow when they go to change it. They will be dumbstruck!"

After a time his wife died and he was left a widower with a clutch of children. This did not suit him, for they were always plaguing him for money to buy food and drink. To forestall this he came to an agreement with his baker about the amount he would give him each week for the household. When his children then asked him "What shall we eat at noon and what this evening?" the answer was "Bread." And when they asked him "What shall we eat with it?" the answer was the same, "Bread." Therefore, it was bread and nothing but bread that was put before them. They also had one or two dogs to eat up the scraps, but before long the baker told him that he wanted to withdraw from the agreement they had made and excuse him the debt rather than continue on the same footing supplying bread for his household, and so a lot more money was saved. Sitting in the tavern one evening, Jan overheard a discussion about fresh herring and how unhealthy it was (if one ate it to excess); it could even give one the plague. He listened and quietly decided to put it to the test, hazarding it with his sons, thinking that the worst that could happen would be the graveyard, which would bring great peace to his house. The next day he bought an entire barrowful of fresh herring and said, "Now lads, here is something tasty." A portion was dried in the chimney to serve as bread to eat with the rest of the herrings, which they boiled and fried. In just a few days they had stripped this parcel of fish to the bone, and Jan, noting nothing amiss with his boys, found reason to accuse the talkers of being liars and mocked their wisdom as vanity, adding that his sons had eaten a whole barrowful of fresh herring and not one of them had caught the plague.

As time passed, his household went more and more to the dogs, as they say, and he had a day's work turning creditors away from his door with sweet words. And then what happened? While sitting with one of his friends, who let him earn money from painting from time to time, and smoking a pipe in a little summer pavilion in his yard, the friend (seeing the decline of his household) advised him to look for a wife who could help him with the children. At that moment a woman came through the house and into the pavilion at the back.

After greeting them she commenced, "Neighbor Jan, I have come to see if it would be convenient for you. You know that something is still owed for sheep's heads and feet and a piece of tripe, and you would now do me a service by paying what is due." Jan, who usually fobbed off such people with some sweet talk, laughed and said, "Well, neighbor Maritje Herculens, it is you, is it? Come sit and talk with us a while." The friend sitting with him immediately and quietly ordered a pitcher of wine, and neighbor Maritje had to drink with them. Jan, who swigged most of it himself, became merry and took neighbor Maritje first by the hand and then by the head, which did not seem to please her and was why she left, after he had promised that he would pay her as soon as he could, and would even bring the money to her house himself.

Our friend returned to his subject right away, saying that "a little widow like that would suit him, that she looked neat and handsome, and seemed to be a good housekeeper." "Surely," Jan replied. "I also think it would be a good thing. She makes a nickel from her business, and it is good rowing with the sail hoisted" (as the saying goes). "On top of that, I would not have to pay the debt she is asking for, and I would have sheep's heads and feet for free." His friend left after advising him to talk the matter over with his sister, who was a *klopje*.[11]

I would be doing my reader a disservice if I did not add this appendix (which I heard of but recently) to Jan's comical life. Even if the recital is a little long, the reader will not be disappointed. His sister, as was said, was a spiritual daughter (and as a boy he was himself raised in the Roman faith, but rarely stumbled over the threshold of a church), and he told her of his plan and she, too, felt that it was

necessary for the sake of the children, for only one of them was a girl and she was far too young to manage such an unruly household.

He hastened out, after his sister had dressed him neatly, went to Maritje Herculens, and paid his old debt (on the *klopje*'s advice), and after pacing to and fro a while, finally said that he had also come to ask for her hand in marriage, and that he loved her dearly. "No, neighbor Jan," said Maritje, "you are trying to make sport of me, as you always do." "Assuredly not," said Jan. "I am no good at wooing but I am in earnest. I ask you to become my wife." "But how would it turn out," said Maritje, "you with six children and I with two?" "With so many children," said Jan, "what does a couple more matter? They will all be provided for." To which she replied, "No, neighbor Steen, I shall not do it and you must speak no more of it, and that's the end of the matter." And with this dismissal he went dejectedly to the *klopje* and told her, "Well, on your advice I have done all I could but she would not hear of it. The wedding is off. Come along, take off my collar and cloak." "Well, brother Jan," said the *klopje*, "so the wedding is off. And I thought it was just beginning." He replied, "I told her plainly that I am no longer any good at wooing so she should not demand it of me." "But brother Jan," said the *klopje*, "the tree does not fall at the first stroke. It will not happen right away. She does not know you. You should have made her acquaintance first. She is a good, decent woman, whereas you are unbridled and strange, and believe that she, like you, will begin lightly and as lightly end it. No, that is not the way of things. You shall go to her again tomorrow, show the widow some friendship, and say that you could not stay away from her. You must go about it with sweetness, not impertinence." He took the word sweetness to heart, and the following day, when once again neatly dressed to go and see his little widow, he entered a sweetshop and bought some treats, which he thrust straight away into the hands of his beloved, whom he found standing by her corner bench with a stove under her apron on which to warm her hands.[12] "Here I am again," said Jan. "I cannot stay away. My *klopje* is of the same mind, that I must not stay away, that I must get to know you better, starting with sweetness." So saying he

pulled the paper with sweets out of his pocket and tucked into them with her. In a while they were dallying so sweetly that he, too, laid his hand on her stove and, emboldened, sometimes placed it a little farther down, giving her to understand what he sought without speaking, which did not displease her. In brief, they agreed on the matter then and there. "But," said Maritje, "what will the *klopje* say when she sees that I am so soon persuaded?" "Well," said Jan, "she will be happy, for it was she who urged me to do this. Come, let us go to her, she will have a welcome for us." Jan thought that the *klopje* would receive this new sister warmly and that he could join in the feast. He was wrong, however, because the *klopje* immediately began delivering a sermon on the duties of the marital state. She praised Maritje for her willingness to manage her brother's household and to discipline the children, then blessed her and allowed them to depart, so that he was cruelly deceived in his plan.

They registered their banns the next day and married a few weeks later. Yet, as before, he did not change his ways for the better. "If he had many eggs he broke many eggshells." And what his wife made at the market was often already spent before she got home, for as a prank he would have a cauldron full of sheep's heads and feet cooked and let his boys gobble it all up. Indeed, he would sit there laughing heartily at setting so many jawbones in motion, or at seeing one of the lads outdoing another in eating, or snatching away a dainty morsel. So little was left of his wife's enterprise, which she very soon abandoned. However, they were contented with each other and satisfied with the way life passed.

I must recount one more of his jests. Our knight of Leiden, Carel de Moor (at this time he often called on Jan Steen, who spoke very openly and was ready to help young painters with information), has told me that Maritje always pestered her husband to paint her in her Sunday best, as one usually sees in portraits.[13] Nothing ever came of it, so Carel offered his services and portrayed her, and she was pleased and showed it to her husband, who also liked it but said that something was missing that he would add himself. He immediately took up his palette and brushes and painted a large basket on her arm filled with boiled sheep's heads and feet, which looked so

comical beside her Sunday clothes that she was forced to laugh, albeit reluctantly. "This," said Jan, "was lacking, that people might recognize her." This was certainly even more amusing than the joke that Peter the painter likewise played on the wife of Rut the painter, as related by Jan Vos:

Rut had painted Saint Tony from life
But then Peter added Rut's own wife.
What was the reason, why was Pete so sly?
Because there was always a woman by Saint Tony's
side.[14]

To bring the story to a close, Jan Steen gained another son from the marriage. He was called Dirk and became a sculptor and later went to one of the German courts. I do not know what happened to the others.

He died in 1678 and was buried by his artist brethren. And so the great painter, having played out his part, passed behind the curtain of his gravestone, which could be adorned with this epitaph:

This stone covers Jan Steen.
There was no other artist
Who painted so ingeniously.
His famed brushwork shows how,
When people become unused to discipline,
They grow ever more unruly.

1. Houbraken 1718–1721, 3:12–26, is the first biography on Steen. I am grateful to Marten Jan Bok and Mariët Westermann for their comments on the translation. An essential work for a proper understanding of Houbraken's work is still De Groot 1893. A critical approach to Houbraken's underlying theoretical views is found in Cornelis 1995, 163–180. See also Chapman 1993 and De Vries 1973.

2. Houbraken used the Dutch saying "De bot was vergalt" (literally, The flounder was galled). A fish was spoiled if one cut into its gall bladder while gutting it.

3. None of Steen's surviving paintings precisely matches this description, which is, rather, "an archetypal composite of Steen's several versions of this subject"; Chapman 1993, 142.

4. This picture, which was once owned by Houbraken, is the *Wedding of Tobias and Sarah* in Brunswick (cat. 32). The description shows that he remembered imperfectly. See also pages 69–81.

5. Braun A-313; see also cat. 30.

6. Braun A-562. Van Hairen's collection was sold at Dordrecht in October 1718.

7. The godfather's presence at the head of a funeral cortege meant that a parent had died.

8. See under Braun 91.

9. Houbraken quoted the Dutch translation of Horace's *Ars poetica* by Andries Pels (1631–1681), which was first published in 1677; see Schenkeveld-van der Dussen 1973, 69, lines 279–283.

10. Schenkeveld-van der Dussen 1973, 85, lines 635–640. Vijgendam and Op 't Water were two wharves beside the Damrak in Amsterdam.

11. This was probably Steen's sister Catharina; see page 32 n. 126.

12. The "stove" was a hand warmer or foot warmer. To an eighteenth-century reader it would undoubtedly have had all sorts of erotic connotations, as the *mignon des dames* that no woman could be without.

13. The Leiden painter Carel de Moor (1655–1738) was knighted by Emperor Charles VI in 1714 as a reward for portraits he had painted.

14. Houbraken used the second edition of Jan Vos, *Alle de gedichten* (Amsterdam, 1726), but he bowdlerized it, for in vol. 1, 437, epigram no. 220, the last line reads: "Sint Teunis heeft altyt een varken aan zyn zy" (Saint Tony always has a pig by his side). For the actual text of Vos' poem, see page 54.

CATALOGUE

1

Winter Landscape

c. 1650

signed at left, on the sledge: *JS* (*JS* in ligature)

panel, 66.7 x 97.5 (26 ¼ x 38 ⅜)

Skokloster Castle, Bålsta

PROVENANCE

Sale, The Hague 1651, to Harald Appelboom (his bill of 3 July 1651) acting for the Swedish field marshal Karl Gustav Wrangel; by descent in the Brahe and Von Essen families; sold to the Swedish state with Skokloster in 1967

LITERATURE

Granberg 1907, 132; Hofstede de Groot 1907, no. 881a; Martin 1954, 29; The Hague 1958, no. 1; De Vries 1977, 29, 32, 35; Braun 1980, 86, no. 11

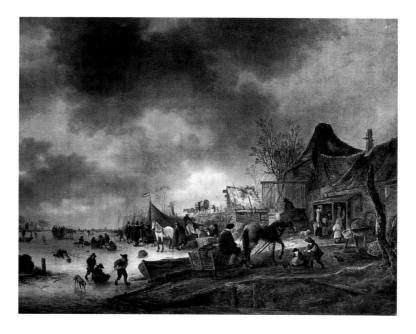

Although *Winter Landscape* is not dated, it is clearly one of Steen's earliest works, for its provenance goes back to a sale held in The Hague in 1651. It and three other paintings by Jan Steen were bought by Harald Appelboom, the agent of Karl Gustav Wrangel (1613–1676), the Swedish governor-general of Pomerania, who later built Skokloster Castle. Appelboom's bill of 3 July 1651 shows that Wrangel paid thirty-two guilders for the painting, a reasonable sum for a work by a young artist who was already regarded as "einem Fürnehmlichen Meister."[1] The panel was probably taken first to Wolgast in Pomerania or to Spieker on the isle of Rügen, where Wrangel was living at the time. On his death the picture passed to his eldest daughter, Maria Juliana, who honored her father's wish by preserving Skokloster, intact for posterity, as a vast *Kunst- und Wunderkammer*.[2] The three other paintings in the 1651 sale, *Story of Hagar*, *Fat Kitchen*, and *Lean Kitchen*, went to Wrangel's two other daughters when his estate was divided in 1676. They have since been identified with *Hagar in the Desert*, now on the art market, and *The Fat Kitchen* and *The Lean Kitchen* in the present exhibition (cats. 2, 3), although it must be said that these identifications are not entirely secure.[3]

Wrangel's acquisition of *Winter Landscape* in 1651 indicates that it is not only one of Steen's earliest works but also one of those rare pictures that can be assumed, with a probability bordering on certainty, to have been painted for the open market. Its original, seventeenth-century frame has been retained, although a modern inlay was added.

Winter Landscape is reminiscent of the work of Isack van Ostade (1621–1649), whose ice scenes of the 1640s must have made a great impression on Steen. This is particularly clear from Van Ostade's painting of 1645 (fig. 1), in which the diagonal composition and odd effect of the silhouetted figures on the ice are closely related to Steen's painting. The strip of light that Steen used to define the path leading to the bridge was also taken from this or another work by Van Ostade. The two figures in North Holland costumes in the left foreground come from the work of Hendrick Avercamp (1585–1634).[4]

Some of the figures in Steen's *Winter Landscape* were quite firmly delineated, but others appear mainly as silhouettes. This is the case with several large figures, such as the man behind the sledge on the left, and especially with the small figures. Many of these were rendered in a cursory, sketchy manner without much attempt to add volume. Steen, it is interesting to note, broke up the sheet of ice with a spit of land, thus cleverly introducing a great sense of depth in the left half of the picture. As so often seen in works by Steen and several of his contemporaries, the activities are watched by a well-dressed cou-

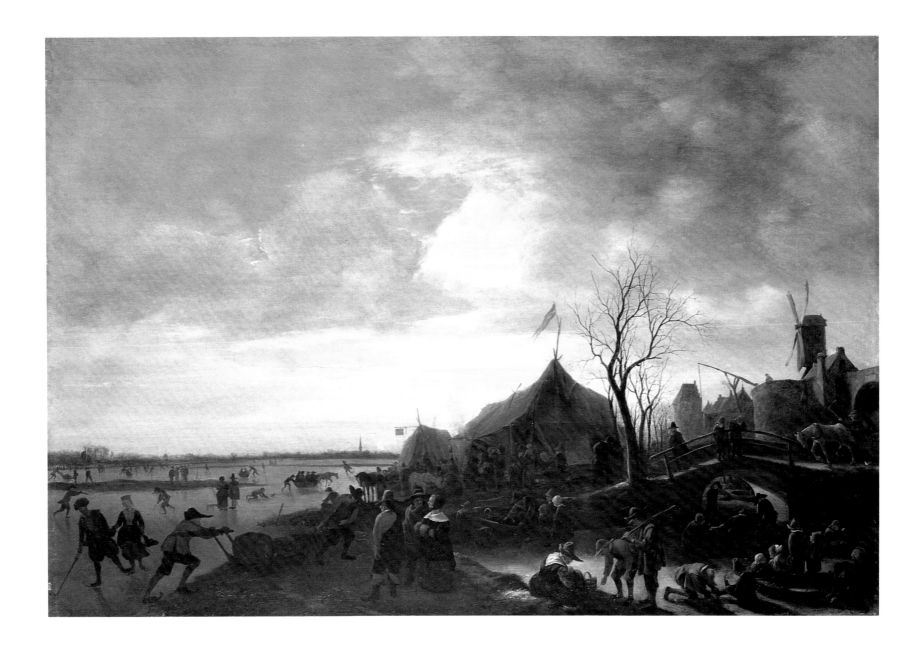

ple who occupies a central position in the composition. Here it is in the foreground, just to the left of center.[5]

Steen must have painted more winter landscapes, for a number that have not survived are mentioned in sale catalogues.[6] These works probably date from his early years, when he was chiefly interested in landscape. One picture from that period that deserves mention is the *Fair near a Riverside Village* (fig. 2).[7] It is slightly larger than the present painting, but the relationship between figures and landscape is similar. The detail in the figures and the suggestion of the vista are also closely related. There, too, an elegant couple has been given a central position in the composition, although it is a little farther back. The similarities become more evident when these two paintings are compared with some other early landscapes, such as the *River Landscape with Ruins on a Hill* or *The Horse Fair at Valkenburg* (page 70, fig. 2), which are also from the artist's early period.[8] In the first work, the figures are almost swallowed up by the landscape, which is seen from a great distance. The countryside in the second painting serves as a setting for numerous amusing vignettes. The figures in *Fair near a Riverside Village*, like those in the *Winter Landscape*, strongly recall the work of Van Ostade. The landscape, however, incorporating a church tower seen through trees is more reminiscent of the work of his father-in-law, Jan van Goyen (1596–1656), whose village views must have provided him with a welcome source of inspiration here.

<div align="right">WTK</div>

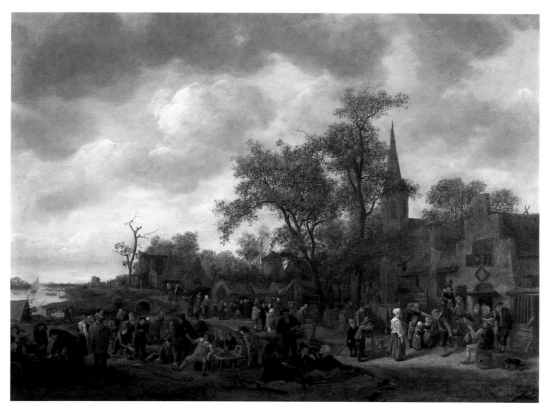

fig. 2. Jan Steen, *Fair near a Riverside Village*, c. 1652, oil on panel, private collection

1. Granberg 1907.

2. See also Amsterdam 1992, 120. Wrangel acquired many pieces for his collections in the Netherlands.

3. For *Hagar in the Desert* see Kirschenbaum 1977, no. 2b, and Braun 1980, no. 142. Both authors date it in the 1660s, but in my view the extremely cursory handling of the figures and the emphasis on the landscape indicate a very early date.

4. See, for example, the painting by Avercamp in the Carter Collection, in which similar figures can be seen just beyond the foreground, Amsterdam 1987, no. 7; also see the figures in the middle ground of a painting in a private collection, Amsterdam 1993, no. 306.

5. Steen's *Fair at Valkenburg* in the Mauritshuis (Braun 1980, no. 81) and the *Peasant Wedding* in the Rijksmuseum (Braun 1980, no. 349) are clear examples of this. See also the *Fair near a Riverside Village*, reproduced here (fig. 2), and the essay by Westermann in the present catalogue (pages 53–67). An example by another artist is the painting *La main chaude* by Cornelis de Man in the Mauritshuis, see Amsterdam 1976a, no. 37. For early appearances of the well-to-do observing peasant jollity see Alpers 1972–1973.

6. See the collection of Pieter van Buytene, Delft, 29 October 1748, no. 56: "Een dito, van denzelven, verbeeld een Wintertje" (Another [piece] by the same [Jan Steen], a winter scene); and see sale Fortuyn, Gouda, 26 April 1808, no. 145: "Een fraai Wintergezicht" (A fine winter scene), this time with the dimensions. See also Hofstede de Groot 1907, nos. 882d, 884, and 886. It must be said, though, that several winter landscapes were later wrongly attributed to Steen, see Braun 1980 nos. B-276, B-278, and B-285.

7. Braun 1980, no. 75; see also Martin 1935a, 212. Braun dates it between 1654 and 1658, whereas the present owner places it c. 1652–1653. In my view, the work's close relationship with the *Winter Landscape* safely dates it to c. 1651.

8. Braun 1980, nos. 1 and 23 respectively.

2

The Fat Kitchen

c. 1650

signed at lower right: *JHSteen* (*JHS* in ligature)

panel, 71 x 91.5 (28 x 36)

Private collection

PROVENANCE

De Keyser Collection, Breda; sale, Antwerp, 23 August 1871, no. 70; Bellefroid collection, Brussels, 1882; Michotte Collection, Brussels; sale, Paul Mersch (of Paris), Berlin, 1 March 1905, no. 103; Lambeau, Brussels; Hijnen, The Hague; sale, The Hague, 31 January 1911, no. 164; d'Audretsch, The Hague; R.A. Cremers, The Hague, 1917; sale, Amsterdam, 30 November 1920, no. 107; S.H. van Esso, Amsterdam, 1926; sale, Amsterdam, 8 June 1948, no. 544; sale, Jacob Lierens, Amsterdam, 18 October 1949, no. 2; H. van der Ploeg, Amsterdam; N.J. Hoos, San Raphael, 1956; Hermann Becker, Dortmund; Hans Cramer, The Hague, 1974; private collection; stolen c. 1980 and recovered c. 1992; sale, Amsterdam, 9 May 1995, no. 21; to the present owner

LITERATURE

Hofstede de Groot 1907, no. 121; Leiden 1926, no. 39; Martin 1926, 9; De Vries 1977, 35, 37; Braun 1980, 88, no. 27; 's-Hertogenbosch 1992, 116, no. 53

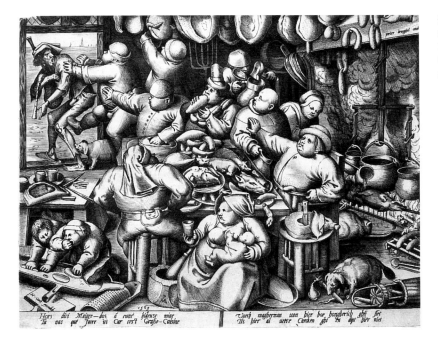

fig. 1. Pieter van der Heyden after Pieter Bruegel the Elder, *The Fat Kitchen*, 1563, engraving, Rijksprentenkabinet, Amsterdam

In this painting Jan Steen shows us a remarkably well-stocked kitchen peopled with portly individuals gorging themselves. Sausages, hams, and poultry hang from the ceiling, which also supports a shelf of cheeses ingeniously suspended from it. A suckling pig is being basted in the hearth on the left, a young mother feeds her two children, and some toddlers tuck into an apple pie. Corpulent people sit at a table headed by a roly-poly character, with sausages around his neck and eggshells on his hat, who cuts the meat. On the right a fiddler supplies the musical entertainment. In the background, a tubby youth with a ham chases a skinny man from the door.

Steen modeled this work and its companion piece *The Lean Kitchen* (cat. 3), reunited here after a long separation, after works by Pieter Bruegel the Elder (c. 1525–1569) (fig. 1 and cat. 3, fig. 1). They are amusing depictions of a popular antithesis. The comical contrast between the obese people, who bar the door to a thin, hungry man, and the skin-and-bones types, who try to get a fat man to share their miserable meal, has always appealed to the imagination. The inscriptions beneath the engravings, which were executed by Pieter van der Heyden (c. 1530–after 1572) in 1563 after Bruegel's designs, also apply to Steen's versions. The one on *The Fat Kitchen* snaps at the thin beggar: "Be off with you, you skinny little man, you may be hungry but this is a fat kitchen, and you don't belong here." The inscription on Bruegel's *Lean Kitchen* announces: "You get a miserly meal from a skinny man's pot, which is why I love going to the fat kitchen."[1]

Steen did not quote Bruegel literally. All sorts of motifs in *The Fat Kitchen* are common to both, such as the full-breasted mother, the two children grabbing something tasty, the basting of the suckling pig. The hams hanging from the ceiling and the gridiron leaning against the wall are identical in each work. Steen modified the composition by reversing it from left to right. He deliberately set out to achieve a different result by adding the theatrical touch of the poultry dangling from the ceiling. This motif helps make the scene far more spacious, unlike Bruegel's packed composition. Steen preferred to give his figures more room to breathe so that he could group them in accordance with what one might call the trademark Steen logic. For example, a clear connection can be made between the nursing mother and the children around her. This cohesion is not just restricted to the figures. The waffle iron in the foreground, for instance, lies beside a stool, upon which sits a Wan-Li platter, its blue now discolored to gray-green, holding some waffles. This type of arrangement is an early demonstration of Steen's great compositional skill.

cat. 2

cat. 3

The fat and lean kitchen paintings are widely re-garded as early works, and the artist was still using his signature "JH [Jan Havicksz] Steen" for *The Fat Kitchen*.[2] The distinctive turned-up noses of the child holding a fork and making a mess of the porridge it is fed and of the kitchen maid basting the pig are characteristic of his early work.[3] His youth may explain his lack of interest in imitating textures; he would later have made something a good deal finer of the Westerwald ewer hanging on the back wall. The two panels can be dated around 1650.

It will probably never be possible to prove whether these two paintings are the fat and lean kitchens acquired in 1651 by the agent of the Swedish marshal Karl Wrangel (see cat. 1).[4] Of Steen's other depictions of the subject, those in Cheltenham are generally dated early, wrongly so in my opinion.[5] Other variants are known, albeit only from old sources.[6] Then there is the problem of the reap-pearance of some parts of the composition in Steen's later work. For instance, the rear view of the bald man draining his tankard—his trousers, incidentally, were painted exquisitely thinly over the light ground—can be recognized in a painting in Liechtenstein that has been identified as a *Fat Kitchen*.[7] It would have been impossible for Steen to repeat such a figure if the two panels dis-cussed here had indeed been shipped to their new Swedish owner in 1651, for he would no longer have been able to refer to them.

The two kitchens have been associated with the work of the Van Ostade brothers, and it is possible that Steen saw Bruegel's versions in their studio, for Adriaen van Ostade (1610–1685) also seems to have used the two engravings.[8] Yet little of the brothers' teaching is seen in Steen's rendering of the settings. Both Adriaen and Isack depicted the effects of light and shade and the subtle brown tones of the wooden structures with great sensi-tivity. Steen's accounts are more reminiscent of the kitchens of the Rotterdam painters Cornelis Saftleven (1607–1681) and Pieter de Bloot (1601–1658).[9] He seems to have borrowed the motif of the hanging birds from the work of the Flemish artist David Teniers (1610–1690), whose example was also important for the Rotterdam artists.[10]

In his later works, Steen often gave a highly personal twist to proverbs, in addition to reworking old subjects in a stunningly fresh way. In his *Dissolute Household* in New York (cat. 21, fig. 1), for example, he depicted a not very edifying blowout with a young man driving a beggar

from the door—a motif that is patently derived from *The Fat Kitchen*.[11] Apart from that, the New York picture is a creative blend of subjects like the Prodigal Son in the Brothel and the Rich Man and Poor Lazarus.

WTK

1. Bartsch 1803–1821, 154 and 159. The inscriptions read: *Wech magherman, van hier, hoe hongerich ghij siet; Tis hier al vette Cuecken, ghi en dint hier niet*, and *Daer magherman die pot roert, is een arm gastrije; dus loop ick nae de vette Cuecken met herten blije.*

2. This signature does not feature in the selection reproduced in Braun 1980, 84–85.

3. Unfortunately, few of the presumed early works are dated. The *Death of Ananias* (Braun 1980, no. 33) of 1651 contains a retroussé nose in profile. See also *The Adoration of the Shepherds*, *The Satyr and the Peasant* and *The Quack*, Braun 1980, nos. 19, 22, and 89 respectively.

4. Martin 1926.

5. Braun 1980, nos. 29, 30; and Wright 1988, 42–43, with ill. V. They were probably executed toward the end of the 1660s, as can be seen from a comparison with the dated painting from 1668 in Bremen (Braun 1980, no. 294). *The Toothpuller* in the Museum Boymans-van Beuningen in Rotterdam (Braun 1980, no. 88) is also generally placed early in the oeuvre, but, in fact, it too probably dates from the late 1660s. Here Steen returned to the subjects of his early work.

6. Braun 1980, nos. A-53 and 54.

7. Braun 1980, no. 212. For a possible pendant see Braun 1980, no. 213a. See also Basel 1987, no. 93.

8. Schnackenburg 1981, 25, 81, no. 9.

9. What is notable is their affinity with the work of the 1630s by the Haarlem master Jan Miense Molenaer, a painter who must have been an important source of inspiration for Steen.

10. For the hanging birds, see, for instance, the paintings by Teniers in The Hague and St. Petersburg, Antwerp 1991, nos. 36 and 49.

11. Linsky Collection, The Metropolitan Museum of Art, New York; Braun 1980, no. 251.

3

The Lean Kitchen

c. 1650
panel, 69.7 x 92 (27 ½ x 36 ¼)
National Gallery of Canada, Ottawa

PROVENANCE
The same as *The Fat Kitchen* (cat. 2) until the 1905 sale; art dealer, Paris, 1921; Ernst Messerli sale, New York, 22 January 1931, no. 69; art dealer, Switzerland, 1950; sale, Lucerne, 16 June 1959, no. 2440; Schaeffer Gallery, New York; acquired by the present owner in 1960

LITERATURE
Hofstede de Groot 1907, no. 122; De Vries 1977, 35, 37, 44; Braun 1980, 89, no. 28; National Gallery of Canada 1987, 273–274, no. 9014

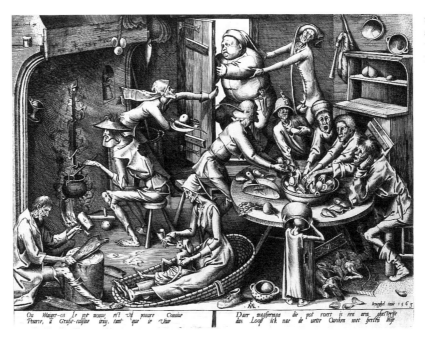

fig. 1. Pieter van der Heyden after Pieter Bruegel the Elder, *The Lean Kitchen*, 1563, engraving, Rijksprentenkabinet, Amsterdam

A number of skinny people around a table in the middle of a room eat some shellfish and a small fish while a woman cuts off a slice of bread for a hungry child. On the right by the hearth, an old man smokes his pipe and a woman wipes a baby's bottom, in wonderful contrast to the mother feeding her children in the companion piece. Everyone is dressed in rags. At the door someone is trying to interest a fat man in a turnip, but he recoils in horror. Steen humorously related the squalor to the life of an artist, for the easel on the left indicates that this is a painter's studio.

In *The Lean Kitchen* Steen once again freely took Pieter Bruegel the Elder (c. 1525–1569) as his inspiration (fig. 1). He not only borrowed the subject and compositional program, but also adapted various compositional elements and details. He used the man on the far right in the engraving, for instance, for the figure at the table on the right. He lifted the motif of a child scraping out a pot and combined it wittily with a dog, undoubtedly thinking of the saying "The dog's had your dinner." The boy's pose was inspired by Bruegel's woman sitting in a cradle. The many details common to both scenes include the garlic and flatfish dangling above the hearth, and someone offering a niggardly meal to a fat person, whose profile in the work by Steen appears to have been taken from the woman by the door in the engraving. In Bruegel's *Fat Kitchen* a bagpiper comes calling, but in this picture the pipes are hanging on the wall. As in his *Fat Kitchen*, Steen gave the figures more space than did Bruegel. This left room for a birdcage hanging from the thatched roof—a motif that Steen often used in his later works, when he filled it with objects of every description.[1] The spaciousness is derived from Adriaen van Ostade (1610–1685), as can be seen from a comparison with his *Family*, an etching of 1647 (fig. 2).[2] The handling of some of the details in the painting, such as the beamed ceiling, the hanging hams, the cutting of bread, and the importunate dog, makes it probable that Steen knew this print.

This early painting demonstrates Steen's precocious ability to group numerous figures in a convincing way. The interaction between them and the clever organization of the group around the table demonstrate the young artist's skill in arranging a composition. The details are sometimes rather coarse, and little is seen of the interest in imitating textures that characterizes much of his later work. This broad manner of painting is rather surprising, for in the kitchen interiors of the late 1640s by Steen's contemporaries, such as Willem Kalf (1619–1693), the detailed execution of food and tableware appears to have been an important consideration for the artist.

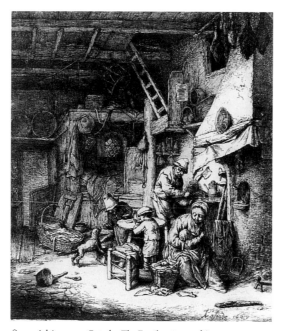

fig. 2. Adriaen van Ostade, *The Family*, 1647, etching, Rijksprentenkabinet, Amsterdam

These two large panels are an impressive ensemble. More important, though, they announced Steen's intention to be more than a painter of landscapes or interiors in the style of the Van Ostade brothers. Even at this early date he clearly had the ambition to amuse. In order to do so he looked carefully at southern Netherlandish graphic art of the sixteenth century, in which foolish behavior is exposed and satirized. Prints after masters like Hieronymus Bosch (c. 1450–1516) and Pieter Bruegel—in which the world is stood on its head, entertaining and obscene jokes are played, and people eat and drink too much—were important influences. The fat and lean kitchen paintings are evidence that he was acting deliberately when he turned to this tradition for inspiration. He avoided, though, the totally unrealistic, literal way in which sixteenth-century graphic art illustrated proverbs and sayings, combining, instead, fanciful jokes to create an implausible scene. The two kitchens are the logical point of departure for a young artist who had set his sights on making his public laugh, and on amusing himself in the process.

WTK

1. See page 45, fig. 8, for example.

2. Bartsch 1803–1821, 46.

4

Village Festival with the Ship of Saint Rijn Uijt

c. 1653
signed (on boat): *IAN STeeN*
panel, 42.5 x 66.5 (16 ¾ x 26 ⅛)
Private collection

PROVENANCE
Possibly collection of François van Hillegaert, Amsterdam, inv.
no. 1707 ("Een scheepje Rijn uijt"); possibly sale, Amsterdam, 14
July 1714, no. 5; possibly sale, Amsterdam (Jonas Witsen), 23
March 1717, no. 14; sale, Paris, 1774; Chevalier S. Érard, Paris; sale,
Paris, 23 April–7 August 1832, no. 140 (M. Érard); W.H. Grenfell,
London; Dowdeswell and Dowdeswell, London, 1904;
J. Walter, Bearwood; Arthur F. Walter, London, 1909; sale,
Christie's, London, 11 June 1920, no. 124; N. Beets, Amsterdam;
Dr. H. Schieffer, Amsterdam; M. Jan Pilaprat; Baraman-Bhinay;
Prince Borghese, Milan; Max F. Lindemann, Basel; sale,
Amsterdam, 18 November 1985, Sotheby Mak van Waay, no. 162

LITERATURE
Smith 1829–1842, 4:2, no. 2; Van Westrheene 1856, 152, 169, nos.
277, 478; Hofstede de Groot 1907, nos. 522, 621; Martin 1909b, 167;
Martin 1910, 182; Leiden 1926, 26, no. 64; Martin 1926, 6, 7, 29;
Bredius 1927, 59–60; Schmidt-Degener and Van Gelder 1927, no. 3,
28; De Groot 1952, 83–84; Amsterdam 1976a, 259; De Vries 1976, 71
and 169, no. 180; Braun 1980, 94–95, nos. 77, 152, no. A-323

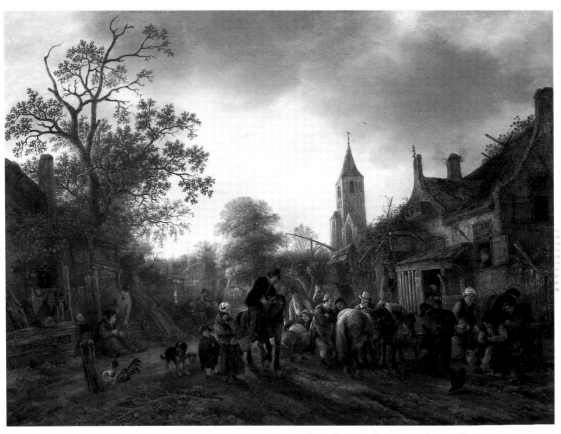

fig. 1. Isack van Ostade, *The Halt at the Inn*, 1645, oil on canvas, National Gallery of Art, Washington, Widener Collection

Village life, and particularly those festive occasions when peasants set aside chores and broke free from daily routine, fascinated Steen early in his career. He enjoyed depicting men, women, and children as they gathered near their small inns and parish churches to dance, eat, drink, and wonder at the mysteries described by quack doctors and the fantasies woven by visiting *rederijker* or theatrical groups.

In this delightful and enigmatic painting, a series of vignettes convey the flavor of such a festival. The bawdy tune of the bagpipe player and the joyous shouts of the circling dancers echo the rustic ambiance of a small village, while behind the dancers children buy *oliebollen* from an old lady and customers examine the wares in a small tent attached to the inn. Not far from them a quack doctor stands behind a table enticing young and old with

his stories and his goods, and a fat innkeeper waits upon a horseman who downs his drink with great relish. In the immediate foreground, a long-suffering wife grabs her drunkard husband as he fruitlessly waves his knife in the air, angry at some real or imagined injustice.

The most remarkable vignette is in the right foreground, where a young, refined gentleman leans forward to bid farewell to a group of revelers departing in a wooden boat (*schuit*). It is not entirely certain who the lively figures in the boat are, how they relate to each other, or why they have visited this village. Most of the passengers, such as the fat, self-satisfied steersman and his robust wife, the violin player, the man singing from a (song?)book, and the smoker tipping his hat to his compatriot on the shore, belong to the middle class. Others, however, are clearly from the lower class: the sailor who pushes the

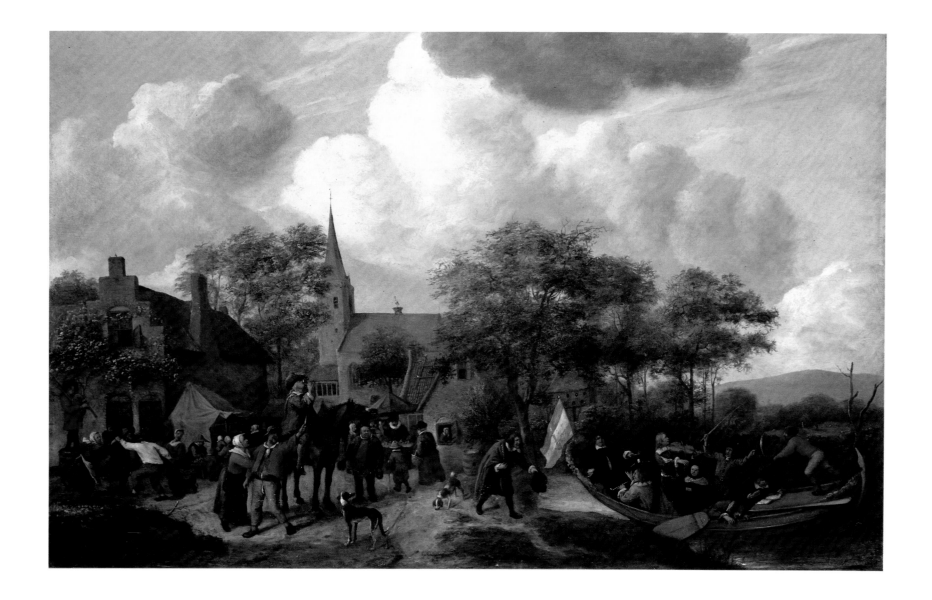

boat off with a long pole, the fisherman flinging his arms in the air to celebrate his catch, and the poor wretch vomiting over the side.

Many interpretations of this group have appeared over the years. Martin, for example, wrote that the passengers are a family who had visited a friend in their pleasure yacht.[1] Schmidt-Degener related the scene to Bredero's descriptions of city dwellers who loved to make merry with villagers.[2] Both De Groot and Braun proposed that they were a company of *rederijkers* leaving a festival.[3]

In fact, it seems less likely that Steen included the group as a narrative extension of the festival than as a moralizing commentary on human folly. The boat's tricolored flag, identical to that of Leiden, provides the thematic link uniting this disparate bunch. On the flag, an ace of spades, a yellow stocking, and a jug clearly allude to the Dutch proverb *Kaart, kous en kan maken menig arm man* (Card [gambling], stocking [women], and jug make many a man poor).[4] Steen provides the full moralizing connotation of these symbols with an inscription flanking them: *Rijn Uijt* ("clean out," or "none left").[5]

The inscription *Rijn Uijt* identifies this small boat as that of Saint Rijn Uijt, the mock patron saint for those who have lost their fortune through women, gambling, and drinking.[6] Rijn Uijt's ship was equated with the ship of fools, popularly called in Dutch folklore the *blauwe schuit* (blue ship) or *lichte schuit* (light boat).[7] Steen's lively, seemingly everyday scene is, thus, based on an old allegorical tradition, one that speaks to the most basic of men's foibles. All manner of fools were permitted to set sail on the pilgrimage to Saint Rijn Uijt, including, as in this ship, drunks vomiting over the side, gluttons, and gamblers (note the playing card on the smoker's hat).[8] The fisherman belongs to this group because the fish he so proudly displays often symbolized foolish behavior.[9] Steen indicates, however, that this bizarre group can expect little in the voyage of life. The dead tree behind the bow of the boat, so different from the verdant trees in the rest of the village, symbolizes the emptiness of their existence.

The young man on the shore seems to have thrown a red book on the ground in front of him, but for what purpose?[10] Perhaps, rather than bidding adieu, he is a scholar who abandons his studies to join the Ship of Saint Rijn Uijt? Indeed, Adriaen van de Venne (1589–1662) included scholars "who did not wish to learn" in his list of those permitted to sail.[11]

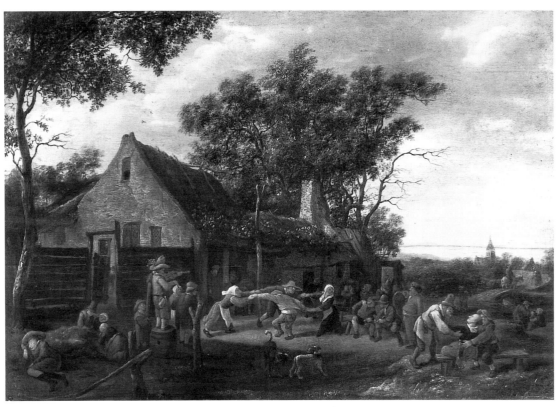

fig. 2. Jan Steen, *Dancing Peasants near an Inn*, c. 1648, oil on panel, Mauritshuis, The Hague

Although the painting is not dated, the style of the figures and the landscape, which has been so admired by critics over the years, suggest that Steen executed it in the early 1650s.[12] The village setting, with its rustic buildings and light-filled trees, is reminiscent of paintings by Isack van Ostade (1621–1649) (fig. 1), which Steen would have seen in Haarlem in the late 1640s, when he studied with Isack's brother Adriaen van Ostade (1610–1685). The freedom and surety with which he painted the billowing clouds reflects the influence of Jan van Goyen (1596–1656), whose daughter he married in 1649.

Similar elements appear in other of Steen's early works. For example, the ring of dancers is similar to that in Steen's *Dancing Peasants near an Inn*, c. 1648 (fig. 2). The most interesting comparison, however, is with *A Country Fair* (fig. 3). Here a boat likewise departs from a village festival, leaving behind a drunken, though less threatening, peasant similarly being restrained by his wife. To judge from its larger landscape forms and greater three-dimensionality of space, Steen must have executed this work slightly later than *Village Festival with the Ship of Saint Rijn Uijt.*

Despite basic compositional similarities, Steen approached the narrative in these two works differently. The boat in *A Country Fair* does not resemble the ship of Saint Rijn Uijt; indeed, the passengers appear to be ordinary peasants on a pleasure trip. Rather than serve as a means to provide an explicit moralizing warning about the foolishness of human behavior, they add to the general sense of merriment.

AKW

1. Martin 1926, 6.

2. Schmidt-Degener and H. E. van Gelder 1927, 28.

3. De Groot 1952, 83; Braun 1980, 94–95.

4. The full text of the proverb is: *Kaart, kous en kan / Maakt menig arm man, / Maar die het recht gebruik van deze drie ooit namen, / Behoefden nimmer zich voor enig mens te schamen.* [Card,

fig. 3. Jan Steen, *A Country Fair*, c. 1653–1656, oil on canvas, private collection

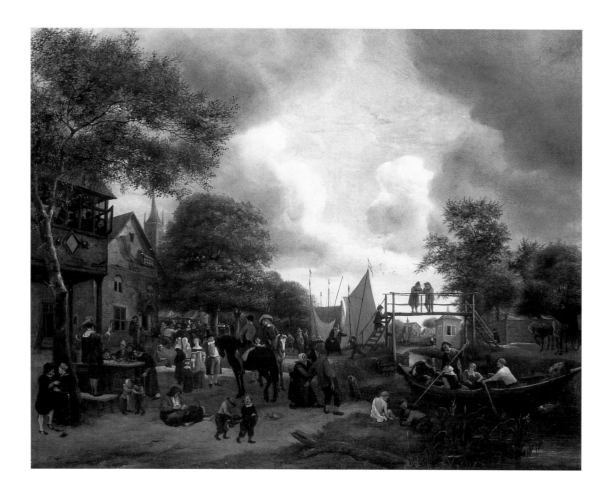

stocking and jug, makes many a man poor, but whoever took proper use of these three, never needed to feel ashamed before any man.] "Kous" is a slang term referring to the female vagina. See De Jongh in Amsterdam 1976a, 259, and cat. 19.

5. The painting was identified as "Een scheepje Rijn uijt" as early as the 1707 sale of Francois van Hillegaert, Amsterdam, a title given to it also by Van Westrheene 1856, no. 277; Hofstede de Groot 1907, no. 522. However, Martin 1909b, 167 incorrectly read the inscription on the flag as "Mooi uit," a mistake repeated by Bredius 1927, 59–60, and Braun 77.

6. For Saint Rijn Uijt see Enklaar 1940, 49–51; Renger 1970, 18–22. A Dutch-English dictionary from 1648 translates the expression "na S. Reyn-uyt varen" (literally, to sail after St. Reyn Uyt) as "to Spend all, or to Leave nothing." Pleij 1983, 185 indicates that the name of this mock saint refers as much to the empty glass as to total poverty.

7. Pleij 1983, 185–195.

8. Adriaen van de Venne depicted the "Boot van Reyn-uyt," and described its occupants, in his *Tafereel van de Belacchende Werelt* (The Hague, 1635), 158–159 (page 55, fig. 3). See Van Vaeck 1994, 2:274–475; 3:800–802. For an illustration of a similarly conceived ship of fools published in 1654, see Pleij 1983, 188.

9. See Stone-Ferrier in Lawrence 1983, 189.

10. The presence of this book was first noted by Dr. H.G. Schmitz-Dräger.

11. Van de Venne 1635, 159: "All de Ionckheyd die wel konnen leeren, en niet en willen."

12. For example, Martin 1909b, 167, described it as "wohl die schönste Landschaft des Meisters."

5

Peasants before an Inn

by 1653
signed lower right: *J. Steen*
panel, 50.2 x 61.6 (19 ¼ x 24 ¼)
The Toledo Museum of Art, Purchased with funds from
the Libbey Endowment, Gift of Edward Drummond
Libbey

PROVENANCE
Sale, Sir Hugh Hume Campbell, London, 16 June 1894; Samuel
Cunliff-Lister, Lord Masham, Swinton; sold by Lady Masham to
dealer D. Katz, Dieren, 1938; bought from Katz by H. E. ten
Cate, Almelo, 1938; Schaeffer, New York; bought from Schaeffer
by the present owner, through the Edward Drummond Libbey
Fund, 1946

LITERATURE
Hofstede de Groot 1907, no. 630; Rotterdam 1938, 35, no. 140;
Museum News Toledo 1946; Toledo Museum 1953, 24–25 ill.;
Braun 1980, 94, no. 59[1]

fig. 1. Adriaen van Ostade, *Dance under
the Trellis*, c. 1652, etching, National
Gallery of Art, Washington, Rosenwald
Collection

On a brilliantly sunny day, country and city folk drink, dance, flirt, and talk in the yard of a picturesque, vine-covered inn on the outskirts of a town. The stone building on the left is the inn proper, identified by its signboard and *wijnkrans*, the wreath hung over the door to announce the new vintage. In the arched doorway, the innkeeper greets an elderly couple whose respectable, if old-fashioned, attire suggests they are city dwellers on an outing. Another well-dressed guest, perhaps the traveler whose horse is being watered, has already been served. On the second floor balcony a young couple sits at a table, while the serving maid chalks up their drinks on a tally board. The more modest wood and cracked plaster structure adjoining the inn is probably the domestic side of the establishment, the home of the innkeeper and his family. From its half door a woman keeps an eye on two children as she watches the gaiety unfold.

The scene she regards is arranged as a series of vignettes. A couple dances to the strains of the rustic bagpipes played by the itinerant musician who stands elevated in the corner formed by the two buildings.[2] They are observed by a young child in the arms of a grandmotherly type. In the right foreground, a humorous flirtation transpires as one man cajoles a plump woman with a large purse, perhaps the inn's hostess, while another playfully tugs at her apron. They, in turn, are watched by a laughing boy with a caged bird who anticipates the "poultry seller" in *The Dancing Couple* (cat. 20). At the very cen-

ter of the scene, a self-absorbed man in an eye-catching red cap is oblivious to this sociability. Clearly in a drink and tobacco-induced stupor, he adds a discordant note in the midst of the gaiety.[3]

Tavern life was one of Steen's favorite themes and it occupied him from the beginning to the end of his career (cats. 46, 48). Perhaps it was because Steen was a brewer's son, a brewer himself, and, later, an innkeeper, that he tended to personalize his tavern scenes. What appears to be a palette hanging to the left of the bagpiper in the Toledo painting, comparable to his self-referential inclusion of an easel in *The Lean Kitchen* (cat. 3), prefigures his self-portrayal as the innkeeper in *Merry Company on a Terrace* (cat. 48).

One might expect such an apparently naturalistic scene to describe life as Steen experienced and observed it. Yet, like most Dutch genre paintings, *Peasants before an Inn* presents a selective view of reality that draws as much from pictorial conventions as from actual observation. The subject of peasants feasting and dancing outside an inn has its roots in the sixteenth-century in the kermis paintings and prints by Pieter Bruegel the Elder (c. 1525–1569). In the seventeenth-century, Haarlem was a center of peasant painting. There, in the works of Adriaen Brouwer (1605/1606–1638), Adriaen van Ostade (1610–1685), and Isack (1621–1649), the inn became the central subject while the other events of the kermis were increasingly relegated to the background or removed altogether (fig. 1).

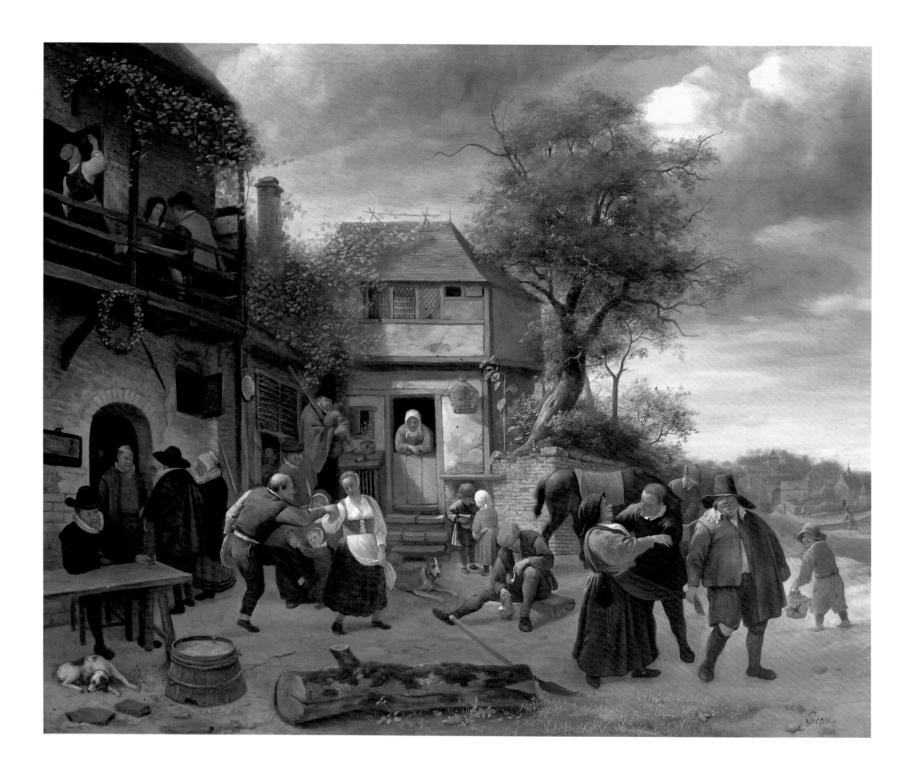

Scenes of peasant life must have been popular among a middle- to upper-class urban clientele to whom the rural peasantry represented an "other" that at once affirmed their civility and provided them with a comic release from the strains of maintaining decorum. At one extreme, Brouwer's roughly painted pictures of peasants smoking, drinking, and fighting in squalid tavern interiors, like Steen's *Interior of an Inn with Cardplayers Fighting* (page 76, fig. 15), derived from an older, satirical, and didactic pictorial tradition that ridiculed peasants for their foolish, reprehensible behavior, and lax morals.[4] Alternatively, more positive images of rural life, for example Isack van Ostade's scenes of travelers halting before inns or Adriaen's sympathetic *Dance under the Trellis* (fig. 1), presumably satisfied city dwellers' nostalgic longings for the purity and simplicity of festive rural life.[5] This notion of the countryside as a place of retreat was registered also in the popularity of pastoral painting and in the actuality of townspeople making outings to the country and buying country homes.

Steen's *Peasants before an Inn* is both cautionary and celebratory, and thus merges these two approaches. On the one hand his treatment of rural life is sympathetic, even idyllic, like Adriaen van Ostade's, to which this picture is indebted compositionally. On the other hand, the intoxicated man in the red cap, reminiscent of Brouwer's smokers, suggests that Steen comments pointedly on the folly of peasant behavior. In combining these two modes he resembles the Flemish painter David Teniers (1610–1690), who was closely associated with Brouwer. Teniers' *Kermis before the Half-Moon Inn* of 1641 (fig. 2), though more densely populated, shares many elements and provides a precedent for the striking inclusion of the man in the red hat as a cautionary note.[6] How Steen knew Teniers' works is not known—presumably it was through his Haarlem connections—but it was characteristic of him to turn farther afield than his most immediate sources and teachers, and particularly to Flemish painting, for artistic inspiration.

Steen's emerging originality is apparent in the ways he recasts pictorial conventions. Throughout his career Steen transformed traditionally low-life themes into a middle class mode of comic moralizing.[7] Here he creates a rural world that is socially and geographically more accessible to his urban clientele, reducing the distance between town and country, intermingling people from both walks of life, and making his peasants more prosperous and respectable. This differs markedly from the

fig. 2. David Teniers the Younger, *Kermis before the Half-Moon Inn*, 1641, oil on canvas, Gemäldegalerie Alte Meister, Dresden

older tradition of representing city visitors as privileged observers of the kermis, as in Teniers' painting.

Steen was a born storyteller who was unfailingly considerate of his audience. Here he presents the viewer with a range of possible responses. The jocular comic type at right, who looks out of the picture, prompts the viewer to laugh in a fully participatory way.[8] In contrast, the dignified man at the table regards the scene with detached amusement. And the woman at the doorway, who by virtue of her placement and frontal position is the viewer's most direct counterpart, is stern and judgmental. Finally, the woman at the chalk board who keeps count of the drinks may remind us that there will be a final reckoning, a price to be paid for indulgence.

The Toledo panel, which is in an excellent state of preservation, is notable for its extremely fine handling, crisp and airless quality, and sharply selective lighting, as well as for the clean and neat lines of the rustic architecture. These stylistic features suggest that Steen painted this work shortly after the looser *Village Festival with the Ship of Saint Rijn Uijt* (cat. 4), with its same fat fellow in the foreground and its similar rendering of trees, and before the more sophisticatedly composed *The Village Wedding* (cat. 6).

HPC

1. This picture is probably not the one listed as Smith 1829–1842, nos. 28 and 133, nor Hofstede de Groot 1907, no. 645, with which it has traditionally been identified.

2. For the bagpipes as an instrument with rural associations and the lower classes in general, see Vandenbroeck 1984, 101–102.

3. For the associations between smoking and dissipation, see Amsterdam 1976a, 54–57, cat. 7.

4. Recent studies of sixteenth- and seventeenth-century peasant imagery include Vandenbroeck 1984, Vandenbroeck 1987; Moxey 1989; and Sullivan 1994. For an analysis of the peasant imagery in the context of literary and artistic genres, see Raupp 1986 and its review by Vandenbroeck 1988.

5. For the pastoral image of the peasantry, Vandenbroeck 1984, 83. See also Schnackenburg 1981 on Adriaen van Ostade.

6. The greater idealization of peasant life in Teniers' paintings may be related to his social position as a court painter to the Archduke Leopold Willhelm, Governor of the Spanish Netherlands (1646–1657).

7. See page 59.

8. Westermann calls the figure, which appears repeatedly throughout Steen's career, the "laughing prompt."

6

The Village Wedding

1653

signed at lower left: *JSteen 1653* (*JS* in ligature)
canvas, 64 x 81 (25 ¼ x 31 ⅞)
Museum Boymans-van Beuningen, Rotterdam (on loan
from the Rijksdienst Beeldende Kunst)

PROVENANCE

Possibly sale, Jacob Cromhout and Jasper Loskart, Amsterdam,
7 May 1709, no. 8 (fl. 350); possibly sale, Samuel van Huls et al.,
The Hague, 24 April 1737, no. 88 (fl. 69); sale, Pieter de Smeth
van Alphen, Amsterdam, 1 August 1810, no. 95 (fl. 2250 to De
Vries); H. van Winter, Amsterdam; Six van Hillegom, Amster-
dam, by 1833; J. P. Six, Amsterdam, by 1856; by descent to J. W.,
Jhr. Six van Vromade; sale, Six, Amsterdam, 29 June 1920, to
F. Mannheimer, Amsterdam; after World War II the painting
became property of the Netherlands, administered by the Dienst
voor 's Rijks Verspreide Kunstvoorwerpen, later Rijksdienst
Beeldende Kunst (National Service for Dispersed Works of Art),
The Hague; lent to the Museum Boymans-van Beuningen, 1948

LITERATURE

Smith 1829–1842, 4:26, no. 84; Van Westrheene 1856, 104, no. 26;
Hofstede de Groot 1907, no. 455; Bredius 1927, 53; Martin 1954, 32,
78; Boymans-van Beuningen 1962, 134, no. 2314; Braun 1980, 92,
no. 56

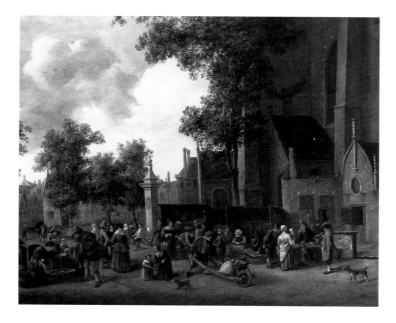

fig. 1. Jan Steen, *Riverfish Market in The
Hague*, c. 1652–1654, oil on panel, Haags
Historisch Museum, The Hague

After the marriage rites had been performed at a church or town hall, it was the custom, in seventeenth-century Holland, for the bridal party to make a procession to the groom's house, or to an inn. There the bride was welcomed and the marriage celebrated with lavish feasting, dancing, and entertainment that might last several days.[1] In *The Village Wedding*, Steen has represented the bride's arrival as a joyous and lighthearted comedy in keeping with the tradition of comic festive wedding imagery.[2] Standing in bright sunlight at the center of the composition, the bride, her eyes demurely downcast, is the focus of everyone's attention, including the dog. She wears an elegant satin gown of silvery white with a blue underskirt and, as a symbol of her chastity, her hair is loose and her head is uncovered except for a small bridal crown. She is preceded by a colorfully attired bridesmaid strewing flowers from a basket and accompanied by two older, matronly women, each of whom wears a striking headdress. The woman to the right of the bride wears a *huik*, a cape with a weighted hood from which protrudes a pom-pom, and the one at left wears a billed variation of the *huik*. By Steen's time, these elaborate hoods must have seemed comically provincial and outdated, suggesting that this is a rural village or that the bride has come from far away, which would be supported by the small size of her entourage. Though they were worn in the northern provinces, they may have been associated with the Spanish governed Southern Netherlands, which would have enhanced a comic reading of the picture. Since the Dutch Revolt, when the United Provinces had gained independence from Spain, the Southern Netherlanders had been the butt of ridicule and derision.

Adding to the comic effect is the groom eagerly bounding down the steps, his hat doffed, to greet his bride. Steen brilliantly pokes gentle fun at his exaggerated gallantry, which he contrasts with her reserve. His antiquated large ruff collar and billowing cape associate him with the stock theatrical suitor that was based on the caricature of a Spanish soldier. This dandified military captain, whose amorous adventures frequently left him the victim of deception, was satirized in such plays as Bredero's *Spanish Brabanter* (1625).[3] Indeed, Bredero's ridicule of the foolish Spanish Brabanter is evident in a scene where Jerolimo, the protagonist, preening, asks his servant "And how's my ruff? Is it right for me?" Robbeknol replies, with marvelous exaggeration, "What a question master. Your apparel suits you so well, in such comely wise, It seems your mother formed you in the womb to wear such clothes."[4] Presumably, the picture's popular title, *"The Spanish Bride,"* which was used in reference to it or another of Steen's wedding paintings as early as 1709, derives from the Spanish connotations of its comic theatrical characters and costumes.[5]

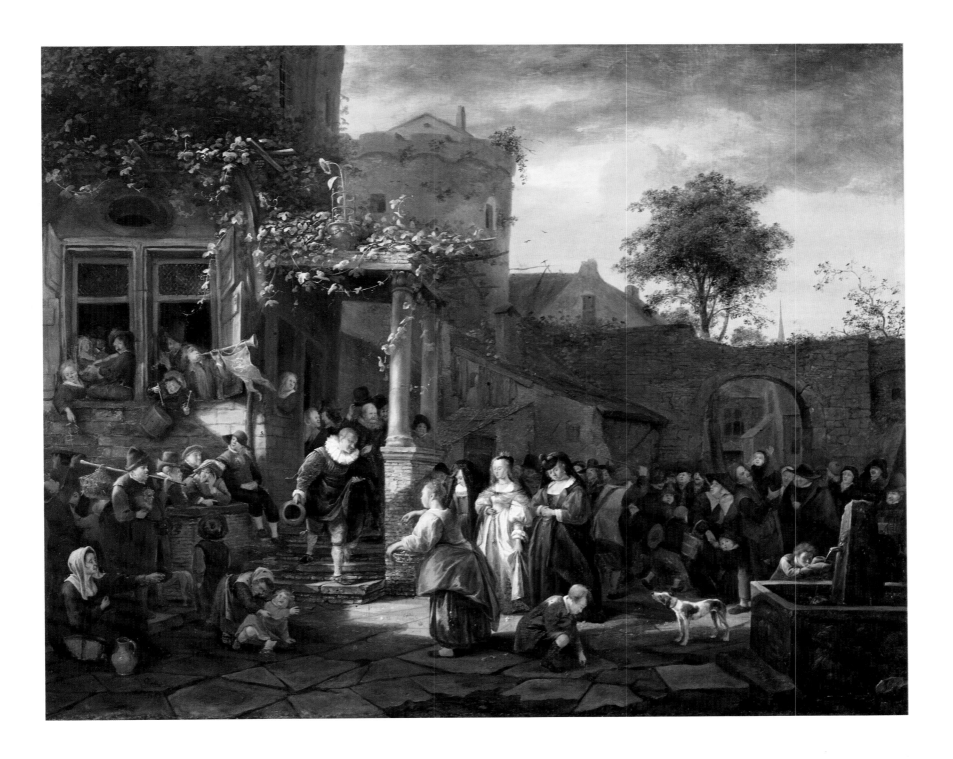

Subsidiary figures enrich the painting's festive effect and reveal, already at this early stage of his career, Steen's genius at depicting a range of human emotions and expressions. Behind the groom, well-dressed guests spill out on the porch to welcome the bride. Among the musicians leaning out the window, a trumpeter heralds her arrival while a drummer probably announces that a celebratory oration is about to be read by a *rederijker*, or rhetorician (see cat. 24). All of this transpires before an audience of villagers, who crowd into the courtyard to get a glimpse of the festivities and, perhaps, to take part in the feasting, for it was the custom for the wedding party to provide food for the poor. Just behind the bride, a man with a stick chases away two misbehaving boys. Otherwise the gawking crowd is well-behaved. Several children—one held up by a man and another pulling at a woman's arms, a boy drinking from his hat at the fountain, and an older boy kneeling to pick up flowers—enhance the picture's sympathetic charm.

A smaller group of onlookers at the left are treated more comically. Beside the poultry seller with a chicken under his arm and a cage on a pole are two men who comment and point. This comic exchange and the relief on the fountain of a man on horseback abducting a woman, combined with the gently mocking theatricality of *The Village Wedding*, has led some authors to suggest that Steen has drawn on the tradition of the "dirty," or pregnant, bride.[6] Although Steen would later represent the "dirty bride" theme in *The Deceitful Bride and the Deceived Bridegroom* (cat. 45, fig. 1), nothing here confirms that there is anything improper in this union. Indeed, several elements in the picture suggest the opposite: the sunflower on the porch roof symbolizes constancy in love because this flower faithfully follows the sun; the vines represent mutual trust, friendship, and interdependence in marriage; and the dog often stands for marital fidelity.[7] However, such humorous, mildly titillating innuendo is characteristic of Steen's comic narratives. To his contemporaries, familiar with the pictorial and theatrical traditions of the dirty bride, the snickering, derisive spectators may well have been enough to raise the possibility that something is amiss here.

The Village Wedding, which Steen painted in 1653 when he was living in The Hague, has rightly been regarded as one of his early masterworks. Like the somewhat earlier *Riverfish Market in The Hague* (fig. 1) and *The Horse Fair at Valkenburg* (page 70, fig. 2), which exhibit a similar soft handling of foliage and architectural elements, this work shows the impact of Steen's training in Haarlem with Adriaen (1610–1685) and Isack van Ostade (1621–1649), tempered by his experience, in The Hague, of the late landscape drawings of Jan van Goyen (1596–1656) and the multi-figured genre scenes of Adriaen van de Venne (1589–1662).[8] Compared to the *Riverfish Market*, *The Village Wedding* is a more sophisticated, mature painting that provides a clearer sense of Steen's highly individual artistic personality and a sense of the direction his work would take in the future. Steen captivates his audience through the compelling yet humorous characterizations of his players and through the suggestive, open-ended quality of his narratives. The Rotterdam painting is the finest of several similar wedding scenes from the 1650s (see fig. 2), the repetition of which suggests there was a market for such pictures among an urban audience nostalgic for a comic-pastoral image of village life.

The Village Wedding also demonstrates Steen's eclectic, witty approach to pictorial tradition. Though the most immediate prototypes are Dutch—Isack van Ostade, Thomas Adriaensz Wyck (c. 1620–1677), and David Vinckboons (1576–1632?)—the peasant wedding theme had been made famous by Pieter Bruegel the Elder (c. 1515–1569).[9] As he would do with other traditionally low-life subjects, Steen has transformed the peasant wedding into a middle-class theme by elevating the social status of the bridal pair. Indeed, it is as if he has inverted the tradition of representing elegant onlookers at peasant festivities by making the rustics the spectators.

He has also transformed the theme by introducing a level of heightened artistic self-consciousness. According to Carel van Mander (1548–1606), Bruegel attended peasant weddings disguised as a guest in order to draw peasants and their customs *naer 't leven* (from life).[10] In light of this claim about realistic images based on studies from life, it is notable that Steen based this picture on art. Indeed, his affirmation of artistic borrowing is evident in his references to the art of Rembrandt (1606–1669): not only is the dramatic lighting scheme Rembrandtesque, but the urchin being helped up by a child (in the left foreground) is a direct quotation in reverse from Rembrandt's 1635 etching *The Pancake Woman* and the snickering men and beggar woman are closely reminiscent of figures in the *Hundred Guilder Print*.[11]

HPC

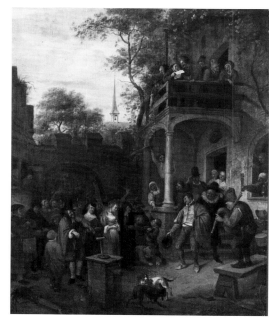

fig. 2. Jan Steen, *The Arrival of the Bride*, c. 1655–1656?, oil on panel, © Fundación Colección Thyssen-Bornemisza, Madrid

1. Apeldoorn 1989, 154–187. Wedding celebrations often led to such excess that local authorities enacted and enforced laws to limit the number of guests and the duration of the feast. I would like to thank Karen A. Sherry for her insightful comments.

2. Vandenbroeck 1984; Barolsky 1990.

3. Gudlaugsson 1945, 30–46.

4. Bredero 1982, 63–64; my thanks to Alexa Longley for this reference.

5. See sale 7 May 1709, no. 8.

6. Sutton in Philadelphia 1984, xlviii. On the theme of the dirty bride see Vandenbroeck 1984, 87–93; Sullivan 1994, 58, 72–73.

7. On the sunflower see Haarlem 1986, 90–92, with additional bibliography. Jacob Cats advised a young woman to focus her attention on her lover as the sunflower turns toward the sun: "En weest aen uwen man een rechte Sonne-blom," Cats 1665, 85. See also Van Veen 1608, 74–75. For vines in marriage portraits, Haarlem 1986, 124–129; see also cat. 13 n. 10.

8. Martin 1927–1928, 331; Thyssen-Bornemisza 1989, 221.

9. On the peasant wedding theme, see Vandenbroeck 1984. On Wyck, see Schnackenburg 1992, 147–149.

10. Van Mander 1604, fol. 233r.

11. Other sources that have been suggested include *The Holy Family in Egypt* from Durer's *Life of the Virgin* series; Thyssen-Bornemisza 1989, 220–221.

7

The Burgher of Delft and His Daughter

1655

signed: *JSteen 1655* (*JS* in ligature)

canvas, 82.5 x 68.6 (32 ½ x 27)

Private collection

Amsterdam only

PROVENANCE

Sale, Comte de Vence, Paris, 9–17 February 1761, lot no. 109 (high price of 250 livres); sale, Engelbert Michael Engelberts and Jan Tersteeg, Amsterdam, 13 June 1808, no. 142 (fl. 75 to Nieuwenhuys); sale, Domsert, London, 1811 (£88 to Charlesson); sale, Alexis Delahante, London, 2 June 1814, no. 18; Christianus Johannes Niuwenhuys, London; bought from him by Colonel Edward Gordan Douglas Pennant, 1st baron Penrhyn, Penrhyn Castle, Wales; to the present owner

LITERATURE

Pennant 1902; Hofstede de Groot 1907, no. 878; Rotterdam 1935, no. 78a; Martin 1954, 33–34; The Hague 1958, no. 7; London 1976, 82–83, no. 103; De Vries 1976, 27; De Vries 1977, 39; Braun 1980, 96, no. 78; Washington 1985, 365, no. 294; Schama 1987, 573–575; Smith 1988, 54–56; Muller 1989; Berlin 1991b, 240; Smith 1990, 165, 167

Of the few portraits Jan Steen painted, most—this picture, *The Leiden Baker Arend Oostwaert and His Wife Catharina Keyzerswaert*, *The Poultry Yard*, and Van Goyen family portrait (cats. 8, 12, and page 20, fig. 14)—are remarkably varied and unconventional. With the exception of the Schouten pairs (cat. 29a–b), Steen seems to have regarded each portrait as a challenge to bring life to the sitters by resorting to strategies of genre painting.[1] It is easy to imagine that conventional portraiture would have had little appeal to a painter with Steen's comic bent and ambitions as a painter of narratives. Houbraken implies as much in his anecdotal account of how Steen could not resist enlivening a formal portrait of his wife by Carel de Moor (1656–1738), by adding the props of her trade as meat seller.[2] The masterful *Burgher of Delft and His Daughter*, Steen's earliest known venture into portraiture, partakes of this merger of genres, while retaining a strong degree of decorum. Given that we know the names of virtually all of Steen's other sitters, it is especially vexing that the identities of these, his most dignified, imposing subjects, remain unknown.[3]

The burgher and his daughter are posed on the stoop of a house, presumably their own, on the Oude Delft canal, at the time one of the most prosperous residential canals in Delft. The brewery that Steen operated from 1654 to 1657 was on its opposite side.[4] On the bridge, at right, is the coat of arms of the city (not of the sitter, which one would expect in a portrait) and just above it a well-dressed citizen. Visible in the distance are, most prominently, the tower of the Oude Kerk on the right and, above the burgher's shoulder, the Delflands Huis and the Prinsenhof on the left. Originally built as the Sint Agathaklooster, the Prinsenhof in 1597 became the headquarters of the Kamer van Charitaten, the municipal organization charged with overseeing charitable giving in Delft.[5]

The Burgher of Delft and His Daughter juxtaposes the haves with the have-nots in order to celebrate the sitter's civic virtue.[6] Steen was a genius at adapting portrait formats to his sitters' social rank and needs: compare this patrician image with his treatments of the tradesman in cat. 8 and aristocratic child in cat. 12. While we do not know who the sitters are, we can assume that the man commissioned the work. To judge by his costly fashionable clothing and prestigious address and by the urban portrait mode, he must have been a prominent member of Delft's governing regent class. The description of him as a burgomaster as early as 1761 suggests he may have

fig. 1. Rembrandt, *The Hurdy-Gurdy Player and His Family Receiving Alms*, 1648, etching, National Gallery of Art, Washington, Rosenwald Collection

held that office.[7] His authoritative seated, frontal pose, with arm akimbo, makes him the focal point of the picture and marks him as master of the two domains he straddles, his home and the town.[8] His private realm is represented by his house, with its beautiful still-life of flowers in a glass vase on the window sill, and, above all, by the girl, presumably his daughter. Her somewhat distant formal pose, her elegant finery of exquisitely rendered satin in a subtle harmony of silver and copper tones, and her fashionable pointed shoes are all in keeping with current portrait conventions and probably reveal the impact of Gerard ter Borch (1617–1681). The absence of wife or mother in this portrait leads us to wonder whether the burgher is a widower and whether that in part determined Steen's decision to represent the poor as a woman, presumably a widow, with a boy. The disjunction between these genre types and the portrait-like formality of the sitters and, in particular, the apparent disengagement of the daughter have led modern critics, with little justifica-

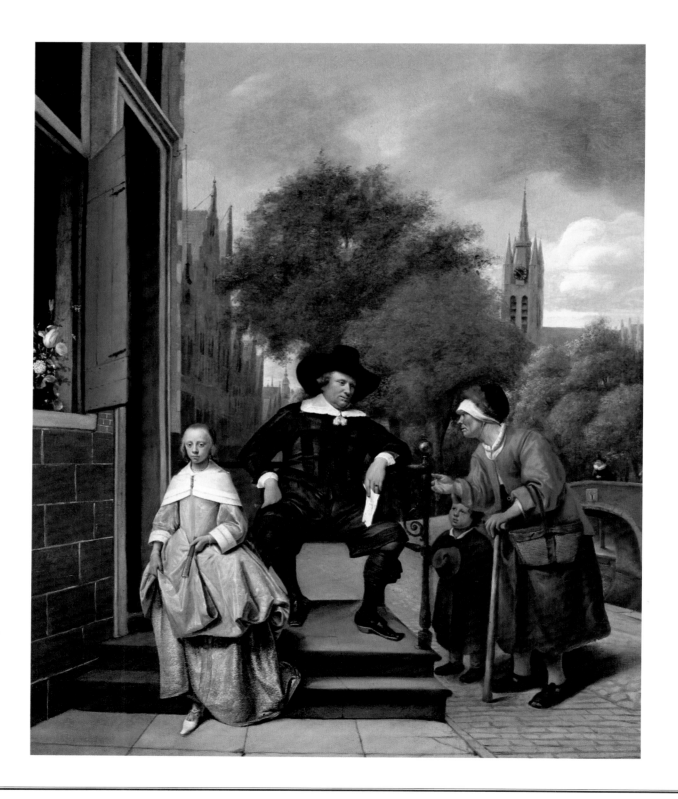

fig. 2. Jan Steen, *Ladies Listening to Musicians*, 1659, oil on panel, Ascott House, National Trust

tion, to read into this picture ironic criticism of the elite.[9]

It is far more likely that to Steen's contemporaries this image would represent the natural social order by conveying the burgher's moral imperative to act in the public realm. His civic responsibility is represented by the townscape, with its church and municipal buildings, and by the two so-called beggars. These humble yet respectable suppliants probably belong to the ranks of the *rechte armen* (right or deserving poor), as opposed to the vagrants, vagabonds, and the like, who were prohibited from begging.[10] The paper the burgher holds may be a document that legitimizes their dependency.[11] Though naturalistic in many respects, *The Burgher of Delft and His Daughter* presumably does not depict an actual encounter. Steen has distinguished the dignified petitioners from the portrait's sitters by portraying them not as individuals but as types. Indeed, as if to underscore her status as generic poor, he quoted the woman from Rembrandt's etching

The Hurdy-Gurdy Player and His Family Receiving Alms of 1648 (fig. 1).[12] Like the many Dutch group portraits of regents of charitable organizations, this image of alms giving speaks broadly to the benefits of private and public charity to society. Mariët Westermann has proposed, more specifically, that it affirms the burgher's good judgment. In seventeenth-century Holland there was great concern to distinguish lazy, deceiving beggars from those misfortunates truly deserving of assistance. Jacob Cats describes the proper distribution of charity as the outcome of careful decision making. This burgher's stern yet sympathetic regard for his petitioners suggests his generosity is well considered.[13]

Artistically, the painting fully participates in the distinctive visual culture of Delft. Steen was remarkably chameleon-like in his ability to assimilate and transform the styles of different artists in the places in which he lived. By the mid 1650s, painting in Delft was distinguished by a near-scientific interest in optics and in the naturalistic rendering of light and space, and by a fascination with architectural painting and city views. These concerns were already evident in the church interiors of Gerard Houckgeest (c. 1600–1661) and Emanuel de Witte (c. 1617–1692) and they would shortly play out in the work of Vermeer (1632–1675) who, in 1655, was just embarking on his career. Steen's absorption of the Delft style is evident in the bright lighting and townscape setting of *The Burgher of Delft and His Daughter*. Specifically, he must have been impressed by the works of Carel Fabritius (1622–1654), who had died the previous year in the explosion of the gunpowder warehouse: Fabritius' *View in Delft With a Musical Instrument Seller's Stall* (National Gallery, London) of 1652 seems to have inspired Steen's composition and rendering of the town.[14] *The Burgher of Delft* is also indebted to the doorway scenes of Nicolaes Maes (1634–1693), who like Fabritius had trained with Rembrandt (1606–1669) and was now living in Dordrecht.[15]

Especially early in his career, Steen appears to have had a knack for galvanizing artists around him wherever he worked, witness his pictorial dialogue with Frans van Mieris (1635–1681) in Leiden. In this case, his composition seems to have had a significant impact on Pieter de Hooch's (1629–1684) courtyard scenes, evident most clearly in his *Portrait of a Family in a Courtyard* (Akademie der Bildenden Kunsten, Vienna).[16] Quite likely, then, Steen set in motion a compositional type that would be picked up by De Hooch and Gabriël Metsu (1629–1667), but that he

himself would repeat only once, in his *Ladies Listening to Musicians* (fig. 2) of 1659. Though presumably not a portrait, this picture shares with *The Burgher of Delft and His Daughter* the contrasts of rich and poor, home and town.

HPC

1. Westermann 1995 discusses Steen's merger of portraiture and genre.

2. Houbraken 1718–1721, 3:25–26

3. Hofstede de Groot 1907, no. 878, identified the man as Gerard Briell van Welhouck, Burgomaster of Delft in 1660, and his daughter, but this identification cannot be substantiated.

4. See pages 29–30.

5. Muller 1989, 281. The building served as a charitable institution until the early 1650s. In 1652 a new Oude Vrouwen Charitatenhuis was built west of the cloister buildings.

6. Schama 1987, 573–575; Muller 1989 interprets this painting against the background of Dutch and, more specifically, Delft political and historical circumstances.

7. Sale, Comte de Vence, Paris (Remy), 9–17 February 1761, no. 109, cited in Westermann 1995, n. 64.

8. For the arm akimbo, see Spicer 1991, 84–128. Smith 1988, 54–56; and Smith 1990, 165–171, discusses the image of the threshold and the opposition between public and private in this and other works.

9. Martin 1954, 33–34; The Hague 1958, no. 7; Braun 1980, no. 78.

10. On charity in the Dutch Republic and the regulation of begging, see Muller 1989; Schama 1987, 578–583.

11. Schama 1987, 575; Muller 1989, 274; Westermann 1995, 313–315. Schama suggests the paper is their license to beg.

12. Smith 1988, 54–56; Berlin 1991b, 239–240.

13. Westermann 1995, 315.

14. Smith 1990, has argued that Fabritius' destroyed *Family Portrait* of 1648, known through a drawing by Victor de Stuers, provided a precedent for Steen's merger of genre and portraiture.

15. See, especially, Maes' *Portrait of a Family on Their Doorstep* (Museum Boymans van Beuningen, Rotterdam) and *Women Giving Alms to a Young Boy* (present whereabouts unknown), illustrated in De Vries 1976, 27. See De Vries 1977, 39.

16. For Steen's impact on De Hooch, see Sutton 1980, 24–25; and Philadelphia 1984, xlviii.

8

The Leiden Baker Arend Oostwaert and His Wife Catharina Keyzerswaert

c. 1658
signed at lower left: *JSteen* (*JS* in ligature)
panel, 37.7 x 31.5 (14 ⅞ x 12 ⁷⁄₁₆)
Rijksmuseum, Amsterdam

PROVENANCE

According to a label on the back of the panel, this painting was still with the sitters' descendants in 1738;[1] sale, J.P. Wierman, Amsterdam, 18 August 1762, no. 45 (Dfl. 160 to Calcoen); sale, Pieter Calckoen Willemsz, Amsterdam, 10 September 1781, no. 121 (Dfl. 181 to Van der Pot); sale, Gerrit van der Pot van Groeneveld, Rotterdam, 6 June 1808, no. 119 (Dfl. 705) to Joh. Eck & Zn. on behalf of the Koninklijk Museum, later Rijksmuseum, Amsterdam

LITERATURE

Smith 1829–1842, 4:4, no. 10; Van Westrheene 1856, 98, no. 4; Thoré-Bürger 1858–1860, 1:117; Hofstede de Groot 1907, no. 872; Moes and Van Biema 1909, 113, 181; Bicker Caarten 1949, 88–89; Robinson 1974, 31; Rijksmuseum 1976, 522; De Vries 1977, 34, 41, 43; Welu 1977, 3; Braun 1980, 98, no. 102; Rotterdam 1983, no. 181; Chapman 1993, 145

This small painting is a witty and convincing combination of portraiture and genre. The baker, Arend Oostwaert according to the label on the back of the picture, has walked out of his shop in his working clothes with freshly baked bread on a peel—the implement used for removing loaves from the oven.[2] Bakers used to blow a horn to let people know that the fresh bread was ready, but on this occasion he has delegated the task to the little boy. The eighteenth-century label states that this is one of Jan Steen's sons; if that is true, it must be Thaddeus, who was seven years old in 1658. Standing in the door of the shop is the baker's wife, Catharina Keyzerswaert—an identification also taken from the old inscription. She is holding up a *zottinnekoek*, a kind of rusk, which she has taken from the basket beside her.[3] Steen gave the rusk a splendid craquelure—a private joke that undoubtedly delighted him. The *duivekater* loaf leaning upright against the wall occupies a prominent position in the still-life display of bread.[4] The pretzels dangling from the pegs above take the place of the usual signboard. The rolls on a rack behind the baker are immediately above the boy's horn. The idea behind this visual joke is probably that, for a change, the viewer is not expected to think of boys blowing bubbles. *Homo bulla* then becomes "Man is a bread roll." The suggestion is of a cornucopia, or horn of plenty, filled with bread by the baker.[5]

The woman and the boy are very well dressed indeed, certainly compared to the baker. Several pentimenti in the woman's clothing show that Steen originally intended to give her more colorful attire. The baker's shirt was originally less open, and another alteration affected the perspective of the projecting wooden cellar, which was initially seen far more from the side. These modifications make it clear that the scene should not be taken too literally as a mirror of everyday life. This is underscored by the careful arrangement of the loaves, with the bread on the peel being included seamlessly in the still life.

The 1738 label on the back of the panel contains some remarkably precise pieces of information. Unfortunately, it was transcribed with quite a few errors in the past and is now severely worn.[6] Until recently, the label had been read as "more than 79 years ago," which dated the painting to 1658. However, the very first transcription, made in 1808, recorded this as "70 years ago." Perhaps the figure did read "79" at some stage, but today the last digit appears to be "0."[7] The baker and his wife were betrothed

fig. 1. Adriaen van Ostade, *Baker with a Young Customer*, c. 1650, oil on panel, Hermitage State Museum, St. Petersburg

18 August 1657 in Leiden and married 7 September of that year in Utrecht; therefore, they possibly commissioned the double portrait to mark the event.[8] Stylistically, too, a date in the late 1650s is the most plausible. In view of the time of year when they married, incidentally, it seems unlikely that the vine would have been in leaf. It may have an allegorical significance, possibly alluding to marital fidelity.[9] Vines, however, are found in other paintings of bakers in front of their shops unaccompanied by spouses; examples can be cited in the oeuvres of Adriaen van Ostade (1610–1685), (fig. 1) and Gabriël Metsu (1629–1667).[10]

The very precise address "on the Rhine," between the Vrouwensteeg and the Catharinagasthuis, can be identified as the present-day Aalmarkt. This does not necessarily mean that the baker was living there when his portrait was painted. At his betrothal, Oostwaert stated that he was living in the Coornbrugsteeg.[11] He undoubtedly moved from the Coornbrugsteeg to "the Rhine" at some point, but whether he did so shortly after his marriage or a little later is not known. Family records are not usually

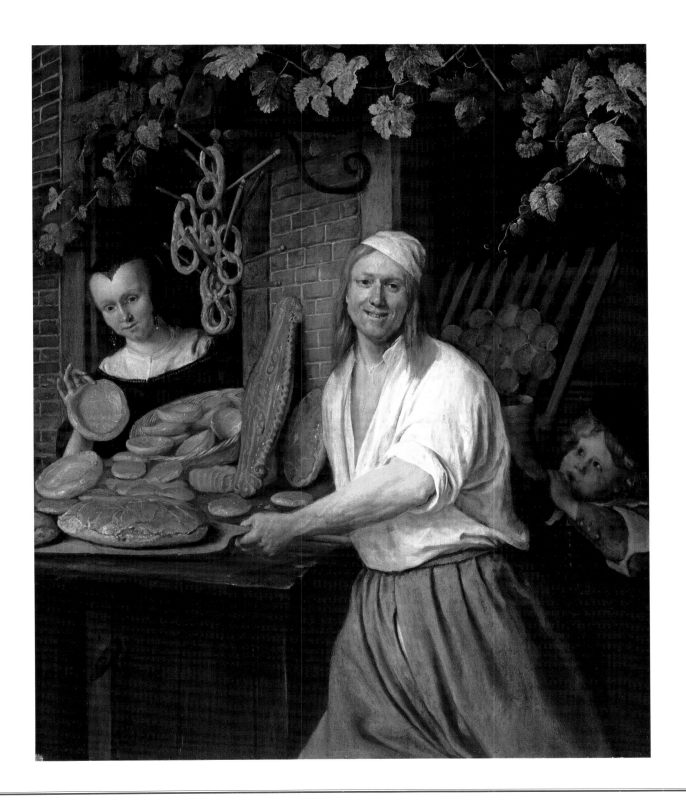

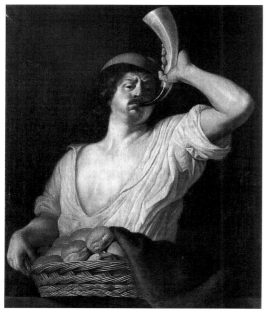

fig. 2. Christiaen van Couwenbergh, *Baker Blowing a Horn*, 1650, oil on canvas, Museum Mayer van den Bergh, Antwerp

that accurate. The uncommonly specific dating of the label—assuming that "more than 79" is correct—was undoubtedly prompted by the age of its writer, who clearly knew that the picture was painted around the time of the sitters' marriage.[12]

The inscription also identifies the little boy, whom Steen introduced as an extra genre element.[13] It is interesting that figures in Steen's paintings were being associated with his family at such an early date. The main point for Oostwaert's descendants, however, may have been to establish that the boy was not one of their kin.

Steen took great trouble to depict each individual brick in the wall. The structure itself remains ill defined in every respect and even recalls the odd buildings that Pieter Aertsen (1509–1575) and his sons used to paint in their genre scenes. This precision recalls Steen's *Rhetoricians at a Window* (cat. 24), where the wall is a key part of the picture and may even be an allusion to the artist's name—*steen* meaning stone, or brick, in Dutch.

Steen was not the first to portray a baker in his working clothes. Although it has been assumed that Adriaen van Ostade (1610–1685) preceded him, the point is not

easy to prove since Van Ostade's two paintings of the subject are undated. The closest of the two is his *Baker with a Young Customer* in St. Petersburg (fig. 1). Although the baker is shown blowing the horn, the presence of the child and the vine tendrils surrounding the door make for a remarkably close relationship to Steen's painting.[14] Van Ostade's bakers give the impression of being nonspecific representatives of this group of tradespeople. However, his brother Johannes was a baker, which is why this painting is assumed to be his portrait. A similar problem of identification arises with Christiaen van Couwenbergh's *Baker* of 1650 in Antwerp (fig. 2). Although sometimes considered a self-portrait, the painting could just as easily depict a Hague baker portrayed by Van Couwenbergh (1604–1667) with his usual overdose of standardized facial types. This, incidentally, is a picture that Steen could have seen, for he was living in The Hague in 1650.[15]

Steen painted tradespeople several times around 1660, and some of those pictures, such as the *Poultry-Seller*, *Fish-Seller*, and *Children at the Market* in Hamburg, bear a strong resemblance to works by Gabriël Metsu.[16] Steen's painting entitled *The Milkman* (fig. 3), in which a baker blows his horn in the background, is actually more reminiscent of Adriaen van Ostade's well-known etching than is the painting discussed here.[17]

Bakers still followed the custom of blowing a horn in the nineteenth century—in the morning when the fresh bread was ready and in the evening when the halfpenny loaves went on sale.[18] Horns were still used in the early years of the present century but were abandoned as a result of the Bakeries Act of 1912, which also led to the disappearance of some delightful children's rhymes.[19]

WTK

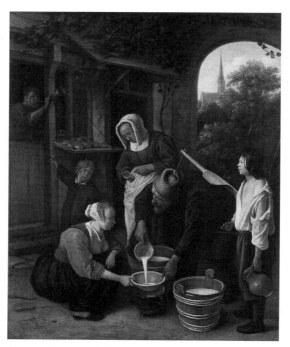

fig. 3. Jan Steen, *The Milkman*, c. 1652–1658, oil on canvas, present whereabouts unknown

1. The following is the traditional, nineteenth-century reading of this eighteenth-century inscription (with illegible passages set in brackets): *Dit is een Familje Stukje,/ [De Backer] is t Portret van Arend Oostwaa[rd]./ De vrou Catarina Keijserswaard/ De Jonge is gedaan naer een jonge van Jan Steen. Dese Backer met zijn Vrou hebben gewoond op den/ Rhyn 3 à [4] Huijs[en] vande vrouwebrugge, tussen de Vrouwesteegh en g[asthuys binn]en Leyden./ Is nu, January 17[38], [ruim] 70 Jaaren geleden geschildert.* (This is a family piece. The baker is the portrait of Arend Oostwaert, the woman Catharina Keyzerswaert. The boy is done after a son of Jan Steen. The baker and his wife lived on the Rhine in Leiden, three or four houses from the Vrouwenbrug, between Vrouwensteeg and the hospital. Now, January 1738, painted more than 70 [an old transcription gives 79] years ago).

2. See Rotterdam 1983, 32.

3. The 1781 sale catalogue states that the woman is holding a *carsteling*, but the sale catalogue of 1808 speaks of a *zottinnekoek*.

4. A *duivekater* loaf features in both of Steen's depictions of the feast of Saint Nicholas: the loaf in the Rotterdam version is very similar to the one in the present painting; see cat. 31.

5. The goddess Ceres with the horn of plenty is the most familiar combination. See also Rotterdam 1983, fig. 62, for a nineteenth-century baker's signboard with Ceres and a cornucopia.

6. Unfortunately, both the year and the word *ruim* are no longer legible. The figure "79" can now only be read as "70." The inscription in the Van der Pot sale catalogue contains relatively few errors.

7. According to Théophile Thoré in his *Musées de la Hollande* (published in 1858 under his pseudonym William Burger), the painting bore the clearly legible date of 1659.

8. Bicker Caarten 1949, 89. The seventeenth-century spelling of the names was found preferable to the eighteenth-century variants given on the label on the back of the panel. The Utrecht sound of the couple's names (-waard, -weert) is not deceptive, for both families came from that city.

9. For the vine and marriage symbolism see Haarlem 1986, 295. Steen may have painted the vine tendrils in order to close off the picture at the top, for they are repeatedly found in that position in his oeuvre. See, for example, the *Couple Sleeping on a Terrace*, in the Samuel Collection, London, Braun 1980, no. 93, where it is an allusion to drinking wine, and *The Weary Traveler*, cat. 14, fig. 2.

10. For Metsu see Robinson 1974, fig. 40. It is difficult to say how this undated painting relates to Jan Steen. What is clear is that it must have been a model for Job Berckheyde's well-known *Baker Blowing His Horn*; see Welu 1977. Vines are also found in many other paintings, where they often surround the entrance to an inn. The window in Steen's *Rhetoricians at a Window* (cat. 24) is topped with the branches of a vine, which is undoubtedly a reference to the rhetoricians' favorite tipple.

11. Havick Steen, the artist's father, grew up near Coornbrug in a house called The Bock, which he sold in 1656. Arend Oostwaert, who was living in Coornbrugsteeg when he got betrothed, was born in Nieuwsteeg in the heart of Leiden. Thus there is a very good chance that the painter and the baker had already met. Steen included the Coornbrug in one of his early paintings, albeit from a distance; see his *Fish Market* in Frankfurt, Braun 1980, no. 9.

Oostwaert killed one François Lobel on 3 December 1681 and then fled the city. An Arent Oostwaert was buried in Leiden from the Nieuwe Rijn on 16 July 1695. With thanks to Marten Jan Bok for this information.

12. The couple had offspring; see Bicker Caarten 1949, 89 n. 1.

13. The boy's features are almost identical to those of the lad in the background of the Rotterdam *Feast of Saint Nicholas*, cat. 30, fig. 1. He is also present in *The Twins* in Hamburg, Braun 1980, no. 294. It is worth pointing out that his appearance in the latter painting, which dates from 1668, makes it clear that the presence of one of Steen's own children in a painting provides a date *post quem* and nothing more. On this point see also De Vries 1977, 43.

14. There is a fine description of this painting in Rooses 1908, 117.

15. For the painting by Adriaen van Ostade and the related etching (B 7) see Rijksmuseum 1976, 431, no. A-301, and Athens (Georgia) 1994, 53–57. In the latter work Slatkes dates the etching c. 1668 and the painting in the late 1640s. For the painting by Christiaen van Couwenbergh see Welu 1977, 5; Rotterdam 1983, no. 62, fig. 39; and Maier-Preusker 1991, 184, no. A 51. Van Couwenbergh's picture seems to derive from Adriaen van Ostade's ideas.

16. Braun 1980, nos. 105, 148, and 147.

17. Sale, London (Sotheby's), 9 July 1975; The Hague 1958, no. 8, fig. 9; Braun 1980, no. B-65, rejects the painting, in my view incorrectly, and attributes it to the otherwise totally unknown G. Brakenburg.

18. Rooses 1908, 117–118.

19. See, for example, Bicker Caarten 1949, 89.

9

Girl Offering Oysters

c. 1658–1660

monogrammed above the door: *IS*

panel, 20.5 x 14.5 (8 ¹/₁₆ x 5 ¹¹/₁₆)

Royal Cabinet of Paintings Mauritshuis, The Hague

PROVENANCE

Sale, Pieter Locquet, Amsterdam, 22 September 1783, no. 349
(fl. 501 to Van Winter); Hendrik van Winter, Amsterdam;
by inheritance to Six van Hillegom, Amsterdam, by 1833;
J. P. Six, Amsterdam, by 1856; by descent; sale, Six, Amsterdam,
16 October 1928, no. 45, to Sir Henri W. A. Deterding, London;
gift by Deterding to the Koninklijk Kabinet van Schilderijen het
Mauritshuis, 1936

LITERATURE

Smith 1829–1842, 4:13, no. 41; Van Westrheene 1856, 104, no. 25;
Hofstede de Groot 1907, no. 853; Bredius 1927, 68; London 1930,
95, no. 191; De Jonge 1939, 50; De Groot 1952, 183; Mauritshuis
1954, 82, no. 818; The Hague 1958, no. 16; De Vries 1976, 24 and
49; Mauritshuis 1977, 228, no. 818; De Vries 1977, 48 and 161, no.
s84; Braun 1980, 27 and 98–99, no. 92; Broos 1987, 345–349, no. 57

In the smallest yet surely one of the greatest of his mas-
terpieces, Jan Steen drew on the extremely fine technique
of the Leiden painters to create a brilliant variation on a
popular pictorial theme, the oyster meal, that was associ-
ated with love and sexual seduction.¹ A charming young
woman flirts with the viewer as she sprinkles salt on an
oyster. On the table before her is an exquisitely painted
still life of several more opened oysters, a silver tray with
a small mound of salt, a packet of pepper and a half-
eaten bread roll, and a glass of wine beside a Delftware
pitcher. In the kitchen, visible through the open door a
man and a woman, presumably servants, stand over a
table preparing more oysters.

Though disarmingly youthful—she is often called a
"girl"—Steen's clientele must have recognized her as a
seductive coquette and the picture as cleverly ripe with
innuendo. In the seventeenth century, just as today, oysters
were regarded as aphrodisiacs. In his widely read medical
handbook of 1651, the doctor Johan van Beverwijck wrote:
"Of all the fish locked in hard shells, the oyster has always
been considered the finest delicacy. For they arouse
appetite and desire to eat and to sleep together, both of
which rather appeal to lusty as well as to delicate people
. . ."² In literary and pictorial traditions, oysters took on
moralizing significance as symbols of lust and worldli-
ness.³ The single open oyster in particular was emblematic
of the danger of deceptive feminine wiles.⁴ Steen frequently
drew on the oyster meal convention or used oysters to
signify luxurious excess (cat. 15), but nowhere does he
make one so irresistible. That the girl salts the oyster
adds spice to the image, both literally and figuratively.⁵

Steen has heightened the eroticism of the oyster meal
by reducing it to a single figure or, if we take the object
of her gaze into account, an intimate tête-à-tete. Part of
this playful seductress's appeal must lie in her ambiguity.⁶
Her wholesome youth seems incongruous with sexual
arousal. Yet her direct inviting glance leaves little doubt
that she offers herself along with the delicious oyster.
This suggestion of a sexual proposition is reinforced by
the curtained bed behind her. The pair in the backroom
suggest an encounter parallel to that in the foreground.
The missing gentleman is the viewer.

Steen brilliantly deploys all his formal resources to
captivate the viewer and make this uniquely private work
the embodiment of seduction. The woman's half-length
format and close proximity to the picture plane reiterate
her invitation. Through his precise, convincing rendering

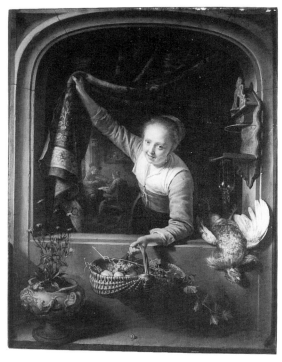

fig. 1. Gerrit Dou, *A Girl with a Basket of Fruit at a Window*, 1657,
oil on panel, The National Trust Waddesdon Manor and The
Courtauld Institute of Art, London

of the velvet and fur of her jacket, the sparkle of the rib-
bon in her wispy hair, the softness of her flesh, and the
juicy succulence of the oysters, Steen has crafted an
exquisite illusion, a delightful assault on the senses. His
delicate, refined brushwork further seduces the viewer,
for it not only demands close scrutiny but also inspires
awe at Steen's mastery of his craft. The picture's small
size prompts a feeling of privileged intimacy that its
arched frame reinforces. This suggestive privacy would
have made the *Girl Offering Oysters* an ideal ornament for
a gentleman's cabinet. Indeed, all of these qualities of
Steen's painting recall the tradition of small erotic col-
lectibles whose visual and tactile allure would have been
enjoyed at close hand, among a connoisseur's friends.⁷

Steen was a remarkably diverse painter who worked
in a wide range of manners and scales. Certainly the tiny
Girl Offering Oysters is his wittiest and most sophisticated
response to the Leiden fine manner.⁸ Though not dated,

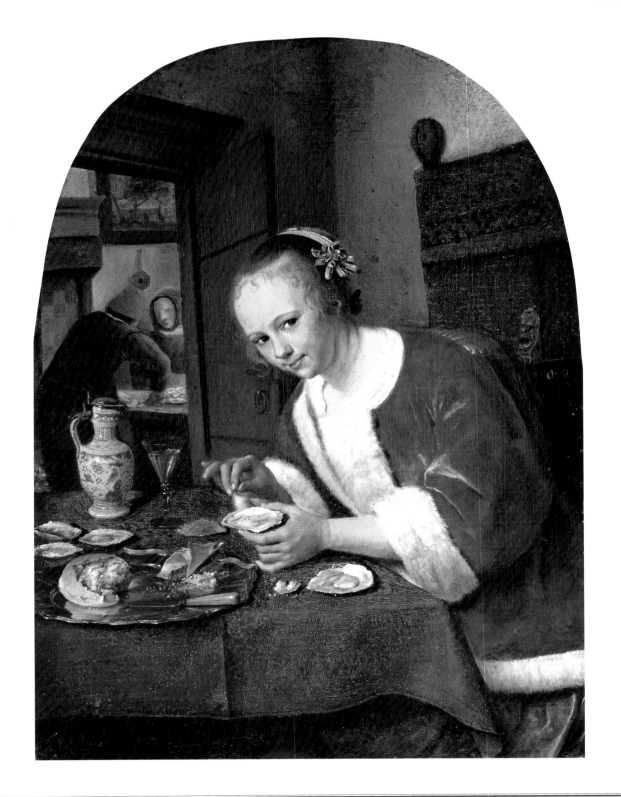

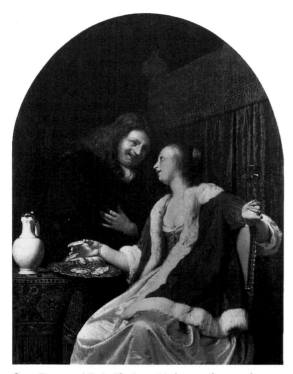

fig. 2. Frans van Mieris, *The Oyster Meal*, 1661, oil on panel, Mauritshuis, The Hague

the picture's unusually small format and resulting extremely delicate handling, which are unparalleled in Steen's work with few exceptions, suggests that he painted it between 1658 and 1660 when he was living in Warmond, a village near Leiden.[9] Despite his debt to the Leiden style, Steen sets himself apart by deliberately varying his technique, which is looser and more abbreviated in the background figures.

The *Girl Offering Oysters* also participates in thematic concerns then in vogue in Leiden. Gerrit Dou (1613–1675) had painted a number of works that comment on the deceptive illusionism of the art of painting, as for example his self-portrait of about 1650 (cat. 19, fig. 3), with its trompe l'oeil curtain that evokes the legend of the painter Parrhasius whose painted curtain fooled even another painter, Zeuxis, and his *Quacksalver* (1652; Museum Boymans-van Beuningen, Rotterdam), which likens the painter's ability to deceive to that of a quack doctor. Dou's subtly erotic images of maids with market baskets in illu-

sionistic architectural frames rely on the commonly held belief that servant girls were deceptive, dishonest, and in need of constant supervision, to create an interplay between sexual and artistic seduction.[10] His *Girl With a Basket of Fruit at a Window* of 1657 (fig. 1), who leans forward from her window to offer herself along with her wares, provides a precedent for the seductive immediacy of Steen's girl. Steen, by departing from the maid conceit and eliminating the artifice of Dou's architectural framework, brings his girl closer to the viewer, making her more accessible.

Steen's artistic sympathies were closer to those of his friend Frans van Mieris (1635–1681), who shared his interest in the comical treatment of amorous subject matter.[11] In the late 1650s and early 1660s, the two artists worked practically in tandem producing naughty or suggestive music lessons, doctor's visits, and oyster meals (cats. 10, 16, 15) that have the same risqué quality.[12] These mildly salacious themes, painted with a veneer of refinement, must have appealed to a clientele that took particular delight in the combination of polished style and elegant costumes with not so refined love imagery. For the composition and setting of the *Girl Offering Oysters* Steen drew directly on Van Mieris' *Doctor's Visit* of 1657 in Vienna (page 18, fig. 11).[13] Van Mieris' *Oyster Meal* of 1661 in the Mauritshuis (fig. 2), which presumably postdates Steen's work, makes an especially instructive comparison that brings out Steen's artistic personality. In Van Mieris' painting, the man, probably the artist himself, is the seducer and the woman accepts his advances. In contrast, Steen's girl has become the seductress and the viewer is the object of her advances.[14] The result is an image of proposition, an irresistible object of desire, that creates an intricate complicity between figure and viewer. Depending on the viewer, who is no longer protected by the distance that allows moral judgment, the painting's assertiveness heightens pleasure or discomfort.[15]

HPC

1. Cheney 1987.

2. Van Beverwijck 1651, 141.

3. Cats 1642, chap. 4: 27, cautions against the use of such "love sprees" as "salty oyster juice."

4. Cheney 1987, 149 n.35.

5. For the metaphoric meanings of salt, see page 61.

6. Braider 1993, 146.

7. This culture of witty erotic images on a small scale is exemplified by Joachim Wtewael's two paintings on copper of *Mars and Venus surprised by Vulcan* (Mauritshuis, the Hague, and The J. Paul Getty Museum, Malibu), both of which are described by Van Mander 1604, fol. 297a.

8. A number of Steen's works from the Warmond years (cats. 10, 11) show the impact of a group of Leiden artists that included Gerard Dou and Frans van Mieris who were known for their refined, polished painting technique. See essay by De Vries.

9. See page 31.

10. Sluijter 1991a; Sluijter 1991b.

11. Houbraken 1718–1721, 3:7.

12. In Van Mieris' *Inn Scene* in the Mauritshuis, for example, copulating dogs and bedding overhanging the sleeping loft leave no doubt as to the outcome of flirtation between soldier and serving maid.

13. Indeed, Broos 1987, 349, has suggested that Steen painted it in emulation of Van Mieris. Another close parallel is Van Mieris' elegant *Woman Stringing Pearls* of 1658 in Montpellier, which, despite its compositional similarity, is distinguished by an emotional remove. Only Van Mieris' mischievous *Man Packing his Pipe* of 1658 approaches Steen's extroversion or emotional assertiveness, an assertiveness that is actually more characteristic of Utrecht half-lengths.

14. *A Woman at Her Toilet* (cat. 19) is a comparable transformation of the Leiden tradition, though it is more indebted to Dou's architectural paintings.

15. On the manner in which the reception of comparable representations of women could vary according to their audience, see Kettering 1993, particularly 109–115.

10

Acta Virum Probant (Actions Prove the Man)

1659

signed just above the keyboard: *IOHANIS STeeN FECIT 16[.][9?]*

panel, 42.3 x 33 (16 ⅝ x 13)

The Trustees of the National Gallery, London

PROVENANCE

Sale, anonymous collector from Friesland et al., Amsterdam, 29 September 1802, no. 50 (fl. 676 to J. Smit); Anna Maria Hogguer, née Ebeling (d. 1812), sale, Amsterdam, 18 August 1817, no. 79 (fl. 1170 to Nieuwenhuys); sale, Le Rouge, Paris, 27 April 1818, no. 55 (7740 francs to Alexis Delahante); Sir Robert Peel, 2d baronet, by 1823; by inheritance to Sir Robert Peel, 3d baronet; bought by the present owner with the Peel collection, 1871

LITERATURE

Smith 1829–1842, 4:37, no. 113; Van Westhreene 1856, 122, no. 102; Hofstede de Groot 1907, no. 409; Bredius 1927, 79; National Gallery London 1960, 396–397, no. 856; De Mirimonde 1967, 340; National Gallery London 1971, 40, no. 17; Kirschenbaum 1977, 40, 176; De Vries 1976, 14, 51, 61; De Vries 1977, 49, 52, 161, no. 87x; Braun 1980, 99, no. 106; Naumann 1981, 1:45, 52, 55; Brown 1984, 134–135; National Gallery London 1991, 424–425, no. 856

In a darkened room, an elegant young woman plays a harpsichord for a male companion, who listens intently. Seen in profile, she sits in her chair and concentrates on the songbook before her, seemingly oblivious to his presence. He, though, is fully aware of her as he leans casually on the harpsichord and stares toward her graceful hands resting on the keys. The viewer too is drawn to the young woman because of her demeanor, pure complexion, and bright satin dress.

The two figures have traditionally been interpreted as music master and pupil, but a tangible erotic tension exists between them.[1] Yet Steen suggests that the prospects for a successful courtship are quite dim. The artist uses body language—hers, upright and direct, and his, informal and oblique—to indicate that a great gulf exists between them. He further describes their differing temperaments through inscriptions on the harpsichord.[2] The inscription just below the young woman's hands, *Soli.Deo.Gloria* (Glory Only to God), is religious. The vertical text on the inner side of the harpsichord lid, however, addresses worldly concerns: *ACTA-VIRVM/PROBANT* (Actions Prove the Man).

Steen's intention, however, is not to represent a realistic scene of courtship, but to exaggerate the awkwardness inherent in the ritual. Indeed, he comments facetiously upon well-established social conventions, current in the upper echelons of Dutch society and ultimately derived from Petrarch.[3] Petrarch's ideal woman was admired both for her physical and spiritual beauty, and for her accomplishments, primarily her musical ability. She was chaste and beyond the reach of the ordinary admirer. While a suitor might wistfully reflect upon the site where he had first fallen in love (most frequently in a garden or grove), he was destined to be frustrated by unreciprocated affection.[4]

The Petrarchan mood in Steen's painting not only includes the idealized yet emotionally removed woman playing a musical instrument, but also the romantic garden, suggested in the design of the tapestry hanging on the rear wall. Even the lovelorn suitor accords with seventeenth-century Petrarchism, for, while he gazes at the beauty of the woman's hands as she plays, he draws back as though slightly timorous in her presence.

Nevertheless, Steen indicates that this suitor will not suffer rejection and despair. He may be, after all, a man of action, worthy of the inscription on the lid of the harpsichord. In the background beyond the doorway, a young servant descends the staircase carrying a large theorbo.

fig. 1. Jacob Cats, 'Quid Non Sentit Amor,' *Proteus, ofte, Minnebeelden verandert in sinne-beelden*, Middelburg, 1618, National Gallery of Art Library, Washington

His arrival signals that the suitor will soon join the young woman for a duet, a metaphor for two people joining in love found in a number of seventeenth-century emblems, among them Jacob Cats' *Quid Non Sentit Amor?* (fig. 1).[5]

The date adjacent to Steen's signature, just above the keyboard, has been badly abraded, but apparently once read 1659.[6] Stylistically the painting relates closely to *Bathsheba Receiving David's Letter*, which probably also dates from the same year (cat. 11).[7] These two works from Steen's Warmond period are similar in scale and share a quiet, almost precious character, where action is minimized. In both scenes, Steen contrasts the bright satin dresses with monochrome tapestry backgrounds. The bare plank floors and illusionistically painted stone arches framing the upper corners are also similar, as are the doorways in the background.

The compositional and thematic framework for *The Music Lesson* derives from the works of Steen's contemporaries Gerard ter Borch (1617–1681) and Frans van Mieris (1635–1681), whose small, delicately executed panel paintings from the mid- to late 1650s often focus upon the rituals of courtship.[8] Steen's sensitive depiction of satin, as

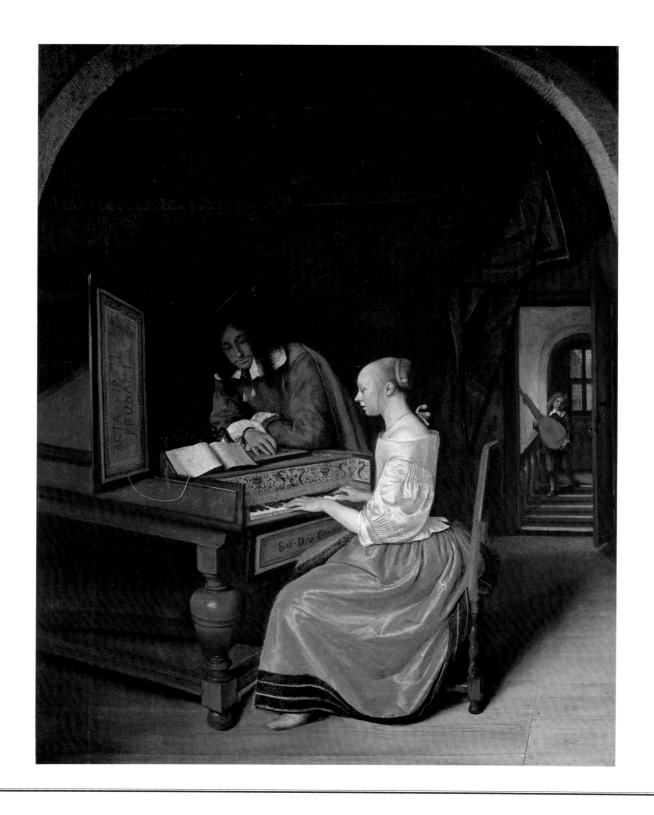

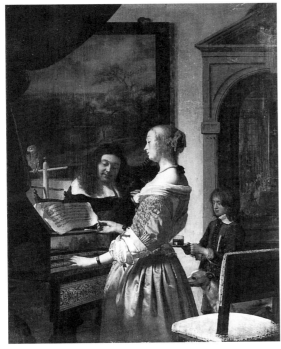

fig. 2. Frans van Mieris, *The Duet*, 1658, oil on panel, Staatliches Museum Schwerin

well as the pose of the young woman, owes much to Ter Borch's *Concert*, c. 1657, in the Louvre.[9] Perhaps even more important for Steen's concept was Van Mieris' *The Duet*, of 1658 (fig. 2).[10] Much as Steen's musician, she also appears indifferent to the presence of her male companion.[11] While Van Mieris' portrayal differs in that the two figures are already playing in concert, he extends the narrative in much the same way that Steen does by including a young servant emerging from the doorway in the background at right. The glass that he carries into the room on a tray suggests the social relaxation to come in a couple's relationship. Van Mieris places the figures against a landscape, while Steen uses a tapestry backdrop.

This comparison, while important for understanding the origins of Steen's thematic and compositional ideas, also reveals marked differences between Steen's artistic personality and that of his Leiden colleague. Steen's painting is less elegant but more direct; his architecture is less substantial, but more effective as a compositional device; and, finally, as with all great humorists, from small gestures and subtle glances he gleans commentaries on the human condition, which Van Mieris, with his elegant, more subtly proportioned figures, could not match.

AKW

1. Smith 1829–1842, 4, no. 113; Van Westrheene 1856, no. 102. Recent descriptions, however, have tended to avoid characterizing the nature of their association. See, for example, National Gallery London 1960, 396, no. 856, where the painting is called *A Young Woman Playing a Harpsichord to a Young Man*, and Brown 1984, 134, where it is given a comparable title.

2. As National Gallery London 1960, 396, inv. no. 856, first noted, the harpsichord is similar in character to those made in Antwerp by the famed instrument maker Andries Ruckers the Elder (1579–c. 1652). An almost identical decorative band with a conventionalized design of flowers, sprays of foliage, and sea-horses, printed on paper, appears on a virginal by Ruckers from 1620 in the Musée Instrumental du Conservatoire at Brussels (repr. Nicolson 1946, fig. 15). For other harpsichords made by the Ruckers family, see The Hague 1994b, 340.

3. For the influence of Petrarch's fourteenth-century lyrics on the Dutch, see, in particular, Forster, 1969, 44–53; and Kettering 1993, 95–124.

4. Kettering 1993, 101.

5. Cats 1618, 85, emblem 42.

6. National Gallery London 1960, 396–397, inv. 856.

7. Another comparable work is Steen's *Ladies Listening to Musicians*, signed and dated 1659 (cat. 7, fig. 2).

8. See Kettering 1993, 101–108. For courtship etiquette as depicted by Dutch artists, see also Franits 1993, 53–61.

9. Gudlaugsson 1959, 2:141, no. 126.

10. This comparison is also noted by De Vries 1976, 14; Naumann 1981, 1:52 n. 20, 55; and Hecht in Amsterdam 1989, no. 12.

11. I would like to thank Meredith Hale for discussing this comparison with me.

11

Bathsheba Receiving David's Letter

c. 1659
signed above the door: *JSteen* (*JS* in ligature)
inscribed on the letter: *alder / Schonte / Bersabé / omdat*
panel, 41.5 x 33 (16 ½ x 13)
Private collection

PROVENANCE
Sale, Johannes Enschedé, Haarlem, 30 May 1786, no. 16; sale,
Pieter Lyonet, Amsterdam, 11 April 1791, no. 232; probably sale,
Henry et al., Paris, 9 April 1822, no. 67 (described as a genre
scene); possibly sale, Christina Susanna de Bosch, née de Vries,
Amsterdam, 3 November 1840, no. 102 (fl. 50 to De Lelie);[1] possibly
sale, Van Saceghem of Ghent, Brussels, 2 June 1851, no. 60 (2600
francs to De Roy);[2] sale, Théodore Patureau, Paris, 20 April 1857,
no. 34; Lord Powerscourt, Powerscourt; Prince of Liechtenstein,
Vienna, by 1907; Princess Murat, Paris, 1911 (exhibited 1911 as no.
157); Knoedler, New York, 1926; Colnaghi, London, 1935; E. Nicolas,
Paris; sold to Edward Speelman, London; sold by 1977, acquired
by the present owner around 1980

LITERATURE
Hofstede de Groot 1907, no. 15; Thieme-Becker, 31: 511;
Gudlaugsson 1945, 63–66; De Groot 1952, 143; Martin 1954, 49;
Kunoth-Liefels 1962, 73–74; Kirschenbaum 1977, 40, 116–117, no. 15;
De Vries 1977, 49, 52, 161, no. 88; Braun 1980, 100, no. 110; Naumann
1981, 1:115–116; New York 1988, no. 47; De Vries 1992, 71–72

Written in privacy, love letters contain sentiments only to
be read by one's beloved. The expectation of privacy in the
writing and receiving of love letters was a well-established
convention by the mid-seventeenth century, one that is
implicit in scenes of letter writers or recipients alone in a
quiet room, reflecting upon or reading the contents,
found in paintings by Steen's contemporaries Gerard ter
Borch (1617–1681), Gabriel Metsu (1629–1667), and Johannes
Vermeer (1632–1675). Occasionally these artists depicted a
maid delivering the letter, thereby suggesting expecta-
tions and anxiety associated with its arrival. When a maid
must wait for a love letter to be read or written, she inevit-
ably stands discreetly to one side, careful not to intrude in
her mistress' private concerns. How, then, should one
approach Jan Steen's Bathsheba, who flouts that conven-
tion by brazenly revealing the contents of King David's
illicit love letter? The viewer, as well as Bathsheba's
inquisitive companion, can easily read the letter's provoc-
ative beginning: "most beautiful Bathsheba—because."

Most of Steen's contemporaries depicted the beauti-
ful Bathsheba bathing outdoors, sometimes already hav-
ing received the king's letter (Samuel 11).[3] Steen, as well,
painted such a scene, in which Bathsheba holds David's
letter and considers his request (fig. 1). In this work, how-
ever, Steen chose to depict the elegantly dressed
Bathsheba receiving the letter within the confines of
her chamber, a setting that allowed the artist to blur the
distinctions between this biblical story and seventeenth-
century love letter scenes.[4]

By fusing history and genre painting Steen was not
only able to suggest the relevance of the biblical story to
contemporary life, but also to shift the narrative empha-
sis from Bathsheba as the object of David's sexual attrac-
tion to Bathsheba as a married woman facing a moral
dilemma. Her open bed curtain and evocative gaze fore-
tell the path she will choose, a decision made all the more
poignant by the contemporary decor of her room, which
would have encouraged viewers to measure her conduct
against seventeenth-century Dutch mores.

Steen's representation of the story is unique, but he
certainly drew his inspiration from varied pictorial and
literary sources. While the Bible does not describe David
writing to Bathsheba, letters had become central to depic-
tions of Bathsheba at the bath. For example, Jan Lievens
(1607–1674), a distant relative of Steen, painted one such
work, which was extensively praised by Philips Angel
(c. 1618–1645 or after), a Leiden painter, etcher, and art

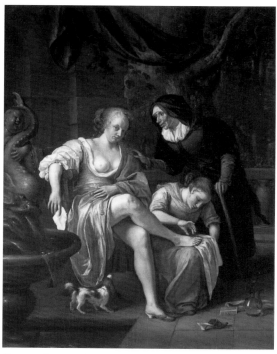

fig. 1. Jan Steen, *Bathsheba after the Bath*, c. 1665–1670, oil on
panel, Collection of the J. Paul Getty Museum, Malibu

theorist whose work Steen surely knew.[5] In his 1642 trea-
tise, *Lof der Schilder Konst*, Angel wrote about the impor-
tance of the letter to the story:

. . . *without doubt such a messenger was an old woman well-
versed in the art of love, or a procuress, so one calls her, who
brought the message, not simply with her mouth alone, but
undoubtedly through a letter (as evidence of a greater authority),
which she handed to Bathsheba, wherein he [David] have [her]
to understand his sweet consideration, which he had over [her],
. . . thereby igniting a sweet blush of modest shame in her per-
son, through the reading of the letter . . . such a hot fire of lust
must have been in Bathsheba, whenever the king sought her.*[6]

The bent, old woman who delivers David's letter in both
this painting and Steen's later version (Braun 311) descends
directly from the procuress Philips Angel describes.

Also important for Steen's *Bathsheba Receiving David's
Letter* are Gerard ter Borch's depictions of contemporary
Dutch life that focus on the writing, reading, and delivery
of letters. Surprisingly few of these letters elicit joy or

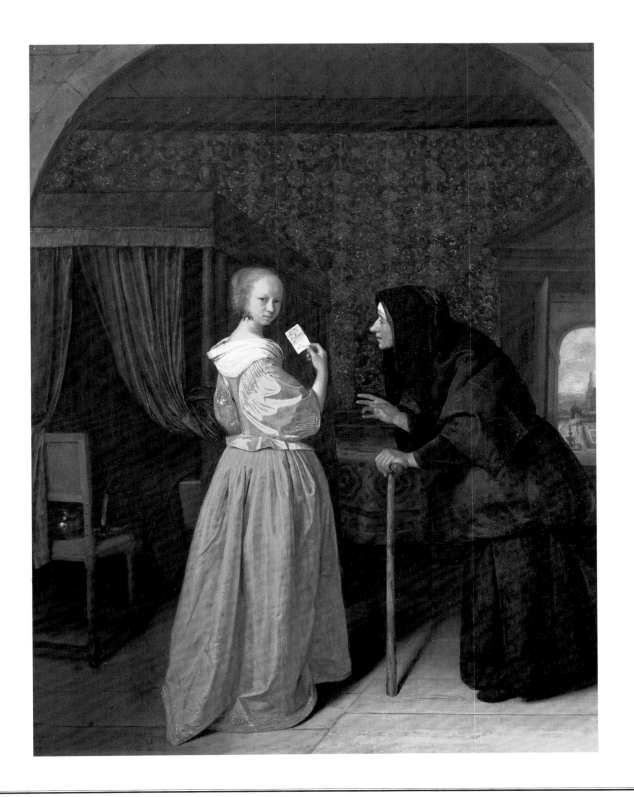

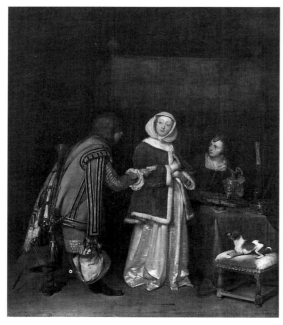

fig. 2. Gerard ter Borch, *The Rejected Letter*, c. 1655, oil on panel, Alte Pinakothek München

excitement; indeed, for some, the letter's arrival induces fear and anxiety.[7] In Ter Borch's *The Rejected Letter*, c. 1655, a young courier has entered a woman's chamber to present her a letter (fig. 2). She looks quizzically at him and appears hesitant to accept. Ter Borch does not reveal the circumstances of this encounter, but through the woman's central placement and expression appears to indicate that she must make a moral choice: to accept the letter, with its unknown message, or to continue in the path of virtue, symbolically suggested by the basin and ewer held by the maid.[8]

It is possible that Ter Borch conceived this work as the story of David and Bathsheba, for the tapestry behind the courier depicts a king with two other figures.[9] Whether Ter Borch's paintings with letter themes derived from this biblical account or from episodes from contemporary life, his imagery must have inspired Steen. However, Steen's explicit narrative style creates a different effect than that of the older master. His message is more direct and less nuanced. He reveals much about Bathsheba's character through her provocative gaze as she discloses the contents of David's letter, betraying the implicit bond of

trust between letter writer and reader. Steen further suggests her openness to sexual liason through the open bed curtains and the pot and candle on the chair.[10]

Compositionally this work relates closely to *Acta Virum Probant (Actions Prove the Man)*, 1659 (cat. 10), another scene with two figures in a room, framed by illusionistically painted stone arches. In each instance the perspective recession of the floor boards, reinforced by the direction of the shadows, leads to an open doorway in the right background. The vista in this painting includes a glimpse of the palace and its grounds, through which walks a red-cloaked gentleman, traditionally identified as David. Although the young women in both paintings wear an identical yellow jacket, Steen emphasizes their different characters through the colors of their dresses— blue, associated with purity and heavenly love, for the woman at the harpsichord, and red, associated with passion, for Bathsheba.[11]

AKW

1. This lot may refer to a different painting, as it was described as "by or after Jan Steen" and as on canvas.

2. Possibly a different painting, as it measured 18 x 15 in.

3. Samuel 11: 2–4. One evening David rose from his couch and strolled about on the roof of the palace. From the roof he saw a very beautiful woman bathing. David made inquiries about the woman, and was answered: "Is not this Bathsheba, the daughter of Eliam, the wife of Uriah the Hittite?" Subsequently, "David sent messangers, and took her; and she came to him, and he lay with her. (Now she was purifying herself from her uncleanness.) Then she returned to her house."

4. See page 16.

5. A painting by Lievens of this subject is illustrated by Sumowski 1983, 3: no 1189.

6. The English translation is taken from Naumann 1981, 1:114. The original text is from Angel 1642, 50: "sonder twijffel, dat [. . .] sulck een Bode zy geweest een oude, ende wel-ervaren Vrouwe in de Minnekunst, ofte een *Koppelersse*, soo men die noemt [. . .] die niet alleenlijck de boodtschap simpelick met de mondt gedaen heeft, maer heeft sonder twijffel een Brief (tot bewijs van meerder macht) mede gebracht, ende die aen *Beth-seba* behandicht, waer in hy wederom sijn soete bedenckinge die hy hier over heeft gehadt, te kennen ghegheven heeft door dien hy een soette blos van eerbare schaemte in haer liet ontsteecken, door 't lesen van den Brief.[. . .] ende dat oversulcx en heete brandt van lust in *Beth-seba* geweest moet zijn, wanneer sy van den *Koninck* versocht wierdt."

7. Gudlaugsson 1959, 2: no. 81; no. 99.

8. For the symbolism of purity associated with the basin and ewer see De Jongh in Amsterdam 1976a, 195, who draws attention to an emblem in Hulsius 1631, 100–104.

9. See Kunoth-Leifels 1962, 74.

10. The shapes of the vase and candle have sexual associations.

11. See Ferguson 1959, 91.

12

The Poultry Yard

1660

signed and dated on the wooden planking at lower left:
JSteen./1660 (*JS* in ligature)
canvas, 107.4 x 81.4 (42 ¼ x 32)
Royal Cabinet of Paintings Mauritshuis, The Hague

PROVENANCE
Probably Anna van den Bongard; Bernardina van Raesfelt; her son Thomas Walraven van Wassenaer-Alckemade, and sold by his descendants c. 1774; Stadholder Willem V, The Hague from 1774; Musée du Louvre, Paris, 1795–1815; Koninklijk Kabinet van Schilderijen, The Hague, 1815–1821; Mauritshuis, since 1821

LITERATURE
Smith 1829–1842, 4:62, no. 183; Van Westrheene 1856, 100–101, no. 13; Hofstede de Groot 1907, no. 330; Mauritshuis 1914, 353; Martin 1922; Martin 1926, 12–13, 18; De Jonge 1939, 27; Bijleveld 1950; Fockema Andraea et al. 1952, 60, 79; The Hague 1958, no. 13; London 1976, no. 105; Mauritshuis 1977, 224; Kirschenbaum 1977, 39, 174; De Vries 1977, 39, 47–48, 128 n. 76; Braun 1980, 100, no. 113; Paris 1986, 318–322

The Poultry Yard is one of Jan Steen's best-loved, most accomplished, and most remarkable paintings. The enchanting young girl, the enclosed privacy of the yard, the portraits of the servants, the variety of birds and other animals, and the gateway with its marvelous view of the castle all contribute to its sumptuous appeal.

The identity of the girl seated on the steps in front of a gateway surmounted by the arms of the Mathenesse-Lokhorst family is not entirely certain. The castle in the background is Lokhorst, also known as Oud-Teilingen, near Warmond, which was owned at the time by Jan van Wassenaer (1626–1687).[1] Some authors believe that the girl is his daughter, Jacoba Maria van Wassenaer (1654–1683). However, the latter appears in a portrait of Jan van Wassenaer's family (fig. 1) by Arnold van Ravesteijn (c. 1615–1690), a little-known portrait painter from The Hague. The girl in that painting, which is still in the collection of Van Wassenaer's descendants at Warfusée Castle, is certainly not the one depicted in *The Poultry Yard*. Moreover, the portrait of a member of such a prominent family as the Van Wassenaers would certainly have displayed her own coat of arms.

Also living in Lokhorst Castle at the time was Anna van den Bongard (1600–1663), together with her foster-daughter, the orphaned Bernardina Margriet van Raesfelt (1649–1681), a niece of Anna's second husband. This is very probably the girl portrayed by Steen. Anna had the usufruct of Lokhorst through her first marriage to Cornelis van Mathenesse, and it was here that she brought Bernardina after her second husband's death in 1657. The arms above the gateway are those of the parents of her first husband.[2] She must have regarded the house as the family home, for her own grandmother—she and Cornelis were first cousins—had grown up there. It is more likely, then, that the foster-mother, rather than Jan van Wassenaer, the tolerant lord of Warmond, commissioned the painting from Steen while he was living in Warmond. Anna van den Bongard was childless, so the presence of Bernardina must have been a great comfort to her, particularly after the violent death of her second husband. Anna died in 1663, and Bernardina went to live at nearby Warmond House. In 1674 she married Gerard van Wassenaer-Alckemade. Lokhorst was sold in 1670 to the noted diplomat Hieronymus van Beverningk (1614–1690), and its contents were moved to Warmond and later taken to Warfusée Castle near Liège by the descendants of Jacoba Maria van Wassenaer. In 1726, Warmond House passed to the son of Bernardina van Raesfelt, Thomas Waldemar van Wassenaer-Alckemade, whose heirs sold it in 1774. It is probably no coincidence that that was the year in which Steen's *Poultry Yard* entered the collection of Stadholder Willem V.[3]

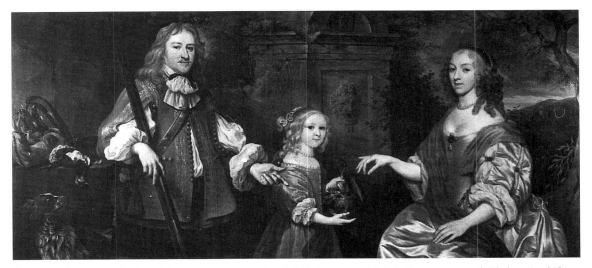

fig. 1. Arnold van Ravesteijn, *Portrait of Jan van Wassenaer (1624–1687), His Deceased Wife Isabella Maria van Haestrecht (died 1656) and Their Daughter Jacoba Maria (1654–1683)*, 1660, oil on canvas, Warfusée Castle

fig. 2. Jacob van Banchem, *Lokhorst House near Warmond*, 1595, drawing, Algemeen Rijksarchief, The Hague

Lokhorst lay to the southwest of the village of Warmond. At some distance from the main house, a staff dwelling stood beside a gateway that Steen undoubtedly used as a source of inspiration. However, unlike the one in the painting, it stood almost at right angles to the house, as can be seen from a drawing of Lokhorst made in 1595 by Jacob van Banchem (fig. 2). It is also worth noting that the massive steps leading up to the gateway in Steen's painting seem out of place in a country as flat as Holland. They are yet another indication that the setting should not be taken too literally.

Steen made ingenious use of the gateway: it links the portrait in the foreground with the castle in the background, and also serves as a backdrop for the poultry yard. It was here that he merged portraiture with genre, just as he did in *The Leiden Baker Arend Oostwaert and His Wife Catharina Keyzerswaert* (cat. 8). The girl is portrayed in great detail, but she is also part of the action, for she feeds milk to a lamb that has wandered off from the others by the bridge leading to the house. A small Italian whippet licks up spilt milk by her feet, and to the left reclines a type of lapdog spaniel known as a *spioen*. Lying on the step behind the girl is her straw hat, which, like the whippet, is adorned with red and blue ribbons. The girl is accompanied by two servants. The one on the right has distinctly portraitlike features and undoubtedly held an important position in the household. He has brought her the milk and has collected the eggs to take back to the house. The servant on the left is probably the poultryman. Although his comical appearance is reinforced by the large tear in his coat, it must be assumed that this too is a portrait.[4]

Steen depicted the poultry with close attention to detail. Various parallels for this can be found in his oeuvre. He portrayed the birds in much the same way in his *Poultry Seller*, where he also made similar use of a view to the distance through a gateway.[5] He demonstrated his skill as a bird painter in other paintings as well, such as *The Cock-Fight* (fig. 3) and *The Wedding Procession*, employing the poultry to heighten the sexual humor of

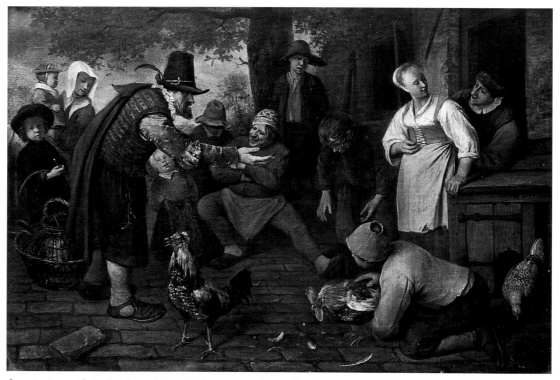

fig. 3. Jan Steen, *The Cock-Fight*, c. 1658–1660, oil on canvas, private collection

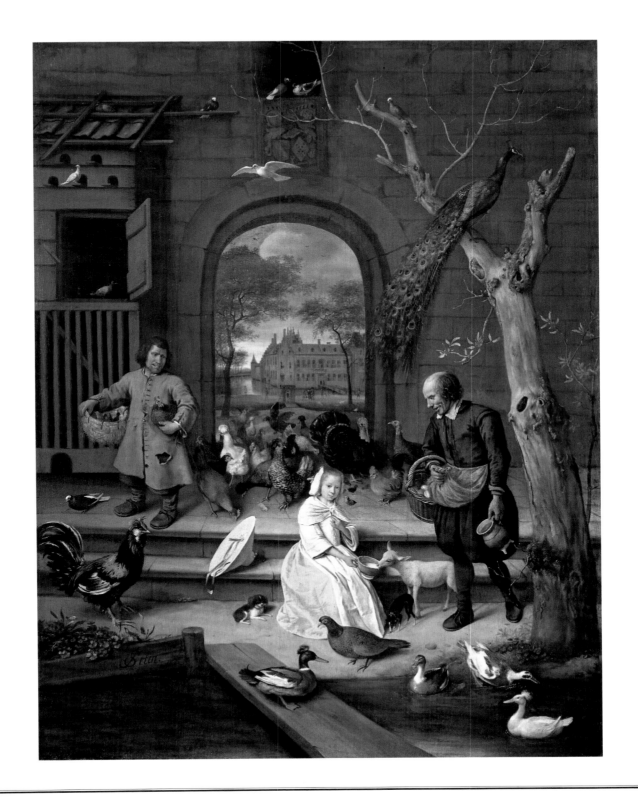

the scenes.[6] In *The Cock-Fight*, the birds brilliantly mirror the behavior of the randy old man, his young challenger, and the naive girl.[7] Steen would have learned how to paint chickens from Isack van Ostade (1621–1649), who depicted them in and around his barns in superb detail. However, chickens are not the only inhabitants of *The Poultry Yard*; also included are doves, turkeys, a pheasant, a peacock, and a few fancy ducks in the water in the foreground.[8] Here Steen was once again dissatisfied with his initial composition, for the third duck from the right, which is now swimming toward the viewer, was originally parallel to the picture plane. Because that was also the angle of the white duck on the right, he apparently felt that this corner of the painting needed a little more variety.

Steen previously used the motif of a gateway in *Ladies Listening to Musicians* of 1659 in Ascott House (cat. 7, fig. 2), but oddly enough only the inner edge supplies the framework for the elegant company being visited by the traveling musicians. *The Weary Traveler* in Montpellier has a similar framing element, but in an even more reduced form.[9] The bare tree on the right in *The Poultry Yard*, incidentally, is very reminiscent of such trees in the work of Gerrit Dou (1613–1675), and one can assume that Steen had seen the latter's famous *Quack* of 1652.[10]

It is impossible to say whether Jan Steen came to Warmond specially to paint this portrait or whether Anna van den Bongard took advantage of his presence there to have her foster-daughter immortalized in her favorite setting.[11] With *The Poultry Yard*, which is unquestionably one of the few works that Steen painted on commission, the artist created a superb masterpiece.

WTK

1. The house can be identified from various drawings and prints. The best illustration is a copy after a lost drawing by Roelant Roghman in the Atlas Bodel Nijenhuis in Leiden; see Paris 1986, 318. See also Martin 1922, fig. 2 and the drawing by Jacob van Banchem (fig. 2) in the Algemeen Rijksarchief, The Hague (inv. no. 2318).

2. The coat of arms over the gateway was probably painted out when the picture left the family collection in the eighteenth century. It reemerged when the painting was restored in 1948.

3. Most of this information is taken from Bijleveld 1950. Jan Stolker (1724–1785) copied the painting (but omitted the coat of arms) in a drawing (c. 1780) that is now in the Museum Boymans-van Beuningen in Rotterdam. At the request of Cornelis Ploos van Amstel, Aert Schouman made a drawing of the painting while it was in Willem v's collection.

4. Bedaux, quoted in Paris 1986, regards the servant on the left as a dwarf and believes that he is the embodiment of evil—an interpretation that strikes me as totally out of place here.

5. Braun 1980, no. 105.

6. See Hofstede de Groot 1907, no. 745, for the painting formerly in the collection of the marquess of Bute; for *The Wedding Procession* see Braun 1980, no. 187.

7. Later in his career, in the *Cock Fight in an Inn* of 1673 (Braun 1980, no. 353), he depicted poultry in a more slapdash, clumsier fashion.

8. The chickens' plumage identifies them as Dutch Uilebaards; see Clason 1980, 176, 180. The pheasant is less successful; it is really nothing more than a dove dressed up as a pheasant.

9. Braun 1980, no. 111.

10. Similar bare trees are also found in other works by Dou with hermits; see Sumowski 1983, nos. 248, 252, and 280 for the Rotterdam picture. Some authors relate Dou's tree to an emblem by Roemer Visscher, "Choice is a worry"; see Amsterdam 1976a, 88. In addition, bare trees often conjure up associations with the young sprig on an old trunk. Neither interpretation enhances the content of Steen's painting.

11. See pages 16–31.

13

The Prayer before the Meal

1660

signed and dated on the placard on the back wall:
JAN STEEN 1660

panel, 52.7 x 44.5 (20 ¾ x 17 ½)

Sudeley Castle Trustees, Gloucestershire, Walter
Morrison Collection

PROVENANCE

Sale, Johannes Enschedé, Haarlem, 30 May 1786, no. 22; anony-
mous sale, Alkmaar, 17 November 1788, no. 1 (fl. 700 to Du Tour);
sale, B. Ocke, Leiden, 21 April 1817, no. 128 (fl. 440 to Ocke),
presumably bought in (described as on canvas); sale, Engelbert
Michael Engelberts et al., Amsterdam, 25 August 1817, no. 91
(fl. 275 to auctioneer De Vries) (described as on canvas); sale,
C. E. E. Baron Collot d'Escury, Leeuwarden, 17 October 1831, no.
33 (with dimensions as 22 x 18 ½ inches); Chaplin, London, 1831;
Edmund Phipps, London, by 1854; Charles Morrison, Basildon
Park, by 1907; by inheritance to his brother Walter Morrison,
who settled the inheritance on his nephew James Archibald
Morrison, 1910; by inheritance to his daughter Mary Morrison,
1934, who had married John Henry Dent Brocklehurst of Sudeley
Castle, Winchcombe, Gloucestershire, in 1924; by inheritance to
Geoffrey Mark Dent Brocklehurst, Sudeley Castle

LITERATURE

Smith 1829–1842, 4:62–63, no. 185; Waagen 1854–1857, 2:227, sup-
plement: 108; Van Westrheene 1856, 162, no. 380; Hofstede de
Groot 1907, nos. 375, 397b; Bredius 1927, 61–62; Martin 1935–1936,
2:264; De Vries 1977, 46, 48, 49–50, 52, 129 n. 79, 161, no. 90x;
Braun 1980, 100, no. 115; Sutton 1982–1983, 29; Brown 1984,
150–151; Philadelphia 1984, 307–308, no. 102

This serene painting of a family praying before beginning
their meal is imbued with quiet spirituality. A stanza from
Proverbs 30:7–9 inscribed on a placard hanging on the
rear wall serves as the family's creed: *Three things I desire
and no more / Above all to love God the Father / Not to covet
an abundance of riches / But to desire what the wisest prayed
for / An honest life in this vale / In these three all is based.*[1]

Their plain clothes, simple furniture, bare walls, and
modest meal of bread, cheese, and ham indicate that they
truly live by their creed. As the mother prays while cud-
dling her child, the father reverently holds his hat before
his face.[2] A key hanging behind the father symbolizes his
trustworthiness.[3] Inscribed on the *belkroon* (a wooden chan-
delier with a bell hanging in the middle) are words from
the Lord's Prayer: *u wille moet geschieden* (thy will be done).

The father and mother remind themselves that life
"in this vale" is transitory by placing on the shelf an
extinguished candle, a large book (probably a Bible), and
a skull.[4] The paper hanging over the shelf reads, *Gedenckt
te sterven* (Think on Death). In their faith, however, death
is followed by resurrection, for a wreath of wheat crowns
the skull. Wheat, which must first die and be buried in
the earth before growing into a new plant, is a symbol of
hope. Like the grain, man must die and be buried to
achieve eternal life.[5]

The earliest of Steen's four representations of this sub-
ject, this scene belongs to a long-established iconographic
tradition.[6] Early seventeenth-century paintings and prints
reflect the ideal of a pious, harmonious, and fertile family
life that had developed within Dutch society, an ideal also
expressed in the writings of Jacob Cats (1577–1660).[7]
Protestant and Catholic families alike commissioned por-
traits of themselves praying before a meal.[8] Artists fre-
quently alluded to harmony and fertility by including bib-
lical texts,[9] especially the third verse of Psalm 128 (127 in
the Catholic Bible): "Thy wife shall be as a fruitful vine by
the sides of thine house."[10] The grapevine climbing
around the window above the mother indicates that
Steen also consulted Psalms.

Steen's scene resembles earlier prayer-before-the-meal
images in that it includes a religious text. However, in the
depiction of a humble rather than wealthy family it differs
from such prototypes. Far closer in mood and character is
Adriaen van Ostade's (1610–1685) intimate etching of 1653
(fig. 1), which was probably Steen's primary compositional
source.[11]

Neither the biblical text nor the furnishings in this

fig. 1. Adriaen van Ostade, *Prayer before the Meal*, 1653, etching,
National Gallery of Art, Washington, Rosenwald Collection

humble home identifies the family's religious persuasion.
While Steen's image transcends denomination, he origi-
nally conceived the painting as a Catholic image. A large
cross (probably a crucifix), now vaguely visible through
the overlying paint, once hung above the father's head.
Steen at some point eliminated the cross, and replaced it
with objects on the shelf that carry comparable symbolic
associations with death and resurrection.

Much of the forcefulness of Steen's image results
from the surety of his painting technique. Rarely did he
convey weight and texture so intently. He carefully mod-
eled his figures with light and shade, endowing them
with classical grandeur. He meticulously rendered the
woven pattern of the frayed cloth over the barrel, and the
crisp folds in the clean white table cloth under the bread
and cheese. Finally, he convincingly suggested the worn
appearance of the father's chair and the rough wood of
the window frame. With this emphasis on the physicality
of objects, *Prayer before the Meal* resembles Steen's *Poultry
Yard*, also painted in Warmond in 1660 (cat. 12).

Steen's compositional focus on a few figures in a cor-
ner before an open window is unusual within his oeuvre,

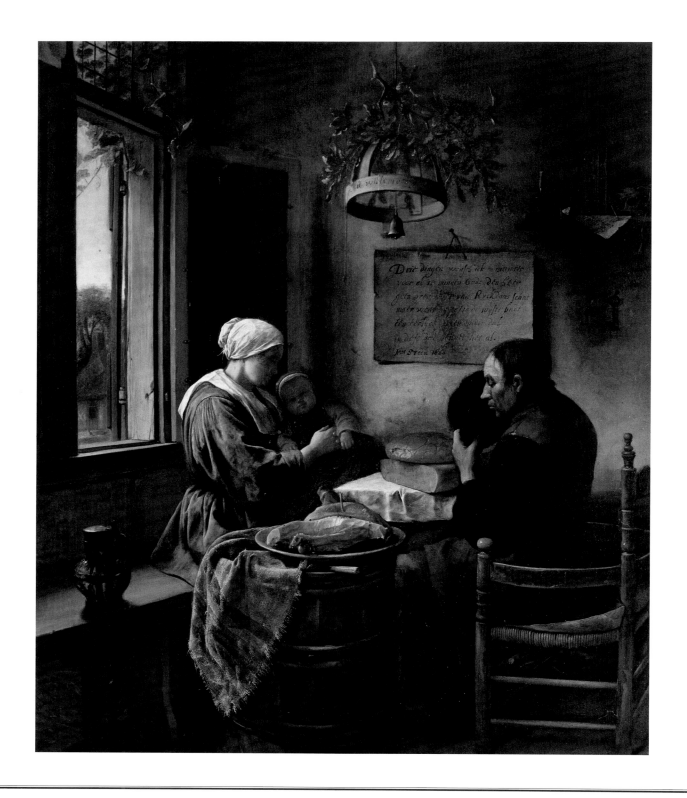

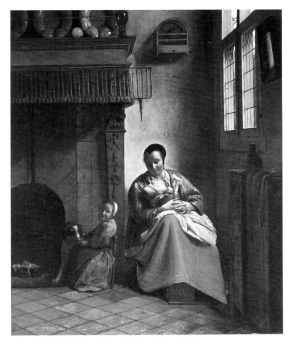

fig. 2. Pieter de Hooch, *Woman Nursing a Child in an Interior*, c. 1658–1660, oil on canvas, The Fine Arts Museums of San Francisco, Gift of the Samuel H. Kress Foundation

and may reflect his awareness of Delft artistic traditions. By 1660 both Johannes Vermeer (1632–1675) and Pieter de Hooch (1629–1684) (fig. 2) placed their scenes of domestic life in similar settings. Steen, however, stands apart from his former Delft colleagues in the way that he exploits this setting. The small vista through the open window suggests at once the family's bond to the community and the privacy of its devotions. Moreover, the opening is wide enough for air and light to enter freely into the room, heightening the sense of realism. Finally, Steen effectively uses the simple architecture of the room, particularly the open window enframing the mother, to enhance the solemnity and dignity of the scene.

Wybrand Hendriks made a drawing after this painting in the late eighteenth century (now Rijksprentenkabinet, Amsterdam).[12]

AKW

1. Translation adapted from Philadelphia 1984, 307. The Dutch text on the placard reads: *Drie dingen wensch ick en niet meer / voor al te minnen Godt den heer / geen overvloet van Ryckdoms schat / maer w ens om tgeen de wyste badt / Een eerlyck Leven op dit dal / in dese drie bestaet het al.*

2. Hecht 1986, 177 n. 15, notes that the saying "in den hoed kijken" (to look in the hat) is an expression indicating silent prayer. I would like to thank Guido Jansen for this reference.

3. See, for example Visscher 1614, emblem 66, "'T Vertroude trouwelijck," which equates trustworthiness with a key. The key also has religious associations that relate thematically to the tenor of this work. Christ said to Saint Peter: "And I will give unto thee the keys of the kingdom of heaven: and whatsoever thou shalt bind on earth shall be bound in heaven" (Matthew 16: 19).

4. The vanitas connotations of the book are less certain than those of the extinguished candle and skull. It could, for example, be a Bible. Nevertheless, many vanitas still lives with extinguished candles and skulls include books as well.

5. For the symbolism of wheat, see Washington 1989b, 103–104.

6. See also cat. 28 For a full listing of other paintings by Steen representing this subject, see Sutton 1982–1983, 29–31, particularly notes 7 and 10.

7. See, in particular, Cats 1625. For the relationship between Cats' writings and such scenes, see Franits 1986, 36–49; Franits 1993, 131–160.

8. See De Jongh in Haarlem 1986, 292–310.

9. See Van Thiel 1987, 128–149.

10. Franits 1993, 82, notes that Petrus Baardt, *Deugden-spoor*, 1645, Leeuwarden, 373, associates the fruitful vine with a "virtuous and chaste wife ("een deugdelijcke huys-vrouwe van eerbaer Zeden")."

11. Philadelphia 1984, 308.

12. The painting was then probably in the collection of Johannes Enschedé, Haarlem.

14

The Cardplayers

c. 1660
signed at lower left: *JSteen* (*JS* in ligature)
panel, 45.5 x 60.5 (17 ⁷⁄₈ x 23 ⁷⁄₈)
Private collection

PROVENANCE

Sale, London, 26 March 1824, no. 160 (£85 1s. to Emmerson); collection M.M. Zachary, London, 1825–1828; sold to John Smith, London; Johann Moritz Oppenheim, London, from c. 1830; his sale, London, 4 June 1864, no. 22 (£294 to Haines); sale, William Delafield, London, 30 April 1870, no. 74 (£525 to Pearce); S. Herman de Zoete, London, from 1885; E. Parsons, London, 1923; Vanderbilt Family Collection, U.S.A; Otto Naumann, New York, 1990; Dutch Renaissance Art Collection, Amsterdam 1990–1995; Robert Noortman, London & Maastricht, 1995; to the present owner

LITERATURE

Smith 1829–1842, 4:40–41, no. 126; Waagen 1854–1857, 2:329; Van Westrheene 1856, 161, no. 374; Hofstede de Groot 1907, no. 727; Braun 1980, 157, no. A-556; New York 1995

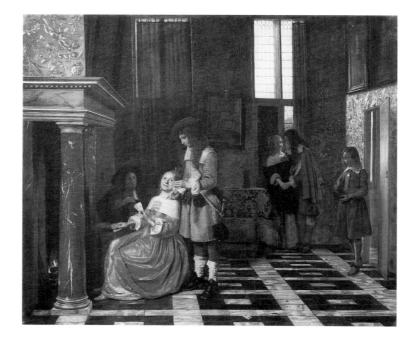

fig. 1. Pieter de Hooch, *Cardplayers by a Fireplace*, c. 1656–1657, oil on canvas, Musée du Louvre, Paris

Although this painting is one of Jan Steen's best-preserved works, it was all but unknown until quite recently.[1] The artist took great care to preserve a high degree of finish in all the details, displaying a consistency that he frequently abandoned in the background of his other pictures. His often cavalier attitude to perspective is here restricted to just one or two passages, such as the row of houses seen through the background window.

Two figures play cards at a table in an interior. The young woman at right holds the ace of clubs in her right hand as she covertly shows the viewer the ace of hearts in her left, a gesture that conveys the subterfuge she plays on her male opponent. Lying on the floor is the ace of spades, and on the table before her is a slate on which the score is being kept with a piece of brilliant white chalk. The sword hanging from the back of the woman's chair may have been simply removed or, more probably, is the stake that the man has already lost in the game. The latter, presumably an officer, is handed a glass of wine by a man clad in black. On the left, a maidservant with a shopping pail on her arm presents a dish with a lobed rim containing pieces of red fruit to a woman seated at the table. Watching all this is a man standing by the fireplace who is filling his pipe from a box of tobacco. Steen took the opportunity to include several superbly painted

details: the most striking are the sword hanging from the chair and the rug folded back on the table.[2]

The interior is quite sumptuous. The scene is set in front of a monumental fireplace lined with delftware tiles depicting soldiers.[3] The overmantel shows a landscape with a horseman, an army tent, and distant mountains, which may allude to military activities in foreign lands. A cittern hangs on the wall to the right of the fireplace. On the left, costly vessels stand on a shallow sideboard with a shelf above. A small Cupid can be made out on one of the doors of the cabinet.[4] An open door on the right gives a view into a second room, where a man is pulling a young woman onto his lap. Steen originally painted a circular window above the doorway, a device that appears in several other interiors.

The theme of a soldier being disarmed by a woman's charms, as was Samson (cat. 34), is common in seventeenth-century Dutch art, but is not always recognized. For example, Nicolaes Maes' (1634–1693) *Eavesdropper* in Dordrecht or Emanuel de Witte's (c. 1617–1692) *Woman at the Clavichord* in Rotterdam can only be understood when one realizes that the men in those pictures have hung up their swords on the hat rack.[5] Numerous paintings by Gabriël Metsu (1629–1667), Pieter de Hooch (1629–1684), Johannes Vermeer (1632–1675), and Gerard ter Borch

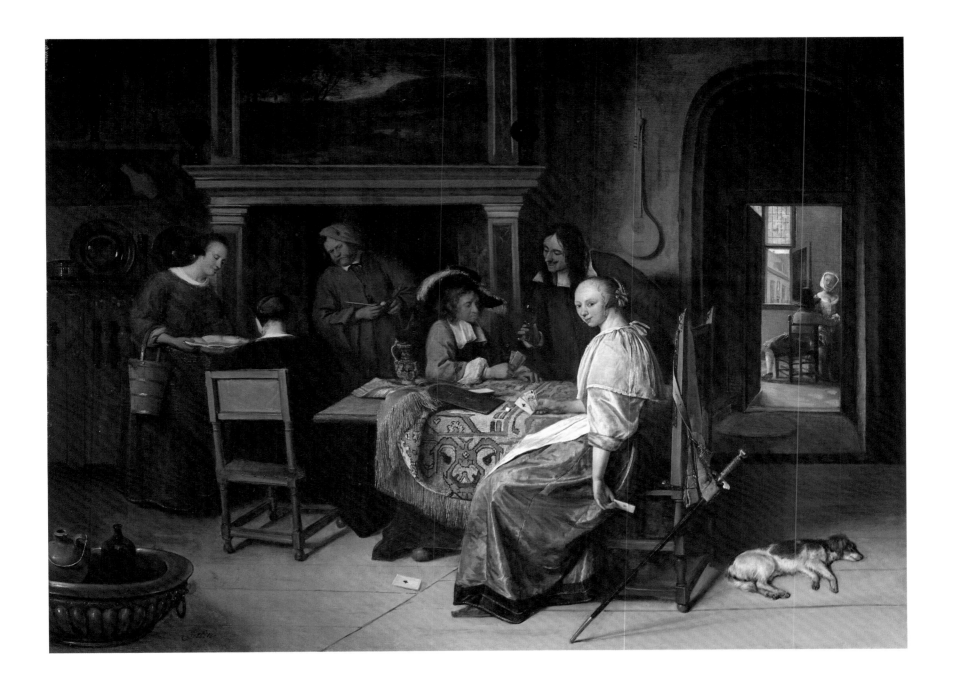

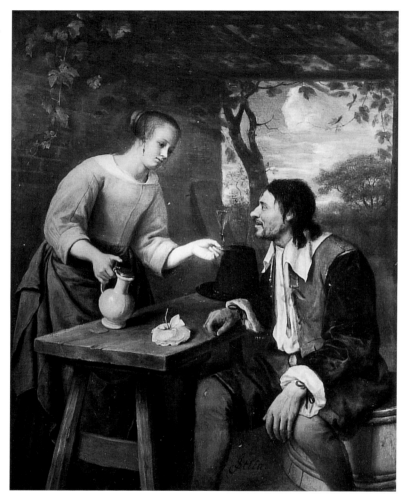

fig. 2. Jan Steen, *The Weary Traveler*, c. 1660–1661, oil on panel, Upton House, Banbury, National Trust

sometimes the untrustworthiness or stupidity of the participants. Invariably, though, references are made to negative aspects of the human character. In that respect, the meaning of Steen's picture is fairly unambiguous: some men, impressed by the ladies' refinement and dress, and by the elegant interior, have placed their trust in appearances, only to be deceived. The opulence is a sham; the background vignette clearly shows that this fine mansion is nothing more than a brothel.[7] The slate on the table is undoubtedly an allusion to sayings such as "to be in the red" or, even worse, "to charge double" (in Dutch, *in de krijt staan* and *met dubbel krijt schrijven*, the latter literally meaning "to write with a double chalk"). The second saying was depicted as early as the sixteenth century by the Master of the Prodigal Son.[8] The dog asleep on the floor may be a reference to its cardplaying master's vigilance, or lack of it.

A painting by Pieter de Hooch in the Louvre shows cardplayers in an interior that is, if anything, even grander than this one (fig. 1).[9] There, too, the women clearly hold all the aces in a game that involves drinking and dalliance. Jan Steen, though, made the deception more overt. However, Pieter de Hooch is mentioned for good reason in this context, for Steen's painting is from that part of his oeuvre executed under the influence of De Hooch, whose work Steen had undoubtedly seen in Delft.[10] The debt is particularly apparent in the spatial organization, with the rear wall parallel to the picture plane and the view through to another room. In that respect, *The Cardplayers* is similar to *Easy Come, Easy Go* of 1661 (cat. 15), and even more so to a related image of 1660 (cat. 15, fig. 1).

In its detailed execution, Steen's painting also recalls the work of Frans van Mieris (1635–1681) and, more distantly, Gerard ter Borch. This is well illustrated by the affinity with Steen's supremely Van Mieris-like painting, *Acta Virum Probant* of 1659 (cat. 10). The rendering of the dress of the woman in the foreground is akin to that of the girl playing the harpsichord, while the man in the London picture is the double of the cardplayer on the far side of the table. The latter work also has a similar spatial arrangement, although it is far less pronounced. The woman with the piled-up hair seen from the back was borrowed from Ter Borch, who used her pose on many occasions.[11]

As is often the case, some of the elements are from other paintings by Steen, or were reused later. The model

(1617–1681) also show soldiers amusing themselves by dallying with young women and neglecting their military duties. In a general sense the theme was derived from the guardrooms depicted by masters like Dirck Hals (1591–1656) and Willem Duyster (1598/1599–1635) in the first half of the seventeenth century.[6] The later artists, however, generally made their interiors more luxurious and were subtler in portraying the interaction between the sexes.

People playing cards had been a recurrent theme in Netherlandish art since Lucas van Leyden's (1489–1533) depictions of this subject in the second decade of the sixteenth century. Interpretations differed, sometimes these paintings emphasized the idleness of the pastime and

fig. 3. Follower of Jan Steen, *The Ace of Hearts*, oil on panel, Nationalmuseum, Stockholm

for the woman with the ace is the same as seen in *Girl Offering Oysters* (cat. 9); even the angle of the head is almost identical. The maidservant on the left appears in very much the same pose in *The Weary Traveler* in Upton House (fig. 2).[12] Steen also repeated the position of the head of the man standing behind the table in his *Couple Drinking* in the Rijksmuseum.[13] Other motifs, like the Westerwald ewer, the sleeping dog, and, to a lesser extent, the folded rug, are also found elsewhere.[14]

Finally, the "peasant" variant of this subject, which is known from a copy in Stockholm (fig. 3), offers an interesting thematic comparison. A cardplaying peasant is about to slam his ace of hearts on the table with great delight as the other players, with trepidation or disappointment written on their faces, await a possibly surprising denouement.[15] Here, too, the score is chalked up on a slate.

The attraction of *The Cardplayers* lies mainly in the superb representation of a luxurious interior full of dazzling details and in the tension between the seemingly peaceful gathering and the deception taking place beneath the surface. That, together with the superb state of preservation, makes this a most exceptional work in Steen's oeuvre.

WTK

1. After spending many years in an American private collection, the picture emerged on the New York art market in 1990; New York 1995.

2. In other paintings Steen was often vague, but here the tablecloth is depicted with great precision. It bears a striking resemblance to the Anatolian carpet illustrated in Ydema 1991, 196, no. a6 and fig. 37.

3. The corner motif on the tiles is the so-called oxhead.

4. Cupid, concealed in the furniture or depicted in some other way, cannot automatically be taken as a reference to love. See, for example, *A Woman Peeling Apples* by Pieter de Hooch in the Wallace Collection in London, Sutton 1980, no. 61.

5. Philadelphia 1984, nos. 67 and 127.

6. For this view see Philadelphia 1984, xxxvii–viii. Duyster's painting in Worcester already comes close to Jan Steen's; see Welu 1975.

7. It can be inferred that painters liked to give brothels a luxurious look. Those who doubt this are referred to the *Robbery in a Brothel* (cat. 42, fig. 1).

8. See, for example, his painting in the Kunsthistorisches Museum in Vienna, Demus et al. 1981, 233–235, ill.

9. Sutton 1980, no. 58. The painting is sometimes dated in the 1670s, but since the women's dress was in fashion in the mid-1650s, the painting can be dated c. 1656–1657. Sutton places it c. 1663–1665. See, for example, Isaak Luttichuys' *Portrait of a Young Woman* of 1656, Rijksmuseum 1976, 355.

10. Also see, however, pages 88–89.

11. Ter Borch's influence is most readily apparent in Steen's *Ladies Listening to Musicians* of 1659 in Ascott House (cat. 7, fig. 2); Braun 1980, no. 107. It, too, includes a woman seen from the back; compare to Ter Borch's *The Paternal Admonition*, Rijksmuseum 1976, 131.

12. Braun 1980, no. 123.

13. Braun 1980, no. 138.

14. One problematic painting is a *Prodigal Son* (Braun 1980, no. B-10; Kirschenbaum 1977, add. 8) featuring the same woman seen from the back, and an identical dog and wine cooler. It is probably not an autograph painting by Steen.

15. Braun 1980, no. B-201.

15

Easy Come, Easy Go

1661

inscribed, signed, and dated on mantelpiece: *Soo gewonne Soo verteert 16 JSteen 61* (*JS* in ligature)

canvas, 79 x 104 (31 x 41)

Museum Boymans-van Beuningen, Rotterdam

PROVENANCE

Anonymous sale, Amsterdam, 11 May 1756, no. 24 (fl. 360); Jan Bisschop, Rotterdam; bought with the Bisschop collection by Adriaen and John Hope, Amsterdam, 1771; John Hope, Amsterdam, 1771–1784; heirs Hope, Bosbeek House, near Heemstede, 1784–1794; Henry Hope, London, 1794–1811; Henry Philip Hope, London, 1811–1839 (kept by Thomas Hope of Deepdene, London, 1819–1831); Henry Thomas Hope, London, 1839–1862; his widow Adèle Bichat, London, 1862–1884; Henry Francis Pelham-Clinton-Hope of Deepdene, London, 1884–1898 (on loan to the South Kensington Museum, 1891–1898); bought with the Hope collection by P. & D. Colnaghi and Wertheimer, London, 1898; L. Neumann, London, by 1907; his sale, London, 4 July 1919, no. 17, again to Colnaghi; Knoedler, 1921; D. G. van Beuningen, Rotterdam and Vierhouten, by 1926; acquired with his collection by the present owner

LITERATURE

Reynolds 1774, 201; Smith 1829–1842, 4:49, no. 148; Van Westrheene 1856, 119, no. 87; Hofstede de Groot 1907, no. 854; Leiden 1926, 18, no. 26; Bredius 1927, 51; London 1930, 125, no. 186; Lunsingh Scheurleer 1935; Martin 1935–1936, 264; De Groot 1952, 113, 121, 137, 141, 155, 159; Keyszelitz 1959; De Vries 1976, 17–19; Amsterdam 1976a, 108–111; De Vries 1977, 52–53; Philadelphia 1984, 309–310; Braun 1980, 105, no. 143

fig. 1. Jan Steen, *Oyster Meal*, 1660, oil on canvas, formerly Collection of the Earl of Lonsdale, Askham Hall, Penrith

In the sale catalogue of 1756 the central figure in the picture is described as a self-portrait by Jan Steen.[1] He has cast himself as a laughing modern-day prodigal, in the throes of self-indulgence, without a care as to the outcome of his luxurious living. In an opulent gaming house or gentlemen's club, richly appointed with a gilded fireplace, marble furniture, tapestries, and a large chandelier, Steen sits alone, gorging on his own private oyster meal.[2] The image of wealth and success, he is attired in the black clothes favored by the merchant class, although his collar has an ostentatiously broad band of lace. Attendants see to his every need: from the right, a seductive young woman with a prominent beauty mark offers him a glass of wine; at his other side, a sharp-nosed old crone, a fish seller, who

resembles Steen's stock procuress type (see cat. 42), shucks more oysters.

The juxtaposition of these two women would, to the viewer familiar with pictorial traditions, evoke the scenes of prostitution that were popular earlier in the century. To such a viewer, the young seductress' genteel holding of the wine glass must have seemed comically out of place in such uncouth company; the gesture of her other hand would have seemed an exaggerated way of offering herself.[3] That Steen salts—spices—his oysters from such a large salt cellar would have added a witty allusion to their erotic connotations (see cat. 9).

Characteristically, Steen lets our enjoyment of this deliciously tempting scene go only so far before warning

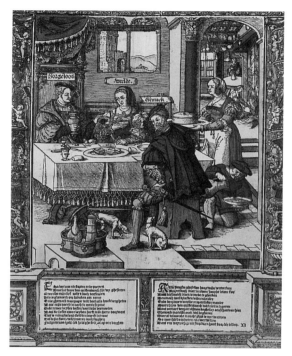

fig. 2. Cornelis Anthonisz., *Sorgheloos at the Inn*, 1541, woodcut, Rijksprentenkabinet, Amsterdam

us of the consequences of unrestrained indulgence. This is one of the few compositions of which Steen painted more than one version.[4] Comparing his first, slightly larger variant of this picture, the *Oyster Meal* of 1660 (fig. 1), sheds light on his strategy for deploying subsidiary figures that guide our moral interpretation of the scene. In revising the composition, Steen provided a foil for the protagonist's overindulgence in the figure of the young page, now moved to the foreground, who waters the wine, an activity emblematic of temperance and moderation.[5] For a second version, Steen took unusual care to rethink the composition and produce something quite different. This is evident in his refined use of red and yellow to harmonize the painting, in the number of changes from the first version, and in the many pentimenti visible in the areas of the chair and the page's left leg. To clarify the picture's message, he also added well-dressed tric-trac players in the backroom at left. Tric-trac, a game of chance like backgammon, was associated with idleness and folly.[6] The violent outcome of such gambling is evident in Steen's *Card Players Quarreling* in Berlin (Braun 346). Further, he added a witness, the humble man leaning against the fireplace at right, whom Joshua Reynolds (1723–1792) plausibly though unverifiably identified as having the features of Frans van Mieris.[7] Presumably a servant—one critic aptly called him the "chucker-out," the bouncer—he regards the laughing Steen with skepticism, suggesting that we too should judge him.[8]

As in the first version, the allegorical program of the chimneypiece reiterates that the protagonist's overindulgence and lack of self-control make him susceptible to the fickleness of Fortune. Inscribed on the mantle is the proverb *soo gewonne soo verteert*, which is usually translated "easy come, easy go," or more accurately and more aptly in this context of conspicuous consumption "easily won, easily consumed."[9] At the center of the carved stone and gilded chimney piece, which Steen derived from an architectural model book with designs engraved by Abraham Bosse (1602–1676), is a nude personification of Fortune, standing on a die, symbol of chance, and an orb, symbol of her instability.[10] Her billowing drapery alludes to the oft made comparison of Fortune's fickleness to the wind. The remaining decoration juxtaposes wealth and good fortune, on the right, and poverty and bad fortune, on the left. Hence, a cornucopia overflowing with coins has as its counterpart a bundle of thorny branches, and the smiling putto with a laurel wreath and scepter is opposite

a crying putto holding a crutch. This contrast between fortune and misfortune is carried through to the stormy seascape behind Fortune, which shows, on the right, a ship sailing safely away from danger, and, on the left, a ship wrecked on the rocks. In seventeenth-century Holland, where the prosperity of so many, indeed of the country as a whole, was tied to the shipping trade, fortune and misfortune were often allegorized with ship imagery.[11]

By the 1660s, it was rare for Dutch genre paintings to illustrate proverbs or moralize so overtly and many of Steen's works stand out as archaizing and stylistically eclectic, features that enhance their artificiality and theatricality (see cat. 21). Broadly speaking, the picture is reminiscent of sixteenth-century traditions of representing a single proverb, found in the work of Pieter Bruegel the Elder (c. 1525–1569) and later continued by Adriaen van de Venne (1589–1662), an artist whose comic approach was important to Steen.[12] More specifically Steen drew on the popular didactic theme of the prodigal son and his secular variant *Sorgheloos* (Careless), characters whose high living in the tavern made them the age's embodiment of folly.[13] Cornelisz Anthonisz.' (c. 1500–1561) *Sorgheloos at the Inn* (fig. 2), the second in a series of six woodcuts dated 1541 about the dissipation and decline of this profligate from popular lore, illustrates the tradition on which Steen drew. But unlike *Sorgheloos*, who is accompanied by *Weelde* (Luxury) and *Ghemack* (Ease or Comfort), and the many other prodigals who revel in the merry company of the tavern, Steen sits alone at the table.[14] In distancing himself from his attendants, Steen gives prominence to his self-image and makes the isolation of the wastrel psychologically vivid.[15]

The verses accompanying Cornelisz Anthonisz' woodcut series shed light on the convention behind Steen's dual role as wastrel and moralist. In each text *Sorgheloos* speaks first and then the narrator addresses the reader. In the caption to the inn scene, *Sorgheloos* tells his companions to drink and "stuff their bellies round. . . . If the money runs out I still have credit." Then the narrator cautions the reader that it is better to be moderate, for living in the "house of Wastefulness" is foolish:

For intemperance will come to a downfall, as you see here daily
You may also desire Ease
But in gaining it you could consume it (Maer al

winnende moecht ghijt te met verteren)
So may you be master of your own will
Because a few worldly goods are soon shat away.[16]

In the text, two first-person voices compete for the reader's attention. By speaking as both wastrel and painter, Steen transforms this literary device into an immediate and personal way of visualizing moral struggle.

Steen painted *Easy Come, Easy Go* just after arriving in Haarlem. While earlier critics interpreted his inclusion of himself as autobiographical, it is more useful to place the picture against a broader background of conventions of self-representation. Steen was one of a number of painters, including Rembrandt (1606–1669), who represented themselves as prodigals. Identifying with the prodigal served to comment generally on the painter's proverbial inclination toward Bacchus and Venus, on his status as outcast, and on the economic vicissitudes of his profession. Moreover, just as the wastrel indulges in luxuries that are transient, so the painter satiates his audience with images that are ultimately deceptive. In Steen's case, representing himself in this guise contributed to the roguish, comical image that was a central feature of his artistic identity.

HPC

1. For the description, see page 22, n. 6.

2. The sumptuousness of this interior is matched only by that in Steen's *Fantasy Interior with Jan Steen and Jan van Goyen* (page 20, fig. 14), which also dates from the early 1660s. On the oyster meal, see cat. 9.

3. See page 60.

4. Steen painted two close versions of *The Merry Household*, now in Philadelphia and the Rijkmuseum. He also probably painted a close variant of *The Stone Operation* (Museum Boymans-van Beuningen, Rotterdam) that has not recently been seen. Perhaps he painted *Easy Come, Easy Go* because of the immediate sale and success of the first version, or perhaps he wanted to improve upon his own work. Philadelphia 1984, 309.

5. For example, J. Matham after H. Goltzius, *Temperance,* and Z. Dolendo after J. de Gheyn, *Temperance.*

6. As in Cornelis Anthonisz' *Idleness* from his woodcut series *The Misuse of Prosperity* of 1546. Keyszelitz 1959, 42–44; Amsterdam 1976a, 109–111; Armstrong 1990, 62.

7. Reynolds 1774, 201; Philadelphia 1984, 310. Reynolds presumably based this identification in part on Houbraken's account of how Steen pulled Van Mieris down with him into dissolution. If indeed this is Van Mieris, his inclusion would be ironic since at the time he was in much better financial shape than Steen.

8. Schmidt-Degener and Van Gelder 1927, 14. A precedent for this witness is found in Lucas van Leyden's woodcut *Tavern Scene,* c. 1518–1520, in the form of the fool who speaks the words "Acht, hoet varen sal" (watch how this will turn out).

9. According to Smith 1829–1842, 4: 49–50, Waagen 1854–1857, 3: 118, and Van Westrheene 1856, 119, *Easy Come, Easy Go* hung in the Hope Collection with a companion, *The Christening* (Berlin, Gemäldegalerie, Staatliche Museen Preussischer Kulturbesitz), which is based on the proverb, "As the old sing, so pipe the young." The Hopes acquired both pictures from the Bisschops. However, since they appear to have arrived in that collection separately, there is no evidence that they were originally paired.

10. Barbet 1633. The prints by Bosse after drawings by Barbet were reused for a Dutch publication of 1641. See Lunsingh Scheurleer 1935; Keyszelitz 1959, 40–42; Philadelphia 1984, 310.

11. Goedde 1989, 151, 153.

12. On proverbs, see cat. 21.

13. Renger 1970; Armstrong 1990, 19–34.

14. In the remaining prints *Sorgheloos* descends to even more dissolute dancing and gambling, is expelled from the inn, and finally ends up in the poor kitchen. His unfortunate end distinguishes him from the Prodigal Son who ultimately gains forgiveness and salvation. See Armstrong 1990, 19–34, figs. 37a–f.

15. Compare the psychological isolation of the prodigal in Steen's late *Garden Party* (cat. 49).

16. For the full text, see Armstrong 1990, 28.

16

The Doctor's Visit

c. 1661–1662
signed on lower step: *JSteen* (*JS* in ligature)
panel, 47.5 x 41 (19 ¼ x 16 ½)
The Board of Trustees of the Victoria & Albert Museum
[exhibited at Wellington Museum, Apsley House,
London]

PROVENANCE
Sale, Johan Pieter Wierman of Leiden, Amsterdam, 18 August
1762, no. 40 (fl. 750 to IJver); anonymous sale, Amsterdam, 4 July
1798, no. 90; sale, Jan Gildemeester Jansz, Amsterdam, 11 June
1800, no. 203 (fl. 203 to Zuyderhof) (described as on canvas); sale,
dowager L. Boreel, Amsterdam, 23 September 1814, no. 19 (fl. 1805
to Nieuwenhuys); sale, Lapeyrière, Paris, 14 April 1817, no. 55
(11,550 francs to the 1st duke of Wellington); and by descent

LITERATURE
Smith 1829–1842, 4:24, no. 75; Waagen 1854–1857, 2:273; Van
Westrheene 1856, 116, no. 72; Hofstede de Groot 1907, no. 137;
Bredius 1927, 49; Martin 1954, 64; Bedaux 1975, 35; Amsterdam
1976a, 234–235; De Vries 1977, 56, 57, 99, 163, no. 109; Braun 1980,
112, no. 186; Sutton 1982–1983, 21–22; Wellington Museum 1982,
129–130, no. 164; Brown 1984, 97–98; Philadelphia 1984, 313

While the many pleasures of viewing a painting by Jan
Steen include the beautifully rendered textures of satin
and fur, and the subtle effects of light as it enlivens figures,
perhaps the most poignant is the humor of the narrative
that unfolds across the picture plane. Like the director of
a small theatrical group, Steen carefully orchestrates his
setting and props to reinforce the drama played out by
the actors.

The doctor's visit, one of Steen's favorite subjects,
allowed him to parody a fascinating social disease that
seemed to affect large numbers of Dutch women at that
time—lovesickness. While he was not the first artist to
focus on this situation, he was certainly the most prolific
and the most successful in conveying both its humor and
its pathos.[1]

Steen depicted this subject, with subtle variations,
numerous times during the 1660s (see, for example, fig.
1).[2] Invariably he portrayed the object of the doctor's
attention as a languid young woman, virtually ignoring,
interestingly enough, the equally widespread phenome-
non of lovesickness among young men.[3] To judge from
the painting's refined technique—particularly evident in
the shimmering blue fabric of the young woman's dress,
the rich texture of her plum-colored velvet jacket, the
glistening surface of the silver candlestick, and the intri-
cate patterns of the rug on the table—Steen must have
executed this work in the early 1660s, shortly after arriv-
ing in Haarlem from Warmond.

Lethargic and melancholic, the young patient sits in a
chair, resting one foot on a footwarmer. With tears in her
eyes she holds her head in her hand while the doctor takes
her pulse.[4] The doctor glances knowingly toward a woman,
perhaps the household's maid, who stands beside him
holding a urine bottle. "The diagnosis," he seems to say
as he gestures in her direction, "is all too clear: she is suf-
fering from lovesickness." Equally certain is the nature of
her response: "I guessed as much."

The viewer, of course, needs only to notice the heart
hanging from the dog's collar or the impish young boy
smiling and holding an arrow in a bow to conclude that
love is at the core of the woman's problem.[5] While Steen's
ingeniously conceived cupid is apparently waiting to
launch his arrow at the viewer, the young maid has been
left heartbroken, a state of being to which the artist
alludes with the scene from Ovid that hangs on the rear
wall.[6] There another mythological hunter, Adonis, bids
adieu to Venus as she urges him to forego the hunt.[7]

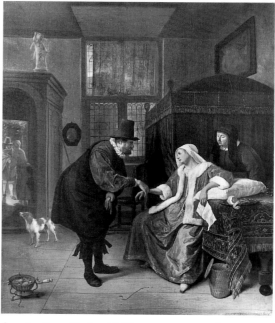

fig. 1. Jan Steen, *The Lovesick Woman*, c. 1661–1663, oil on canvas,
Alte Pinakothek München

Venus' efforts fail, and her lover will be speared by a boar,
leaving her alone with nothing more than memories of
their last embrace.[8]

Steen comments on the folly and vanity of the
lovesick maiden in a number of ways. Her foolishness,
for example, is reflected in another painting-within-the-
painting, Frans Hals' (c. 1582/1583–1666) depiction of the
comic figure of *Peeckelhaering* (fig. 2).[9] The temporal
nature of her woe is underscored by the clock, with its
small armored figure poised ominously as the hammer
for the bell.

Steen clearly enjoyed poking fun at the participants—
at the pomposity of the doctor, the gullibility of the
accompanying woman, and the lamentable melancholia
of the striken patient.[10] Nevertheless, Steen's physician
does use analytical methods—taking the pulse and testing
the urine—traditionally recommended for diagnosing this
illness.[11] Since antiquity the pulse was thought to gauge
the condition of the heart.[12] The appearance, or even the
name of the lover, was thought to affect the patient's
heartbeat. Doctors also believed that the color, texture,

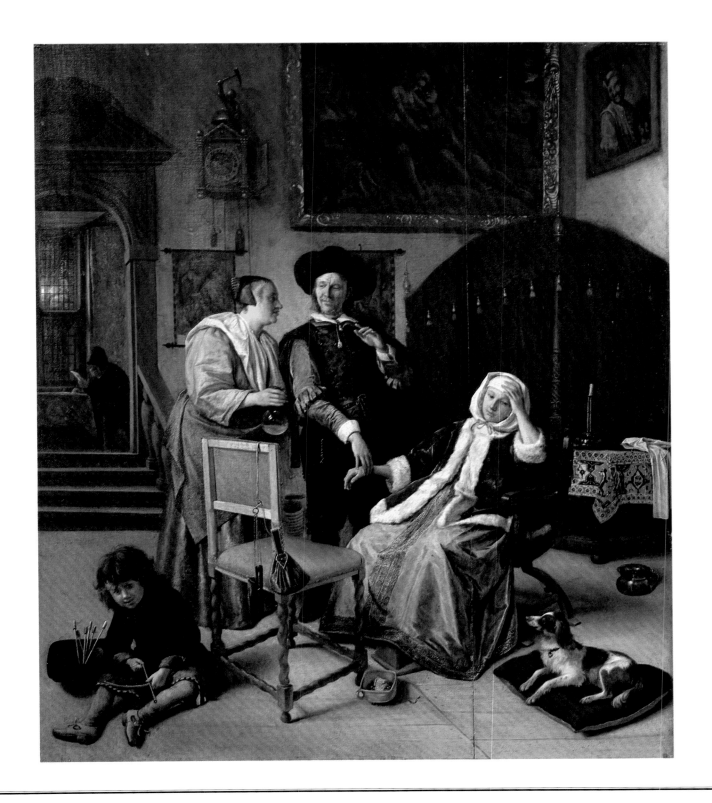

fig. 2. Frans Hals, *Peeckelhaering*, c. 1628–1630, oil on canvas, Staatliche Kunstsammlungen, Gemäldegalerie, Kassel

clarity, and smell of the urine reflected the character of the Humors in the blood, which, if unbalanced by lovesickness, induced a state of melancholia.[13]

Some physicians even claimed that the examination of a woman's urine could determine whether she was pregnant.[14] The urine was first heated, which may account for the small brazier on the floor by the woman's feet.[15] The brazier could also be used to singe a ribbon taken from the woman's garment, producing a smell that, according to folklore, would revive her after fainting.[16]

The mid-seventeenth century medical community disputed many of these assertions.[17] One critic deemed those who prescribed them *Quacksalversche Pis-besienders* (quackish piss-lookers).[18] Johan van Beverwijck, a famous doctor and popular author, even asserted in 1642 that one could not distinguish between urine from a man and a woman, let alone whether a woman was pregnant.[19] Certainly, the impression Steen gives—that a number of charlatans belonged to the medical profession and that many gullible citizens remained susceptible to their charms—is not far from the truth.[20]

Steen's fascination with lovesickness, as well as that of other painters from Leiden, particularly Gerrit Dou (1613–

1675) and Frans van Mieris the Elder (1635–1681) (page 18, fig. 11), reflects a widespread contemporary interest in this subject. Between 1654 and 1696, seventeen dissertations were written on the subject at the universities of Leiden and Utrecht.[21] Theatrical productions, in which medical buffoons treat melancholic women, were also increasingly popular, particularly in the 1660s.[22] These farces were premised on Ovid's conclusion, familiar to Dutch audiences through Otto van Veen's 1614 *Emblemata Amorum*, that the only cure for lovesickness is the lover himself.[23] Many of these plays, however, had a peculiar twist: lovesickness was feigned rather than real. Lovers adapted this ploy to persuade recalcitrant fathers to allow their marriage.[24]

One wonders if Steen played on these same ideas. Such a story line might account for the presence of the elderly man in the back room, who sits at a table hunched over his accounts.[25] While his relatively small scale and dark clothing make him seem thematically insignificant, Steen, in fact, gives him compositional prominence by placing him at the vanishing point of the perspective system. Interestingly, in a number of Steen's other paintings of lovesick maidens, figures in doorways play an important, if subsidiary, role in the narrative, as, for example, the young lover arriving with a letter in *The Lovesick Woman* in Munich (fig. 1). In both instances Steen leaves the story open-ended, allowing the viewer to participate in forging the outcome of the drama.[26]

AKW

1. Particularly important for the development of the genre was Frans van Mieris the Elder's *The Doctor's Visit*, 1657, Kunsthistorisches Museum, Vienna. See page 18, fig. 11.

2. De Vries 1977, 98–101.

3. Traditionally the problem was seen to affect both sexes, although in slightly different ways. See, for example, the discussion of lovesickness and gender in Wack 1990, 110–113. Steen did occasionally depict male lovesickness, as, for example, his *Antiochus and Stratonica* (Braun 1980, no. 302).

4. Her inability to carry out daily responsibilities is indicated by the belt she has removed, which hangs over the back of the empty chair and to which are attached her blue-satin purse and black knife case.

5. Steen often included plaster casts of Cupid in such scenes. See, for example, fig. 1. Although indistinct, the two prints hanging behind the lovesick maiden must serve a similar function. The print on the left appears to represent Venus and putti in a landscape.

6. The toy arrows are blunt on the end. Braun 1980, no. 186, interprets the blunt arrows as an indication that the young woman's husband, whom he identifies as the old man in the back room, is no longer able to satisfy her amorous needs. However, as the young boy appears to have constructed the arrows by wrapping paper around a wooden dowel, it seems more likely that they are meant to represent ones that could be lit like flares, such as that seen in a painting of Venus and Amor by Godfried Schalcken in Kassel (Amsterdam 1989, cat. 43). An arrow of this nature would suggest that Cupid is waiting to "light a fire" with the right lover. I would like to thank Esmée Quodbach for drawing my attention to this painting by Schalcken.

7. Weber 1994, 301, identifies the visual source for *Venus and Adonis* as a print by Maerten van Heemskerck. Steen also included the painting of Venus and Adonis in the background of other paintings of the Doctor's Visit, including that in Munich (see fig. 1).

8. *Metamorphoses* 10: 529–559.

9. See Bax 1979, 218. Slive in Washington 1989a, 216, cat. 31, notes that an engraving after *Peeckelhaering* was used as a frontispiece to a contemporary anthology of jokes and jests. Steen almost certainly owned the painting by Hals, since it also appears in *Baptismal Party*, Berlin (inv. no. 795 D), where it hangs as a pendant to a version of Hals' *Malle Babbe* (perhaps that in the Metropolitan Museum of Art, New York).

10. Gudlaugsson 1945, 12–19, 60, and Bedaux 1975, 42, associate the doctor's costume with figures from the *commedia dell'arte*, but Kauffmann in Wellington Museum 1982 cites the authority of Mrs. M. Ginsburg in asserting that the "wide hat and slashed sleeves were part of the rather conservative professional dress of the seventeenth century." However, even if Steen has accurately recorded a professional's dress, albeit old-fashioned, he has given it a comic air, particularly through the raised brim of the hat.

11. Bedaux 1975, 17, notes that testing the urine and measuring the pulse in suspected cases of lovesickness had been recommended since the time of Hippocrates and Galen.

12. Wack 1990, 136.

13. In the pathology of the period, the unbalancing of the Four Humors (blood, black, and yellow bile, and phlegm) was understood as integral to understanding the character of the Four Temperaments. As Sutton 1982–1983, 22, explains, erotic love, associated with the sanguine temperament, "warmed and enlivened the body with fluids. However, without an outlet for this passion the body dried out and became cold, and the person succumbed to sadness and despondency. Since cold and dryness were characteristics of the melancholic temperament, repressed or unsatisfied love was believed to cause melancholy."

14. Bedaux 1975, 22.

15. Van Gils 1920, 200.

16. Van Gils 1920, 201.

17. Petterson 1987, 204–205, explains that the seventeenth-century diagnosis of lovesickness associated the problem with a cessation of menstruation, which resulted in a pale face, headache, pounding heart, loss of appetite, upset stomach, sleepiness, and melancholia.

18. Bedaux 1975, 22. This term was used by the Delft physician Petrus Forestus. His 1589 Latin publication was published in Dutch in 1626.

19. Van Beverwijck's text from his widely read *Schat der Ongesontheyt*, first published in 1642, is quoted in Bedaux 1975, 24.

20. Visscher 1614, 128, emblem 6, *Raeck wel / heb wel*, for example, warns about so-called doctors who have bought their diplomas abroad. See also Bedaux 1975, 42, and Amsterdam 1976a, 243.

21. Petterson 1987, 204 n. 13 and 14, for the titles of the dissertations.

22. Van Gils 1917 and Petterson 1987, 212–214.

23. Van Veen 1614, 168–169, in his emblem *Amans Amanti Medicus*. Petterson 1987, 209, fig. 13. While many theatrical doctors stumble with their diagnoses, it must be said that most of Steen's physicians recognize the problem, and even realize that they can offer little help. In the Munich painting (fig. 1), for example, the woman holds a sheet of paper with the inscription "No medicine will help since it is the pain of love."

24. One such plot, for example, appeared in *De liefdendokter*, a play by Adriaan Bastiaansz Leeuw, based on Molière's *L'amour-medicin*, apparently first performed in 1666, thus a few years after the date of Steen's painting. Angeniet, the daughter of Kommer, a prominent citizen, suffers from lovesickness. When her father discovers that her unhappiness is caused by her longing for a husband, he gets mad and refuses to let her marry. Radegont, Angeniet's maid, and Barnaart, Angeniet's lover, make a plan to deceive Kommer so that Angeniet and Barnaart can get married. Barnaart pretends to be a doctor, visits Angeniet, and "cures" her. He tells Kommer that he has cured Angeniet's lovesickness by courting her. Barnaart also arranges a fake marriage as part of the "treatment." I would like to thank Ingrid Vermeulen and Tessa Luger for their synopses of the play.

25. While Braun 1980, 112, no. 186, has interpreted the man to be the young woman's husband, it seems more probable that he is her father.

26. See page 53.

17

The Garden outside an Inn

c. 1661–1663

signed at lower right, on the plank strengthening the
table legs: *JSteen* (*JS* in ligature)

canvas, 68 x 58 (26 ¾ x 22 ⅞)

Staatliche Museen zu Berlin, Gemäldegalerie

PROVENANCE

From the Royal Prussian collections; Kaiser Friedrich Museum,
Berlin 1830; Staatliche Museen, Berlin-Dahlem

LITERATURE

Smith 1829–1842, supplement: 490, no. 45; Van Westrheene 1856,
136, no. 164; Hofstede de Groot 1907, no. 658; Bredius 1927, no.
60; Schmidt Degener and Van Gelder 1927, 57; De Jonge 1939, 22;
Martin 1954, 68; The Hague 1958, no. 11; Staatliche Museen Berlin
1975, 409–410; De Vries 1977, 44, 48; Braun 1980, 106–107, no. 152;
Brown 1984, 186

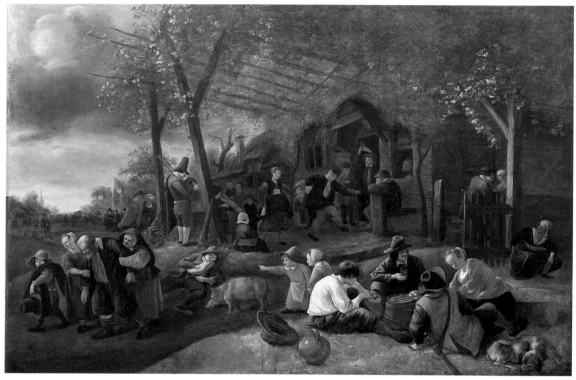

fig. 1. Jan Steen, *Peasant Kermis*, c. 1668–1670, oil on panel, Frans Halsmuseum, Haarlem

Jean-Nicolas Parival, professor of French at the University
of Leiden, noted in 1669 that many Dutch people were in
the habit of going into the countryside on their days off
in fine weather, and that the jaunt always included a visit
to an inn.[1] Here Jan Steen has depicted one of the result-
ing throngs in a garden outside an inn, where people
have paused to relax and refresh the inner self. A man
with his wife and child sits at a wooden table beneath a
canopy of leaves supported by a pergola. The woman
gives the boy something to drink, and in her left hand she
holds a large, pewter jug. The man fillets a herring with a
knife while a dog looks on eagerly.[2] Hanging over the
woman's head is the tallyboard on which orders were
noted. Another one hangs from a tree a little farther off.
Standing behind the table is a grinning fish-seller with
dried dabs over his shoulder. A basket of shrimps rests on
his arm with a measuring jug hanging from it.[3] At the
other tables people drink, smoke, and court. The door to
the inn in the background is open, but the building itself
is largely hidden by a thin screen of trees. The garden is
closed off in the right background by a covered alley,
which is possibly where shuffleboard was played. That, in
any event, was the purpose of a similar structure in a
painting by Adriaen van Ostade (1610–1685) of 1677.[4]

Steen's scene derives its charm mainly from its peace-
ful, rustic mood and the relaxed gathering of various
people. In that respect the picture is closely related to the
London *Skittle Players outside an Inn* (cat. 22), in which
Steen also explored the effect of the evening light,
although more insistently. In the *Garden outside an Inn* this
is particularly evident in the bright lighting of the man in
the foreground.

Half-covered inn gardens with visitors taking their
ease are a recurrent theme in Steen's oeuvre. They range
from simple compositions with just a few figures, such as
The Weary Traveler in Upton House (cat. 14, fig. 2), to
elaborate, complex scenes like the far more lively and
intricate painting of 1663 in Washington (cat. 20). It can

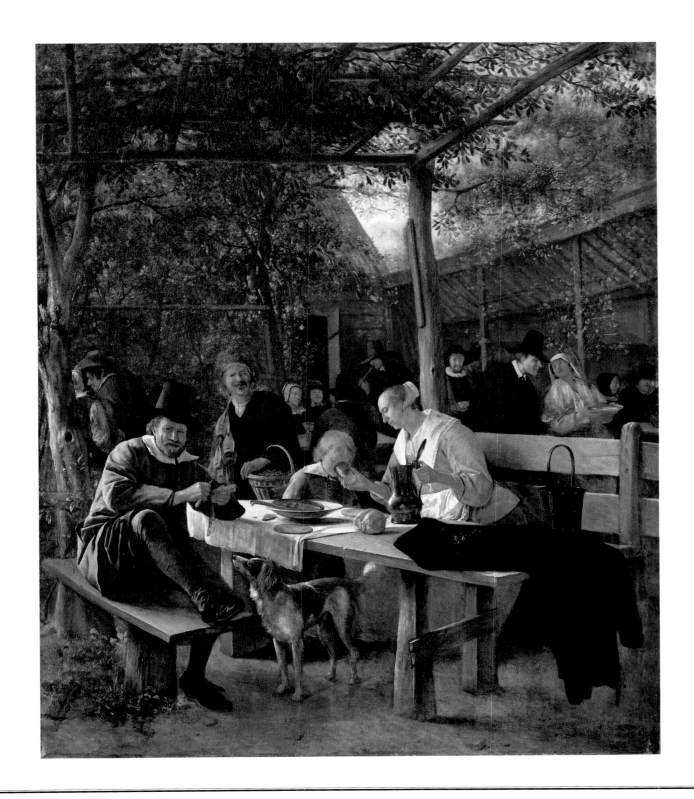

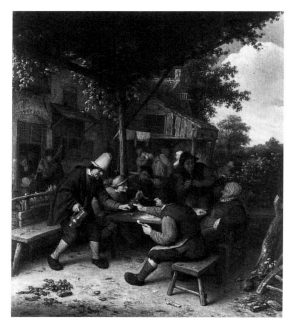

fig. 2. Adriaen van Ostade, *Garden of an Inn*, 1676, oil on panel, Staatliche Kunstsammlungen, Gemäldegalerie, Kassel

be assumed that the *Garden outside an Inn* was painted before then, but certainly no earlier than 1660. A similar roof of foliage appears in *The Over-Familiar Guest in an Inn* in a private collection, while a slightly smaller, horizontal painting in Florence, *The Little Violinist*, is related to it in spirit.[5]

The man beside the serving girl holding a large dish on the right has sometimes been taken as a Quaker, a member of the strict religious group that was a favorite butt of jokes in the seventeenth century. His black garb certainly looks rather stiff, but in essence it differs little from that of the man sitting on the left, were he to don the cloak that lies on the table. One detail that is certainly ridiculous is the cartwheel ruff worn by the man walking behind the couple on the right, for this item of dress had gone out of fashion more than twenty years before.

Some authors have identified the inn as the one that Jan Steen ran on the Langebrug in Leiden. However, that would only be possible if the painting postdated 1670, which is quite definitely not the case. This is more likely a rural inn of the kind mentioned by Parival. Trying to pin down the location is rather pointless, as can be

demonstrated by the *Peasant Kermis* in the Frans Halsmuseum in Haarlem, for the vast roof of foliage in that garden would not have survived the first autumn storm (fig. 1).[6]

The idea that the expression "Giving someone a herring" (an allusion to the fish over the fisherman's shoulder) can be applied to this picture is decidedly far-fetched.[7] Nor is it reprehensible that the boy is shown drinking beer, which had a low alcohol content in the seventeenth century and was also drunk by children simply to quench their thirsts.[8]

A comparison with *The Fat Kitchen* (cat. 2) is sufficient to illustrate the change in Steen's artistic focus. His main concern in that painting was to tell a story. *The Garden outside an Inn*, however, is first and foremost a mood painting; any narrative it may contain is of secondary importance. Steen also concentrated more on detail, as can be seen from a comparison of the pewter jug found in both pictures. In *The Fat Kitchen* it is only sketchily indicated, but here it has a convincing sheen.

Steen repeatedly used specific motifs in different compositions. For example, a similar fisherman appears in the Brussels *Rederijkers Carousing (In Liefde Vry)* (page 56, fig. 6), and the woman in the fine red jacket appears as the pourer in the Rotterdam *Easy Come, Easy Go* (cat. 15). The similarity, though, escapes notice because of the very different dress and minor changes in the women's features. The dog, however, is almost exactly the same in both pictures: it is reversed from left to right and has a slightly different coat.

Steen probably painted such inn scenes following the example of his teacher Adriaen van Ostade. However, a late work by Van Ostade, the *Garden of an Inn* of 1676 in Kassel, shows the master taking his pupil's example to heart (fig. 2).

WTK

1. Quoted in this context by Zumthor 1959, 185 and Brown 1984, 186. Parival's book *Les Délices de la Hollande* was written in 1669 and published anonymously in Amsterdam in 1678. A second edition appeared in 1738.

2. The earlier museum catalogues in Berlin identify this man as Jan Steen, but this identification has now wisely been abandoned.

3. That they are indeed shrimps is apparent from a painting in Steen's manner in which a fish-seller is selling shrimps to guests at an inn; see Braun 1980, no. B-66.

4. Wellington Museum in London, reproduced in Brown 1984, 209.

5. Braun 1980, nos. 207 and 160 respectively. For the Italian painting see also Chiarini 1989, 530–531, inv. no. 1979.256, with color illustration.

6. Braun 1980, no. 165. Parival, it is interesting to note, mentions the shady bower of greenery, see Zumthor 1959, 185.

7. Brown 1984, 186.

8. Amsterdam 1994, 87, 111, for example.

18

Twelfth Night

1662
signed on stool in center: *JSteen 1662* (*JS* in ligature)
canvas, 131.4 x 164.1 (51 ¾ x 64 ⅝)
Museum of Fine Arts, Boston

PROVENANCE
Possibly Henric Bugge van Ring, Leiden (inventory), 1666; possibly anonymous sale, Amsterdam, 20 April 1695, no. 2 (fl. 130); possibly sale [Jacob Abrahamsz Dissius], Amsterdam, 16 May 1696, no. 63 (fl. 129); possibly sale, Crawford, London, 26 April 1806, no. 23 (£43 1s. to Jackson, Chelsea); sale, Henry Hirsch, London (Christie's), 12 June 1931, no. 22, ill., bought in; sale, same owner, London (Christie's), 11 May 1934, no. 144, ill. (£2625 to H. van Praagh); D. Katz, Dieren, 1934; Kleykamp, The Hague, 1934; J. C. Hartogs, Arnhem, 1934–1954; H. Schaeffer, New York, 1954; bought from Schaeffer, 1954, by the present owner

LITERATURE
Smith 1829–1844, 4:25, no. 79; Van Westhreene 1856, 150, no. 259; Hofstede de Groot 1907, no. 503a; Boymans-van Beuningen 1938, 36, no. 146; De Groot 1952, 75–77; De Jonge 1954, 32–34; Martin 1954, 63, 79; Kirschenbaum 1977, 41–42; De Vries 1977, 53, 162, no. 96; Walsh 1979, 504; Braun 1980, 108, no. 159; Van Wagenberg-Ter Hoeven 1993–1994, 85–86

The Feast of the Epiphany, or Twelfth Night, was traditionally celebrated in the Netherlands on 6 January with a meal where friends and relatives gathered to eat and make merry. *Driekoningenavond* originated as a medieval church feast with public performances and festivals reenacting the story of the three kings' search for the baby Jesus and of King Herod's Massacre of the Innocents.[1] *Rederijkers* who traveled from town to town performed these so-called Herod plays. Although secular performances of such plays were severely restricted during the Reformation, Catholics continued to celebrate this festival in taverns and homes.[2]

Traditionally, a "king," chosen from among the celebrants, assumed his position by chance, either by finding a bean in a cake baked expressly for the occasion or, as in this instance, by lottery. Lottery also determined the roles of others—members of the court, including the fool, cook, musician, steward, taster, and porter. In Steen's striking conception of the scene the role of king has fallen to the smallest child, who, wearing a decorated paper crown and supported by his smiling mother, stands on the table and proudly holds the honorary glass. Steen also depicts the chosen lots, identifying the role participants would assume during the evening, pinned to their hats and clothes.[3]

The high point of the evening occurred when the king took his first swig from the glass, at which time the whole company would shout: "the king drinks!" Nevertheless, while the young king in Steen's large painting seems poised to take his first sip, other revelers have already begun celebrating. A young boy tests a freshly baked waffle, traditional fare for this feast, and laughingly offers the rest to the king. Eggshells litter the floor near a large pot containing the batter, indicating that more waffles are yet to come. The young man with his back to the viewer holds open the lid of his tankard, and a violinist has begun to play. A jester provides levity by lewdly sticking his tongue out at the prim couple to the left while thrusting his phallically decorated staff in their direction.[4]

The celebration is equally enjoyed by those not at the table. In the lower left a girl has hitched up her skirt as she prepares for jumping over three lit candles, symbolic of the three kings.[5] A young boy watches the game, ostensibly to check to see if she abides by the rules, but, in true Steen fashion, he pays more attention to the girl's exposed knees than to her feet. Finally, the joyous group being welcomed at the door by the maid are star-singers, roving minstrels who wander the streets wearing paper crowns and carrying the traditional "star" that led the biblical kings to the Christ child.[6] With their luminous "star" lighting the night sky, these groups enlivened Twelfth Night celebrations and were often invited to join the indoor festivities.

Many of the songs at Twelfth Night referred to Herod, who, according to legend, remained in his palace while the three kings searched for Christ. Reputed to be a drunkard, he was in all respects a mock king, unworthy of his crown, as is apparent in paintings by Jacob Jordaens (1593–1678), David Teniers the Younger (1610–1690), Gabriel Metsu (1629–1667), Jan Miense Molenaer (c. 1610–1668), and Steen as well (fig. 1). Steen further emphasized the king's foolish nature in the Buckingham Palace painting by the bellows on which he stands and the print hanging behind him, inscribed with the Dutch proverb, *What use are candle and glasses if the owl won't look*.[7]

Steen's Boston interpretation of the Twelfth Night festival is distinctive in that a child takes the role of king.[8] This may well reflect the idea of a "topsy-turvy-world," where roles become reversed. It may also, however, indicate that Steen derived his scene from a tradition in medieval plays where the king represents the Christ child. Underlying this tradition was a legend that the wise men cried "The king drinks!" when they saw Christ first drink from his mother's breast.[9] Steen also included a child as king in two other Twelfth Night scenes, his painting from 1668, now in Kassel (cat. 33), and that now in Los Angeles (cat. 33, fig. 1).

Steen adapted the basic compositional format for this work from his earlier paintings, in particular, *Easy Come, Easy Go* (cat. 15), while dramatically changing the character of the light and perspective for thematic emphasis.[10] He enhanced the revelers' sense of intimacy through the warm candlelight illuminating their faces, an effect strengthened by the obscured light source. He manipulated perspective to draw the viewer's eye to the young king, both through the oblique position of the foreground stool and the rapidly receding angle of the fireplace hood. The floor tiles provide a secondary perspective system leading to a vanishing point near the doorway on the left, a device that directs the viewer's attention to the star-singers.

The increased informality and large scale of *Twelfth Night* almost certainly reflects Steen's response to artistic traditions in Haarlem, where he had only recently moved

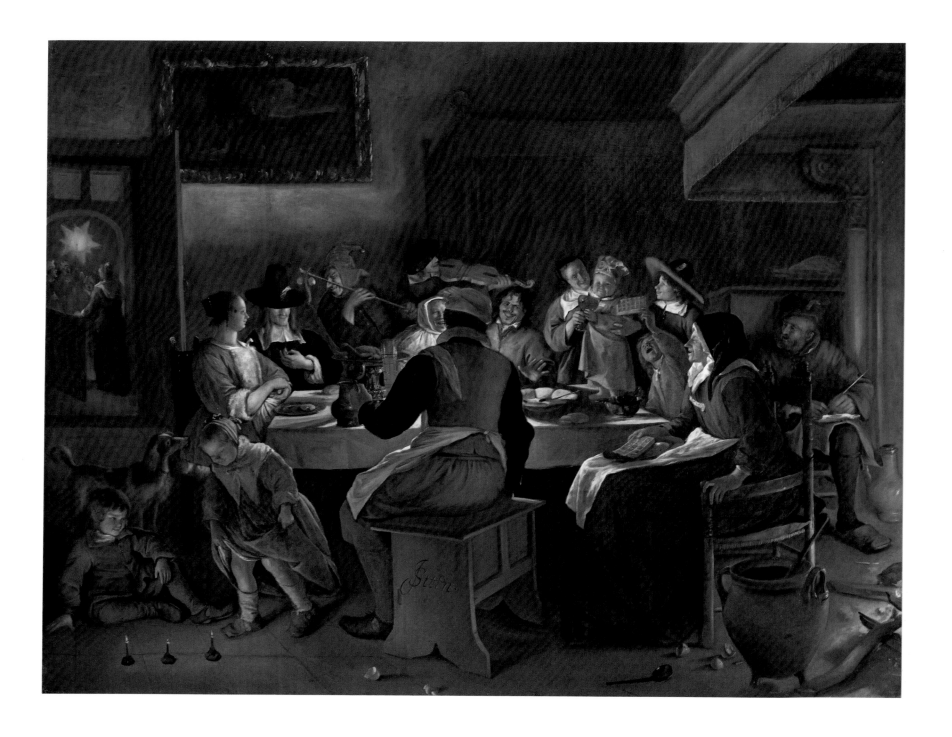

fig. 1. Jan Steen, *Twelfth Night*, c. 1661–1662, oil on panel, The Royal Collection © 1996, Her Majesty Queen Elizabeth II

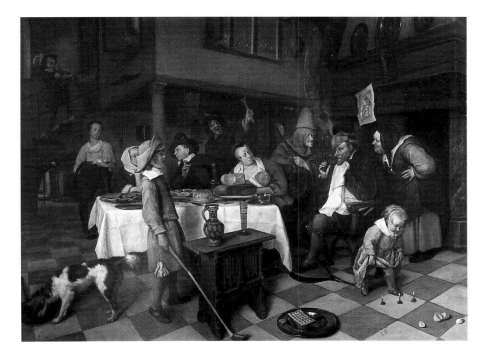

to have been constructed from a sausage and two eggshells. Bax 1979, 193, notes that the egg became a symbol of unchastity because it was regarded as an aphrodisiac. This meaning may also be attached to the eggshells littering the floor. Sexual overtones may also exist in the gesture of the man near the fire who stuffs a finger in the bowl of his pipe.

5. Sometimes, as in Steen's version of the subject in Kassel (cat. 33), the candles were placed in a single three-pronged candle holder.

6. Steen also includes star-singers at the door in his *Twelfth Night* scene in Buckingham Palace (see fig. 1). For illustrations of images of star-singers see Van Wagenberg-Ter Hoeven 1993–1994, figs. 1, 2, 3, 4, 6.

7. *Wat baten kaars en bril, als de uil niet kijken wil.* In the seventeenth century, the owl could be either a symbol of wisdom or a symbol of foolishness. Amsterdam 1976a, 247.

8. The association of the child king with the Christ child was also made by Margaret Hanni in a 1989 graduate seminar paper from Boston University (curatorial files, Museum of Fine Arts).

9. Coon 1665, 131, as noted by Van Wagenberg-Ter Hoeven 1993–1994, 78 n. 64.

10. The compositional structure of these works are remarkably similar. For example, in both paintings a male figure, situated apart from the group at the right, observes the activity at the table, while a separate vignette involving children takes place in the lower left. The same dog also appears in both paintings.

11. The 1666 inventory of Henric Bugge van Ring, Leiden, describes "a large piece being a merrymaking on Three Kings' night by Jan Steen." See Bredius 1927, 99. Westermann (personal communication) associated this reference with the Boston painting.

in 1661. His reaquaintance with Frans Hals (c. 1582/1583–1666), Adriaen van Ostade (1610–1685), and Jan Miense Molenaer must have been particularly important. Hals' free and bold brushwork served as a model for capturing the joyous exuberance of young children, and his civic guard portraits for organizing large numbers of figures at a table. Genre scenes by Ostade and Molenaer of the 1650s and early 1660s, while not large in scale, often depicted merrymakers informally situated in dimly lit, expansive interior settings. Indeed, their peasant genre scenes, which grew out of Bruegelian traditions that Adriaen Brouwer (1605/1606–1638) transported to Haarlem in the 1620s, may well have induced Steen to turn once again to Flemish art for inspiration, as he had done when he was in Haarlem at the beginning of his career. Steen's response to Flemish painting at this stage of career, whether the work of Jacob Jordaens, Jan Lievens (1607–1674), or David Teniers the Younger, appears not only in his choice of subject matter but also in his freedom of execution and broadness of style (see also cat. 20).

The clientele for whom Steen worked has always eluded scholars. Did he, for example, paint for Haarlem patrons once he had moved to that city? In this instance,

it appears not. The recent identification of this painting with the inventory of a Catholic family from Leiden indicates that Steen maintained his contacts with Leiden even during his Haarlem years.[11]

AKW

1. For the history of the feast, see Weiser 1952, 141–143.

2. The content of the celebration varied from region to region. For a discussion of the history and depiction of Twelfth Night celebrations in the Netherlands, see Van Wagenberg-Ter Hoeven 1993–1994.

3. Although Steen has not legibly written the identities of most of the participants, the slip of paper worn by the king appears to read *[k]onin[g?]h*. The lot worn by the woman holding a waffle on the right seems legible, but the apparent letters "Syrch" do not constitute a Dutch word. Since she, and the man seated with his back to the viewer, wear aprons, they may have cooked the waffles.

4. De Groot 1952, 74, cites a poem in which the fool punishes those who do not yell "De Koning drinkt!" at the appropriate moment, which perhaps explains why the fool turns toward this staid couple. The man's tall hat and formal wardrobe, moreover, relate to the costume of the Quaker in Steen's *In Luxury Beware*, 1663 (cat. 21). For Steen's satirical representations of Quakers, see Wind 1995. The "genitalia" at the end of the jester's staff appear

19

A Woman at Her Toilet

1663

signed and dated on stone columns: *JSteen 1663* (*JS* in ligature)

panel, 64.7 x 53 (25 ½ x 20)

Her Majesty Queen Elizabeth II

PROVENANCE

Possibly anonymous sale, Amsterdam, 20 March 1764, no. 4; sale, De Vigny et al., Paris, 1 April 1773, no. 58 (621 livres to Paillet); sale, David Fiers Kappeyne of Middelburg, Amsterdam, 25 April 1775, no. 92; sale, Gabriel François Joseph, chevalier de Verhulst, Brussels, 16 August 1779, no. 157 (fl. 315); anonymous sale, Brussels, 19 July 1820, no. 225; dealer Alexis Delahante brought it from Brussels to London, where he sold it to George IV, 1821; it was kept at Carlton House, and then moved to Buckingham Palace by 1841; it was at Windsor Castle from 1972 to 1979, after which it was returned to Buckingham Palace

LITERATURE

Smith 1829–1842, 4: 10, no. 32; Waagen 1854–1857, 9–10; Van Westrheene 1856, 111, no. 53; Hofstede de Groot 1907, no. 340; Bredius 1927, 67; De Groot 1952, 118–119; Martin 1954, 47–48; The Hague 1958, no. 25; De Vries 1977, 54, 55, and 162, no. 99; Kirschenbaum 1977, 39–40; Braun 1980, 110, no. 178; Royal Collection 1982, no. 189; London 1988b, no. 36

In this extremely refined and evocative work, a young woman sits provocatively at the edge of her bed while pulling on a stocking. She stares unabashedly at the viewer, implicitly a man, fully aware that her dress is pulled up over her knees and that her unlaced jacket reveals the fullness of her breast. Her inviting expression and suggestive demeanor offer the promise of uninhibited sensual pleasure. Her open bed curtains reveal her sheets, pillows, sleeping lap dog, and chamber pot (*pispot*), increasing the viewer's prurient desire. A seventeenth-century observer would also have enjoyed Steen's conscious play on associations in contemporary slang between the stocking (*kous*) and female erotic love.[1] For example, one pejorative term jokingly used to describe women was *piskous*.[2]

To reach this seductive woman, one has to pass through an imposing arched doorway flanked by marble columns, a weighty structure that Steen emphasizes by illusionistically painting his name and date as though carved into the stone.[3] The viewer must also step over a lute with a broken string, a music book, and, of all things, a skull wrapped in a vine. The ensemble is enough to make one stop and think, which is, in fact, exactly what Steen encourages the viewer to do.

With this massive architectural structure Steen announces that *A Woman at Her Toilet* is an allegorical painting. This entryway, which could never be confused with one into a Dutch woman's private chamber, provides both a visual and thematic framework for the scene. The elaborately carved structure evokes permanence and stability, strengthening the moral authority inherent in the symbolism of the sculpted festoon above the arch. Its sunflowers were a traditional symbol for constancy, in particular, faithful, spiritual love.[4] Grapevines, beyond their Eucharistic associations, also symbolized fertility and domestic virtue.[5] The iconographic ancestors of the anguished cherub are weeping cupids chastised for enticing mortals with sensual, profane love.[6] The moral framework, thus, is quite clear: by passing through the entryway one leaves behind the firm foundations of spiritual love and domestic harmony.

In case the viewer should overlook this message carved in stone, Steen adds a number of explicit warnings to discourage him from impetuously accepting the woman's invitation. The most obvious are the skull and lute with its broken string sitting on the doorsill, clear references to the transitory nature of sensual pleasure. The most poignant, however, is the woman's very act of

fig. 1. Roemer Visscher, "Al safjens soetjens," *Sinnepoppen*, Amsterdam, 1614, National Gallery of Art Library, Washington

pulling on her stocking. This gesture is virtually identical to an emblem in Roemer Visscher's *Sinnepoppen* that warns about the danger of impetuous behavior (fig. 1).[7] Visscher notes that by pulling on a stocking too fast, one can easily create holes and ruin it. Similarly, impetuous behavior such as yielding to sensual pleasure, can often bring one shame.[8]

Many of the same compositional elements exist in an apparently similar, although visually less complex, version of this subject (fig. 2). In the Rijksmuseum painting, however, Steen eliminates explicit vanitas elements, including the candle and jewelry box on a nightstand. He has also slightly changed the manner in which the woman grasps her stocking. As is also clear from the pronounced indentations above her calves, she pulls her stocking off rather than puts it on.[9]

The subjects of the two works are, in fact, fundamentally different. Rather than an allegorical scene about restraint in the face of sexual temptation, the Rijksmuseum painting provides a subtly erotic glimpse of a woman preparing for bed. Her revealing pose, while extremely

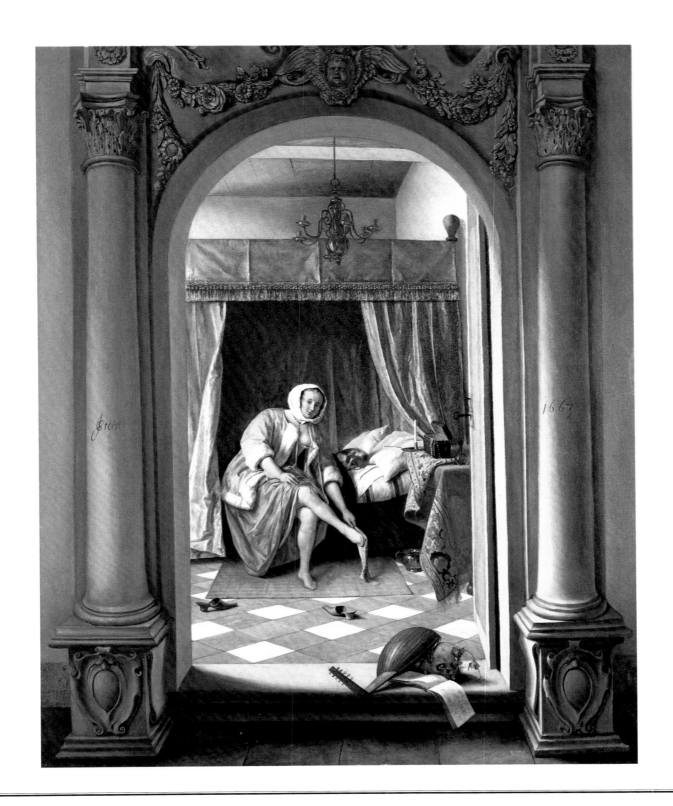

suggestive, is only inadvertently so. She looks down at her foot, seemingly unaware of the viewer's presence. While both scenes are risqué, the Rijksmuseum's painting's naughtiness relates to its voyeuristic character. Steen, rather than the woman, invites the viewer to peek into her darkened chamber for an unexpected sensual experience.

A Woman at Her Toilet is one of Steen's most carefully conceived and executed works, where he fully exploits his mastery of color, light, and texture to create the illusionism so essential to the scene. Few passages in his oeuvre, for example, rival the delicate color harmonies of pink and gray in the marble tiles, or the sensitive modeling of the lute. The increased translucency of paint over time has revealed remnants of the careful perspective drawing that Steen made before painting the tiles. Also visible are the tiles and door sill beneath the lute and skull, indicating that these iconographic elements were added at the last stages of the painting process.

Steen's decision to have the observer view the scene through an architectural enframement is probably also

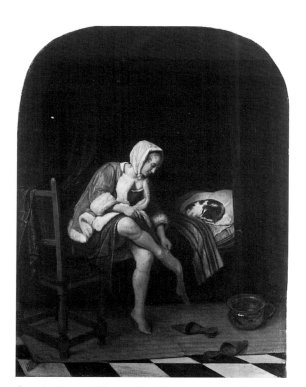

fig. 2. Jan Steen, *A Woman at Her Toilet*, c. 1659–1660, oil on panel, Rijksmuseum, Amsterdam

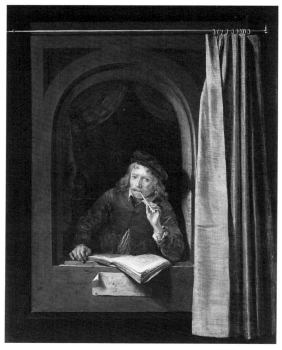

fig. 3. Gerrit Dou, *Self-Portrait*, c. 1650, oil on panel, Rijksmuseum, Amsterdam

indebted to Leiden traditions. Gerrit Dou (1613–1675), in particular, specialized in precisely executed genre scenes situated behind illusionistically painted stone niches. Occasionally, as in his *Self-Portrait*, c. 1650, (fig. 3), he even signed his name illusionistically and included a book protruding over the stone niche. However, Steen's conceit is different: he depicts a woman sitting in a room beyond a doorway, rather than a figure in a niche. Moreover, the woman's room is brilliantly lit, and defined with a clarity that almost certainly reflects Steen's awareness of paintings by Pieter de Hooch (1629–1684) and Johannes Vermeer (1632–1675).[10] In the end none of these stylistic sources can account for the distinctive quality of this work, which in its explicit moralizing character and direct emotional appeal embodies the essence of Steen's artistic personality.[11]

AKW

1. See De Jongh in Amsterdam 1976a, 259. As De Jongh notes, Steen was fully aware of slang expressions linking stocking (*kous*) and female love since the Dutch saying *Kaart, kous en kan maakt menig arm man* (Card, stocking, jug make many a man poor) appears as a rebus on a flag in his *Village Festival with the Ship of Saint Rijn Uijt* (cat. 4).

2. De Jongh in Amsterdam 1976a, 245.

3. Steen may have created this illusionistic effect as a play on his own name (*steen* means "stone" in Dutch).

4. Sunflowers always turn to face the sun as a true lover always follows his beloved. See Bruyn and Emmens 1956, 3–9, who discuss the meaning of sunflower imagery. Steen may well have derived the idea of including sunflower motifs in such a festoon from sculptural decorations on the Nieuwe Kerk, Haarlem (Bruyn and Emmens 1956, fig. 5).

5. See, in particular, Psalm 128, where it is written: "Thy wife shall be as a fruitful vine by the side of thine house."

6. For the punishment of Cupid, see Panofsky 1933. For a discussion of the sculptural tradition of weeping cupids in the Netherlands, see Schatborn 1975.

7. The association between this gesture and Visscher's emblem was convincingly made by De Jongh in Amsterdam 1976a, 245, 259–260.

8. Visscher 1614, emblem 4, *Al safjens soetjens*. The Dutch text reads: *Die een kous (die vast om't been sluyten sal) aentrecken wil, die moet met langsinnigheydt te wercke gaen, dan soo hy met fortse of haestigheydt wil voortvaren, sal de hiel daer deur scheuren, en met een ghelapte hose ter feeste gaen: waer by men verstaet, datter veel dingen zijn, die de langmoedige kloeckaert uytvoeren sal, dat de korsele heethooft met schande sal laten steecken.*

9. The woman in the Buckingham Palace painting is certainly pulling on her stocking, which is only just covering her toes. While stocking marks also are seen on her legs, they are far less pronounced than those on the Rijksmuseum painting, suggesting that some time has elapsed since she has worn them.

10. See Royal Collection 1982, 123.

11. Jan Ekels II made a copy of this painting. See his sale, Amsterdam, 18 April 1791, no. 48.

20
The Dancing Couple

1663
signed at lower left: *JSteen 1663* (*JS* in ligature)
canvas, 102.5 x 142.5 (40 ⅜ x 56 ⅛)
National Gallery of Art, Washington, Widener Collection

PROVENANCE
Possibly sale, Samuel van Huls et al., The Hague, 24 April 1737
(fl. 140); probably sale, Count van Hogendorp, The Hague,
27 July 1751, no. 6 (fl. 830); Jan and Pieter Bisschop, Rotterdam,
by 1752, until 1771; bought with the collection of Jan Bisschop by
Adriaen and John Hope, Amsterdam, 1771; John Hope, Amsterdam,
1771–1784; heirs Hope, Bosbeek House, near Heemstede, 1784–1794;
Henry Hope, London, 1794–1811; Henry Philip Hope, London,
1811–1839 (kept by Thomas Hope of Deepdene, London, 1819–
1831); Henry Thomas Hope, London, 1839–1862; his widow Adèle
Bichat, London, 1862–1884; Henry Francis Pelham-Clinton-Hope of
Deepdene, London, 1884–1898 (on loan to the South Kensington
Museum, 1891–1898); bought with the Hope collection by P. & D.
Colnaghi and Wertheimer, London, 1898; Thomas Agnew &
Sons, London, by 1901, sold in same year to Peter A. B. Widener,
Elkins Park, Pennsylvania, who owned it until his death in 1915;
inheritance from Estate of Peter A. B. Widener by gift through
power of appointment of Joseph E. Widener, Elkins Park,
Pennsylvania; to the present owner in 1942

LITERATURE
Reynolds 1781, 169, 200, 204; Smith 1829–1842, 4: 50, no. 150; Waagen
1838, 334, no. 3; Waagen 1854–1857, 2:118; Van Westrheene 1856,
119–120, no. 89; Widener 1885–1900, 2:165; Hofstede de Groot 1907,
no. 655; Valentiner 1910, 5–12; Martin 1954, 79; The Hague 1958,
no. 18; De Vries 1977, 53–54, 130 n. 91 and 162, no. 97; Braun 1980, 83,
110, no. 180; Niemeijer 1981, 166 and 197, no. 216; Philadelphia
1984, 312; Sutton 1986, 309; The Hague 1990, no. 59; Buijsen 1991,
63–66; National Gallery Washington 1995, 364–369

This joyous scene under a vine-covered arbor of a coun-
try inn relates to the festive spirit of a local village fair, or
kermis.[1] The girl with a white cap talking over the porch
railing holds a child's pinwheel, sold at such fairs, as is the
delightful hammer toy held by the young child on her
mother's lap.[2] The kermis, however, was not only for
children. People of all ages and social classes enjoyed the
festivities and many traveled from miles around to partici-
pate. Proscriptions for proper behavior were temporarily
put aside and the celebrants enjoyed sensual pleasures to
their fullest. In Steen's painting, a young country ruffian,
to the enormous delight of onlookers, has led a comely
and seemingly shy city lass to dance. Lasciviously bedecked
in a beret decorated with cock feathers, he robustly kicks
his feet in tune with the music while she demurely ven-
tures forth, uncertain, but not unwilling to join in the fun.

Steen was a marvelous narrative artist, in large part
because of the way he exaggerated expressions, attitudes,
and even his figures' costumes to tell his story. Infrared
photographs and x-radiographs of this painting indicate
that he made a number of compositional changes to
enhance the contrast between the two main protagonists.
Initially, the male dancer was bareheaded. He held a
rather ordinary hat, with no feathers, and wore a smaller
collar (fig. 1).[3] By placing the beret with cock feathers on

his head and enlarging the ruff on his collar to an inap-
propriate size, Steen provided him with a costume com-
parable to those seen in the *commedia dell'arte*, and, thus,
established the role of this rude peasant as a dandy in
search of sensual pleasure.

A comparable change occurred with the laughing
peasant standing outside the porch. Steen initially depict-
ed him heartily toasting with a tall beer glass.[4] Perhaps
the artist transformed the celebrant into a passer-by stop-
ping to observe the scene in order to emphasize the
unusual character of this pair of dancers. By making the
peasant a poultry seller, however, he not only changed
the nature of the man's participation but also his thematic
impact. The Dutch verb *vogelen* means both "to bird" and
"to have sexual intercourse."[5] Thus, Steen almost certain-
ly included the poultry seller as a visual pun to highlight
the sexual character of the dance taking place directly
before him.

Steen rarely conceived his narratives without some
comment on the fallacies of human behavior, often draw-
ing upon his wide-ranging familiarity with Dutch proverbs
and emblematic traditions. The centrally placed empty
barrel, for example, is a reference to a well-known folk
saying adapted as an emblem in Roemer Visscher's
Sinnepoppen: *Een vol vat en bomt niet* [A full barrel doesn't

fig. 1. X-radiograph,
cat. 20

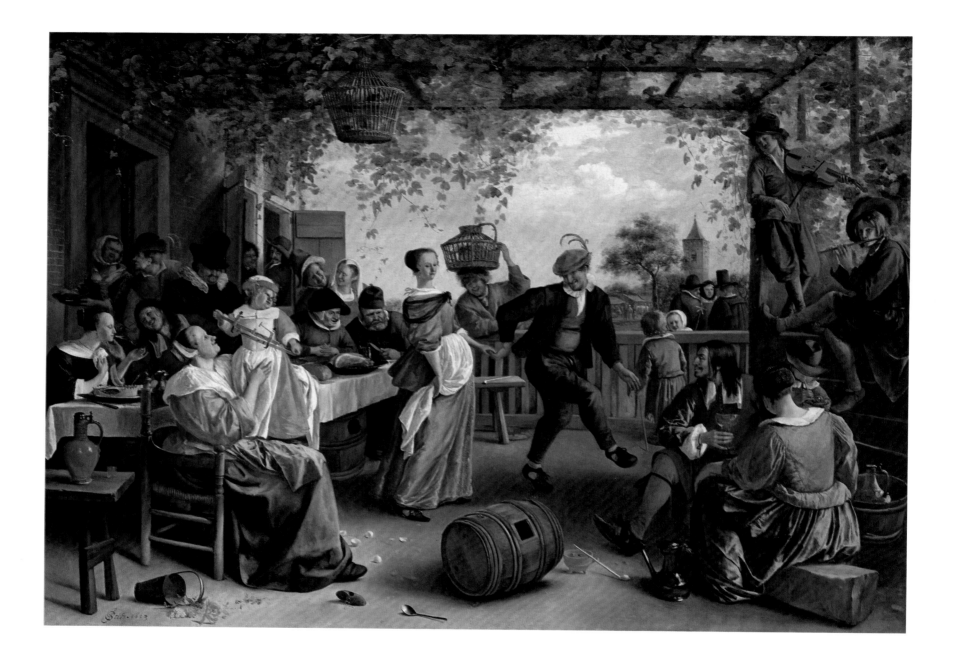

Een vol vat en bomt niet.

fig. 2. Roemer Visscher, "Een vol vat en bomt niet," *Sinnepoppen*, Amsterdam, 1614, National Gallery of Art Library, Washington

resound] (fig. 2).[6] Visscher's emblem warns that while ignorant people fill the air with words, wise, sensible people deport themselves in a quiet, capable manner.[7] While this emblematic reference offers a commentary on the foolishness of the dancing couple, other motifs suggest the transient nature of illicit pleasures. Broken eggshells and cut flowers have traditional *vanitas* associations in Dutch art, as does the boy blowing bubbles, a visual reference to *homo bulla*.[8] While a bubble looks wondrous and glistening at its best, it can disappear in an instant.[9]

Steen also compared the foolish relationship of the ill-matched dancing couple to other couples whose attachments rest upon firmer foundations: the mother who playfully holds her child on her lap; an old couple who have grown together over the years; and a young couple, whose tender love is evident in the way the young man, Steen himself, reaches over to touch his partner, a woman identified as his wife.[10] To contrast the dancing couple and these groups Steen has once again included objects from daily life associated with emblematic images. A cage with two birds, for example, hangs above the old couple, resembling an emblem in P. C. Hooft's *Emblemata Amatoria* (Amsterdam, 1611). The emblem, *Voor vryheyt vaylicheyt* (Instead of freedom, safety) stresses that love is strengthened when limits are placed upon it, and that

with freedom comes danger.[11] The contrast in meaning between this cage with birds and the cage held by the poultry seller could not be more extreme.

Finally, the hammer toy so prominently held by the young child in her mother's lap may well serve to emphasize the importance of harmony in human relationships.[12] This toy allows two men to hammer a stake in unison as the slats are moved to and fro. In character it relates to an emblem in Jacob Cats' *Spiegel van den Ouden ende Nieuwen Tijdt* (The Hague, 1632), in which several men work in timed unison as they hammer on an anvil.[13] Cats' commentary broadens the theme of teamwork by emphasizing that to live together in harmony each must contribute his or her own special quality. In particular, he notes that when the husband honors his wife and the wife her spouse, the household lives in peace.[14]

The large scale of this work is characteristic of the artist's paintings on canvas after he moved to Haarlem. During this period he painted in a freer and more expressive manner than he did in Leiden and Warmond. His figures also reflect his renewed contact with Haarlem artistic traditions. The aged couple at the end of the table, for example, is reminiscent of couples in paintings by Adriaen van Ostade (1610–1685).

Large scale kermis scenes, however, are more characteristic of Flemish painting than Dutch. It may be that Steen, encouraged by the strong bonds between Haarlem artists and Flemish artistic traditions, also looked at paintings by artists working in the tradition of Pieter Bruegel the Elder (c. 1525–1569).[15] Closest in concept to *The Dancing Couple* are kermis paintings by David Teniers the Younger (1610–1690). One motif common to both artists is a man seated at a table who reaches over to chuck a woman's chin. Teniers also delighted in dressing his rakish peasants in berets decorated with cock feathers. Had Steen looked to Teniers for inspiration, he might have transformed the Flemish prototype into a specifically Dutch idiom, tempering the visual delight in the sensuality of the image with a provocative intellectual and ethical framework. Indeed, Steen confined his narrative to the foreground, where the pictorial world mingles with the real, to insure that the moral issues confronting the revelers become ones the viewer must consider as well.

AKW

1. As Wouter Kloek has noted (in conversation with the author), a pentimento exists in the shape of the church spire, which demonstrates that Steen did not represent a specific church.

2. According to Nynke Spahr van der Hoek from the Speelgoed-en Blikmuseum, Deventer (letter of 27 July 1989, in NGA curatorial files), this toy is probably German in origin.

3. His pose, in reverse, recalls a figure in a smaller-scale depiction of the scene on panel, perhaps Steen's first essay with this composition. When this painting was exhibited (as *Dorps-feest* or *Village Festival*, oil on panel, 59 x 37 cm) in The Hague 1958, no. 18, it was in the collection of the duchess of Brissac, Paris.

4. The arm and beer glass are visible to the naked eye on the surface of the painting.

5. De Jongh 1968–1969, 22–74.

6. This phrase, slightly altered, is still part of the Dutch language. The contemporary version is: *holle vaten klinken het hardst* [hollow barrels sound the loudest].

7. Visscher 1614. The full text of the emblem is as follows: *Dese Sinnepop is soo klaer datse weynigh uytlegginghe behoeft: want men siet dat de onverstandighe menschen de aldermeeste woorden over haer hebben, op straten, op marckten, op wagens en in schepen; daer de verstandighe wyse lieden met een stil bequaem wesen henen gaen.*

8. Hendrik Goltzius (after?), *Quis Evadet* (The Allegory of Transitoriness) 1594, engraving; see *Bartsch Illustrated* 1978, 292, no. 10 (97).

9. For a discussion of this theme in Dutch art and literature see Amsterdam 1976a, 45–47.

10. The identification was first made by Broos in The Hague 1990, 422, on the basis of a comparison with an image of a woman who has been tentatively identified as Steen's wife, Margriet van Goyen, in *As the Old Sing, So Pipe the Young* (cat. 23).

11. Hooft 1611, 66, emblem 28: *Voor vryheyt vaylicheyt. In vancknis vordert my de Min; en was ick vry / Het ongheluck had onghelijck meer machts op my.*

12. For an excellent article that examines the ways in which children's games could provide commentaries on adult life, see Hindman 1981, 447–475.

13. I would like to thank E. L. Widmann for calling my attention to this relationship in her seminar paper at the University of Maryland in 1990, "Jan Steen and the Philosophy of Laughter: Rederijkers and the Theatre of Genre."

14. Cats 1632, 14–15: *Die moeten yder mensch het sijne leeren geven, De man die vier' het wijf, het wijf haer echten man, Soo isset dat het huys in vrede blijven kan.*

15. De Vries 1977, 130 n. 91, suggests that the composition is based on a composition by Pieter Brueghel the Younger (c. 1564–1637/1638) [see Marlier 1969], 440, 442, nos. 1, 2, and 3). Broos in The Hague 1990, 423, on the other hand, suggests a painting by Pieter Aertsen (1509–1575).

21

In Luxury Beware

1663

signed and dated on barrel at lower left: *JS 16[63?]*
(*JS* in ligature)
inscribed on slate at lower right: *In weelde Siet Toe*; and
below: *000001 Soma op.*
canvas, 105 x 145 (41 ⅜ x 57)
Kunsthistorisches Museum, Gemäldegalerie, Vienna

PROVENANCE
Possibly sale, Cornelis van Dijck, The Hague, 9 May 1713, no. 38
(fl. 201); sale, Bertels, Brussels, 1779, no. 40 (fl. 610); Charles duc de
Lorraine, Brussels; his estate inventory of 1680, no. 6; second
estate inventory of 1783, no. 27; by inheritance to the Imperial
Collection, Vienna, 1783

LITERATURE
Smith 1829–1842, 4: 12, no. 35; Van Westrheene 1856, 157, no. 347;
Hofstede de Groot 1907, no. 102; De Groot 1952, 63–65, 90–93,
110, 155, 159; The Hague 1958, no. 28; Kunsthistorisches Museum
1972, 88, no. 67; De Vries 1976, 9, 18; De Vries 1977, 53, 55, 57, 58,
no. 98; Braun 1980, 110, no. 179; Philadelphia 1984, 311–312, no. 104;
Salomon 1987, 315–343; Chapman 1995

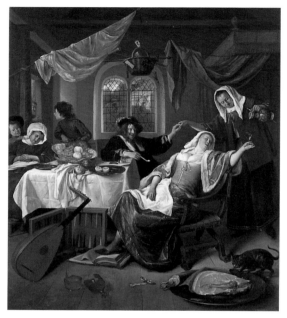

fig. 1. Jan Steen, *The Dissolute Household*, c. 1665, oil on canvas,
The Jack and Belle Linsky Collection, The Metropolitan
Museum of Art, New York

In this household gone awry, mother has fallen asleep
and things have gotten out of hand. Right under her
nose, the dog eats a meat pie on the table. Other ani-
mals—a pig, a duck, and a monkey—who have no busi-
ness being there, invade her home. Her children, some of
whom resemble Steen's, run quietly amuck: the baby in
the highchair has hold of money and valuables and has
thrown to the floor his bowl and an important document,
to judge by its seals; a little boy tries his hand at smoking;
his older sister surreptitiously pilfers the cupboard; and an
adolescent fiddles idly.[1] This misrule pales compared to the
unseemly behavior of the central couple. The man, per-
haps the father, lewdly slings his leg across the lap of a
beautiful seductress. She, in turn, holds the wine she
proffers provocatively between his legs. Her alluring
smile, indecorously assertive gaze (compare cats. 9, 48),
sumptuously painted yellow satin gown, and necklace
with a ring identify her as a loose woman, probably a
prostitute.[2]

Characteristically Steen turns this farcical scene into a
lesson, as in *Easy Come, Easy Go* and *As the Old Sing, So Pipe
the Young* (cats. 15 and 23). A comically out-of-place pious
old pair serves as an ineffectual foil to this prodigal family.

The hunched man, identified as a quaker by the "quacker"
on his shoulder, is oblivious to the disorder. The woman,
probably a *begijntje* or nun, shakes her finger at the wastrel,
who laughs off her warning. Inscribed on the slate (at
lower right), itself a symbol of reckoning, is the proverb
from which the picture gets its title, *in weelde siet toe* (in
luxury, watch out), and the words *soma op* (sums up).[3]

To judge by its boisterous composition, large scale fig-
ures, and loose, confident brushwork, all characteristics of
Steen's early Haarlem years, the once legible date 1663 is
probably correct.[4] During the 1660s, Steen painted several
pictures of dissolute households, including those in the
Linsky collection (fig. 1) and the Wellington Museum
(page 13, fig. 5), which is inscribed *bedurfve huishow* (disor-
derly household), that admonish about the evils of mis-
rule in the home. Of these, only *In Luxury Beware* singles
out Luxury (*Weelde*), the complex of insatiable desires that
included worldliness, avarice, intemperance, gluttony, and
lasciviousness, as the cause of domestic decay through the
warning on the slate and by personifying Luxury in the
central female figure. Traditionally Luxury was associat-
ed with effeminacy, the effect of which was to corrupt the

fig. 2. Adriaen van de Venne, "'t Zijn stercke beenen die
weelde dragen konnen," from Jacob Cats, *Spieghel van de
Oude en de Nieuwe Tijd*, Amsterdam, 1632, National Gallery
of Art Library, Washington

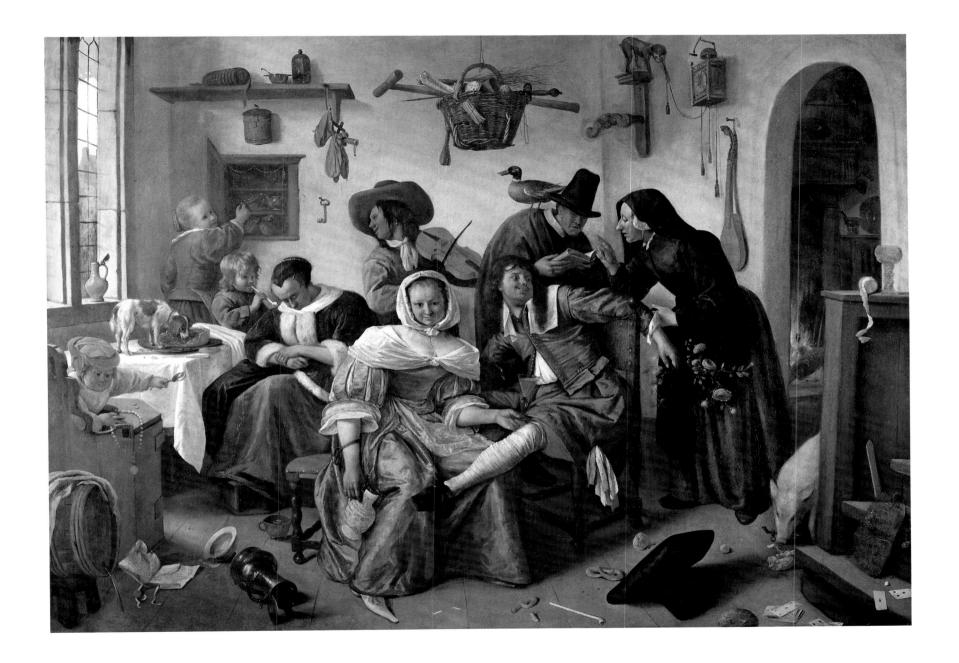

virtuous manly life, and was personified by a sexually seductive, opulently adorned female.[5] Adriaen van de Venne (1589–1662) represented the proverb *het zijn sterke benen, die de weelde kunnen dragen* (strong legs are needed to carry luxury) as a man struggling under the weight of Luxury (fig. 2), whose slashed sleeves and fancy shoes resemble those of Steen's woman.[6]

Steen was unique in representing the dissolute household.[7] Gerard de Lairesse (1641–1711), who recommended both the good and the bad family as suitable subjects for painters, must have had Steen's paintings in mind when he wrote that

In a bad family . . . we see the father careless [zorgeloos], the mother lavish, the boys wanton, the girls pert and the servants idling and dishonest. The father is indolent, the mother unreasonably indulgent to the children, the girls fancy and proud, the boys are romping and gambling, and the servants catching at what they can hold on to, thinking it is best to fish in troubled water. Servants and maids snuggle up together, tipple daily, all at their master's expense, until finally one finds the dog in the pot.[8]

Among Steen's contemporaries and immediate predecessors, such overt misrule was largely confined to tavern scenes and peasant genre.[9] A rare precedent for a disorderly middle-class home, in which a family violently succumbs to luxury, is *Discord*, a print of 1589 (fig. 3) by Crispijn de Passe the Elder (1565–1637). De Passe's print formed a pair with *Concord* (cat. 28, fig. 1), an image of a pious, less ostentatious family, saying grace. Steen must have known these prints: for *The Prayer before the Meal* (cat. 28) he borrowed the chair seen from the back in *Concord*; and, for *In Luxury Beware*, he seems to have derived the father's slung leg from *Discord*.

In an oeuvre that ranges from the seemingly naturalistic to the obviously artificial, *In Luxury Beware*, like his other dissolute households and cautionary family scenes (see cat. 23), stands at the extreme of theatrical artifice. The Linsky *Dissolute Household*, with its banner and bedcurtain that evoke stage curtains, seems especially theatrical (compare cat. 45, fig. 2). To convey the didacticism of these works, Steen employs such pictorial devices as the shallow stagelike space, the arrangement of figures across the picture plane, and the profusion of clutter. Moreover, these works, like the pictorial traditions on which they draw, tend to rely on proverbs, allegories, personifications, symbols, and short inscriptions.

fig. 3. Crispijn de Passe the Elder, *Discord*, 1589, engraving, Rijksprentenkabinet, Amsterdam

Proverbs, short, simple sayings that held great truths, were particularly popular in the sixteenth century. Although, by his time, Steen was exceptional in making paintings based on proverbs, they nonetheless remained current through such books of proverbs as Jacob Cats' *Moral Emblems*. Aside from the proverb on the slate, countless other reinforcing sayings are represented by pictorial motifs. The pig with the spigot from the wine keg sniffing a rose refers to *strooit geen rozen voor de varkens*, (don't spread roses [pearls] before swine); and the proverbially lustful monkey playing with the weights of the clock evokes "in foolishness time is forgotten." Having provided these cues, *In Luxury Beware* challenges its audience to discern additional proverbs in other motifs. The boy smoking surely refers to "as the old sing, so pipe the young," and the girl at the cupboard to "opportunity makes a thief." The wastrel's hat on the floor suggests a common expression of carelessness and intemperance.[10]

Steen also employs an emblematic pictorial language. Keys symbolized a wife's charge of her household and here a key, the *clavis interpretandi*, hangs strategically on the wall above the negligent sleeping mother and below an empty purse.[11] The basket hanging from the ceiling, which appears in other dissolute households and in *The Effects of Intemperance* (cat. 38, fig. 1), is a didactic device that reminds the viewer—the players in the picture are

oblivious to it—of the outcome of this high living. It contains cards and a sword, signs that unrestrained appetites lead to gambling and fighting, and numerous objects associated with punishment, poverty, and disease, including a switch, a beggar's crutch, and a *Lazarusklep*, or leper's clapper, which beggars with contagious diseases carried.[12] Like emblem books, *In Luxury Beware* is endlessly repetitive—unrestrained—in stating, restating, and reinforcing its message that Luxury leads to ruin.

HPC

1. Adolescents in the home were suspect by nature; for the association of fiddles with lust and idleness, The Hague 1994b, 290–291.

2. On the slung leg pose as a symbol of sexual intercourse, see Steinberg 1968. On prostitutes in yellow satin, see Westermann 1996a. One of the prostitutes in Steen's *Robbery in a Brothel* (cat. 42, fig. 1) wears the same necklace.

3. For the slate, see cat. 5.

4. Waagen 1862, 2: 132.

5. Berry 1994, 87–125.

6. In Cornelis Anthonisz' *Sorgheloos at the Inn* (cat. 15, fig. 2), the personification *Weelde* is one of the prodigal's companions.

7. Houbraken 1718–1721, 3:15, acknowledged his claim to this theme when he described a picture that most closely resembles the Wellington Museum version.

8. De Lairesse 1740, 188: "In tegendeel ziet men van een kwaade Huishouding, dat de Vader zorgeloos, en de Moeder kwistig is; dat de Jongens baldadig, en de Dochters ligtvaardig zyn; de Dienstboden luy en ongetrouw. De Vader ziet na niemand om, de Moeder geeft aan de Kinderen wat hun lust; de Meisjens zyn dertel en hovaardig; de Jongens stoeijen en dobbelen; de Dienstboden zoeken te grypen met hunne handen van alle kanten, denkende in ontroerd water is goed vissen; Knechts en Meisjens kruypen by malkander, zuipen en slempen dagelyks, en alles teert van den hoogen boom af, tot dat men eindelyk de hond in de pot vind."

9. Franits 1993. Middle-class domestic scenes, for example the bright interiors by Vermeer and De Hooch that Steen subverts here, tend to veil transgression as they extol the values of the virtuous household.

10. *Hij gooit zijn hoed maar voor de deur*. For these and the many other proverbs contained in this picture, see De Groot 1952, 63–65, 90–93; Philadelphia 1984, 311–312.

11. Franits 1993, 69–70.

12. De Groot 1952, 65; Philadelphia 1984, 312. See *The Feast of Saint Nicholas* (cat. 30) for a more lighthearted use of a switch.

22

Skittle Players outside an Inn

c. 1663
panel, 33.5 x 27 (13 ¼ x 10 ⅝)
The Trustees of the National Gallery, London

PROVENANCE

Possibly sale, Jacob Cromhout and others, Amsterdam,
8 May 1709, no. 78 (Dfl. 53); sale, Cornelis van Dijk, The Hague,
10 May 1713, no. 40 (Dfl. 51); sale Pieter Testas, Amsterdam, 29
May 1757, no. 41 (Dfl. 172 to Jan ten Compe); sale, Coenraad van
Heemskerck, The Hague, 7 October 1765, no. 30 (Dfl. 140 to
Fouquet); sale, Randon de Boisset, Paris, 3 February 1777, no. 128
(FF 1,600 to Poullain); sale, Poullain, Paris, 15 March 1780, no. 77
(FF 2,600 to Boileau); Comte de Vaudreuil, Paris, 24 November
1784, no. 63 (FF 3,401 to Paillet); J.P.B. Lebrun, Paris 1792; sale,
Destouches, Paris, 21 March 1794, no. 104 (FF 4,500 to Drouillet);
G. Saint-Maurice, Paris, 1796–1797; sale, Montaleau, Paris, 19 July
1802, no. 144 (FF 2,900 to Henri); sale, De Preuil, Paris, 25
November 1811, no. 95 (FF 4,950 to Lebrun); Prince de
Talleyrand, Paris 1814–1817; to William Buchanan in 1817 and sold
on to Edward Gray that same year; sale, Alexis Delahante,
London, 14 July 1821, no. 94 (145 guineas); Alexander Baring, later
1st baron Ashburton, 1829; sold in 1907 to Agnew; in 1909 to
George Salting, London; bequeathed by the latter to the present
owner in 1910

LITERATURE

Smith 1829–1842, 4:10–11, no. 33; Van Westrheene 1856, 113–114,
nos. 63 and 438; Hofstede de Groot 1907, nos. 737 and 738a; De
Vries 1977, 48; Braun 1980, 104, no. 135; Brown 1984, 202, 210;
National Gallery London 1991, 420–430, no. 2560

Three people have settled on the grass to enjoy a drink or
smoke a pipe outside an inn that was doubtless called the
Swan. To their right, two men and a boy watch a game of
skittles. Jan Steen placed the player too close to the skit-
tles, but his concentration and energy, as well as the keen
interest of the spectators, distract attention from the con-
fusion of this spatial relationship at first. The initial
impression is of a congenial game in rural surroundings
in which the burdens of daily life have been shed in order
to partake in some innocent amusement.

Steen repeatedly tried to capture the carefree mood
of a day off; one example is *The Garden outside an Inn* in
Berlin (cat. 17). People playing skittles often fill an impor-
tant role in those paintings, which have a *dolce far niente*
in the open air as the subject and an inn as a not entirely
innocuous haven nearby.[1] That is the case in an early
work in which the game is played amidst other amuse-
ments enjoyed at a fair (cat. 1, fig.2).[2] In another early
painting Steen also concentrated on several aspects of
outdoor recreation: people playing cards and skittles near
an inn as they are watched by a figure who is stretched
out full length in the grass (fig. 1).[2] There, too, he devoted
considerable attention to the landscape, but he was not
yet able to create a mood in his painting like this one.
Since a swan appears on the signboard in both pictures, it

seems unlikely that he intended to depict a real inn in
either one; the scene is probably a generalized rural set-
ting. The identification of Haarlem Woods as the loca-
tion of the inn and playing field in the London painting
must therefore be rejected.[3]

Steen depicted players close to the skittles on more
than one occasion.[4] In other works, such as the painting
in Vienna (fig. 2), he gave them and the people around
them far more space.[5] He also provided a leafy setting for
both the Vienna and London pictures. In the first, a dense
screen of trees serves as the backdrop to the foreground
scene; in the London panel, the marvelous transparency
of the trees is an improvement. Also the pose of the
player is much more convincing in the London work,
partly because the man stands more firmly on his feet
and, perhaps, because the ball was switched from the left
to the right hand. These arguments have led scholars to
propose an early dating for the Vienna picture—the fact
that it was prepared with a few sketches is cited as fur-
ther evidence.[6] This date, though, is far from certain, for
in the background is a well-dressed couple whose cos-
tumes were fashionable in the early 1670s.[7]

The London *Skittle Players outside an Inn*, like so many
other works by Jan Steen, was painted quite rapidly. The
artist did not follow an overall plan. For example, the

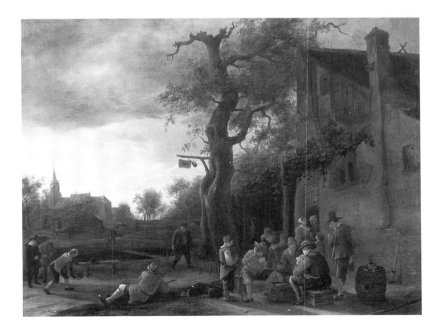

fig. 1. Jan Steen, *The Skittle Players*,
c. 1650, oil on panel, Museum
Boymans-van Beuningen,
Rotterdam (on loan from a
private collection)

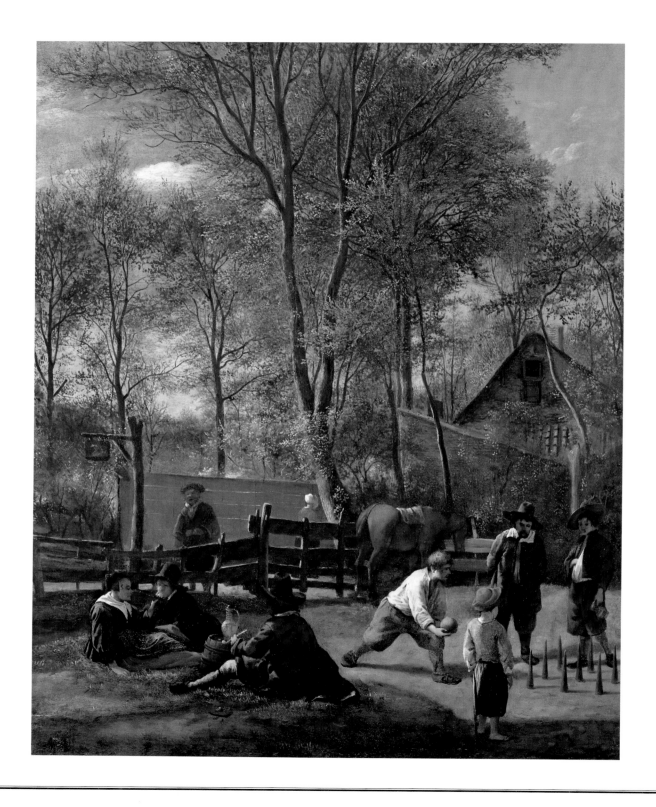

1. Examples are Braun 1980, nos. 37, 49, 50, 51, 82, among others.

2. Braun 1980, no. 73, which must be dated c. 1650.

3. The inn was described as being in Haarlem Woods in the 1713 sale. The numerous pentimenti, among other considerations, make it more likely that the location is imaginary.

4. See, for example, Steen's *Inn with Skittle Players* in Philadelphia, Braun 1980, no. 49. Adriaen van Ostade did the same, as shown by his drawing of 1673 in Vienna, Schnackenburg 1981, 2:116, fig. 246, and the associated painting, HdG 857.

5. Braun 1980, no. 13.

6. For the sheet with two sketches, which are the only drawings that can reliably be attributed to Steen, see Schatborn 1981, 79.

7. This painting is usually dated early, around 1650. De Vries 1977, 71, was the first to place it late in Steen's career, c. 1674, which is plausible given the figures' dress. In his later years Steen quite often used motifs from his early work.

8. See the *Farm near The Hague* in the collection of the duke of Westminster or the *Cows in a Meadow by a Farmhouse* in the Rijksmuseum, see The Hague 1994a, nos. 9 and 30 respectively.

9. A copy after *Skittle Players outside an Inn*, which has no pentimenti at all, is dated 1672, Rijksmuseum 1976, 525, no. A 1763. Such a late date is not plausible for the London painting.

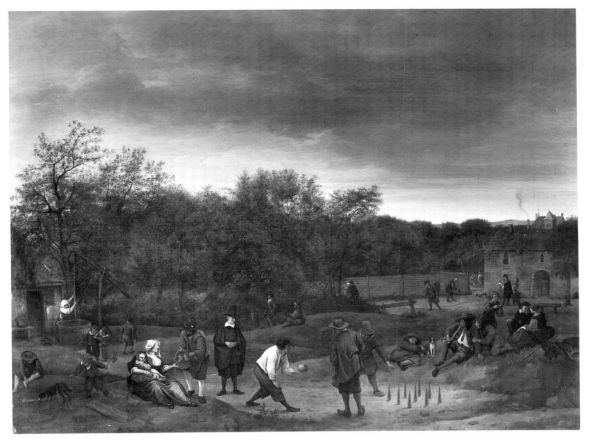

fig. 2. Jan Steen, *Wooded Landscape with Skittle Players*, c. 1670–1672, oil on panel, Kunsthistorisches Museum, Vienna

fence on the far side of the path was painted over the trees, and the fisherman with his blue cap was then painted over that. The horse and the men watching the game were only included after the open fence was completely finished, and it is possible that the boy was in turn painted over the left-hand spectator. Fortunately, Steen's approach did not result in an untidy composition. He apparently started out by painting the landscape, with an inn set among translucent trees, and then worked up the foreground.

The transparency and tonality of the slender trees set the mood of the painting, which is agreeably enlivened with attractive local colors, such as the boy's yellow shirt and the red jacket and white cap of the woman walking along the path. The hoarding and the fence give the composition several ingenious horizontal effects: in the case

of the hoarding, the light showing through the joins between the planks, and with the fences, the light striking the tops of the rails.

The rendering of the trees and the fall of light are reminiscent of the work of Paulus Potter (1625–1654), particularly of his paintings in which an evening atmosphere is evoked by fading sunlight and long shadows.[8] Steen undoubtedly saw his work in The Hague when Potter was the neighbor of Jan van Goyen (1596–1656), whose daughter Margriet became Steen's first wife in 1649. This painting, though, must have been executed well after 1650. The fashionable attire of the man seen from the back on the left makes a date of c. 1663 more likely.[9]

WTK

23

As the Old Sing, So Pipe the Young

c. 1663–1665

inscribed: *Liet/Soo voer gesongen soo/ na gepepen dat is al lang/ g(e)bleken ick sing u vo(or)/ so(o) volcht ons na(er)/ van een tot hon(derd) jaar*

canvas, 134 x 163 (52 ¾ x 64 ³/₁₆)

Royal Cabinet of Paintings Mauritshuis, The Hague

PROVENANCE

Sale, Hermina Jacoba baroness van Leyden, née Countess de Thoms, Warmond, 31 July 1816, no. 35 (fl. 1260 to Josi for Steengracht, The Hague); by descent to Jhr. Hendrik Adolf Steengracht van Duivenvoorde, Paris, 9 June 1913, no. 70 (bought for 375,000 francs for the Netherlands, with aid of the Vereniging Rembrandt); presented to the present owner, 1914

LITERATURE

Smith 1829–1842, 4:34–35, no. 106; Van Westrheene 1856, 107, no. 35; Hofstede de Groot 1907, no. 529; Mauritshuis 1914, 356–357; Leiden 1926, 15, no. 9; Bredius 1927, 49, 57; London 1930, 124, no. 182; De Groot 1952, 146, 155; Mauritshuis 1954, 81, no. 742; The Hague 1958, no. 29; De Vries 1976, 10, 18, 25; Mauritshuis 1977, 227, no. 742; De Vries 1977, 19, 57–58, 121, 164; Braun 1980, 114, no. 201; Sutton 1982–1983, 35–36; Broos 1987, 335–359; Németh 1990; Chapman 1990–1991

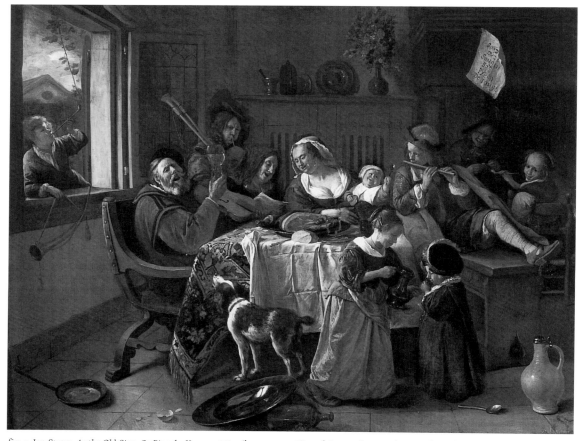

fig. 1. Jan Steen, *As the Old Sing, So Pipe the Young*, 1668, oil on canvas, City of Amsterdam, on loan to the Rijksmuseum, Amsterdam

Steen represents the popular proverb "As the old sing, so pipe the young" as a punning play on children smoking and blowing on pipes in imitation of their elders. Three generations of a family gather around a table draped with a carpet and set with a pewter plate of oysters, an oversized lemon, and a bunch of grapes. At the center of the composition, a baby sleeps in the arms of a loving mother. To either side of them a grandfatherly man smiles benevolently and an old woman wearing pince-nez, presumably his wife, displays a song sheet on which is inscribed a version of the proverb: "Song/ As it is sung, thus it is piped, that's been known a long time, as I sing, so (everyone) do the same from one to a hundred years old." Behind the grandmother's back a subsidiary group of "pipers" includes Jan Steen as the laughing—or perhaps singing—father, who mischievously teaches his son to smoke a pipe.

Characteristically Steen has cast himself in a role that undermines his paternal authority and he has enlisted other family members as transgressors, too. The little smoker has been identified as his son Cornelis. Another boy playing the bagpipes, most likely his oldest son Thadeus, and a little girl, perhaps his daughter Eva, look out of the picture, to engage the viewer's attention.[1] The same people, including the old man, appear, now a few years older, in the more boisterous *As the Old Sing, So Pipe the Young* dated 1668 (fig. 1). In this later picture, Steen allies himself with the children by blowing on the basest pipe of all, the bagpipe, instrument of fools and lechers.[2]

The woman in the foreground of the Mauritshuis picture stands out from this family group. Slouched across her chair, she is the image of indulgence, her lasciviousness implied by her footwarmer and indecorously untied

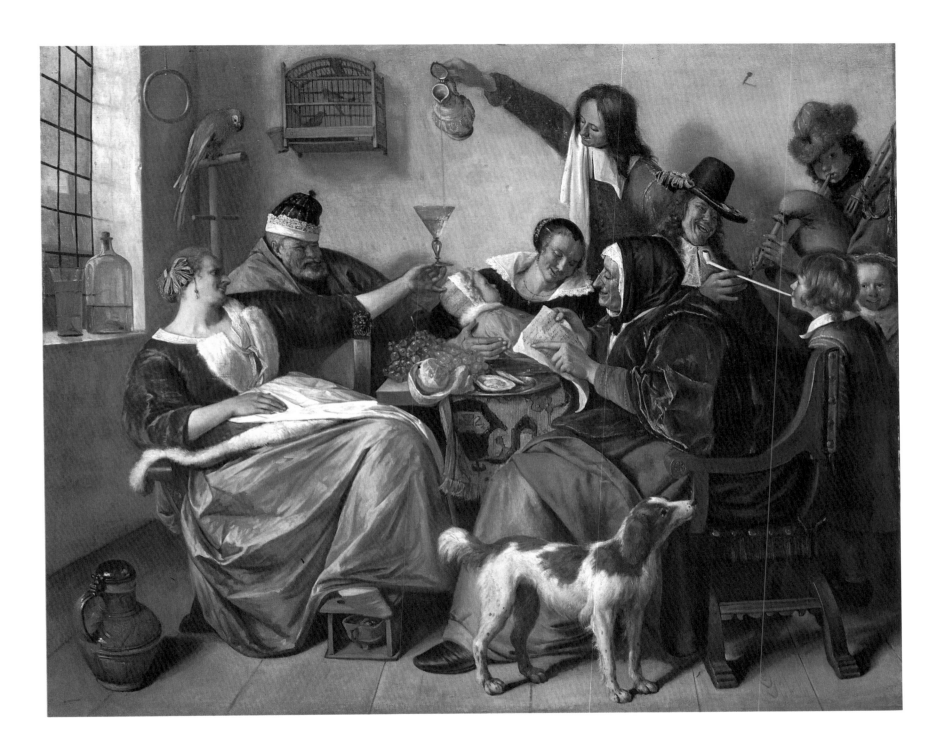

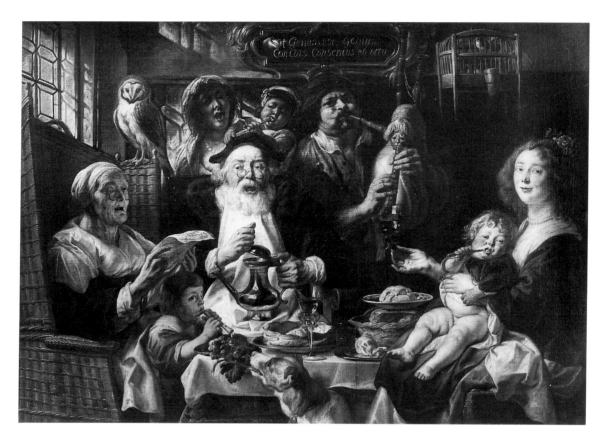

fig. 2. Jacob Jordaens, *As the Old Sing, So Pipe the Young*, 1640, oil on canvas, Musée du Louvre, Paris

jacket, her worldliness by her fancy pink satin skirt and fur-trimmed green velvet jacket, and her intemperance by her raised glass, into which a servant conspicuously pours a stream of red wine. The parrot above her, symbol of learning and imitation, reiterates her role as negative exemplar.[3] She has been identified as Steen's first wife, Margriet van Goyen.

Aptly, Steen has cast himself and his family in a painting that addresses the themes of learning and imitation in several ways. Seventeenth-century literary usage indicates that this proverb could emphasize either inborn human nature or the importance of example and upbringing.[4] At its most pessimistic, it referred to the eternal regeneration of humankind's innate foolishness, as in the inscription to *The Family of Fools* published by Hieronymus Cock (c. 1510/1520–1570).[5] In his *Spiegel van den ouden en nieuwen tijd* (1632), the Protestant Jacob Cats used this and a related proverb, *'t wil al muysen wat van katten komt* (all those born of cats are inclined to catch mice), in a series of say-

ings about the innate instincts of animals, from which he concludes that, since human nature, too, is inborn, it is futile to try to change it.[6] In contrast Adriaen Poirters, a Jesuit from the southern Netherlands writing in 1646, cited both proverbs in verses that warned parents not to indulge themselves, for it was their responsibility to set good examples for their children. Steen juxtaposed the same proverbs in his late *Family of Cats* (cat. 48, fig. 1).[7]

Certainly, images of children drinking and smoking admonish parents to provide proper models. However, the nature versus nurture debate was current in Steen's time and it may be that his pictures of *As the Old Sing, So Pipe the Young* would have prompted his contemporaries to ponder the proverb's implications in more nuanced ways. The possibility of reading this motto as both a more typically Calvinist (Jacob Cats) and a Catholic (Adriaen Poirters) argument on human nature may have accounted for its great popularity. The striking centrality of very young children and, sometimes, the incorporation of christening imagery, suggest these paintings raised precisely the question as to whether a child's nature is determined by birth or is a function of education and upbringing.[8] In his manuscript autobiography of 1631, Constantijn Huygens wrote that, in the first years of his childhood, the factors that determined his character were hardly discernable, and that only from his later behavior did it become clear "in what ways I was loyal to my nature and to what extent I was influenced by my education."[9]

Steen's versions of *As the Old Sing, So Pipe the Young* seem to be conceived as visual expositions on an inherently slippery proverbial truth, with each one offering an ever so slightly different answer. In the Mauritshuis painting, the grandfather's *kraamherenmuts*, the hat traditionally worn by new fathers, draws attention to the sleeping baby strategically located between the glass of wine and the proverb on the song sheet, and underscores the father's abdication of his paternal duties. In the face of his mischievous self-display, one cannot help but think that, whether by temperament or through upbringing, Steens will, so to speak, be Steens.

Steen was an inveterate borrower.[10] His pictures were inspired by a tradition that had its roots in the art of Hieronymus Bosch (c. 1450–1516) and Peter Bruegel the Elder (c. 1525–1569) and that Jacob Jordaens (1593–1678) continued in the seventeenth century. Steen, who seems to have had a special affinity for Jordaens' comic didacticism, drew directly on the Flemish painter's representa-

tions of this proverb. Although no contact between the two artists is documented, in 1649 and 1650 Jordaens was carrying out a commission for the Huis ten Bosch near The Hague.[11] The monumentality and fluid brushwork of the Mauritshuis painting suggest Steen knew one of Jordaens' paintings (fig. 2) first-hand and not just through the engraving by Schelte à Bolswert (1586–1659).[12]

Of Steen's several, cleverly varied versions of *As the Old Sing, So Pipe the Young*, none is as warmly engaging as this picture, Steen's largest genre painting.[13] The picture's spontaneity is enriched by the artist's warm palette, evident in his use of red to unify the composition, and by his unusually free painting technique.[14] Not only do two figures engage us directly, but the varied and convincing facial expressions give others a remarkably true-to-life quality. Standing before it, one has the sense of being in the very presence of this *gezellige* family gathering. For at least some viewers this sense of engagement with real family life would have been heightened by the presence of Steen and his family members in the painting.[15]

HPC

1. For the identification of the children, see Broos 1987, 355; and for their dates of birth, see pages 28, 31. I am grateful to Roberta Mayer and Aneta Georgievska-Shine for their comments on this painting.

2. On the bagpipe as a low instrument with erotic and foolish connotations, see Vandenbroeck 1987, 54; The Hague 1994b, 202–205, 242–247, with additional bibliography.

3. Bedaux 1990, 122, suggests that in portraits of children, the parrot symbolized docility and the ability to learn. Here and in *The Parrot* (Amsterdam, Rijksmuseum), which juxtaposes a boy feeding a cat with men gambling, Steen subverts the positive symbolism of the parrot to use it as a sign that children imitate the misbehavior of their elders.

4. Németh 1989; Németh 1990.

5. Hollstein 1949, 3: 142, no. 29; Riggs 1977, 316, no. 18; Vandenbroeck 1987, 50.

6. Cats 1632, 64–65, emblem 21.

7. See Németh 1990, 272–273.

8. The *Family of Cats* prominently features Steen's young son from his second marriage; the painting in Berlin and another in the Mauritshuis are also christening scenes.

9. Huygens 1987, 17–18: "De factoren, die het latere karakter bepalen, kan man slechts door schamele aanwijzingen uit de eerste kinderjaren opmaken. Toch wil ik enkele van die dingen hier vooraf laten gaan, die ik, volgens de waarneming mijner ouders, om en bij mijn eerste twee levens jaren deed. Wat ik daarna ouder geworden gedaan heb, zal, als men het vergelijkt,

duidelijker laten uitkomen, in welk opzicht ik mijn natuur ben getrouw gebleven en in hoever ik de invloed van mijn opvoeding heb ondergaan."

10. See cats. 2, 46.

11. For summaries of the documents concerning the presence of Jordaens or his works in the Northern Netherlands between 1646 and 1664, see Antwerp 1993, 14–18.

12. Schelte à Bolswert's engraving is after Jordaens' earliest known painting of this subject, which is dated 1638 and is now in Antwerp. See Hollstein 1949, 3: 87, no. 293. The closest model is that now in a private collection in France, which though it contains fewer figures, is Jordaens' only full-length version of the subject.

13. Other versions are in Berlin, The Hague, Montpellier, and Amsterdam (Braun nos. 188, 200, 202, and 295). See Sutton 1982–1983, 36 n. 2.

14. The picture is neither signed nor dated, although as late as Mauritshuis 1935, 332–333, no. 742, it was described as being signed "J. Steen fect" on the wall at left.

15. See Chapman 1995 on the peculiar resonance of using one's own family members in pictures about the family.

24

Rhetoricians at a Window

c. 1663–1665
inscribed on the shield beneath the window: *IVGHT NEMT IN*; and on the paper held by the man at left: *LOF LIET*
canvas, 74 x 59 (29 ⅛ x 23 ¼)
Philadelphia Museum of Art, The John G. Johnson Collection

PROVENANCE
Possibly sale, London (Christie's), 1827 (£110); sale, Mrs. Skeffington Smyth of Godalming, London, 3 March 1906, no. 82 (£892 19s. to Coureau); F. Kleinberger, Paris, 1906; probably acquired from Kleinberger by John G. Johnson, who owned it by 1907; to the present owner

LITERATURE
Probably Smith 1829–1842, 4:52, no. 156; probably Van Westrheene 1856, 154, no. 299; Hofstede de Groot 1907, no. 694; Bredius 1927, 75; Heppner 1939–1940, 29; Martin 1954, 83; Braun 1980, 116, no. 217; Sutton 1982–1983, 25–28, no. 6; Philadelphia 1984, 315–317, no. 106

fig. 1. Jan Steen, *Fair at Oestgeest*, c. 1655, oil on canvas, © 1994 The Detroit Institute of Arts, Gift of Mr. and Mrs. Edgar B. Whitcomb

According to Weyerman, Frans van Mieris (1635–1681) and Jan Steen had a competition as to who could complete a painting of a certain size in the shortest time, which Steen won with a picture of "three rhetoricians who were hanging out of a window singing at a peasant kermis." The painting was "so imaginatively conceived and so skillfully painted that art critics deemed it a miracle."[1] Whether this story is apocryphal or true, the choice of a picture much like this one in Philadelphia as a competition piece to demonstrate Steen's talent and skill was especially apt.[2] The unique theatricality of his art is brilliantly encapsulated in his representation of *rederijkers*, members of one of the amateur dramatic and literary societies called *rederijker-skamers*, or chambers of rhetoricians, presenting an oration to the public.

The connection between painting and literature, expressed in the topos *ut pictura poesis* (as is painting so is poetry), which was so central to seventeenth-century European painting, assumed a special character in the Netherlands where painters and rhetoricians formed close creative alliances, working together to stage plays and festival productions. Especially earlier in the century, *rederijker* societies included not only such literary figures as Roemer Visscher, Pieter Cornelisz Hooft, Joost van den Vondel, and Gerbrand Adriaensz Bredero, but also the painters Carel van Mander (1548–1606), Hendrick Goltzius (1558–1616/1617), Frans Hals (c. 1582/1583–1666) and Adriaen Brouwer (1605/1606–1638). As far as we know, Steen did not belong to a *rederijker* society. Yet, while many of his contemporaries, notably Rembrandt (1606–1669) but also Jan Miense Molenaer (1610–1668) and Pieter Quast (1606–1647), drew on the theater, Steen stands apart for the extent of his fascination with and appropriation of aspects of stage performance.[3]

In the Philadelphia painting, one of his many images of *rederijkers*, Steen draws a visual parallel between the

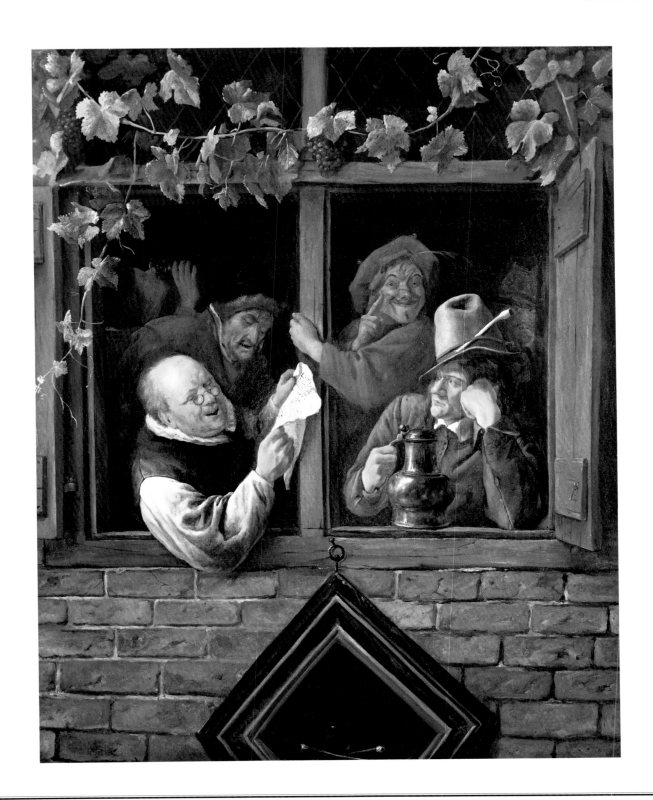

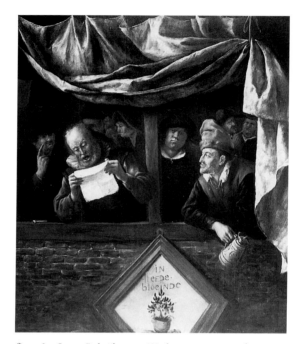

fig. 2. Jan Steen, *Rederijkers at a Window*, c. 1655–1657, oil on panel, Worcester Art Museum, Worcester, Massachusetts, Museum purchase, Eliza S. Paine Fund in memory of William R. and Francis T. C. Paine

rhetoricians' performance and the painting's address to the beholder. From an open window hung with vines, the balding *declamator*, or orator of the chamber, in his characteristic doublet, full sleeves, and small ruff collar, peers through his glasses to read from the paper he holds.[4] The heading LOF LIET, song of praise, indicates that, despite his amiable, every-day appearance and rustic setting, his oration is a particular classical rhetorical form, the epideictic oration of praise used on ceremonial occasions.[5] Looking over his shoulder is his introverted, serious counterpart, the *factor*, or poet, who was responsible for composing the verse that the *kamer* presented.

The arrangement of these somewhat comically exaggerated types mirrors their different rhetorical functions. Opposite, and perhaps in dialogue with, the two *rederijkers* on the left who compose and perform verse of praise, are two figures whose critical stance corresponds to the rhetoric of blame. The skeptical man in a melancholic pose, who holds a tankard and has a pipe in his hat, may be the *momus*, or critic. Behind him is his comic counterpart, the jester, identified by his red fool's cap with a cock's feather, who addresses the viewer directly.[6] His broad grin and raised finger, which seems to say "watch out" or "take notice," signify his dual function to provoke laughter and, at the same time, expose and rebuke human folly.[7] In him some critics have recognized Steen's features.[8] While the resemblance, if there, is loose, it is indeed this *rederijker* character who is at the root of the fool's guise that Steen repeatedly assumed (page 44, fig. 6).[9]

Barely visible, in the room behind, are two thinly painted, shadowy figures, one emptying his wineglass and the other smoking. They may refer to the *rederijkers'* notorious drunken feasts, which are more clearly commented upon in Steen's *Rederijkers Carousing* in Brussels (page 56, fig. 6). Their proverbial reputation resulted in a popular expression *rederijker-kannekijker* (the rhetorician: one who is always looking into his empty tankard).[10] They also serve as living emblems of the particular *rederijker-kamer* represented here, *De groene laurierspruit* (The Green Laurel Shoot) from The Hague.[11] Hanging from a nail attached to the window frame is the diamond shaped shield, or blazon, with this chamber's emblem, a wineglass and crossed pipes, and its barely visible motto IVGHT NEMT IN (Youth takes in), which in Dutch means "youth is attractive" but also refers punningly to imbibing. The blazon identifies this as the window of a rhetoricians' meeting hall, such as that represented in the Detroit *Fair at Oegstgeest* (fig. 1).[12]

Such specificity raises an important question about this and Steen's other images of *rederijkers*, which is to what extent are they historically accurate representations and to what extent are they fictional—comic or satiric—interpretations. The *rederijkers* had originated in the fifteenth century and flourished in the sixteenth century, when most towns had at least one chamber of rhetoric. Their members, ranging from artisans and merchants to scholars, colored the towns' cultural life with poetry readings, plays, and tableaux vivants performed at fairs and triumphal entries of visiting royalty, and with *landjuwelen* or public competitions among chambers from various towns. Their name derived from the original rhetorical function of their productions, which was to persuade the audience of moral issues in an entertaining manner. *Rederijker* imagery permeated precisely the kind of sixteenth-century didactic prints to which Steen so often resorted: Cornelis Anthonisz' (c. 1500–1561) *Sorgheloos* series (cat. 15, fig. 2) illustrates a moralizing text written by an Amsterdam *rederijker* and Maerten van Heemskerck's (1498–1574) *Bel and the Dragon* prints (page 17, fig. 9) incorporate pairs of fools derived from the *sinnekens* of *rederijker* drama who comment on the main action.

fig. 3. Adriaen van Ostade, *The Singers*, c. 1660–1670, etching, National Gallery of Art, Washington, Rosenwald Collection

By Steen's time, however, this kind of moralizing had come to seem old-fashioned. The public appeal of the *rederijkers* was being lost to the burgeoning popularity of touring troupes and eclipsed by the emergence of a professional theater increasingly relying on classical precepts. Though the societies continued to perform many of the same functions through the first part of the seventeenth century, without their earlier prestige, they dwindled away or were forced to merge, while their competitions became almost invariably sponsored by innkeepers rather than the chambers themselves.[13] Moreover, they were frequently the butt of ridicule in poems and plays (by, among others, Bredero) ostensibly lamenting the demise of "Lady Rhetoric," but actually voicing a caustic criticism of the *rederijkers'* notorious lack of decorum.[14]

Steen's treatment of the *rederijkers* is at once comical and indicative of his fond appreciation of their theatrical importance. The Philadelphia painting, which to judge by its deft handling style and warm coloring dates from the early to mid-1660s, is the most sophisticated of his several versions of the theme of rhetoricians at a window. The more loosely composed painting in Worcester (fig. 2), which includes a trompe l'oeil curtain, probably dates from the mid-1650s. But while his handling may be refined, Steen has conceived these stock players as a motley crew, reflective of their, by then, rustic and provincial connotations. The rusticity and the compositional format suggest a derivation from Adriaen van Ostade (1610–1685) (fig. 3), although, since Van Ostade's print is difficult to date, the possibility remains that this is Steen's invention.[15]

By employing the window frame composition, Steen creates a fictive realm that is co-extensive with the viewer's space. This kind of spatial illusion is the very opposite of the Albertian paradigm of a picture as a window into the world. The interest in this pictorial mode was current among Steen's contemporaries such as Rembrandt, Samuel van Hoogstraten (1626–1678), and, most important for our artist, the Leiden painters, especially Gerrit Dou (1613–1675). All of them used the window motif to create images of figures that extend into a space in front of the picture plane and directly address the viewer (cat. 9, fig. 1 and cat. 19, fig. 3). By using *rederijkers*, whose role it is to advance arguments through a dialogical discourse, Steen cleverly likened the painter's ability to convince the beholder of the reality of painted fictions to the rhetoricians' art of verbal persuasion.

HPC

1. Weyerman 1729–1769, 2: 363.

2. The roughly painted, somewhat abbreviated composition in Munich (Braun 218) most closely resembles the picture Steen supposedly painted in competition with Frans van Mieris. Compare pages 89–90.

3. See page 15, for a discussion of the previous scholarship on Steen and the theater.

4. For the identity of the figures, see Braun 217.

5. This classical and renaissance rhetorical form is called a demonstrative or epideictic oration. See O'Malley 1979, 36–44; Deneef 1973.

6. Heppner 1939–1940, 26.

7. For a discussion of the roles, see Philadelphia 1984, 315–316; Heppner 1939–1940, 29.

8. Sutton 1982–1983, 27. The fool in this and other versions of the theme has been identified as Steen since the early nineteenth century. See, for example, sale Leiden 1800, which probably refers to the painting in Munich.

9. See Chapman essay. It has been suggested that these main figures embody the four temperaments, for, just as the stage was a metaphor for the world, so these four contrasting types may have been conceived as representing all aspects of human nature. See Antal 1925, 118. See cat. 25 for Steen's identification with the sanguine temperament.

10. Philadelphia 1984, 316.

11. Heppner 1939–1940, 29.

12. Steen also represented *rederijker* meeting halls in the *Merry Company at an Inn*, location unknown; see Braun 275.

13. Meijer 1971, 110.

14. See pages 56–58.

15. Athens (Georgia) 1994, 109–112, dates Van Ostade's etching to c. 1668, while leaving open the possibility that it is based on a lost painting that Van Ostade executed in the early 1650s.

25

Self-Portrait as a Lutenist

c. 1663–1665

signed at lower right: *JSteen* (*JS* in ligature)

panel, 55.3 x 43.8 (21 ¾ x 17 ¼)

Fundación Colección Thyssen-Bornemisza, Madrid

PROVENANCE

Sale, Josephus Augustinus Brentano, Amsterdam, 13 May 1822, no. 324 (fl. 295 to Albert Brondgeest, Amsterdam), bought in or bought for Anthony Meynts; sale, Anthony Meynts, Amsterdam, 15 July 1823, no. 120 (fl. 397 to Engelbert Michael Engelberts, Amsterdam); Jan Gijsbert, baron Verstolk van Soelen, The Hague, by 1833; bought with forty-two other paintings from his estate by Thomas Baring, London, 1846 (fl. 1600); inherited by his nephew Thomas Baring, later 1st earl of Northbrook, Stratton Park, Hampshire, and later London, 1876; inherited in trust with the Stratton Collection of Pictures by his son Francis Baring, 2d earl of Northbrook, London; bought by Duveen Bros., after the Leiden exhibition of 1926, probably in 1927, and taken to Paris; Jacques Goudstikker, Amsterdam, by 1928; bought from Goudstikker by Baron Heinrich Thyssen-Bornemisza, Castle Rohoncz, Hungary, before 1930; by descent to the Collection Thyssen-Bornemisza, Villa Favorita, Lugano; to the present owner, 1993

LITERATURE

Smith 1829–1842, 4:39–40, no. 121; Van Westrheene 1856, 114, no. 64; Hofstede de Groot 1907, no. 863; London 1909, 21, no. 35; Leiden 1926, 24, no. 53; Martin 1926, 10; Bredius 1927, 13, 64; Schmidt-Degener and Van Gelder 1927, 15, 66, no. 28; De Jonge 1939, 36, 47–48; Gudlaugsson 1945, 47, 48; Martin 1954, 16; The Hague 1958, 21; De Vries 1976, 7, 8; Kirschenbaum 1977, 76; Braun 1980, 104, no. 136; Raupp 1984, 221; Thyssen–Bornemisza 1989, 162–167, no. 32; Chapman 1990–1991, 187–188; Chapman 1995, 372–376

fig. 1. Johannes van Swieten, *Lute-Playing Painter*, c. 1660, oil on panel, Stedelijk Museum de Lakenhal, Leiden

It was, in Steen's day, a topos of artistic invention, derived from ancient poetic theory, that to represent human emotions convincingly the painter should be able to transform himself into an actor.[1] With this deftly painted, strikingly casual image of himself laughing and playing a lute, Steen has portrayed himself specifically as the comic actor. In assuming this guise he has pushed the limits of self-portraiture. Compared with his only extant formal self-portrait (cat. 40), the *Self-Portrait as a Lutenist* is distinguished both by Steen's broad brushwork and by his unusually relaxed pose and carefree expression. His jovial actor's guise is consistent with both the essential theatricality of his style and the comic persona he created by repeatedly featuring himself as a rake or profligate in such pictures as *Easy Come, Easy Go* (cat. 15) and *The Merry Threesome* (cat. 42).[2]

First identified as a self-portrait in a mezzotint by Jacob Gole (d. 1738),[3] from the eighteenth to the early twentieth century, it was embraced as a self-portrait that captured the essence of Steen's character. More recent

critics, reluctant to accept this work as a self-portrait with autobiographical implications, have interpreted Steen as either portraying himself in the guise of, or serving as a convenient model for, a stock theatrical suitor, on the basis of his colorful, archaic costume and his huge lute, an instrument with erotic resonance.[4] Yet other kinds of characters wear similar garb and Steen's hearty laugh and casual pose distinguish him from the stock suitor, who typically appears elegant or even excessively refined.[5]

Steen's innovative blend of the conventions of portraiture with those of genre is characteristic of most of his portraits, including *The Burgher of Delft* (cat. 7) and *The Leiden Baker Arend Oostwaert and His Wife* (cat. 8). While indebted to single genre paintings of jesters, musicians, and merry drinkers found in Utrecht and Haarlem pictorial traditions, the manner in which Steen here portrayed himself sitting in front of a curtain and beside a table also relates to Frans Hals' disarmingly informal *Portrait of Willem van Heythuysen* of about 1638 (Musées Royaux des Beaux-Arts de Belgique, Brussels). Hals' portrait, which was in Haarlem when Steen moved there in 1661, provides a possible precedent for one of the most distinctive features of Steen's self-portrait, the casual configuration of his legs. According to the Italian theorist Giovanni Paolo Lomazzo, to depict a patron with one knee on the other was a serious breach of decorum.[6] To judge by Steen's pose and by the loose, spontaneous brushwork and thin paint, which recall the immediacy of paintings by Hals (c. 1582/1583–1666) and Jan Miense Molenaer (1610–1669) in Haarlem, he probably painted his self-portrait shortly after his arrival in that city.[7] It was in Haarlem, where Steen consistently imbued his work with references to farcical theater and literature, that he made the most concerted effort to project a theatrical persona.

By portraying himself as a comic actor Steen transformed a tradition, associated with Leiden, of representing artists playing musical instruments for poetic inspiration.[8] Comparing the *Lute-Playing Painter* of about 1660 (fig. 1) by the Leiden artist Johannes van Swieten (1635?–1661) illustrates just how far Steen departs from the convention. Both show the artist seated by a table before a curtain and strumming a lute, but the similarities end there. Steen's coarse jocularity, aggressively informal pose, and even his simple shoes distinguish him from Van Swieten's elegantly clad, wistful painter. Further, Steen has removed himself from the studio setting by eliminating any artist's paraphernalia.

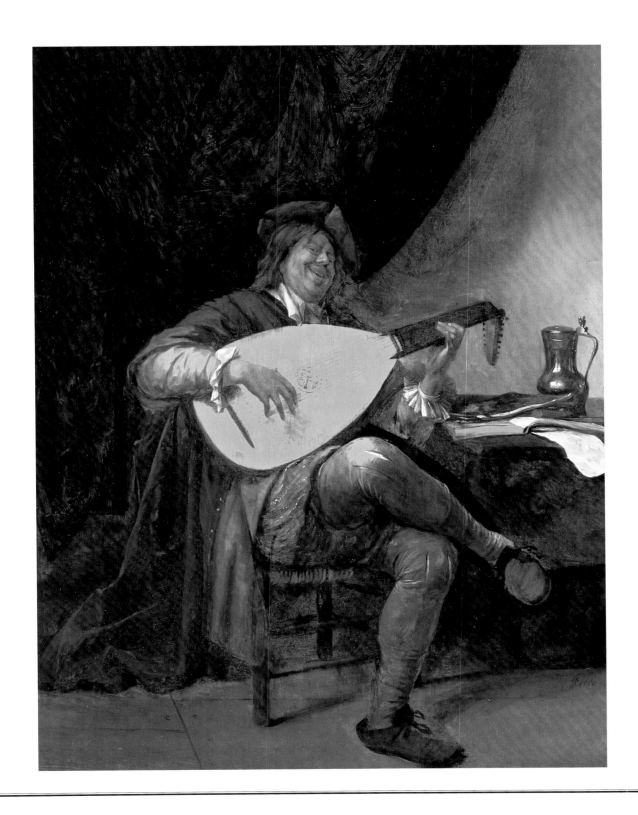

fig. 2. Cesare Ripa, "Sanguine Temperament," *Iconologia*, Amsterdam, 1644, National Gallery of Art Library, Washington

In recasting the refined music-making artist as a comedian in theatrical garb, Steen subverts the ideal of the *pictor doctus*, the educated, poetically inspired painter of noble subjects, which had such a strong hold in Leiden.[9] In so doing he invokes an alternative notion of the artist violating decorum in art and life, typified most notably by Adriaen Brouwer (1605/1606–1638) in Haarlem and by Rembrandt (1606–1669) and the Bambocciant.[10] Steen's image corresponds remarkably to the personification of the sanguine or jovial temperament described by Cesare Ripa (fig. 2). In the 1644 Dutch edition of Ripa's *Iconologia*, a widely used compendium of personifications that would have been familiar to Steen and his audience, the *Sanguigno of Blygeestige Complexie* (Sanguine or High-spirited Complexion) is characterized as

A jovial laughing young man, with a wreath of various flowers on his head, plump of body, and above that blond hair, with red and white color mixed in this face, playing on a lute: and by the heavenward turn of his eyes he makes it known that he delights in celebration and song. To one side stands a goat with a bunch of grapes in his mouth, and to the other an open music book . . . the sanguine temperament is pictured this way because from among those ruled by temperate and perfect blood come the liveliest, sharpest wits of the day, from whom laughter and merriment come forth . . . [and who] are entertaining and jocular and love acting and singing.[11]

The way Steen looks upward, laughing or singing merrily to the tune of his lute, suggests that the relation between his image and this description is more than just fortuitous. His tankard takes the place of the grapes, the attribute of Bacchus; his oversized lute makes the missing goat, signifying Venus, redundant. Steen's garb, extroverted posture, and rotund form accord with Ripa's attribution of strong powers of communication to the plump sanguine temperament.

Ripa concludes by saying that the sanguine person is "clever at all the arts." Though artists were more often associated with the melancholic temperament, it would seem that Steen here claims to be governed by a humor more suited to his comic bent. He is the down-to-earth, comic painter of ordinary people, inspired by Bacchus and Venus. Some forty years after the artist's death, Houbraken would echo this sentiment near the beginning of his biography when he said of Steen that he "whose nature is inclined to farce" is better equipped than "a melancholy person" to represent the whole range of "bodily movements and facial expressions that spring from the many impulses of the spirit."[12]

HPC

1. Horace, *Ars Poetica*, 99–104, in Horace 1967, 23–32; Van Mander 1973, 1: 159; Van Hoogstraeten 1678, 109–110; Chapman 1990, 12–21; page 42.

2. See page 19. For Jan Vos' suggestion that the looseness of a painting could reflect the moral looseness of its maker, Westermann 1995, 301.

3. This print was published in Amsterdam before 1738 with the inscription *Jan Steen ad se ipsum Pinxit*. Hollstein 1949, 4: 216, no. 121.

4. De Vries 1973, 227–229. For an extensive discussion of opinions regarding the self-portrait status of this work, see Thyssen-Bornemisza 1989, 166–167. A similarly attired figure in Steen's *Ascagnes and Lucelle* (Corcoran Gallery of Art, Washington), which illustrates a courtship scene from Bredero's play *Lucelle*, prompted Gudlaugsson 1945, 46–47, to identify Steen as playing the role of a stock suitor.

5. As Raupp 1984, 221 n. 233, pointed out, his costume resembles that worn by a violinist, who is not a suitor, in his *Marriage of Cana* in Dresden (Braun 1980, no. 371).

6. Cited by Slive in Washington 1989a, 276.

7. For a list of other opinions on the picture's date, see Thyssen-Bornemisza 1989, 167.

8. Raupp 1978.

9. Emmens 1968, 31–38, discusses the contrasting notions of *pictor doctus* and *pictor vulgaris*.

10. For Brouwer as satiric painter, Raupp 1987; Filipczak 1987, 116–117. For Rembrandt, Emmens 1968, 30–38, 45–48, 67–69, 73–75, and Chapman 1990, 95–98, 132–137. For the Bambocciant, Levine 1988.

11. Ripa 1644, 75–76.

12. Houbraken 1718–1721, 3: 12.

26

The Little Alms Collector

c. 1663–1665
signed in lower left: *J. Steen*
panel, 59 x 51 (23 ¼ x 20)
Ville de Paris, Musée du Petit Palais

PROVENANCE
Possibly sale, F. J. O. Boymans, Utrecht, 31 August 1811, no. 78 (described as 22 x 19 inches); sale, Dubois, Paris, 7 December 1840, no. 30; Dutuit Collection, Rouen; bequest of the collection by Auguste Dutuit to the City of Paris, 1907

LITERATURE
Smith 1829–1842, supplement:480, no. 19; Van Westrheene 1856, 151, no. 275; Hofstede de Groot 1907, nos. 304, 307, 311; Paris 1970, 207, no. 200; Sutton 1982–1983, 9–11; Braun 1980, 120, no. 246

fig. 1. P. C. Hooft, "Voor vryheyt vaylicheyt," *P.C. Hooft's Werken*, Amsterdam, 1671, National Gallery of Art Library, Washington

Steen delighted in depicting the festive spirit of family celebrations so important to seventeenth-century Dutch life. On Pentecost children wearing flowers or paper foliage would proceed through the streets singing of the *vrolycke* or *fiere pincxterbloem* (the merry or proud pentecostal flower). The *pinksterbruid* or *pinksterbloem* (Pentecost bride or Pentecost flower) led the procession and, as in this delightful scene, wore white robes and carried a small cup into which bystanders dropped coins.[1]

The procession evolved from two separate traditions, one pagan and the other Christian, celebrating the arrival of spring and Pentecost. On May day families adorned their homes with flowers and branches of pale green, tender leaves, and children, led by a May queen, danced around the Maypole. Pentecost, a Jewish day of thanksgiving for the year's harvest, commemorates the descent of the Holy Spirit upon the Apostles and Disciples (Acts 2: 1–4). Prior to the Reformation, Pentecost was a particularly festive religious holiday, and also a time for baptism and communion, when celebrants wore white garments.[2] The conflation of pagan and religious traditions in Dutch popular culture accounts for the attire of Steen's child: just as the crown and train serve as attributes of the May queen, so the cap and apron relate to the white robes worn for baptism and communion.

The family in Steen's *The Little Alms Collector* consists of a couple, their infant child, and a robust grandfather, the jovial bearded man who reaches over the wooden

fence to place a coin in the child's small tin cup. Their substantial home is covered with vines, possibly symbolic of domestic harmony.[3] A wicker bird cage, representing conjugal felicity, hangs from the eaves (fig. 1).[4] The dovecote on the wall behind the figures alludes to the Pentecostal tradition of releasing white doves in the church.[5]

Steen emphasizes the mother's importance in family life by enframing her within the arched doorway. Her child welcomes the young May queen with a *pinksterbloem* plucked from the potted plant.[6] As the May queen shyly accepts the grandfather's gesture of good will, the mother and child look on tenderly. At the same time, however, her young husband, pipe in hand, stares in bemusement at the pair of pants he has noticed underneath the child's raised apron. The May queen's older companion, who carries the train, looks on with a wry expression.

Steen depicted several Pentecostal processions, including an early work now in Philadelphia (fig. 2).[7] The Paris and Philadelphia paintings share many elements—a child shyly holding a cup, an older companion carrying the

fig. 2. Jan Steen, *May Queen (The Charming Pentecostal Flower)*, c. 1648–1651, oil on panel, The John G. Johnson Collection, Philadelphia Museum of Art

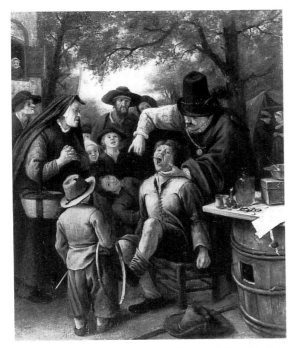

fig. 3. Jan Steen, *The Toothpuller*, 1651, oil on panel, Mauritshuis, The Hague

train, and the family watching from their fenced-in yard. Among the significant differences between these works are the May queen's paper crown, instead of a floral wreath, and the pants beneath a white apron rather than a dress beneath a white robe. The procession, moreover, is remarkably short, consisting of only the May queen and the older attendant. Finally, the floral decorations here are unusually sparse.

The children may be poor, perhaps orphans, who often took part in such processions as a way to earn money.[8] The painting may also reflect the restrictions imposed by Protestants because of the festival's religious character.[9] These restrictions varied from town to town. In Haarlem, for example, a city statute passed in 1635 forbade processions of children wearing decorative branches.[10]

Although the smiling man behind the May queen and the two youths watching the procession at the left would seem to add a festive note to the scene, the hoop and pinwheel the boys carry have negative connotations in emblematic literature. The *molentje* (pinwheel) symbolizes fickleness and foolishness, and the hoop is a metaphor for a person whose life leads nowhere.[11] Roemer Visscher, for example, illustrates his emblem *Beter stil ghestaen* (Better to stand still) with a boy and a hoop, explaining: "It is better to stand still than to make oneself tired with work that is useless."[12] Steen used this same motif for a negative commentary in *The Toothpuller*, 1651 (fig. 3), where a boy holding a hoop observes a quack operating on an unsuspecting patient. Perhaps also criticizing the scene are an old couple gossiping before the arched gateway at the rear.

Steen's reasons for introducing these figures are not entirely certain. Given his own Catholicism, it is surprising that he included motifs that could be construed as critical of this Catholic tradition. Since completing the earlier painting now in Philadelphia, Steen may have become critical of Pentecostal processions, which by the seventeenth century had lost much of their religious character. Perhaps Steen did not approve of young boys assuming the role of May queen, or of using the religious celebration as an excuse for begging.[13]

While *The Little Alms Collector* has been dated from the mid-1650s to the mid-1660s, a date around 1663–1665 seems most probable.[14] The broad handling of forms and distinctive characterization of figures are similar to Steen's manner of painting in *The Dancing Couple*, 1663 (cat. 20). Both works, moreover, exhibit Steen's renewed interest in the work of Adriaen van Ostade (1610–1685) after he moved to Haarlem. Here, Ostade's influence is found in the scene's limited focus, the careful modeling of the building's varied textures, and the saturated colors. Similar figure types also appear in other paintings from the mid-1660s. For example, the bearded old man also plays a role in the *Feast of Saint Nicholas*, c. 1665–1668 (see cat. 30).

AKW

1. For information about this tradition see Ter Gouw 1871, 221–233; Schotel 1903, 204–208; Schrijnen 1930, 227–229; Woordenboek, 12:1914–1915.

2. The English word Whitsunday (White Sunday) originated because of this custom.

3. As Robinson has noted in Philadelphia 1984, 289 n. 4, the image was inspired by Psalm 128: "Thy wife shall be as a fruitful vine by the side of thine house: thy children like olive plants round thy table."

4. Hooft 1611, 66, emblem 28: *Voor vryheyt vaylicheyt. In vancknis vordert my de Min; en was ick vry / Het ongheluck had onghelijck meer machts op my.*

5. Doves were a symbol of the Holy Spirit. I would like to thank Esmée Quodbach for drawing my attention to this motif in the painting. Steen used the dove symbolically in a different context in *The Poultry Yard* (cat. 12).

6. The identity of this plant (*Cardámine praténsis*), a form of cress, is evident through a comparison to the description and illustration in Bailey 1914, 2, 661.

7. See Sutton 1982–1983, 9–11.

8. Ter Gouw 1871, 226.

9. Schotel 1903, 205–206.

10. Schotel 1903, 205. This restriction must have severely altered the character of the religious holiday in Haarlem. According to Pieter Biesboer (conversation with the author) Pentecost was extremely important in Haarlem in the sixteenth century, with St. Bavo's serving as a pilgrimage center for celebrants.

11. For the child with a windmill, see Amsterdam 1976a, 99. For the child with a hoop, see Cats 1665, 3.

12. Visscher 1614, emblem 21, *Beter ist stil ghestaen / dan hem self moede te maecken met werck / dat tot gheen nut gebracht mach worden.*

13. A critical assessment of the transformation of the tradition from that of a May queen to a beggar is seen, for example, in Ter Gouw 1871, 224, "De Pinksterbloem was oudtijds een koningin—sedert eeuwen reeds is ze een bedelaarster geworken. 't Schijnt dat het oude vrolijke volksfeest reeds in de zestiende eeuw ontaard en aan 't gemeen overgelaten is"; and on 226, "En daarom bleven de Pinksterbloemen, hoe verlept dan ook, tot in onzen tijd voortleven; maar als bedelpartij."

14. De Vries 1977, 43, no. 65 dates it about 1654–1658; Braun 1980, no. 246, dates it c. 1665.

27

The Drawing Lesson

c. 1663–1665

panel, 49.3 x 41 (19 ⅜ x 16 ¼)

signed, at lower left: *JS* (in ligature) *ti . . .*

Collection of the J. Paul Getty Museum, Malibu

PROVENANCE

Possibly Petronella Oortmans, née de la Court, Amsterdam, inventory, 1707; in which case her sale, Amsterdam, 19 October 1707, no. 30 (fl. 105); possibly anonymous sale, Amsterdam, 15 May 1708, no. 7 (fl. 45); sale, François Hessel, Amsterdam, 11 April 1747, no. 1 (fl. 255); sale, duc de Lavallière, Paris, 21 February 1781, no. 74 (Frf 1800 to Roche); anonymous sale, Paris, 14 April 1784, no. 163 (Frf 1400 to Desmarais); Colnaghi, London, 1897; Forbes and Paterson, London, 1901; Dowdeswell and Dowdeswell, London, by 1907; A. de Ridder, Cronberg, by 1913; his sale, Paris, 2 June 1924, no. 68, ill., to F. Kleinberger, Paris; A. Reimann, Steensbygaard, Stensved, Denmark, by 1926; Edward Speelman, 1983; bought from Speelman by the present owner, 1983

LITERATURE

Smith 1829–1842, 4:12, no. 36; Hofstede de Groot 1907, no. 247 (and possibly 248); Leiden 1926, 26, no. 61; Bredius 1927, 61, no. 25; Martin 1954, 17, 81; The Hague 1958, no. 27; Delft 1964, no. 105; De Vries 1977, 53, no. 81; Braun 1980, 111, no. 182; Getty Museum 1988, no. 27; Walsh 1989, 80–86; Steinberg 1990; Walsh 1996

According to the artist Carel de Moor (1656–1738), it was a delight to hear Steen expound on the theory and practice of painting, about which he had considerable knowledge.[1] It is especially apt, then, that the art of painting is the subject of one of his finest, most beautifully handled, and best preserved works, a picture that probably belonged to one of Leiden's most prominent collectors, Petronella de la Court.

In a spacious studio, an elegantly attired artist, palette in hand, interrupts his work on the painting in the background to correct a drawing by one of his pupils, either the boy apprentice or the young woman. On the table before them is a precisely rendered array of drawing tools and materials, including pens, sticks of chalk and charcoal, a shell and other small ink vessels, as well as two contrasting models for the pupils to copy, a chiaroscuro woodcut head of an old man by Jan Lievens (1607–1674) and a plaster nude, identified as *Saint Sebastian* by Alessandro Vittoria (1525–1608).[2] Steen not only provides a rare glimpse into artistic practice—other realistic details include the bottle of varnish clarifying on the window sill and the stretched canvas—he also paints an accurate picture of artistic instruction.

In seventeenth-century Holland, painting was still learned through apprenticeship to a master and the first step in this process was learning to draw.[3] The boy, who derives from Ter Borch's *The Letter* (page 18, fig. 10), looks to be the right age for an apprenticeship that usually began between the ages of nine and fourteen.[4] Artistic pedagogy, a theme treated by Rembrandt (1606–1669) and Michael Sweerts (1624–1664), is also the subject of Steen's delightfully intimate, more rustic, yet more precisely painted *Drawing Lesson* (fig. 1) in which a painter corrects the drawing of an attentive apprentice.[5] Here, as in the Getty painting, Steen evokes the first two of the three prescribed stages in which drawing was taught, copying after prints and drawings, and drawing from plaster casts of admired classical models.[6] The final stage, drawing from the live model, has not yet been reached.

However much it appears to describe studio practice, Steen's Getty picture is also a highly contrived picture about painting. Although stylistic similarities to the *Woman at Her Toilet* of 1663 (cat. 19) suggest Steen also painted *The Drawing Lesson* in Haarlem at about this time, this painting relates to allegorical studio scenes and self-portraits by the Leiden painters Gerrit Dou (1613–1675) and Frans van Mieris (1635–1681), which sought to elevate

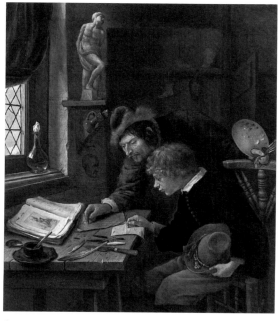

fig. 1. Jan Steen, *Drawing Lesson*, c. 1665–1666, oil on panel, private collection

painting by alluding emblematically to current theories of art.[7] Steen includes many such abstract references: the violin on the back wall refers to the inspirational powers of music; the plaster face and foot evoke the classical casts that were recommended as suitable models; and the juxtaposition of Fame's laurel wreath and a skull at lower right brings to mind the saying *ars longa, vita brevis*.[8] The statuette of a cow on the shelf has several possible associations: it might evoke the ancient painter Myron's renowned realistic depiction of a cow or the ox of Saint Luke, the protector of painters and the "first" practitioner of their craft.[9]

By dispersing painting's elevated attributes to the periphery of the *Drawing Lesson*, Steen shifts its emphasis from a notion of art expressed through allegory to a celebration of artistic practice.[10] The drawing lesson is the focus of this painting. Dutch writers on art beginning with Carel van Mander regarded *tekenkonst*, or drawing, as the foundation of art.[11] As Gerard de Lairesse (1641–1711) put it in 1701 in a statement that may explain the winglessness of the putto suspended on a red cord:

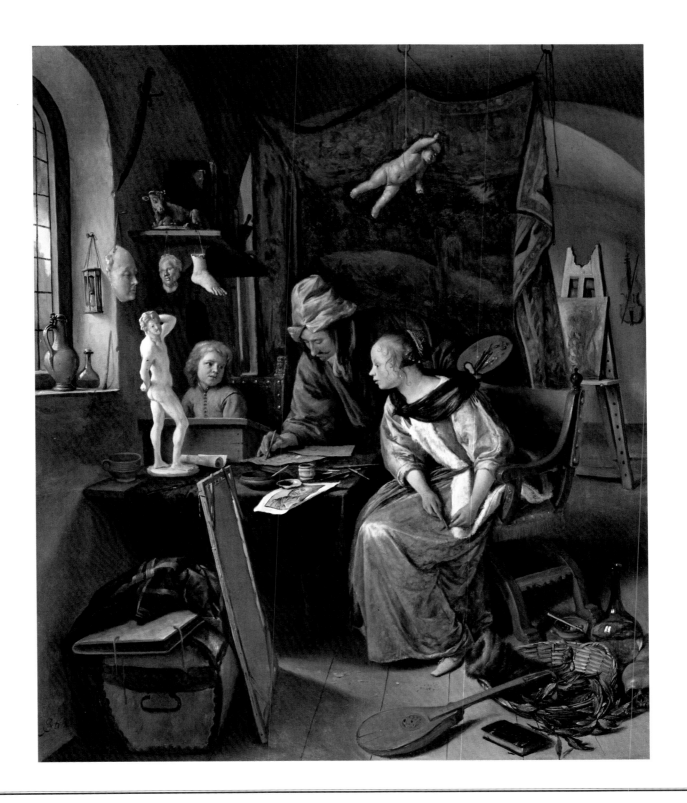

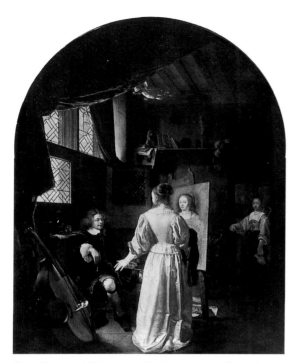

fig. 2. Frans van Mieris, *Artist's Studio*, c. 1655–1657, formerly in Gemäldegalerie Alte Meister, Dresden, destroyed during World War II

Just as drawing . . . ought to be the foundation which furnishes a firm basis for the art of painting, so it is beyond contention that perspective is the fundamental principle of the art of drawing, and that lacking it one cannot become an assured draftsman, just as it is impossible to fly without wings.[12]

This conspicuous putto has far reaching amorous connotations. At one level, it evokes the notion that the painter paints *amoris causa*, for the love of art, the noblest of a triad of motives.[13] At a seemingly more mundane level, it hints at a mildly titillating narrative transpiring in the studio. It hovers directly above the most intriguing figure here, the colorfully dressed young woman who is placed so prominently at the center of the composition, between the artist's drawing hand and his palette. Clearly she is central to the meaning of the picture, but just who is she? Her gesture of cutting a pen or sharpening chalk was traditionally identified with the idea of Practice. Like drawing, it was one of the fundamentals of painting.[14] Her lifelike presence suggests that she might be an apprentice, though women were rarely trained as such, unless by their fathers or uncles.[15] It seems unlikely that she is a well-bred amateur, learning drawing as part of her cultural education.[16] Her sumptuous satin and fur-trimmed clothes, which seem colorful for a patrician, resemble those worn by Steen's other seductresses (see cats. 9, 16, 19). Further, she is in an implausible situation. Lairesse describes the perils of sitting for a portrait in a studio full of images that "create a longing" for sensual pleasures or "put virgins to the blush."[17]

Whether this young woman, who leans forward so earnestly, is entranced by the lesson or, as Steinberg suggests, by the nude cast set so indecorously before her is unclear.[18] But the male nude and strategically placed cupid, like that similarly suspended above artist and model (note the position of her hand!) in Frans van Mieris' *Artist's Studio* of 1655 to 1657 (fig. 1), call into question the propriety of her presence in the studio. Does this master—like Steen's music teachers and doctors (cats. 10, 16)—have designs on her or is he so absorbed in his demonstration that he is immune to her warm presence and, in this way, becomes the butt of Steen's humor?[19] Steen, in this picture recasts the relation between love and painting.[20] The notion that the artist paints *amoris causa* is transformed from a high-minded allegory to a genre painting about the power of desire, desire that begets images.

Despite its erudite references, then, to read this work exclusively as an elevated allegory denies its understated wit and human warmth. Further, it fails to acknowledge discrepancies between cherished theoretical ideals and Steen's own artistic practice. This painter's implausibly grand studio and impractically fashionable attire—his *kamerjas* is also worn by *Gerrit Schouten* (cat. 29a)—elevate his profession and hardly accord with the roguish image Steen projected of himself. Given the lack of drawings by Steen and the possibility that he was one of a number of Dutch painters, including Metsu (1629–1667), Vermeer (1632–1675), and, in Haarlem, Frans Hals (c. 1582/1583–1666), who discarded their drawings or worked directly on canvas or panel, the centrality of drawing to the picture may be ironic.[21] At the very least, Steen suggests that good training is nothing without inspiration.

In recasting high-brow allegory as middle-brow genre, Steen calls into question, and perhaps pokes fun at, the theoretical pretensions of his Leiden counterparts, and celebrates his own brand of comic genre painting. His is a painting about daily life—specifically about the craft of painting—in which history painting, visible in the easel at the rear of the studio, is relegated to the background.[22] In a picture ostensibly about drawing, sumptuous, deftly handled pigments reign. In a picture about the fundamentals of artistic education, the apprentice takes second place to an unlikely pupil, the young woman who is at once a personification of practice and the artist's inspiration, a very real, desirable muse.

HPC

1. Weyerman 1729–1767, 2: 364; see page 14.

2. Valentiner 1942, 149.

3. On the education of artists in the seventeenth century, see Providence 1984; Miedema 1986–1987; Schatborn 1981, 11–32; Bok 1990, 58–68; and De Klerk 1986–1987, 283–288.

4. Montias 1982, 66–68; Miedema 1986–1987, 270–271.

5. Van Hoogstraten 1678, 26–36, advised masters to correct pupils drawings "by sketching right on the drawings."

6. Van Hoogstraten 1678, 26–36; Goeree 1668, 34–35; Walsh 1996. In this smaller *Drawing Lesson*, which includes a plaster cast after Michelangelo's *Bound Slave* (Louvre, Paris), the pupil is copying a drawing of the Madonna and child based presumably on Marcantonio Raimondi's engraving after Raphael's *Madonna of Foligno* (Pinacoteca Vaticana, Rome). See Sutton in New York 1995, 107–110.

7. Sluijter 1993; Gaskell 1982, 15–23. Walsh 1989 and Walsh 1996 discusses the allegorical content of this painting. For a discussion

on Dutch studio scenes see Raupp 1984; Lemmens 1964; Delft 1964. For Vermeer's *Art of Painting* see Wheelock 1995, 129–139.

8. For music as inspiration, see the life of De Lairesse in Houbraken 1753, 3: 110–111. For plaster casts, see De Lairesse 1707, as quoted on page 18. The face may also evoke the mask signifying imitation, an attribute of Pictura in Ripa 1644, 452–453, and in Frans van Mieris' *Pictura* (The J. Paul Getty Museum). See Walsh 1989 and Walsh 1996 for a full discussion of the allegorical and symbolic contents of this painting.

9. Walsh 1996 notes that the cow may be an unknown variant of a terracotta cow by Adriaen van de Velde (Louvre, Paris) and that the statuette in the *Drawing Lesson* must have been available in Italy, where it appeared, for example, in Guercino's *Saint Luke Displaying a Painting of the Madonna and Child* (1652, The Nelson-Atkins Museum of Art, Kansas City).

10. Since the panel on the easel at the rear of the studio resembles Steen's biblical subjects more than any other, Walsh 1996, reads the *Drawing Lesson* as an allegory of drawing as the foundation of history painting, the most important genre in the classical hierarchy of subject matter.

11. Schatborn 1981, 11–31, summarizes the seventeenth-century Dutch literature on drawing.

12. De Lairesse 1701, 53; see also De Jongh 1983, 205.

13. The artist's other two goals are profit, represented by the painter's grand studio and elegant attire, and fame or honor, represented by the laurel wreath at bottom right. See Van Hoogstraten 1678, 345–361, and also Van Hoogstraten's peep box (National Gallery, London).

14. Emmens 1963, 125–136. A precedent for this pairing of drawing and pen sharpening as the fundamentals of painting is found in *The Art Academy*, 1578, by Cornelis Cort (1533/1536–1578) after Johannes Stradanus (1523–1605) and Dou's *Allegory of Education*. A copy after Dou's lost original by William Joseph Laquy (1738–1798) is in the Rijksmuseum.

15. Haarlem 1993, 19. Although the pupils resemble Steen's children, the artist here is not identifiable as Steen, which is striking given how unambiguously he can represent himself in his paintings (see cats. 15, 23). See Steinberg 1990, 123.

16. Walsh 1989, 82.

17. De Lairesse 1778, 267.

18. Steinberg 1990, 113–116. Though Steinberg's reading of her gaze is certainly open to question, Steen's near contemporary Jan van Mieris shortly later portrayed an allegorical figure of painting staring directly at the genitals of a nude male cast. See Naumann 1981, pl. 55, (as by Frans van Mieris), more recently attributed to Jan.

19. Compare the *Music Lesson* (Wallace Collection, London) and the various *Doctors' Visits* for somewhat prurient, titillating subjects.

20. Steen's innocent seductress is a tamer, unwitting version of the muse in Richard Brakenburg's *Terpsichore in the Studio* (page 55, fig. 4), which was surely painted in response to this picture.

21. Only two drawings attributable to Steen are known, one is a double-sided study for two figures in Steens' early *Skittle Players outside an Inn* in Vienna (Rijksprentenkabinet, Amsterdam) and the other is a compositional study (Ashmolean Museum, Oxford) for the *Trial of the Infant Moses* in the Wetzlar Collection. For the Amsterdam drawing, Amsterdam 1981, 79; the Oxford sheet, traditionally attributed to Steen, will be published as by Steen in Jane Shoaf Turner's forthcoming catalogue of Netherlandish drawings at the Ashmolean Museum. See Van Regteren Altena 1943; De Vries 1992, 82–91.

22. While the subject of the painting is not clearly identifiable, it looks like a rest on the flight into Egypt or another outdoor biblical theme.

28

The Prayer before the Meal

c. 1663–1665

signed over fireplace: *JSteen* (*JS* in ligature)

canvas, 99 x 85 (39 x 33 ½); without additions at top and sides: 38 ¾ x 31 ¼

The Duke of Rutland, Belvoir Castle, Grantham

PROVENANCE

First recorded in the collection of the dukes of Rutland in the nineteenth century, but probably acquired by the 4th duke of Rutland (d. 1787); and by descent

LITERATURE

Smith 1829–1842, supplement: 508, no. 90; Van Westrheene 1856, 129, no. 135; Belvoir Castle 1891, no. 13; Hofstede de Groot 1907, no. 374; Martin 1909b, 156–158; Bredius 1927, 62; Van Gils 1940a, 192; De Groot 1952, 153; The Hague 1958, no. 40; De Vries 1977, 166, no. 148; Braun 1980, 110, no. 174; Sutton 1982–1983, 29; Philadelphia 1984, 308

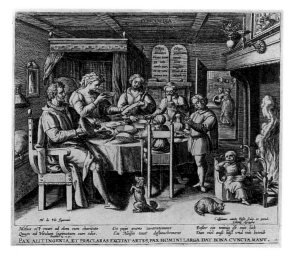

fig. 1. Crispijn de Passe the Elder, *Concordia*, 1589, engraving, Rijksprentenkabinet, Amsterdam

The noonday meal was an important family occurrence in Dutch life, for it afforded an opportunity for parents and children to come together to express their appreciation for God's bounty. It also provided an excellent opportunity for parents to guide their childrens' moral and spiritual growth on a daily basis.[1] Here, for example, the mother patiently teaches her young daughter how properly to hold her hands in prayer. Devotions were often conducted just before the midday meal, where the children were exhorted to practice obedience, virtue and piety. Indeed, this theme was one that a large number of Dutch artists depicted throughout the seventeenth century (see fig. 1).[2]

As in the painting in the Morrison Collection (cat. 13), the *belkroon* above the table is inscribed with words from the Lord's Prayer, which here read, *Ons dagelyck Broot* (Our daily bread). As in the other scene a scroll hangs above the fireplace with verses from the Book of Proverbs: *Solamons / gebet / Overvloedige / Ryckdom noch / Armmoede groot / En wilt my heere / op dieser Aerdt / nit ghevenndt . . . [illegible] . . .* (Solomon's prayer: My Lord desires to give neither overflowing riches nor great poverty on this Earth).[3] Finally, hanging behind the father is likewise a key, symbol of trustworthiness.[4]

Solomon's prayer celebrates God's wisdom in dispensing life's rewards with moderation, indicated by the simple repast of bread, beans, and a platter of parsnips and carrots. The family, however, has benefited more substantially from God's largess than has the humble couple in the Morrison painting (cat. 13). The room is well appointed, with large fireplace, leaded-glass windows, and substantial furniture. The family, particularly the girl seen from the back who wears a plum-colored satin dress with large, flared sleeves, wear the latest fashions. A final testament to the family's wealth is the servant girl who assists with the meal. A large basket full of freshly baked breads and a finely wrought earthenware jug further emphasize the overriding sense of prosperity and well-being.

Even with such good fortune, it is occasionally difficult to lead a righteous life. Sensual desires sometimes interfere with pious thoughts. This all-to-human failing seems to have afflicted the father of the family, for as he folds his hands around his hat in prayer, his eyes stray upward in the direction of the comely servant girl. In Steen's world, of course, the young learn from the old (see cat. 23), so it is not surprising that the father's son likewise is distracted from his prayers. As he holds his hat to his face, he peeks smilingly at the maid and the platter of food she holds in her hand.

The Prayer before the Meal presents a human aspect of a scene that Steen may have felt many Dutch artists had represented with excess sanctimoniousness (fig. 1).

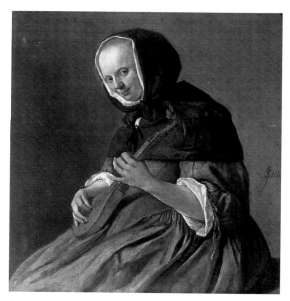

fig. 2. Jan Steen, *Woman Playing the Sistrum*, c. 1662–1665, oil on panel, Mauritshuis, The Hague

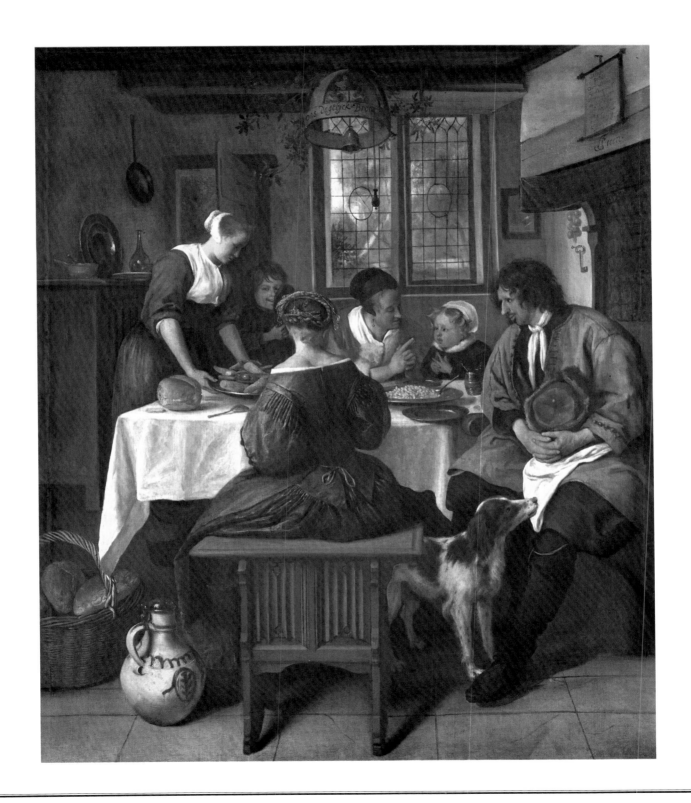

Important to the painting's compositional success is the anonymous female figure with her back to the viewer. Her large form closes the family circle at the table, enhancing the sense of privacy. Steen also carefully positioned her to establish a link between the two subtle vignettes occuring at the table. Although her body is turned toward the maid, she looks back to the mother teaching her daughter to pray, thus drawing the viewer's attention to the painting's primary theme.

The painting appears to date from the early to mid-1660s, when Steen tended to combine the refined handling of paint from his Warmond period with a boldness of concept gained in Haarlem.[5] During these years he frequently depicted figures seated at a table; indeed, the pose of the young woman seated with her back to the viewer is reminiscent of that of the man at the front of the table in *Twelfth Night*, 1662 (cat. 18).[6] The dress the young woman wears, moreover, is identical to that of Steen's *Woman Playing the Sistrum*, c. 1662–1665 (fig. 2). Finally, Steen's subtle humor in depicting family relationships is found in other works from this period, including *As the Old Sing, So Pipe the Young*, c. 1663–1665 (cat. 23), where the identical dog also appears.

AKW

1. Franits 1986, 36–43.

2. For a painting by Steen with a similar emphasis, see *Prayer before the Meal*, c. 1662–1665, National Gallery, London, inv. no. 2558. For other images of this subject see Franits 1986; Van Thiel 1987.

3. While the sentiments are those of Proverbs 30: 8, Van Gils 1940, 192, discovered that the verses in Steen's painting were part of a longer poem, which he found on the last page of Johan Rammazeyn, *Die Historie van den ouden Tobias*, Gouda 1647. De Vries 1977, 129 n. 79, discovered a 1606 panel in the Aartsbisschoppelijk Museum, Utrecht, inv. no. 334, depicting a scroll with a comparable text.

4. See, for example, Visscher 1614, emblem 66, "'T Vertroude trouwelijck," which equates trustworthiness with a key. For a religious association of the key, see cat. 13 n. 3.

5. This date is similar to Braun's suggestion of 1662–1666, see Braun 1980, no. 174; it also corresponds to Bredius, who looked at the age of Steen's son who modeled for the little boy and then proposed 1662, see Bredius 1927, 62. De Vries 1976, 78, however, suggested a later date for this painting (c. 1665–1668).

6. In this painting, however, the figure also served to block the light source on the table.

29A

Portrait of Gerrit Gerritsz Schouten

29B

Portrait of Geertruy (?) Gael, Second Wife of Gerrit Gerritsz Schouten

1665

The man's portrait is signed *JSteen* at center right (*JS* in ligature) and dated *A° 1665* on the account book, with the inscription *Journ./GS* in monogram; the woman's portrait is signed *JSteen* at upper right (*JS* in ligature)
panel, 28.5 x 22.9 (11 ¼ x 9); 28.4 x 22.7 (11 ³⁄₁₆ x 8 ¹⁵⁄₁₆)
Private collection

PROVENANCE
Probably Cornelia Schouten, daughter of the sitters and wife of Willem Schouten; her daughter, Geertruyd Cornelia Schouten, wife of Matthijs van Bree; Cornelia Maria van Bree, wife of Pieter Tiarck; Maria Jacoba Tiarck, wife of Jean Baptiste, Count d'Oultremont, 1750; and by descent

LITERATURE
Bijleveld 1950, 10; Martin 1954, 71–72; Belonje 1983, 23–27; Lunsingh Scheurleer et al. 1986–1992, 1:99, 2:264

fig. 1. Jan Steen, *Gerrit Gerritsz Schouten Sr. (died 1663)*, c. 1665, oil on panel, private collection

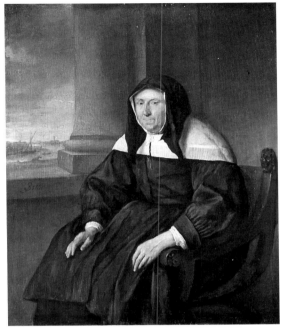

fig. 2. Jan Steen, *Catharina Jans (died after 1665)*, c. 1665, oil on panel, private collection

Jan Steen's oeuvre includes only a few known portraits. His *Self-Portrait* (cat. 40) is unique in his oeuvre, and even the handful of genrelike portraits, such as *The Leiden Baker Arend Oostwaert and His Wife Catharina Keyzerswaert* (cat. 8), the so-called *Burgher of Delft and His Daughter* (cat. 7), and the girl's likeness in *The Poultry Yard* (cat. 12), appear mainly to be exceptions that prove the rule. All the same, Steen must have made further forays into this genre, as is clear from the three portraits that he painted for Geldolph van Vladeracken in 1666 in order to pay off arrears of interest. Also, other portraits are mentioned in contemporary sources.[1] The "portraits of Warmond magistrates" referred to by Bijleveld and Martin turn out to be those of the Schouten family.

These two portraits have never previously been exhibited. They have led a sheltered existence, and regrettably so, for they provide welcome information on this almost unknown facet of Steen's artistry. The paintings of Gerrit Gerritsz Schouten and his wife are from a series of four. They seem to be by-products of Steen's vast output, works that he painted as a favor for a friend or good

acquaintance simply because he enjoyed a change from his usual work.

The sitters' identities are known from old annotations on the backs of the panels.[2] Belonje was able to provide further information since the provenance matches the identification perfectly. Gerrit Gerritsz was a brewer in "The Elephant" in Haarlem. He was also a Catholic; therefore, he shared a certain bond with the artist, who was also born into a family of Catholic brewers. The prominent Gael family of Haarlem, to which Gerrit Schouten's wife belonged, also had a Leiden branch to which Jan Steen was related.

The two portraits not included in the exhibition depict Gerrit Gerritsz' parents (figs. 1 and 2). His mother, Catharina Jans, wears widow's weeds: a cap and a black dress. The father, Gerrit Gerritsz Schouten, Sr. (died 1663), is pictured beside a Bible with ornamental fastenings and a skull; he therefore must have already been dead when the portrait was painted. The sitter's rather wooden appearance also suggests this is not a likeness done from life but a postmortem portrait.

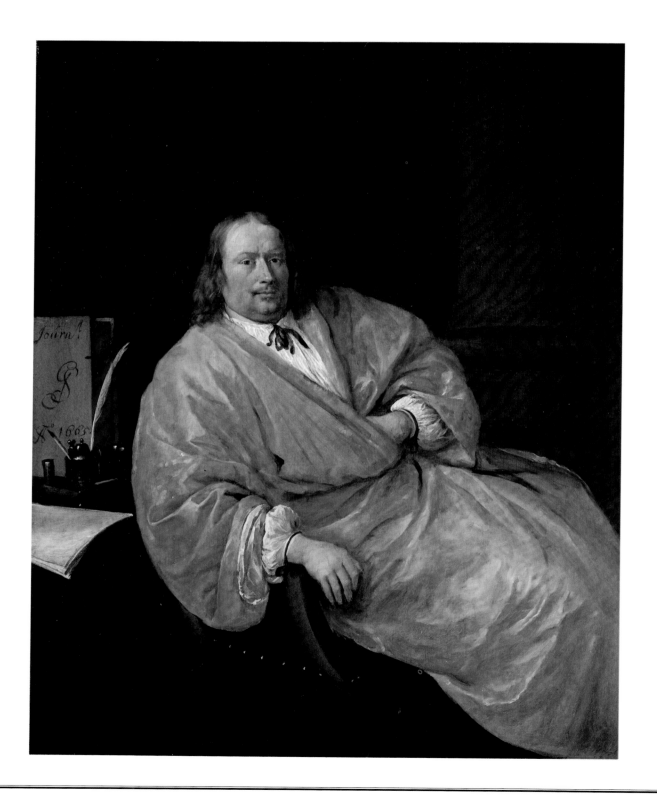

fig. 3. Jan Steen, *Revelry outside the Elephant Inn*, c. 1652–1656, oil on canvas, present whereabouts unknown

Steen knew the Schouten family long before 1665.[6]

The remarkably fluent painting of the portraits is done in a rich palette. The man's pinkish red Japanese gown contrasts pleasingly with the heavily embroidered, oriental fabric worn by his wife. Ropes of pearls and a silver toilet box give her a distinguished look, while her husband has adopted a robust, somewhat nonchalant pose. His monogrammed account book of 1665, which was undoubtedly the year in which these portraits were painted, is an indication of the thoughts that should be uppermost in his mind.

Steen stressed the woman's elegance by giving her small hands. Pentimenti at this point show that he had painted them a little differently at first, but even then they were not much larger. In the portrait of Gerrit Schouten, Jr., Steen managed to impart great liveliness to the large, uniform surface of the gown by placing subtle gradations of color next to each other. This characteristic manner shows that he was a painter *pur sang*.

WTK

1. The annotation on the back of Gerrit Schouten's portrait reads: *A / ../ ../ .. getrouwt- / En .. weest wed. van .. / .../ hij is gestorven / .. mart ..1680 / out 5..'*; the note on the back of Mrs. Schouten's portrait reads: *'... Loene / .../ Getrout .. / Gerrese schouten voor de / tweede mael / Sij sterft de 28 juni 1673*.

2. See the essay by Bok in this catalogue and Braun 1980, 13. Of course, whether Steen actually painted the portraits for Van Vladeracken is not certain. In 1673, Lambert Hendricksz van der Straaten pledged a *een conterfeijsel van Jan Steen* (portrait by Jan Steen) as security; see Braun 1980, 14.

3. The information on the wood is from the dendrochronological examination carried out by Dr. Peter Klein of Hamburg in 1995. Bijl (see pages 83–91 in this catalogue) has pointed out that the portrait of Catharina Jans is of the standard size used in Uitgeest. That village, which was the site of the first Dutch sawmill, was close to Limmen, where the Schoutens had their country estate.

4. Information taken from Belonje 1983, 20–21.

5. Reproduced in Belonje 1983, fig. 8.

6. Braun 1980, no. 53. Braun dates the painting between 1652 and 1656. In 1983 it was with the dealer Robert Noortman in Maastricht and London.

The four small portraits are not all the same size. The panel depicting Catharina Jans is a bit wider than the other three panels, which, unlike hers, came from the same tree.[3] This fact suggests that the portrait of Catharina Jans was painted first and that Steen added the others later. Since the likeness of Gerrit Schouten, Jr., is dated 1665, his mother's portrait was probably painted earlier but after her husband's death in 1663.

In 1636, Gerrit Schouten, Sr., bought the Elephant brewery in Haarlem from Pieter Hendricksz van Dijck. The Schouten family also acquired the country estate of Dampegeest from him, although only after overcoming considerable difficulties. Gerrit, Jr., took over the brewery

from his mother after his father's death.[4] Dampegeest, near Limmen, would have been extremely important to the Schoutens, for manorial rights were attached to it, and ownership must have considerably raised their social standing. The vista of land and water in the portrait of Catharina Jans probably depicts the church of Alkmaar in the distance, which was clearly visible from Limmen. A drawing of Dampegeest that is now in Alkmaar indicates that one of the brewery owners must have placed an effigy of an elephant on the house, alluding to the business back in Haarlem.[5] Jan Steen's *Revelry outside the Elephant Inn* (fig. 3), an early painting that was once in the Metropolitan Museum in New York, may be an indication that

30

The Feast of Saint Nicholas

c. 1665–1668

signed at lower right: *JSteen* (*JS* in ligature)

canvas, 82 x 70.5 (32 ¼ x 27 ¾)

Rijksmuseum, Amsterdam

PROVENANCE

Sale, Seger Tierens, The Hague, 23 July 1743, no. 178 (Dfl. 695); Hendrik van Heteren, The Hague, 1743–1749; Adriaan Leonard van Heteren, The Hague, 1749–1808; Adriaan Leonard van Heteren Gevers, The Hague and Rotterdam, 1809; acquired with his collection that year for the Koninklijk Museum, later Rijksmuseum, Amsterdam

LITERATURE

Hoet 1752–1770, 2:459; Smith 1829–1842, 4:5, no. 15; Van Westrheene 1856, 99, no. 6; Hofstede de Groot 1907, no. 510; Bredius 1907, 20; Moes and Van Biema 1909, 150, 152, 192; Rijksmuseum 1976, 522; De Vries 1977, 65–66; Braun 1980, 114, no. 199; Boer 1994

This *Feast of Saint Nicholas* is one of the most popular paintings in the entire history of Dutch art, a celebrity due not just to Steen but also to the fact that this delightful festival has survived to the present day. Many aspects of the modern celebration are also found in the painting: placing a shoe by the hearth in the hope of finding a present in it the next morning; singing around the chimney, which Saint Nicholas is supposed to slide down; and receiving presents or, in the case of naughty children, a switch. Teasing children by hiding their presents and an overabundance of candy are also part of the fun of this typically Dutch feast.

Although the family depicted here is often said to be Jan Steen's and some of the children are certainly modeled after his, this identification is based on sheer supposition.[1] The artist loved to include himself in his works, and if this was indeed his family, one would certainly expect to find him joining in the party. The complete absence of a father figure is in itself remarkable.

The central figure is a small girl. She is beckoned by her mother, seated on the right, and has been thoroughly spoiled by receiving a doll representing John the Baptist and a shopping pail full of candy. A boy not much older than herself has received a *kolf* club from the saint; the ball lies by his mother's feet. He crows over his crying brother on the left, who has almost grown out of his stylish suit. The slightly older girl behind him is often taken to be Steen's daughter Eva. Her attire, though, clearly identifies her as a young maidservant. She holds up his present, a shoe with a switch with which naughty children were smacked on the bottom. The grandmother, though, beckons to the boy, for a better present has evidently been hidden in the four-poster bed. The aged grandfather, whose collar is about thirty years out of fashion, sits amidst his progeny, unperturbed by all the commotion. On the right some children sing a song to Saint Nicholas around the chimney, among them a little boy who bears a striking resemblance to the artist's son in *The Leiden Baker Arend Oostwaert and His Wife Catharina Keyzerswaert* (cat. 8). His older brother holds a toddler on his arm grasping a gingerbread man in the form of Saint Nicholas, which indicates the source of all the presents.

Apart from its extremely clever arrangement of figures, this painting is notable for the many still-life details, such as the basket full of delicacies in the left foreground and the *duivekater* loaf and other objects on the beautiful Renaissance seat on the right, which Steen also included

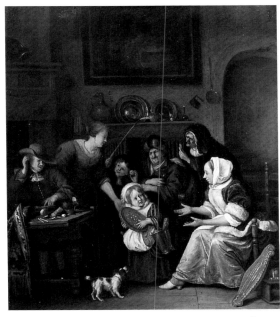

fig. 1. Jan Steen, *The Feast of Saint Nicholas*, c. 1667–1668, oil on panel, Museum Boymans-van Beuningen, Rotterdam

in the Kassel *Twelfth Night* (cat. 33). Some are notable for the highly successful rendering of textures, and some contain wonderful echoes of other objects in the room. The visual rhyme of the two shoes, one on the floor at the front and the other containing the birch, is a brilliant touch linking foreground with background.

Steen also depicted the psychological interaction between the figures with great sensitivity. Houbraken, with good reason, praised this "lifelike and ingenious" composition, making special mention of the tearful boy who has received the birch.[2] The action of the figures circles around the old man and ends at the two people with their backs to each other in the right background.

The mother is one of Steen's most classic figures. She recalls the work of Gabriël Metsu (1629–1667), and in Steen's oeuvre she relates to several sleeping or drunken figures.[3] In *As the Old Sing, So Pipe the Young* (cat. 23), the old woman singing is in virtually the same pose.

Steen painted several versions of *The Feast of Saint Nicholas*. In the Rotterdam variant (fig. 1), he repeated several elements, such as the beckoning gesture of the mother, who appears much younger; the pose of the girl

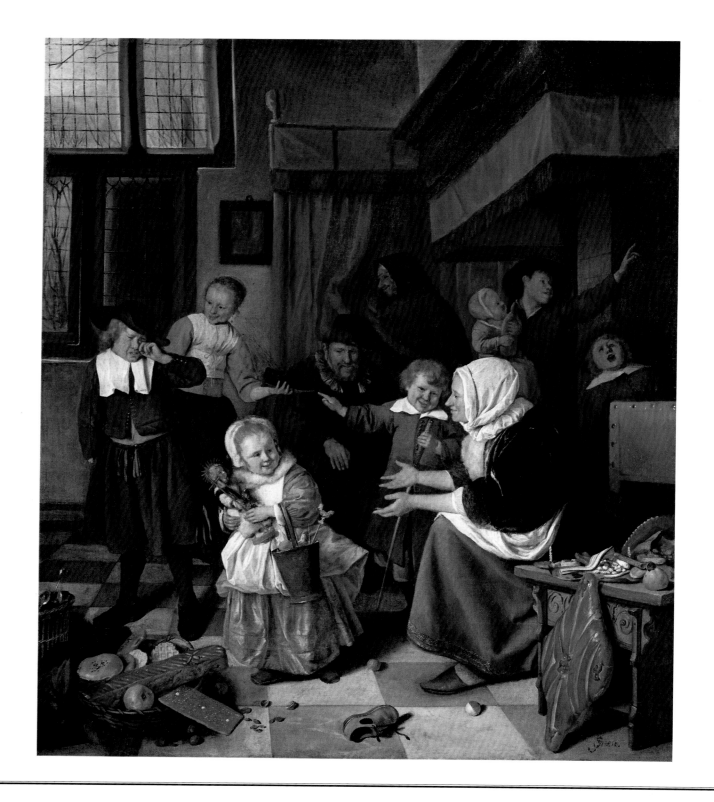

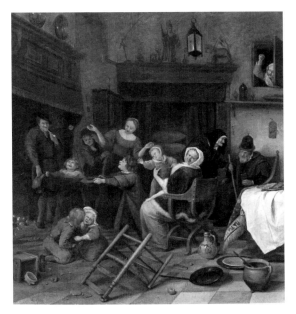

fig. 2. After Jan Steen (?), *The Feast of Saint Nicholas as a Dissolute Household*, c. 1668, oil on panel, private collection

1. The children have been identified as follows: Eva (the eldest girl), Thaddeus (the boy crying), Cornelis (with the *kolf* club) and Catharina (the girl in the middle). Taken as a whole, though, this is an imaginary family.

2. See Houbraken's life of Jan Steen in this catalogue, pages 93–97.

3. See, for example, the painting by Metsu in San Diego, Robinson 1974, fig. 76. See also Braun 1980, nos. 93, 197, 274.

4. Steen's *Parrot Cage* in the same museum is stylistically close to the Rotterdam *Feast of Saint Nicholas* and can therefore also be dated to the late 1660s.

5. Boer 1994, 20.

6. The painting was given this title at the De la Court Backer sale, Leiden, 8 September 1764; see Lunsingh Scheurleer et al. 1986–1992, 2:449 and 5:196. See also Braun 1980, no. 308a and Boer 1994, 21. This painting is so similar in style and composition to a picture in Hamburg dated 1668 that it, too, was probably executed around then. For this work see Braun 1980, no. 294.

7. All these "popish abominations" are absent in a fourth and final variant of the *Feast of Saint Nicholas*, which, however, is probably not autograph. See Boer 1994, 22, ill.

in the foreground; and the *duivekater* loaf on the right. The Rotterdam work could not have been painted before 1669, given the cravat and the round hat worn by the distraught young boy.[4] It has rightly been pointed out that overtly Catholic elements, such as the John the Baptist doll and the gingerbread Saint Nicholas, are missing in this version.[5] In another composition, the autograph version of which is missing, Jan Steen combined the feast of Saint Nicholas with a dissolute household (fig. 2). It, too, includes a prank that is part of the festivities, which is to scatter candy into the room from an unexpected direction, making the children think that it has come rattling down the chimney. The overturned chair and quarreling children led one eighteenth-century owner to label this painting "a dissolute household."[6] It has also been described as a typically Roman Catholic treatment because of the statuette of Saint Nicholas and the image of the Virgin Mary.[7] However, to assume that the "expurgated" version in Rotterdam was intended for a Protestant client is going too far, for celebrating the feast of Saint Nicholas would have been absolutely taboo in Calvinist circles.

WTK

31

The Supper at Emmaus

c. 1665–1668
signed in lower left: *JSteen* (*JS* in ligature)
canvas, 134 x 104 (53 ½ x 41 ½)
Rijksmuseum, Amsterdam

PROVENANCE
Probably Jacob le Beuf, Leiden, by 1727; sale, Alexander Le
Breton van Doeswerff, Leiden; sale, Macalester Loup et al., The
Hague, 20 August 1806, no. 4 (fl. 185); sale, Arend van der Werff
van Zuidland, Dordrecht, 31 July 1811, no. 99 (bought in at fl.
300); sale, Jan Hulswit, Amsterdam, 28 October 1822 (fl. 401 to
Brondgeest on behalf of Richard Le Poer, 2d earl of Clancarty,
Garbally, Galway); by descent to Richard Somerset Le Poer,
4th earl of Clancarty; his sale, London, 12 March 1892, no. 83
(£38 17s. to Colnaghi); Gijsbert de Clercq, Amsterdam, by 1894;
bought from the De Clercq collection by the Vereniging
Rembrandt on behalf of the present owner, 1900

LITERATURE
Weyerman 1729–1769, 2:364; Hofstede de Groot 1907, no. 65;
Plietzsch 1916, 131; Leiden 1926, 13; Bredius 1927, 37; Schmidt-
Degener and Van Gelder 1927, 16, 54, no. 20; De Groot 1952, 172,
179; Gerson 1952, 33; Martin 1954, 23, 71; Slive 1956, 7; Rosenberg,
Slive, and Ter Kuile 1966, 137; Rijksmuseum 1976, 524, no. A1932;
De Vries 1977, 39, 40, 158, no. 50; Kirschenbaum 1977, 20, 42–43,
138, no. 65; Braun 1980, 102, no. 122; Halewood 1982, 7

The two followers of Jesus had not expected an evening like this, although it had been an extraordinary day.[1] That morning they had met Mary Magdalene, Joanna, and Mary, mother of James, who had found Jesus' empty tomb. One of the women had even seen a vision of angels who said that Christ was alive. When they met a stranger on the way to Emmaus, they related to him their disbelief in these amazing events. He chastised them as "foolish men, and slow of heart to believe all that the prophets have spoken!" That night, when he blessed them while breaking bread, they recognized their companion's true identity. At that very moment, Christ vanished.

Christ, his insubstantial form no longer visible to the disciples, radiates ethereal light as he peers into the grape arbor. The painting's recent restoration revealed that Christ also gestures toward the disciples, who sit with bowed heads, withdrawn as though in prayer, their noble features and physicality lending the scene its remarkable solemnity. Burdened by Christ's admonition, they try to comprehend the meaning of this most recent unforeseen event.[2] The weighty dignity of the painting extends even to the servant girl delivering bread and the boy pouring wine, who, while unaware of the miracle that has just transpired, deport themselves with great propriety.[3]

For an artist who delighted in dramatizing the narrative moment through exaggerated gestures and expressions, Steen's subdued interpretation of *The Supper at Emmaus* is exceptional. Indeed, the reflective character of this image differs from most other representations. Artists traditionally depicted the dramatic moment when the apostles react in astonishment, and even fear, upon realizing the true identity of their companion. Rembrandt (1606–1669), for example, showed that moment of revelation in his 1648 painting and 1654 etching (fig. 1), images that Steen certainly knew.[4]

Steen drew upon the pictorial tradition realized by Rembrandt, and even adapted Rembrandt's general compositional structure—figures placed around a small table situated parallel to the picture plane.[5] The comparison, however, reveals differences in both the narrative moment and the psychological character of the scene. Steen shifted the narrative emphasis—from the revelation of Christ's divinity to the apostles' state of mind—by placing Christ to one side and situating one of the apostles in the center, the position traditionally reserved for Christ.[6] The implications of this compositional change, where a pensive apostle sits in Christ's place, would not have been

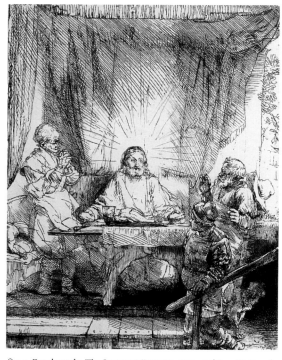

fig. 1. Rembrandt, *The Supper at Emmaus*, 1654, etching, National Gallery of Art, Washington, Gift of W.G. Russell Allen

lost on contemporary viewers. While both apostles evoke the deep faith of those who followed Christ's teachings, they are but human and must confront the limits of their understanding.

The apostles' attitudes are those of two humble men devoutly praying before a meal. Indeed, their meal of bread and wine has profound theological implications. With open gesture, Christ urges them to partake of the bread and wine, which traditionally symbolize the bond between the resurrected Christ and his believers. Steen's interpretation of the event is consistent with the Catholic view of the Eucharist and the doctrine of transubstantiation as formulated at the Council of Trent.[7] Steen's still and solemn image, in fact, touches upon one of the most dissonant theological debates then raging between Catholics and Protestants.[8]

Steen reinforces his theological message by including plants with symbolic associations. The grapevine climbing the arbor above the apostles has many Christian allu-

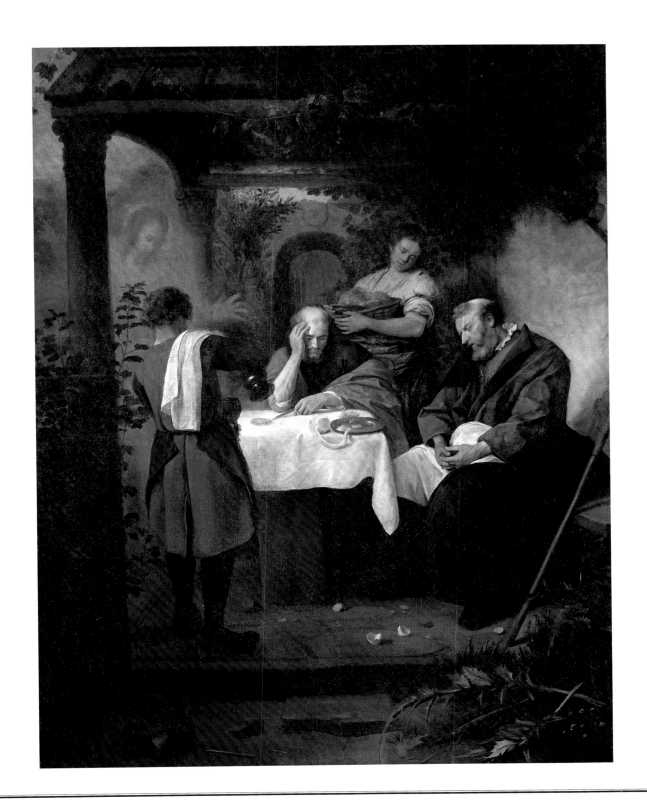

sions, ranging from the vineyard as a protected place for the children of God, to Christ's own words: "I am the vine, you are the branches."[9] The thistle plant in the lower right symbolically indicates earthly sorrow as well as the Passion of Christ.[10] Although the bush to the left and the small flowers in the lower right cannot be identified, they probably contain similar symbolic associations.[11] Steen almost certainly included a half-peeled lemon on the table and broken egg shells on the stone floor for symbolic reasons as well, perhaps because the lemon traditionally symbolizes fidelity in love and broken eggshells often refer to the transience of life.

This painting has often been compared to *Prayer before the Meal* of 1660 (cat. 13), in part because of its similar emotional character.[12] The large scale and broad handling of paint in *The Supper at Emmaus*, however, indicate a later date, probably in the mid- to late 1660s. A comparable work is *The Return of the Prodigal Son*, c. 1668–1670 (cat. 39), in which Steen has likewise placed relatively large figures in a shallow, architecturally defined space. Steen's treatment of foliage in these works is also similar, particularly the grapevines covering the arbors.

The Supper at Emmaus was greatly esteemed by Weyerman, Steen's eighteenth-century biographer, who believed that this work demonstrated the fact that Steen "occasionally had unusual and exalted thoughts to express his stories in a miraculous way."[13] However, Steen's painting has not always been considered a successful achievement. In 1927, for example, Schmidt-Degener and Van Gelder wrote that Steen's interpretation of the story lacked Rembrandt's expression of the "depth of inner life."[14] Perhaps the problem rests with Steen's effort to subordinate the biblical narrative in favor of its theological implications. Nevertheless, *The Supper at Emmaus* remains among the most daring and provocative religious paintings in Dutch art.

AKW

1. For the story of the finding of the empty tomb, the apostles' travels to Emmaus, and the supper at Emmaus, see Luke 24: 1–33.

2. Only later, when Jesus appeared to the eleven apostles in Jerusalem, did they understand that his life, death, and resurrection fulfilled the writings of the prophets; Luke 24: 33–52.

3. The pose of the servant girl, and her sense of dignity, are reminiscent of Johannes Vermeer's *The Milkmaid*, Rijksmuseum, Amsterdam; Washington 1995, 63–71. I would like to thank Quint Gregory for calling my attention to this connection.

4. Rembrandt's painting is in the Louvre, Paris (Br. 578). Rembrandt suggests the transformation of Christ's body from a physical to a spiritual being through the light that radiates from his body while simultaneously consuming his form. This effect is most pronounced in the first state of the etching.

5. The arched architectural motif directly behind the centrally placed apostle is similar in character to the large arch behind Christ in Rembrandt's painting of 1648 in the Louvre.

6. Christ's position at the table belongs to a pictorial tradition deriving from Leonardo da Vinci's *Last Supper*. The visual connections between Rembrandt's print and Leonardo da Vinci's *Last Supper* have been frequently stressed in the literature. See particularly Münz 1952, 2: 106, 233; and Gantner 1964, 144–147.

7. As quoted from Glen 1977, 92, ". . . that, by the consecration of the bread and of the wine, a conversion takes place of the whole substance of the bread into the substance of the body of Christ our Lord, and of the whole substance of the wine into the substance of His blood."

8. For a fuller discussion of these issues, see Knipping 1974, 299–303. Knipping 1974, 302, notes that "the majority of Catholic exegetists in that period" associated the Supper at Emmaus with the Eucharist because "Christ breaking the bread and his benediction over it was considered as an eucharist reality."

9. Ferguson 1959, 21. Christ's words are from John 15: 5.

10. See Ferguson 1959, 20.

11. The bush on the left may be a rose bush and the flowers violets.

12. Kirschenbaum 1977, 138, cat. 65.

13. As quoted from Weyerman 1729–1769, 2:364: ". . . ongemeene en verheevene gedachten had, om zijne Historien uyt te drukken op een wonderlijke wijze. . . ."

14. Schmidt-Degener and Van Gelder 1927, 16.

32

The Wedding of Tobias and Sarah

c. 1667–1668
signed at lower left: *JSteen* (*JS* in ligature)
canvas, 131 x 172 (52 ½ x 68 ½)
Herzog Anton Ulrich-Museum, Brunswick
Amsterdam only

PROVENANCE
Arnold Houbraken; bought by the duke of Wolfenbüttel,
Brunswick, by 1710; removed to Paris by Napoléon, 1807;
returned to the Brunswick collection, which forms the basis
of the Herzog Anton Ulrich-Museum, 1815

LITERATURE
Houbraken 1718–1721, 3:16; Smith 1829–1842, supplement: 501,
no.73; Van Westrheene 1856, 137, no. 167; Hofstede de Groot 1907,
no. 457; Fink 1926–1927, 230–233; Bredius 1927, 23; Heppner
1939–1940, 42; Simon 1940, 162; De Groot 1952, 21, 30–31, 128, 131,
201; Martin 1954, 10, 51; Stechow 1958, 97; The Hague 1958, no. 44;
Duits 1965, 4–9; De Vries 1976, 25; Kirschenbaum 1977, 123, no.
25b; De Vries 1977, 9, 62, 114, 132, no. 132x; Braun 1980, 126, no.
281; Washington 1980, 29; Herzog Anton Ulrich-Museum 1983,
194–195, no. 313; Amsterdam 1991, 115

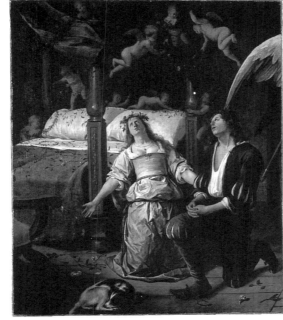

fig. 1. Jan Steen, *The Wedding Night of Tobias and Sarah*, c. 1668, oil on canvas, Collection Museum Bredius,
The Hague/Centraal Museum, Utrecht

Sarah had been married seven times before and each time her husband had died on their wedding night. Now Tobias has asked for Sarah's hand at the urging of his guardian angel Raphael, who has told him how to drive out the evil spirit that so jealously guards Sarah's chastity. The young couple's anguished love is expressed through Sarah's tearful adoration and Tobias' heavenward gaze and dramatic profession of faith. To their right stands the angel Raphael, his hand in a gesture of blessing, who may be wingless because he has not yet revealed his angelic identity. According to the biblical text, after Sarah's father consented to the marriage, he sent for his wife and told her to bring paper, and he wrote out a marriage contract granting Sarah to Tobias as his wife (Tobit 7:11–16).[1] After that they began to eat and drink. At left, Sarah's parents watch as a notary draws up the contract. At right, a maid lays the table and a servant taps the wine cask in preparation for the feast to follow.

The apocryphal Book of Tobit was a popular source for mastering biblical illustration among Dutch artists, including Pieter Lastman (1583–1633) and Rembrandt (1606–1669).[2] Following a model by his presumed teacher

Nicolaes Knüpfer (c. 1603–1655), Steen himself painted the *Wedding Night of Tobias and Sarah* (fig. 1) in which the couple kneel in fervent prayer as the angel exorcises the devil by burning the heart and liver of the fish that Tobias had earlier caught.[3] The moment shown in the Brunswick image, which Steen painted in two other versions (see cat. 45), was rarely, if ever, represented and so seems to have been Steen's invention.[4]

The lack of pictorial precedents suggests Steen's choice of this subject may have been prompted by a literary source, Jacob Cats' *Trou-ringh* (Marriage Ring), published in 1637, a popular didactic poem that applied morals drawn from great historical unions to contemporary marriage. Cats, who considered marriage contracts to be worldly and immoral, notes that the marriage contract in the Book of Tobit is the only one to be found in the Old or New Testament.[5] In contrast, he cited the creation of Eve as the first genuine marriage. Drawing out Cat's connection, Steen depicted a painting of the creation of Eve hanging on the wall above the heads of Sarah's parents.

In a spirit analogous to Cats' updating of lessons from the history of marriage, Steen has imparted to this solemn

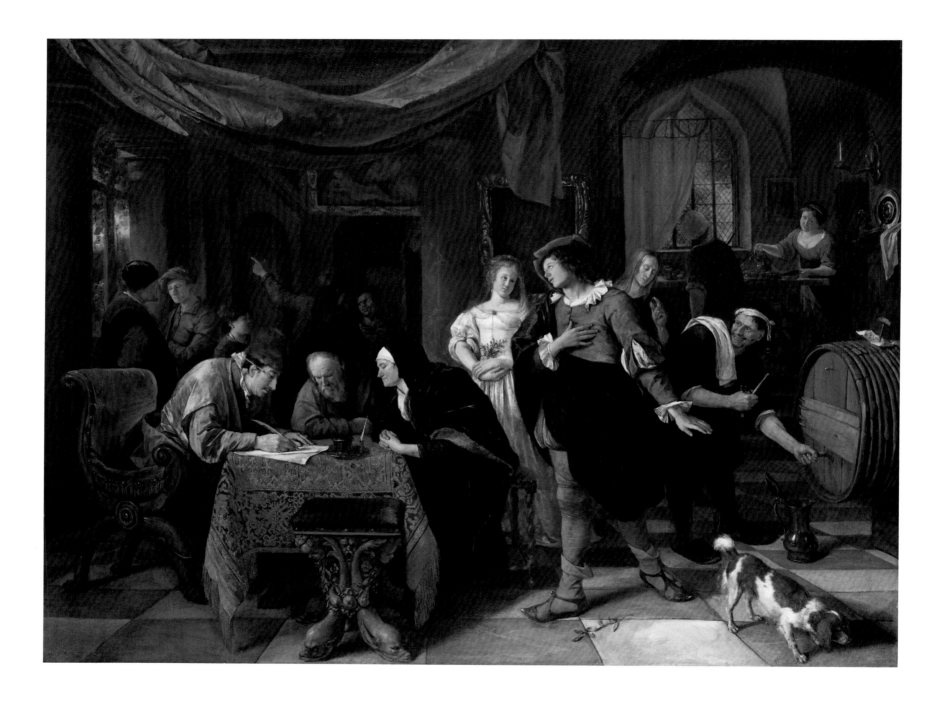

fig. 2. Adriaen van de Venne, "The Marriage Contract," from Jacob Cats, *Houwelyck*, Dordrecht, 1634, Department of Special Collections, University of Chicago Library

biblical subject a contemporary comic tone. Typically, Steen blurred the boundaries between genre and history painting (see cat. 11), a practice, characteristic of seventeenth-century Dutch theater and literature as well, that served to make the lessons of the Scriptures relevant to daily experience. Allusions to the scriptural source—the fish pedestal of the stool reserved for Tobias and the image of the creation of Eve—are overshadowed by figures and details more appropriate to a genre painting. Such touches as the contemporary or theatrical (rather than biblical) costumes and interior setting, the carpet covered table, and the foxy notary, with his pen behind his ear, bring to mind literary references to and prints of secular marriage contracts, as for example the image designed by Adriaen van de Venne (1589–1662) for Cats' other marriage poem, *Houwelyck* (fig. 2).[6] The leering servant who puts the spigot in the keg may evoke the proverb "There is danger too strictly to confine / Either young wenches or new wine," which is also found in Cats' *Houwelyck*.[7]

Hofstede de Groot recorded that the painting was dated 1667, although it no longer bears any date.[8] Similarities to the sumptuously painted *Samson and Delilah* of 1668 (cat. 34), however, support placing it in this period, a few years before the *Wedding Night of Tobias and Sarah* (fig. 1) with its similar though more monumental figures. Today the large and imposing Brunswick painting is regarded as one of

Steen's most masterly histories, but for generations it carried the title *The Marriage Contract*. It is hard for us to imagine that, to the seventeenth-century viewer, the picture's modern guise may have obscured its Old Testament subject.

Surprisingly Arnold Houbraken, who had owned the work, failed to recognize its biblical subject, though he praised the clarity of Steen's narrative.[9] He described it somewhat inaccurately in his biography of Steen:

I cannot omit to mention the subject of a large painting (which was in my house for a long time . . .) that showed a bridegroom and bride, two old folk, and a notary. The figures' actions were depicted so naturally that it was as if one saw the event taking place before one's very eyes. The old people appeared to be setting forth their views with high seriousness to the lawyer who, with his pen on the paper, listened attentively while poised to write. The bridegroom, looking mightily displeased, stood in a pose as if stamping his foot in a fury, hat and marriage token dashed on the floor, shoulder and hands raised. He looked sideways at his bride, as if he wanted to lay the blame on the old folk and apologize to her, while she stood looking on with tears rolling down her cheeks. This was all so readily apparent from both the countenances and attitudes [gestelteit] of the figures, and from other circumstances, it was as if it were inscribed there."[10]

Houbraken's misconstruing of the picture reflects his estimation of Steen as essentially a comic genre painter, a view that overlooked Steen's contribution as a serious history painter. Nevertheless, his description provides valuable insight into the criteria by which Steen's contemporaries may have judged his art. To Houbraken, the picture embodied the comic theatrical nature of Steen's manner of staging a story; in particular it exemplified the repertory of codified poses and rhetorical gestures through which his figures persuasively communicated their passions. In a footnote to the word *gestelteit* (in the above quotation), a dramaturgical term meaning attitude or affect, he recommends, quoting Andries Pels' Dutch translation of Horace's *Ars Poetica*, that painters learn how to represent figures in their proper emotional attitudes by watching actors. He praises the ancient practice of having "pantomimes" between the acts of plays and adds:

This serves to teach youthful painters to get used to impress in themselves a set image of all the movements of the body that are generated from the urgings of the soul, by which they virtually make their images speak, after the example of Jan Steen.[11]

To Houbraken, Steen's figures approximated the comportment of actors on the stage. Though reconstructing dramatic practices of the seventeenth century is difficult, other aspects of Steen's image—Tobias' costume and the curtain above, for example—also evoke the theater of his time.

HPC

1. Fink 1926–1927, 230–233, was the first modern art historian to identify this as a subject from the apocryphal Book of Tobit; see also Duits 1965.

2. Boonen in Amsterdam 1991, 114–117.

3. Museum Bredius 1991, 207–210, no. 155. In addition a *Tobias Curing His Father's Blindness* (Braun A-13) attributed to Steen was destroyed in 1864.

4. The version in the M. H. de Young Memorial Museum, San Francisco, is in the present exhibition (cat. 45); the other (Braun 309) is currently lost. Aert de Gelder also painted this scene (Art Gallery, Brighton). See Sumowski 1983, 2: 1163, no. 733, and Von Moltke 1994.

5. Cats 1637, as cited in Fink 1926–1927, 231–232; Kirschenbaum 1977, 86, 92.

6. Cats 1625, 271; Hollstein 1949, 35: 96, no. 237.

7. Cats 1625, cited in Kirschenbaum 1977, 94.

8. Hofstede de Groot 1928, 253.

9. Compare Raupp 1983, 405–406, who argues that Houbraken deliberately misidentified the subject. However, it seems unlikely that Houbraken would pass up an opportunity to criticize Steen's historical manner. My thanks to Jack Horn for discussing this issue with me.

10. See Houbraken 1718–1721, 3:16–17. See also De Vries 1973, 229.

11. Houbraken 1718–1721, 3:16–17.

33

Twelfth Night

1668

signed in lower left: *JSteen* (*JS* in ligature)

canvas, 82 x 107.5 (32 ¼ x 42 ⅜)

Staatliche Museen Kassel

PROVENANCE

Sale, J. van Loon, Delft, 18 July 1736 (250 florins to Valerius Röver); acquired with the Röver collection by Wilhelm VIII, Count of Hessen, who brought it to Kassel, where it appears in the collection inventory of 1749; taken to the Louvre, Paris, 1806; returned to Kassel, 1815; presently exhibited in the Gemäldegalerie, Schloss Wilhelmshöhe

LITERATURE

Smith 1829–1842, supplement: 494, no. 54; Van Westrheene 1856, 138, no. 170; Hofstede de Groot 1907, no. 494; Leiden 1926, 14, no. 5; Bredius 1927, 55; Schmidt-Degener and Van Gelder 1927, 76–77; De Groot 1952, 76, 100; Martin 1954, 52, 63; The Hague 1958, no. 46; Kassel 1958, 145, no. 296; Kirschenbaum 1977, 47, 49, 94; Braun 1980, 128, no. 296; Brown 1984, 156–158; Van Wagenberg-Ter Hoeven 1993–1994, 86

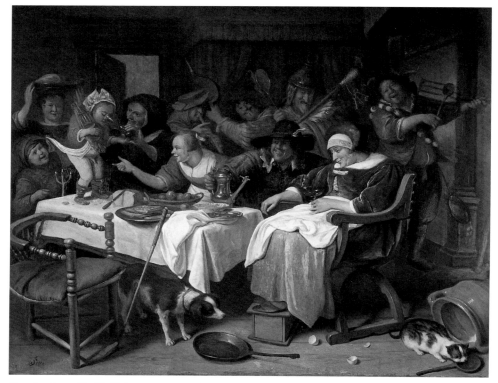

fig. 1. Jan Steen, *Twelfth Night*, c. 1666–1667, oil on canvas, Los Angeles County Museum of Art, Marion Davies Collection

One of the great delights of Steen's paintings is their spontaneity, suggesting that the convivial atmosphere of festive evenings like Twelfth Night somehow infected his very manner of painting.[1] With consummate ease, his figures all play their parts—fool, musician, drunken wench, or king, as the case may be. His paintings are so successful that the party never seems forced or staged. The actors have taken their roles to heart, and Steen, wandering in and about their midst, captures the ebb and flow of their music, laughter, and conversation.

He succeeds by creating scenes that do not appear composed, by focusing attention on figures that do not seek it, and by enlivening the painting with deft brushwork. Much like a Bredero song, Steen's *Twelfth Night* is a loosely structured compilation of vignettes inextricably bound through a broadly shared experience. Here, in one way or another, everyone fully participates in the spirit of the evening, and Steen, as adept with the brush as is Bredero with a pen, reveals the personalities of each participant.

At the center, of course, is Steen himself, the jovial host, who turns to sing to the music of the violin player. Next to Steen, his wife, Margriet van Goyen, sits with arms crossed, and smiles contentedly toward the "fool" enthusiastically playing the *rommelpot*. They play their parts so well that it seems hard to believe that lot determined the roles they have assumed in the evening's festivities.[2] Also perfectly characterized is the pastor (preacher), identified by the text on the paper stuck to his hat, who sits with a restrained group of celebrants at the far end of the table.

The focus of attention is the young king who wears a decorated paper crown and drinks from a large glass. While kings generally rule over a diverse populace, certainly none had such a winsome array of admirers. They range from the smiling nun who encourages him to drink from his glass and the young boy with a basket on his head who clutches his jacket as though it were a royal train, to the whimsical musician banging a ladle on a

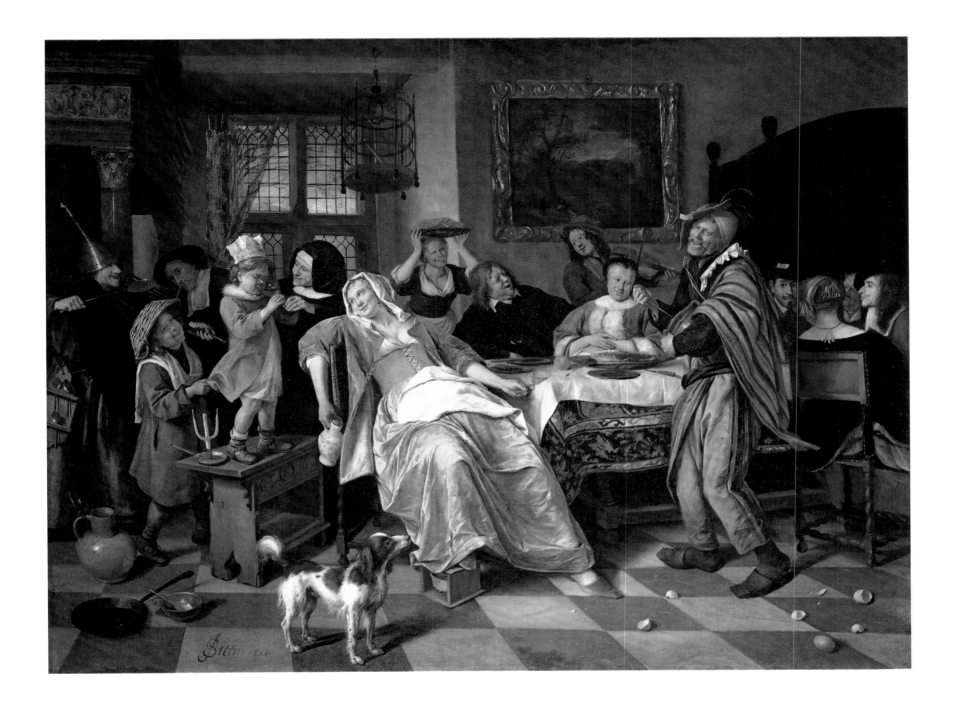

grate while sporting a funnel with a clay pipe for a cap.[3] The most outrageous admirer is the inebriated woman with partially exposed bosom who smiles back at the king as she precariously balances a half-filled wine glass in her left hand. Far be it for her to abide by tradition and wait for the king to finish his draft before commencing with the revelry! Indeed, she embodies the type of bawdy behavior that the "fool" playing the *rommelpot* celebrates with his song.[4]

Excessive drinking and lustful behavior were two of the complaints Dutch clergymen levied against the celebration of Twelfth Night in the early seventeenth century. The theological objection, of course, was that the celebration was associated with Catholic traditions. Calvinists condemned it, together with other church festivals, for promoting papal superstition.[5] Steen, however, clearly took none of these objections to heart. He actually celebrated the Catholic nature of the occasion by having a Beguine nun, probably his sister, hold the glass of the Twelfth Night king.[6] Even the inebriated and lustful young woman in the foreground seems more harmless than offensive.

By the mid-seventeenth century, a general climate of toleration in Dutch society allowed domestic celebrations of Twelfth Night, which may account for the many paintings Steen made of this subject during the 1660s (see cat. 18). While many of the same elements appear in his Twelfth Night scenes—the *Koningskaarsjes* (the three kings candles, here depicted as a three pronged candelabra), waffles, here being delivered by a maid who carries a platter on her head, broken eggshells on the floor, musicians, fools, attentive dogs, and a child king—each celebration has its own character. One of the most proper of these, appropriately, is the Boston painting (cat. 18), while the painting now in Los Angeles (fig. 1) includes a far more exuberant group of celebrants. Indeed, the child king in this painting commands very little respect. The Kassel painting contains a fascinating blend of the two. While a rowdy carnival rabble-rouser, dressed in an outrageous costume and banging on kitchen utensils, has invaded this party, he has not affected its character to the extent that the ensemble of musicians has in the Los Angeles painting. The "preacher" and his friends, for example, remain a model of decorum.

This painting is one of Steen's most carefully conceived works, yet it emanates life and vitality. His brushwork is confident, whether capturing the flickering light reflected off a wrinkled satin dress or the wry expression of a celebrant's face. He subtly emphasizes the most important characters in the scene. For example, Steen raises the young king to the level of the others by placing him on a bench, and accentuates his importance by situating him at the focal point of his perspective system. He features the inebriated woman by creating a vertical axis through her body that extends from the empty bird cage hanging over her head to the dog at her feet.[7] Such care suggests that the painting was commissioned, but nothing is known about its early history.

AKW

1. For an explanation of the tradition of Twelfth Night, see cat. 18.

2. Steen's wife has tucked her lot, with the designation *Moeder* (mother) under her fur-lined jacket. The *rommelpot* player has a piece of paper with the word *Sot* (fool) attached to his hat.

3. Bax 1979 identifies the symbolic associations of many of the attributes traditionally found during carnivals. The funnel, worn as a hat by the figure to the far left, signifies foolishness and inconsistency. Like a funnel, out of which everything runs, the fool cannot keep anything in his head (181–182). The pipe stuck in the top of the funnel could signify transitoriness. The basket worn by the young boy was associated with gluttony. The word *korf* originally meant both stomach and basket; thus, wearing a basket on one's head was a representation of extreme appetite (219). The cock feathers worn by the fool signify folly and licentiousness (190). Cock feathers are also worn by the male dancer in *The Dancing Couple* (see cat. 20).

4. Steen accents her figure through her central placement and the shimmering fabric of her dress caused by strong light striking her form.

5. Van Wagenberg-Ter Hoeven 1993–1994, 93.

6. Houbraken 1718–1721, 3:22. Steen's sister was a beguine in Haarlem. For more about beguines, see Van Wagenberg-Ter Hoeven 1993–1994, 86, note 94; and page 32, n. 126 in the present catalogue.

7. These elements, and the foot warmer, may have symbolic significance.

34

Samson and Delilah

1668

signed at lower right: *JSteen 1668* (*JS* in ligature)

canvas, 67.5 x 82 (26 ½ x 32 ½)

Los Angeles County Museum of Art, Gift of
The Ahmanson Foundation

PROVENANCE

Possibly sale, Jacob van Hoek, Amsterdam, 12 April 1719, no. 6
(fl. 250); possibly sale, George Bruijn, Amsterdam, 16 March 1724,
no. 7 (fl. 300); sale, Wijnand Coole, Rotterdam, 6 August 1782,
no. 65; sale, Marquis de Chamgrand et al., Paris, 20 March 1787,
no. 39 (600 livres to Donjeux); sale, Daniel de Jongh, Rotterdam,
26 March 1810 (fl. 370); N. Oosthuyzen, The Hague; Oskar
Huldschinsky, Berlin, by 1898; his sale, Berlin, 10–11 May 1928,
no. 36 (£2300 to Julius Böhler); sale, L. van den Bergh of
Wassenaar, Amsterdam, 5–6 November 1935, no. 29; Bachstitz,
The Hague, 1938; confiscated by the German State and removed
to Germany, c. 1940–1945; returned to The Netherlands and
Bachstitz, c. 1945; probably sold after Bachstitz's death, 1951;
anonymous sale, Amsterdam (Paul Brandt), 1960; Nystad, The
Hague; H. J. de Koster, Wassenaar, by 1962; private collection,
The Netherlands; Hoogsteder-Naumann, New York; acquired by
the present owner, 1987

LITERATURE

Smith 1829–1842, 4: no. 90; Van Westrheene 1856, 145, no. 205;
Sedelmeyer 1898, no. 195; Hofstede de Groot 1907, no. 10; Bode
1908, 19–20, no. 28; Bredius 1927, 28; Van Gils 1935, 130–133;
Welcker 1937, 254–262; Gudlaugsson 1938, 66–68; Amsterdam
1939, 43; Heppner 1939–1940, 40–41, nos. 1–2; Van Regteren-Altena
1943, 97–117; De Groot 1952, 34; Martin 1954, 79; Kirschenbaum
1977, 113, no. 10; De Vries 1977, 63, 165, no. 139x; Braun 1980,
128–129, no. 297; Los Angeles 1991, 169–172

Sleep came easily for Samson after the splendid feast, par-
ticularly when the seductively dressed Delilah beckoned
him to rest his head on her welcoming lap. He had set
aside his sword and removed his exquisitely feathered
headdress before lying down on the plush carpet that
covered the red velvet divan upon which she sat. She
soothed him by resting her hand gently on his long, flow-
ing locks, which he had only recently revealed to her as
the source of his super-human strength. He never sus-
pected that she would betray him by summoning a man
to cut his hair, thereby robbing him of his strength.[1]

Steen's interpretation of this biblical story (Judges 16:
4–21) focuses on both the human drama and its immedi-
ate aftermath. Philistine soldiers, hiding in dim twilight
behind the tapestry and curtains of the loggia, stealthily
close in, preparing to pounce upon the sleeping Nazarite
once his hair has been shorn. Steen conveys the urgency
of the moment through the attitude of the muscular
maid behind the barber, who holds open the tapestry
with one hand while quieting the soldiers for fear that
they would wake Samson. Steen indicates the unexpected
and sudden nature of their arrival through the gestures
and expressions of two figures at the far left—a turbaned
man uncomprehendingly scratching his head, and a black
servant staring wide-eyed in terror as he turns to flee
from the impending confrontation.

While the figures in the background heighten the
drama of the story, Steen introduces a narrative element
to emphasize the extent of Delilah's treachery. In the bib-
lical account, Delilah betrays her lover to her compatriots
for money, but she does not actually cut Samson's locks.
Steen, however, depicts her calmly taking a pair of shears
from a servant's hands, as she watches the barber's first
snip with undisguised pleasure. Delilah's audacity distracts
the barber at that most dangerous moment—when he is
about to cut the first of Samson's locks.

The story of Samson and Delilah is one of passion
and deceit, and from it moralizing lessons can be taught.
The morals Steen drew from the story were that one must
beware of female cunning, and that one must not forget
one's commitment to a righteous life.[2] He incorporated
these moral lessons in ways that contemporary viewers
would have immediately understood. For example, Samson
lies in Delilah's lap in a manner that resembles Johann de
Brune's emblem *Een hoeren schoot is duyvels boot*, 1624,
which equates the lap of a whore to that of Delilah (fig. 1).[3]
The visual connection with this emblematic image not

fig. 1. Johan de Brune, "Een hoeren shoot is duyvels boot,"
Emblemata of Zinne-Werck, Amsterdam, 1624, National Gallery of
Art Library, Washington

only emphasizes Delilah's deceptive intentions, but also
associates Samson's downfall with his abandonment to
sensual pleasure. Steen further emphasizes the moral
turpitude of the main figure group by including a vignette
of childhood innocence in the right foreground. The
motif of a child teaching a dog to sit related emblemati-
cally to the importance of moral training as a means to
restrain human passions.[4]

Not only is Steen's didactic treatment of this biblical
story evident in his use of emblematic motifs, but it per-
meates his presentation. The theatrical structure of this
scene has prompted a number of authors to suggest that
the source for Steen's interpretation is a play by Abraham
Koninck, *Simson's treurspel* (The Tragedy of Samson), first
published in 1618.[5] Indeed, theatrical references abound:
the brightly, lit raised dais upon which the principal drama
unfolds; the architectural backdrop that provides a setting
for the secondary figures; and the enormous swag curtains.

A large glass ball, out of place in the architecture,
hangs at the parting of the curtains. This motif often has
vanitas associations, and Steen may have included it to
reinforce the moralizing tenor of the painting.[6] A glass
ball, however, also had other associations. The eighteenth-
century theorist Gerard de Lairesse (1641–1711) wrote that
"the mind is like a glass ball hung up in the middle of a
room, which receives all the objects present, and retains
the impression of them."[7] Steen, then, may well have
included the ball as a warning to the viewer to consider
all components of the painting before coming to an
understanding of its meaning. Indeed, he has imbued this

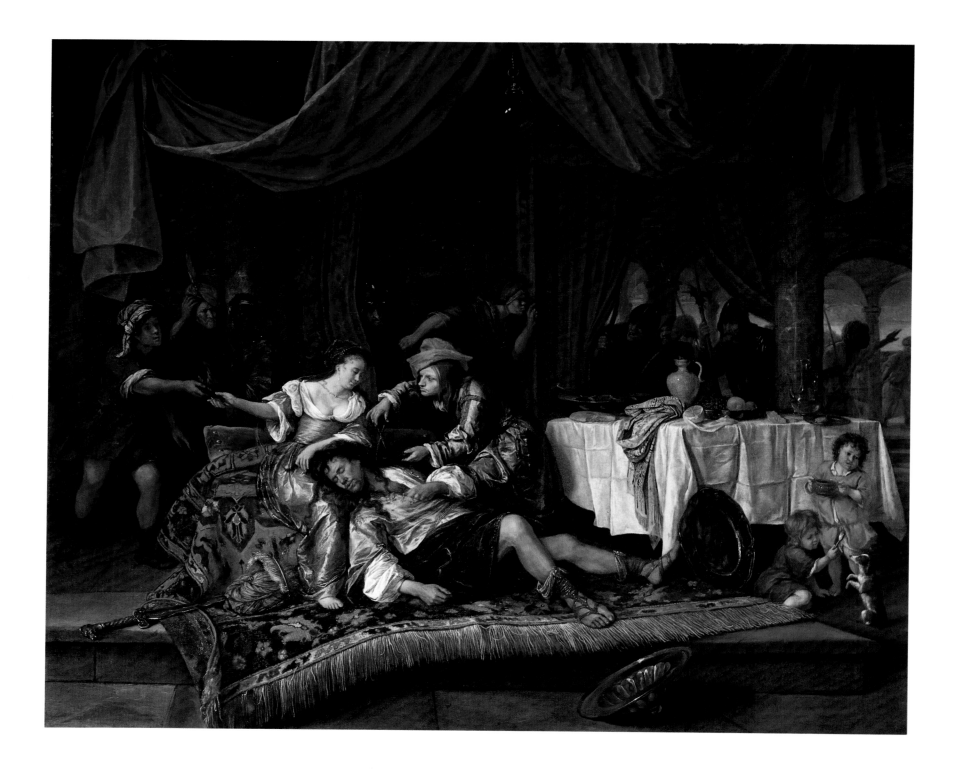

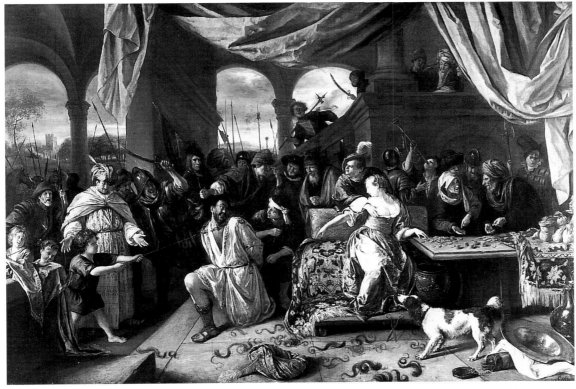

fig. 2. Jan Steen, *The Capture of Samson*, c. 1668, oil on canvas, Wallraf-Richartz-Museum, Cologne, photo: Rheinisches Bildarchiv

painting with a moral seriousness absent, for example, from his farcical interpretation of *The Capture of Samson* in Cologne (fig. 2).

Samson and Delilah, dated 1668, is an excellent example of Steen's painting style in the late 1660s. He gives prominence to his composition's focus by concentrating color and light accents. He also reduces the visual interference of the background figures and architecture by painting them broadly in subdued tones, with accents of light and color in Delilah's flesh, the barber's red hat, and the white tablecloth. Steen further emphasizes the main figure group with a more descriptive and refined painting technique. With a sure and delicate touch he suggests both the sheen of Delilah's translucent veil and the glint of metal enlivening Samson's exotic costume. He reserved his most extraordinary effects for the plush, richly patterned carpet, using its almost tangible verisimilitude to draw the viewer's attention to Samson's reclining body.

He reinforced this visual emphasis through the perspective of the dais and sword.

The pictorial tradition for depictions of Samson and Delilah in Germany and The Netherlands in the sixteenth and seventeenth centuries is extensive, yet it does not appear that Steen relied on earlier precedents.[8] None of these portrayed Delilah preparing to assist the barber, and none placed the scene in such an elaborate interior. While Steen's unusual interpretation of the story lends credence to the theory that he drew inspiration from a theatrical production, his thoughtful conception is also consistent with his broader approach to pictorial representation during the late 1660s.

AKW

1. Samson's gullibility was truely remarkable, since Delilah had already unsuccessfully tried three times to learn the secret of his strength. In each instance he had provided her with a false account of his strength, and in each instance she had revealed his "secret" to the Philistines (Judges 16: 4–14).

2. See Kahr 1972 for a discussion of the theological implications of the story of Samson and Delilah and an overview of representations of the story.

3. De Brune 1624, no. 33.

4. As Bedaux 1990, 112–122, explains, the metaphorical use of a trained dog as a symbol of education derives from Plutarch's treatise on education, *De liberis educandis*. The image of a dog seated on his haunches is found in Cats 1625, in the engraving accompanying the poem *Maeghde-Wapen* (Maiden's Arms). Franits 1993, 154–157, interprets the motif as alluding to the efficacy of education in modifying children's instincts.

5. The association between the two was first made by J. B. F. van Gils, according to Welcker 1937, 254 n. 1. It has been reiterated by a number of authors, including Kirschenbaum 1977, 113, and Gand in Los Angeles 1991, 171. Gudlaugsson 1938, 68, places Koninck's drama into a Dutch tradition of tragic plays written in a comic mode with starkly realistic imagery, a characterization that relates to Steen's approach to the subject. However, the example of Koninck's comic approach that Gudlaugsson offers, the playwright's portrayal of the barber's anxiety as he fearfully begins to cut Samson's hair, does not enter into Steen's painting.

6. For an overview of various vanitas associations of the glass orb, see Bergström in Washington 1989b, 115.

7. De Lairesse 1778, 107. I would like to thank Alicia Walker for this reference. Although a comparable seventeenth-century explanation of the symbolism of a glass globe is not known, it is probable that De Lairesse drew his interpretation from an earlier tradition. For a theological interpretation of the meaning of a glass globe, see De Jongh 1975–1976, 73–74.

8. See Kahr 1972, fig. 4, 8, 9, 20; and Münster 1994, 72–81, for a list of Dutch depictions of the theme. Albrecht Dürer and Lucas van Leyden both depicted the scene outdoors, with Delilah in the act of cutting Samson's hair. Peter Paul Rubens, Rembrandt van Rijn, and Jan Lievens posed Samson lying face down in Delilah's lap imploring one of the Philistines to cut his hair. Steen's interpretation of the scene also differs fundamentally from that of Christiaen van Couwenbergh, painted c. 1630 (Dordrechts Museum). As discussed in Münster 1994, 266, cat. 36, this painting was commissioned by the city of Dordrecht as a decoration for the townhall, where it was to serve as an *exemplum virtutis*.

35

The Severe Teacher

c. 1668
signed on the table support: *JSteen* (*JS* in ligature)
panel, 57.5 x 57[1] (22 ⅝ x 22 ½)
Private collection

PROVENANCE

Sale, Pieter van Copello, Amsterdam, 8 May 1767, no. 66 (625 to Kok); sale, Amsterdam, 6 August 1810, no. 93 (Dfl. 315 to Bredius); sale, Willem van Gendt, The Hague, 25 October 1830, no. 5; J.R. West, Stratford-upon-Avon, before 1833; R. Langton Douglas, London 1918; J. Goudstikker, Amsterdam 1919; Robert Koeber, Harburg, before 1925; private collection, Germany; sale, London (Sotheby's), 6 December 1989, no. 59; private collection

LITERATURE

Smith 1829–1842, 4:6, no. 18; Van Westrheene 1856, 124, no. 110; Hofstede de Groot 1907, no. 299; Leiden 1926, no. 49; Schmidt-Degener and Van Gelder 1927, 60; Braun 1980, 112, no. 183; Durantini 1983, 116; Philadelphia 1984, 319

The Severe Teacher, which not long ago was feared to have perished in the Second World War, derives its strength from the vigorous and brisk execution. Bold brushstrokes can be seen almost everywhere, as Jan Steen built up the fairly simple composition swiftly but successfully. Only behind the old teacher, who was relieved of a hunchback at the last minute, did the artist hesitate a moment and correct himself. The rapid execution imparts a great sense of unity to the composition, and allows the viewer to share in Steen's delight at his artistry.[2]

Children received their basic education in large classes in the seventeenth century. In addition to the traditional routine of learning by rote, they were given time for individual exercises, when older children were expected to help younger ones. Such a scene is depicted in the painting in Edinburgh (cat. 41). Although that work is quite definitely not a record of everyday reality, it is still an important source of information on seventeenth-century schooling. In the vignette on the left of the Edinburgh paintings, older children look after their younger classmates. The teacher's main tasks were to hand out the materials, such as newly trimmed pens, ink, and paper, and to correct the pupils' work. Students had to come to his desk one by one to show their latest efforts. These activities are encapsulated in *The Severe Teacher*. One child presents his work to the teacher, the boy in the foreground prepares for his turn, and the one seen from the back has been allowed to leave the class. Another of the teacher's responsibilities was to administer punishment, not only for poor work but also for all sorts of other offenses as well, sometimes at the parents' request. Schools and teachers, who were often badly paid, generally had a bad reputation. Village schools and teachers, in particular, were singled out for mockery. Jan Steen, who had undoubtedly had his own share of bad experiences during his schooldays, certainly did nothing to correct the popular image of the schoolmaster.

Discipline was a central tenet of education in the seventeenth century. According to the Calvinists, children were evil by nature and could only be saved by God's grace, to which they could be made receptive by a good education. Corporal punishment was administered without hesitation, for did the Book of Proverbs not say: "He that spareth his rod hateth his son"?[3] However, many examples can be cited of seventeenth-century parents who guided their children's steps with a gentle hand. That is why Jacob Cats wrote: "Force is not fitting for

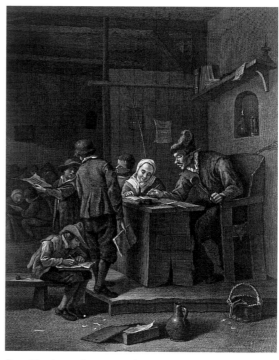

fig. 1. Noach van der Meer II after Jan Steen (?), *The Schoolmaster*, engraving, Rijksprentenkabinet, Amsterdam

young spirits, be gentle in your management, in all you would embark upon."[4] Although the Catholic Jan Steen would not have shared the Calvinist view of destiny, his attitude to discipline was probably not very different, and it is unlikely that he found much inspiration in Cats' words. The lines of verse beneath *The Schoolmaster*, attributed to Steen (fig. 1), which is known only from this eighteenth-century engraving, were more likely prompted by the enlightened spirit of that later age.[5]

Steen depicted the subject of a schoolmaster and naughty pupils with verve and variety. An approving view of the schoolroom of the kind found in Gerrit Dou (1613–1675), *Evening School*, with its studious children, is absent from Steen's oeuvre.[6] However, he depicted the training of artists as a virtuous activity. Examples include a painter's studio where an inquiring boy is being instructed by a master who corrects his work (cat. 27, fig. 1) and *The Young Draftsman* in Leiden, where the young man is studying assiduously by candlelight.[7]

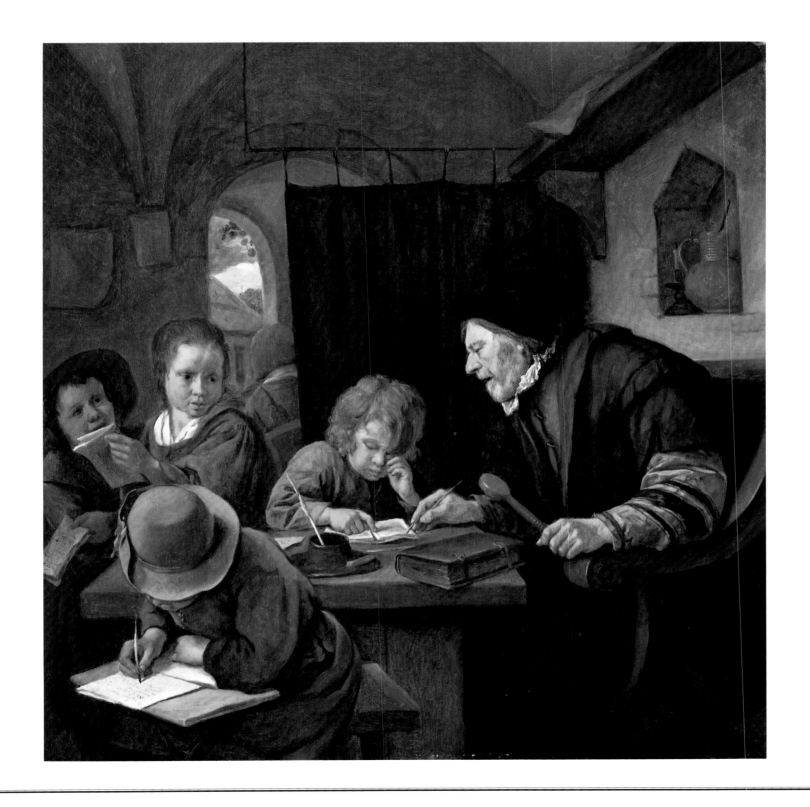

Steen's earliest depiction of a classroom is known from the engraving by Noach van der Meer II (c. 1740–after 1810) previously mentioned. As in so many seventeenth-century paintings, including those by the Van Ostade brothers, its subject is an uncertain and impoverished existence. The engraver went to the trouble of reproducing Steen's signature, so the composition merits more than just passing interest.[8] If Van der Meer worked from an original by Steen, it must have been one executed around 1650, or perhaps a little earlier. The teacher's pose and the niche in the wall behind him are taken from a work by Steen's Leiden colleague Gerrit Dou, whose *Schoolmaster* of 1645 in Cambridge contains virtually the same components (fig. 2). However, the similarity to the picture discussed here is even more marked: the lectern is in the same position, the teacher appears in a comparable pose, and a niche is behind him.[9] In Dou's picture, the teacher's ire is directed at the unfortunate viewer, while Steen focused on the interaction between the main characters. The love of mockery that characterizes all of Steen's later treatments of the theme is completely absent in the lost painting. Other works, such as the not very funny *Toothpuller* in the Mauritshuis (cat. 26, fig. 3), make it clear that the artist only developed his sense of irony gradually.[10] From an artistic point of view, too, a comparison of *The Toothpuller* with *The Severe Teacher*, which must have been painted around the middle of the 1660s, is interesting. The head hidden by a hat appears in both pictures, but in *The Severe Teacher* Steen's treatment is far more adventurous, with a much greater feel for the painterly effect. Here the studious head is largely concealed by the hat, which is also notable for its rich chiaroscuro and resultant plasticity.

Steen depicted a schoolroom on three occasions in the 1660s, his golden age. His main purpose in the Edinburgh picture was to portray the chaos in the class (cat. 41). In the famous painting in Dublin (page 12, fig. 2), as in the present work, he restricted the scene to the chastising teacher and the children immediately around him. In the Dublin painting he limited the figures to a splendid trio in a small but cleverly perceived psychological drama: the grumpy old schoolmaster, the naughty boy, and the teasing, laughing girl.[11] All three paintings are undated. I suggest that the Dublin scene was painted around 1663. The painting discussed here must be dated around 1665, for it is a rapid and sketchy reprise of the subject with the addition of the industrious young

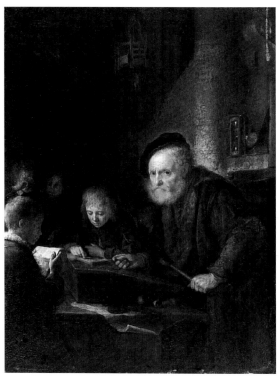

fig. 2. Gerrit Dou, *The Schoolmaster*, 1645, oil on panel, Fitzwilliam Museum, Cambridge

scribe.[12] The Edinburgh picture, in which the central section is based on the present work, would have been executed a few years later.

Steen repeated the subject in several later works that are remarkable for their lack of subtlety. One is the *Sleeping Schoolmaster* of 1672, with its large, unruly class.[13] He took up the subject of the strict schoolmaster again in a composition in which the teacher is actually doling out his harsh punishment. There, though, the tension created by not knowing the denouement is completely lost.[14]

The sharp contrast between the painting in Dublin and *The Severe Teacher* shows just how much variety Steen could inject into his work. In the former, apart from the psychological tension, Steen paid close attention to the telling detail and the rendering of textures. The colors appear to be placed beside each other, but in *The Severe Teacher* they have been integrated. The harmony of the simple composition, the delight in the act of painting,

and the forcefulness of the color—such as the bright red of the stick of sealing wax on the edge of the inkpot—are the strong points of *The Severe Teacher*.

WTK

1. Because the painting is cradled, it is difficult to see whether it has retained its original size. The very small difference between height and width could be owing to the wood shrinking less along the grain than at right angles to it. If that is the case, the painting could originally have been completely square.

2. The sketchiness is very like that of *The Merry Threesome* (cat. 42), which was probably painted a little later.

3. Proverbs 13:24; see also Proverbs 22:15 and 29:15.

4. As quoted in Kruithof 1990, 38.

5. The inscription reads: *De Schoolvos geeft de plak om een geringe fout; / Zijn slag is dubbelt raak als 't kind de hand op houdt; / Hij doet die in de hand en aan de knokkels klemmen - / 't Is een pedante gek wiens plak zijn drift moet temmen* (The schoolmaster gives the ferule for the slightest mistake. His blow strikes home twice when the child holds out its hand. He takes the ferule, his knuckles whitening. He whose ferule must tame his anger is a pedantic madman). This view is very close to that of Hiëronymus van Alphen, whose positive ideas on the possibility of improving children were related to the enlightened attitude of Jean-Jacques Rousseau. Van der Meer's work for Jacob Buys, who made many illustrations for Van Alphen's children's rhymes, suggests that this little poem came from that circle.

6. Martin 1913, 170; Rijksmuseum, Amsterdam, inv. no. Sk-A-87.

7. Braun 1980, no. 256.

8. Hofstede de Groot 1907, no. 301. A painting, with the composition reversed like the engraving, was auctioned in Cologne in 1962, Braun 1980, no. B-81. It could have been copied from the engraving or from Steen's original painting.

9. Martin 1913, 68; Fitzwilliam Museum 1960, 1:27, no. 33; see also Durantini 1983, 114. It is not entirely clear how Steen's painting relates to a *Schoolmaster* by Quiringh van Brekelenkam (c. 1620– c. 1669) in Uppsala. The two are quite clearly connected, since the teacher's hands and the hand with which the pupil is pointing are identical. Lasius 1992, 87, no. 26, dates the Van Brekelenkam c. 1663; it once bore the date 1664. Compare also Durantini 1983, figs. 56, 57.

10. Braun 1980, no. 32, fig. on page 20.

11. Philadelphia 1984, no. 107.

12. Two of the children in *The Severe Teacher* can also be identified in a painting in Basel, *Children Teaching a Cat to Read*, Braun 1980, no. 184. This, however, does not supply any further evidence for arriving at a date. The dendrochronological examination of *The Severe Teacher* carried out by Dr. Peter Klein of Hamburg in 1995 indicates that the panel could not be used before 1657 and in all probability only after 1667. This information presents a difficulty for the dating of the painting to 1665, as suggested here.

13. Braun 1980, no. 350 (present whereabouts unknown).

14. Braun 1980, no. 248. Stylistically, this painting with its distinctive lost profile of the child being punished ties in with a small, consistent group of late works by Steen. The core is formed by *The Frolicsome Couple* in Leiden (Braun 1980, no. 235), the *Dovecote* in a private Zurich collection (Braun 1980, no. 237), and the *Marriage Contract* in the Hermitage in St. Petersburg (Braun 1980, no. 236). Braun 1980, 118, recognized that these paintings belong to a series, together with a fourth (Braun 1980, no. 238) of which no known illustration exists. Together they form an allegory of love. Braun dates the suite 1664–1668, but I would suggest placing it in the 1670s.

36

Amnon and Tamar

c. 1668–1670
signed at lower left: *JSteen.* (*JS* in ligature)
panel, 67 x 83 (26 ⅜ x 32 ⅝)
Wallraf-Richartz-Museum der Stadt Köln

PROVENANCE
Sale, Johan Pompe van Meerdervoort, Zoeterwoude, 19 May
1750, no. 25 (Dfl. 106 to P. Locquet); sale, Joan Hendrik van
Heemskerck, The Hague, 29 March 1770, no. 106 (Dfl. 125 to
Twent); Etienne le Roy, Brussels 1848; sale, Mathieu Neven,
Cologne, 17 March 1879, no. 190; Neven-Dumont Collection,
Cologne; Wilhelm Adolph von Carstanjen, Cologne, before 1907;
purchased with his collection in 1936

LITERATURE
Smith 1829–1842, 4:8, no. 24; Van Westrheene 1856, 145, no. 203;
Hofstede de Groot 1907, no. 16; Heppner 1939–1940, 43; Wallraf-
Richartz-Museum 1967, 114, no. 2536; Kirschenbaum 1977, 67–68,
87, 100, 117, no. 16; Braun 1980, 132, no. 310; Ydema 1991, 141, no.
167; Münster 1994, 21–22, no. 47

This work tells the curious story of Amnon and Tamar—
a tale of love that turned into hatred. Steen placed it in a
magnificent theatrical setting and worked up the compo-
sition with rich, saturated colors, albeit a little carelessly
in some passages. The painting is an excellent sample of
his interests and expertise at the end of the 1660s.

The story of Amnon and Tamar is told in the Book of
Samuel (2 Samuel 13), which deals with the events of
King David's reign, but for obvious reasons it was not
usually included in children's Bibles. Both were children
of David, but Amnon was so smitten by his half-sister
Tamar that he grew weak with love of her. On a friend's
advice he decided to use guile to get his heart's desire. He
took to his bed, made himself sick, and, when his father
came to see him, begged that Tamar bring him some
food, for that would certainly cure him. When she came
to him with some cakes she had baked herself, he tried to
get her into bed, and when she refused, he raped her. In
an instant Amnon's love turned into hatred and he drove
Tamar out. That is the moment captured by Steen. The
Bible goes on to relate that Tamar, clad in the multicol-
ored robes worn by the king's virgin daughters, rent her
gown and put ashes on her head. She went to live in the
house of her full brother, Absalom, who patiently bided
his time before murdering Amnon two years later during
a meal for his brothers. Thus he avenged the outrage
done to Tamar. Absalom met his own end when, after ris-
ing in revolt against his father, he had to flee David's
armies. He was riding beneath a tree when his hair
caught in its branches, and he hung there helplessly until
run through by his enemies. The Bible is silent on the
subsequent history of the unfortunate Tamar.

Steen's scene is set in a richly appointed room with
Amnon's bed on the right and on the left a view through
to an arcade with an open door. Amnon reclines on the
bed in a rather odd pose with one foot, which was hidden
by an overpaint for many years, in an impossible position
pointing down toward the floor.[1] Apparently, he is kicking
Tamar out of the room as she is led away by a laughing
manservant. Amnon, his torso twisted to the right, is cov-
ered by a Persian rug that has been turned back. The deft
imitation of the textures of the rug and mattress make
this a particularly attractive part of the painting. The
foreground is filled with flowers, precious vessels, and a
stool with a silver dish and a peeled lemon, which is the
only allusion to Tamar's meal. In the background is a
beautifully framed painting of a dancing figure. Dancing

fig. 1. Philips Galle after Maerten van Heemskerck, *Tamar
Turned out of Amnon's House*, 1559, engraving, Rijksprenten-
kabinet, Amsterdam

was considered an indecent activity, as in the case of the
Israelites and the Golden Calf.[2] Above Amnon's head
hangs a beautiful, briskly painted globe. Its significance is
not entirely clear, although it may be the mirror of the
world. The rose petals in the foreground probably allude
to the loss of Tamar's virginity. How the cupid's head on
the stool should be interpreted is not clear. All that is cer-
tain is that this love is one-sided, violent, and mercurial.
The small dog is often associated with vigilance and is
found in several of Steen's paintings. In the *Couple in a
Bedroom* (cat. 37), it is reversed but retains its ribbon.
Although some have recognized the artist himself in the
servant beside Tamar, the likeness fails to persuade me.

The subject is rare in the visual arts, and as a result
this picture has been wrongly identified time and again.[3]
In 1559, Maerten van Heemskerck (1498–1574) devoted a
narrative series of six engravings to the story, and it
seems likely from his print of the dismissal of Tamar,
which was engraved by Philips Galle (1537–1612) (fig. 1),
that Jan Steen knew this model.[4] Oddly enough, he made
no use of the narrative detail of the overturned breakfast
table, presumably because he thought it would distract
attention from the main action.

Adriaen van de Venne (1589–1662) also depicted the
dismissal of Tamar as an illustration for Jacob Cats'
Houwelyck of 1625, which was reprinted many times.[5]
There the wretched Tamar is being driven out of the

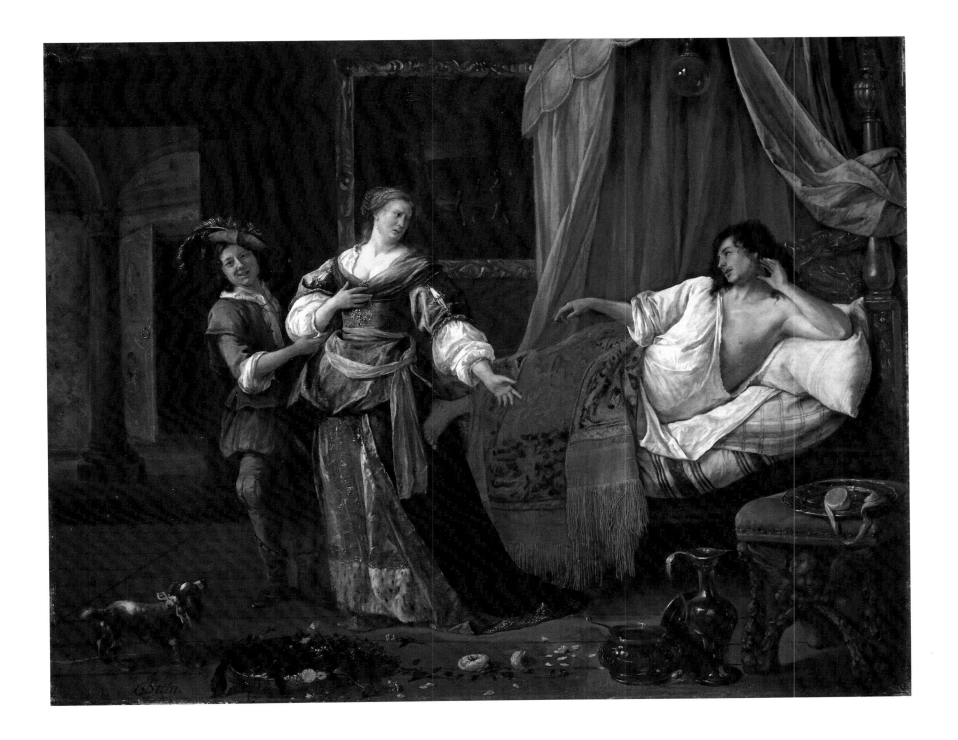

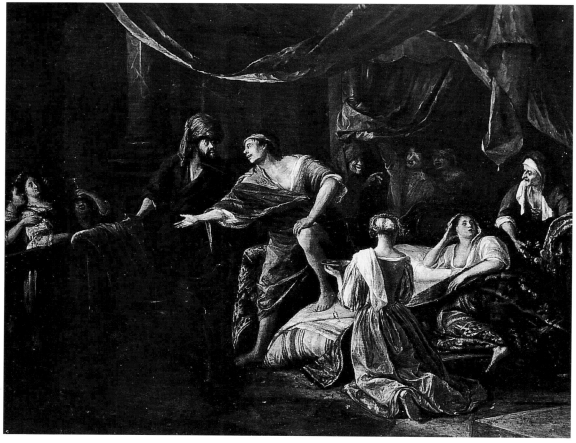

fig. 2. Jan Steen (?), *Antiochus and Stratonica (?)*, c. 1670, oil on panel, present whereabouts unknown

cality of both paintings suggests that Jan Steen's main purpose was to portray surprising, dramatic events.

The lavish presentation and the figure of Tamar, who has a small head on a large body, range this picture with the dated works from around 1670. Amnon's head is encountered frequently in the oeuvre, in *The Return of the Prodigal Son* (cat. 39), for example, and in *Antiochus and Stratonica* (fig. 2). The same male profile is found in *The Wedding of Tobias and Sarah* (cat. 32) in which, interestingly, the woman has Tamar's features. Finally, the painting contains an obvious reference to *The Eager Lover* (page 45, fig. 8), where the same type of young man is on the point of seizing hold of a woman. Incidentally, Steen repeated the eager lover's elegant cuffs in *Amnon and Tamar*, but gave them to the unfortunate woman.[9]

WTK

1. See Wallraf-Richartz-Museum 1967 for the overpainted foot. The overpaint can be seen in the very earliest photograph of the painting, which is bound into a copy of the 1879 sale catalogue in the Rijksmuseum library.

2. For dancing as a symbol of immodest behavior see, for example, Amsterdam 1993, no. 45.

3. Pigler 1974, 1:157, mentions a painting of this subject by Jacob Jordaens that Waagen saw at the Academy in St. Petersburg. For the incorrect identifications see Wallraf-Richartz-Museum 1967.

4. See Veldman 1993, 1:102–103, nos. 110–115 for this series engraved by Philips Galle and published in Antwerp by Hieronymus Cock. *Tamar Turned out of Amnon's House* is no. 113. Claes Jansz Visscher used the series in 1646 for his *Grooten figuerbibel*.

5. See page 63, fig. 17, and Kirschenbaum 1977, fig. 119.

6. Heppner 1939–1940, 43. The play was reprinted many times until 1763.

7. Sale, London (Sotheby's), 16 April 1980, no. 72; Kirschenbaum 1977, no. 84B/54; Braun 1980, no. 302. Doubt has been cast on the autograph nature of this painting because of its uneven quality. The composition, though, is quite clearly derived from Steen.

8. For the first interpretation, which was proposed by Horst Schneider, see also Heppner 1939–1940, 43. The second suggestion was made long ago and has recently been resurrected by J. Nieuwstraten of the Netherlands Institute for Art History (RKD) in The Hague.

9. Braun 1980, no. 272.

room by a servant armed with a stick. The slightly unexpected message is that a girl should take good care of her virginity and preserve it for marriage. In the framework of Cats' book the episode served as an example of the unforeseen dangers a young woman should guard against. It is far from certain that Jan Steen's painting should be interpreted in this way. For example, the story of Amnon's *amour fou* was also the subject of a rhetoricians' play written by Jacob Coenraetsz Mayvogel, "Thamars ontschaking, of de verdoolde liefde van Amnon" (Tamar debauched, or Amnon's wayward love), which was published in 1642 and performed in Amsterdam in 1659.[6] The theatrical look of Steen's scene makes it tempting to associate the painting with this play about obsessive infatuation.

Another painting by Steen that is related in content to *Amnon and Tamar* depicts a dramatic love story with figures in biblical or classical garb; its subject may be Antiochus and Stratonica (fig. 2).[7] The young prince Antiochus rose from his sickbed when he spied Stratonica, his stepmother, whom he secretly loved. Seleucus, the prince's father, saw that all was lost and surrendered his wife to his son. Another theory is that the painting shows Jacob discovering that he is married to Leah instead of Rachel, who had been promised to him by Laban, the girls' father (Genesis 29:25). In either case the scene is of an unusual love story.[8] Whereas one likes to regard Steen's *Amnon and Tamar* as a warning that one should not succumb to impetuous passion, the reverse is the case with the story of Antiochus and Stratonica. The theatri-

37

Couple in a Bedroom

c. 1668–1670
signed at lower left: *JSteen* (*JS* in ligature)
panel, 49 x 39.5 (19 ¼ x 15 ½)
Museum Bredius, The Hague

PROVENANCE
Sale, De Beurnonville, Paris, 3 June 1884, no. 312 (Frf 1,090 to Bourgeois); F. Kleinberger, Paris; Abraham Bredius, The Hague, before 1898; his bequest to the city of The Hague, 1946

LITERATURE
Hofstede de Groot 1907, no. 829; Braun 1980, 133, no. 322; Museum Bredius 1991, 214, no. 158 (with bibliography); Ydema 1991, 188, no. 845

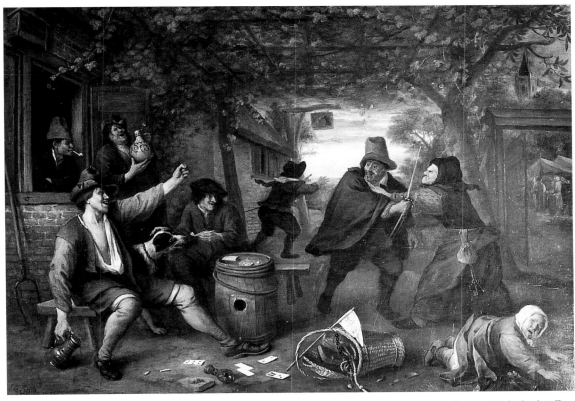

fig. 1. Jan Steen, *Cardplayers Fighting outside an Inn*, 1671, oil on panel, Gemeentemuseum, Arnhem (on loan from the Netherlands Office for Fine Arts, The Hague)

The Raising of the Shirt was the title of a painting auctioned in Rotterdam on 27 April 1713. The work exhibited here, in which an older man pulls a young woman into bed by the hem of her undergarment, is undoubtedly the same painting.[1] By focusing on a single, key feature of a composition, earlier titles of paintings sometimes make it almost impossible to mistake one work for another.

The action in this picture is quite hilarious. The man, with his shirt gaping open, has already dived into the four-poster bed and is pulling the woman toward him. She is stepping from a chair onto the edge of the bed and in an instant will be rolling in the sheets with her companion. Her mad scramble and his primitive action and lecherous laugh clearly indicate that both are looking forward to their impending get-together. One comical detail is the nightcap on the man's head—an item of clothing apparently considered essential for sexual intercourse.

The scene is probably set in a brothel. The interior is far from plain, as can be seen from the imposing, carved bed and the monumental, classically composed chimney-breast behind it. Lying on the chair are the woman's clothes, which include a jacket trimmed with white fur, a red bodice, and a red stocking, and certainly do not contradict the assumption that she is a woman of easy virtue.[2] The sexual implications of the scene are reinforced by the coal pan, the bottle of drink, and the pipe lying aside on the edge of the chamber pot. The Dutch expression, "Knocking out a pipe," is still used in the present century as a euphemism for visiting a brothel, and it certainly seems applicable to this picture.

Jan Steen and his contemporaries repeatedly depicted brothels as opulent interiors, but rarely was the actual transaction portrayed so directly. In many such scenes the subject is loss of honor and of money, as in *Robbery in a Brothel* (cat. 42, fig. 1), while the *Drunken Couple* in the Rijksmuseum, in which an owl with candle and specta-

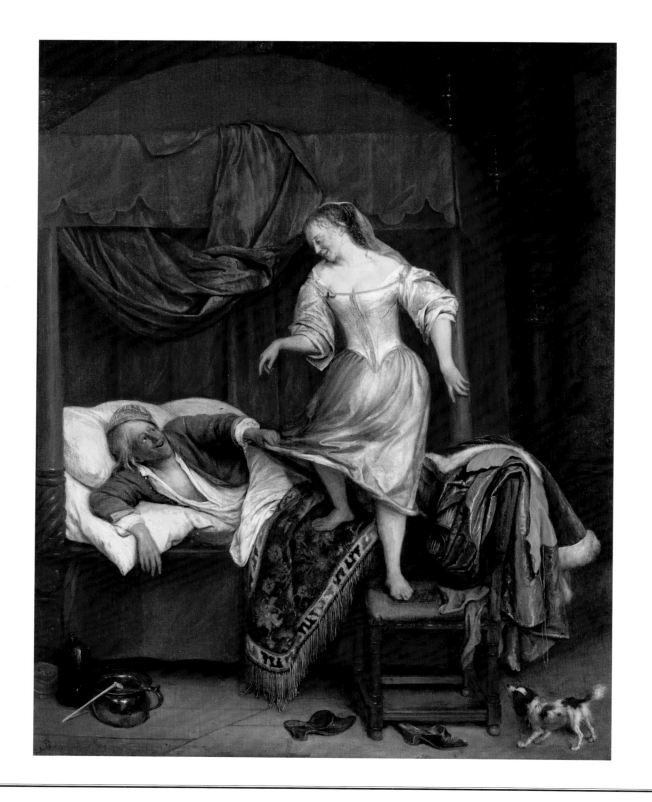

cles witnesses the debauch, is a depiction of stupidity.[3] Blankert has endeavored to place the Museum Bredius picture in the tradition of unequal lovers, but no real reason exists for doing so. True, the man is older than the woman, but the difference in their ages is not really that marked. Moreover, the financial element that is essential to scenes of unequal lovers is missing.[4] Nor do any elements seem to suggest admonition or instruction, except perhaps the vigilant, barking dog. No one in the room, however, is paying it the slightest attention.[5]

Hardly a better illustration can be found of Steen's frank, explicit depiction of sexual behavior, as described by De Jongh in his essay (pages 43–49). The viewer is involved in the scene as a voyeur. That Steen was aware of this is clear not only from a "through the keyhole" type of painting like *A Woman at Her Toilet* (cat. 19) but also from the related picture in the Rijksmuseum (cat. 19, fig. 2). The remarkable peephole view granted the beholder corresponds to that in the *Bathsheba* in Malibu (cat. 11, fig. 1), where Bathsheba is seen receiving the letter written by David, who has just been spying on her. By confronting the viewer with David's field of vision, Steen seems to place David's sinfulness on the shoulders of all those looking at the painting.

The various copies made after the *Couple in a Bedroom* testify to the popularity of the scene. It is noteworthy that most show the woman's legs bare to above the knees.[6] Steen, of course, depicted several other displays of sexual behavior, from simple petting to the horrifying rape in *Amnon and Tamar* (cat. 36). One could not, however, call him a moralist first and foremost. *Amnon and Tamar* provided him with the opportunity to paint a theatrical scene and fine materials, and, in *Lot and His Daughters* in Constance, he depicted not a mythical procreation ritual but an absurd spectacle of drunken lovemaking.[7] Another related work is *The Eager Lover* (page 45, fig. 8), in which a girl rather halfheartedly tries to ward off the advances of a young man who has already taken his place by the bed. That work clearly has a moralistic intent, for the girl's finger is raised in warning and a figure, possibly a pastor, reads in the yard outside.[8]

Because *Couple in a Bedroom* is closely related to few works within Steen's oeuvre, it is not easy to date. It appears to be a fairly late work but does not have the pastellike colors of Steen's final years nor the flat look of his work around 1674, when he paid considerably less attention to detail in what are otherwise complex compositions.[9] The painting, then, should probably be placed a little earlier. It seems to have the greatest number of parallels with the *Cardplayers Fighting outside an Inn* of 1671 (fig. 1), in which the drunken braggart on the left bears some resemblance to the man in the present painting.[10]

WTK

1. Sale, Rotterdam, 27 April 1713, no. 5 (Dfl. 40); Hoet 1752–1770, 1:365.

2. For the meaning of the red stocking, see the essay by Eddy de Jongh in this catalogue, pages 47–49, and also Amsterdam 1976a, 245.

3. Braun 1980, nos. 240 and 327.

4. The overpainted purse that Blankert was looking for proved to be nonexistent; see Museum Bredius 1978, 129.

5. See also cat. 38.

6. Museum Bredius 1991, 214.

7. Braun 1980, no. 257; see also Münster 1994, 231–232, no. 10, with color ill.

8. Braun 1980, no. 272.

9. See especially the large *Interior of an Inn* of 1674 in the Louvre (page 80, fig. 23).

10. Braun 1980, no. 345.

38

Wine Is a Mocker

c. 1668–1670

signed on well, at left: *JSteen* (*JS* in ligature)

inscribed over doorway: *De Wÿn is een Spoter, Proverbyn...*
20.1

canvas, 87.3 x 104.8 (34 ⅜ x 41 ¼)

Norton Simon Art Foundation, Pasadena

PROVENANCE
Possibly anonymous sale, Amsterdam, 17 September 1727, no. 12
(fl. 265); possibly sale, Huybert Ketelaar, Amsterdam, 19 June 1776,
no. 223 (fl. 11 to Wubbels); sale, Edward Solly, London, 31 May 1837,
no. 268 (82 guineas or £86 or ƒ920); private collection in the Dutch
region Twenthe, 1938; anonymous sale, London (Sotheby's),
30 June 1965, no. 100 (£14,000 to Patch); Hans Cramer, The
Hague, by 1968; bought by the present owner, 1969

LITERATURE
Smith 1829–1842, supplement: 487, no. 37; Van Westrheene 1856,
163, no. 390; Hofstede de Groot 1907, no. 103; Bredius 1927, 63;
Rotterdam 1938, 36, no. 147; Haarlem 1946, 35, no. 125; Steadman
1972, 36; Braun 1980, 112, no. 191; Rumsey 1985, 324–325

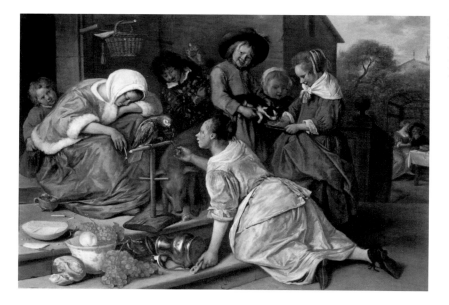

fig. 1. Jan Steen, *The Effects of
Intemperance*, c. 1663–1665,
oil on panel, Reproduced by
courtesy of the Trustees, The
National Gallery, London

Before a rustic, vine-covered building, probably an inn, a
woman so drunk she has passed out is being loaded into
a wheelbarrow by a youth and a man, under the mocking
eyes of her gossipy neighbors. The ruddy-faced woman,
one of Steen's most beautifully painted figures, is in disar-
ray from head to foot. Her disheveled hair escapes from a
head scarf gone askew; her chemise and fancy fur-trimmed
pink jacket are undone, exposing her breast; and her mag-
nificent skirt of pink and blue *changeant* satin is hiked up
to reveal the edge of her petticoat and a bit of flesh at the
top of each stocking.[1] This shocking exposure of flesh,
like her bright red stockings, identifies her with loose
women or prostitutes in *A Woman at Her Toilet* and *Couple in
a Bedroom* (cats. 19, 37), and her ostentatious attire resembles
that in the *Girl Offering Oysters* (cat. 9).[2] While her finery,
and the way Steen has highlighted her to stand out from
the surrounding rustics, may seem incongruous with her
sorry state, luxury and worldliness were regarded as a sure
path to ruin, as also conveyed in *In Luxury Beware* (cat. 21).

Steen's narratives often engage us by leaving the unfold-
ing or outcome of the story up to our imagination. Here,
for example, we might wonder if the surrounding children
are the drunken woman's, come to take her home from
the tavern. Behind her a younger boy displays a metal
marketing pail and a glass bottle, as if to announce that
drink has led her to neglect her duty to feed her children.[3]

Looking on with amusement are a little girl and a boy on
a hobby horse, which in Jacob Cats' *Houwelyck* is emblem-
atic of the folly of self-delusion, for the child "thinks he
rides a brave horse . . . but he who considers well finds
there only wood and nothing else."[4] The children, as is
the case in several of Steen's explicitly moralizing paint-
ings, are most likely modeled after Steen's own, although
it is hard to securely identify the woman as his wife.[5]

Above this scene, inscribed on the edge of the small
roof overhanging the doorway, is the painting's moral:
De Wÿn is een Spoter. The biblical proverb, which in full
reads, "Wine is a mocker, strong drink is raging, and
whosoever is deceived thereby is not wise," warns of the
folly and consequences of intemperance. To reiterate the
moral—Steen typically gives the viewer such cues as to
how to judge the scene—the villagers, right down to the
excitedly barking dog, mock and rebuke the drunken
woman. At the half door, a sharp-faced man and woman,
brilliantly characterized as at once concerned and smug
in their moral superiority, point and comment knowingly
to each other. At the open window, two men laugh, one
with an earthenware bowl that is perhaps filled with water
to rouse the drunkard. In the left background, beneath a
stone archway, a laughing woman draws water from a
well. She, too, may think a good dousing will revive the
drunk. This farcical situation, with its laughing faces and

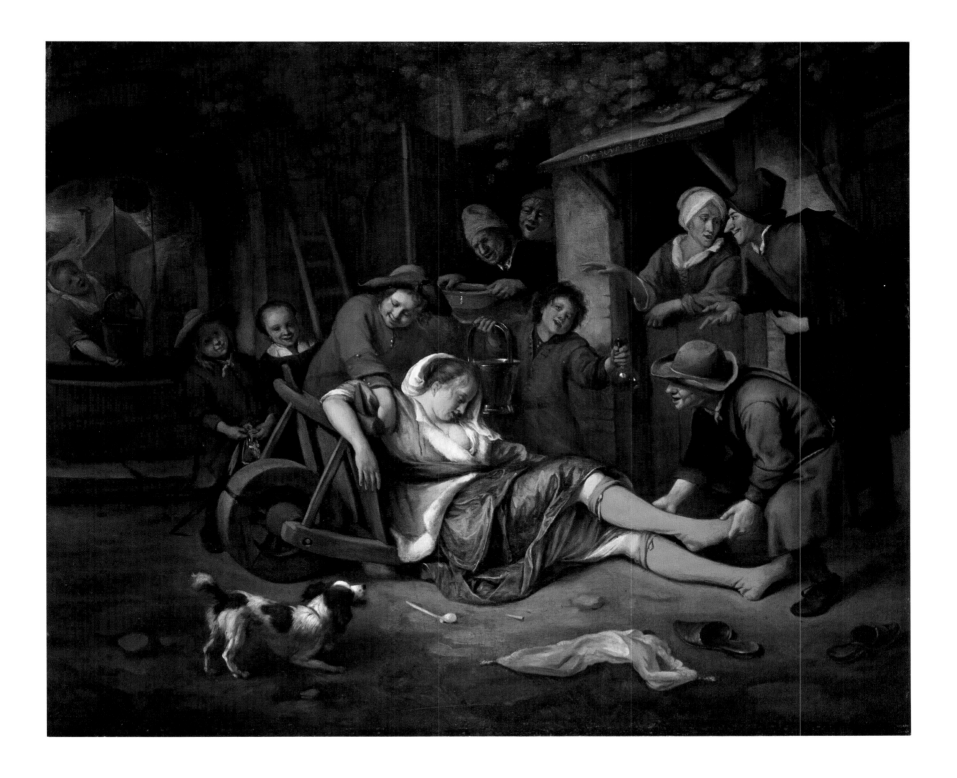

fig. 2. Johannes Theodorum and Johannes Israelem de Bry, "Desidiam ignaui sequimur, lentumq soporem," *Emblemata Saecularia, Mira et Iucunda*, Frankfurt, 1596, National Gallery of Art Library, Washington

exaggerated gestures, first grabs us as comic. But, as is so often the case with Steen's comedies, closer examination prompts us to ponder its more serious implications.

Drunkenness was a problem in Steen's society; witness the many sermons preached against it and the publication in 1665 of Jacobus Sceperus' *Bacchus. Den ouden en huyden-daegschen Dronckenman* (The Drunkard of Past and Present Times), one of many such tracts, which warned that drink "leads men to whoring, adultery, lewdness, and dishonor."[6] But to find imagery that moralizes as specifically as do this picture and *The Effects of Intemperance* (fig. 1), we have to look to the previous century.[7] In many details the paintings are alike: the drunken, sleeping woman is attired in similar finery and Steen has cast his own children as by-standers. However, while both pictures rely on sixteenth-century modes of image making, their narrative moralizing strategies differ. The London picture, like *In Luxury Beware* (cat. 21), is artificially couched in an emblematic pictorial language, including the parrot drinking wine (emblematic of imitation), and the references to proverbs and expressions (the little boy at left about to pick the drunken woman's

pocket, the one strewing roses before swine, and the children feeding pie to the cat). The consequences of drunkenness are summed up by the basket filled with symbols of poverty and ruin (see cat. 21).[8] In contrast, *Wine is a Mocker* tells more of a story and its consequences are embodied in human ruin and the shame that transpires from it rather than a symbolic basket. Yet it too draws on the previous century, above all in its representation of a proverb, which appears as a text in the painting.

De Bry's *Emblemata Saecularia, Mira et Iucunda*, a book of comic moralizing emblems first published in Frankfurt in 1596, treats so many of the themes that appear in Steen's paintings, including the lean and fat kitchens, the alchemist, the doctor's visit, and the ill-matched pair (see cats. 2, 3, 16, 42), that it is tempting to think he knew it. The caption to emblem 4 (fig. 2), a drinking scene that includes a foppish man in a wheelbarrow, can be paraphrased as: "We give ourselves up to unmanly sloth and dull sleep," implying that through drink and sloth these men betray their manly virtue.[9] The verses accompanying this illustration, which seem directed specifically at the upper classes, admonishing them against an indulgence in luxury that leads to dissipation, point to yet another aspect of sloth: its capacity to degrade humanity to a lower, baser level. The man carted about is a dandy, his elegant attire in sharp contrast to the simple garb of the peasant pushing the wheelbarrow. Likewise, Steen's lady is incongruent amongst, and in danger of becoming like, the rustic folk around her. Of course men overindulge in Steen's paintings, but when it comes to embodying intemperance, as in *Wine is a Mocker* and *The Effects of Intemperance*, the drinker is a woman, which is consistent with seventeenth-century notions of women as being by nature weaker and more prone to sloth and drunkenness.[10]

To judge by the combination of loose handling and brown tonalities with the extremely sumptuous rendering of satin, similar to that in *Twelfth Night*, *Samson and Delilah*, and *As the Old Sing, So Pipe the Young* (cats. 33, 34, and cat. 23, fig. 1), all dated 1668, Steen painted *Wine is a Mocker* toward the end of his decade in Haarlem. Haarlem's famed, but declining, brewing industry and Steen's personal connection to brewing may account in part for both his interest in and the demand for such tavern scenes and drinking themes.[11] It is a cliché that we suspect the brewer or wineseller of imbibing too much, and, indeed, as reputed by Houbraken, Steen was "his own best customer."[12] Regardless of how much he did or did not

drink, Steen cleverly capitalized on the inherent irony of a brewer preaching against drunkenness.

HPC

1. See Ripa 1644, 452–453, and Frans van Mieris' *Pictura* (The J. Paul Getty Museum, Malibu) for the personification of painting in a dress of changing colors; on the difficulty of painting satin, see Van de Wetering 1993.

2. For a discussion of stockings in Steen's paintings see pages 47–49 and cats. 19 and 37.

3. Metal pails such as this were used to carry meat, fish, and other sloppy food. See Steen's *Riverfish Market in The Hague*, cat. 6, fig. 1.

4. Cited in Durantini 1983, 236.

5. Chapman 1995 discusses Steen's use of his children in moralizing pictures about education, temperance, and familial virtue.

6. Sceperus 1665. See Amsterdam 1976a, 247–248.

7. A series of four prints by Jacob Matham shows drunkenness leading to gluttony, lechery, gambling, and fighting, themes that appear in a variety of paintings by Steen, including *The Pig Must in the Pen* (*Wie een varken is de moet in 't kot*) (Mauritshuis, The Hague).

8. National Gallery, London 1991, 1:431–432, no. 6442.

9. *Desidiam ignaui sequimur, lentumq soporem.*

10. See also Vermeer's *Drunken, Sleeping Maid at a Table* and its discussion in Slive 1968, including the bibliography on drunkenness and sleep. For another example of a gender reversal, similar to Steen's, see the *Peasant Pushing his Wife in a Wheelbarrow*, by master "b x g," in Amsterdam 1985, 201–202, no. 103.

11. One wealthy Leiden brewer, Hendrick Bugge van Ring, owned six paintings by Steen in 1667. See page 64.

12. Houbraken 1718–1721, 3:161.

39

The Return of the Prodigal Son

c. 1668–1670
signed at lower left: *JSteen* (*JS* in ligature)
canvas, 119.4 x 95.2 (47 x 37 ½)
Private collection, Montreal
Washington only

PROVENANCE
Possibly anonymous sale, Amsterdam, 12 September 1708,
no. 39 (fl. 161); Finspong; Von Platen; Count Carl de Geer,
Kulla Gunnerstorp, Sweden; Wachtmeister, Kulla-Gunnerstorp,
Sweden, by 1886; to the present owner

LITERATURE
Hofstede de Groot 1907, no. 55; Bredius 1927, 36; Kirschenbaum
1977, 100, 135, no. 55; Braun 1980, 130–131, no. 307

fig. 1. Lucas van Leyden, *The Return of the Prodigal Son*, 1510, engraving, Rijksprentenkabinet, Amsterdam

The parable of the prodigal son (Luke 15: 18–24), who squandered his patrimony in riotous living and then, reduced to poverty, confessed his sins and returned home to his forgiving father, captured the Netherlandish imagination in the sixteenth and seventeenth centuries for its message of God's willingness to forgive repentant sinners. The son's carousing, which is at the root of many Dutch merry companies and brothel scenes, informed Steen's images of secular profligacy, *Easy Come, Easy Go* and *In Luxury Beware* (cats. 15, 21).[1] When he represented the actual biblical narrative, however, Steen turned to the episode of the prodigal's return to paint one of his finest, most beautifully rendered works in a serious mode.[2]

At the threshold of his house, the father, filled with love and compassion, comes out to welcome home his penitent son. The son, bare-legged and shoeless, his clothes in tatters, kneels in a prayerful gesture of profound repentance and faith. Members of the household also come to greet him, emphasizing the totality of his acceptance. The white dog, whose fine grooming perhaps indicates the father's wealth, greets him eagerly. As the father had commanded, a woman in red brings the son his clothes, here a fine blue robe; and a youth leads the fatted calf that will be slaughtered to celebrate the occasion. Other figures—the woman with the basket of produce on her head and the man trumpeting through the open window— herald the feasting and merrymaking that will ensue. This

celebration caused the prodigal's older brother to complain that the disobedient son was undeserving of such attention. The father replied: "It was meet that we should make merry and be glad for this thy brother was dead and is alive again; and was lost and is found" (Luke 15:32). Steen's unusual consolidation of these later events in the story emphasizes the celebration of the son's return and hence reinforces the parable's central message of forgiveness and redemption.[3]

For inspiration in conceptualizing this theme Steen turned to prints by the two most famous artists from his native Leiden, Lucas van Leyden (1489–1533) and Rembrandt (1606–1669) (figs. 1, 2). Lucas van Leyden's *Return of the Prodigal Son* of about 1510 is the source of the son's pose and the father's costume, especially his cap. X-radiographs reveal that Steen first drew the father's head turned toward the viewer, closer to the way it is in Lucas' engraving, and that he then painted it in profile.[4] Lucas van Leyden's expansive image is characteristic of the sixteenth-century tradition in that it shows other episodes of the story on a smaller scale in the background: at right the impoverished prodigal feeding with swine refers to the earlier part of the story; and just to the left of the father, the slaughtering of the calf refers to the rejoicing to follow. Steen's oddly disembodied calf's head cleverly alludes to his artistic indebtedness: Lucas van Leyden had acknowledged the engraving by Albrecht Dürer (1471–1528) of the prodigal son

fig. 2. Rembrandt, *Return of the Prodigal Son*, 1636, etching, National Gallery of Art, Washington, Rosenwald Collection

dling, comparable to that in *Samson and Delilah* of 1668 (cat. 34), and on the similarity of the prodigal to figures in other pictures of this same period, most notably the *Wedding of Tobias and Sarah* and *Amnon and Tamar* (cats. 32, 36). However, Steen painted *The Return of the Prodigal Son* in a different pictorial mode from these theatrical histories in spacious stagelike settings. In its monumentality and focused immediacy, the picture resembles others in this solemn mode, the earlier *Dismissal of Hagar* and *The Supper at Emmaus* (page 71, fig. 4, and cat. 31), both of which also, and not coincidentally, draw on compositions by Rembrandt. Though his handling is vastly different from Rembrandt's, the warm tonality, which also characterizes the *Supper at Emmaus* and in the present picture derives from Steen's incorporation of the red-brown ground into parts of the composition, suggests he may have deliberately evoked Rembrandt's coloring when representing these emotional scenes.[6] This solemnity has been difficult for modern viewers to appreciate probably because it represents such a marked departure from Steen's usual comic historical mode, yet it must have been in keeping with seventeenth-century expectations of a profound biblical narrative.[7]

HPC

amid the swine by directly quoting from it the hindquarters of a cow and inserting nearby a cow's head with its body concealed. Steen has, in turn, quoted the cow's head from Lucas.

For his compositional scheme Steen relied, in reverse, on Rembrandt's etching of 1636 (fig. 2), which similarly situates the meeting of father and son at a doorway below an open window. Rembrandt's print characteristically isolates a single, emotionally charged moment of the narrative. Steen, by referring to the feasting and merrymaking, has partly returned to the tradition of including more than one moment in the story. However much he relies on these sources, Steen recasts the narrative. Particularly innovative is the way the father grasps the son's praying hands with his own, in a gesture that emphasizes the son's faith and heavenly appeal.[5] The story appealed both to Protestants, for whom it supported the doctrine of salvation through grace alone, and to Catholics, who emphasized that the son's confession and atonement won him God's mercy. If anything here reflects Steen's Catholicism, then it might be the prodigal's demeanor of prayerful contrition.

This painting can be dated to the late 1660s on the basis of Steen's loose, thin, but beautifully finished han-

1. For the pictorial tradition of the prodigal son and related secular imagery, see Vetter 1955; Renger 1970; Haeger 1986, 128–138.

2. This is Steen's only known securely identifiable representation of any episode of the biblical proverb, although some of his genre paintings (cat. 49, for example) have been called "Prodigal Sons" in the past.

3. Haeger 1983, 31–32.

4. National Gallery of Art conservation laboratory examination report, April 1994.

5. The closest source for this gesture is the praying figure of the prodigal in Dürer's engraving (Bartsch 28).

6. The warm red-brown ground is visible through thinly painted passages and is used for the shadowed parts of several faces and as a visible underlayer for the brown robe of the woman with the basket on her head.

7. Kirschenbaum 1977, 100, cites this picture as evidence that "Steen failed as a religious painter . . . in those few works in which he attempted to make direct spiritual statements."

40

Self-Portrait

c. 1670
signed at right on the balustrade: *JSteen* (*JS* in ligature)
canvas, 73 x 62 (28 ¾ x 24 ⅜)
Rijksmuseum, Amsterdam

PROVENANCE
Sale, Johan van der Marck, Leiden, 25 August 1773, no. 458 (Dfl. 16.10 to Pothoven); acquired from Charles Howard Hodges, Amsterdam, in 1821 (Dfl. 150)

LITERATURE
Smith 1829–1842, 4:61, no. 182; Van Westrheene 1856, 97, no. 1; Hofstede de Groot 1907, no. 860; Leiden 1926, no. 1; Martin 1926, 11; Bredius 1926, no. 1; De Jonge 1939, 2; Martin 1954, 16, 71; The Hague 1958, no. 42; Rijksmuseum 1976, 521 (with earlier literature); De Vries 1976, 7; De Vries 1977, 61; Braun 1980, 124, no. 266; Sutton 1982–1983, 3; Steinberg 1990, 123; Chapman 1990–1991, 183–184; Chapman 1993, 364; Chapman 1995, 373–376

Jan Steen portrayed himself as a successful member of society only once in his life: in this *Self-Portrait*. Nothing in the painting suggests that he is an artist, unless it is the summary right hand—the hand that is often missing in artists' self-portraits. At the same time, this picture is incontrovertible proof that countless comical heads in Steen's paintings are indeed based on his own likeness.

Numerous authors have either praised this painting or dismissed it. In 1833, the art dealer John Smith pronounced it "an indifferently painted picture." Wilhelm Martin, one-time director of the Mauritshuis, on the other hand, felt that it expressed all the painter's psychological qualities: "What a sensible head, what human dignity, what a penetrating, artist's gaze!"[1] The comprehensive restoration of the painting in 1995 places these reactions in an entirely new light. It must now be concluded that Steen painted a spirited self-portrait but that he then made numerous changes that left it rather muddled.

The artist rests his right arm on the back of a chair as he stands before a balustrade with a view over a briskly painted landscape, executed partly wet-in-wet, which oddly enough recalls the work of his father-in-law Jan van Goyen (1596–1656). Behind him, to the left, is a red curtain with a tasseled cord, which is found in several contemporary portraits. To the right of the curtain Steen himself overpainted part of the wall with the landscape. Before the restoration, both landscape and curtain were concealed behind an undifferentiated, dark brown background that hung like a dark cloud over the artist's head. Now, the head stands out splendidly against the curtain. The unhappy transition between head and background has been eliminated, and even some locks of hair have come to light. Strangely, though, the balustrade does not continue to the left of the figure.[2]

Steen wears a suit of black cloth with a bow at the shoulder and a broad white jabot. It is the portrait of a vigorous, self-assured man with a good dose of mockery in his makeup. The changes that he made to the picture were quite sweeping. The portrait image was originally intended to be larger, which probably left no room for the hands.[3] This is suggested by a pronounced pentimento near the back and modifications to the position of the arms. Steen changed his mind twice about his apparel. Initially he wore a much larger jabot of more or less the same cut as the present one. He then replaced it with a cravat of the kind that came into fashion around 1668. He finally settled on the jabot he now wears.

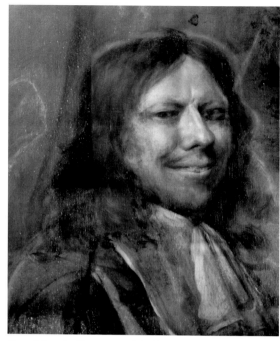

fig. 1. Infrared reflectogram of the face, cat. 40

These three versions of the collar are clearly visible in the infrared reflectograms (fig. 1). Steen also made major alterations to his face. The left eye was originally somewhat larger and higher up; the change makes the head a little less *en face*. The preliminary painted sketch depicted a broad smile with parted lips. The impression given by the reflectogram that Steen's teeth are visible is created by cracks in the paint layer.[4] As first painted, the mouth was probably more curved, forming a jovial expression that was replaced by this more sensitive, ironic smile.[5] This reworking turned the original robust and very direct portrait into a more elegant likeness expressing a subtler skepticism.

As a classical, distinguished portrait, this is an exceptional work in Steen's oeuvre. It is in the stylistic tradition of the work of celebrated portrait painters of the day, including Bartholomeus van der Helst (1613–1670) and especially Abraham van den Tempel (1622/1623–1672), who was working in Amsterdam at the time but originally came from Leiden. The affinity can clearly be seen in a similar, bravura male portrait in Naples, in which the rendering of textures is not overly insistent (fig. 2).

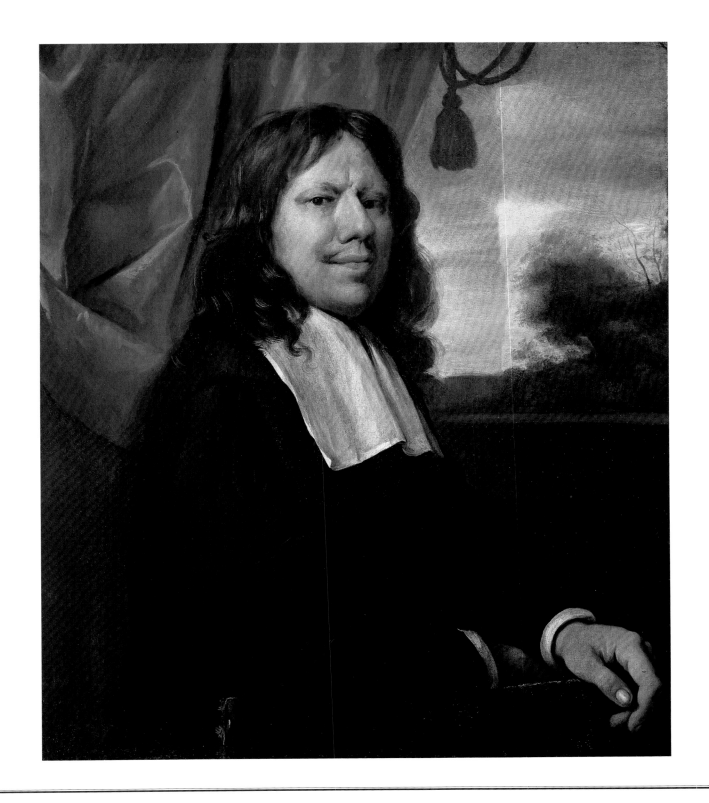

fig. 2. Abraham van ter Tempel, *Portrait of a Man*, Palazzo Reale, Naples

1. Martin 1954, 16: "Wát een verstandige kop, welk een menselijke waardigheid, welk een doordringende schildersblik!"

2. It must be assumed that the overpainting was done in the eighteenth century.

3. The thread cupping shows that the canvas was never larger than it is now.

4. No trace of teeth could be seen under the microscope.

5. A detailed discussion of the changes and restoration will be published in the forthcoming report on the Rijksmuseum's Jan Steen restoration project.

6. See also the essays by Chapman (pages 11–23), De Jongh (pages 42–44), and Westermann (pages 61–62) in this catalogue.

7. Braun 1980, no. 306. Virtually the same head, but with a slightly more jocular expression, was used in *The Doctor's Visit* (page 44, fig. 6) in Philadelphia, in which the artist brandishes a herring and two onions.

8. Braun 1980, no. 104.

9. Some authors date the painting as early as 1666.

Steen depicted himself many times in his own paintings. His presence, sometimes looking at the viewer and inviting comment, but often participating in the merry goings-on, has inspired many authors.[6] The likeness in *Antony and Cleopatra* (page 11, fig. 1) comes the closest to this *Self-Portrait*.[7] However, the head seen in the infrared reflectogram resembles that of the man in the *Woman Sleeping and Man Smoking a Pipe (The Revelers)* in the Hermitage (page 12, fig. 3), which is generally recognized as a self-portrait.[8]

The picture is usually dated in the mid-1660s.[9] However, new information about the dress and especially about the overpainted cravat, which only came into fashion at the very end of that decade, makes it more likely that the *Self-Portrait* was painted in 1670 or a little later. Personal losses experienced by Steen during this period might account for his change of appearance. His wife and parents died around 1670. The final, more conservative version of the collar, painted over the fashionable cravat, may reflect his mourning.

WTK

41

A School for Boys and Girls

c. 1670
unsigned, undated[1]
canvas, 81.7 x 108.6 (32 ⅛ x 42 ¾)
National Galleries of Scotland, Edinburgh

PROVENANCE
Gerret Braamcamp, Amsterdam, before 1752; his sale, Amsterdam, 31 July 1771, no. 211 (Dfl. 1,200 to Greenwood); sale, Marquess Camden, London (Christie's), 12 June 1841, no. 70 (£1,092 to Seguir for Lord Egerton); Lord Francis Egerton, later 1st earl of Ellesmere; by descent to the 5th earl of Ellesmere, later 6th duke of Sutherland; loaned by him to the present owner in 1946; acquired in 1984

LITERATURE
Hoet 1752–1770, 2:508; Smith 1829–1842, 4:7, nos. 20 and 205, 9:516, supplement no. 110; Waagen 1854–1857, 2:45; Van Westrheene 1856, 130, no. 139; Hofstede de Groot 1907, no. 287; The Hague 1958, no. 52; De Vries 1977, 59; Braun 1980, 136, no. 335; Smith 1981; Durantini 1983, 154; Philadelphia 1984, 319; Elkins 1988, 260–264; Edinburgh 1992, no. 68

Jan Steen created an exceptional masterpiece with this *School for Boys and Girls*, in which he demonstrated not only his great gift as a director of a crowd of actors but also his knowledge of visual sources. He displayed a skill in arranging groups early in his career, witness his two kitchens (cats. 2, 3), in which he also adroitly used earlier models. In the *School*, though, the complexity is raised to the highest pitch.[2] The numerous incidents in this extravagant composition almost shatter the illusion of reality. Nevertheless, the contrast between the calm demeanor of the master and the schoolmistress—he unruffled, she assiduous—and the chaos surrounding them makes the entire scene clear at a glance. Steen littered the composition with narrative details. The references to other works of art are legion: seldom has Steen so clearly quoted other artists or commented on their work.

Steen was vying with several Haarlem masters of his day. The organized tangle of figures in a dimly lit room, which has the look of a scene in a peep box, is clearly based on the sometimes complex compositions of slightly older artists, such as Jan Miense Molenaer (c. 1610–1668) and Adriaen and Isack van Ostade (1610–1685; 1621–1649). They, however, did not invent the subject. A classroom replete with dozens of pupils and a ridiculous schoolmaster was the subject of an ironic print of 1557 by Pieter van der Heyden (c. 1530–after 1572) after Pieter Bruegel the Elder (c. 1525–1569) (fig. 1). As a depiction of a chaotic classroom, it was an influential model, but more than fifty years passed before the subject was taken up and popularized by Jan Miense Molenaer.[3] Although Steen, too, probably knew the engraving after Bruegel, his version contains not a single identifiable borrowing.[4]

Despite Molenaer's primacy in painting a chaotic classroom and the fact that Steen was quite obviously guided by his approach, Steen's main influences here were the Van Ostade brothers. His composition is broadly based on a *Classroom* of 1644 by Isack van Ostade (fig. 2).[5] For the use of detail, the fall of light, and silhouettes, Steen's model was probably Adriaen's *The Schoolmaster* of 1662 in the Louvre (fig. 3).[6] What is missing from the Van Ostade paintings is broad humor, which soon degenerated into gross exaggeration in Steen's own *Sleeping Schoolmaster* of 1672 and in works by such followers as Richard Brakenburg (1650–1702).[7]

Steen took parts of his composition from Raphael's *School of Athens*—a work he quoted in other paintings as well.[8] He undoubtedly knew it from the engraving by

fig. 1. Pieter van der Heyden after Pieter Bruegel the Elder, *The Ass in School*, 1557, engraving, Rijksprentenkabinet, Amsterdam

Giorgio Ghisi (1520–1582) that was published by Hieronymus Cock (1510–1570) (cat. 43, fig. 2). Although almost none of the borrowings are literal, many figures and even groups are closely related. The children on the far left of the painting correspond to the group of three philosophers in the same position in the engraving. Where Raphael (1483–1520) allowed the foreground to be dominated by a philosopher who has turned his back on the world, Steen depicted a pupil who has fallen asleep after polishing off a large carrot. And if one assumes that the boy standing on the table on the left is breaking into song, then Steen must have been thinking of the statue of Apollo with his lyre in the left background of the engraving.[9] Steen's satire is subtle here: the gathering of the greatest minds of classical antiquity is paraphrased in a chaotic assembly of schoolchildren still wet behind the ears in a Dutch barn got up to look like a school. Many of Steen's contemporaries would undoubtedly have missed the irony, but those who got the point must have regarded this as an incomparable way of pillorying respect for scholarship.

The class in *School for Boys and Girls* is presided over by a shortsighted schoolmaster, who trims his quill pen, and an old schoolmistress in a splendid white headdress, who checks some children's work. With the boy at the lectern and the pupil walking away in the background, she is a repetition of the teacher in *The Severe Teacher* (cat. 35). Instead of the latter's ferule, though, she holds a switch in the shape of a bundle of twigs. Several attentive pupils gathered around her form a calm group in the sea

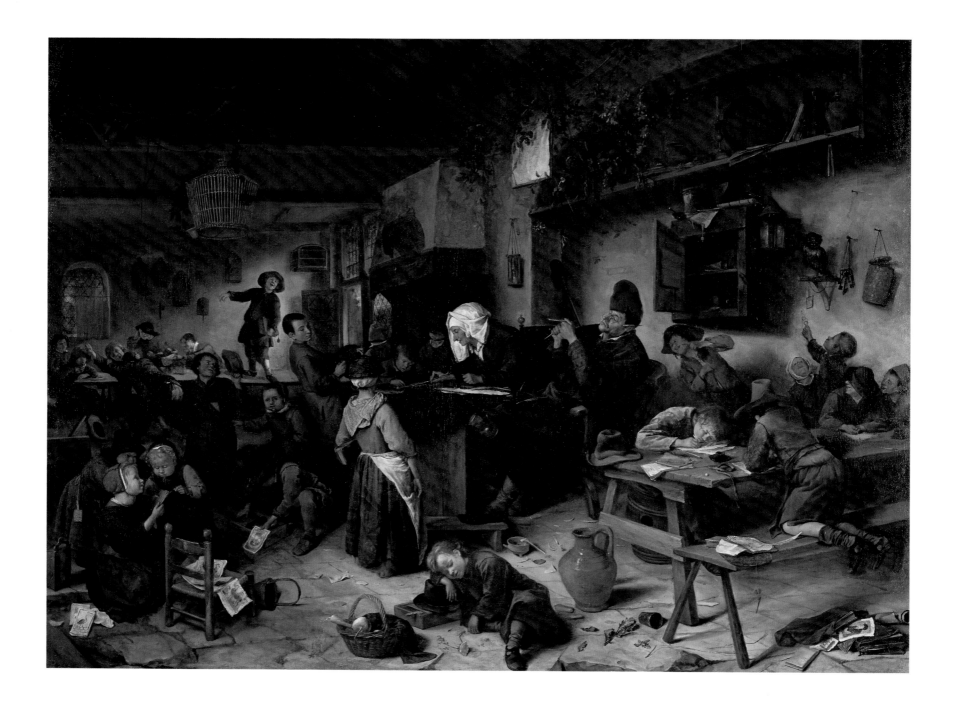

of chaos. The girl seen from behind, incidentally, was heavily reworked by Steen, as is clear from the odd zigzag pattern in her dress and her fishwife's cap, which is rather unceremoniously painted over a white headdress.[10]

A teacher trimming his pen was often depicted by Steen's Leiden contemporary, Gerrit Dou (1613–1675).[11] The best-known example occurs in his erudite triptych of around 1660, which was also in Gerret Braamcamp's collection at one time and is acknowledged to be an allegory of education.[12] The main elements of Dou's triptych supposedly proclaim that nature has to be perfected through education and practice. If this interpretation is correct, Steen's picture amounts to a sublime parody of that idea.

However, the motif can also allude to the sense of sight, as is clear from a quill-cutting schoolmaster by Hendrick Martensz Sorgh (1610/1611–1670) (fig. 4), which belongs to a series of the five senses.[13] One important detail expands on this motif. On the right a child holds out a pair of spectacles to an owl standing on a perch on the wall beside a lantern, which is needlessly lit. This is a clear reference to a well-known Dutch saying: "What good are a candle and glasses if the owl simply refuses to see."[14] This proverb, cautioning that people can never

achieve anything if they lack the will, may be directed at the unwilling pupils and especially at the boy making faces behind the teacher's back. However, the owl is offered exactly the same kind of glasses as those perched on the latter's nose, so the saying is also directed at him. At the last minute, Steen made a few changes to the boy holding out the spectacles. Another raised arm, painted out rather untidily, can be seen with the naked eye.

Lying on the floor in the right foreground is a print, which is a portrait of Erasmus. Because much of his writings were used in educational readers in the seventeenth century, he was regarded as an educator par excellence. Jan Steen himself doubtless became acquainted with Erasmus' work when he attended the Latin School in Leiden. In the left foreground, various birds and a deer can be made out on the catchpenny prints. Just behind them a kneeling boy, his face hidden by his large hat, puts a childhood portrait of Prince Willem III in his wooden satchel.[15] The presence of that portrait does not make this painting a political manifesto, although the boy himself was clearly a fan of the popular young prince, who was banned from carrying out official duties, only to become stadholder in the politically disastrous year 1672.[16]

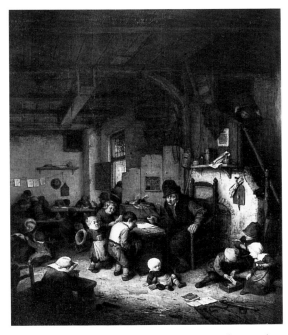

fig. 3. Adriaen van Ostade, *The Schoolmaster*, 1662, oil on panel, Musée du Louvre, Paris

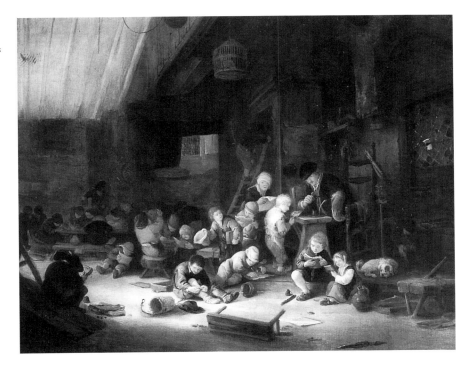

fig. 2. Isack van Ostade, *The Classroom*, 1644, oil on panel, present whereabouts unknown

It would be interesting to know how the painting should be dated for several reasons. Was it executed before or after 1672? Did Steen know Adriaen van Ostade's important *Schoolmaster* of 1662? How does Steen's painting relate to his other pictures of the subject, notably *The Severe Teacher* (cat. 35)? Unfortunately not many clear points of reference exist. To my mind, Steen's dated works of 1668 and later preclude placing the *School for Boys and Girls* late in his oeuvre. One point of contact might be the *Wedding Feast in an Inn* of 1667 in Apsley House in London, which has a very similar chiaroscuro. At around that time Steen made more frequent use of slightly lanky but well-drawn figures, such as the boy kneeling on the bench on the right. Accepting a date of around 1667 means that Steen could have seen Van Ostade's *Schoolmaster*. However, Van Ostade employed a comparable contrast between light and shade at a much earlier date.[17] If the painting was executed in or after 1672, Steen would undoubtedly have used another portrait of Willem III, one showing him as stadholder. It seems more likely that he modified the arrangement of his *Severe Teacher* for this complex composition rather than the

reverse, namely that he fell back on the simple program derived from Gerrit Dou after completing this important Edinburgh painting.[18]

Jan Steen enriched Dutch art enormously with this sarcastic *School* and his other treatments of the subject. An irony of history is that as early as the eighteenth century he was held up as an example of a talented individual whose carefree way of life made a proverb of "Jan Steen's household," and whose behavior, amusing though it might be, should certainly not be imitated by schoolchildren.[19]

WTK

1. Several inscriptions are in the painting, some of them partly decipherable. The large pamphlet above the schoolmaster's head has a long but barely legible text. On the bench beside the kneeling boy on the right one can make out the fragment ...*Proph*, so he may have just put aside the law and the prophets.

2. Steen's use of perspective usually comes in for some sharp criticism. In this painting he slyly used some curved depth lines; see Elkins 1988.

3. There is an important *Classroom* by Molenaer on loan in Kassel. See also a painting of 1636 (with French & Co.) and another that was in the Wichtrach Sale (Heininger & Co.), 29 November 1973.

4. See Brown 1984, 152–153. One interesting parallel is that Bruegel, too, played with the motif of the "candle and spectacles," although with an ass, not an owl, as the protagonist.

5. Panel, 43 x 54 cm; Sale, New York (Christie's), 1 June 1990, no. 36. See also Schatborn 1986, 87–89. The date is also read as 1641, but 1644 must be correct. Isack van Ostade would, in turn, have followed his brother Adriaen. See, for example, his early paintings in Warsaw (Durantini 1983, fig. 67) and in the Louvre. The latter is dated 1641 (Louvre 1979, 101, no. MI 948).

6. Louvre 1979, 100, no. 1680.

7. Braun 1980, no. 350, and Durantini 1983, figs. 82–83. Another imitation of Jan Steen (Durantini 1983, fig. 77) must also be placed in Brakenburgh's circle.

8. Smith 1981; see also cat. 43 for another use of this composition.

9. The *Sleeping Schoolmaster* (Braun 1980, no. 350) also has a boy standing on a table and singing.

10. The original headdress was probably similar to that of the small girl behind the table on the right.

11. Martin 1913, 68, 93.

12. Dou's triptych is lost, but the composition has been preserved in a copy by Willem Laquy now in the Rijksmuseum. For its identification as an allegory of education see Emmens 1963 and Amsterdam 1976a, no. 17.

fig. 4. Hendrik Sorgh, *Quill-cutting Schoolmaster*, c. 1640, oil on panel, Harrach Collection

13. Heintz 1960, 72–73. *Smell* is now missing from this series.

14. Steen depicted this saying in a number of brothel scenes, one being Amsterdam 1976a, no. 65.

15. The portrait is based on the painting by Adriaen Hanneman in the Rijksmuseum, which is dated 1654; see Ter Kuile 1976, no. 25, and Rijksmuseum 1976, 279, no. A-3889. The print depicted by Steen is known from an eighteenth-century impression; see Amsterdam 1976b, 129, no. 288, with color ill.

16. Steen has two paintings of *Prince's Day* to his name, one of them dated 1661; Braun 1980, nos. 144 and 276. See especially De Vries 1992.

17. In his painting of 1647, for example, Hofstede de Groot 1907, no. 816.

18. See also cat. 35.

19. See Haarlem 1816, 55.

42
The Merry Threesome

c. 1670–1672
signed on the fence at right: *JSteen* (*JS* in ligature)
panel, 39 x 49.5 (15 ⅜ x 19 ½)
Private collection

PROVENANCE
Sale, Gerard Godfried Baron Taets van Amerongen, Amsterdam,
3 July 1805, no. 139 (for fl. 150); Roos, Amsterdam, by 1833; I.
Scheltens, Amsterdam; Fleischmann, London; D. Katz, Dieren,
1935; H. Kohn, The Hague; on loan to the Royal Cabinet of
Paintings Mauritshuis, The Hague; to the present owner

LITERATURE
Hoet 1752–1770, 1: 219, no. 8; Smith 1829–1842, 4:40, no. 122;
Van Westrheene 1856, 160, no. 372; Hofstede de Groot 1907,
nos. 429a, 843; Emmerling 1936, 73; Gudlaugsson 1945, 57–59;
Martin 1954, 56; The Hague 1958, no. 55; De Vries 1976, 24–25;
Braun 1980, 136, no. 340; The Hague 199b, 290–292, no. 39

The pleasures of deception! A middle-aged violinist smiles with unabashed delight at a woman half his age who robs him while an old crone distracts him with a glass of wine. The man is Steen himself, now older and fatter, playing a comic role he had played many times. His broad smile and red slashed beret evoke the theatrical *Self-Portrait as a Lutenist* (cat. 25), while his floppy collar and blue striped sleeves identify him more specifically with stock fools from the popular theater and his own paintings (see cat. 24).[1] His eager lust is expressed by his phallic white clay pipe and reiterated by his fiddle, traditional instrument of lechers.[2] His sublime contentment makes him seem more willing victim than innocent prey. Indeed, he is so besottedly smitten by the young thief and so flattered by her attention that he goes along with her deception.

She, in turn, makes an unusual display of lifting the coin from his purse. With an exaggerated rhetorical gesture she openly points to her thieving hand, as if to tell us just what she is up to.[3] Because she addresses him, too, her pointing seems directed as much to him as to the viewer. Her light-colored satin dress and jewelry associate her with the seductresses in *In Luxury Beware* and the *Merry Company on a Terrace* (cats. 21, 48) and with the prostitutes in Steen's earlier variation on the pickpocket theme, the *Robbery in a Brothel* (fig. 1). Here the naive mark, who has fallen asleep in a high-class brothel, is at the mercy of two prostitutes and an old matchmaker who relieve him of his watch, while a laughing fiddle-player, who somewhat resembles Steen, and a pipe smoker look on. Compared to the pair of wily whores in the Louvre picture, the earnest young woman in *The Merry Threesome* is strikingly lacking in coquettishness, just as her thievery is surprisingly unfurtive. Like the *Girl Offering Oysters* (cat. 9), she is a disarmingly youthful study in deceptive innocence. The sewing cushion on her lap heightens her ambiguity. As a symbol of feminine virtue and diligence, it is part of her deception. But to the viewer familiar with Jacob Cats, who uses the sewing cushion in an emblem about disap-

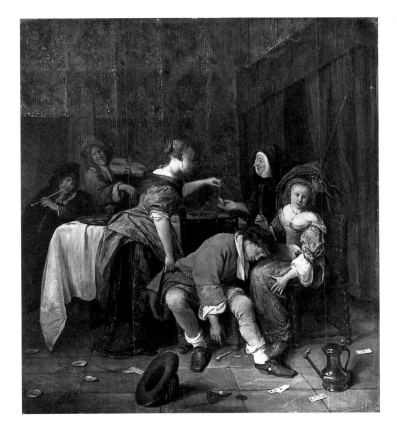

fig. 1. Jan Steen, *Robbery in a Brothel*, c. 1665–1668, oil on panel, Musée du Louvre, Paris

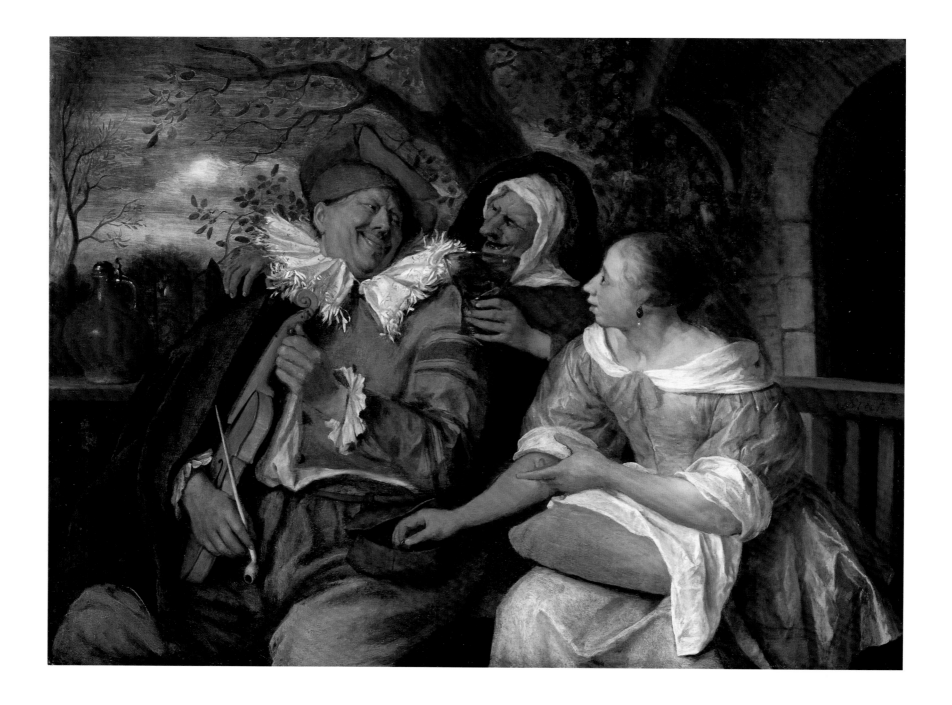

fig. 2. Lucas van Leyden, *The Fool and the Woman*, 1520, engraving, National Gallery of Art, Washington, Rosenwald Collection

pointment and sorrow in love, it implies that the poor buffoon will ultimately get nowhere.[4]

Steen painted *The Merry Threesome* in the early 1670s after he had left Haarlem to return to his native Leiden. It is a small painting, distinguished by a marvelously deft handling of paint, especially in the loose brushwork of the lace fringe on the man's collar, which heightens the picture's air of breezy spontaneity. The scene is set out of doors and bathed in warm, natural light: the threesome sit by a fence before an arched stone doorway and a tree with foliage painted so thinly it shimmers. Steen's rare use of the three-quarter length compositional format makes the image unusually arresting and immediate. Not only has he limited the number of figures and brought them close to the viewer, but he has eliminated any extraneous details, his usual disarray of cluttered, often symbolic, objects. Steen has reduced the picture to an interplay of exaggerated gesture and engaging emotional expressions.[5]

It was Steen's genius that he could imbue stock characters with such new life and impart to an old, by his time clichéd, subject such clever narrative possibilities. Throughout his career, Steen was often deliberately anachronistic in playing on pictorial traditions that his contemporaries would have recognized as old-fashioned, but in his late works this witty, eclectic archaizing seems to have become intensified and more varied, as in *The School for Boys and Girls*, *A Village Revel*, and *The Garden Party* (cats. 41, 46, 49). For *The Merry Threesome*, Steen invoked and transformed the tradition of the ill-matched pair (fig. 2), a subject about the foolishness of humankind, which had enjoyed tremendous popularity in German and Netherlandish art and literature of the previous century.[6] Steen had treated this theme before, notably in the *Old Suitor* (Braun 253), an interior scene in full-length, but only in this late picture does he allude so clearly to the theme's pictorial heritage by employing a three-quarter format. This composition, combined with the addition of the cackling crone as the accomplice, is also reminiscent of a more recent half-length type, the procuress theme painted by Dirck van Baburen (c. 1595–1624), Gerard Honthorst (1590–1656), and others, which Steen could have known from his contact with Utrecht.[7]

Both traditions are about the folly to which men can be reduced by lust and deception. The unequal lovers theme, which typically shows an old man lusting after a young woman who picks his pocket,[8] comments on the foolishness of old age, as expressed in the proverb *Hoe ouder hoe sotter* (the older the more foolish, or there's no fool like an old fool). It satirizes the ridiculous behavior of men who lose their money because they have become slaves to their passions and it expresses the greedy, deceptive nature of women, a characterization in keeping with sixteenth- and seventeenth-century prejudices that were conveyed in print series about the dangerous powers of womenkind. Though occasionally a fool plays a subsidiary role in pictures of unequal lovers, in an etching of 1520 by Lucas van Leyden (1489–1533) (fig. 2) the old lecher has actually become a leering fool with a fool's scepter and a prominent purse.[9]

In the *Merry Threesome* Steen has taken an old theme about folly and updated it, replacing its preachy moralism with a lighthearted comic, theatrical spirit. While the picture still comments on the power of love to blind an old man to a young woman's dangerous wiles, it shifts the emphasis from folly to deceit. Though Steen had explored

the nature of seduction and deception elsewhere (cats. 9, 24), here he has rendered the deception so pleasurable and open that he exposes its workings and assumptions. When it concerns a fool this blissfully complicitous, deception is a game from which both participants benefit and that both agree to play.

HPC

1. Gudlaugsson 1945, 54–61, identifies the costume as that worn by various types of fools, including Hansworst and Falstaff, in European popular theater. Steen wears the same red beret in his role as fool in *The Doctor's Visit* in Philadelphia (page 44, fig. 6). Clothes of similar coarse blue striped material, which appears to be mattress ticking (see the bed in the *A Woman at Her Toilet* [cat. 19]), are worn by some of Steen's other objects of ridicule, for example *The Alchemist* (London, Wallace Collection) and the teacher in the *Village School* (Dublin) and by Steen in the role of the rommel-pot player in the *Deceitful Bride and Deceived Bridegroom* in Vienna (cat. 45, fig. 1).

2. On the sexual connotations of the fiddle, see The Hague 1994b, 290–292 and fig. 1, which is a print by Adriaen Matham with an explicit caption.

3. Her theatrical gesture evokes stage practice and an earlier didactic pictorial tradition. See, for example, Lucas van Leyden's woodcut *Tavern Scene*, c. 1518–1520, in which a fool points to a woman picking a man's pocket and says "acht, hoet varen sal" (see how it will go).

4. Franits 1993, 22–29, 35–36, fig. 23, cites an emblem from Cats 1627, that shows a woman with a sewing cushion seated beside a suitor. The text uses sewing as a metaphor for wounding or disappointing a lover.

5. A full-length variation on this image, which Braun 1980, 136–137, no. 339, mistakenly identifies as an oil sketch for the *Merry Threesome*, is in the Rijksmuseum. As is often characteristic of later copies, the symbolism is made more explicit by the inclusion of a pinwheel, which evokes "he runs with pinwheels," an expression used to describe fools and drunks.

6. Silver 1974, Stewart 1979.

7. Examples of the procuress theme are Dirck van Baburen, *The Procuress*, Museum of Fine Arts, Boston, inv. no. 50.2721, in The Hague 1990, 149–152, cat. 5; and Gerard van Honthorst, *The Procuress*, Centraal Museum, Utrecht, no. 152, in Utrecht 1986, 297–299, cat. 66.

8. Much less often it paired an old woman with a young man.

9. See also Quinten Metsys' *Ill-Matched Lovers* (National Gallery of Art, Washington) and the discussion of it in National Gallery Washington 1986, 146–150.

43

The Wedding Feast at Cana

c. 1670–1672

signed in lower right on wine barrel: *IHS*

panel, 63.5 x 82.5 (25 x 32 ½)

National Gallery of Ireland, Dublin

PROVENANCE

Probably sale, Adriaen van Hoek Jansz., Amsterdam, 7 April 1706, no. 17 (fl. 555); sale, Bicker and Wijkersloot, Amsterdam, 19 July 1809, no. 51 (fl. 1150 to auctioneer I. Spaan) (described as on panel); sale, Alexis Delahante, London, 2 June 1814, no. 37 (£120 15s. to Woodburn); anonymous sale, London, 1815 (£136 10s. to Baring); sale, Amédée Constantin, Paris, 1829 (4006 francs to Christianus Johannes Nieuwenhuys, London); his sale, London, 10 May 1833, no. 117 (£194 5s. to Norton); sale, Lord Northwick of Cheltenham, London, 24 May 1838, no. 100 (£294 to Clowes) (bought in, according to Smith Supplement 1842); sale, Casimir Périer of Paris, London, 5 May 1848, no. 14 (£199 10s. to Woodin); John Walter, Bearwood; bought from Walter by Alfred Beit, between 1895 and 1900; by descent to Otto Beit, later Sir, 1906; by descent to Sir Alfred Beit, Russborough, Blessington, Ireland, 1930; presented by Sir Alfred and Lady Beit to the present owner, 1987

LITERATURE

Smith 1829–1842, 4: 31–32, no. 100 and supplement: 493–494, no. 52; Van Westrheene 1856, 118, no. 85; Waagen 1854–1857, supplement: 296; Beit Collection 1904, 58; Hofstede de Groot 1908, nos. 48, 49; Martin 1909b, 170–171; Beit Collection 1913, 14–15, no. 57; Leiden 1926, 18, no. 23; Bredius 1927, 32–33; Schmidt-Degener and Van Gelder 1927, 11–12, 34–36; Bax 1952, 113–115; De Groot 1952, 81, 153, 181–182; Martin 1954, 40; The Hague 1958, no. 51; Stechow 1972, 78–80; Kirschenbaum 1977, 21, 46, 84, 95–98, 131–133, no. 48–49; Braun 1980, 134, no. 329

fig. 1. Jan Steen, *The Marriage Feast at Cana*, 1676, oil on canvas, The Norton Simon Foundation, Pasadena, California

Christ's first public miracle occurred at a wedding feast at Cana in the Galilee (John 2: 1–11). When Christ arrived at the wedding banquet with several of his disciples, his mother, who was also in attendance, informed him that the guests had exhausted the supply of wine. Christ then asked the servants to fill six stone jars with water, which he miraculously converted into wine. The steward of the feast pronounced the new wine superior to the first vintage, marveling that the bridegroom had saved the best wine for last.

The Wedding Feast at Cana must have fascinated Steen, for he represented this biblical story six times over the course of his career.[1] Each of these paintings portrays an extravagant banquet, where guests heartily celebrate in an expansive architectural space. The story's biblical context allowed Steen to depict exotic costumes evocative of ancient Israel, and a wide range of character types— rich and poor, elegant and slovenly, sober and inebriated. Its religious content also challenged the artist and he delighted in distinguishing between those who recognized the miracle and those who remained oblivious to it. Finally, the story allowed Steen to depict a scene fundamental to the doctrine of transubstantiation, a crucial theological concept for the Catholic faith.

The wedding party in this remarkable painting sits at a long L-shaped banquet table situated on a raised platform. Musicians serenade from the balcony, festoons of tree branches and garland swags hang from the vaulted ceiling and stone arches, and cuttings of greenery lay on the marble floor. The bride and groom sit on the left side of the table under an orange canopy of honor and a foliated *belkroon* (bell crown) that symbolizes the sanctity of matrimony. Happily engrossed in each other, the couple remains oblivious to both the large gathering of celebrants and the miraculous source of the new wine.

Steen portrays Christ as an unassuming individual who requires neither drama nor fanfare to perform his miracle. Somberly dressed in long, monochrome robes, he stands to the right of center, quietly blessing three pitchers of water drawn from the fountain. A young servant kneels before him and pours a glass of the new wine. The portly steward of the feast, identified by his white apron, a maid, and a dwarf distribute wine from the three previously blessed pitchers.

The bridal couple are not the only ones to overlook Christ's miracle: most of the other guests are equally unaware. For some, particularly the old woman in the foreground carrying morsels of food in a white napkin, the party has already lasted too long. Anxious to prevent her inebriated husband from drinking the new vintage that the plump dwarf offers, she coaxes him to stand. Another drunken reveler, unaware of the replenished wine supply,

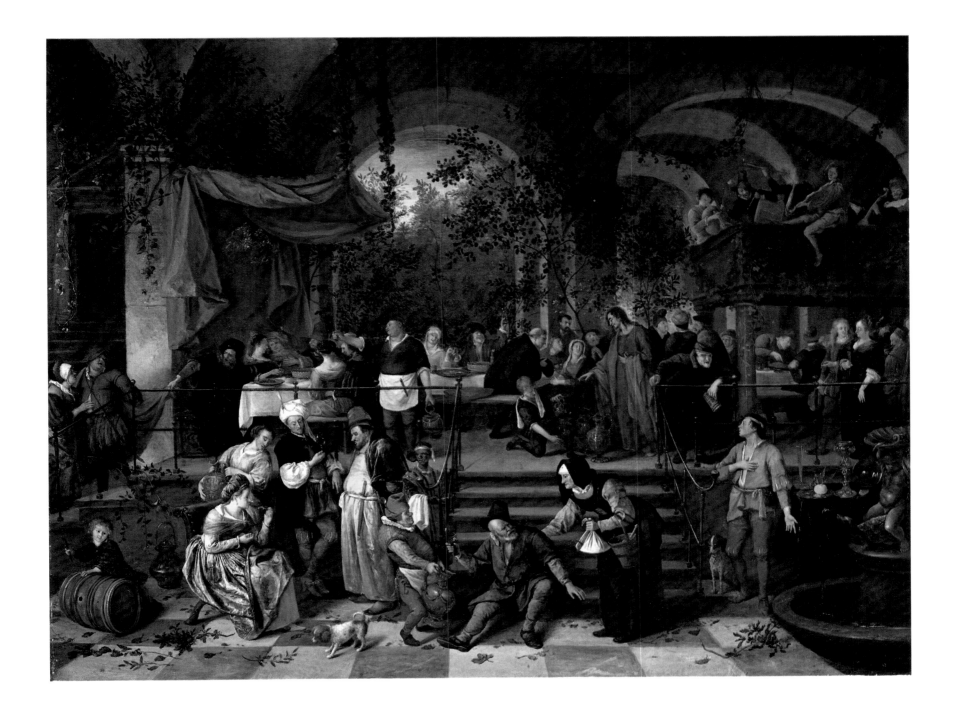

fig. 2. Ghirisio Ghisi after Raphael, *The School of Athens*, 1550, engraving, Museum Boymans-van Beuningen, Rotterdam

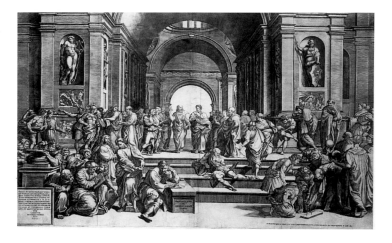

certain connections can be drawn.[5] Steen's composition, however, does have an important pictorial antecedent in Italian art, Raphael's *School of Athens*, 1510–1511 (Stanza della Segnatura, Vatican), which he could have known through a reproductive engraving (fig. 2).[6] Although similarities in architecture and figural grouping, ranging from the central arch motif to the drunken peasant sprawled on the stairs, confirm the relationship between the two works, Steen imaginatively transformed Raphael's formal and harmonious composition into his own idiom. Steen's inventive use of this icon of High Renaissance art provides further evidence that his artistic concerns were far loftier than has been traditionally believed.[7]

AKW

has also decided to leave the party. As he descends the steps to the left, a servant girl stops him while an aged celebrant seated beside the bride grabs his cloak. The steward of the feast offers the most compelling reason to stay: a tall flute glass of the new wine. In the foreground left, an elegant woman in a silvery-gray dress proofs the wine as her portly husband, a turbaned Easterner, a Moorish servant, and the maid carefully observe her response.[2]

Steen emphasizes these dynamic groups by exquisitely coloring and modeling the figures, carefully choreographing their actions and skillfully integrating them into the larger composition. One of the few figures to notice Christ's miracle is a jovial celebrant in the center background, bearing Steen's own features who raises his glass to toast Christ's achievement. While grateful for the wine, his hearty demeanor reveals that he is ignorant that the wine has appeared through divine intervention. Steen's deliberate placement of this toasting celebrant near the vanishing point of his perspective system gives the drinker's attitude broad thematic significance. Perhaps for Steen his good-natured, yet unknowing, reaction represents man's limited ability to understand Christ's essential nature.

Indeed, only a few individuals truly perceive. Among them are Mary and three disciples, who look up at Christ in gratitude and astonishment. A tonsured monk with hat in hand, a seemingly incongruous guest at this occasion, rises from his seat and stares reverently at Christ's hand. Most transfixed by the miracle is the young servant in the lower right. Informed about the miracle by an old codger leaning over the metal railing, he marvels at the transformation of the water he had drawn from the fountain. As

he looks up at Christ, he holds his right hand to his heart and points to the fountain with his left. Steen effectively uses the sweeping diagonal of the metal railing to visually connect the servant and the Christ he recognizes.

This work, the most remarkable of Steen's many depictions of the wedding feast at Cana, was described by Wilhelm Martin as "a jewel of a cabinet painting."[3] While its pictorial qualities are exquisite, its theological implications are also profound. For example, Steen signed his painting with an unusual monogram, an *IHS* that he placed on the empty wine barrel at the left.[4] Steen's monogram, coincidentally identical to that of Christ, directly links Christ to wine, and thus with the Eucharist. Moreover, as Stechow emphasizes, the fountain from which the pitchers were filled symbolizes the waters of eternal life. Just as Christ transforms this water into wine, so the wine of the Eucharist becomes his blood. By including a tonsured monk as a witness to Christ's miracle, Steen provided a visual defense for the Catholic doctrine of transubstantiation.

Steen probably painted this work in the early 1670s, for its spacious and architecturally structured composition resembles his *Sacrifice of Iphigenia*, of 1671 (page 14, fig. 6). The detailed rendering of the foreground figures indicates that it must predate Steen's 1676 version of this subject (fig. 1), where many of the same compositional elements return, including the woman carrying leftovers and the child rolling away an empty barrel.

Some scholars have suggested that Steen based his scene upon theatrical productions, but, besides the dwarf who resembles Policinelle from the *commedia dell'arte*, no

1. For a discussion of these works, which date from 1656 to 1676 (see fig. 1), see Stechow 1972.

2. The motif of the woman drinking while being watched by her spouse is also found at the background left of the version of this theme in the Norton Simon Collection (see fig. 1). In the catalogue discussion of that painting in the Demidoff sale, Paris, 1880, no. 1126, the couple was identified as a rabbi and his wife. This interpretation may be correct because the woman's hair is covered, and Orthodox Jewish women may not show their hair after they have married. Steen may have intended the same identification for the couple in the National Gallery of Ireland painting. Significantly, they do not recognize Christ's miracle or understand its implications. I would like to thank Esmée Quodbach for bringing this reference to my attention.

3. Martin 1954, 40.

4. Stechow 1972, 79. Stechow's theory is more convincing than that advanced by F. Schmidt-Degener in Schmidt-Degener and Van Gelder 1927, 11 (and reiterated by Kirschenbaum 1977, 95–96) that Steen intended his monogram to correspond with *In Hoc Signo [vinces]*, the sacred letters of Constantine.

5. Bax 1952, 114, notes the connection with the *commedia dell'arte* figure. Kirschenbaum 1977, 84, suggests that Steen could have known the figures through the etchings of Callot. Heppner 1939–1940, 44, postulates that *rederijkers* gave performances of the "Marriage of Cana" at the weddings of wealthy families, and that Steen's paintings would have served to commemorate wedding celebrations; Stechow 1972, 79, however, rightly rejects Heppner's thesis.

6. The compositional relationships to Raphael's *School of Athens* were first made by De Groot 1952, 180–181. It also seems probable, as Stechow 1972, 73, notes that Steen knew paintings executed in the manner of Veronese's monumental *Marriage at Cana*, 1562 (Louvre, Paris).

7. For an interesting overview of the negative assessments of this painting by earlier critics, particularly in regards to its intellectual content, see Kirschenbaum 1977, 132.

44

The Wrath of Ahasuerus

c. 1671–1673

signed in lower left: *JSteen* (*JS* in ligature)

canvas, 129 x 167 (50 ¾ x 65 ¾)

The Trustees of the Barber Institute of Fine Arts,
The University of Birmingham

PROVENANCE

Sale, Richard Pickfatt, Rotterdam, 12 April 1736, no. 44; Colonel
A. W. Hankey, Beaulieu, Hastings, England; C. Sedelmeyer,
Paris, by 1899; bought by Rodolphe Kann, Paris; bought with the
Kann collection by Duveen Bros., 1907; F. Kleinberger, Paris,
1926; K. W. Bachstitz, Berlin, The Hague, and London, after 1926;
bought from Bachstitz by the Barber Institute of Fine Arts, 1939

LITERATURE

Sedelmeyer 1899, 64; Bode 1900, 12; Bode 1907, 75; Hofstede de
Groot 1907, no. 18; Martin 1924, 8; Leiden 1926, 23, no. 48;
Bredius 1927, 29; Schmidt-Degener and Van Gelder 1927, 17, 55,
no. 21; Amsterdam 1929, no. 139; London 1930, 129, no. 208;
Martin 1935b, 34–35; De Jonge 1939, 54; Heppner 1939–1940, 42;
Wilenski 1945, 154–155; Birmingham 1952, 102; Martin 1954, 55–56;
The Hague 1958, no. 49; Lurie 1965, 95; Kirschenbaum 1977,
118–119, no. 18; Birmingham 1983, 30

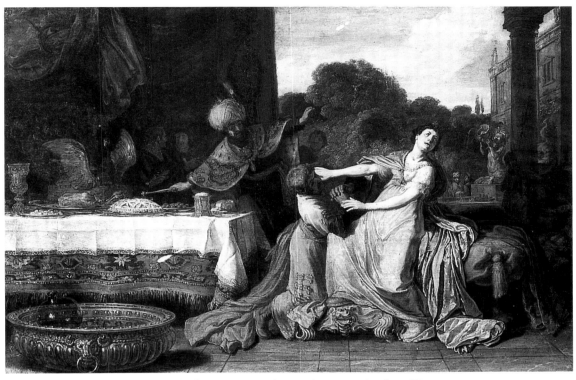

fig. 1. Pieter Lastman, *Haman Pleads to Esther for Mercy*, c. 1618, oil on panel, Muzeum Narodowe, Warsaw

In this, one of Steen's largest and most melodramatic
paintings, an outraged King Ahasuerus has leapt to his feet
in response to the damning accusations of Queen Esther
against his chief minister Haman. Servants recoil in fear as
Ahasuerus rails at the cowering Haman with clenched fist
and bulging eyes. His violent reaction has so shaken the
banquet table that a vase has crashed to the floor and an
enormous peacock pie, caught by the artist in mid-air,
tumbles over the table's edge. Esther, who evokes sincerity
and moral authority through her steadfast gaze and heart-
felt gesture, points with one hand toward the falling pie, a
symbol of luxury, pride, and arrogance, to indicate that
such vices were the root causes of Haman's downfall.[1]

The feast is the culminating episode in the book of
Esther (7: 1–10), which describes the vicissitudes of the
Jews living in exile in Persia almost five hundred years
before the birth of Christ. Unbeknownst to Ahasuerus
when he chose her as his queen, Esther was Jewish. She
had been raised as an orphan by her cousin and guardian

Mordecai, who became a trusted advisor to the king after
he had helped to subvert an assassination plot. Mordecai,
visible in the background left of Steen's painting, later
insulted Haman, the king's chief minister, by refusing to
bow before him. Haman reacted by writing a decree in
the name of Ahasuerus calling for all the Jews in Persia to
be massacred and their goods seized. To combat Haman's
evil intentions, Esther prepared a banquet where she
revealed to the king that she was Jewish and that because
of Haman's treachery she and all of her people would be
destroyed.[2] Outraged, the king later ordered that Haman
be hung from the very gibbet originally prepared for
Mordecai's death.

The story of Esther appealed to the Dutch, who found
parallels between Esther's triumph over Haman—a pious
and virtuous woman vanquishing a proud and tyrannical
enemy—and their successful uprising against Spanish
domination.[3] Steen's imposing composition draws upon
both pictorial, historical, and literary sources for its con-

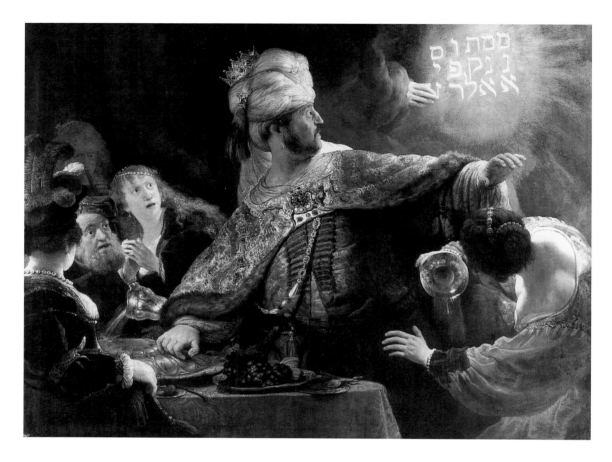

fig. 2. Rembrandt, *Belshazzar's Feast*, c. 1636, oil on canvas, Reproduced by courtesy of the Trustees, The National Gallery, London

ception. The primary visual source was the depiction of a later episode in the story of Esther by Pieter Lastman (1583–1633), *Haman Pleads to Esther for Mercy*, c. 1618 (fig. 1). Although Steen shifts the direction of Ahasuerus' gaze and poses him with a clenched fist, he retains Lastman's conception of Ahasuerus standing with outstretched arms behind a table laden with food, including a peacock pie.[4]

Rembrandt's imposing *Belshazzar's Feast*, c. 1636 (fig. 2) may also have inspired Steen's painting.[5] Although the subject is different, the scenario is quite similar: a king disrupts a banquet by reacting strongly to a sudden revelation. Rembrandt (1606–1669) enhances the drama through chiaroscuro, by limiting the number of figures in the composition, by bringing them close to the picture plane, and by exaggerating their facial expressions. Steen adopts all of these devices, including the exaggerated whites of Ahasuerus' eyes. Rembrandt emphasizes the suddenness of the revelation by depicting a chalice as it is knocked

over, an effect Steen similarly achieves with the tumbling peacock pie.[6]

Steen's dramatic presentation, however, also seems indebted to theatrical productions. Much as with *Samson and Delilah* (cat. 34), the drama unfolds in the immediate foreground, while an architectural backdrop provides a setting for the secondary figures. The large tapestry hanging above provides an exotic setting suitable for a biblical drama, but retains the character of a stage prop. Also related to Dutch theater are the broad gestures and expressions that enliven the scene.[7] Heppner has convincingly related Steen's interpretation of the banquet feast to Joannes Serwouters' play, *Hester oft verlossing der Jooden* (Hester, or the Deliverance of the Jews), first published in 1659.[8] He notes that Steen's depiction of Ahasuerus' wrath accords with the king's line: "Shame on thee, Haman, now curse the hour of thy birth"; and that Haman's cowering pose conveys his despair: "Where shall I hide myself? I dare not look upon the face of the king."[9]

Although traditionally dated c. 1668, Steen probably executed the Birmingham painting in the early 1670s.[10] A number of stylistic relationships exist with his *Wedding of Tobias and Sarah* from c. 1671–1673 (cat. 45). Steen renders the architecture and draped tapestry in both works in a similarly suggestive and schematic manner. Moreover, architecture in each scene reveals a broadly and atmospherically painted vista. Other specific points of reference exist. The young servant girl standing behind Haman reappears in precisely the same pose as Sarah. Finally, the bearded old man who served as the model for Mordecai has been transformed into the father of the bride in the San Francisco painting.

The circumstances surrounding the commission of this majestic painting are unknown. The primary appeal may have been the drama inherent in this popular biblical story. It may also be possible that Esther's feast still retained political implications for the Dutch comparable to those felt earlier in the century. The perceived parallels between Esther's triumph and the successful revolt of the Dutch against Spanish oppression may have been reawakened at the time of the French invasion of the Dutch Republic in 1672.[11]

One final possibility, proposed in 1747, purportedly by Steen's biographer Weyerman, in an amusingly conceived dialogue between Steen and Rubens (1577–1640) (pages 53–54), is that Steen painted this work to illustrate Proverbs XIX, verse 12: "The king's wrath is like the roaring of a lion." The long and detailed description of the

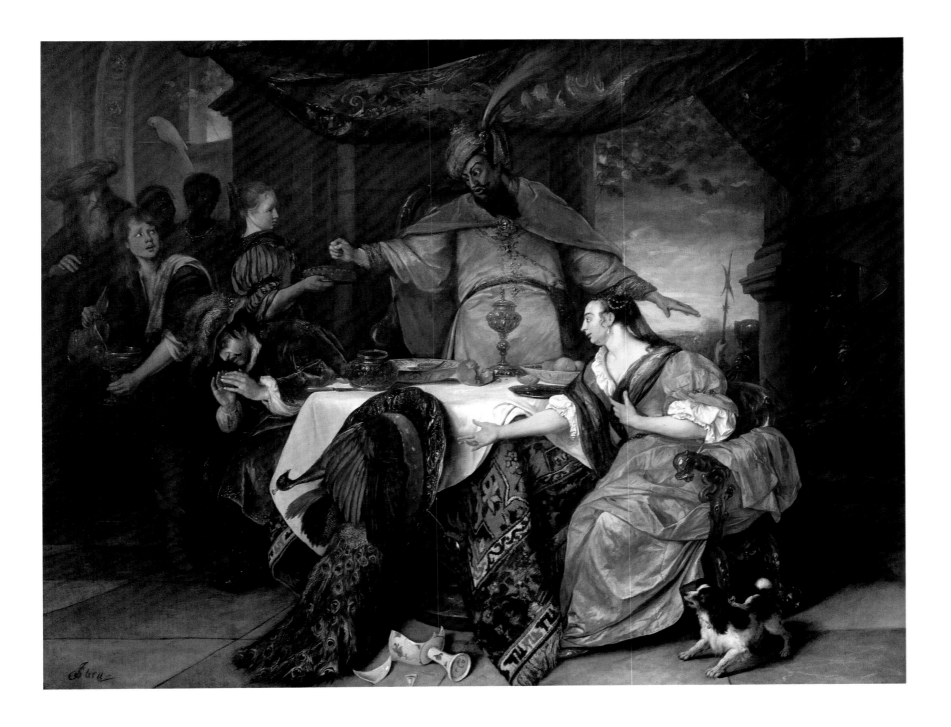

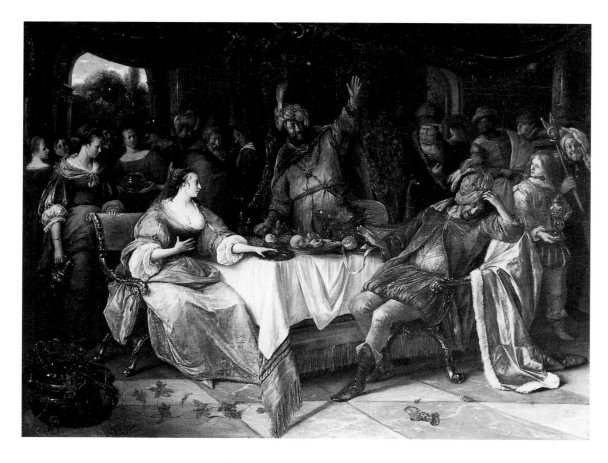

fig. 3. *The Wrath of Ahasuerus*, 1668, oil on canvas © The Cleveland Museum of Art, 1995, John L. Severance Fund

painting indicates that the author knew it well. Interestingly, he has Steen introduce his painting by stating that it is "one of my largest and most serious pieces." The author then concludes his dialogue with Rubens' assertion that this work demonstrates Steen's capacity to create "serious as well as humorous paintings."[12]

AKW

1. Although the peacock pie was commonly imbued with such symbolic associations in seventeenth-century Dutch art, strictly speaking it is the peacock rather than the pie that has emblematic associations with pride and luxury. The peacock, for example, is the traditional symbol of *Superbia*, the vice of pride. For its associations with luxury, see Visscher 1614, 95, emblem 34.

2. The Jewish feast of Purim commemorates the deliverance of the Jews from Haman.

3. For the association of the Dutch with the story of Esther, see Kahr 1966. Kuretsky in Washington 1980, 282, notes that Esther's intercession with Ahasuerus was viewed in Christian traditions as an Old Testament prefiguration of the Virgin's intercession with God for the salvation of mankind.

4. The pose of Ahasuerus in Steen's smaller version of the subject, *The Wrath of Ahasuerus*, c. 1668, in Cleveland (fig. 3), confirms that Steen knew Lastman's work. For a discussion of this painting, see Kuretsky in Washington 1980, 282, cat. 85. The close conceptual relationship between the Cleveland painting and Lastman's *Haman Pleads to Esther for Mercy*, including the relative scale and number of figures in the scene, suggests that Steen executed the Cleveland painting prior to the larger, and bolder scene in the Barber Institute of Fine Arts.

5. Belshazzar's pose also reflects that of Ahasuerus in Lastman's *Haman Pleads to Esther for Mercy*.

6. This device of showing objects falling off tables and platters occurs frequently in Flemish art. See, for example, Jacob Jordaens, *The King Drinks*, c. 1640, Koninklijke Musea voor Schone Kunsten van België, Brussels.

7. For a similar effect, see the executioner in Steen's *Sacrifice of Iphigenia* (page 14, fig. 6). De Groot 1952, 69 n. 8, and Kirschenbaum 1977, 141, no. 74, relate Steen's painting to Vondel's 1666 translation of Euripides' *Iphigenia in Tauris*.

8. For other plays devoted to the story of Esther, see Van de Waal 1974, 201–225.

9. Serwouters 1659, 49, as translated in Heppner 1939–1940, 42.

10. See, for example, Kirschenbaum 1977, 118–119, no. 18.

11. Such associations may help account for the large number of Esther scenes painted in the last years of the seventeenth century by Aert de Gelder (1645–1727).

12. *Maandelyksche besichten* 1747, 243–245. "Steen" in this dialogue calls this painting "een van myne grootste en serieuste stukken," and "Rubens" acknowledges "[. . .] dat gy zo wel ernstige als boertige taferelen hebt kunnen voortbrengen." I would like to thank Guido Jansen for this reference.

45

The Wedding of Tobias and Sarah

c. 1671–1673

signed on the base of the table at lower right: *JSteen* (*JS* in ligature)

canvas, 103 x 123 (41 x 50 ¼)

The Fine Arts Museums of San Francisco, Gift of The de Young Museum Society

Washington only

PROVENANCE

Possibly anonymous sale, Amsterdam, 6 March 1708, no. 4 (fl. 205); sale, Henrietta Westerhof, née Van der Schagen, Amsterdam, 16 May 1781, no. 53 (fl. 1300 to Hoofman); sale, M. Hoofman, Haarlem, 2 June 1846, to Quarles van Ufford; bought from Quarles van Ufford by Christianus Johannes Nieuwenhuys, London; sale, Charles Auguste Louis Joseph, duc de Morny, Paris, 31 May 1865, no. 78, (bought in at Frf 5000); Princess Murat, Paris; sale, Murat family, Paris, 2 March 1961, no. 157, to Rosenberg & Stiebel and Fredrick Mont, New York; bought by The de Young Society for the M. H. de Young Memorial Museum, San Francisco; in 1972 a merger between the museum and the California Palace of the Legion of Honor created The Fine Arts Museums of San Francisco

LITERATURE

Smith 1829–1842, supplement 501; Van Westrheene 1856, 146; Hofstede de Groot 1907, nos. 25, 487; Fink 1926–1927, 231; De Groot 1952, 30–33; Kirschenbaum 1977, 51, 63–64, 92–95, 121–123; Braun 1980, 138–139, no. 355

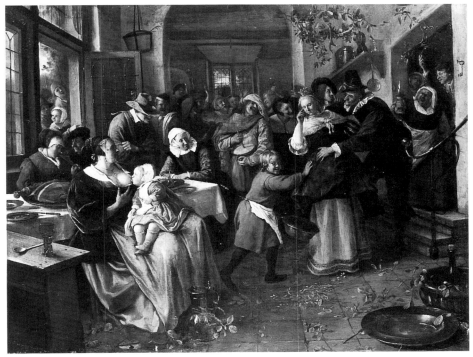

fig. 1. Jan Steen, *The Deceitful Bride and Deceived Bridegroom*, c. 1668–1670, oil on canvas, Kunsthistorisches Museum, Vienna

About five years after he painted *The Wedding of Tobias and Sarah* in Brunswick (cat. 32), Steen returned to the same episode from the Book of Tobit in this smaller, extremely fine painting in San Francisco. He had rendered the first version so genrelike that Arnold Houbraken, who owned it, characterized it as a scene from daily life.[1] Here Steen recasts the theme in an elegant, historical narrative mode that in his day must have seemed more appropriately and more recognizably biblical.[2] Comparison with the near contemporary *The Deceitful Bride and the Deceived Bridegroom* (fig. 1), a delightful comic rendition of the Dirty Bride theme, demonstrates that by this late stage of his career, the stylistic gap between Steen's histories and his genre scenes had widened considerably.[3] Indeed, it is hard to imagine that the San Francisco picture would have been mistaken for a genre painting.

The essentials of the story remain the same as in the Brunswick version, though the composition is reversed and the players rearranged.[4] Houbraken would soon praise the theatricality of the earlier picture (see page 94), and that is precisely what Steen has amplified here, by restaging the scene in a grander, more spacious architectural setting that resembles, albeit loosely, the symmetrical stage of the Amsterdam *schouwberg*, or professional theater (fig. 2). The enormous curtain, which, though it has suffered some damage, is still a magnificent tapestry canopy, serves the same stage-evoking function in a number of Steen's other late histories (cats. 34, 44).

In the San Francisco picture, Steen has clarified the narrative. He has reworked the arrangement of Sarah, Tobias, and the guardian angel Raphael. To emphasize the marriage, Steen places Tobias and Sarah directly below a wreath of sunflowers, symbolic of marital fidelity.[5] Between them, as if in the role of the priest who sanctifies the marriage, he puts Raphael, who had brought the couple together and will ensure the success of their union (see cat. 32, fig. 1). And he has given Raphael wings, making his angelic identity more apparent. Tobias' faith is central to the story, for that is what

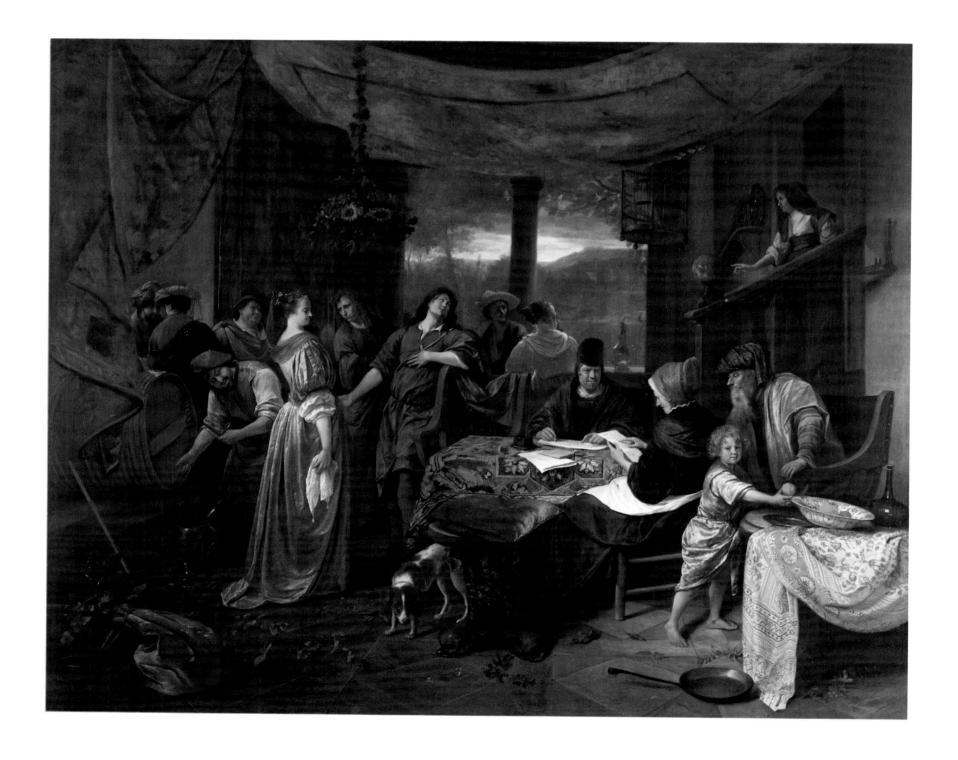

fig. 2. Salomon Savry, *Stage of the Amsterdam Schouwburg*, 1658, etching, Nederlands Theater Institut, Amsterdam

will protect him from the fate of Sarah's seven previous husbands, all of whom died on their wedding nights. Steen reworks Tobias' pose so that he at once directs his profession of faith heavenward and reaches out to his beloved Sarah. In the Brunswick picture, by contrast, though his eyes roll upward, his gesture seems directed toward the figures at the table. Compared to his Burgundian stage costume in the earlier version, Tobias is now clothed *a l'antique*, in a tunic and flowing robe that would have been recognized as more appropriately biblical. To clarify Sarah's role in the narrative Steen has revised her; the shimmering satin dress evokes the pastoral. Now rendered in profile, she professes her faith in a downward gaze that contrasts appropriately with Tobias' dramatic plea. Her conspicuous white handkerchief is a token of marriage.[6]

Steen has set up a contrast between the heartfelt spirituality of this faithful pair and the worldliness of the threesome who concern themselves with drawing up the marriage contract. At the carpet-covered table, Sarah's mother scrutinizes the document, reading each word as she follows with her finger, while the notary writes up another page. This sly notary, who is strategically situated between loving bridal pair and pecunious parents, represents what Jacob Cats and others regarded as a misguided treatment of marriage as a contractual agreement, hence an inappropriate privileging of the law over the word. In

him we recognize Jan Steen. While he often appeared in his genre paintings—in the *Deceitful Bride and the Deceived Bridegroom* he is the reveler at center, playing the sexually suggestive *rommel pot* that alludes to the bride's unchaste state—Steen rarely cast himself so centrally in a history painting. In the San Francisco painting, just as it had in *Easy Come, Easy Go* and *As the Old Sing, So Pipe the Young* (cats. 15, 23), his role as negative exemplar serves to sharpen the picture's moralizing message.

Other subsidiary changes from the Brunswick version also elaborate on the theme of love and marriage and so amplify the narrative. One sprig of myrtle on the floor flowers into many. At right a child looks directly out at us and displays a large orange, another marriage symbol. In the Brunswick painting, the tapped keg alludes to the celebratory feast that is to follow; and the fish legs of the table refer to the fish's liver that Tobias would soon burn to drive out the evil spirit. These elements are still here, but now Steen relates more of the story by introducing, at lower left, Tobias' traveling sack, a reminder of his journey with Raphael, and by including a woman on the stairs at right who gestures toward Tobias and Sarah, as if inviting them to the bridal chamber. Opulent fabrics and exotic costumes and turbans further heighten the picture's biblical mood. In the right foreground, Steen has covered the table with a beautiful white, red, and black cloth of Indian chintz, which he must have owned and

loved for its exoticism, since it appears in so many other history pictures from the late 1660s and early 1670s, including *Samson and Delilah* (cat. 34) of 1668 and *The Sacrifice of Iphigenia* (page 14, fig. 6) of 1671. In a small, approximately contemporary version of this *Wedding of Tobias and Sarah*, Tobias drapes this cloth around him as a kind of cape.[7]

Stylistically this picture is comparable in its spaciousness and handling of paint to other histories of the early 1670s, *The Sacrifice of Iphigenia* and, especially *The Wrath of Ahasuerus* (cat. 44). Differences between this painting and the earlier Brunswick version provide evidence of how Steen participated in the broader Dutch shift toward greater elegance, refinement, and classicism in the last third of the century. In this later work, figures are elongated, their costumes more appropriately biblical, and more sumptuously painted, and the setting is more classicizing. Yet still Steen's biblical grandeur remains at a distance from, and would certainly never be mistaken for, the idealized classicism of his younger colleagues Gerard de Lairesse (1641–1711) or Adriaen van der Werff (1659–1722). The exaggerated theatricality of the rhetorical gestures and stagelike setting, the comical human touches, and the way Steen personalizes the picture's message by including himself all reflect his distinctive, inimitable artistic personality.

HPC

1. Houbraken 1718–1721, 3: 16–17; see pages 94 and 205.

2. I would like to thank Melinda Vander Ploeg-Fallon for sharing with me her insightful analysis of this painting.

3. For the Dirty Bride theme, see cat. 6 n. 6.

4. See the *Return of the Prodigal Son* (cat. 39) for an instance in which Steen reversed the composition of a model by another master.

5. See cat. 6 n. 7.

6. Dickey 1995 discusses the handkerchief, in portraits, as a marriage token and a symbol of sorrow and compassion. Conceivably, it plays that dual role here.

7. Ebeltje Hartkamp-Jonxis, curator of textiles at the Rijksmuseum, kindly provided this information. For the smaller version see Braun 1980, no. 309; Duits 1965.

46

A Village Revel

1673

signed lower right: *JSteen* (*JS* in ligature)

canvas, 110.4 x 147 (43 ½ x 58 ¼)

Inscribed on the inn sign: *T MIS VERSTANT 1673*; and on
the placard being attached to the wall beside the front
door: *DIT HUIS IS TE HUER*

Her Royal Majesty Queen Elizabeth II

PROVENANCE

Acquired by George IV by 31 December 1806; first recorded in
store at Carlton House, 1816; in the Picture Gallery at
Buckingham Palace by 1841

LITERATURE

Smith 1829–1842, 4:3, no. 6; Waagen 1838, 2:357; Jameson 1844, 47,
no. 111; Waagen 1854–1857, 2:10, no. 5; Royal Collection 1885, no.
56; Hofstede de Groot 1907, no. 628; Heppner 1939–1940, 45;
Braun 1980, 138, no. 354; Royal Collection 1982, 125, no. 193

fig. 1. Pieter van der Heyden after
Pieter Bruegel the Elder, *Elck*, 1558,
engraving, Rijksprentenkabinet,
Amsterdam

Life in this village has gone so amuck that even the inn is
for rent. This inn with its signboard of a bare defecating
ass, a symbol of worldly folly, is *'T misverstant*, a term
that encompasses both misunderstanding and its conse-
quences.[1] To its vine-covered porch a man affixes a sign
advertising *Dit huis is te huer* (This house is for rent),
which at once suggests not just vacancy but moral bank-
ruptcy and plays on the word "whore." The dovecote
above the porch leaves no doubt that this tavern is, like
many in the seventeenth century, a house of ill repute,
for *duyf-huys* (dove house) was then a word for brothel.[2]
The woman in the red hat, probably one of the whores,
leads a man up the steps as another woman, presumably
his wife, beats him with a leper's clapper. Hay in the inn's
upper window brings to mind the saying *al hoy*, meaning
everything is hay or nothingness.

Steen has marshalled an impressive cast of misbe-
havers to deliver his message about the outcome of
human sinfulness. In front of the inn, peasants brawl,
going at each other with knives and pitchforks, husbands
and wives fight, and women have gained the upper hand.
The colorful comic nature of the scene does not disguise
the threat of this collapse of moral order. The perilous
consequences of foolish behavior, symbolized by the bas-
ket filled with a crutch, switch, and the like as *In Luxury
Beware* (cat. 21), have here come to pass.

This seeming chaos, however, is actually a carefully
constructed compendium of traditional—by Steen's time
old-fashioned—images of folly. Since the beginning of his
career (cats. 2, 3), Steen had been drawn to Brueghelian
peasant imagery. Indeed, he may well have set out to be
the Bruegel of his age. But compared to this late work,
his early outdoor village scenes, the *Village Festival with
the Ship of Saint Rijn Uijt, Peasants before an Inn*, and *Village
Wedding* (cats. 4, 5, 6), seem based on the observation of
country life as well as on pictorial tradition. For now
Steen has strayed so far from descriptive naturalism that
his interest in pictorial precedents has almost completely
taken over. He revisits his own earlier works and inven-
tively appropriates well-known motifs from the moraliz-
ing art of the past. *A Village Revel*, like the nearly con-
temporary *Village Fair with a Quack* (page 58, fig. 10), epit-
omizes Steen's fascination with archaizing.

Steen has transformed the well known pictorial type
of the peasant kermis before an inn, popularized by
Pieter Bruegel the Elder (c. 1525–1569), Adriaen van de
Venne (1589–1662), and Adriaen (1610–1685) and Isack
(1621–1649) Van Ostade, into a comical compendium of
human folly and transgression. He represents not the
usual feasting, drinking, and dancing but the dangerous
end results of idleness, excess, and immoderation. This
compilation of vignettes is closely reminiscent of the

fig. 2. Adriaen van de Venne, *Wretchedness*, 1621, grisaille on panel, Rijksmuseum, Amsterdam

engraving *Laziness* after Cornelis Metsys (c. 1511–after 1580) (page 62, fig. 15). Filling his pipe, and looking directly out at the viewer from the extreme foreground, Steen's cooper, like Metsys', personifies the idleness that is the root of this misrule. He also provides a clue as to the identity of the oddest, most incongruous figure here, the gaunt, bearded man beside him, whose oversized collar, striped sleeves, and old-fashioned armor make him an object of ridicule. His lantern identifies him with the ancient philosopher Diogenes, who lived in a barrel, which he inhabits in Steen's *Village Fair*. Like his genre-fied counterpart Elck, or Everyman (fig. 1), Diogenes carried a lantern in broad daylight.[3] According to the ancient story, when asked why he was carrying his lantern in the marketplace on a bright day, Diogenes replied that he was searching for a human being.[4] In Vondel's version of the of the story, Diogenes responds to his interrogators: "Your beastly life proves that you are men only by name and beasts in your deeds."[5] This mock, vainly searching Diogenes/Elck is just as foolish as the fools who sur-

round him. At right is the proverbial ship of fools, an image that goes back to Hieronymus Bosch (c. 1450–1516) and Sebastian Brandt (1458–1521) (see cat. 4). Its passengers are the virtual embodiments of sin—the monk drinking personifies intemperance; the boys stuffing their mouths with apples, gluttony; and the man and woman fighting, anger.

Sexual folly is central to *A Village Revel*. Steen comically represents the effects of lust and concupiscence. The old man hobbling on his crutch through the center of the picture seems an unlikely sexual symbol. Yet his basket of eggs identifies him with sixteenth-century images that satirize the peasants' lust by pairing a virile man holding a basket of eggs and a woman with a fowl.[6] Eggs were thought to be necessary for potency and here the suggestion is that these are what this old fellow sorely needs. Just how clever Steen could be in his play on old motifs becomes evident when we realize that the egg carrier's usual female counterpart is there in the left foreground. Having dropped her yoke and spilled her milk, she fends off a younger man and holds on with dear life to a fowl—now a particularly suggestive cock. Though modern viewers might want to read her refusal to submit to man's domination and her possession of a symbol of male potency as an image of woman's liberation, for Steen's contemporaries it surely represented a threatening reversal of the proper social order. The aggressive woman with a red flag who strides with her skirts uplifted and a broom between her legs is further evidence of this upheaval. Both witch and rabble rouser, she leads a band of women descending on the inn.[7]

At the left rear, misbehavior plummets into dangerous chaos. In front of the inn, a peasant with a knife accosts two sly men; and an irate fellow wielding a hammer kicks a man to the ground while one woman tries to restrain him as another beats him with her shoe. Fighting was regarded as the ultimate outcome of folly, as is evident in Steen's *Interior of an Inn with Cardplayers Fighting* (page 76, fig. 15). Within the gateway, almost out of view (like Steen's other moralizing footnotes) peasants battle with pitchfork and flail, a vignette that evokes Adriaen van de Venne's grisaille *Wretchedness* (fig. 2).

A master of clever juxtapositions, Steen has positioned himself, in his oft-played role of comic narrator, just above this all-out fighting. He is the jolly fellow brandishing a hambone who looks out us, laughing, as he precariously descends a ladder. If the ladder has any purpose

besides raising him above this chaos, it is to provide a way to hang the inn sign or wreath. The year before he painted the *Village Revel*, Steen had petitioned to open an inn in his house in Leiden.[8] In this picture, as in the *Merry Company on a Terrace* (cat. 48), he capitalizes on his image as roguish innkeeper.

HPC

1. On the ass as a symbol of folly, see Bax 1979, 52–53. For a sixteenth-century text that connects defecation with worldliness, see cat. 15. Prior to the recent cleaning of the painting, the signboard pictured an ox head and the inscription read "TBOTVERSTANT." I am grateful to Nina Serebrennikov for discussing *The Village Revel* with me.

2. Bax 1979, 124. In the sixteenth and seventeenth centuries, *duve* (dove) was a word for prostitute and *doffer* (cock pigeon) could mean lover or adulterer.

3. For Elck, see Calmann 1960; Klein 1963, 157–158.

4. Washington 1980, 214–215. For the representation of Diogenes in the sixteenth and seventeenth centuries, see Schmitt 1993, with no mention of Steen's unusual treatment of the subject.

5. Quoted by Blankert in Washington 1980, 214.

6. For the sexual connotations of eggs, see page 45, and Raupp 1986, 41, 45.

7. Dekker 1987.

8. See page 32.

47

The Worship of the Golden Calf

c. 1673–1677
signed on gourd in lower right corner: *J. Steen*
canvas, 178.4 x 155.6 (70 ¼ x 61 ¼)
North Carolina Museum of Art, Raleigh, Purchased with
funds from the State of North Carolina

PROVENANCE
Anonymous sale, Amsterdam, 14 May 1749, no. 15; sale, Balthazar
Beschey, Antwerp, 1 July 1776, no. 13 (fl. 84 to J. F. Beschey); his
sale, Antwerp, 21 August 1787, no. 33 (fl. 130 to D'Roy); possibly
sale, Bryant, London, 1864 (bought in at £85); private collection,
Austria, 1925; A. M. Vroeg, Mookerheide, by 1926 and still in 1937;
Schaeffer, New York; bought from Schaeffer by the present
owner, 1952

LITERATURE
Hofstede de Groot 1907, no. 7; Leiden 1926, 27, no. 69; Bredius
1927, 29; Martin 1927–1928, 326, 330; Stechow 1928–1929, 174–175;
Martin 1954, 56–57; North Carolina Museum of Art 1956, 52, no.
68; Milwaukee 1976, 74–75, no. 32; Kirschenbaum 1977, 51, 69,
71–73, 97, 99, 111–112, no. 7; Braun 1980, 138, no. 351; Sutton
1982–1983, 19

With uninhibited joy and pleasure, the Israelites celebrate through song, dance, food, and drink the golden calf they had fashioned for themselves. Everyone takes part in the festivities, from the young couple in the foreground gazing lasciviously at one another, to the child hanging from the limb of a tree and the chain of dancers ringing the golden calf. The sounds of tambourine, flute, drum, triangle, and a barking dog add to the boisterous revelry, as the smell of food cooking in a large kettle over a roaring fire fills the air. Fine satin fabrics, elaborately patterned carpets, expensive vessels, cut flowers, and ripened fruit lend an air of sensual abundance and excess. From a platform near the golden calf the high priest Aaron presides over the festivities and waves a censer containing burning incense.

The Book of Exodus (32: 4–6) describes how the Israelites, impatient because Moses had not yet returned from Mount Sinai, asked Aaron to "make us gods." He in turn asked for their rings of gold and, with a graving tool, fashioned them into a "molten calf." The Israelites looked upon the calf and exclaimed:

'These are your gods, O Israel, who brought you up out of the land of Egypt!' When Aaron saw this, he built an altar before it; and Aaron made proclamation and said, 'Tomorrow shall be a feast to the Lord.' And they rose up early on the morrow, and offered burnt offerings and brought peace offerings; and the people sat down to eat and drink, and rose up to play.

The worship of the golden calf defied one of the fundamental laws of God's covenant. The Israelites had received the covenant at the foot of Mount Sinai after Moses had led them out of Egypt, and out of oppression. God had called to Moses to confirm that they would be his chosen people as long as they obeyed his voice and kept his covenant (Exodus 19: 5–6). It was also from Mount Sinai that God had issued the ten commandments, amidst clouds and accompanied by thunder, lightning, and the sound of trumpets. Terrified, the people had reacted by asking Moses to be God's spokesman. God then commanded him to tell the people of Israel: "You shall not make gods of silver to be with me, nor shall you make for yourselves gods of gold" (Exodus 20: 23). The worship of the golden calf, thus, expressly broke their convenant with God, a sin for which Moses attempted to atone, but which, nevertheless, earned God's wrath in the form of a plague.

Steen does not explicitly warn against the grave moral transgressions committed by the celebrants. He includes

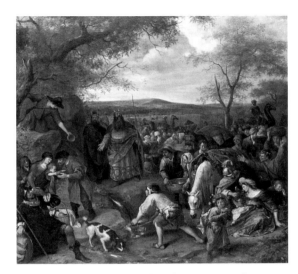

fig. 1. Jan Steen, *Moses Striking the Rock*, c. 1670–1671, oil on canvas, Philadelphia Museum of Art, The John G. Johnson Collection

neither God's nor Moses' angry reaction to the idolatry of the Israelites. Indeed, Moses is absent from the scene, and does not even appear, as is normally the case, in a small background vignette, smashing the tablets. Only a small parrot, held by the young boy to the left who looks out at the viewer, provides a subtle, easily overlooked comment on the dangers of sensual pleasure. In emblematic tradition, the parrot served as a warning against allowing appetites to dictate one's actions in the same reflexive manner that this bird responds to the human voice.[1]

The boy and parrot, however, are akin to the small voice of one's nagging conscience in a scene when everyone appears oblivious to the moral shortcomings of their actions. Through the sensual appeal of his image, Steen invites the viewer to empathize with, and even laugh at, the Israelites' hedonism. One should enjoy the obvious sexual allusion in the way the young man plays the triangle, or the slightly inebriated expression of his female companion as she sits with knees spread; and one is meant to groan at the crassness of the old woman, who appears much like a procuress, enticing the innocent flower girl with a gold coin. Critical judgment comes later, only after the viewer has understood how quickly and easily one can be seduced into breaking God's covenant.

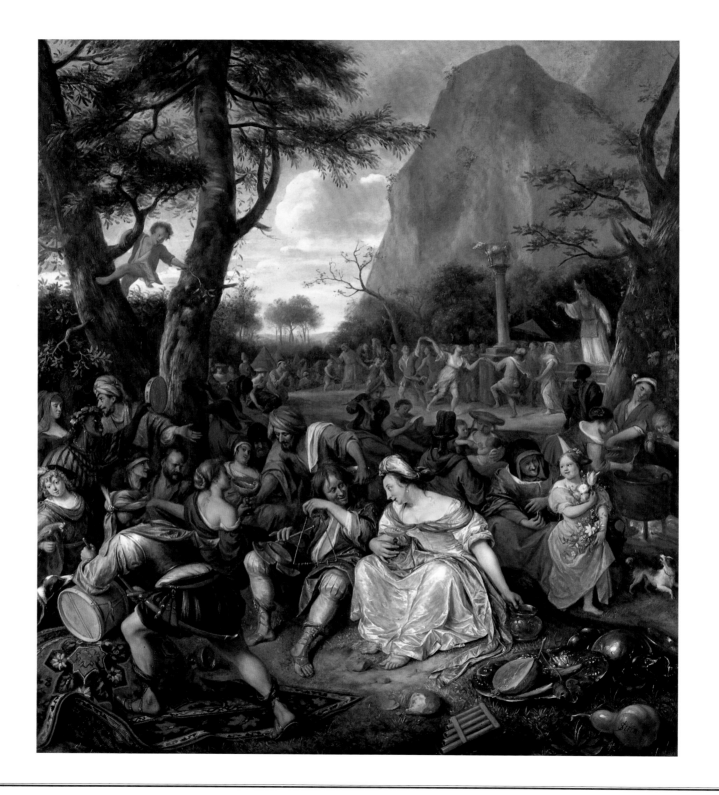

fig 2. Lucas van Leyden, *The Adoration of the Golden Calf*, c. 1529–1530, oil on panel, Rijksmuseum, Amsterdam

Steen painted various episodes from the Book of Exodus throughout his career.[2] As Sutton notes, Steen here adapted a number of compositional elements, and even figures, from an earlier painting of 1670–1671 (fig. 1).[3] Stylistically, this extremely large painting must date from the mid-1670s.[4] Steen's multi-figured compositions from those years often depicted one luxuriously dressed female situated in the midst of a pulsating crowd of revelers (see also cat. 48). While he suggested the delicate, soft sheen of satin dresses, the secondary figures are somewhat more heavily and broadly painted. Figures, landscape, and architectural settings from this period often serve more as a backdrop for the actors rather than as an organically related extension of the scene taking place.

Throughout his career Steen sought inspiration in the works of sixteenth-century masters. A rare direct connection can be discerned in the center panel of a triptych by Lucas van Leyden (1489–1533), *Dance around the Golden Calf* (fig. 2). As in Lucas' triptych, Steen filled the foreground with a large number of figures and relegated the dance to the background. Steen even included a number of sixteenth-century costume elements, including the woman's hat in the foreground and the cut leggings of her male companion. Indeed, the close connection between the two works indicates that Steen may have sought to pay homage to his great Leiden predecessor. Nevertheless, Steen fundamentally transformed Lucas' narrative structure. While Lucas included small background vignettes to illustrate episodes occuring prior and subsequent to the main scene—Moses speaking to God and Moses smashing the tablets—Steen dispensed with this sequential narration. With his more modern approach, he involved the viewer directly in the judgmental process.

While Steen's homage to his Leiden predecessor may be a manifestation of city pride, it is unclear whether Steen painted this work for a Leiden patron. The first record of *The Worship of the Golden Calf* is in an Amsterdam collection in 1749. Moreover, Lucas' triptych was not in Leiden in the early 1670s, but in Amsterdam.[5] Perhaps an Amsterdam collector, aware of Steen's ability to reinterpret sixteenth century images, commissioned a painting from Steen based on this famous prototype.

Steen occasionally gave an added dimension to his narratives in the way he signed his works. Not only did he make puns with his name and his monogram (cat. 19), he drew attention to specific objects by placing his signature over the objects. It was probably a conscious decision to place his signature on a gourd in the lower right of this composition. Names carved in gourds, of course, grow larger and deeper as the gourd ages. Maybe Steen wished for his name and fame to grow in a similar way. Or maybe he wanted to remind the viewer of one of Jacob Cats' emblems *'t Neemt toe, men weet niet hoe* (It grows, how one does not know), in which Cats exploited the phenomenon of the carvings in gourds. One of his explanations for the emblem is that while God's word is not always immediately apparent, its meaning becomes more apparent over time.[6]

A K W

1. Homann 1971, 62–63.

2. For the varied dates proposed for this work, see Sutton 1982–1983, 18.

3. See Sutton 1982–1983, 19.

4. Kirschenbaum dates this painting in the early 1670's, comparing the openness of the composition to Steen's *The Sacrifice of Iphigenia*, dated 1671 (see page 14, fig. 6), see Kirschenbaum 1977, 51, 111–112, cat. 7. Although Martin 1926, 330, proposed a date of around 1648, all subsequent authors have placed this work in the early 1670s.

5. For the provenance history of Lucas' triptych, see Smith 1992, 106–107, cat. no. 11.

6. Cats 1627, 32–33, emblem 6. I would like to thank Esmée Quodbach for bringing this reference to my attention.

48

Merry Company on a Terrace

c. 1673–1675

signed at lower right on base of balustrade: *JSteen* (*JS* in ligature)

canvas, 141.5 x 131.5 (55 ½ x 51 ¾)

The Metropolitan Museum of Art, New York, Fletcher Fund

PROVENANCE
Sale, Gerrit Schimmelpenninck, Amsterdam, 12 July 1819, no. 112 (for fl. 2499 to Albert Brondgeest); possibly sale, Watkins, London, 1854; sale, David P. Sellar of London, Paris, 6 June 1889, no. 70 (engraving by R. de Los Rios), bought in; sale, same owner, London, Christie's, 17 March 1894, no. 123, to Colnaghi, London; P. A. B. Widener, Philadelphia, c. 1894–1915; Joseph E. Widener, Philadelphia, 1915–1925; Douwes Brothers, Amsterdam, 1925–1928; A. J. M. Goudriaan, The Hague, and later J. M. A. Roosenburg-Goudriaan 1928–1957, on long-term loan to the Museum Boymans, Rotterdam; Captain Rosenberg, c. 1957–1958; Schaeffer, New York, 1958; bought by the present owner

LITERATURE
Smith 1829–1842, 4:5, no. 109; Van Westrheene 1856, 153, no. 296; Hofstede de Groot 1907, no. 443; Salinger 1959, 121–131; De Vries 1959, 30–31, 64; Banks 1977, 193–194; Braun 1980, 142, no. 374; Chapman 1993, 135–150

Steen's works frequently engage us by means of a figure who looks out at us and invites our participation (cats. 9 and 21). Here, the woman seated at the center of the picture tilts her head flirtatiously and captivates us with her inviting gaze. One of Steen's most brazen and most sumptuously painted seductresses, she wears a provocatively undone bodice of light blue satin and a skirt of deftly handled *changeant* copper and green. The two pink roses at her cleavage are flowers associated with Venus, the goddess of love. Underscoring her erotic appeal are her bright red shoes, rich with connotations of female sexuality.[1] Her wantonness is heightened by her pose: she rests one arm on the thigh of the romantic cittern player and, with the other, precariously holds out her glass for yet more wine. Her apron suggests she is the hostess or innkeeper's wife. The same woman also appears in the late *Bathsheba* (Braun 356) and *The Family of Cats* (fig. 1), and, although her identity is unverifiable, she is quite likely modeled after Steen's second wife, Maria Herculens, whom he married in 1673.

Her counterpart, the fat, jolly innkeeper, identified too by his apron, looks out at us and laughingly reiterates the invitation to join in the merrymaking. With his disheveled clothing and loose demeanor, he is a perfect match to the lady of the house. Even the earthenware jug that he suggestively holds up in his lap corresponds to her "thirsty" glass, eager to be re-filled. As in *The Family of Cats*, we recognize him as Jan Steen in a favorite role: the one derived from the presenter or narrator in theatrical and pictorial tradition.[2] Together, host and hostess draw our attention to the little boy in the lower left corner, who is distinguished by his ostentatious, black plumed beret and coral colored satin gown with brass buttons and a cape. Out of place in this jovial gathering, he invokes the fashionable portraits of children in pastoral guises, such as the *Portrait of Michiel Pompe van Slingelandt* of 1649 by Jacob Gerritsz Cuyp (1594–1650), which typically include animals—the obedient dog, the well-broken-in horse, the bridled goat, the innocent lamb—as emblems of the children's discipline, education, and proper upbringing (fig. 2).[3] Some years earlier, Steen had inventively drawn on this pastoral type for *The Poultry Yard* (cat. 12). In *Merry Company on a Terrace*, in an ironic reversal of these attributes of the well-reared child, and probably of this pretentious portrait type as well, Steen's little boy has harnessed his fine toy horse to the dog, insightfully characterized as indignant at being part

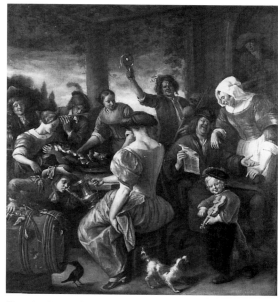

fig. 1. Jan Steen, *The Family of Cats*, c. 1675, oil on canvas, Szépmüvészeti Muzeum, Budapest

of this game and mistrustful of the boy's small whip. Discipline is misplaced when the overindulged child is left to take it into his own hands.

In this monumental late painting, Steen has recast the merry company theme in a theatrical and imaginary mode. Many of the revelers making music, flirting, and drinking wear sixteenth-century garb that would have evoked the stage. The cittern player is dressed in theatrical costume with slashed sleeves and pantaloons, and Steen himself wears slit sleeves. Just behind the artist, in what seems like a deliberate juxtaposition, is a "real" fool with a scepter, identified by the sausage on his cap as the stock character Hans Worst.[4] With his lasciviously wagging tongue, he accosts the generously *decolletéed* maid, while another burlesque type vies for her attention with an erotically charged flute.[5] In the ironically titled *Galant Offering* (fig. 3) a similar, lewd fool presents to the lady of the house an appropriately cocky gift of a herring and two onions. Next to this threesome a grandfatherly man in a comically large collar keeps his wineglass out of the reach of a baby girl, held in all her coral finery by her grandmother. At right, a youth stands on a ladder to pick a bunch of grapes to the amusement of a boy and girl. These young people, and the serenader on the balustrade,

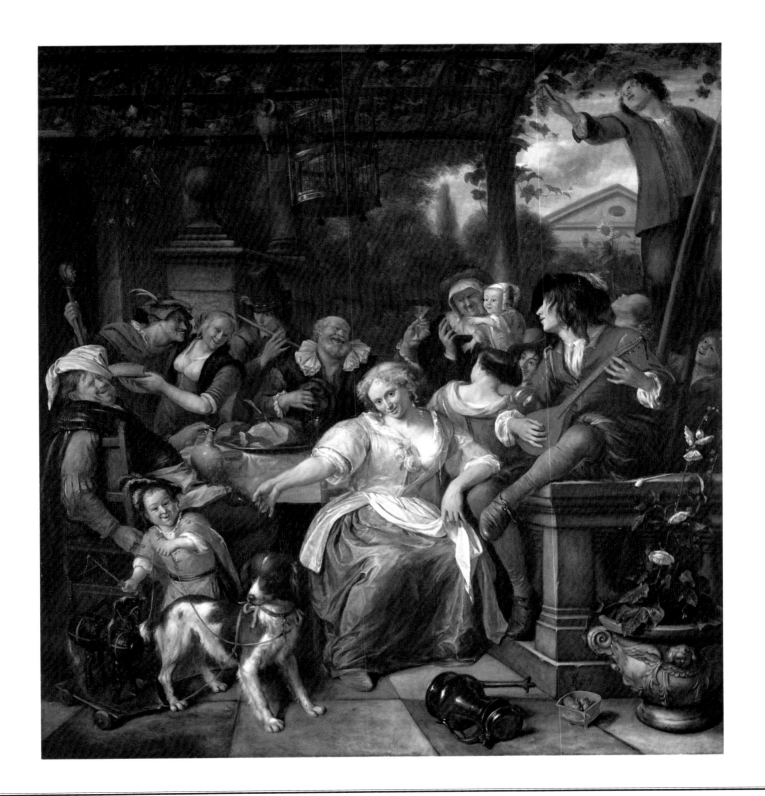

appear to be modeled after Steen's own children. Grapes feature prominently in family portraits as attributes of a fertile and virtuous marriage.[6] Though this is no portrait (despite its portraitlike edge), the grapes signal yet one more send up of the convention of family portraits. Whereas in traditional portraits of that type, grapes embody a fertility sanctioned by matrimony, this wayward family seems to breed on their bacchic juice, rather than on their sweet wholesomeness.

The stately garden backdrop, resembling the settings of pastoral family portraits, is too refined for these roisterers, as if they have risen above their proper lot in life. The lush growth of trees and pediment of an imposing home in the background indicate that this is a park or love garden, much like that in *The Garden Party* (cat. 49).

Steen routinely merged the home and the inn, which, at this time, may have particularly mirrored his own circumstances. For in 1672, two years after inheriting his father's house in Leiden, he applied for permission to open an inn there. However, this conflation of life and art should be understood as a comic strategy, not as autobi-

ography. Aside from the theatrical nature of this image, Steen evokes earlier pictorial traditions. The artist has here conflated the indoor merry company with the outdoor garden party under a pergola, two themes that were popular in the late sixteenth and early seventeenth centuries (see cat. 49, fig. 1).

Like these, Steen's picture is about foolish excess, yet he presents his moralizing message in more forgiving terms. References to folly still abound, whether conveyed through the temptress and the lewd fool, the owl perched outside the birdcage, or the overturned pitcher and brazier for lighting pipes.[7] However, compared to *In Luxury Beware* (cat. 21) with its emblematic basket to warn of folly's outcome, in this lighthearted image he has gone farther to make the unacceptable irresistible.

As a painting from Steen's last Leiden period, *Merry Company on a Terrace* shares with other late works its self-conscious changes of style and exaggeration of features from earlier in his career. While some paintings such as *A Village Revel* and *The Wedding Feast at Cana* (cats. 46, 43) grow even more spacious and their figures get smaller and more numerous, this painting fits within a second mode that includes *The Rich Man and Lazarus* (private collection) and *The Family of Cats* (fig. 1).[8] These works amplify the Jordaens-like aspects of some of the earlier pictures (for example, cat. 23): figures become more robust and monumental, they are grouped tightly yet more casually and pushed closer to the picture plane, drapery becomes more sumptuous and foliage becomes lusher. Steen's brushwork exhibits a new richness and softness as well. In certain respects these changes are in keeping with the increasing elegance of Dutch painting in the last third of the century. But in other respects, Steen's humor and theatricality become all the more comical and all the more stagy when cast, or miscast, in this customarily elegant sober style.

HPC

1. Red shoes, like red stockings, carried specific sexual significance. See Lowenthal 1995, 13.

2. Chapman 1990–1991, 190–193.

3. Bedaux 1990, 109–155; Franits 1993, 148–160. One of the closest formal precedents to Steen's boy-with-dog is the 1597 portrait of Frederick de Vries by Hendrick Goltzius (Bartsch 190), the so-called *Goltzius' Dog*. The engraving shows an aristocratically dressed boy, Goltzius' pupil at the time, beside an equally distinguished dog. The Latin dystich by Petrus Scriverus that accompanies this portrait expresses the youth's innocence and loyalty

fig. 2. Jacob Gerritsz Cuyp, *Portrait of Michiel Pompe van Slingelandt*, 1649, oil on canvas, Dordrechts Museum, Dordrecht (on loan from Rijksdienst Beeldende Kunst)

fig. 3. Jan Steen, *The Gallant Offering*, c. 1665–1668, oil on canvas attached to panel, Musées Royaux des Beaux-Arts de Belgique, Brussels

to his teacher. An evocation of this famous image in such a morally flexible "Merry Company" would have certainly caused a knowing chuckle among some of Steen's viewers.

4. For Hans Worst, see Gudlaugsson 1945, 54–57.

5. The Hague 1994b, 290, ill. 1.

6. De Jongh 1974; Bedaux 1990, 71–108.

7. For the owl as an emblem of blind folly, see cat. 41; for the overturned pitcher and brazier for lighting pipes as symbols of intemperance, see cat. 23.

8. Though neither of these works is dated, they have generally been assumed to come from the last years of Steen's career, probably between 1673–1675 and his death in 1679.

49

The Garden Party

1677
signed on the arched door frame: *J Steen. 1677* (*JS* in ligature)
canvas, 67 x 88 (26 ⅜ x 34 ⅝)
Private Collection, Belgium

PROVENANCE
Probably a member of the Paedts family, Leyden, from 1677;
possibly anonymous sale, Amsterdam, 12 September 1708, no. 39
(fl. 161); sale, Nic. Tjark et al., Amsterdam, 10 November 1762,
no. 28; sale, Johan van der Linden van Slingeland, Dordrecht, 22
August 1785, no. 398 (fl. 200 to Fouquet); anonymous sale,
Amsterdam, 5 December 1796, no. 104 (fl. 300 to Thompson);
sale, Thomas Emmerson, London, 15 June 1832 (£220 10s.); Lord
Northwick, Cheltenham, by 1833; his sale, London, 24 May 1838,
no. XX; sale, Meffre ainé (pseudonym of the Comte de Morny),
Paris, 25 February 1845, no. 86; sale, Héris, Brussels, 19 June 1846,
no. 69; sale, Désiré van den Schrieck, Louvain, 8 April 1861,
no. 104; sale, Count Fürstenberg et al., Cologne, 6 August 1877;
Gottschewski, Hamburg, 1920; De Burlett, Berlin, 1921;
K. Haberstock, Berlin, 1924; bought from Haberstock by
C. R. Semmel, Berlin, after 1924; Duits, Amsterdam, 1933; purchased from Duits (fl. 12,000 by L. Rozelaar), Amsterdam, 1933;
private collection, United States, by 1954; to the present owner

LITERATURE
Smith 1829–1842, 4:55–56, no. 163; Van Westrheene 1856, 119, no.
86; Hofstede de Groot 1907, no. 52; Bijleveld 1926, 132–135; Leiden
1926, 20, no. 72; Bredius 1927, 54; Schmidt-Degener and Van
Gelder 1927, 81–82, pl. 40; Martin 1927–1928, 326; Gudlaugsson
1945, 46; Martin 1954, 57; The Hague 1958, 58; Rosenberg, Slive,
and Ter Kuile 1966, 237; Kirschenbaum 1977, 52–55, 151, no. 13;
Braun 1980, 142, no. 373.

fig. 1. David Vinckboons, *Outdoor Merry Company*, 1610, oil and tempera on panel, Gemäldegalerie der Akademie der bildenden Künste in Wien

A delightful late work that shows Steen to have been vital and creative to the end of his career, *The Garden Party* at once revives early seventeenth-century *buitenpartijen* (outdoor merry companies) and anticipates the *fêtes galantes* of the rococo. In a garden bounded by imposing classicizing edifices and a park dense with lush foliage, couples flirt and lovers dally to the serenading of a guitar and flute. This courting takes place in an imaginary world, which Steen has defined by creating two distinct realms. The lady and gentlemen strolling decorously behind the balustrade and in front of the distant stately house, which resembles one in Leiden, wear the elegant fashions of the 1670s. The foreground figures, in contrast, are dressed in fanciful theatrical costumes and their gestures, poses, and facial expressions are exaggerated. The fluteplayer, reminiscent of figures from Utrecht or even Venetian pastoral painting, imparts an arcadian note to the staged remoteness of this love garden.[1] With this artifice, enhanced by his light palette, soft brushstrokes, and refined description of satins and brocades, Steen has created the ideal setting for love.

Yet the initial illusion of an idyll is literally burst by the two urchins blowing bubbles on the steps, familiar reminders of the transience of earthly delights.[2] More important, Steen has created a psychological tension and eroticized the picture by hinting at a comical yet mildly poignant narrative. Confounding our expectations that the most prominent pair seated at the center be amorous-

ly intimate, Steen has these would-be lovers turn their heads apart, their attentions elsewhere. The languid young man has eyes only for the wine being poured into his glass. His flushed face and dishevelment suggest he has drunk too much for wine to inspire love and instead bring to mind the proverb "wine is a mocker," which Steen had painted several times (see cat. 38).[3] In contrast, his voluptuous companion, whose *décolletage* and luxurious satin gown distinguish her, perhaps, as a courtesan, seems eager for love. Her eyes meet those of the handsome guitar player, elegant in his plumed hat, brocade vest, slashed pants, and a fine handkerchief, whose strategically placed sword hilt indicates his arousal.[4] This suggestion of illicit love is echoed in the flirting between the man and the servant and between the old man and young woman at the table at left, who evoke the sixteenth-century theme of the ill-matched pair.[5]

Juxtaposed with this imagery of luxurious worldly love are subsidiary emblematic details that refer to true love and marriage and thus support the work's underlying cautionary message. The young woman who caresses the old man also points to an orange, a symbol of fertility in marriage and an apt foil to the proverbially infertile union of unequal lovers.[6] The sunflower in the more stolid, background realm symbolizes fidelity because of its habit of always facing the sun.[7] The facade in the foreground provides a somber architectural setting for a cautionary reminder of the sort that is so characteristic of

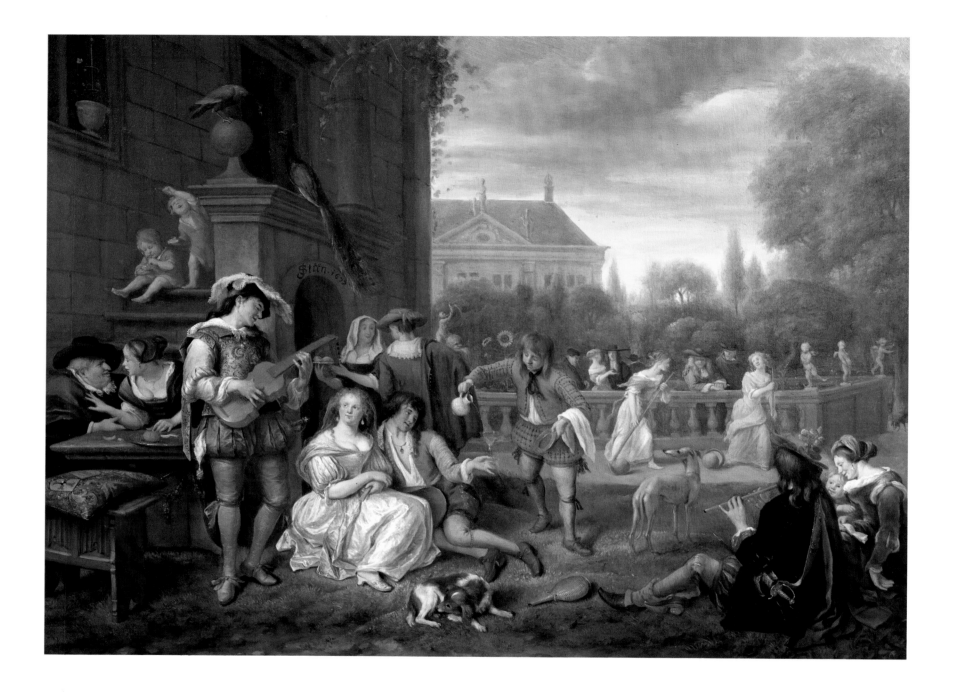

Steen: in addition to the *homo bulla* urchins, the pair of peacocks brings to mind an emblem showing a male and female peacock with lovers in the background inscribed "The heart on high and the eye to the grave, that banishes splendor and pride."[8] A comment on "the game of love" is further embodied in the two young women in marvelously diaphanous gowns who play *beugelen*, or ringball, a game with erotic connotations clearly conveyed in the motto *Niet voor, maer door* (Not in front, but through).[9] But the game's more elevated reference to the futility of frivolous love is expressed in the caption of another emblem: "It is a proverb: in the game of love, he who loses always wins."[10]

Though it has been suggested that in the *Garden Party* Steen parodied upper-class Dutch society,[11] this is unlikely since he probably painted it for a prominent Leiden family. While the circumstances of its production are not documented, they can be surmised from the coat of arms of the Paedts family on the cushion on a stool in the left foreground and from the resemblance between the elegant house in the background and the rear facade of the residence of Jacob Paedts, one of the members of this established patrician clan.[12]

Further, the painting seems to have been designed to appeal to a patrician client. On the one hand, the picture played to the current vogue for pleasure gardens and rural estates, for amatory songbooks and country house poems, and for portraits and conversation pieces in garden settings by Jacob van Loo (1614–1670) and Gerbrand van der Eeckhout (1621–1674).[13] On the other hand, a sophisticated, informed client would have recognized the *Garden Party* as a witty recasting of an old theme, the Garden of Love, and appreciated Steen's characteristic archaizing with its lighthearted, somewhat anachronistic comment on human nature. Of late medieval origin, the theme found its culmination in Rubens' (1577–1640) sumptuous *Garden of Love* (Prado, Madrid), which celebrates an aristocratic ideal of courtship.[14] Steen's comically indecorous gathering lacks the politesse of Rubens' poetic *conversation à la mode*, but the two works share essential features of the type: a formal park setting with a classicizing edifice and fountains, elegant courting couples, music-making, and cupids. Characteristically, Steen has transformed Rubens' heavenly putti into a delightfully lifelike trio of statues of cupids that skate, piss, and are blindfolded. Aspects of Steen's picture indicate he was responding specifically to more familiar precedents, the early sev-

enteenth-century Dutch *buitenpartijen* by David Vinckboons (1576–1632) (fig. 1), Willem Buytewech (c. 1590–1630), Dirk Hals (1591–1656), and Esaias van de Velde (c. 1591–1630) that simultaneously celebrated Holland's new prosperity and independence yet warned against the consequences of luxury and excess.[15]

Steen's moralizing bent must have drawn him to the out-moded didacticism of these *buitenpartijen*. However, Steen has distilled the material accoutrements of excess in the early garden parties—the lavish banquets, elaborate wine coolers, peacock pies—to little more than that single glass of wine being poured by the page in red, thereby transferring emphasis to human appetites and emotions. The inebriated young man is reminiscent, in his isolation, of the more dissipated figures from the early tradition, some of whom are actually the Prodigal Son.[16] It was probably for this reason that Steen's picture has been called the Prodigal Son in the past:[17] though there is no direct reference to the biblical theme, at least some of Steen's contemporaries would have linked this work with the pictorial and theatrical tradition and regarded the young man as a modern day prodigal.

One of the last dated paintings in his oeuvre, *The Garden Party* shows that Steen was still capable of inventing a marvelous composition. Further, it helps us to date other works such as *A Merry Company on a Terrace* (cat. 48) that share its light palette and subdued pastel coloring. Viewed together, these two pictures exemplify Steen's two late modes, one of monumental figures that crowd the picture space (as, for example, cat. 48) and the other more spacious and open.

It seems surprising that a picture that so clearly draws on an early seventeenth-century type should also be such an uncanny premonition of Watteau's *fêtes galantes*.[18] Though it can not be cited as a specific source for eighteenth-century French painters, it is possible to see how this revival of the love garden type and transformation of old-fashioned moralizing into heightened emotionalism point toward the next century.

HPC

1. Utrecht 1993 and Kettering 1983 for pastoralism in Dutch literature and art.

2. For the soap bubble as a *vanitas* symbol, see Stechow 1938, 227–228; Amsterdam 1976a, 45; Durantini 1993, 232–239. A bubble blowing child adds a similar footnote in Steen's *Life of Man* (Royal Cabinet of Paintings Mauritshuis, The Hague). For additional references, see cat. 20.

3. See cat. 38.

4. Like the flute, the guitar was an instrument with low connotations. For its presence in low-life tavern scenes, see David Rijckaert III, *The Guitar Player*, 1641, in The Hague 1994b, cat. 35.

5. Silver 1974; Stewart 1979. On the unequal lovers theme, see cat. 42, which commented on the folly of mercenary or licentious love.

6. Bedaux 1990, 48.

7. Jacob Cats advised a young woman to focus her attention to her lover as the sunflower turns toward the sun: *En weest aen uwen man een rechte Sonne-blom*, in Cats 1665, 85. See also Van Veen 1608, 74–75. On the sunflower, see Haarlem 1986, 90–92, with additional bibliography. See cat. 6 n. 7.

8. *Het hart om hoogh en 't oogh na't graf, / Dat schaft de praal en hooghmoedt af*, Van der Veene 1642, 92–93.

9. This game, similar to golf, was played with a longer stick and a larger ball and its object was to hit the ball through a ring. This motto accompanied an illustration attributed to Adriaen van de Venne of an elegant couple playing ringball. See Royalton-Kisch 1988, 84.

10. *C'est un proverb; aux ieu d'Amour. / Celuy qui perd, gaigne tousiour*, Snijders 1629, 98–99. For skittles as a game of love, see Goodman 1979, 147–158.

11. Kuznetsov 1958, 410–412; The Hague 1958, no. 58; Kirschenbaum 1977, 53–54.

12. For this resemblance between the painted building and the house of Jacob Paedts at Rapenburg 19 in Leiden, see Bijleveld 1926, 132–35. Bredius suggested that this picture was painted to commemorate a Paedts wedding that took place the next year, which is possible given the amorous yet cautionary nature of the subject matter and the tradition of celebrating marriage with festive comedy. Bredius 1927, 54. See Barolsky 1978, 158–182, for paintings as comic epithalamia.

13. For paintings of more contemporary garden parties, see Pieter de Hooch's *Game of Skittles* (Waddesdon Manor, Aylesbury, Buckinghamshire) and Ludolf de Jongh's *Women in a Garden* (Count Natale Labia Collection, Cape Town).

14. Steen could have known Rubens' composition through an engraving of 1665. See Goodman 1992, 78–80, for this print and the accompanying lyrics.

15. Haverkamp-Begemann 1959, 24 Amsterdam 1976a, 273–275, Amsterdam 1993, 90–100.

16. As, for example, in Vinckboons' print. For the conflation of the two pictorial traditions in these garden parties, the Garden of Love and the didactic parable of the Prodigal Son, see Philadelphia 1984, 329.

17. Hofstede de Groot no. 52; Leiden 1926, cat. 72, 28.

18. The Hague 1958, no. 58; Rosenberg, Slive, and Ter Kuile 1966, 237; Kirschenbaum 1977, 53, 151; Banks 1977, 187–196.

BIBLIOGRAPHY

Ackermann 1993: Ackermann, Philipp. *Textfunktionen und Bild in Genreszenen der niederländischen Graphik des 17. Jahrhunderts.* Alfter.

Albach 1977: Albach, Ben. *Langs kermissen en hoven: Ontstaan en kroniek van een Nederlands toneelgezelschap in de 17de eeuw.* Zutphen.

Album Studiosorum **1875:** Du Rieu, Guilielmo. *Album Studiosorum Academiae Lugduno Batavae 1625–1875.* The Hague.

Alfrink 1942: Alfrink, Bern. "Raphael, niet Daniël bij Jan Steen." *Oud-Holland* 59: 127–128.

Alpers 1972–1973: Alpers, Svetlana. "Bruegel's Festive Peasants." *Simiolus* 6: 163–176.

Alpers 1975–1976: Alpers, Svetlana. "Realism as a Comic Mode: Low-life painting seen through Bredero's Eyes." *Simiolus* 8: 115–144.

Alpers 1988: Alpers, Svetlana. *Rembrandt's Enterprise: The Studio and the Market.* Chicago.

Ampzing 1630: Ampzing, Samuel. *Baals-hoogten....* Haarlem.

Amsterdam 1929: *Tentoonstelling van oude kunst.* Rijksmuseum.

Amsterdam 1939: *Bijbelsche kunst.* Rijksmuseum.

Amsterdam 1975: *Leidse universiteit 400. Stichting en eerste bloei— ca. 1650.* Rijksmuseum.

Amsterdam 1976a: De Jongh, Eddy, et al. *Tot lering en vermaak: Betekenissen van Hollandse genrevoorstellingen uit de zeventiende eeuw.* Rijksmuseum.

Amsterdam 1976b: Van Veen, C. F. *Centsprenten. Nederlandse volks- en kinderprenten/ Catchpenny prints. Dutch Popular and Children's prints.* Rijksprentenkabinet.

Amsterdam 1978: *Het vaderlandsch gevoel: vergeten negentiende-eeuwse schilderijen over onze geschiedenis.* Rijksmuseum.

Amsterdam 1985: Filedt Kok, J. P. *The Master of the Amsterdam Cabinet, or The Housebook Master, ca. 1470–1500.* Rijksprentenkabinet.

Amsterdam 1987: Sutton, Peter C., et al. *Masters of 17th-Century Dutch Landscape Painting.* Rijksmuseum.

Amsterdam 1989: Hecht, Peter. *De Hollandse fijnschilders: van Gerard Dou tot Adriaen van der Werff.* Rijksmuseum.

Amsterdam 1991: Tümpel, Christian. *Het Oude Testament in de schilderkunst van de gouden eeuw.* Joods Historisch Museum.

Amsterdam 1992: Bergvelt, Elinoor, and Renée Kistemaker, eds. *De wereld binnen handbereik. Nederlandse kunst- en rariteitenverzamelingen, 1585–1735.* Amsterdams Historisch Museum.

Amsterdam 1993: Luijten, Ger, et al. *Dawn of the Golden Age. Northern Netherlandish Art, 1580–1620.* Rijksmuseum.

Amsterdam 1994: Kistemaker, R. A., et al. *Bier! Geschiedenis van een volksdrank.* Amsterdams Historisch Museum.

Amsterdamsche lichtmis **1983:** *De Amsterdamsche lichtmis, of zoldaat van fortuin.* Bert Pol, ed. Muiderberg.

Amsterdamse mengelmoez **1658:** *Het eerste deel van de Amsterdamse mengelmoez: Bestaende uit veelderhande bootzigh, en geestigh rijm-tuigh, als kusjens, minne-deunen, verjaar-zangen, drink-lieden, klink-rijmen, en tusschen de zelve verzien met rondeeltjens, en andere snaak-erijtjens.* Amsterdam.

Angel 1642: Angel, Philips. *Lof der schilder-konst.* Leiden.

Ankersmit 1990: Ankersmit, Frank R. *De navel van de geschiedenis: over interpretatie, representatie en historische realiteit.* Groningen.

Antal 1925: Antal, Friedrich. "Concerning Some Jan Steen Pictures in America." *Art in America and Elsewhere* 13 (April): 106–116.

Antwerp 1991: Klinge, Margret. *David Teniers de Jonge: Schilderijen, tekeningen.* Koninklijk Museum voor Schone Kunsten.

Antwerp 1993: D'Hulst, R. A., Nora de Poorter, and Marc Vandenven. *Jacob Jordaens (1593–1678).* 2 vols. Koninklijk Museum voor Schone Kunsten.

Apeldoorn 1989: Van Boheemen, Petra, et al. *Kent, en versint eer datje mint: Vrijen en trouwen 1500–1800.* Historisch Museum Marialust.

Armstrong 1990: Armstrong, Christine Megan. *The Moralizing Prints of Cornelis Anthonisz.* Princeton.

Asselijn 1968: Asselijn, Thomas. *Jan Klaaz of Gewaande Dienstmaagt.* G. Stellinga, ed. Gorinchem.

Athens (Georgia) 1994: Pelletier, S. William, Leonard J. Slatkes, and Linda Stone-Ferrier. *Adriaen van Ostade: Etchings of Peasant Life in Holland's Golden Age.* Georgia Museum of Art.

Avontuer van twee goelieven **1988:** E. K. Grootes et al., eds. *Wonderlicke avontuer van twee goelieven: Een verhaal uit 1624.* 2d. ed. Muiderberg.

Bailey 1914: Bailey, L. H. *Standard Cyclopedia of Horticulture.* London.

Bal 1990: Bal, Mieke. *Verf en verderf. Lezen in Rembrandt.* Amsterdam.

Baldinucci 1681–1728: Baldinucci, Filippo. *Notizie de' professori del disegno...* 6 vols. Florence.

Banks 1977: Banks, Oliver. *Watteau and the North. Studies in the Dutch and Flemish Baroque Influence on French Rococo Painting.* New York.

Barbet 1633: Barbet, J. *Livre d'architecture d'autels, et de chiminées....* Paris.

Barner 1970: Barner, W. *Barok-Rhetorik.* Tübingen.

Barolsky 1978: Barolsky, Paul. *Infinite Jest: Wit and Humor in Italian Renaissance Art.* Columbia.

Barolsky 1990: Barolsky, Paul. *Michelangelo's Nose: A Myth and its Maker.* University Park.

[Barth] 1624: [Barth, C. W.] *Incogniti scriptoris nova poemata... Nieuwe Nederduytsche gedichten ende raedtselen.* 3d ed. Leiden.

Barthes 1986: Barthes, Roland. "The Reality Effect." *The Rustle of Language.* Richard Howard, trans. New York: 141–148. 1st ed., Paris, 1968.

Bartsch 1803–1821: Bartsch, Adam von. *Le peintre graveur.* 21 vols. Vienna. (also abbreviated as **B**.)

Bartsch Illustrated 1978: Strauss, Walter L., ed. *The Illustrated Bartsch.* Vol.1. New York.

Basel 1987: Doesschate-Chu, P. ten, and P. Boerlin. *Im Lichte Hollands.* Kunstmuseum.

Bax 1951: Bax, Dirk. *Skilders wat vertel.* Oxford.

Bax 1952: Bax, Dirk. *Hollandse en Vlaamse schilderkunst in Zuid-Afrika.* Amsterdam.

Bax 1979: Bax, Dirk. *Hieronymus Bosch: His Picture Writing Deciphered.* Rotterdam.

Bazin 1952: Bazin, Germain. "La notion d'intérieur dans l'art Néerlandais." *Gazette des Beaux-Arts* 39 (January): 5–26.

Beck 1972: Beck, Hans-Ulrich. *Jan van Goyen, 1596–1656.* Vol. 1. Amsterdam.

Bedaux 1975: Bedaux, Jan Baptist. "Minnekoorts-, zwangerschaps-, en doodsverschijnselen op zeventiende-eeuwse schilderijen." *Antiek* 10 (June–July): 17–42.

Bedaux 1990: Bedaux, Jan Baptist. "Discipline for Innocence. Metaphors for Education in Seventeenth-century Dutch Painting." *The Reality of Symbols: Studies in the Iconology of Netherlandish Art 1400–1800.* The Hague: 109–169.

Beit Collection 1904: Bode, Wilhelm von. *Die Kunstsammlungen des Alfred Beit in seinem Stadthause in Park Lane zu London.* Berlin.

Beit Collection 1913: Bode, Wilhelm von. *Catalogue of the Collection of Pictures and Bronzes in the Possession of Mr. Otto Beit.* London.

Bellori 1672: Bellori, Giovanni Pietro. *Le vite de' pittori, scultori et architetti moderni.* Rome. (Reprint. Genoa, 1968.)

Belonje 1983: Belonje, Johan. *Het Huis Dampegeest bij Limmen.* Arnhem.

Belvoir Castle 1891: *Portraits and Pictures, Belvoir Castle.* Belvoir Castle.

Van den Berg 1992: Van den Berg, B. *De Pieterskerk in Leiden.* Utrecht.

Bergström 1966: Bergström, Ingvar. "Rembrandt's Double-Portrait of Himself and Saskia at the Dresden Gallery: a Tradition Transformed." *Nederlands Kunsthistorisch Jaarboek* 17: 143–169.

Berlin 1991a: Brown, Christopher, Jan Kelch, and Pieter van Thiel. *Rembrandt: The Master & His Workshop. The Paintings.* Gemäldegalerie, Staatliche Museen zu Berlin.

Berlin 1991b: Bevers, Holm, Peter Schatborn, and Barbara Welzel. *Rembrandt: The Master and His Workshop. Drawings and Etchings.* Kupferstichkabinett, Staatliche Museen zu Berlin.

Berry 1994: Berry, Christopher J. *The Idea of Luxury: A Conceptual and Historical Investigation.* Cambridge.

Van Beverwijck 1651: Van Beverwijck, Johan. *Schat der Gesontheydt.* Utrecht.

Bicker Caarten 1949: Bicker Caarten, A. "Het vroegere gebruik van de bakkershoren in Leiden en Rijnland." *Jaarboekje voor geschiedenis en oudheidkunde van Leiden en omstreken* 41: 85–91.

Bijleveld 1926: Bijleveld, W. J. J. C. "Het tuinfeest van Jan Steen." *Oud-Holland* 43: 132–135.

Bijleveld 1950: Bijleveld, W. J. J. C. *Om den Hoenderhof door Jan Steen.* Leiden.

Birmingham 1952: *Catalogue of the Paintings, Drawings, and Miniatures in the Barber Institute of Fine Arts.* Cambridge.

Birmingham 1983: *Handbook of the Barber Institute of Fine Arts.* Birmingham.

Blankert 1978: Blankert, Albert. *Vermeer of Delft.* Oxford.

Van Bleyswijck 1667: Van Bleyswijck, Dirck. *Beschryvinge der stadt Delft.* 2 vols. Delft.

Boccaccio 1697: Boccaccio, Giovanni. *Contes et nouvelles de Bocace Florentin...enrichie de figures en taille-douce gravées par Mr. Romain de Hooge.* 2 vols. Amsterdam.

Bode 1873: Bode, Wilhelm von. "Zur Biographie und Characteristik Jan Steen's." *Zeitschrift für Bildende Kunst* 8: 352–357.

Bode 1900: Bode, Wilhelm von. *Gemäldesammlung des Herrn Rudolf Kann in Paris.* 2 vols. Vienna.

Bode 1907: Bode, Wilhelm von. *Catalogue de la collection Rudolphe Kann.* 4 vols. Paris.

Bode 1908: Bode, Wilhelm von. *Die Sammlung Oscar Hainauer.* London.

Boer 1994: Boer, Eugenie M. A. "*Voor elc wat wils,* Vier Sint-Nicolaasfeesten van Jan Steen." *Antiek* 24 (November): 17–23.

Bok 1990: Bok, Marten Jan. "'Nulla dies sine Linie': De opleiding van schilders in Utrecht in de eerste helft van de zeventiende eeuw." *De zeventiende eeuw* 6: 58–68.

Bok 1994: Bok, Marten Jan. "Vraag en aanbod op de Nederlandse kunstmarkt, 1580–1700." Ph.D. diss., Rijksuniversiteit, Utrecht.

Böse 1985: Böse, J. H. "*Had de mensch met één vrou niet connen leven...*" *Prostitutie in de literatuur van de zeventiende eeuw.* Zutphen.

Boymans-van Beuningen 1938: *Meesterwerken uit vier Eeuwen.* Rotterdam.

Boymans-van Beuningen 1962: *Catalogus schilderijen tot 1800.* Rotterdam.

Braider 1993: Braider, Christopher. *Refiguring the Real: Picture and Modernity in Word and Image, 1400–1700.* Princeton.

Brandt and Hogendoorn 1992: Brandt, George W., and Wiebe Hogendoorn, eds. *German and Dutch Theatre, 1600–1848.* Cambridge.

Braun 1980: Braun, Karel. *Alle tot nu toe bekende schilderijen van Jan Steen.* Rotterdam.

Bredero 1617: Bredero, Gerbrand Adriaensz. *G.A. Brederoos Moortje....* Amsterdam.

Bredero 1622: Bredero, Gerbrand Adriaensz. *Boertigh, amoreus, en aendachtigh groot lied-boeck.* Amsterdam.

Bredero 1966: Bredero, Gerbrand Adriaensz. *Groot-Lied-Boek.* A. A. van Rijnbach, ed. Rotterdam.

Bredero 1982: Bredero, Gerbrand Adriaensz. *The Spanish Brabanter. A Seventeenth-Century Dutch Social Satire in Five Acts.* H. David Brumble III, trans. New York.

Bredius 1882–1883: Bredius, Abraham. "De boeken van het Leidsche St. Lucas-Gilde." *Archief voor Nederlandsche kunstgeschiedenis* 5: 172–259.

Bredius 1896: Bredius, Abraham. "Jan Josephszoon van Goyen: nieuwe bijdragen tot zijne biographie." *Oud-Holland* 14: 113–125.

Bredius 1899: Bredius, Abraham. *Jan Steen: met honderd platen.* Amsterdam.

Bredius 1907: Bredius, Abraham. "Jan Steen." *Elsevier's Geïllustreerd Maandschrift* 16: 13–24.

Bredius 1915–1922: Bredius, Abraham. *Künstler-Inventare.* 7 vols. The Hague.

Bredius 1926: Bredius, Abraham. "Een Jan Steen van 1646?" *Oud-Holland* 63: 267–268.

Bredius 1927: Bredius, Abraham. *Jan Steen.* Amsterdam.

Bremmer 1943: Bremmer, H. P. "Het gebed voor den maaltijd." *Maandblad voor beeldende kunsten* 20: 154–157.

Bremmer 1946: Bremmer, H. P. "Jan Steen de aanbidding der herders." *Die constgshellen* 1 (December): 164–166.

Brieger 1943: Brieger, Peter. "War Guests of Canada: A Titian and a Jan Steen." *Canadian Art* 1 (October–November): 2–4.

Broersen 1993: Broersen, E. "Judith Leystar, een kloeke schilderes." In Haarlem 1993: 15–37.

Broos 1987: Broos, Ben. *Meesterwerken in het Mauritshuis.* The Hague. Paris, 1986.

Broos 1990: Broos, A. J. M. *Tussen zwart en ultramarijn: De levens van schilders beschreven door Jacob Campo Weyerman (1677–1747).* Amsterdam.

Brown 1984: Brown, Christopher. *Images of a Golden Past: Dutch Genre Painting in the Seventeenth Century.* New York. (Dutch ed. Amsterdam, 1984.)

De Brune 1624: De Brune, Johan. *Emblemata of zinne-werck.* Amsterdam. (2d ed., 1661.)

Brussels 1985: Van der Stock, Jan. *Cornelis Matsys 1510/1511–1556/1557: oeuvre graphique.* Bibliothèque Royale Albert I.

Bruyn 1991: Bruyn, Josua. "Rembrandts werkplaats: functie en productie." In Berlin 1991: 68–89.

Bruyn et al. 1982–1989: Bruyn, Josua et al. *A Corpus of Rembrandt Paintings.* 3 vols. The Hague.

Bruyn and Emmens 1956: Bruyn, Josua and J. A. Emmens. "De zonnebloem als embleem in een schilderijlijst." *Bulletin van het Rijksmuseum* 4: 3–9.

Buijsen 1991: Buijsen, Edwin. "Een terugblik op het symposium *De Kunst van het Verzamelen.*" *De Kunst van het Verzamelen* (October), 7–11 (Mauritshuis Cahiers).

Burty 1860: Burty, P. H. "Mouvement des arts et de la curiosité." *Gazette des Beaux-Arts* 6 (April): 47–59.

Bury 1961: Bury, A. "Scipio and Jan Steen." *Connoisseur* 147 (April): 134.

Butler 1982–1983: Butler, Marigene H. "Appendix: An Investigation of the Technique and Materials Used by Jan Steen." In *Jan Steen: Comedy and Admonition. Philadelphia Museum of Art Bulletin* 78 (Winter/Spring): 44–61.

Cain 1903: Cain, Georges. *La collection Dutuit au Petit Palais des Champs-Elysées.* Paris.

Calmann 1960: Calmann, Gerta. "The Picture of Nobody. An Iconographical Study." *Journal of the Warburg and Courtauld Institutes* 23: 60–104.

Cats 1618: Cats, Jacob. *Proteus of sinne- en minnebeelden.* Middelburg.

Cats 1625: Cats, Jacob. *Houwelyck: Dat is de gansche gelegentheyt des echtenstaets.* Middelburg.

Cats 1627: Cats, Jacob. *Proteus, ofte, minne-beelden verandert in sinne-beelden.* Rotterdam.

Cats 1632: Cats, Jacob. *Spiegel van den ouden ende nieuwen tijdt....* The Hague.

Cats 1637: Cats, Jacob. *Trou-ringh.* Dordrecht.

Cats 1642: Cats, Jacob. *Houwelyck....* Haarlem.

Cats 1665: Cats, Jacob. *Alle de Werken.* Amsterdam.

Chapman 1990: Chapman, H. Perry. *Rembrandt's Self-Portraits: a Study in Seventeenth-Century Identity.* Princeton.

Chapman 1990–1991: Chapman, H. Perry. "Jan Steen's Household Revisited." *Simiolus* 20 (2): 183–196.

Chapman 1993: Chapman, H. Perry. "Persona and Myth in Houbraken's Life of Jan Steen." *Art Bulletin* 75: 135–150.

Chapman 1995: Chapman, H. Perry. "Jan Steen as Family Man. Self-Portrayal as an Experienced Mode of Painting." *Nederlands Kunsthistorisch Jaarboek* 46: 368–393.

Cheney 1987: Cheney, Linda de Girolami. "The Oyster in Dutch Genre Paintings: Moral or Erotic Symbolism?" *Artibus et historiae* 15: 135–158.

Chiarini 1989: Chiarini, Marco. *Gallerie e musei statali di Firenze. I dipinti olandesi del Seicento e del Settecento.* Rome.

Clason 1980: Clason, A. T., ed. *Zeldzame huisdierrassen.* Zutphen.

Cleves 1983: *Die Lebenstreppe: Bilder der menschlichen Lebensalter.* Städtisches Museum Haus Koekkoek.

Cologne 1991: Levine, David A. and Ekkehard Mai, eds. *I Bamboccianti: Niederländische Malerrebellen im Rom des Barock.* Wallraf-Richartz-Museum.

Coon 1665: Coon, P. *Almanach voor heden en morgen.* Antwerp.

Cornelis 1995: Cornelis, Bart. "A reassessment of Arnold Houbraken's *Groote schouburgh.*" *Simiolus* 23: 163–180.

Criegern 1971: Criegern, Axel von. "Abfahrt von einem Wirthaus, Ikonographische Studie zu einem Thema von Jan Steen." *Oud-Holland* 86: 9–31.

Crombie 1964: Crombie, T. "Netherlands November." *Apollo* 80 (November): 410.

Curtius 1963: Curtius, Ernst Robert. *European Literature and the Latin Middle Ages.* New York and Evanston.

Defoer 1980: Defoer, H. L. M. "'Ex Morte Levemen,' een Ongelijk Paar door Jan Steen." *Antiek* 15 (December): 262–266.

Dekker 1987: Dekker, Rudolf M. "Women in Revolt: Popular Protest and Its Social Basis in Holland in the Seventeenth and Eighteenth Centuries." *Theory and Society: Renewal and Critique in Social Theory* 16 (May): 337–362.

Dekker and Roodenburg 1984: Dekker, Rudolf M., and Herman Roodenburg. "Humor in de zeventiende eeuw: opvoeding, huwelijk en seksualiteit in de moppen van Aernout van Overbeke (1632–1674)." *Tijdschrift voor Sociale Geschiedenis* 10: 243–266.

Delft 1964: *De schilder en zijn wereld.* Stedelijk Museum 'het Prinsenhof.'

Demus et al. 1981: Demus, Klaus, Friderike Klauner, and Karl Schütz. *Flämische Malerei von Jan van Eyck bis Pieter Bruegel D.Ä. Führer durch das Kunsthistorisches Museum* 31. Vienna.

Deneef 1973: Deneef, A. Leigh. "Epideictic Rhetoric and the Renaissance Lyric." *The Journal of Medieval and Renaissance Studies* 3: 203–231.

Descamps 1753–1764: Descamps, J. B. *La Vie des peintres flamands, allemands, et hollandais.* 4 vols. Paris.

Van Deursen 1991: Van Deursen, A. T. *Mensen van klein vermogen. Het 'kopergeld' van de Gouden Eeuw.* Amsterdam. (English ed. Cambridge and New York, 1991.)

Dickey 1995: Dickey, Stephanie S. "Met een wenende ziel...doch droge ogen. Women Holding Handkerchiefs in Seventeenth-Century Dutch Portraits." *Nederlands Kunsthistorisch Jaarboek* 46: 332–367.

Dixon 1995: Dixon, Laurinda S. *Perilous Chastity: Women and Illness in Pre-Enlightenment Art and Medicine.* Ithaca, New York.

Doove 1968: Doove, J. A. F. "Van Rhynsburch x Steen = De Voys: familierelaties tussen drie Leidse geslachten." *Jaarboekje voor geschiedenis en oudheidkunde van Leiden en omstreken* 60: 39–57.

Dudok van Heel 1991: Dudok van Heel, S. A. C. "Rembrandt van Rijn (1606–1669): Een veranderend schildersportret." In Berlin 1991: 50–67.

Dudok van Heel 1994: Dudok van Heel, S. A. C. "De remonstrantse wereld van Rembrandts opdrachtgever Abraham Anthoniszn Recht." *Bulletin van het Rijksmuseum* 42: 334–346.

Van Duijn 1976: Van Duijn, W. "De voorouders van Jan Steen."

Ons voorgeslacht. Orgaan van de Zuid-Hollandse Vereniging Voor Genealogie 31: 118–127.

Duits 1965: Duits, Clifford, ed. "The Marriage of Tobias and Sara by Jan Steen." *Duits Quarterly* 7: 4–9.

Duker 1893–1915: Duker, A. C. *Gisbertus Voetius.* 3 vols. Leiden.

Durantini 1983: Durantini, Mary Frances. *The Child in Seventeenth-Century Dutch Painting.* Ann Arbor.

Edinburgh 1992: Williams, Julia Lloyd. *Dutch Art and Scotland. A Reflection of Taste.* National Gallery of Scotland.

Elkins 1988: Elkins, James. "Das Nusslein Berisset auf, ihr Künstler! Curvilinear Perspective in Seventeenth-Century Art." *Oud-Holland* 102: 257–276.

Emmens 1956: Emmens, J. A. "Ay Rembrant, maal *Cornelis* stem." *Nederlands Kunsthistorisch Jaarboek* 7: 133–166.

Emmens 1963: Emmens, J. A. "Natuur, Onderwijzing en Oefening. Bij een drieluik van Gerrit Dou." *Album Discipulorum aangeboden aan Prof. Dr. J. G. van Gelder.* Utrecht: 125–136.

Emmens 1968: Emmens, J. A. *Rembrandt en de regels van de kunst.* Utrecht. Reprint, Amsterdam, 1979.

Emmens 1981: Emmens, J. A. "Apelles en Apollo: Nederlandse gedichten op schilderijen in de 17de eeuw." Master's thesis, 1956. In *Kunsthistorische Opstellen.* 1. Amsterdam: 5–60.

Emmerling 1936: Emmerling, Jan. "Rotterdam." *Pantheon* 17: 73.

Enklaar 1940: Enklaar, T. *Uit Uilenspiegel's kring.* Assen.

Falkenburg 1991: Falkenburg, R. L. "Recente visies op de zeventiende-eeuwse Nederlandse genre-schilderkunst." *Theoretische Geschiedenis* 18: 119–140.

Ferguson 1959: Ferguson, George. *Signs and Symbols in Christian Art.* New York.

Filipczak 1987: Filipczak, Zirka Zaremba. *Picturing Art in Antwerp 1550–1700.* Princeton.

Fink 1926–1927: Fink, August. "Jan Steen's Hochzeit des Tobias." *Zeitschrift für Bildende Kunst* 60: 230–233.

Fink 1949: Fink, August. "Jan Steen die Eheverschreibung." *Atlantis* 21: 181–182.

Fischel 1935: Fischel, Oskar. "Art and the Theatre." *Burlington Magazine* 66 (January): 4–14, 54–67.

Fitzwilliam Museum 1960: Gerson, Horst, et al. *Fitzwilliam Museum. Catalogue of Paintings I,* Cambridge.

Fock 1990: Fock, C. Willemijn. "Kunstbezit in Leiden in de 17de eeuw." In Th. H. Lunsingh Scheurleer, C. Willemijn Fock, and A.J. van Dissel. *Het Rapenburg: Geschiedenis van een Leidse gracht.* vol. 5. Leiden: 3–36.

Fockema Andreae et al. 1952: Fockema Andreae, S. J., et al. *Kastelen, ridderhofsteden en buitenplaatsen in Rijnland.* Leiden.

Forster 1969: Forster, Leonard Wilson. *The Icy Fire: Five Studies in European Petrarchism.* Cambridge.

Franits 1986: Franits, Wayne. "The Family Saying Grace: A Theme in Dutch Art of the Seventeenth Century." *Simiolus* 16: 36–39.

Franits 1993: Franits, Wayne. *Paragons of Virtue: Women and Domesticity in Seventeenth-Century Dutch Art.* Cambridge, Mass.

Franits 1994: Franits, Wayne. "Between Positivism and Nihilism: Some Thoughts on the Interpretation of Seventeenth-Century Dutch Paintings." *Theoretische Geschiedenis* 21: 129–152.

Fredericksen 1973: Fredericksen, B. B. "J. Paul Getty Museum: La Peinture flamande et hollandaise." *Connaissance des Arts* 277 (March): 58.

Fredericksen 1985: Fredericksen, B. B. "Recent Acquisitions of Paintings at the J. Paul Getty Museum." *Burlington Magazine* 127 (April): 261–268.

Gantner 1964: Gantner, Joseph. *Rembrandt und die Verwandlung klassischer Formen.* Bern.

Gaskell 1982: Gaskell, Ivan. "Gerrit Dou, His Patrons and the Art of Painting." *Oxford Art Journal* 5: 15–23.

Gaskell 1987: Gaskell, Ivan. "Tobacco, Social Deviance and Dutch Art in the Seventeenth Century." In Henning Bock and Thomas W. Gaehtgens, eds. *Holländische genremalerei im 17. jahrhundert. Symposium Berlin 1984.* Berlin: 117–137.

Van Gelder 1959: Van Gelder, H. E. "In het Museum Bredius II." *The Hague. Dienst voor schone kunsten Gemeente* 2: 8–15.

Van Gelder 1926: Van Gelder, J. G. "Een vroeg werk van Jan Steen." *Oud-Holland* 43: 203–210.

Van Gelder 1961: Van Gelder, J. G. "Two Aspects of the Dutch Baroque, Reason and Emotion." In Millard Meiss, ed. *De artibus opuscula XL: Essays in Honor of Erwin Panofsky.* I: 445–453.

Gent 1981: Gent, Lucy. *Pictures and Poetry 1560–1620: Relations between Literature and the Visual Arts in the English Renaissance.* Leamington Spa.

Gerson 1948: Gerson, Horst. "Landschappen van Jan Steen." *Kunsthistorische Mededelingen van het Rijksbureau voor Kunsthistorische Documentatie* 3: 50–56.

Gerson 1952: Gerson, Horst. *Het tijdperk van Rembrandt en Vermeer. De Nederlandse schilderkunst.* vol. 2. Amsterdam.

Getty Museum 1988: Fredericksen, Burton B. *Masterpieces of Painting in the J. Paul Getty Museum.* Malibu.

Gibson 1981: Gibson, Walter S. "Artists and *Rederijkers* in the Age of Bruegel." *Art Bulletin* 63: 426–446.

Gifford and Palmer [forthcoming]: Gifford, Melanie, and Michael Palmer. "Jan Steen's Painting Practice: *The Dancing Couple* in the Context of the Artist's Oeuvre." *Conservation Research.* Studies in the History of Art, vol. 57, Monograph Series II. Washington.

Van Gils 1917: Van Gils, J. B. F. *De dokter in de oude Nederlandsche tooneelliteratuur.* Haarlem.

Van Gils 1920: Van Gils, J. B. F. "Een detail op de doktersschilderijen van Jan Steen." *Oud-Holland* 38: 200–201.

Van Gils 1935: Van Gils, J. B. F. "Jan Steen en de rederijkers." *Oud-Holland* 52: 130–133.

Van Gils 1937: Van Gils, J. B. F. "Jan Steen in den schouwburg." *Op de Hoogte* 34 (March): 92–93.

Van Gils 1940a: Van Gils, J. B. F. "Het Gebed voor den Maaltijd door Jan Steen." *Oud-Holland* 57: 192.

Van Gils 1940b: Van Gils, J. B. F. "Theseus bij Achelous van Jan Steen." *Oud-Holland* 57: 145–148.

Van Gils 1942a: Van Gils, J. B. F. "Jan Steen in den schouwburg." *Oud-Holland* 59: 57–63.

Van Gils 1942b: Van Gils, J. B. F. "Toch Daniël niet Raphael bij Jan Steen." *Oud-Holland* 59: 184–186.

Glen 1977: Glen, Thomas L. *Rubens and the Counter Reformation: Studies in His Religious Paintings between 1609 and 1620.* New York.

Goedde 1989: Goedde, Lawrence O. *Tempest and Shipwreck in Dutch and Flemish Art Convention, Rhetoric, and Interpretation.* University Park, Pennsylvania.

Goeree 1668: Goeree, Willem. *Inleydinge tot de al-ghemeene teyckenkonst....* Middelburg.

Gombrich 1972: Gombrich, Ernst H. *Symbolic Images: Studies in the Art of the Renaissance.* London.

Goodman 1979: Goodman, Elise. "The Sources of Pieter de Hooch's *The Game of Skittles.*" *Studies in Iconography* 5: 147–158.

Goodman 1992: Goodman, Elise. *Rubens: The Garden of Love as "Conversatie à la Mode."* Amsterdam and Philadelphia.

Ter Gouw 1871: Ter Gouw, J. *De Volksvermaken.* Haarlem.

De Graaff 1966: De Graaff, A. F. "Remonstranten uit Leiden en omgeving." *Rijnland, tijdschrift voor sociale genealogie en streekgeschiedenis voor Leiden en omstreken* no. 9/10 (July): 246–262.

Granberg 1907: Granberg, O. "Schilderijen in 1651 voor Karl Gustav Graf vom Wrangel te 's Gravenhage aangekocht." *Oud-Holland* 25: 132.

Greenblatt 1980: Greenblatt, Stephen. *Renaissance self-fashioning: from More to Shakespeare.* Chicago.

Groen and Hendriks 1989: Groen, Karin, and Ella Hendriks. "Frans Hals: a Technical Examination." In Washington 1989: 109–127.

Groenendijk 1984: Groenendijk, Leendert F. *De nadere reformatie van het gezin: De visie van Petrus Wittewrongel op de Christelijke huishouding.* Dordrecht.

Groenendijk 1989: Groenendijk, Leendert F. "De nadere reformatie en het toneel." *De zeventiende eeuw* 5: 141–153.

Groeneweg 1995: Groeneweg, Irene. "Regenten in het zwart: vroom en deftig?" *Nederlands Kunsthistorisch Jaarboek* 46: 198–251.

Groenhuis 1977: Groenhuis, G. *De predikanten: de sociale positie van de gereformeerde predikanten in de Republiek der verenigde Nederlanden voor + 1700.* Groningen.

De Groot 1952: De Groot, C. W. *Jan Steen—beeld en woord.* Utrecht and Nijmegen.

Grootes 1992: Grootes, E. K. "De ontwikkeling van de literaire organisatievormen tijdens de zeventiende eeuw in Noordnederland." *De zeventiende eeuw* 8: 53–65.

Gudlaugsson 1938: Gudlaugsson, Sturla J. *Ikonographische Studien über die holländische Malerei und das Theater des 17. Jahrhunderts.* Würzburg.

Gudlaugsson 1945: Gudlaugsson, Sturla J. *De Komedianten bij Jan Steen en zijn tijdgenooten.* The Hague. (English trans. by James Brockway, Soest, 1975.)

Gudlaugsson 1947: Gudlaugsson, Sturla J. "Bredero's Lucelle door eenige zeventiende eeuwsche meesters uitgebeeld." *Nederlands Kunsthistorisch Jaarboek* 1: 183–185.

Gudlaugsson 1959: Gudlaugsson, Sturla J. *Geraert Ter Borch.* 2 vols. The Hague.

Gudlaugsson 1975: See Gudlauggsson 1945

Van Guldener 1948: Van Guldener, Hermine. "De Aanbidding der Herders van J. Steen." *Phoenix* 3 (February): 50–54.

Haarlem 1816: *Levensschetsen van vaderlandsche mannen en vrouwen.* 8th ed. Maatschappij tot Nut van 't Algemeen. (1st ed. 1791.)

Haarlem 1946: *Haarlemsche meesters uit de eeuw van Frans Hals.* Frans Halsmuseum.

Haarlem 1986: De Jongh, Eddy. *Portretten van echt en trouw—Huwelijk en gezin in de Nederlandse kunst van de zeventiende eeuw.* Frans Halsmuseum.

Haarlem 1993: Biesboer, Pieter, et al. *Judith Leyster, schilderes in een mannenwereld.* Frans Halsmuseum.

Haeger 1983: Haeger, Barbara Joan. "The Religious Significance of Rembrandt's *Return of the Prodigal Son*: An Examination of the Picture in the Context of the Visual and Iconographic Tradition." Ph.D. diss. University of Michigan.

Haeger 1986: Haeger, Barbara Joan. "The Prodigal Son in Sixteenth and Seventeenth-Century Netherlandish Art: Depictions of the parable and the Evolution of a Catholic Image." *Simiolus* 16: 128–138.

Hagstrum 1958: Hagstrum, Jean H. *The Sister Arts: The Tradition of Literary Pictorialism and English Poetry from Dryden to Gray.* Chicago.

The Hague 1958: *Jan Steen.* Mauritshuis.

The Hague 1990: Broos, Ben P. J., et al. *Great Dutch Paintings from America.* Mauritshuis.

The Hague 1993: Buijsen, Edwin, and J. W. Niemeijer. *Cornelis Troost and the Theatre of His Time: Plays of the 18th Century.* Mauritshuis.

The Hague 1994a: Walsh, Amy, Edwin Buijsen, and Ben Broos. *Paulus Potter. Schilderijen, tekeningen en etsen.* Mauritshuis.

The Hague 1994b: Buijsen, Edwin, et al. *The Hoogsteder Exhibition of Music and Painting in the Golden Age.* Kunsthandel Hoogsteder & Hoogsteder.

Haks 1985: Haks, D. *Huwelijk en gezin in Holland in de 17de en 18de eeuw. Processtukken en moralisten over aspecten van het laat 17de- en 18de-eeuwse gezinsleven.* 2d edition. Utrecht.

Halewood 1982: Halewood, William H. *Six Subjects of Reformation Art: A preface to Rembrandt.* Toronto.

Halewood 1993: Halewood, William H. "Rembrandt's Low Diction." *Oud-Holland* 107: 287–295.

Van Hamel 1918: Van Hamel, A. G. *Zeventiende-eeuwsche opvattingen en theorieën over litteratuur in Nederland.* The Hague.

Hamann 1936: Hamann, R. "Hagardarstellungen ausserhalb der Rembrandtkreises." *Marburg Jahrbuch für Kunstwissenschaft* 8–9: 558–559.

Hanou 1985: Hanou, André. "Weyerman's Maandelyksche 't zamenspraaken (1726)." In P. Altena et al., eds. *Het verlokkend ooft: Proeven over Jacob Campo Weyerman.* Amsterdam: 160–194.

Harrebomée 1856–1870: Harrebomée, P. J. *Spreekwoordenboek der Nederlandsche taal of verzameling van Nederlandsche spreekwoorden en spreekwoordelijke uitdrukkingen.* 3 vols. Utrecht.

Harmsen 1989: Harmsen, A. J. E. *Onderwys in de tooneel-poëzy: De opvattingen over toneel van het kunstgenootschap Nil Volentibus Arduum.* Rotterdam.

Haverkamp-Begemann 1959: Haverkamp-Begemann, Egbert. *Willem Buytewech.* Amsterdam.

Hecht 1986: Hecht, Peter. "The Debate on Symbol and Meaning in Dutch Seventeenth-Century Art: An Appeal to Common Sense." *Simiolus* 16: 173–187.

Hedinger 1987: Hedinger, Bärbel. "Zur politischen Ikonographie der Wandkaste bei Willem Buytewech und Jan Vermeer." Henning Bock and Thomas W. Gaehtgens, eds. *Holländischen Genremalerei im 17. Jahrhundert. Symposium Berlin, 1984.* Berlin: 139–168.

Heintz 1960: Heintz, G. *Katalog der Harrach'schen Gemäldegalerie.* Vienna.

De Hemelaer 1612: De Hemelaer, J., trans. *Horatius Flaccus De arte poetica, dat is: Van de weldichtens kunst.* Haarlem.

Hempel 1965: Hempel, Wido. "Parodie, Travestie und Pastiche: zur Geschichte von Wort und Sache." *Germanisch-Romanische Monatsschrift* Neue Folge 15: 150–176.

Henkel 1931–1932: Henkel, M. D. "Jan Steen und der Delfter Vermeer." *Der Kunstwanderer* 14: 265–266.

Hennus 1930: Hennus, M. F. "In den Oud-Schilderijen Handel." *Maandblad voor Beeldende Kunsten* 7 (September): 220–232, 284.

Heppner 1936: Heppner, Albert. "Heinrich Heine en Jan Steen." *Op de Hoogte* 33: 317–319.

Heppner 1939–1940: Heppner, Albert. "The Popular Theatre of the Rederijkers in the Work of Jan Steen and his Contemporaries." *Journal of the Warburg and Courtauld Institutes* 3: 22–48.

Hermerén 1969: Hermerén, Göran. *Representation and Meaning in the Visual Arts.* Lund.

's-Hertogenbosch 1992: de Mooij, Ch., ed. *Vastenavond—Car-naval. Feesten van de omgekeerde wereld.* Noordbrabants Museum.

Herzog Anton Ulrich-Museum 1983: Klessmann, Rüdiger. *Die holländischen Gemälde.* Brunswick.

Heyns 1625: Heyns, Zacharias. *Emblemata, Sinne-Beelden streckende tot christelicke bedenckinghe ende leere der zedicheyt.* Rotterdam.

Hill 1957: Hill, M. D. "Representations from the Old Testament in the Museum's Collection of Paintings." *North Carolina Museum of Art Bulletin* I (Summer): 12–13.

Hindman 1981: Hindman, Sandra. "Pieter Bruegel's *Children's Games*, Folly, and Chance." *Art Bulletin* 63: 447–475.

Hobson 1929: Hobson. "Chinese Porcelain in Dutch Pictures." *Country Life* 65 (February 16): 243–244.

Hoet 1752–1770: Hoet, Gerard. *Catalogues of naamlyst van schilderyen.* 3 vols. The Hague.

Hoff 1964: Hoff, U. "Dutch and Flemish Pictures in Melbourne [Interior]." *Apollo* 79 (June): 450.

Hofstede de Groot 1892: Hofstede de Groot, Cornelis. "Een Altaarstuk van Jan Steen." *De Nederlandsche Spectator* (February 10): 104–105.

Hofstede de Groot 1893: Hofstede de Groot, Cornelis. *Arnold Houbraken und seine Groote Schouburgh kritisch beleuchtet.* The Hague.

Hofstede de Groot 1907: Hofstede de Groot, Cornelis. *A Catalogue Raisonné of the Works of the Most Eminent Dutch Painters of the Seventeenth Century.* Edward G. Hawke, trans. Vol. 1. London. (also abbreviated as **HdG.**)

Hofstede de Groot 1927: Hofstede de Groot, Cornelis. *Beschreibendes und kritisches Verzeichnis der Werke der hervorragendsten holländischen Maler des XVII. Jahrhunderts.* Vol. 10. Esslingen and Paris.

Hofstede de Groot 1928: Hofstede de Groot, Cornelis. "Jan Steen and His Master Nicholaes Knüpfer." *Art in America and Elsewhere* 16 (October): 249–253.

Holl 1974: Holl, O. *Lexikon der christlichen Ikonographie.* Rome.

Hollandt ont-kermist 1672: I. I. V. P. *Hollandt ont-kermist door de Franse kermis-gast met een goede raedt in dese quade tijdt.* Amsterdam.

Hollstein 1949: Hollstein, F. W. H. *Dutch and Flemish Etchings, Engravings and Woodcuts.* Amsterdam.

Holmes 1909: Holmes, C. J. "Notes on the Chronology of Jan Steen." *Burlington Magazine* 15 (December): 243–244.

Homann 1971: Homann, Holger. *Studien zur Emblematik des 16. Jahrhunderts.* Utrecht.

Hood 1979: Hood, William. "Jan Steen as a Landscape Painter and a New Van Goyen." *Burlington Magazine* 121 (January): 35.

Hooft 1611: Hooft, P. C. *Emblemata Amatoria.* Amsterdam.

Hoogenboom 1993: Hoogenboom, A. *De stand des kunstenaars. de positie van kunstschilders in Nederland in de eerste helft van de negentiende eeuw.* Leiden.

Van Hoogstraeten 1678: Van Hoogstraeten, Samuel. *Inleyding tot de hooge schoole der schilderkonst: Anders de zichtbaere Werelt.* Rotterdam.

Horace 1929: Fairclough, H. R. ed. and trans. *Horace: Satires, Epistles, Ars Poetica.* London.

Houbraken 1718–1721: Houbraken, Arnold. *De groote schouburgh der Nederlantsche konstschilders en schilderessen.* 3 vols. Amsterdam.

Houbraken 1753: Houbraken, Arnold. *De groote schouburgh der Nederlantsche konstschilders en schilderessen.* 3 vols. The Hague. (Reprint, Amsterdam, 1976.)

Howard 1910: Howard, Henry. "Jan Steen." *L'Art et les artistes* 11 (June): 99–107.

Hulsius 1631: Hulsius, Bartholomeus. *Emblemata sacra, dat is, Eenige geestelicke sinnebeelden.*

D'Hulst 1982: D'Hulst, R.-A. *Jacob Jordaens.* Antwerp.

Huygens 1653: Huygens, Constantijn. *Tryntje Cornelis.* The Hague.

Huygens 1968: Huygens, Constantijn. *Avondmaalsgedichten en heilige dagen.* F. L. Zwaan, ed. Zwolle.

Huygens 1987: Huygens, Constantijn. *Mijn Jeugd.* C. L. Heesakkers, trans. Amsterdam.

Jameson 1844: Jameson, Anna. *A Companion to the Most Celebrated Private Galleries of Art in London.* London.

Janson 1952: Janson, Horst W. *Apes and Ape Lore in the Middle Ages and the Renaissance.* London.

De Jonge 1939: De Jonge, C. H. *Jan Steen.* Palet Series. Amsterdam.

De Jongh 1968–1969: De Jongh, Eddy. "Erotica in vogelperspectief: de dubbelzinnigheid van een reeks 17de-eeuwse genrevoorstellingen." *Simiolus* 3: 22–74.

De Jongh 1971: De Jongh, Eddy. "Réalisme et réalisme apparent dans la peinture Hollandaise du 17è siècle." In *Rembrandt et son temps.* Musées Royaux d'Art et d'Histoire, Brussels: 143–191.

De Jongh 1974: De Jongh, Eddy. "Grape Symbolism in Paintings of the Sixteenth and Seventeenth Centuries." *Simiolus* 7: 166–191.

De Jongh 1975–1976: De Jongh, Eddy. "Pearls of Virtue and Pearls of Vice." *Simiolus* 8: 69–97.

De Jongh 1983: De Jongh, Eddy. "The Artist's Apprentice and Minerva's Secret: An Allegory of Drawing by Jan de Lairesse." *Simiolus* 13: 201–217.

De Jongh 1992a: De Jongh, Eddy. "Seventeenth-Century Dutch Painting: Multi-Faceted Research." In N.C.F. van Sas and E. Witte, eds. *Historical Research in the Low Countries.* The Hague, 35–46.

De Jongh 1992b: De Jongh, Eddy. "De dissonante veelstemmigheid sinds Haaks *Hollandse schilders in de Gouden Eeuw.*" *Theoretische Geschiedenis* 19: 275–291.

De Jongh 1993: De Jongh, Eddy. "Die 'Sprachlichkeit' der nieder-

ländischen Malerei im 17. Jahrhundert." In *Leselust: niederländische Malerei von Rembrandt bis Vermeer.* Sabine Schulze, ed. Schirn Kunsthalle, Frankfurt, 23–33.

De Jongh 1994: De Jongh, Eddy. "Woord en beeld: de salon van de gezusters Kunst." *Kunstschrift* 38: 6–12.

Kahr 1966: Kahr, Madlyn. "The Book of Esther in Seventeenth Century Dutch Painting." Ph.D. diss., New York University.

Kahr 1972: Kahr, Madlyn. "Delilah." *Art Bulletin* 54 (Summer): 282–299.

Kamphuyzen 1624: Kamphuyzen, D. R. *Stichtelyke Rymen.* 1713 edition. Amsterdam.

Kassel 1958: *Katalog der Staatlichen Gemäldegalerie zu Kassel.* Kassel.

Kauffmann 1943: Kauffmann, Hans. "Die Fünfsinne in der niederländischen Malerei des 17. Jahrhunderts." 133–157. In *Kunstgeschictliche Studien: Festschrift für Dagobert Frey zum 23. April 1943.* Hans Tintelnot, ed. Breslau.

Kauffmann 1982: Kauffmann, Thomas da Costa. "The Eloquent Artist: Towards an Understanding of the Stylistics of Painting at the Court of Rudolf II." *Leids Kunsthistorisch Jaarboek* 1: 119–148.

Kelk 1932: Kelk, Cornelius J. *Jan Steen.* Amsterdam.

Kemp 1976: Kemp, Martin. "'Ogni dipintore dipinge se:' A Neoplatonic Echo in Leonardo's Art Theory?" In *Cultural Aspects of the Italian Renaissance: Essays in Honor of Paul Oskar Kristeller.* C. H. Clough, ed. Manchester and New York: 311–323.

Kemp 1992: Kemp, Martin. "Virtuous Artists and Virtuous Art." In *Decorum in Renaissance Narrative Art.* Francis Ames-Lewis and Anka Bednarek, eds. London: 15–23.

Kettering 1983: Kettering, Alison McNeil. *The Dutch Arcadia: Pastoral Art and Its Audience in the Golden Age.* Montclair.

Kettering 1993: Kettering, Alison McNeil. "Ter Borch's Ladies in Satin." *Art History* 16 (March): 95–124.

Keyszelitz 1959: Keyszelitz, R. "Zur Deutung von Jan Steens 'Soo gewonnen soo Verteert." *Zeitschrift für Kunstgeschichte* 22: 40–45.

Kirschenbaum 1977: Kirschenbaum, Baruch D. *The Religious and Historical Paintings of Jan Steen.* New York and Montclair.

Klessmann 1986: Klessmann, Rudiger. "Duke Anton Ulrich: Connoisseur of Dutch and Flemish Painting (Seventeenth Century)." *Apollo* 123 (March): 157.

Klein 1963: Klein, H. Arthur. *Graphic Worlds of Peter Bruegel the Elder.* New York.

De Klerk 1986–1987: De Klerk, E. A. "Academy-beelden and 'teeken-schoolen' in Dutch Seventeenth-Century Treatises on Art." *Leids Kunsthistorische Jaarboek* 5/6: 283–288.

Kloos 1989: Kloos, Titia. "Het Feestmaal van Cleopatra door Gerard Lairesse." *Bulletin van het Rijksmuseum* 37: 91–102.

Kneppelhout van Sterkenburg 1864: Kneppelhout van Sterkenburg, K. J. F. C. *De gedenktekenen in de Pieters-kerk te Leyden.* Leiden.

Knevel 1994: Knevel, P. *Burgers in het geweer. de schutterijen van Holland, 1550–1700.* Hilversum.

Knipping 1974: Knipping, John B. *Iconography of the Counter Reformation in the Netherlands.* 2 vols. Nieuwkoop and Leiden.

Knotter 1987: Knotter, A. "Bouwgolven in Amsterdam in de 17e eeuw." P. M. M. Klep, et al., eds. *Wonen in het verleden, 17e–20e eeuw. Economie, politiek, volkshuisvesting, cultuur en bibliografie* NEHA-series. Vol. 3. Amsterdam: 25–37.

Koerner 1993: Koerner, Joseph Leo. *The Moment of Self-Portraiture in German Renaissance Art.* Chicago.

De Koning 1610: De Koning, Abraham. *Tragedi-comedie over de doodt van Henricus de Vierde, koning van Vrancrijk en Naverrae.* Amsterdam. (1967 Zwolle edition. G.R.W. Dibbets, ed.)

De Koning 1618: De Koning, Abraham. *Simsons treurspel.* Amsterdam.

Koopmans and Verhuyck 1991: Koopmans, Jelle and Paul Verhuyck. *Een kijk op anecdotencollecties in de zeventiende eeuw: Jan Zoet, Het Leven en Bedrijf van Clément Marot.* Amsterdam and Atlanta.

Koslow 1975: Koslow, Susan. "Frans Hals's Fisherboys: Exemplars of Idleness." *Art Bulletin* 57 (September): 418–432.

Kris and Kurz 1979: Kris, Ernst, and Otto Kurz. *Legend, Myth, and Magic in the Image of the Artist: A Historical Experiment.* New Haven. Alastair Laing, trans. and Lottie M. Newman, ed.

Kruithof 1990: Kruithof, B. "Zonde en deugd in domineesland." Ph.D. diss., Amsterdam.

Krul 1644: Krul, Jan Harmensz. *Pampiere Wereld.* Amsterdam. 1681 edition.

Ter Kuile 1976: Ter Kuile, O. "Adriaen Hanneman, 1604–1671, een Haags portretschilder." Ph.D. diss., Alphen aan den Rijn.

Kuipers 1980: Kuipers, L. H. "In de wereld, maar niet van de wereld: de wisselwerking tussen de doopsgezinden en de hen omringende wereld." In *Wederdopers, menisten, doopsgezinden in Nederland, 1530–1980.* S. Groenveld, J.P. Jacobszoon and S.L. Verheus, eds. Zutphen: 219–239.

Kunoth-Leifels 1962: Kunoth-Leifels, Elisabeth. *Über die Darstellungen der 'Bathseba im Bade'. Studien zur Geschichte des Bildthemas 4. bis 17. Jahrhundert.* Essen.

Kunsthistorisches Museum 1972: *Hollandisch Meister des 15., 16., und 17. Jahrhunderts: Katalog der Gemäldegalerie.* Vienna.

Kuznetsov 1958: Kuznetsov, I. V. "Kartiny Iana Stena v Gosudarstvennom Ermitazha." *Ezhegodnik, Akademiia nauk SSSR, Institut Istorii Iskusstv.* Moscow: 371–415.

De Lairesse 1701: De Lairesse, Gerard. *Grondlegginge ter Teekenkonst.* Amsterdam.

De Lairesse 1707: De Lairesse, Gerard. *Groot schilderboek....* 2 vols. Amsterdam.

De Lairesse 1740: De Lairesse, Gerard. *Het Groot Schilderboek.* Haarlem. (Reprint, Soest, 1969.)

De Lairesse 1778: De Lairesse, Gerard. *The Art of Painting, in all its Branches....* John Frederick Fritsch, trans. London.

Lampsonius 1572: Lampsonius, Dominicus. *Pictorum aliquot celebrium Germaniae inferioris effigies.* Antwerp.

Lapauze 1907: Lapauze, Henry. *Catalogue sommaire des collections Dutuit.* Paris.

Larsen 1958: Larsen, Erik. "Jan Steen's *Soo de Ouden Songen, so Pijpen de Jongen* at the Museum of Rio de Janeiro." *Gazette des Beaux-Arts* 51 (January): 27–32.

Lasius 1992: Lasius, Angelika. *Quiringh van Brekelenkam.* Doornspijk.

Lawrence 1983: Stone-Ferrier, Linda. *Dutch Prints of Daily Life: Mirrors of Life or Masks of Morals?.* Spencer Museum of Art, University of Kansas.

Van Leeuwen 1966: Van Leeuwen, Frans. "Een Jan Steen, De Aanbidding der Herders in het Rijksmuseum." *De Kroniek van de Vriendenkring van het Rembrandthuis* 20: 59–64.

Leiden 1926: *Jan Steen Tentoonstelling.* Stedelijk Museum de Lakenhal.

Leiden 1991: Vogelaar, C., ed. *Rembrandt en Lievens in Leiden: "een jong en edel schildersduo."* Stedelijk Museum de Lakenhal.

Lemmens 1964: Lemmens, G. Th. H. "De schilder in zijn atelier." In *Het schildersatelier in de Nederlanden 1500–1800.* Nijmegen.

Leuker 1991: Leuker, Maria-Theresia. "De last van 't huys, de wil des mans..." *Frauenbilder und Ehekonzepte im niederländischen Lustspiel des 17. Jahrhunderts.* Münster.

Levine 1988: Levine, David A. "The Roman limekilns of the Bamboccianti." *Art Bulletin* 70 (December): 569–589.

Levine 1991: See Cologne 1991

Van Lieburg 1989: Van Lieburg, F. A. *De nadere reformatie in Utrecht ten tijde van Voetius: Sporen in de gereformeerde kerkeraadsacta.* Rotterdam.

Lloyd 1973: Lloyd, C. "New Drawings by Richard Dodd [in an Abingdon, Berkshire private collection]." *Master Drawings* 11 (Spring): 46.

Loevenich 1965: Loevenich, Karl. *A Long Lost Jan Steen: "The Artist's Children".* New York.

London 1909: *Jan Steen.* Dowdeswell and Dowdeswell.

London 1930: *Commemorative Catalogue of the Exhibition of Dutch Art.* Royal Academy.

London 1976: Brown, Christopher. *Art in Seventeenth Century Holland.* National Gallery.

London 1988a: Bomford, David, Christopher Brown, and Ashok Roy. *Art in the Making. Rembrandt.* National Gallery.

London 1988b: *Treasures from the Royal Collection.* The Queen's Gallery, Buckingham Palace.

London 1992: Sutton, Peter C. *Dutch and Flemish Seventeenth-Century Paintings. The Harold Samuel Collection.* The Corporation of London.

Los Angeles 1991: *The Ahmanson Gifts: European Masterpieces in the collection of the Los Angeles County Museum of Art.* Los Angeles County Museum of Art.

Louvre 1979: De Lavergnée, Arnauld Brejon, et al. *Catalogue sommaire illustré des peintures du Musée du Louvre, I, Ecoles flamande et hollandaise.* Paris.

Lowenthal 1995: Lowenthal, Anne W. *Joachim Wtewael: "Mars and Venus Surprised by Vulcan."* Malibu.

Lunsingh Scheurleer 1935: Lunsingh Scheurleer, T. H. "De Schoorsteenontwerpen van I. Barbet en hun Invloed in Nederland." *Oud-Holland* 54: 261–266.

Lunsingh Scheurleer et al. 1986–1992: Lunsingh Scheurleer, Th. H., C. Willemijn Fock, and A. J. van Dissel. *Het Rapenburg. Geschiedenis van een Leidse gracht.* 6 vols. Leiden.

Lurie 1965: Lurie, Ann. "Jan Steen: Esther, Ahasuerus, and Haman." *Bulletin of the Cleveland Museum of Art* 52 (April): 94–100.

Maandelyksche berichten 1747: Maandelyksche berichten uit de andere waerelt; of de spreekende dooden... driehondert en zevende zamenkomst; tusschen den beroemden konst-schilder en ridder Petrus Paulus Rubens, en den om zyn zonderling leven en koddige stukken zo bekenden Jan Steen. Amsterdam.

Van Maanen 1978: Van Maanen, R. C. J. "De vermogensopbouw van de Leidse bevolking in het laatste kwart van de zestiende eeuw." *Bijdragen en Mededelingen Betreffende de Geschiedenis der Nederlanden* 93: 1–42.

Magurn 1955: Magurn, Ruth Sanders. *The Letters of Peter Paul Rubens.* Cambridge, Mass.

Maier-Preusker 1991: Maier-Preusker, Wolfgang. "Christaen van Couwenbergh (1604–1667). Oeuvre und Wandlungen eines holländischen Caravaggisten." *Wallraf-Richartz-Jahrbuch* 52: 163–236.

Mak 1944: Mak, J. J. *De rederijkers.* Amsterdam.

Van Mander 1604: Van Mander, Karel. *Het schilder-boeck.* Haarlem.

Van Mander 1973: Van Mander, Karel. *Den grondt der edel vry schilderconst.* Hessel Miedema, ed. 2 vols. Utrecht. (1st published in Van Mander 1604.)

De Marchi and Van Miegroet 1994: De Marchi, N., and Hans J. van Miegroet. "Art, Value, and Market Practices in the Netherlands in the Seventeenth Century." *Art Bulletin* 76: 451–464.

Marius 1906: Marius, G. H. *Jan Steen, zijn leven en zijn kunst.* Amsterdam.

Marlier 1969: Marlier, Georges. *Pieter Brueghel le jeune.* Brussels.

Marquillier 1903: Marquiller, *Les Arts* 2 (March): 24–25.

Martin 1971: Martin, Gregory. "Seventeenth-Century Dutch Painting at the Petit Palais." *Apollo* 93 (February): 118–119.

Martin 1908: Martin, Wilhelm. "Anciens dessins du Cabinet des Estamps d'Amsterdam." *L'Art Flammand et Hollandais* 9 (May): 162–170.

Martin 1909a: Martin, Wilhelm. "L'Exposition Jan Steen à Londres." *L'Art Flamand et Hollandais* 12 (July–December): 129–158.

Martin 1909b: Martin, Wilhelm. "Jan Steen en zijn kunst op de Tentoonstelling te London." *Onze Kunst* (July): 141–172.

Martin 1910: Martin, Wilhelm. "Studien zu Jan Steen anlässlich der Ausstellung seiner Werke in London." *Monatshefte für Kunstwissenschaft* 3: 179–189.

Martin 1913: Martin, Wilhelm. *Gerard Dou, des Meisters Gemälde.* Stuttgart-Berlin.

Martin 1922: Martin, Wilhelm. "Jan Steen's Kippenhof van 't Huis Oud Teilingen." *Oudheidkundig Jaarboek:* 165–167.

Martin 1924: Martin, Wilhelm. *Jan Steen.* Amsterdam.

Martin 1926: Martin, Wilhelm. *Jan Steen, over zijn leven en kunst, naar aanleiding van Jan Steen tentoonstelling te Leiden.* Leiden.

Martin 1927–1928: Martin, Wilhelm. "Neues Über Jan Steen." *Zeitschrift für Bildende Kunst* 61: 325–341.

Martin 1935a: Martin, Wilhelm. "Jan Steen as a Landscape Painter." *Burlington Magazine* 67: 211–212.

Martin 1935b: Martin, Wilhelm. "Wrath of Ahasuerus." *Bulletin of the Bachstitz Gallery.* The Hague: 34–35.

Martin 1935–1936: Martin, Wilhelm. *De Hollandsche schilderkunst in de zeventiende eeuw. Rembrandt en zijn tijd.* Vol. 2. Amsterdam.

Martin 1947: Martin, Wilhelm. "Vraagstukken betreffende Jan Steen." *Oud-Holland* 62: 93–102.

Martin 1951: Martin, Wilhelm. *Dutch Painting of the Great Period: 1650–1697.* D. Horning, trans. London.

Martin 1954: Martin, Wilhelm. *Jan Steen.* Amsterdam.

Mauritshuis 1914: Bredius, Abraham, and Wilhelm Martin. *Musée royal de la Haye (Mauritshuis). Catalogue raisonné des tableaux et des sculptures.* The Hague.

Mauritshuis 1935: Martin, Wilhelm. *Catalogue raisonné des tableaux et sculptures.* The Hague.

Mauritshuis 1954: *Beknopte catalogus der schilderijen en beeldhouwwerken.* 11th ed. The Hague.

Mauritshuis 1977: *Mauritshuis. The Royal Cabinet of Paintings. Illustrated General Catalogue.* The Hague.

De Mayerne 1901: Berger, Ernst, ed. *Quellen für Maltechnik [...] De Mayerne Manuskript.* Munich. (Reprint, Vaduz, 1984.)

Meadow 1993: Meadow, Mark. "Volkscultuur of humanistencultuur? Spreekwoordenverzamelingen in de zestiende-eeuwse Nederlanden." *Volkskundig Bulletin* 19: 208–240.

Ter Meer 1991: Ter Meer, Tineke. *Snel en dicht: Een studie over epigrammen van Constantijn Huygens.* Amsterdam and Atlanta.

Meige 1900: Meige, Henry. "Les Médecins de Jan Steen." *Janus* 5: 187–190, 217–226.

Meijer 1971: Meijer, Reinder P. *Literature of the Low Countries. A Short History of Dutch Literature in the Netherlands and Belgium.* Assen.

Melion 1991: Melion, Walter S. *Shaping the Netherlandish Canon: Karel van Mander's Schilder-Boeck.* Chicago and London.

Van Merwede van Clootwijck 1651: Van Merwede van Clootwijck, Matthijs. *Uyt-heemsen oorlog, ofte Roomse min-triomfen.* The Hague.

Metropolitan Museum of Art 1984: Liedtke, Walter. *Flemish Paintings in the Metropolitan Museum of Art.* 2 vols. New York.

Metamorphoses: Ovid. *Metamorphoses.* Frank Justus Miller, trans. 2d rev. ed. Vol. 2. Cambridge, Mass. and London. 1984.

Michel 1901: Michel, G. *La Galérie de M. Rodolfe Kahn.* Paris.

Miedema 1977: Miedema, Hessel. "Realism and Comic Mode: The Peasant." *Simiolus* 9: 205–219.

Miedema 1980: Miedema, Hessel. *De archiefbescheiden van het St. Lukasgilde te Haarlem: 1497–1798.* 2 vols. Alphen aan den Rijn.

Miedema 1981: Miedema, Hessel. *Kunst, kunstenaar en kunstwerk bij Karel van Mander. Een analyse van zijn levensbeschrijvingen.* Alphen aan den Rijn.

Miedema 1986–1987: Miedema, Hessel. "Over vakonderwijs aan kunstschilders in de Nederlanden tot de zeventiende eeuw." *Leids Kunsthistorisch Jaarboek* 5/6: 268–283.

Miedema 1993: Miedema, Hessel. "De 'lof der schilderkunst'— Regarding the Paintings of Gerrit Dou (1613–1675) with a Tractate from Philips Angel in 1642." (In Dutch.) *Oud-Holland* 108: 251–255.

Miedema 1994: Miedema, Hessel. Review of Sluijter 1993. *Oud-Holland* 103: 251–253.

Milwaukee 1976: *The Bible through Dutch Eyes: From Genesis through to Apocrypha.* Milwaukee Art Center.

De Mirimonde 1961: de Mirimonde, A. P. "La Musique dans les oeuvres Hollandaises des Louvre." *Revue de Louvre* 123: 129–130.

De Mirimonde 1964: de Mirimonde, A. P. "Les concerts parodiques chez les maîtres du nord." *Gazette des Beaux-Arts* 64 (November): 272–274.

De Mirimonde 1967: de Mirimonde, A. P. "La Musique dans les allégories de l'amour." *Gazette des Beaux-Arts* 69 (May–June): 319–346.

Moes 1889: Moes, E. W. "Genesis XXXV van Jan Steen." *Oud en Nieuw,* 67–70.

Moes and Van Biema 1909: Moes, E. W., and E. van Biema. *De Nationale Konst-Gallery en het Koninklijk Museum.* Amsterdam.

Molhuysen 1918: Molhuysen, P. C. *Bronnen tot de geschiedenis der Leidsche Universiteit.* The Hague.

Montias 1982: Montias, John Michael. *Artists and Artisans in Delft: A Socio-economic Study of the Seventeenth Century.* Princeton.

Von Moltke 1994: von Moltke, J. W. *Arent de Gelder: Dordrecht 1645–1727.* Doornspijk.

Moxey 1989: Moxey, Keith. *Peasants, Warriors, and Wives: Popular Imagery in the Reformation.* Chicago.

Muller and Noël 1985: Muller, Ellen, and Jeanne Marie Noël. "Kunst en moraal bij humanisten: theorie en beeld." In *Tussen heks en heilige: het vrouwbeeld op de drempel van de moderne tijd, 15de/16de eeuw.* Nijmeegs Museum "Commanderie van Sint-Jan." Nijmegen: 129–159.

Muller 1989: Muller, Sheila D. "Jan Steen's *Burgher of Delft and His Daughter*: A Painting and Politics in Seventeenth-Century Holland." *Art History* 12 (September): 268–297.

Munich 1982: *Graphik in Holland: Esaias und Jan van de Velde, Rembrandt, Ostade und ihr Kreis.* Staatliche Graphische Sammlung.

Münster 1994: *Im Lichte Rembrandts: das Alte Testament im Goldenen Zeitalter der niederländischen Kunst.* Christian Tumpel, ed. Westfälisches Landesmuseum.

Münz 1952: Münz, Ludwig. *Rembrandt's Etchings.* 2 vols. London.

Museum Bredius 1978: Blankert, Albert. *Museum Bredius. Catalogus van de schilderijen en tekeningen.* The Hague.

Museum Bredius 1990: Blankert, Albert. *Museum Bredius. Catalogus van de schilderijen en tekeningen.* Zwolle and The Hague.

Museum News Toledo 1946: "An Early Masterpiece by Jan Steen." *Museum News: The Toledo Museum of Art* (December): 3–8.

Muylle 1986: Muylle, Jan. *Genus Gryllorum, Gryllorum Pictores: legitimatie, evaluatie and interpretatie van genre-iconografie en van de biografieën van genreschilders in de Nederlandse kunstliteratuur (ca. 1550–ca. 1750).* 2 vols. Ph.D. diss., Louvain.

National Gallery Canada 1987: Laskin, M. and M. Pantazzi. *European and American Painting, Sculpture, and Decorative Arts, 1300–1800. Catalogue of the National Gallery of Canada.* 2 vols. Ottawa.

National Gallery London 1960: Maclaren, Neil. *The Dutch School.* London.

National Gallery London 1971: Martin, Gregory. *National Gallery of London Dutch Painting.* Munich.

National Gallery London 1991: Maclaren, Neil, revised and expanded by Christopher Brown. *National Gallery Catalogues: The Dutch School 1600–1900,* 2 vols. London.

National Gallery Washington 1986: Hand, John Oliver, and Martha Wolff. *Early Netherlandish Painting* in The Collections of the National Gallery of Art Systematic Catalogues, Washington.

National Gallery Washington 1995: Wheelock, Arthur K., Jr. *Dutch Paintings of the Seventeenth Century* in The Collections of the National Gallery of Art Systematic Catalogues, Washington.

Naumann 1981: Naumann, Otto. *Frans van Mieris the Elder.* 2 vols. Doornspijk.

Németh 1989: Németh, Istvan. "Sur l'Interprétation d'un Tableau de Jan Steen à Budapest." *Bulletin du Musée Hongrois des Beaux-Arts* 70/71: 93–100, 177–180.

Németh 1990: Németh, Istvan. "Het Spreekwoord 'Zo d'ouden zongen, zo pijpen de jongen' in Schilderijen van Jacob Jordaens en Jan Steen: Motieven en Associates." *Jaarboek van het koninklijk museum voor schone kunsten Antwerpen* (1990): 271–286.

New York 1988: Adams, Ann Jensen. *Dutch and Flemish Paintings from New York Private Collections.* National Academy of Design.

New York 1995: *Inaugural Exhibition of Old Master Paintings.* Otto Naumann Ltd.

Nicolson 1946: Nicolson, Benedict. *Vermeer: Lady at the Virginals.* London.

Niemeijer 1981: Niemeijer, J.W. "De kunstverzameling van John Hope (1737–1784)." *Nederlands Kunsthistorisch Jaarboek* 32: 127–230.

Nieuwen clucht-vertelder 1669: *Den nieuwen clucht-vertelder.* Amsterdam.

Noordam 1994: Noordam, D. J. *Geringde buffels en heren van stand. Het patriciaat van Leiden, 1574–1700.* Hilversum.

Nootwendich vertoogh 1614: *Nootwendich vertoogh der alleen-suyverende springh-ader aller kinderen Gods: Vervaet in verscheyden antwoorden op de uytgegeven caerte der Wijngaertrancxkens, onder 'twoort Liefd' boven al.* Haarlem.

North Carolina Museum of Art 1956: Valentiner, Wilhelm R. *Catalogue of Paintings, North Carolina Museum of Art.* Raleigh.

North Carolina Museum of Art 1983: Bowron, Edgar Peters, ed. *The North Carolina Museum of Art, Introduction to the Collections.* Chapel Hill.

Odding 1994: Odding, Arnoud. "Ein durchaus paedagogischer Mensch: Willem Vogelsang 1875–1954." Master's thesis, Leiden.

Van Oerle 1975: Van Oerle, H. A. *Leiden binnen en buiten de stadsvesten.* 2 vols. Leiden.

Ogden and Richards 1923: Ogden, C. K., and I. A. Richards. *The Meaning of Meaning: a Study of the Influence of Language upon Thought and of the Science of Symbolism.* Cambridge.

Olbrich 1981: Olbrich, Harald and Helga Möbius. "Wahrheit und Wirklichkeit: Zum Realismus Holländischer Kunst." *Zeitschrift für Bildende Kunst* 9: 320–326.

Olipodrigo 1654: *De Olipodrigo.* Willem Schellinks, ed. 2 vols. Amsterdam.

O'Malley 1979: O'Malley, John W. *Praise and Blame in Renaissance Rome.* Durham.

Van Oss 1977: Van Oss, O. "Review of B. D. Kirschenbaum, *The Religious and Historical Paintings of Jan Steen.*" *Connoisseur* 195 (July): 228.

Van Overbeke 1991: Van Overbeke, Aernout. *Anecdota sive historiae jocosae: een zeventiende-eeuwse verzameling moppen en anekdotes.* Rudolf Dekker and Herman Roodenburg, eds. Amsterdam.

Van Overvoorde 1926: Van Overvoorde, J. C. "Uit de Laatste Levensjaren van Jan Steen." *Oudheidkundig Jaarboek* 3: 148–150.

Ozinga 1929: Ozinga, M. D. *De protestantse kerkenbouw in Nederland.* Amsterdam.

Panofsky 1933: Panofsky, Erwin. "Der gefesselte Eros: Zur Genealogie von Rembrandts Danae." *Oud-Holland* 50: 193–217.

Paris 1970: *La siècle de Rembrandt. Tableaux hollandais des collections publiques françaises.* Musée du Petit Palais.

Paris 1986: Broos, Ben. *De Rembrandt à Vermeer. Les peintres hollandais au Mauritshuis à la Haye.* Grand Palais.

Paris 1992: Habert, Jean, et al., eds. *Les Noces de Cana de Véronèse: Une Oeuvre et sa restauration.* Musée National du Louvre Paris.

Pelletier et al.: See Athens (Georgia) 1994

Pels 1681: Pels, Andries. *Gebruik én misbruik des tooneels.* Amsterdam. (2d ed. Amsterdam 1706.)

Pels 1677: Pels, Andries. *Q. Horatius Flaccus dichtkunst, op onze tyden, én zéden gepast.* Amsterdam. (1973 ed. M. A. Schenkeveld-van der Dussen, ed. Assen.)

Pennant 1902: Pennant, Janet Douglas. *Catalogue of Pictures at Penrhyn Castle and Mortimer House in 1901.* Bangor on Dee.

Pers 1628: Pers, Dirck Pietersz. *Bacchus wonder-wercken...Hier is by-gevoeght de Suypstad, of dronckaerts leven....* Amsterdam.

Petterson 1987: Petterson, Einar. "*Amans Amanti Medicus*: die Ikonologie des Motivs *Der ärtzliche Besuch.*" In *Holländische Genremalerei im 17. Jahrhundert. Symposium Berlin 1984.* Henning Bock and Thomas W. Gaehtgens, eds. Berlin: 193–224.

Philadelphia 1984: Sutton, Peter C. *Masters of Seventeenth-Century Dutch Genre Painting.* Philadelphia Museum of Art.

Pigler 1974: Pigler, A. *Barockthemen.* 3 vols. Budapest.

Vanden Plasse 1638: Vanden Plasse, C. L., ed. *Alle de wercken so spelen gedichten brieven en kluchten van den gheest-rijcken poëet Gerbrand Adriaensz. Bredero Amsterdammer.* Amsterdam.

Plautus 1617: *M. Accii Plauti Amphitruo.* Trans. Isaacus van damme. Leiden.

Pleij 1975/1976: Pleij, Herman. "De sociale functie van humor en trivialiteit op het rederijkerstoneel." *Spektator* 5: 108–127.

Pleij 1979: Pleij, Herman. *Het gilde van de Blauwe Schuit: Literatuur, volksfeest en burgermoraal in de late middeleeuwen.* (2d ed., Amsterdam, 1983.)

Plietzsch 1916: Plietzsch, Eduard. "Niebenwerke Holländischer Maler des 17. Jahrhunderts." *Zeitschrift für Bildende Kunst* 27: 129–142.

Plokker 1984: Plokker, Annelies. *Adriaen Pietersz. van de Venne (1589–1662), de grisailles met spreukbanden.* Louvain and Amersfoort.

Poggio 1968: Poggio de Florentijn. *Groot grollenboek: boerten en verhalen uit de vijftiende eeuw.* Gerrit Komrij, trans. Amsterdam.

Polak 1976: Polak, Ada. "Glass in Dutch Painting." *Connoisseur* 193 (October): 116–125.

Posner 1973: Posner, D. "The Lady as Woman of Pleasure." *Art in Context Watteau: A Lady at her Toilet.* New York: 66–75.

Prak 1985: Prak, M. *Gezeten burgers. De elite in een Hollandse stad: Leiden 1700–1800.* Amsterdam and Dieren.

Providence 1984: *Children of Mercury: The Education of Artists in the Sixteenth and Seventeenth Centuries.* List Art Center, Brown University.

Prynne 1639: Prynne, William. *Histrio-mastix ofte schouw-spels treur-spel, dienende tot een klaer bewijs van de onwetlijckheden der hedendaechsche comedien.* Trans. and abridged by I. H. Leiden.

Quodbach 1992: Quodbach, Esmée. "Jan Steen: beeld en zelf-beeld." Master's thesis, Rijksuniversiteit Utrecht.

RBK 1992: *Rijksdienst Beeldende Kunst. Old Master Paintings, An Illustrated Summary Catalogue.* Zwolle and The Hague.

Raupp 1978: Raupp, Hans-Joachim. "Musik im Atelier. Darstellungen musizierender Künstler in der niederländischen Malerei des 17. Jahrhunderts." *Oud-Holland* 92: 106–129.

Raupp 1983: Raupp, Hans-Joachim. "Ansätze zu einer Theorie der Genremalerei in den Niederlanden im 17. Jahrhundert." *Zeitschrift für Kunstgeschichte* 46: 401–418.

Raupp 1984: Raupp, Hans-Joachim. *Untersuchungen zu Künstlerbildnis und Künstlerdarstellung in den Niederlanden im 17. Jahrhundert.* Hildesheim.

Raupp 1986: Raupp, Hans-Joachim. *Bauernsatiren: Entstehung und Entwicklung des bäuerlichen Genres in der deutschen und niederländischen Kunst ca. 1470–1570.* Niederzier.

Raupp 1987: Raupp, Hans Joachim. "Adriaen Brouwer als Satiriker." In *Holländische Genremalerei im 17. Jahrhundert. Symposium Berlin 1984.* Henning Bock and Thomas W. Gaehtgens, eds. Berlin: 225–251.

Reinold 1981: Reinold, Lucinda Kate. "The Representation of the Beggar as Rogue in Dutch Seventeenth-Century Art." Ph.D. diss., University of California, Berkeley.

Van Regteren-Altena 1943: Van Regteren-Altena, J. Q. "Hoe teekende Jan Steen?" *Oud-Holland* 60: 97–117.

Renger 1970: Renger, Konrad. *Lockere gesellschaft: Zur Ikonographie des Verlorenen Sohnes und von Wirtshausszenen in der niederländischen Malerei.* Berlin.

Renger 1984: Renger, Konrad. "Verhältnis von Text und Bild in der Graphik." In *Wort und Bild in der Niederländischen Kunst und Literatur des 16. und 17. Jahrhunderts.* Hermann Vekemann and Justus Müller Hofstede, eds. Erfstadt: 151–161.

Renger 1986: Renger, Konrad. *Adriaen Brouwer und das niederländische Bauerngenre 1600–1660.* Munich.

Revius 1976: Revius, Jacobus. *Over-Ysselsche sangen en dichten.* W. A. P. Smit, ed. Utrecht.

Reynolds 1774: Reynolds, Sir Joshua. "The Sixth Discourse." In *The Literary Works of Sir Joshua Reynolds.* Vol. I. Henry William Beechy, ed. London. 1881.

Reynolds 1781: Reynolds, Sir Joshua. *Discourses, Idlers, a Journey to Flanders and Holland, in the Year MDCCLXXXI.* Edinburgh.

Reynolds 1797: Reynolds, Sir Joshua. *Discourses on Art.* Robert R. Wark, ed. New Haven, 1975.

Ridderus 1663: Ridderus, Franciscus. *Nuttige tijd-korter voor reizende en andere luiden.* Rotterdam.

Riggs 1977: Riggs, Timothy. *Hieronymous Cock, Printmaker and Publisher.* New York.

Rijksmuseum 1976: Van Thiel, Pieter J. J. *All the Paintings of the Rijksmuseum.* Amsterdam and Maarssen.

Rijksmuseum 1992: *All the Paintings of the Rijksmuseum in Amsterdam, First Supplement, 1976–1991.* Amsterdam.

Rintjus 1656–1657: Rintjus, Henrik, ed. *Klioos kraam, vol verscheide gedichten.* 2 vols. Leeuwarden.

Ripa 1644: Ripa, Cesare. *Iconologia of uytbeeldingen des verstands....* Dirck Pietersz Pers, trans. Amsterdam.

Robinson 1974: Robinson, Franklin W. *Gabriel Metsu (1629–1667).* New York.

Roethlisberger and Bok 1993: Roethlisberger, M. G., and Marten Jan Bok. *Abraham Bloemaert and his Sons. Paintings and Prints.* Doornspijk.

Rome 1978: *Immagini dal Veronese: incisioni dal sec. XVI al XIX dalle collezioni del Gabinetto nazionale, Villa alla Farnesina alla Lungara.* Gabinetto Nazionale delle Stampe.

Rooses 1908: Rooses, Max. *De schilderkunst van 1400 tot 1800 in Vlaanderen en Holland, Italië, Duitschland, Spanje, Frankrijk, en Engeland.* Amsterdam.

Rosenberg 1897: Rosenberg, Adolf. *Terborch und Jan Steen.* Bielefeld and Leipzig.

Rosenberg, Slive and Ter Kuile 1966: Rosenberg, Jakob, Seymour Slive, and E. H. ter Kuile. *Dutch Art and Architecture 1600–1800.* Baltimore.

Rotgans 1708: Rotgans, Lukas. *Boerekermis.* Amsterdam.

Rotterdam 1935: *Vermeer, oorsprong en invloed. Fabritius, de Hooch, de Witte.* Museum Boymans.

Rotterdam 1974: *Willem Buytewech 1591–1624.* Museum Boymans-van Beuningen.

Rotterdam 1983: *Brood. De geschiedenis van het brood en het broodgebruik in Nederland.* Museum Boymans-van Beuningen.

Royal Collection 1885: Robinson, Sir J. C. *Catalogue of the Pictures in Her Majesty's Gallery and the State Rooms at Buckingham Palace.* London.

Royal Collection 1982: White, Christopher. *The Dutch Pictures in the Collection of Her Majesty the Queen.* Cambridge.

Royalton-Kisch 1984: Royalton-Kisch, Martin. "The King's Crown: A Popular Print for Epiphany." *Print Quarterly* I (March): 43–46, 51.

Royalton-Kisch 1988: Royalton-Kisch, Martin. *Adriaen van de Venne's album in the Department of Prints and Drawings in the British Museum.* London.

Rumsey 1985: Rumsey, Thomas R. *Men and Women in Revolution and War, 1600–1815.* Wellesley Hills, Mass.

Salinger 1959: Salinger, M.M. "Jan Steen's Merry Company." *Metropolitan Museum of Art, New York. Bulletin* 17 (January): 121–131.

Salomon 1987: Salomon, Nanette. "Jan Steen's Formulation of the Dissolute Household, Sources and Meanings." In Henning Bock and Thomas W. Gaehtgens, eds. *Holländische Genremalerei im 17. Jahrhundert. Symposium Berlin 1984.* Berlin: 315–343.

Von Sandrart 1675–1679: Von Sandrart, Joachim. *L'Accademia Todesca della Architectura, Scultura and Pittura: Oder Teutsche Academie der Edlen Bau- Bild- und Mahlery-Künste....* 2 vols. Nuremberg.

Sceperus 1665: Sceperus, Jacobus. *Bacchus. Den ouden en huydendaegschen dronckenman: Ontdeckt uyt de heydensche historien, onderrigt uyt de Heylige Schriften.*

Schama 1979: Schama, Simon. "The Unruly Realm: Appetite and Restraint in 17th Century Holland." *Daedalus* 108 (Summer): 103–123.

Schama 1987: Schama, Simon. *The Embarrassment of Riches: an Interpretation of Dutch Culture in the Golden Age.* New York. (Dutch ed. Amsterdam, 1988.)

Schatborn 1975: Schatborn, Peter. "Over Rembrandt en Kinderen." *De Kroniek van het Rembrandthuis* 27: 8–19.

Schatborn 1981: Schatborn, Peter. *Figuurstudies. Nederlandse tekeningen uit de 17de eeuw.* The Hague.

Schatborn 1986: Schatborn, Peter. "Tekeningen van Adriaen en Isack van Ostade." *Bulletin van het Rijksmuseum* 34: 82–92.

Scheller 1961: Scheller, R. W. "Rembrandt's reputatie van Houbraken tot Scheltema." *Nederlands Kunsthistorisch Jaarboek* 12: 81–118.

Schenkeveld-van der Dussen 1986: Schenkeveld-van der Dussen, Maria A. "Camphuysen en het *genus humile*." In *Eer is het Lof des Deuchts: Opstellen over renaissance en classicisme aangeboden aan dr. Fokke Veenstra,* H. Duits, A.J. Gelderblom, and M.B. Smits-Veldt, eds. Amsterdam: 141–153.

Schenkeveld-van der Dussen 1989: Schenkeveld-van der Dussen, Maria A. "De poetica van een libertijnse zelf-voyeur." *De nieuwe taalgids* 82: 2–15.

Schenkeveld 1991: Schenkeveld, Maria A. *Dutch Literature in the Age of Rembrandt: Themes and Ideas.* Amsterdam and Philadelphia.

Schmidt 1986: Schmidt, P. P. *Zeventiende-eeuwse kluchtboeken uit de Nederlanden: Een descriptieve bibliografie.* Utrecht.

Schmidt-Degener and Van Gelder 1927: Schmidt-Degener, F. and H. E. van Gelder. *Jan Steen: Forty Reproductions in Photogravure of the Artist's Principal Works.* London.

Schmidt-Degener 1936: Schmidt-Degener, F. "L'Image de la Hollande à travers son art." *Gazette des Beaux-Arts* 15 (March): 172.

Schmitt 1993: Schmitt, Stefan. *Diogenes: Studien zu seiner Ikonographie in der niederländischen Emblematik und Malerei des 16. und 17. Jahrhunderts.* Hildesheim, New York, and Olms.

Schnackenburg 1981: Schnackenburg, Bernhard. *Adriaen van Ostade, Isack van Ostade. Zeichnungen und Aquarelle: Gesamtdarstellung mit Werkkatalogen.* 2 vols. Hamburg.

Schnackenburg 1992: Schnackenburg, Bernhard. "Die Anfänge von Thomas Adiaensz. Wyck (um 1620–1677) als Zeichner und Maler." *Oud-Holland* 106: 143–156.

Schotel 1903: Schotel, G. D. J. *Het Oud-Hollandisch huisgezin der zeventiende eeuw.* Arnhem.

Schrijnen 1930: Schrijnen, Josef. *Nederlandsch volkskunde.* Vol. 2. Zutphen.

Schrevelius 1662: Schrevelius, Cornelius, ed. *Publii Terentii comoediae sex post optimas editiones emendatae, accedunt, Aelii Donati, commentarius integer.* Leiden.

Schulz 1970: Schulz, W. "Schellinks, Doomer, and Jan Steen: Zu den Schellinks-Zeichnungen im Kupferstichkabinett." *Pantheon* 28 (September): 415–425.

Schwartz and Bok 1990: Schwartz, Gary and Marten Jan Bok. *Pieter Saenredam: The Painter and His Time.* Maarssen and The Hague.

Sedelmeyer 1898: Sedelmeyer, Charles. *Illustrated Catalogue of 300 Paintings by Old Masters.* Paris.

Sedelmeyer 1899: Sedelmeyer, Charles. *Illustrated Catalogue of the Fifth Series of 100 Paintings by Old Masters.* Paris.

Serres 1988: Serres, Michel. "Ambrosia and Gold." In *Calligram. Essays in New Art History from France.* Norman Bryson, ed. Cambridge: 116–130.

Serwouters 1659: Serwouters, Joannes. *Hester, ofde verlossing der Jooden.* Amsterdam.

Silver 1974: Silver, Lawrence. "*The Ill-Matched Pair* by Quinten Massys." *Studies in the History of Art* 6: 105–123.

Simon 1940: Simon, Kurt. "Jan Steen and Utrecht." *Pantheon* 26 (July): 162–165.

Siple 1939: Siple, W. H. "Rediscovered Painting by Jan Steen: *The Admonition.*" *Cincinatti Museum Bulletin* 10 (October): 97–106.

Slive 1953: Slive, Seymour. *Rembrandt and His Critics 1630–1730.* The Hague.

Slive 1956: Slive, Seymour. "Notes on the Relationship of Protestantism to Seventeenth Century Dutch Painting," *Art Quarterly* 19: 2–15.

Slive 1968: Slive, Seymour. "Een drokende slapende meyd aan een tafel by Jan Vermeer." In *Festschrift Ulrich Middeldorf.* Berlin: 452–459.

Slive 1970–1974: Slive, Seymour. *Frans Hals.* 3 vols. London and New York.

Sluijter 1988: Sluijter, Eric J. "Schilders van `cleyne, subtile ende curieuse dingen.` Leidse `fijnschilders` in contemporaine bronnen." In Eric Jan Sluijter, M. Enklaar and P. Nieuwenhuizen, eds. *Leidse Fijnschilders. Van Gerrit Dou tot Frans van Mieris de Jonge, 1630–1760.* Stedelijk Museum de Lakenhal, Leiden: 14–77.

Sluijter 1991a: Sluijter, Eric J. "Over fijnschilders en 'betekenis': Naar aanleiding van Peter Hecht, *De Hollandse fijnschilders.*" *Oud-Holland* 105: 53–55.

Sluijter 1991b: Sluijter, Eric J. "Didactic and Disguised Meanings? Several Seventeenth-Century Texts on Painting and the Iconological Approach to Northern Dutch Paintings of This Period." In *Art in History, History in Art. Studies in Seventeenth Century Dutch Culture.* David Freeberg and Jan de Vries, eds. Santa Monica: 175–207.

Sluijter 1991–1992: Sluijter, Eric J. "Venus, visus en pictura." *Nederlands Kunsthistorisch Jaarboek* 42–43: 337–396.

Sluijter 1993: Sluijter, Eric J. *De lof der schilderkunst. Over schilderijen van Gerrit Dou (1613–1675) en een traktaat van Philips Angel uit 1642.* Hilversum.

Smit 1962: Smit, W. A. P. *Van Pascha tot Noah: Een verkenning van Vondels drama's naar continuïteit en ontwikkeling in hun grondmotief en structuur.* Vol. 3. Zwolle.

Smith 1982: Smith, David R. *Masks of Wedlock: Seventeenth-Century Dutch Marriage Portraiture.* Ann Arbor.

Smith 1987: Smith, David R. "Irony and Civility: Notes on the Convergence of Genre and Portraiture in Seventeenth-Century Dutch Painting." *Art Bulletin* 69 (September): 407–430.

Smith 1988: Smith, David R. "'I Janus': Privacy and the Gentlemanly Ideal in Rembrandt's Portraits of Jan Six." *Art History* 11 (March): 42–63.

Smith 1990: Smith, David R. "Carel Fabritius and Portraiture in Delft." *Art History* 13 (June): 156.

Smith 1992: Smith, Elise Lawton. *The Paintings of Lucas van Leyden.* Columbia and London.

Smith 1981: Smith, Graham. "Jan Steen and Raphael." *Burlington Magazine* 123 (March): 159–160.

Smith 1829–1842: Smith, John. *A Catalogue Raisonné of the Works of the Most Eminent Dutch, Flemish, and French Painters.* 8 vols. and supplement. London.

Smits-Veldt 1991: Smits-Veldt, Mieke B. *Het Nederlandse renaissancetoneel.* Utrecht.

Snoep 1968–1969: Snoep, D. P. "Een 17de eeuws liedboek met tekeningen van Gerard ter Borch de Oude en Pieter en Roeland van Laer," *Simiolus* 3: 77–134.

Snijders 1629: Snijders, Michael. *Amoris divini et humani antipathia.* Antwerp.

Spicer 1991: Spicer, Joneath. "The Renaissance Elbow." In *A Cultural History of Gesture.* Jan Bremmer and Herman Roodenburg, eds. Ithaca, New York: 84–128.

Staatliche Museen Berlin 1975: Gemäldegalerie Staatliche Museen Preussischer Kulturbesitz Berlin. *Katalog der ausgestellten Gemälde des 13–18. Jahrhunderts.* Berlin-Dahlem.

Stallybrass and White 1986: Stallybrass, Peter, and Allon White. *The Politics and Poetics of Transgression.* London.

Stalpart van der Wiele 1960: Stalpart van der Wiele, Joannes. *Madrigalia.* M. C. A. van der Heijden, ed. Zwolle.

Starter 1618: Starter, Jan Jansen. *Blyeyndich-truyrspel van Timbre de Cardone ende Fenicie van Messine, met een vermaecklijck sotte-clucht van een advocaet ende een boer op't plat Friesch.* Leeuwarden.

Steadman 1972: Steadman, David W. "The Norton Simon Exhibition at Princeton." *Art Journal* 32 (Fall): 35–37.

Stechow 1928–1929: Stechow, Wolfgang. "Bemerkungen zu Jan Steens Künstlerischer Entwicklung." *Zeitschrift für Bildende Kunst* 62: 173–179.

Stechow 1945: Stechow, Wolfgang. "The Love of Antiochus with Faire Stratonice." *Art Bulletin* 27 (December): 221–237.

Stechow 1958: Stechow, Wolfgang. "Jan Steen's Merry Company." *Allen Memorial Art Museum Bulletin* 15 (Spring): 91–100.

Stechow 1972: Stechow, Wolfgang. "Jan Steen's Representations of the Marriage in Cana." *Nederlands Kunsthistorisch Jaarboek* 23: 73–83.

Steinberg 1968: Steinberg, Leo. "Michelangelo's Florentine *Pietà*: The Missing Leg." *Art Bulletin* 50: 343–353.

Steinberg 1990: Steinberg, Leo. "Steen's Female Gaze and Other Ironies." *Artibus et historiae* 11: 107–128.

Van der Steur 1966: Van der Steur, A. G. "Aantekeningen betreffende de remonstrantse gemeente te Warmond." *Rijnland* 9/10 (July): 265–294.

Stewart 1979: Stewart, Alison. *Unequal Lovers: A Study of Unequal Couples in Northern Renaissance Art.* New York.

Van Stipriaan 1994: Van Stipriaan, R. "Vrouwenzaken als motief en thema: Over de bruikbaarheid van zeventiende-eeuwse komisch toneel als sociaal document." *De Nieuwe Taalgids* 87: 385–400.

Stoichita 1993: Stoichita, Victor I. *L'Instauration du tableau.* Paris.

Stone-Ferrier 1985: See Lawrence 1983

Sullivan 1994: Sullivan, Margaret. *Bruegel's Peasants: Art and Audience in the Northern Renaissance.* Cambridge.

Sumowski 1983: Sumowski, Werner. *Gemälde der Rembrandt-Schüler.* 6 vols. Landau and Pfalz.

Sutton 1980: Sutton, Peter C. *Pieter de Hooch.* Oxford.

Sutton 1982–1983: Sutton, Peter C. "The Life and Art of Jan Steen." In *Jan Steen: Comedy and Admonition. Philadelphia Museum of Art Bulletin* 78 (Winter/Spring): 337–338, 3–43.

Sutton 1984: Sutton, Peter C. "Masters of Dutch Genre Painting." In Philadelphia 1984, xiii–lxvi.

Sutton 1986: Sutton, Peter C. *Guide to Dutch Art in America.* Washington and Grand Rapids.

Sweerts 1678: De Vrye, Hippolytus [pseudonym for Hieronymus Sweerts]. *De tien vermakelikheden des houwelyks.* 2d ed. Amsterdam.

Sweerts 1689: Sweerts, Hieronymus (?). *Den berg Parnas.* Amsterdam.

Sweerts 1698–1700: Sweerts, Hieronymus. *Koddige en ernstige opschriften, op luyffens, wagens, glazen, uithangborden, en andere tafereelen.* 4 vols. 3d ed. Amsterdam.

Swillens 1957: Swillens, P. T. A. *Prisma schilderslexicon.* Utrecht and Antwerp.

Taylor 1989: Taylor, Charles. *Sources of the Self: The Making of Modern Identity.* Cambridge, Mass.

Tengnagel 1969: Tengnagel, Mattheus Gansneb. *Alle werken….* J. J. Oversteegen, eds. Amsterdam.

Van Thiel 1961: Van Thiel, P. J. J. "Frans Hals' portret van de Leidse rederijkersnar Pieter Cornelisz van der Morsch, alias Piero (1543–1629): Een bijdrage tot de ikonologie van de bokking." *Oud-Holland* 76: 153–172.

Van Thiel 1987: Van Thiel, Pieter J. J. "*Poor parents, rich children* and *Family saying grace*: Two Related Aspects of the Iconography of Late Sixteenth- and Seventeenth-century Dutch Domestic Morality." *Simiolus* 17: 90–149.

Thieme-Becker: Thieme, Ulrich and Felix Becker. *Allgemeines Lexikon der Bildenden Künstler.* 37 vols. Leipzig. 1907–1950.

Thierry de Bye Dólleman and De Savornin Lohman 1973: Thierry de Bye Dólleman, M. and R. C. C. de Savornin Lohman. "Oorsprong en genealogie van de Haagse familie Van Adrichem." *Jaarboek van het Centraal Bureau voor Genealogie* 27: 203–232.

Thierry de Bye Dólleman and Van der Steur 1988: Thierry de Bye Dólleman, M. and A. G. van der Steur. "Het Rijnlands-Haarlemse geslacht Van Grieken, ca. 1350–ca. 1600." *Jaarboek van het Centraal Bureau voor Genealogie* 42: 43–91.

Thoré-Bürger 1858–1860: Bürger, William (Etienne Joseph Théophile Thoré). *Musées de la Hollande.* 2 vols. Brussels.

Thoré-Bürger 1862: Bürger, William (Etienne Joseph Théophile Thoré). "Le Musée d'Anvers. IV" *Gazette des Beaux-Arts* 12 (February): 152–167.

Thyssen-Bornemisza 1989: Gaskell, Ivan. *Seventeenth-century Dutch and Flemish Painting.* London.

Toepel 1937: Toepel, P. M. C. *Onze honden.* Amsterdam

Toledo Museum 1953: Godwin, Molly Ohl. *Master Works in the Toledo Museum of Art.* Toledo.

Travaglino 1938: Travaglino, P. H. M. "Jan Steen Psychologisch Bezien." *Maandblad voor Beeldende Kunsten* 15: 236–247.

Treur-Klacht 1637: *Treur-Klacht van Liefd'-bloeyende.* Amsterdam.

Tuinman 1727: Tuinman, Carolus. *Oorsprong en uytlegging van dagelyks gebruikte Nederduitsche spreekwoorden.* Vol. 2. Middelburg.

Tümpel 1991: Tümpel, Christian. "De oudtestamentische historieschilderkunst in de gouden eeuw." In Amsterdam 1991: 8–23.

Utrecht 1986: Blankert, Albert, and Leonard Slatkes. *Holländische Malerei im neuen Licht: Hendrick ter Brugghen und seine Zeitgenossen.* Centraal Museum.

Utrecht 1993: Van den Brink, Peter. *Het gedroomde land: Pastorale schilderkunst in de gouden eeuw.* Centraal Museum.

Van Vaeck 1988: Van Vaeck, Mark. "Adriaen van de Venne and His Use of Homonymy as a Device in the Emblematical Process of a Bimedial Genre." *Emblematica* 3: 101–119.

Van Vaeck 1994a: Van Vaeck, Mark. "Vonken van hoogdravende wijsheid: Over spreekwoordschilderijen." *Kunstschrift* 38: no. 5, 17–23.

Van Vaeck 1994b: Van Vaeck, Mark. *Adriaen van de Venne's Tafereel van de belacchende werelt (Den Haag, 1635),* 3 vols. Ghent.

Vaeck-verdryver 1620: *Den vaeck-verdryver van de swaermoedighe gheesten, vertellende vermakelijcke kluchtjens.* Amsterdam.

Valentiner 1910: Valentiner, Wilhelm R. "Die Ausstellung holländischer Gemälde in New York." *Monatshefte für Kunstwissenschaft* 3: 5–12.

Valentiner 1940: Valentiner, Wilhelm R. "Fair at Oegstgeest by Jan Steen." *Detroit Institute Bulletin* 19 (March): 65–69.

Valentiner 1942: Valentiner, Wilhelm R. "Alessandro Vittoria and Michelangelo." *Art Quarterly* 5: 148–157.

Vandenbroeck 1984: Vandenbroeck, Paul. "Verbeeck's Peasant Weddings: A Study of Iconography and Social Function." *Simiolus* 14: 79–123.

Vandenbroeck 1987: Vandenbroeck, Paul. *Beeld van de andere, vertoog over het zelf: Over wilden en narren, boeren en bedelaars.* Koninklijk Museum voor Schone Kunsten, Antwerp.

Vandenbroeck 1988: Vandenbroeck, Paul. Review of Raupp 1986. *Simiolus* 18: 73.

Van Veen 1608: Van Veen, Otto. *Amorum Emblemata.* Antwerp. (Reprint, New York, 1979.)

Van der Veene 1642: Van der Veene, Jan. *Ian vander Veens Zinnebeelden, oft Adams appel.* Amsterdam.

Van der Veer 1926: Van der Veer, J. C. "The Jan Steen Tercentary." *Art News* 24 (June 12): 1, 8.

Veldman 1976: Veldman, Ilja M. "Maarten van Heemskerck and the Rhetoricians of Haarlem." *Hafnia: Copenhagen Papers in the History of Art* (1976): 96–112.

Veldman 1993: Veldman, Ilja M. "Maarten van Heemskerck." *The New Hollstein.* 2 vols. Roosendaal.

Van de Venne 1623: Van de Venne, Adriaen. "Zeeusche meyclacht ofte schyn-kycker." *Zeeusche nachtegael, ende des seds dryderley gesang.* Middelburg. 55–68.

Van de Venne 1635: Van de Venne, Adriaen. *Tafereel van de belacchende werelt.* The Hague.

Verhoef 1983: Verhoef, J. M. *De oude Nederlandse maten en gewichten.* Amsterdam.

Veth 1927: Veth, Cornelis. "Jan Steen (1626–1679)." *Kunst und Künstler* 25 (August): 426–431.

Veth 1931: Veth, Cornelis. "Pieter Brueghel de Oude en Jan Steen." *Maandblad voor Beeldende Kunsten* 8 (November–December): 323–330, 354–363.

Vetter 1955: Vetter, R. M. "Jan Steen Flagon and Related Continental Pewter." *Antiques* 67 (February): 138–142.

Visscher 1614: Visscher, Roemer. *Sinnepoppen.* Amsterdam.

Van Vloten 1878–1881: Van Vloten, J. *Het Nederlandsche kluchtspel van de 14e tot de 18e eeuw.* 3 vols. Haarlem.

Van den Vondel 1654: Vondel, Joost. trans. *Q. Horatius Flaccus Lierzangen en Dichtkunst.* Amsterdam.

Van denVondel 1660: Vondel, Joost. *Koning Epidus.* Amsterdam.

Van den Vondel 1661: Vondel, Joost. *Tooneelschilt of pleitrede voor het tooneelrecht.* Amsterdam.

Van den Vondel 1927–1937: Vondel, Joost. *De werken.* 10 vols. Amsterdam.

Vos 1667: Vos, Jan. *Medea.* Amsterdam

Vos 1726: Vos, Jan. *Alle de gedichten…* 2 vols. Amsterdam.

De Vries 1959: De Vries, A. B. "Jan Steen: The Profundity of Pranks." *Art News* 58 (March): 40–45

De Vries and Van der Woude 1995: De Vries, J. and A. van der Woude. *Nederland 1500–1815. De eerste ronde van moderne economische groei.* Amsterdam.

De Vries 1973: De Vries, Lyckle. "Jan Steen: Seine Stellung in der Tradition des Genrebildes." *Sitzungsberichte der Kunstgeschichtliche Gesellschaft zu Berlin* 23 (October 1974–May 1975): 10–12.

De Vries 1976: De Vries, Lyckle. *Jan Steen: De schilderende Uilenspiegel.* Weert.

De Vries 1977: De Vries, Lyckle. "*Jan Steen 'de kluchtschilder.'*" Ph.D. diss., Groningen.

De Vries 1983: De Vries, Lyckle. "Jan Steen zwischen Genre- und Historienmalerei." *Niederdeutsche Beitrage zur Kunstgeschichte* 22: 113–128.

De Vries 1990: De Vries, Lyckle. "Portraits of People at Work." In *Werk opstellen voor Hans Locher.* Jan de Jong, Victor Schmidt, and Rik Vos, eds. Groningen: 52–59.

De Vries 1991: De Vries, Lyckle. "Hollandse Meesters uit Amerika, Jan Steen in expositie en catalogus." *Akt* 15: no. 50, 13–22.

De Vries 1992: De Vries, Lyckle. *Jan Steen: Prinsjesdag.* Palet Serie. Bloemendaal.

Waagen 1838: Waagen, Gustav F. *Works of Art and Artists in England.* 3 vols. London.

Waagen 1854–1857: Waagen, Gustav F. *Treasures of Art in Great Britain.* 3 vols. and supplement. London.

Waagen 1862: Waagen, Gustav F. *Handbuch der deutschen und niederländischen Malerschulen.* 2 vols. Stuttgart.

Van de Waal 1974: Van de Waal, H. *Steps towards Rembrandt: Collected Articles 1937–1972.* R. H. Fuchs, ed. Patricia Wardle and Alan Griffiths, trans. Amsterdam.

Wack 1990: Wack, Mary Frances. *Lovesickness in the Middle Ages: the Viaticum and Its Commentaries.* Philadelphia.

Van Wagenberg-Ter Hoven 1993–1994: Van Wagenberg-Ter Hoven, Anke A. "The Celebration of Twelfth Night in Netherlandish Art." *Simiolus* 22: 65–96.

Wallraf-Richartz-Museum 1967: Vey, Horst and A. Kesting. *Katalog der niederländischen Gemälde von 1550 bis 1800 im Wallraf-Richartz-Museum und im öffentlichen Besitz der Stadt Köln.* Cologne.

Walsh 1979: Walsh, John. "Little-known Paintings in the Museum of Fine Arts, Boston." *Apollo* 110 (December): 504.

Walsh 1989: Walsh, John. "Jan Steen's *Drawing Lesson* and the Training of Artists." *Source* 9 (Fall): 80–86.

Walsh 1996: Walsh, John. *Jan Steen: "The Drawing Lesson."* Malibu.

Washington 1980: Blankert, Albert, et al. *Gods, Saints & Heroes: Dutch Painting in the Age of Rembrandt.* National Gallery of Art.

Washington 1985: *The Treasure Houses of Britain: Five Hundred Years of Private Patronage and Art Collecting.* Gervase Jackson-Stops, ed. National Gallery of Art.

Washington 1989a: Slive, Seymour, et al. *Frans Hals.* National Gallery of Art.

Washington 1989b: Bergström, Ingvar. *Still Lifes of the Golden Age: Northern European Paintings from the Heinz Family Collection.* Arthur K. Wheelock, Jr., ed. National Gallery of Art.

Washington 1990: Schneider, Cynthia P. *Rembrandt's Landscapes: Drawings and Prints.* National Gallery of Art.

Washington 1995: *Johannes Vermeer.* National Gallery of Art.

Watson 1960: Watson, F. B. J. "The Collections of Sir Alfred Beit: I." *Connoisseur* 145 (May): 158.

Wazny and Eckstein 1987: Wazny, T., and D. Eckstein, "Der Holzhandel von Danzig/Gdansk - Geschichte, Umfang und Reichweite." *Holz als Roh- und Werkstoff* 45: 509–513.

Weber 1991: Weber, Gregor J. M. *Der Lobtopos des 'lebenden' Bildes: Jan Vos und sein "Zeege der schilderkunst" von 1654.* Hildesheim, Zurich, and New York.

Weber 1994: Weber, Gregor J. M. "'om te bevestige[n], aen-te-raden, verbreeden ende vercieren' -rhetorische Exempellehre und die Struktur des 'Bildes im Bild.'" *Festschrift für Prof. Dr. Justus Müller Hofstede. Wallraf-Richartz-Jahrbuch* 55: 287–314.

Weiser 1952: Weiser, Francis X. *Handbook of Christian Feasts and Customs.* New York.

Welcker 1937: Welcker, A. "Jan Steen's Samson and Delila." *Oud-Holland* 54 (6): 254–262.

Weller 1992: Weller, Dennis Paul. "Jan Miense Molenaer (c. 1609/1610-1668): The Life and Art of a Seventeenth-Century Dutch Painter." 2 vols. Ph.D. diss., University of Maryland.

Wellington Museum 1982: Kauffmann, C. M. *Catalogue of the Paintings in the Wellington Museum.* London.

Welu 1977: Welu, James A. "Job Berckheyde's 'Baker.'" *Worcester Art Museum Bulletin* 6 (May): 1–9.

Van Wessem 1957: Van Wessem. "Jan Steen (1626–1679): Het Oestereetstertje." *Openbaar Kunstbezit* 1: 7a–7b.

Westermann 1995: Westermann, Mariët. "Jan Steen, Frans Hals, and the Edges of Portraiture." *Nederlands Kunsthistorisch Jaarboek* 46: 298–331.

Westermann 1996a: Westermann, Mariët. "How Was Jan Steen Funny? Strategies and Functions of Comic Painting in the Seventeenth Century." Jan Bremmer and Herman Roodenburg, eds. *A Cultural History of Humour from Antiquity to the Present.* Cambridge.

Westermann 1996b: Westermann, Mariët. *A Wordly Art: The Dutch Republic 1585–1718.* New York and London.

Westermann 1996c: Westermann, Mariët. "The Amusements of Jan Steen." Ph.D. diss., New York University.

Van Westrheene 1856: Van Westrheene, Tobias. *Jan Steen: Étude sur l'art en Hollande.* The Hague.

Van Westrheene 1864: Van Westrheene, Tobias. *Jan Steen: Historisch-romantische Schetsen.* Leiden.

Weston 1974: Weston, Wallace. "A Marriage at Cana by Jan Steen." *Quarto* 3 (July): unpaginated.

Van de Wetering 1991: Van de Wetering, Ernst. "Rembrandt's Manner: Technique in the Service of Illusion." In Berlin 1991: 12–39.

Van de Wetering 1993: Van de Wetering, Ernst. "Het satijn van Gerard Ter Borch." *Kunstschrift* 37 (November–December): 28–37.

Weyerman 1729–1769: Weyerman, Jacob Campo. *De levens-beschrijvingen der Nederlandsche konst-schilders en konst-schilderessen.* 4 vols. The Hague and Dordrecht.

Wheelock 1995: Wheelock, Arthur K., Jr. *Vermeer and the Art of Painting.* New Haven and London.

White 1982: See Royal Collection 1982

Widener 1885–1900: *Catalogue of Paintings Forming the Collection of P.A.B. Widener, Ashbourne, near Philadelphia.* 2 vols. Paris.

Wijsenbeek-Olthuis 1987: Wijsenbeek-Olthuis, T. *Achter de gevels van Delft.* Hilversum.

Wilenski 1945: Wilenski, R. H. *Dutch Painting.* London.

Wind 1995: Wind, B. "A Quaker in Jan Steen (*Beware of Luxury*)." *Source-Notes in the History of Art* 14 (Winter): 30–34.

Wittkower and Wittkower 1963: Wittkower, Rudolf, and Margot Wittkower. *Born under Saturn: The Character and Conduct of Artists: a Documented History from Antiquity to the French Revolution.* London.

Wood 1993: Wood, Christopher S. *Albrecht Altdorfer and the Origins of Landscape.* Chicago.

Woordenboek: *Woordenboek der Nederlandsche taal.* 25 vols. The Hague and Leiden. 1882–1991.

Wright 1988: Wright, Christopher. *Catalogue of Foreign Paintings from the de Ferrieres Collection and Other Sources.* Cheltenham.

Ydema 1991: Ydema, Onno. *Carpets and Their Datings in Netherlandish Paintings 1540–1700.* Zutphen.

Zöllner 1992: Zöllner, F. "'Ogni pittore dipinge sé': Leonardo da Vinci and Automimesis." 137–160. In *Der Künstler über sich in seinem Werk: Internationales Symposium der Bibliotheca Herziana Rom 1989.* M. Winner, ed. Weinheim.

Zumthor 1959: Zumthor, Paul. *La vie quotidienne en Hollande au temps de Rembrandt.* Paris.

Zwigtman 1840: Zwigtman, C. *Levens-bijzonderheden van Jan Steen, geschetst in twee zangen.* Tholen.